COLLECTING BY DESIGN

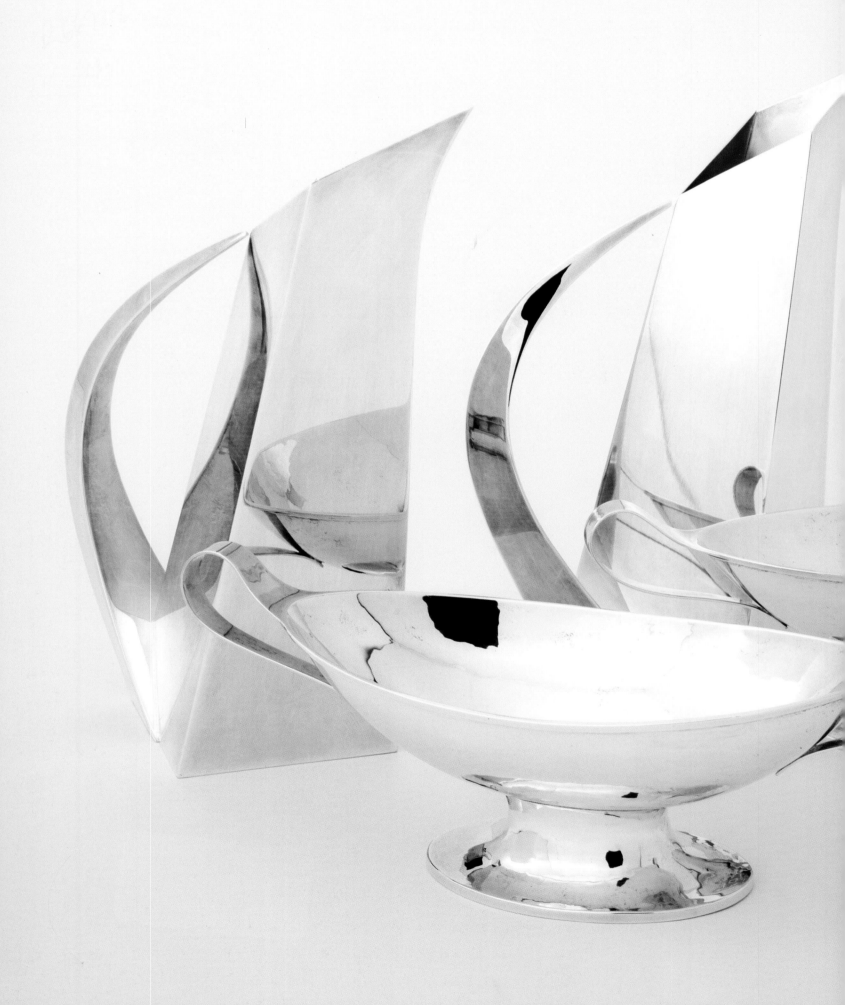

COLLECTING BY DESIGN

Silver and Metalwork of the Twentieth Century
from the
MARGO GRANT WALSH COLLECTION

Timothy A. O'Brien
with
Margo Grant Walsh

Introduction by Cindi Strauss

The Museum of Fine Arts, Houston

Distributed by Yale University Press, New Haven and London

This book accompanies the exhibition
*Designed by Architects: Metalwork from
the Margo Grant Walsh Collection*, organized
by the Museum of Fine Arts, Houston,
and presented there from March 15 to
August 3, 2008.

Generous funding for the exhibition
was provided by Gensler.

Generous funding for the book was provided
by Beverly H. Bremer, Roy J. Zuckerberg,
and an anonymous donor.

All case and individual photographs are the
property of Margo Grant Walsh and are
reproduced with her permission. The objects
illustrated on pages 5, 9, 11, 31, 35, 41, 51,
79, 91, 113, and 133 that are designated
as the property of the Portland Art Museum
are reproduced with its permission.

Photography: Paul Foster
Graphic Design: Carlo Macaione,
with Phenon Finley-Smiley
Index: Kay Banning

Distributed by Yale University Press,
New Haven and London
www.yalebooks.com

Cover illustrations: (front) *Beaker* (2003),
Wally Gilbert, sterling silver, parcel gilt, and
moonstones; (back, clockwise from top) *Spoon*
(c. 1915), unknown maker, sterling silver and
moonstone; *Container* (1915), Grann & Laglye,
sterling silver and amber; *Dish* (c. 1970), Thune,
sterling silver and enamel; all objects from
the Margo Grant Walsh Collection.

Title page: Pitchers (c. 1970s–1980s), Pampaloni,
sterling silver; *Pair of compotes* (c. 1920),
Mulholland Bros., Inc., sterling silver; all objects
from the Margo Grant Walsh Collection.

Library of Congress Cataloging-in-Publication Data
O'Brien, Timothy A.
Collecting by design : silver and metalwork of the
twentieth century from the Margo Grant Walsh
collection / Timothy A. O'Brien, with
Margo Grant Walsh ; introduction by
Cindi Strauss.
 p. cm.
Issued in connection with the exhibition
Designed by Architects: metalwork from the
Margo Grant Walsh collection, organized by the
Museum of Fine Arts, Houston, and presented
there from March 15 to August 3, 2008.
Includes bibliographical references and index.
Summary: "Margo Grant Walsh is an award-
winning interior architect with an impeccable
eye for collecting silver. She has amassed an
unparalleled collection of more than 800
exquisitely designed and beautifully crafted
pieces of silver and metalwork by internationally
acclaimed artists and workshops. This book is the
first to document her collection"—
Provided by publisher.

ISBN 978-0-300-13892-4 (pbk. : alk. paper)
1. Silverwork—Private collections—
United States—Exhibitions.
2. Art metal-work—Private collections—
United States—Exhibitions.
3. Architect-designed art metal-work—
History—20th century—Exhibitions.
4. Walsh, Margo Grant—
Art collections—Exhibitions.
I. Walsh, Margo Grant.
II. Strauss, Cindi.
III. Museum of Fine Arts, Houston.
IV. Title.
NK6410.O27 2008
739.2'37420747641411—dc22
2007049717

Printed in Italy by Arti Grafiche Amilcare Pizzi

CONTENTS

Foreword VI
Blake Summers

Preface VII
Peter C. Marzio

A Collector's Quest VIII
Margo Grant Walsh

Acknowledgments X

Introduction to the Margo Grant Walsh Collection XII
Cindi Strauss

ENGLISH ARTS AND CRAFTS 1

AMERICAN ARTS AND CRAFTS 29

LEGACY OF THE ARTS AND CRAFTS MOVEMENT 53

SCANDINAVIAN STYLE 67

THE MODERNIST IMPULSE 93

MEXICAN AND AMERICAN INDIAN SILVER 111

CONTEMPORARY SILVER FROM THE UNITED KINGDOM 119

Select Bibliography 135

Index 136

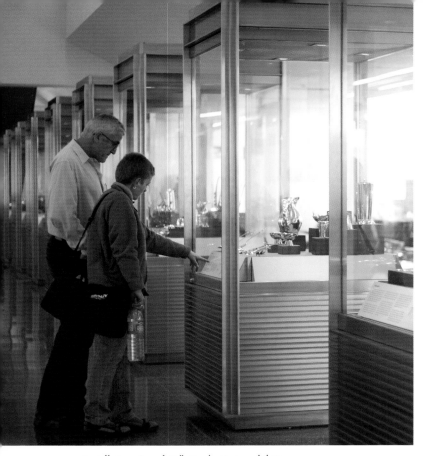

Installation view of *Collecting by Design* exhibition
at the San Francisco Airport Museums.

FOREWORD

Art Museum in 2002 and 2003. We realized that the breadth and
diversity of her collection could not be conveyed in one gallery
alone; therefore, two galleries of forty cases were dedicated to the
exhibition. We were pleased to give Grant Walsh the opportunity
to display an unprecedented number of her beautiful works of art
in one place and at one time.

We enjoyed collaborating with Grant Walsh on selecting and
organizing the work to be exhibited. Her strong sense of how
her collection should be viewed, coupled with her professional
experience in design, was invaluable. Grant Walsh's silver was
often grouped or paired to afford new insights, reveal diverse
influences, and, at times, invite conjecture. The interconnection
of designers and craftsmen from different parts of the world
and across several generations was striking.

Margo Grant Walsh's collection is refreshingly different from
others. There is an organic nature to it that is clearly the result
of someone who delights in the process of identifying significant
pieces of superior design. Many of her acquisitions, especially
those of the Arts and Crafts movement, were made at a time that
predates the current widespread appreciation of twentieth-century
fine silver and metalwork.

The exhibition *Collecting by Design* has served to enlighten all of
us at the San Francisco Airport Museums on the motivations
and process of an astute and passionate collector.

Blake Summers
Director and Chief Curator
San Francisco Airport Museums

We were delighted when Margo Grant Walsh first approached us
with the idea of exhibiting her extraordinary collection of silver
and metalwork. She was familiar with our exhibitions program
from her frequent visits to San Francisco, and she has long-stand-
ing affections for the city in which she launched her prominent
career as an interior architect. Grant Walsh expressed a desire to
share her collection with a diverse audience that might not other-
wise attend an exhibition of fine silver in a traditional museum.
We agreed that the galleries of the International Terminal at
the San Francisco Airport Museums (SFO) were ideal for work
collected from around the world, reflecting design trends and
artistic movements that spanned the twentieth century.

Twenty-five years of collecting had resulted in the acquisition
of more than eight hundred pieces, which were dispersed between
Grant Walsh's homes in Portland, Oregon, and New York City.
Furthermore, a portion of her silver was donated to the Portland

PREFACE

It started as a job. Margo Grant Walsh, a trailblazer in the field of architecture and interior design, was enlisted to design a display case for a client's American seventeenth-century silver tankard. As one of the principals at the prominent firm of Gensler, Grant Walsh was more than equipped for the assignment, and yet this one took her by surprise—and took her in a completely new direction. This singular object ignited an interest that would lead her on a personal quest to build a rare collection of silver and metalwork, which runs the gamut from the nineteenth century to the present.

What makes Margo Grant Walsh's collection of special interest is its diversity. The stature or biography or nationality of the designer is not Grant Walsh's main criterion, although her impressive collection reads like a who's who of craftsmen and metalsmiths. Whether the works date from the early 1900s or were designed only a few years ago, they are honest forms made of honest materials, and they speak to each other across the various time periods and traditional classifications that are described in this book.

With her eye for excellence, Grant Walsh naturally is attracted to objects that are exquisitely designed and impeccably well crafted. They are also 100 percent functional.

Architect-designed metalwork is a recurring theme of this international collection and will be the subject of a focus exhibition opening this March at the Museum of Fine Arts, Houston.

We wish to thank Beverly H. Bremer, Roy J. Zuckerberg, and an anonymous donor for underwriting this book, which is the first to offer a comprehensive overview of Margo Grant Walsh's collection. Ms. Grant Walsh's mantra is that great design speaks a universal language. Perhaps you will find within these pages a work that sparks your own passion, and that speaks directly to you the way that elegant tankard first spoke to Margo Grant Walsh.

Peter C. Marzio
Director
The Museum of Fine Arts, Houston

Beginning with my first Basic Design courses at Portland State College's night school in the late 1950s, my focus and career have been trained on three-dimensional design of corporate interiors for business, law, banking, and financial clients.

About halfway into my forty-four-year career, having pioneered offices in New York, Boston, Washington, D.C., and London, for Gensler, I realized my professional focus had moved from hands-on design to management, marketing, and mentoring. It required multitasking for a surfeit of quality clients; thankfully, I had wonderful teams of young professionals and partners to support my efforts.

Leadership can be a daunting responsibility, and a solitary one, despite the demand to be constantly engaged in one's work. I needed an outlet for those few quiet hours I could claim as my own. Collecting came to mind, as did decorative arts. When pursued and cultivated, an unspoken passion can lead to opportunities farther afield.

I arrived at collecting silver by a fluke. In 1981, when I was managing principal of Gensler New York, I helped an important Wall Street client design his private office. He asked if my team of interior architects could design a pedestal and Plexiglas cover to display a piece of silver from his outstanding personal collection. I was intrigued. One Sunday afternoon, two weeks later, I attended a Sotheby's silver auction preview in New York. My Wall Street client Roy Zuckerberg was there, studiously perusing the lots of seventeenth- and eighteenth-century American, English, and Continental silver. He handled a couple of pieces, commenting on their marks and fine craftsmanship, and endeavored to educate me on their provenance. I bought the auction catalogue and soon realized I was in investment banker's territory. The items far exceeded my modest budget, and I was not in love with the objects. They were not me.

Two weeks later I attended my first New York Pier Antiques Show, where I met Rosalie Berberian, who would become a mentor. She had assembled a wonderful collection of American Arts and Crafts silver and jewelry. The pieces were beautifully designed, impeccably crafted, functional, and affordable. Soon, thanks to Rosalie, Kalo, Arthur Stone, Jarvie, Mulholland Bros., Lebolt, and Marcus became familiar names. The silver bug had bitten!

During the next twenty-three years of my professional career, I took advantage of every rare day off to nurture my growing passion. On business trips to London, which averaged eight a year for eight years, I sought out dealers and attended flea markets and Sunday afternoon London hotel shows to enhance my burgeoning knowledge of twentieth-century silver. On my visits, I stayed at a then modest hotel two blocks from the Victoria and Albert Museum, which became my private viewing venue. I also did not miss an opportunity to attend premier antique shows and visit museum exhibitions, building my collection in the process.

While in London in 1984 I met Nicholas Harris, who became my other important mentor. Nick educated me about the British objects and artisans associated with the Arts and Crafts movement and metalwork there, opening new avenues in my education. I learned of the many similarities the British objects shared with my American Arts and Crafts pieces, but they were different.

I never missed the chance to visit the jewelry stores on Regent Street. A young dealer at Garrard's, Andrew Teiden, introduced me to estate silver, then relegated to the rear cases in the shop. Soon I acquired pieces by Ramsden and Carr, A.E. Jones, and Guild of the Handicraft. I put my acquired knowledge to work when I went to the flea markets or to Portobello Road, Alfie's, Camden Passage, and the King's Road shops, expanding, adding to, and deepening my collection.

My interest in copper, white metal, mixed metals, and jewelry began in the mid-1980s. Most of the pieces I acquired at that time were unmarked, and I was intent on learning about their makers and origins. Were they unknown or just obscure or "training pieces"? These examples of metalwork were exquisitely well crafted and beautifully designed but also without marks or provenance. They were mysteries I was intent on eventually solving.

One afternoon in 1990, a client finally dragged me to the famed London Silver Vaults in the heart of the City's legal and financial district. I was overwhelmed. After this visit I set off in search of twentieth-century treasures typically buried in the Vaults. In the late twentieth century, many great pieces languished in obscurity in that vast silver bazaar.

By the early 1990s, my focus shifted from British and American Arts and Crafts to a more global array of objects of twentieth-

"A piece of silverwork to be really interesting must be endued with a Spirit of Art..."

— Designer and silversmith Albert Edward Jones
Birminham, England, 1906

century metalwork. I began to acquire Mexican, Scandinavian, Austrian, German, and Italian pieces of the mid-twentieth century and later. I was fascinated by the apparent stylistic affinities across diverse cultures and countries. Silver was truly a global art/craft form and at the time still affordable.

In 2002 the Portland Art Museum sponsored my first exhibit, comprising 250 objects from my U.S. and U.K. twentieth-century silver and metalwork collection. In 2002, I began to travel extensively to museums and visited personal collections of silver with serious collectors, professional appraisers, and museum curators under the guidance of Elenor Alcorn and Christopher Hartop.

At the close of the twentieth century, having moved on from Gensler, and with time to focus, I realized I had assembled an important collection of simple, functional, and well-designed silver, metalwork, and jewelry. This collection now numbers more than one thousand works and is housed in five different locations on opposite coasts.

The twenty-first century has heightened enthusiasm for decorative arts of the twentieth century. I believe I am well positioned to contribute to knowledge about silver and metalwork from this amazing century. Although I am not a scholar, a curator, or an expert—I am merely a self-educated collector—I have an enduring passion for this marvelous medium of metals. I do have an overwhelming regret—my lack of languages. I have built a library filled with countless books in languages that I cannot decipher. Yet I learn from the photography and artisans' names. After all, great design is a universal language.

And I believe that great design speaks to everyone. I was able to test this philosophy recently. My first employer, in 1960, was Skidmore, Owings & Merrill in San Francisco. The firm in 2001 completed the soaring, modern International Terminal at the San Francisco International Airport, finished in grey and white marble and granite with polished stainless accents. Cool, crisp, and elegant—a wonderfully complementary venue to exhibit my collection.

San Francisco International Airport was the first airport museum to have received accreditation from the American Association of Museums. The professional staff at the San Francisco Airport Museums helped me to mount an exhibition in 2007 of nearly

five hundred pieces from my collection. Supplementing my personal loan was a selection of thirty-two works I gifted to the Portland Art Museum in 2002 and 2003.

The objects exhibited in 2007 were created by artists from sixteen countries spanning the late 1880s through 2003. The exhibit was potentially seen by over one hundred thousand passengers, crew, staff, and visitors as they departed San Francisco. It was fitting that a global collection should be presented to travelers headed to their international destinations. I am grateful to Blake Summers, director, chief curator, and leader of a superb team of professionals; the talented Abe Garfield, who was curator and exhibition designer (he thought the Margo red/orange silk was great with the silver and other metalwork); Barbara Geib, the meticulous and helpful registrar; and Timothy A. O'Brien, curator, who is a superb and creative writer. He reduced my thoughts, comments, and dictations to their essence. They and their outstanding colleagues were wonderful, collaborative partners (even as they occasionally chided me for not wearing protective gloves when handling my own silver).

I am pleased now to collaborate with the Museum of Fine Arts, Houston, on this publication, which is the first to document part of my collection and is intended to serve as a companion to the museum's focused exhibition titled *Designed by Architects: Metalwork from the Margo Grant Walsh Collection*, to be presented from March to August 2008. The museum has been in the forefront of collecting decorative arts on a visionary level and has built an outstanding collection of furniture and decorative arts by architects. This collection, which is funded by the local design community, should be a model for every fine museum.
I wish to thank Peter C. Marzio, director of the museum; Cindi Strauss, curator of modern and contemporary decorative arts and design; and Jack Eby, exhibition design director, for their steadfast support. Also, I want to thank Diane Lovejoy, publications director, for her insight into and enthusiasm for the project, and Yale University Press for its keen interest in distributing this book to the widest and most appreciative audience possible.

Margo Grant Walsh

ACKNOWLEDGMENTS

This catalogue is made possible through the generosity of Beverly Bremer (Atlanta) and Roy Zuckerberg (New York), friends and devotees and collectors of silver, and through the guidance of Peter Marzio, director of the Museum of Fine Arts, Houston (MFAH).

It is due to the efforts of the MFAH, especially Cindi Strauss and her team, Jack Eby, and Diane Lovejoy, that this catalogue became a reality. Cindi and Jack visited San Francisco to view the very extensive San Francisco Airport Museums exhibition *Collecting by Design* and understood its value and potential as the smaller MFAH exhibition, *Designed by Architects: Metalwork from the Margo Grant Walsh Collection.*

There were times when the doubt and frustration with presenting my collection on the scale of the show in San Francisco led me to believe the exhibition would not happen. It was a great challenge for a solo collector to undertake this mission without an inventory, photographs, professional assistance, appraisals, sponsor, curator, or academic credentials. So it seemed a minor miracle when *Collecting by Design* opened in February 2007 (running until August 2007). I am indebted to the many people who believed in me.

I am especially grateful for the contributions of the wonderful professional staff at the San Francisco Airport Museums who collaborated with me—a collector—especially Blake Summers, Abe Garfield, Barbara Geib, Timothy A. O'Brien, and their superb support staff, especially Candis Hakim, Carson Murdach, and Nancy Mintz. A special thanks to my patient, talented, and undaunted Portland photographer, Paul Foster.

In the last weeks of 2006, many volunteers helped with the care, logistics, and organization of celebrating this vast array of silver and metal objects; they include Hiloria Arbruccias, Tom Baione, Jean Caramatti, Frances Coyne, Colette Dolan, Judy Grahn, Robin Huffman, Becky Kelly, Shih Hua Liong, Mariella Sabillon, and Stefanie Shunk. I could not have managed the collection without the help of Elizabeth Gee, an ex-colleague and Gensler tech whiz who supported me with Microsoft Excel to sort, sift, move, and manipulate the entirety of the collection. On top of her full-time job, Elizabeth was willing to suspend her showcase acting career on my behalf. She knew, on my own I could only get myself in software chaos. All of these helpers gave me the confidence to persevere. There was no question that I had the will.

My Gensler/Houston colleagues, especially Marilyn Archer, Jim Furr, and Carlo Macaione, the book designer from the Gensler/Houston office, were immeasurably instrumental in their support of my endeavors and my introduction to the MFAH. Carlo lent his considerable experience and creativity to the design and layout of the catalogue.

Of course, I owe a debt of gratitude to those special friends who encouraged me when I was at my most doubting: Ralphe Baker, Andrew Belshner, James E. Best, Didier Haugspaugh, Katrina Kostic Samen, Anne Kriken, Penny and Fred Lyon, Bud Luther, David Mann, Dick Maxwell, Naoma Tate, Bill Van Erp, Suki and Bill Weir, Diane West, and Dan Winey.

The public exhibition of my collection of twentieth-century silver began in Portland, Oregon, in 2001. I owe a special thanks to the "godparents" of my collection, John and Lucy Buchanan and the Board of the Portland Art Museum (PAM), especially Arlene and Harold Schnitzer. Through my personal attorney, Pierre Merle, they visited my New York apartment in 2001 and decided to mount my first public exhibition in 2002. The PAM team that made the first and second modest exhibitions of my collection successes were Anne Eichelberg, Bruce Guenther, Marcella Peterson, Prudence Roberts, and Don Urquhardt.

As a full-time high-profile professional designer and a part-time silver fan, over the last seven years I have been fortunate to meet many collectors, professionals, writers, and allies in the world of silver, publishing, and the decorative arts. All contributed to my body of knowledge and have an enduring commitment to silver and design of the twentieth century. Globally located, they include Neils and Karen Andersen, Jane Avery, Dorothea Burstyn, Elissa and Paul Cahn, Lisa Funder, Alex Goriansky, Leslie Greene Bowman, Chris Hartop and Juliet Nusser, Lisa Koenisberg, Annelies Krekel-Aalberse, James McConnaughy, Barbara Missett, Chris Miers, Fern Prosnitz, Jewel Stern, William Stout, Kevin Tucker, Peggy Loar Voorhees, Beth Wees, Janet Zapata, and especially Philippa Glanville, who encouraged me solely via e-mail. Their encouragement, friendship, and guidance were invaluable in keeping me going.

And, of course, I am indebted to the world of dealers and appraisers who trained me in many of the intricacies of provenance and production necessary for a collector such as I, who was focused mainly on "design." They include Art 1900, Aram Berberian, Wolfgang Bauer, Rosalie Clausson, John Featherstone-Harvey, Nathan Horowicz, James Infante, Don Kelly, Peter Kassai, Richard Kurtzman, Nat Leslie, Spencer Marks, Greg Nanamura, Greg Pepin, Ira Portnoy, Max Protech, Leah Roland, Andrew Teiden, Sandy Stanley, Carole and Jan Van Den Bosch, Gene Waddell, Michael Weller, and Louis Wine. I was also assisted by the anonymous dealers in Camden Passage, Portobello Road, and the London Silver Vaults. They may not have understood why I was not more interested in provenance, weight, and marks, but we found common ground when it came to the craftsmanship, function, and beauty of the objects.

My professional design career and passionate silver collecting were first brought to the public's attention by some great individuals in the design press, including Stanley Abercrombie, Eve Kahn, Barbara McCarthy, Wendy Moonan, Beverly Russell, Andrea Truppin, Isabel Venero, Pilar Vilados, and Ricardo Zapata. One cannot undertake a project of the magnitude of a public exhibition without the guidance of a legal and financial team. Thank you to Arthur Getz, Charles Haynor, Joan Hill, and Stephen Nakamura, Esq.

I want to conclude by offering my gratitude to Rosalie Berberian and Nicholas Harris for their friendship, knowledge, generosity, and inspiration. They started me on my journey by grounding me in American and English Arts and Crafts silver and metalwork. Without that foundation this collection could not exist. Without Beverly's and Roy's friendship and their belief in my efforts, this catalogue would not exist. How can I ever thank you.

Margo Grant Walsh
New York, October 2007

Margo Grant Walsh's collection of metalwork spans the period dating from the late nineteenth century to today: an era of innovation and unbridled creativity in the arts. Her collecting is driven by an abiding belief in the power of design. She has consistently sought exquisitely designed and well-crafted objects whose function is readily apparent. Within these parameters, Grant Walsh has particularly focused her collecting on the diversity of form and aesthetic expression of the arts and crafts movements in America, Great Britain, Denmark, Germany, and Austria, as well as on the arts and crafts legacy that informs later Mexican, Native American, and British pieces.

The roots of the Arts and Crafts movement in Britain—its name was coined in London in 1887—emerged from the growing opposition to the dehumanizing effects of the Industrial Revolution on traditional craft industries. Fearing both the loss of jobs and traditional skills, reformers such as John Ruskin, William Morris, Charles Robert Ashbee, Alexander Fisher, and others attacked the shift toward industrial manufacturing and advocated a return to guild traditions like those established during the Middle Ages. Specifically, guild workers during Medieval times focused on high-quality craftsmanship and created what the reformers described as simple, honest forms made from natural, honest materials. The integrity of the craftsman and his artistic output was paramount to arts and crafts reformers, lending their cause the added dimension of addressing social injustice. The movement found acceptance throughout Europe and the United States, thereby underscoring the commonalities reformers faced across the globe.

The breadth of objects in Grant Walsh's British and American arts and crafts collection dispels the widely held belief that there was one aesthetic style present within the movement. The revival of old techniques such as enameling, hand-raising metal, and the use of cabochon-cut semiprecious stones can be seen in pieces made by Charles Robert Ashbee and the Guild of Handicraft. Folk traditions and Medieval and Celtic patterns appear in the Ramsden & Carr and Liberty & Co. objects. Simple forms featuring mixed metals, cabochon enamels, or repoussé decoration by artisans such as A.E. Jones offer yet another version of the style. Examples of American arts and crafts objects in Grant Walsh's collection highlight this country's focus on expressing the pure beauty of metal.

Whether the works were made in the Boston area, Chicago, or San Francisco, American craftsmen such as Arthur J. Stone, the Kalo Shop, the Mullholland Brothers, Robert Jarvie, Shreve and Company, and Dirk and William van Erp created useful wares that, in addition to their hand-hammered surfaces, often featured Medieval or Celtic lettering, strap work, or stylized natural motifs.

Grant Walsh's collection also provides insight into the global nature of arts and crafts metalwork. In Denmark, the influence of the British arts and crafts movement is best exemplified by the work of Georg Jensen, who established his own silver-smithing shop in 1904. Like Charles Robert Ashbee, Jensen created both holloware and jewelry whose forms bore evidence of handwork through hammer marks and the use of cabochon stones. Although Jensen was looking at Ashbee in regard to aesthetics, his development of a more commercial enterprise necessitated the use of large-scale production techniques and the hiring of designers, as opposed to only working craftsmen, to fulfill the demand. Grant Walsh's collection also contains objects by other important Danish craftsmen and designers from the period, such as Thorvald Bindesbøll, Evald Nielsen, Mogens Ballin, and Karl Gustav Hansen, all of whose silverwork designs bear the aesthetic hallmarks of British reform design.

Recent exhibitions and publications on the international arts and crafts movement have underscored the fact that, regardless of the rhetoric and popularly held beliefs, the arts and crafts was neither anti-industrial nor anti-modern.[1] Its followers idealized the preindustrial past, but they did not fully reject the industrial present.[2] Throughout Britain, the Continent, and America, an alliance developed between the makers and industry, although tension existed between craftsmen who advocated a strict adherence to guild traditions and the preeminence of handwork, and those who believed that applying industrial practices to good design offered freedom and led to greater economic success.

This comfort level with the machine can best be seen in the history of the arts and crafts movement in Germany. Initially influenced by the ideals put forth by Morris, Ruskin, and others, by 1900 German artists began to reject the British emphasis on the handmade. Instead, they focused on the functional

simplicity of the style, ultimately establishing workshops equipped with production technology.[3] These early-twentieth-century workshops, including the artist's colony at Darmstadt, created Modernist objects whose machine-assisted designs received praise and support from government progressives.

Unlike most collectors of arts and crafts metalwork who adhere closely to the prescribed late-nineteenth- to early-twentieth-century time period associated with the movement, Margo Grant Walsh has consistently been interested in how the values of the arts and crafts have been translated into other time periods and cultures. While her connection to Native American cultures was initially through her heritage, the fact that the works to which she was attracted were made by hand in tribal workshops using historical traditions as models certainly is aligned with her interest in arts and crafts ideals. Likewise, Grant Walsh's collection of metalwork and jewelry by William Spratling, Hector Aguilar, and Salvador Vaca Terán speaks to the arts and crafts legacy of workshops and artist colonies in Mexico. Another thread that binds this material to the earlier British and Scandinavian work is the influence of Georg Jensen on William Spratling's design aesthetic. Jensen's adaptation of Ashbee's ideas provides a direct link between the two.[4]

In part, Grant Walsh's inquisitiveness about metalwork today led her to modern and contemporary British silversmiths, such as Gerald Benney and Christopher Lawrence, whose roots as craftsmen reflect their interest in the arts and crafts philosophy as well as their work for industry. Grant Walsh's travel to the annual Goldsmiths' Hall exhibition of contemporary metalwork and jewelry has introduced her to pieces by Wally Gilbert and Graham Leichman Stewart. Their aesthetic recalls the early arts and crafts designs of Ashbee as well as that of the Australian-born but British-trained silversmith Stuart Devlin, whose elaborate, opulent works feature heavily textured or otherwise embellished surfaces.

Although in building her collection Margo Grant Walsh has prioritized the handmade in accordance with the values of the arts and crafts, she has also assembled a small group of production pieces. These works date from the 1930s to today and were often designed by architects. This secondary thread was initially an unconscious one. Because of Grant Walsh's career as an interior architect, she naturally gravitated toward objects whose form and volume appealed to her Modernist eye. In retrospect, the dual themes of architects and architecture pervade the collection: a significant number of the arts and crafts metalwork artists to whom Grant Walsh was initially drawn were trained as architects themselves, as were many of their followers who were active later in the twentieth century. The circle of influence is therefore complete.

Cindi Strauss
Curator of Modern and Contemporary
Decorative Arts and Design
The Museum of Fine Arts, Houston

[1] Wendy Kaplan, "Design for the Modern World," in Wendy Kaplan, *The Arts & Crafts Movement in Europe & America* (London:Thames & Hudson, 2004),12.
[2] Ibid.
[3] Rüdiger Joppien, "Germany: A New Culture of Things," in Kaplan, *The Arts & Crafts Movement in Europe & America*, 72–73.
[4] I am grateful to Christine Gervais, assistant curator of Rienzi and Decorative Arts at the Museum of Fine Arts, Houston, for this observation.

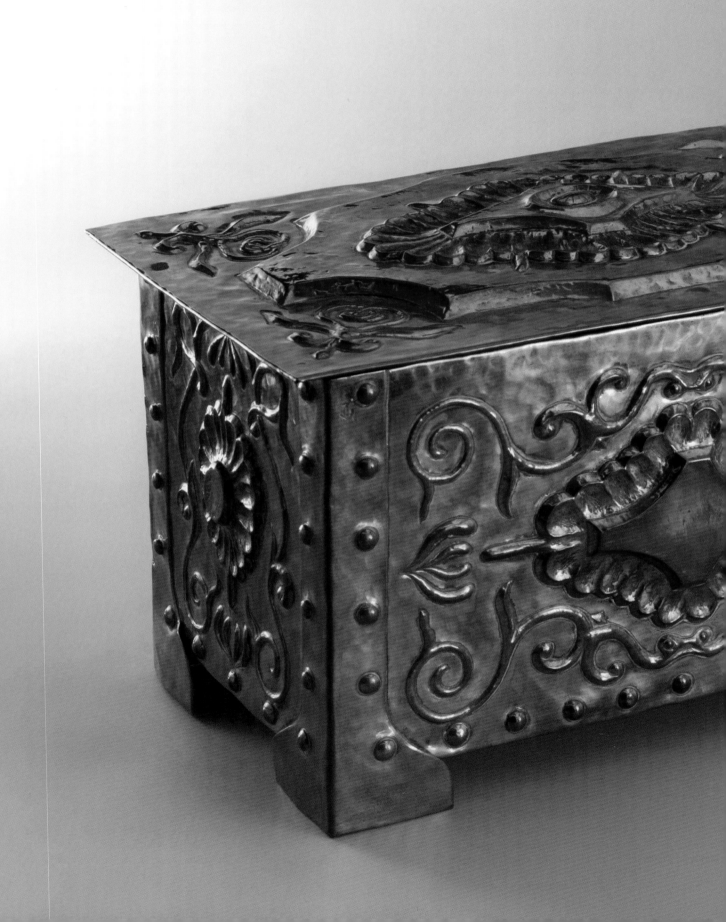

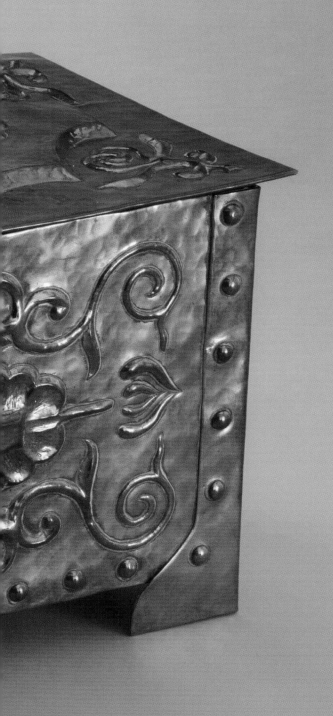

ENGLISH ARTS
AND CRAFTS

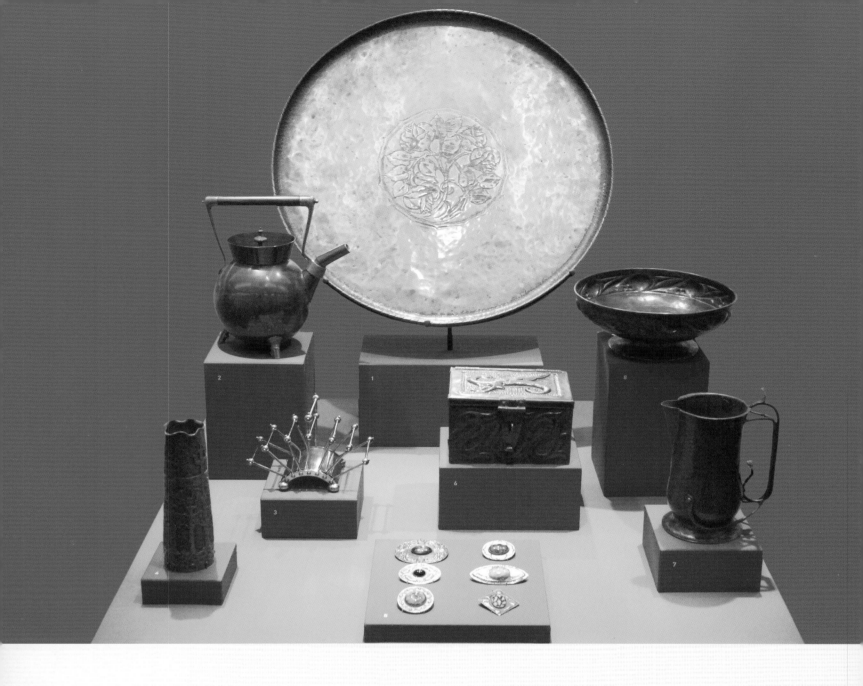

ENGLISH ARTS AND CRAFTS

The Arts and Crafts movement began in England during the Industrial Revolution as a challenge to the dehumanizing direction of the design and manufacture of domestic goods. Additionally, there was a strong artistic impulse to produce an alternative to the perceived fussiness of Victorian styles and cheap industrial ornamentation. Metalwork crafted by artists working in this spirit varies greatly in design and execution. Objects crafted from a diversity of metals may be ornate or unadorned, angular or curved, roughly hammered or planished smooth—yet they are all intended to reflect a philosophy that encouraged clever design and human craftsmanship over industrial manufacturing.

Christopher Dresser's designs (2, 3) were radically different from any contemporary style in the late nineteenth century. His focus on the object's form—rather than its ornamentation—was a precursor to modern designs of the twentieth century. Dresser's work was inspirational to

many early Arts and Crafts metalsmiths who emphasized function and simplicity of design in their work.

John Pearson was one of the four founding members of the influential *Guild of Handicraft* in London. Pearson was a talented artist who designed and crafted many early and influential pieces of Arts and Crafts metalwork. His deeply embossed copper humidor (6) features a winged sea serpent on its lid and a sea snake on its front panel. Pearson's repoussé decoration often featured fantastic images and was emulated by many of his contemporaries.

Coppersmith Hugh Wallis produced exceptional works of beaten copper, pewter, and brass. A large part of Wallis' output comprised heavily hammered copper trays decorated with distinctive floral motifs and patterned rims. Whereas many of the trays have had Wallis' distinctive pewter inlay polished out, much of it remains on this fine example (1).

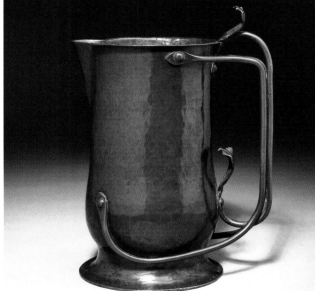

Top: Brooch (1910), by unknown maker, *Number 5*
Bottom: Pitcher (c. 1900), Birmingham Guild of Handicraft, *Number 7*

Case 1

1 **Tray** (1911)
Hugh Wallis (1871–1944)
Manchester, England
copper, pewter inlay
N407N407

2 **Teapot** (c. 1885)
Christopher Dresser (1834–1904)
London, England
copper, brass, wood
N054N054

3 **Letter rack** (1881)
Christopher Dresser (1834–1904)
London, England
sterling plate
N164N164

4 **Vase** (c. 1900)
*Charles Wilmott (active late
19th-early 20th century)*
London, England
pewter
N055N055

5 **Brooches** (c. 1910)
unknown makers
London, England
white metal, Ruskin enamels, stone
N270N270

6 **Humidor** (c. 1900)
John Pearson (active 1885–1900)
London, England
copper, wood liner
N013N013

7 **Pitcher** (c. 1900)
*Birmingham Guild of Handicraft
(1890–1905)*
Birmingham, England
copper
S072S072

8 **Footed bowl** (1900)
unknown maker
England
copper
S123S123

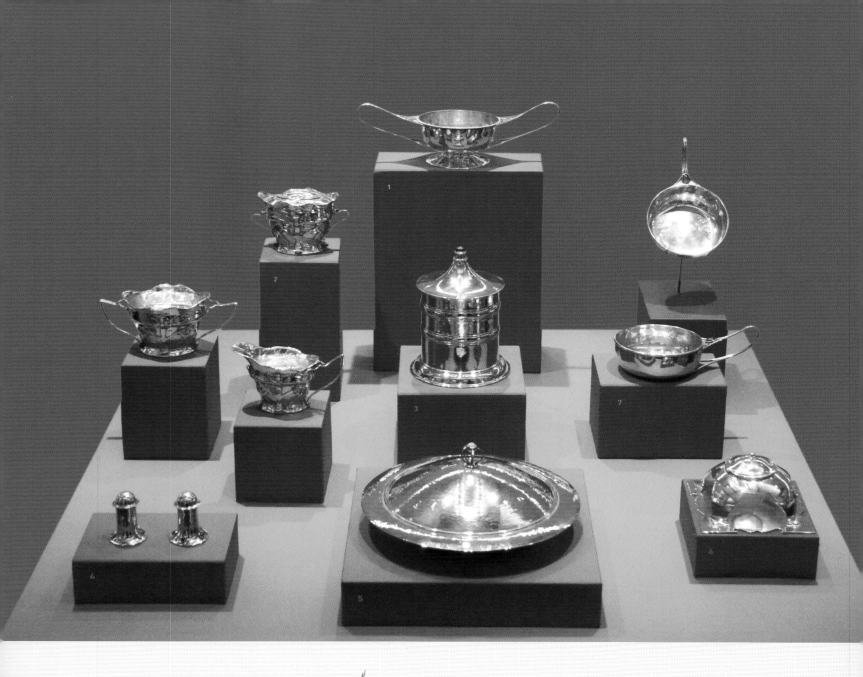

THE GUILD OF HANDICRAFT

During the Arts and Craft movement, a number of designers founded guilds to encourage the ideal of craftsmanship and to train apprentices in metalwork and other time-honored crafts. The *Guild of Handicraft*, established by architect, designer, and author **Charles Robert Ashbee** in London in 1888, was an early and important model that inspired many imitations throughout the world. Ashbee's *Guild* taught silver-smithing to untrained workers and encouraged new craftsmen to realize their own designs. The democratic collective eventually numbered more than seventy workers, and their accomplished work was popular at exhibitions. Ashbee sought to make real his basic principle of "making useful things, of making them well and of making them beautiful; goodness and beauty...synonymous terms."

The *Guild of Handicraft*'s influence on the design and decoration of metal objects was far-reaching, as evidenced by this bowl by *Marcus & Co. of New York* (1). The bowl's curvaceous and elongated handles closely resemble the wirework handles of many of Ashbee's designs (7). Ashbee brilliantly merged medieval forms, techniques, and materials with contemporary design motifs. Ashbee's meticulously handwrought silver pieces are tastefully decorated with stone or glass elements in the bases of salt and pepper casters (4), the lids of a muffin dish (5) and a footed jar (3), and the handles of jam or butter dishes (7).

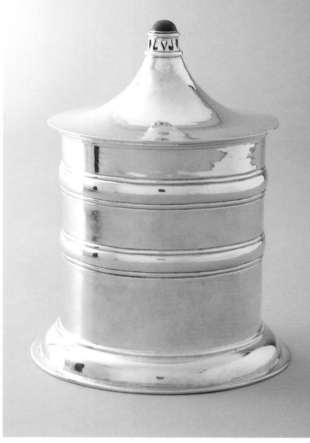

Footed jar with lid (1913), The Guild of Handicraft, *Number 3*

Case 2

1 **Bowl with handles** (c. 1910)
Marcus & Co. (c. 1880–1927)
New York, New York
sterling silver
P069S006

2 **Partial tea service** (1902)
*Birmingham Guild of Handicraft
(1890–1905)*
Birmingham, England
sterling silver
∗ 2001.129.14A–C

3 **Footed jar with lid** (1913)
*The Guild of Handicraft
(London, 1888–1902, 1908–1913/
Chipping Campden, 1902–1908)*
London, England
sterling silver, glass liner, stone
P107P107

4 **Salt and pepper casters** (c. 1900)
*The Guild of Handicraft
(London, 1888–1902,
1908–1913/Chipping Campden,
1902–1908)*
London, England
silver, amethyst, quartz
S037S037

5 **Muffin dish** (c. 1905)
Charles Robert Ashbee (1863–1942)
Chipping Campden, England
silver plate, turquoise
P106S012

6 **Inkwell** (1902)
*Birmingham Guild of Handicraft
(1890–1905)*
Birmingham, England
sterling silver, glass liner
∗ 2001.129.13A,B

7 **Pair of jam or butter dishes** (1905)
*The Guild of Handicraft
(London, 1888–1902,
1908–1913/Chipping Campden,
1902–1908)*
London, England
sterling silver, carnelian cabochons
P124S018

∗ *Courtesy of the Portland Art Museum,
The Margo Grant Walsh 20th Century
Silver and Metalwork Collection*

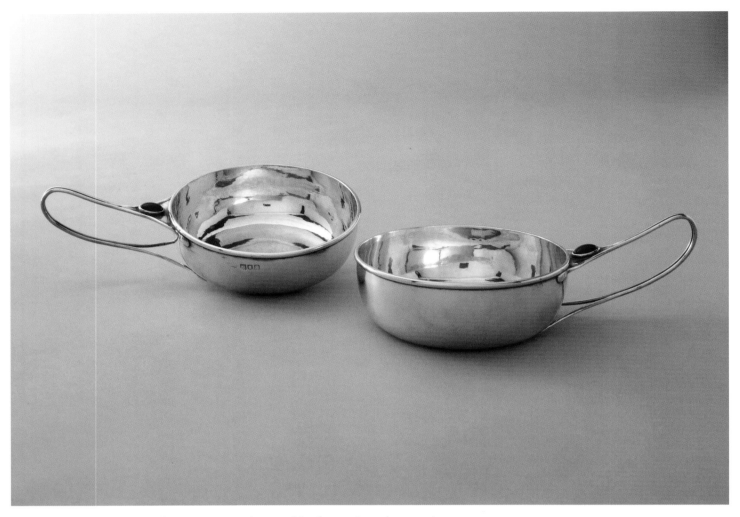

Pair of jam or butter dishes (1905), The Guild of Handicraft, *Number 7*

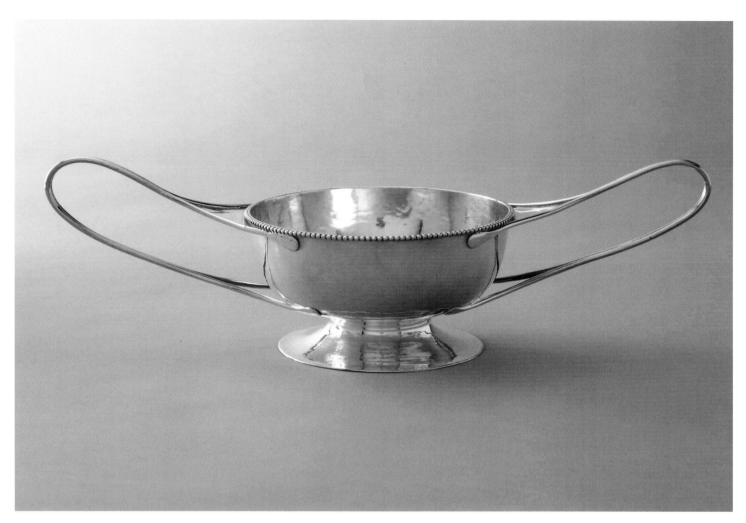

Bowl with handles (c. 1910), Marcus & Co., *Number 1*

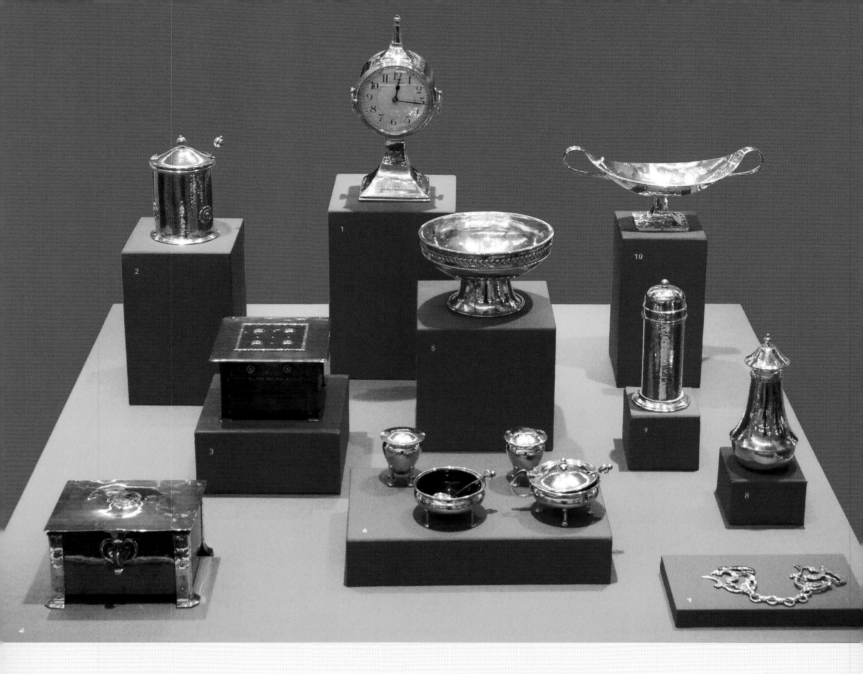

ALBERT EDWARD JONES

Designer and silversmith **Albert Edward Jones** developed a reputation as an extremely innovative craftsman while training at the *Birmingham Central School of Arts*. He was influenced by the Arts and Crafts movement while working at the *Birmingham Guild of Handicraft* and started his own shop in 1902. Early success attracted a number of prominent artists such as W. Howson Taylor (founder of Ruskin Pottery), A. J. Gaskin, Bernard Cuzner, and A. S. Dixon to his operation. Jones produced a number of ecclesiastical pieces and presentation silver as commissions for cathedrals, schools, and individuals throughout England.

Jones' designs of jars (2), condiment sets (6), and casters (8, 9) are refined and thoroughly modern. Their heavy hammer marks and restrained ornamentation reflect the craftsmanship and simplicity of design for which Jones was known. The accomplished manner in which he mixed metals resulted in spectacular pieces that were architectural and elegant. This copper jewelry box (3) is intricately decorated with silver bands and one of his favorite motifs, individual flowers. One of Jones' many innovations was a process for enriching the color of copper alloy. The resulting color produces a wonderful contrast on this box (4) with sterling silver legs riveted at the corners. The lid is set with a beautiful green cabochon.

Box (1902), Albert Edward Jones, *Number 4*

Case 3

1 **Presentation clock** (1929)
Albert Edward Jones
(1879–1954)
Birmingham, England
sterling silver, glass
*2001.129.09

2 **Condiment jar** (c. 1913)
Albert Edward Jones
(1879–1954)
Birmingham, England
sterling silver, glass liner
*2001.129.02A-D

3 **Jewelry box** (c. 1900)
School of Albert Edward Jones
Birmingham, England
copper, silver, velvet liner
P133S078

4 **Box** (1902)
Albert Edward Jones
(1879–1954)
Birmingham, England
sterling silver, copper,
enamel cabochon
P132M008

5 **Raised bowl** (1916)
Designed by Albert Edward Jones
(1879–1954)
Birmingham, England
sterling silver
*2001.129.03

6 **Condiment set** (1913)
Albert Edward Jones
(1879–1954)
Birmingham, England
sterling silver
*2001.129.11A-H

7 **Cloak clasp** (1906)
unknown maker
Birmingham, England
sterling silver
N287N287

8 **Caster** (1926)
Albert Edward Jones
(1879–1954)
Birmingham, England
sterling silver
*2001.129.06A,B

9 **Caster** (1921)
Albert Edward Jones
(1879–1954)
Birmingham, England
sterling silver
*2001.129.05A,B

10 **Compote** (1912)
Albert Edward Jones
(1879–1954)
Birmingham, England
sterling silver
*2001.129.01

*Courtesy of the Portland Art Museum,
The Margo Grant Walsh 20th Century
Silver and Metalwork Collection

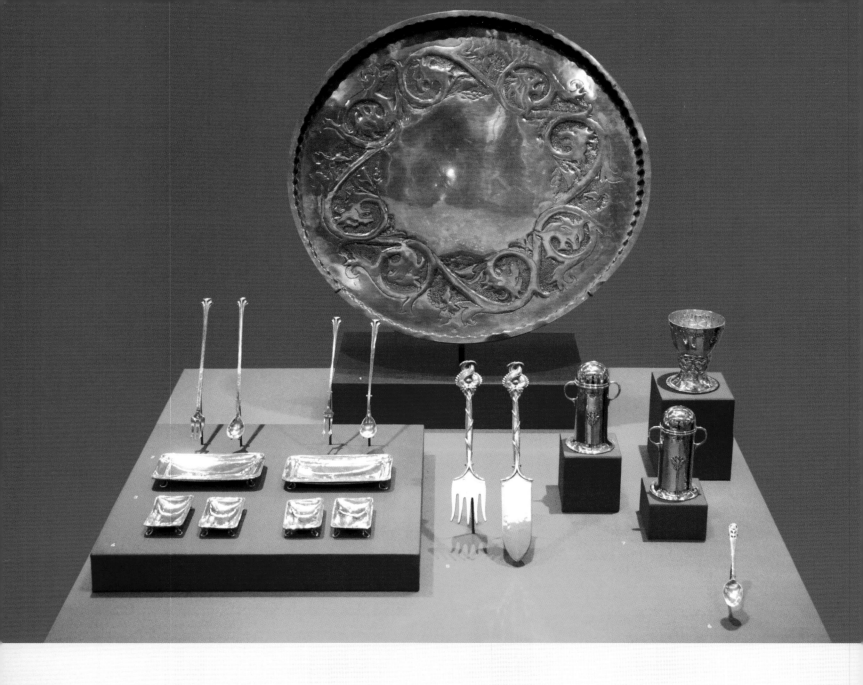

Omar Ramsden

Omar Ramsden, the son of a silver manufacturer, met Alwyn Carr while both were attending evening classes at *Sheffield School of Art* in 1890. Ramsden and Carr continued their studies at the *Royal College of Art* in London where they established a partnership to produce finely crafted silver in 1898. Their designs, influenced by Gothic and Renaissance forms and motifs, were crafted with the assistance of skilled artisans. One of their trademarks was the use of Celtic-style inscriptions to decorate objects such as this goblet (8). While Ramsden and Carr produced a great deal of ornate silver work for ecclesiastical use, they also designed elegantly simple forms (3, 4) in the mode of Arts and Crafts. Omar Ramsden and Alwyn Carr dissolved their partnership in 1919 and proceeded to produce distinctive work separately, such as these sterling pickle utensils and fish servers (2, 5) by Omar Ramsden.

In the latter part of the nineteenth century, the *Keswick School of Industrial Arts* was established in northern England to instruct students in the traditional arts of spinning, woodcarving, and metalwork. The *Keswick School* was modeled on medieval guilds and the belief that the lives of working people are improved through craft. *Keswick* quickly developed a national reputation for the quality of its metalwork—particularly that of copper, which had been mined locally for centuries. This brass tray (1) features a repoussé design that reflects the Norse heritage of the area.

Bernard Instone was only twelve years old when he was awarded a scholarship to the *Central School of Arts and Crafts* in Birmingham. He designed and crafted silver pieces and often produced jewelry for commission. Instone's hammered spoon (6) features a delicate rose design typical of his decorations inspired by nature.

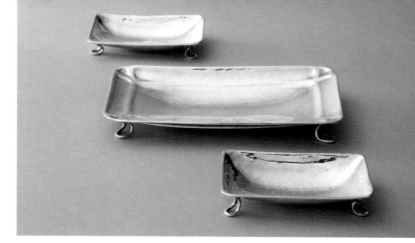

Condiment dishes (1913), Omar Ramsden and Alwyn Carr, *Numbers 3 and 4*

Case 4

1 **Tray** (c. 1905)
Keswick School of Industrial Arts
(1884–1984)
Keswick, England
brass
N408N408

2 **Pickle and olive set** (1938)
Omar Ramsden (1873–1939)
London, England
sterling silver
P164N049

3 **Condiment dishes** (1913)
Omar Ramsden (1873–1939)
and Alwyn Carr (1872–1940)
London, England
sterling silver
P167N047

4 **Condiment dishes** (1913)
Omar Ramsden (1873–1939)
and Alwyn Carr (1872–1940)
London, England
sterling silver
P168N048

5 **Fish servers** (1939)
Omar Ramsden (1873–1939)
London, England
sterling silver
P165N046

6 **Spoon** (1935)
Bernard Instone (1801–1987)
Birmingham, England
sterling silver
NXXXNXX1

7 **Salt casters** (1912)
George Lawrence Connell & Co.
(c. 1902–date unknown)
Birmingham, England
sterling silver
P166N261

8 **Goblet** (1901)
Omar Ramsden (1873–1939)
and Alwyn Carr (1872–1940)
England
sterling silver
*2001.129.16

*Courtesy of the Portland Art Museum,
The Margo Grant Walsh 20th Century
Silver and Metalwork Collection

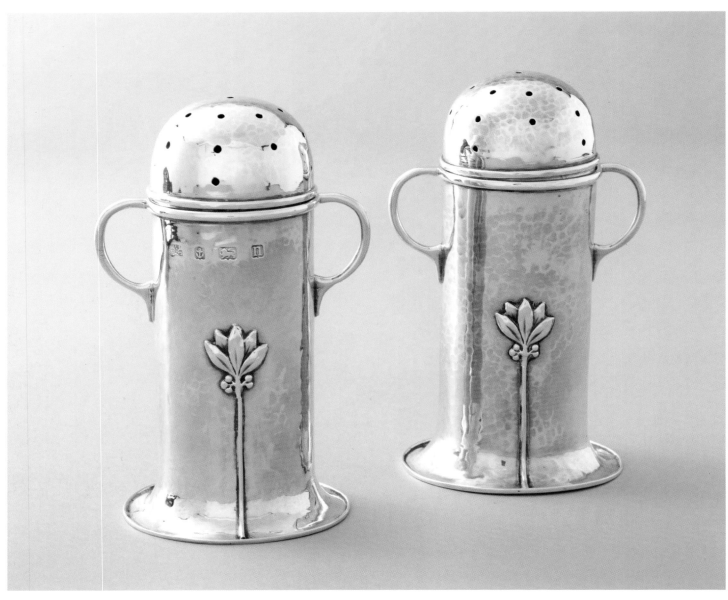

Salt casters (1912), George Lawrence Connell & Co., *Number 7*

Tray (c. 1905), Keswick School of Industrial Arts, *Number 1*

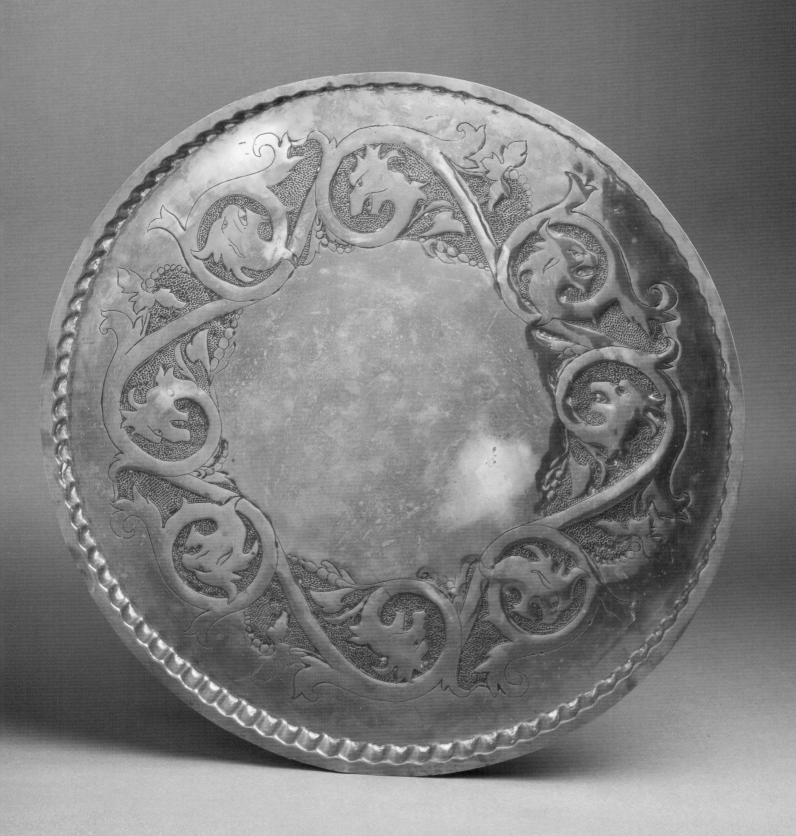

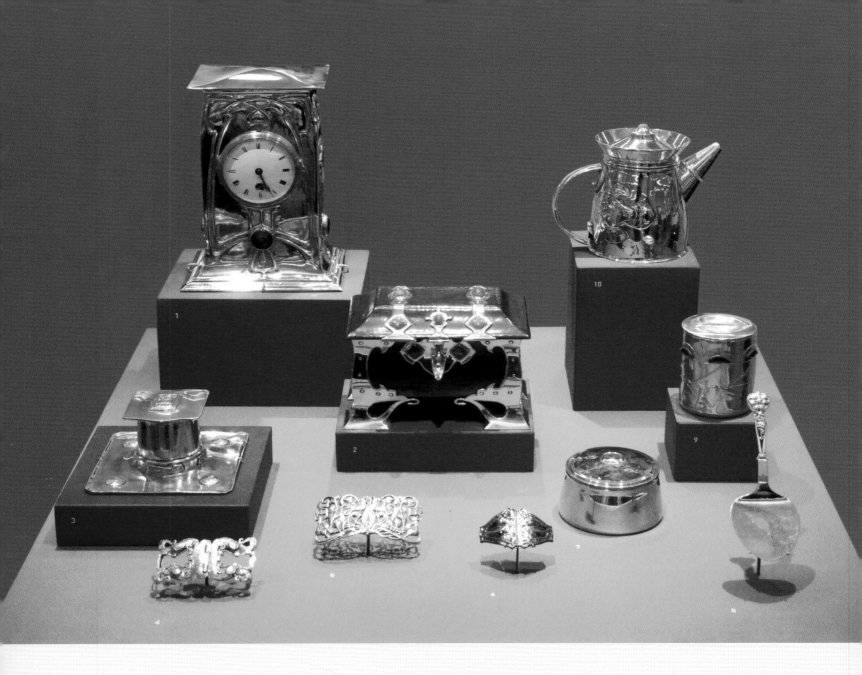

LIBERTY & CO.

Dedicated craftsmen produced remarkable handwrought metalwork in the guild tradition at the turn of the twentieth century, but the production limitations of the process assured that relatively few homes would be adorned with such work. Adding to this dilemma, the high cost of hand-production rendered most work unaffordable to the general public—the very people the Arts and Crafts movement wished to affect.

London's *Liberty & Co.*, a successful retailer of exotic textiles, jewelry, and furniture, lured a number of key designers from the Arts and Crafts and Art Nouveau movements to design metalwork that would be manufactured, then embellished by hand-finishing techniques. While this concept was sacrilegious to Arts and Crafts adherents, *Liberty's* success brought modern designs to an unprecedented number of people around the world through its branches in England, Europe, and the United States.

Liberty produced two lines of silver and pewter work. The Cymric range comprised modern forms decorated with stylized leaves and patterns inspired by the ancient Celtic art to which designer **Archibald Knox** was devoted. This lidded jug decorated with a large Celtic knot (10) is a fine example of work from *Liberty's* Cymric range.

Liberty's innovative Tudric range, which included beautiful items crafted from pewter (3, 9), was intended as a more affordable alternative to the Cymric silver. *William Tonks & Sons* crafted this refined Art Nouveau mantle clock (1) in the style of those designed by Knox for *Liberty's* Tudric line. **Oliver Baker's** design of this casket (2) for *Liberty* skillfully combines copper, sterling silver straps, and cabochons of green quartz in a stunning presentation.

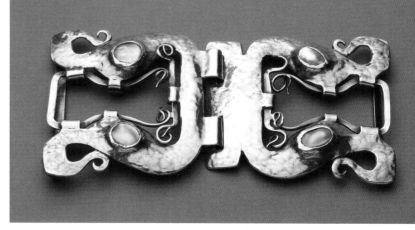

Buckle (1901), Oliver Baker for Liberty & Co., *Number 4*

Case 5

1 Mantle clock (c.1900–1910)
*William Tonks & Sons
(1789–1953)*
Birmingham, England
white metal, enamel cabochons
P109M007

2 Presentation casket (1903)
*Oliver Baker (1856–1939) for
Liberty & Co. (1875–present)*
London, England
sterling silver, copper,
green quartz
P110S053

3 Inkwell (c. 1908)
*Tudric range, Liberty & Co.
(1875–present)*
London, England
pewter
N017N017

4 Buckle (1901)
*Oliver Baker (1856–1939) for
Liberty & Co. (1875–present)*
Birmingham, England
sterling silver, blister pearls
S098S098

5 Buckle (1900)
*William Comyns & Sons
(1885–1953)*
London, England
sterling silver
S099S099

6 Buckle (1903)
*Cymric range, Liberty & Co.
(1875–present)*
Birmingham, England
sterling silver, enamel
P177S103

7 Container (1902)
*Cymric range, Liberty & Co.
(1875–present)*
London, England
sterling silver, enamel
S003S003

8 Server (1901)
Liberty & Co. (1875–present)
London, England
sterling silver
N258N258

9 Container (c. 1910–1920s)
*Tudric range, Liberty & Co.
(1875–present)*
London, England
pewter, enamel cabochons
S097S097

10 Jug with lid (1901)
*Cymric range, Liberty & Co.
(1875–present)*
London, England
sterling silver, bone,
amethyst cabochon
P108S023

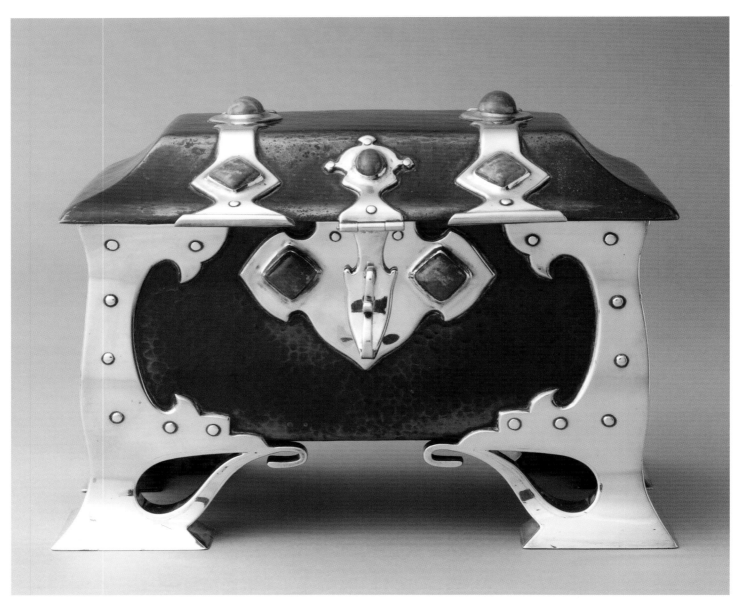

Presentation casket (1903), Oliver Baker for Liberty & Co., *Number 2*

Jug with lid (1901), Cymric range, Liberty & Co., *Number 10*

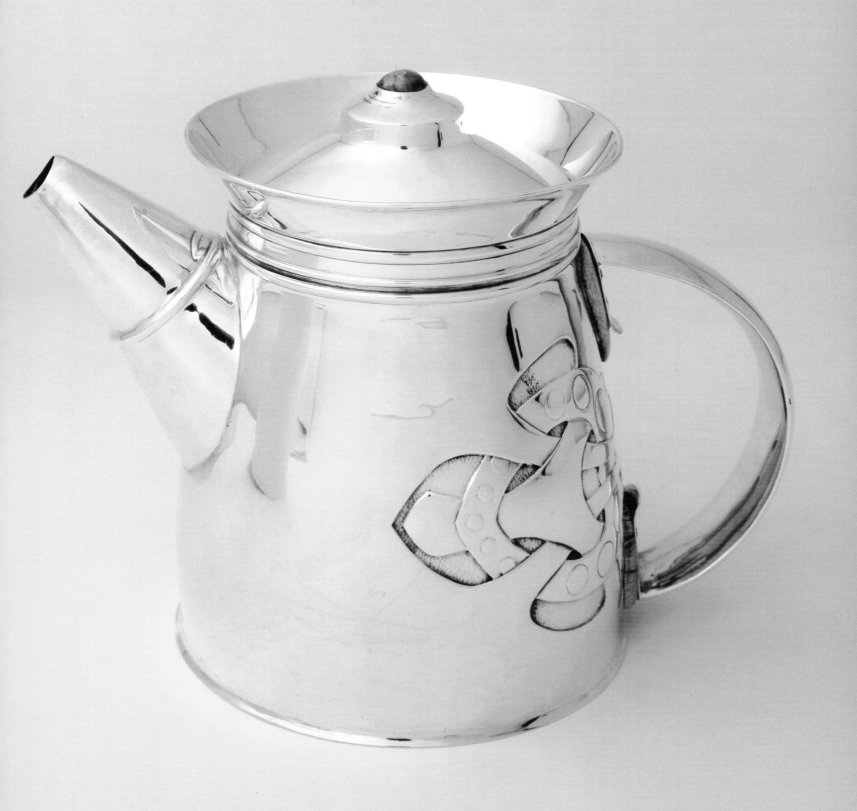

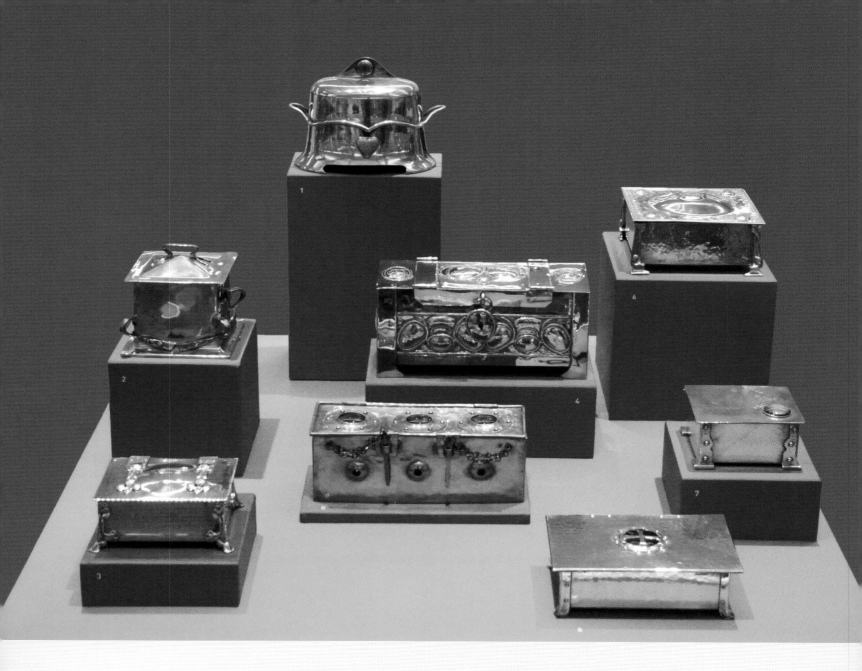

MIXED METALS AND "RUSKIN ENAMELS"

Silver and gold are frequently the materials from which fine metal-work is crafted, but many beautiful pieces produced in the early twentieth century were made from other metals. Copper and pewter are masterfully combined in **Oliver Baker's** elegant box (2) for *Liberty's* Tudric range. Polishing has revealed the copper from which this large silver-plated document casket (4) was crafted.

Gems shaped by polishing rather than cutting are called cabochons. In the early 1900s, *Ruskin Pottery*—named in honor of the ideological founder of the Arts and Crafts movement, **John Ruskin**—began producing small round cabochons of glazed enamel to be used as

decorative elements for metalwork and jewelry. The brilliant and nuanced colors achieved by the artists at *Ruskin Pottery* were very popular with the public. London's *Liberty & Co.* started using Ruskin's enamels in its metalwork instead of more expensive semiprecious gemstones, and they quickly became a major part of the company's output. Cabochon enamels gained favor with the craftsmen of this period and were incorporated in a number of objects, particularly boxes (1, 5, 6, 7, 8). Other potteries produced similar enamels, but *Ruskin Pottery's* work was so distinct and popular that the term "Ruskin enamel" is often used for decorative cabochons regardless of their origin.

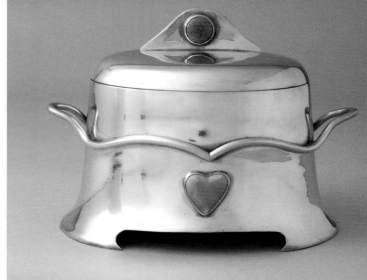

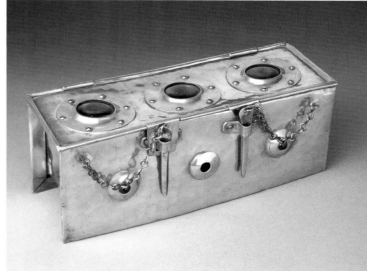

Top: Container with hinged lid (c. 1910-1920), by unknown maker, *Number 1*
Bottom: Box (c. 1915), by unknown maker, *Number 5*

Case 6

1 **Container with hinged lid**
(c. 1910–1920)
unknown maker
England
pewter, enamel
N015N015

2 **Box** (c. 1910–1920)
*Tudric range, Oliver Baker for
Liberty & Co. (1875–present)*
London, England
pewter, copper
P134S085

3 **Cigarette box** (1902)
*William Hutton & Sons Ltd.
(1800–1930)*
London, England
sterling silver, wood liner
S021S021

4 **Box** (c. 1910–1920)
unknown maker
silver plate, copper
P147S058

5 **Box** (c. 1915)
unknown maker
pewter, enamel, glass
P144S084

6 **Box** (c. 1920s)
unknown maker
white metal, Ruskin enamel
N075N075

7 **Cigarette box** (c. 1910)
unknown maker
England
pewter, enamel, wood liner
N078N078

8 **Cigarette box** (c. 1920)
*Cambray Ware
(active late 19th–early 20th century)*
England
pewter, enamel, wood liner
S083S083

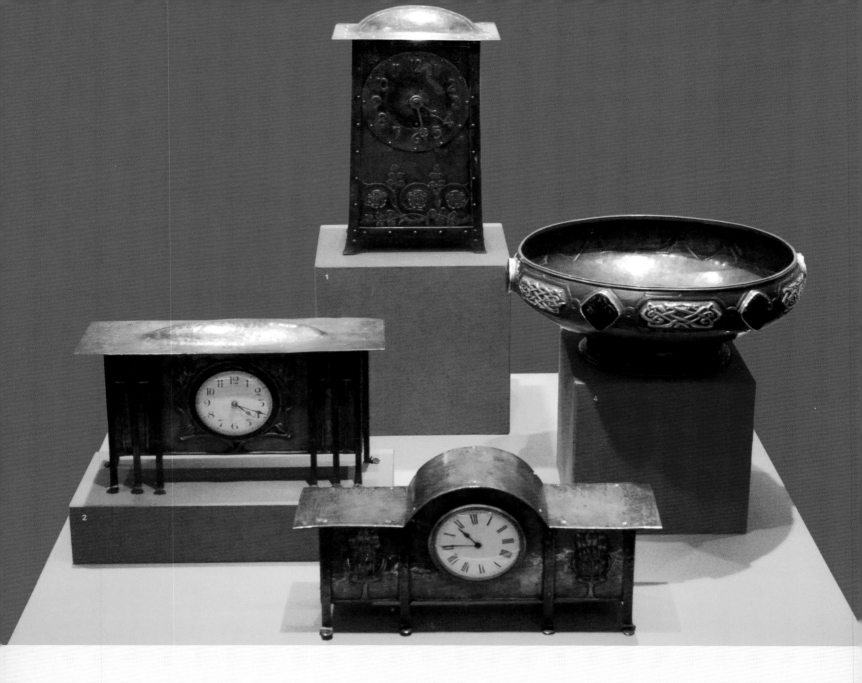

MANTLE CLOCKS

Remarkably, the makers of many exquisitely crafted metal pieces remain anonymous. This is particularly true of utilitarian items of copper, such as clocks. The distinctive domed clock with the brass faceplate (1) is based on a famous 1895 design by Arts and Crafts architect and designer C. F. A. Voysey. Many artists have rendered this unique tapered and domed form in wood, brass, pewter, or silver. It has been decorated with wood inlay, enamel, glass, and other materials. This copper version features an embossed frieze of Tudor roses and branches with leaves.

This copper mantle clock (3) has been attributed to a Glasgow-based Arts and Crafts designer, **George Henry Walton**. Peacock blue

enamels and repoussé floral decoration are on either side of the clock face. The clock set with Ruskin enamels behind applied tree forms on either side (2) has been attributed to English Arts and Crafts. Ornately crafted clock housing was often produced separately from clockworks that were later installed by firms such as *Liberty & Co*.

This magnificent bowl (4) is believed to have originated in Scotland. The vessel's copper body is masterfully decorated with Celtic-influenced designs of interlaced silver—each one distinct and some covered with green enamel. It resembles the designs of **Archibald Knox**, *Liberty's* designer from the Isle of Man who integrated Celtic design with the sensibilities of the Arts and Crafts movement.

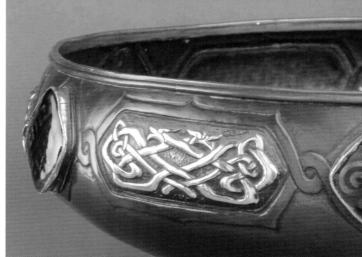

Detail of Bowl (c. 1900), by unknown maker, *Number 4*

Case 7

1 **Mantle clock** (c. 1900–1910)
School of C.F.A. Voysey
Great Britain
copper, brass
N067N067

2 **Mantle clock** (c. 1900–1910)
unknown maker
England
copper, iron, enamel, porcelain, glass
N066N066

3 **Mantle clock** (c. 1910)
*Attributed to George Henry Walton
(1867–1933)*
Glasgow, Scotland
copper, enamel, porcelain, glass
N068N068

4 **Bowl** (c. 1900)
unknown maker
Great Britain
copper, silver, enamel
N080N080

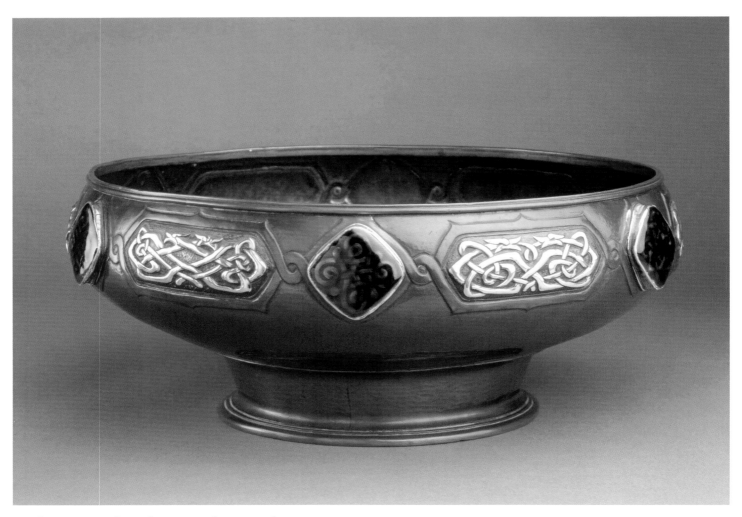

Bowl (c. 1900), by unknown maker, *Number 4*

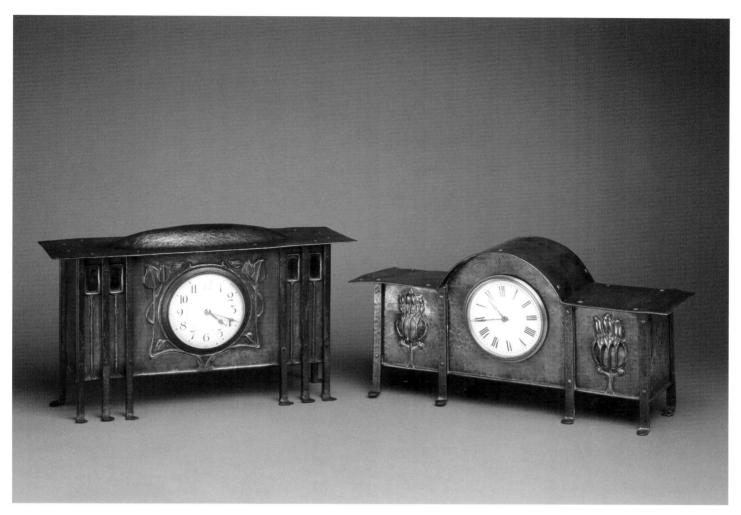

Left, mantle clock (c. 1910), attributed to George Henry Walton, *Number 3*

Right, mantle clock (c. 1900–1910), by unknown maker, *Number 2*

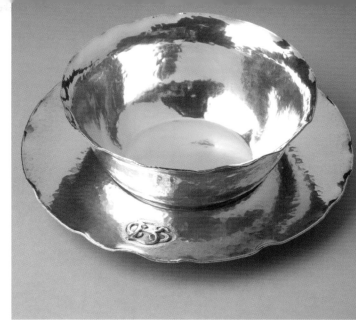

Dessert bowl and undertray (c. 1915), Clemens Friedell, *Number 3*

Case 11

1 **Tea and coffee service** (c. 1920s)
Mulholland Bros., Inc. (1915–1934)
Evanston, Illinois
sterling silver
*2003.051 A-I, K

2 **Pitcher** (c. 1920s)
Mulholland Bros., Inc. (1915–1934)
Evanston, Illinois
sterling silver
*2003.051 J

3 **Pair of dessert bowls and undertrays**
(c. 1915)
Clemens Friedell (1872–1963)
Pasadena, California
sterling silver
P0885063

*Courtesy of the Portland Art Museum,
The Margo Grant Walsh 20th Century
Silver and Metalwork Collection

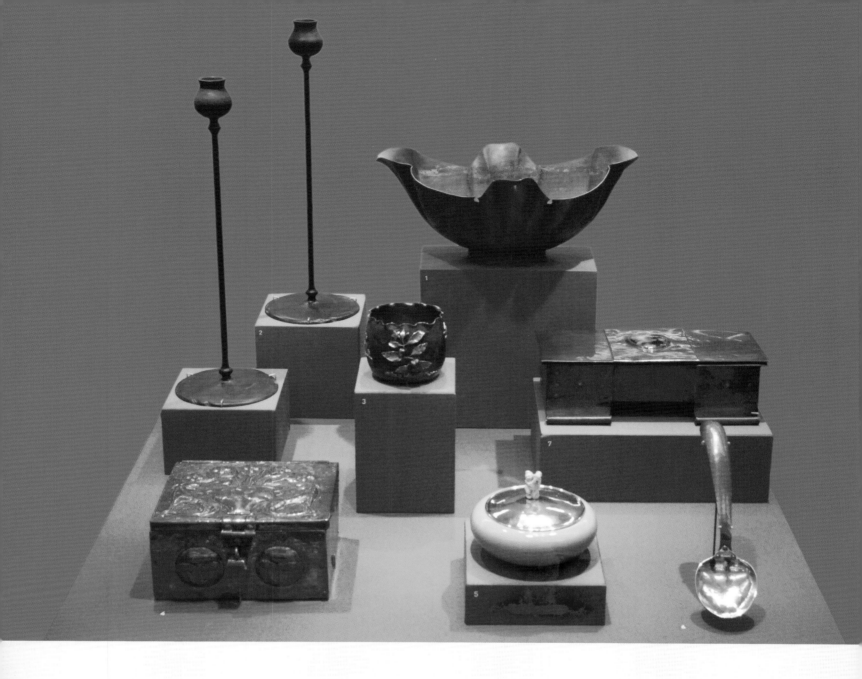

THE MIDWESTERN INFLUENCE

Marie Zimmermann's lobed, copper planter (1) is one of many varia-
tions on her renowned Chinese-inspired bowls. Zimmermann's artistic
designs were executed in a number of metals, many of which were
decorated with her inventive patinas. Her modern designs of simple
forms received critical acclaim throughout her lengthy career—tran-
scending the periods of Arts and Crafts, Art Deco, and Art Moderne.

Twentieth-century silversmiths, similar to their predecessors, produced
items from a number of metals, sometimes mixing them, and some-
times utilizing other materials like ceramic, ivory, stones, and enamels.
The *T. C. Shop* in Chicago was founded in 1910 when silversmith
Emery Todd left the *Kalo Shop* and partnered with designer

Clemencia Cosio. Their mixed-metal serving spoon (6) is one of
the rare productions from the T. C. Shop to incorporate copper. It
features the hammered surface and simple design that characterizes
much of their work.

The ceramic bowl with silver cover (5) was cooperatively produced by
the famed *Rookwood Pottery* of Cincinnati and silversmith **Horace
Potter**, a founder of the *Cleveland School of Arts and Crafts*. The ivory
finial is typical of Potter's use of Chinese antiques to decorate his
work. Potter's frequent collaborations with a number of fellow
craftsmen were in the spirit of the Arts and Crafts movement's values.

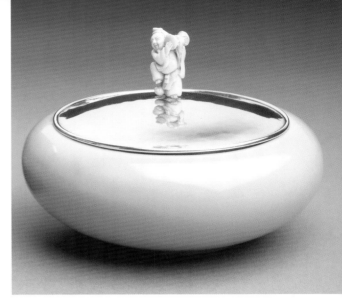

Ceramic bowl with cover (c. 1920), Rookwood Pottery/
Potter Studio, *Number 5*

Case 12

1 Planter (c. 1915)
Marie Zimmermann
(1878–1972)
New York, New York
copper
N074N074

2 Pair of candlesticks (1920)
School of Robert Jarvie
Chicago, Illinois
bronze
N001N001

3 Small Pot (c. 1885)
Gorham Manufacturing Co.
(1831–present)
Providence, Rhode Island
sterling silver, copper
N084N084

4 Humidor (c. 1900)
John Pearson
(active 1885–1900)
London, England
copper, wood liner
N013N013

5 Ceramic bowl with cover
(c. 1920)
Rookwood Pottery
(1880–1960)/
Potter Studio (1915–1924)
Cincinnati, Ohio/
Cleveland, Ohio
ceramic, sterling silver, ivory
N083N083

6 Serving spoon (c. 1915)
T. C. Shop (1910–1923)
Chicago, Illinois
sterling silver, copper
N053N053

7 Box (1905)
unknown maker
England
copper, enamel
N271N271

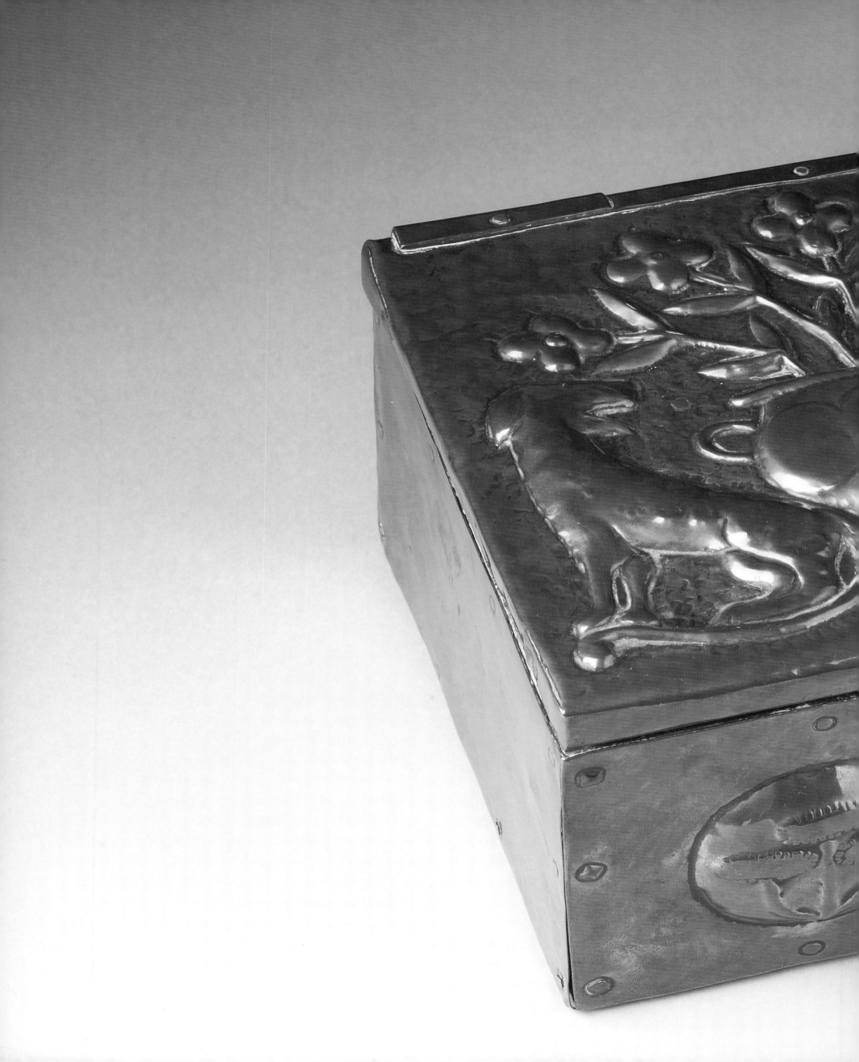

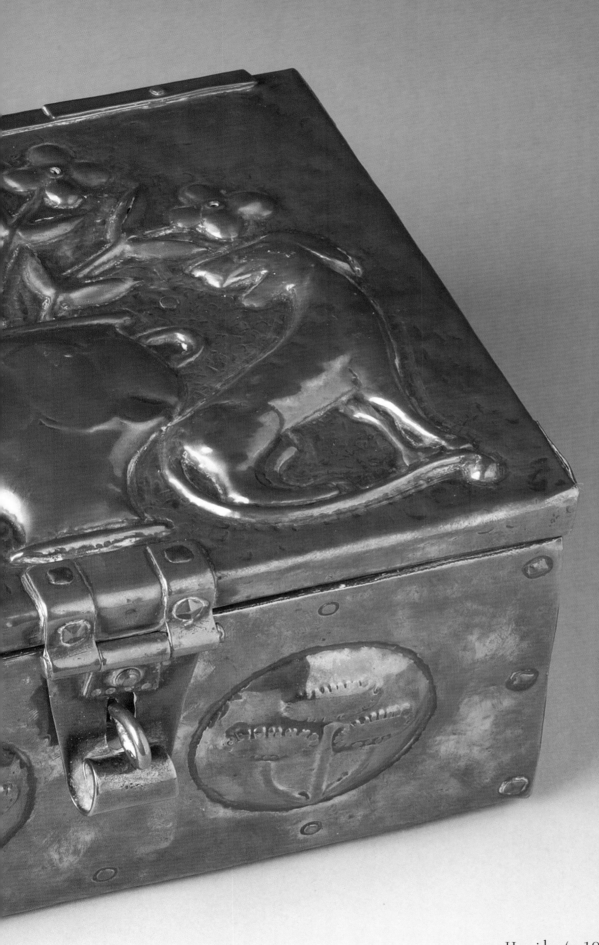

Humidor (c. 1900), John Pearson, *Number 4*

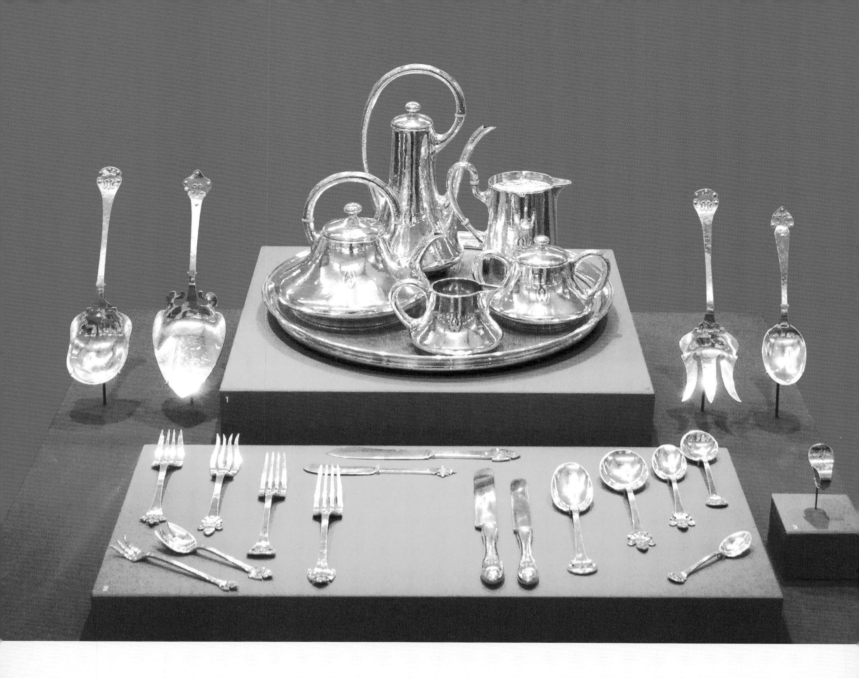

SHREVE & CO.

Brothers George and Samuel Shreve opened a small jewelry store in San Francisco in 1852, seeking to capitalize on the sudden wealth from the gold and silver boom in California. The *Shreve Jewelry Store* sold European luxury goods and jewelry crafted by firms in New York and Boston. In the 1880s the Shreve brothers opened a factory and quickly earned a reputation of excellence for their design and manufacture of fine quality jewelry. The company was particularly known for their gold and diamond stickpins and brooches.

In the early 1900s, Shreve's silversmiths gained distinction as they began to experiment with hand-hammered surfaces on holloware (1) and flatware produced from die-cut forms. This nineteen-piece sterling flatware set (2) comes from a monumental service for twelve

in Shreve's rare fourteenth-century pattern. Sets such as these would have been commissioned by an affluent customer, whose monogram appears on the heavy, riveted, and distinctly designed handles.

John O. Bellis, originally a jeweler, became Shreve's most prominent craftsman. This napkin clip (3) is a fine example of Bellis' hammered surfaces and accomplished decorative detail. *Shreve & Co.* published illustrated catalogues featuring more than twenty of their exclusive designs of flatware. Production lasted until 1967, thus ending the career of the oldest manufacturer of fine silver in California and one of the last major regional silver producers in the United States. *Shreve & Co.* continues today as a retailer of fine jewelry and metalwork.

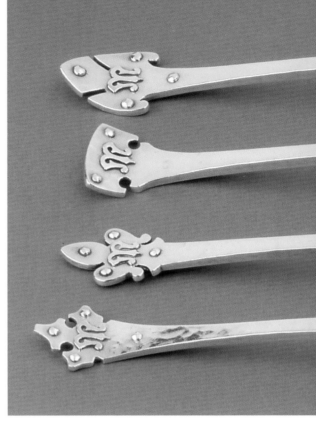

Detail of Flatware (c. 1910), Shreve & Co., *Number 2*;
set of flatware illustrated on the following two pages

Case 13

1 **Tea and coffee service** (c. 1910)
Shreve & Co. (active 1852–1967)
San Francisco, California
sterling silver, ivory, wood
*2003.051.09A-J

2 **Flatware** (c. 1910)
Shreve & Co. (active 1852–1967)
San Francisco, California
sterling silver
N035N035

3 **Napkin clip** (c. 1915)
*John O. Bellis (1872–1943) for
Shreve & Co. (active 1852–1967)*
San Francisco, California
sterling silver
P096P096

*Courtesy of the Portland Art Museum,
The Margo Grant Walsh 20th Century
Silver and Metalwork Collection

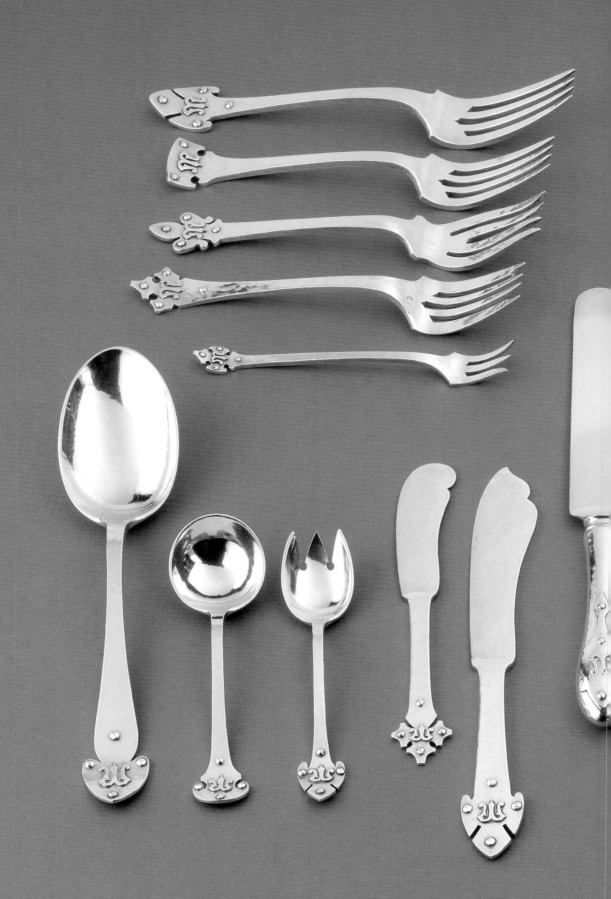

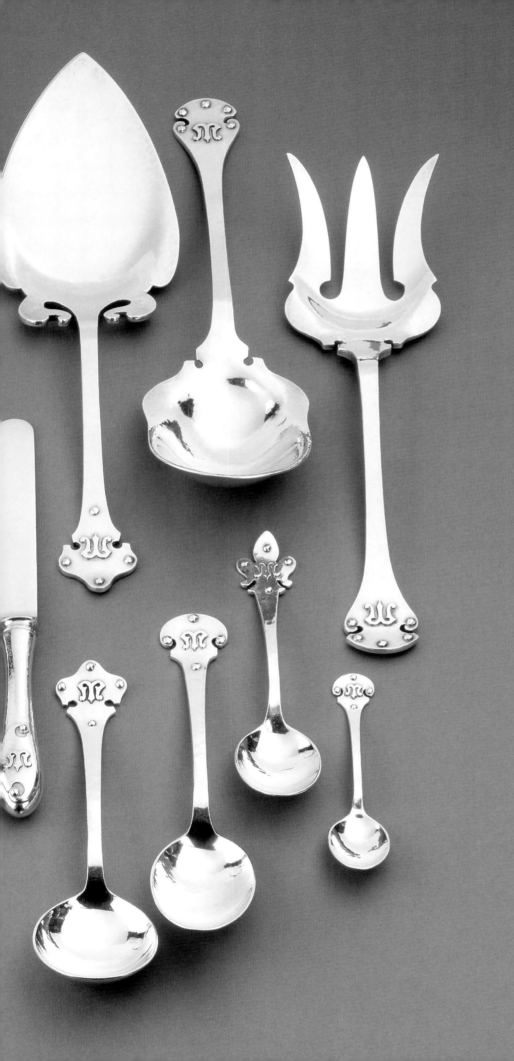

DIRK AND WILLIAM VAN ERP

Dirk van Erp learned to craft metal at his family's hardware business in his native Holland. His first metalworks in the United States were brass and copper vases that he hand hammered from discarded shell casings at a San Francisco military shipyard. In 1908 he opened the *Copper Shop* in Oakland, California, where his elegantly simple forms were highly valued. He became famous for his hammered copper lamps with shellacked mica shades—usually amber colored.

While most metalsmiths reduced the effect of their hammer blows by repeatedly leveling the surface, van Erp chose to emphasize the mark, and make it part of the decoration. He also developed a number of rich, dark patinas to cover and protect his work. He employed these

innovative techniques for decorating candlesticks, bowls, desk-top items, and the form of this unique lantern (2). A true adherent to Arts and Crafts principles, van Erp worked by hand with simple tools, resulting in high-quality objects that varied in size and detail.

When Dirk van Erp retired in 1929, his son **William van Erp** assumed the ownership and management of his studio. William's work was primarily in silver and reflects the Art Moderne style he favored. His beautiful trays with ivory feet (1, 5, 9) were designed for utility. They were intended to contain glass casserole dishes and provide a more elegant presentation of entrées.

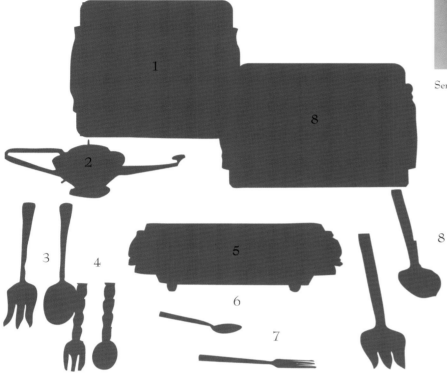

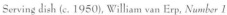

Serving dish (c. 1950), William van Erp, *Number 1*

Case 14

1 **Serving dish** (c. 1950)
William van Erp (1900–1977)
San Francisco, California
silver plate
N064N064

2 **Lantern** (c. 1920)
Dirk van Erp (1860–1933)
San Francisco, California
copper
N060N060

3 **Salad servers** (c. 1930)
Porter Blanchard (1886–1973)
Pacoima, California
sterling silver
N223N223

4 **Salad servers** (c. 1940)
Porter Blanchard (1886–1973)
Pacoima, California
sterling silver
N127N127

5 **Serving dish** (c. 1950)
William van Erp (1900–1977)
San Francisco, California
silver plate, ivory
N063N063

6 **Spoon blank** (c. 1960)
William van Erp (1900–1977)
San Francisco, California
sterling silver
*Gift to Margo Grant Walsh from
William van Erp, Jr. and Dirk van Erp, Jr.*
N092N092

7 **Fork blank** (c. 1920)
Dirk van Erp (1860–1933)
San Francisco, California
sterling silver
*Gift to Margo Grant Walsh from
William van Erp, Jr. and Dirk van Erp, Jr.*
N093N093

8 **Salad servers** (c. 1965)
Allan Adler (1916–2002)
Studio City, California
sterling silver, ebony
N220N220

9 **Serving dish** (c. 1950)
William van Erp (1900–1977)
San Francisco, California
silver plate, ivory
N062N062

DESIGNED FOR THE DESK TOP

Silversmiths have historically produced items for practical use. For many artists, crafting marketable items such as picture frames, letter openers, and bookends sustained them between more expensive and elaborate commissions. During the period of the Arts and Crafts movement, bringing beauty to objects of utility was considered a noble and important endeavor for fine silversmiths.

The Roycroft Community in East Aurora, New York, was a self-contained community devoted to making beautiful books based on the example of *William Morris's Kelmscott Press* in England. Roycrofters, as they were known, first began to produce metalwork simply to meet the needs of their growing facility. They became quite accomplished in their techniques of producing hammered metal objects, many with lacquered patinas. The Roycrofters marketed popular decorative items such as these bookends (1) in nationwide sales catalogues.

Many makers of metal items for everyday use remain anonymous. The copper picture frames (2, 8), one pair embossed with a floral motif and set with Ruskin enamels, are unsigned by their makers. So, too, is this well-made letter opener (4) with elongated hammer marks and sterling silver straps riveted to the handle.

This pen tray with Art Nouveau decoration (5) was made by the *Art Crafts Shop* in Buffalo, New York. In 1906 the business became the *Heintz Art Metal Shop*, producing objects that were machine-shaped and distinguished by their unique patinas (3). Sculptor Tony Hochstetler's letter opener (6), handcrafted in the form of a ginkgo leaf, is a recent example of artistic design and beauty in an object of everyday use.

Pen tray (1905), Art Crafts Shop, *Number 5*

Case 15

1 Bookends (c. 1910–1920)
*Roycroft Community
(1893–1938)*
East Aurora, New York
copper
P141S082

2 Pair of picture frames
(c. 1910)
unknown maker
Great Britain
copper, Ruskin enamel
N052N052

3 Letter opener (c. 1925)
*Heintz Art Metal Shop
(1906–1930)*
Buffalo, New York
patinated copper, silver
N273N273

4 Letter opener (c. 1915)
unknown maker
copper, sterling silver
N274N274

5 Pen tray (1905)
*Art Crafts Shop
(c. 1902–1905)*
Buffalo, New York
copper, silver, stone
P112S091

6 Letter opener (2002)
Tony Hochstetler (b. 1964)
Fort Collins, Colorado
patinated bronze
N272N272

7 Pen tray (c. 1920)
Albert Berry (1878–1949)
Seattle, Washington
copper, mother-of-pearl
T017S121

8 Pair of picture frames
(c. 1910)
unknown maker
England
copper
N051N051

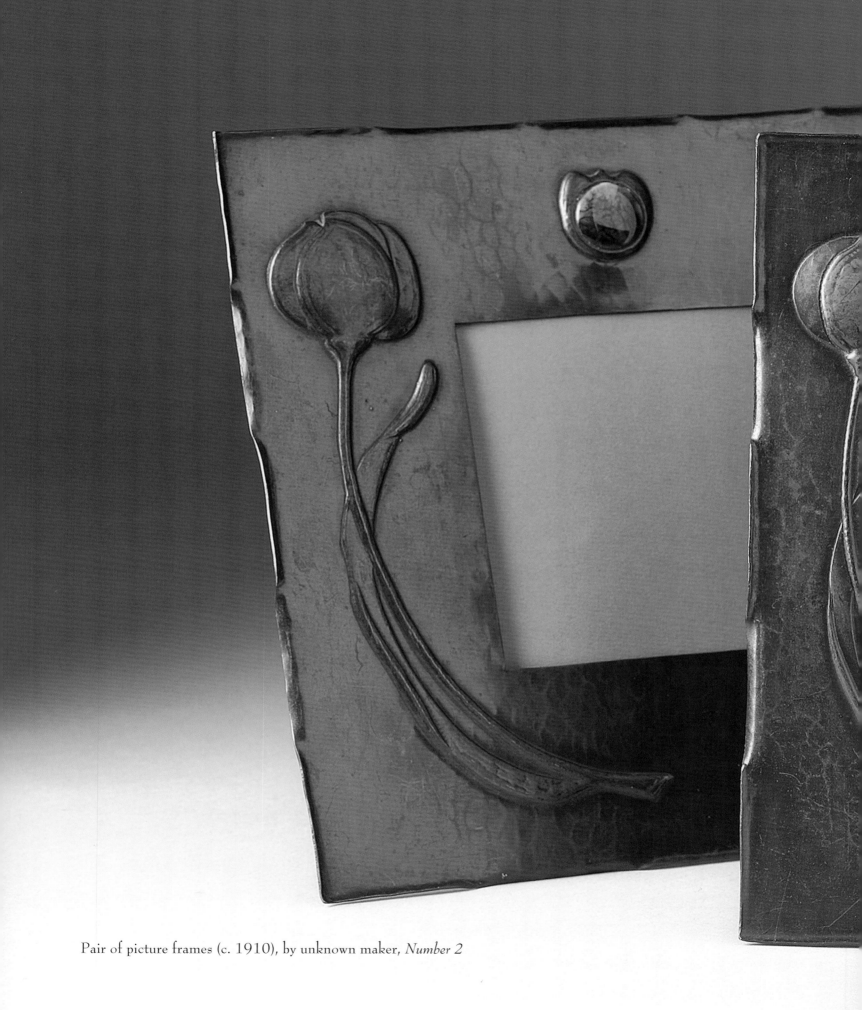

Pair of picture frames (c. 1910), by unknown maker, *Number 2*

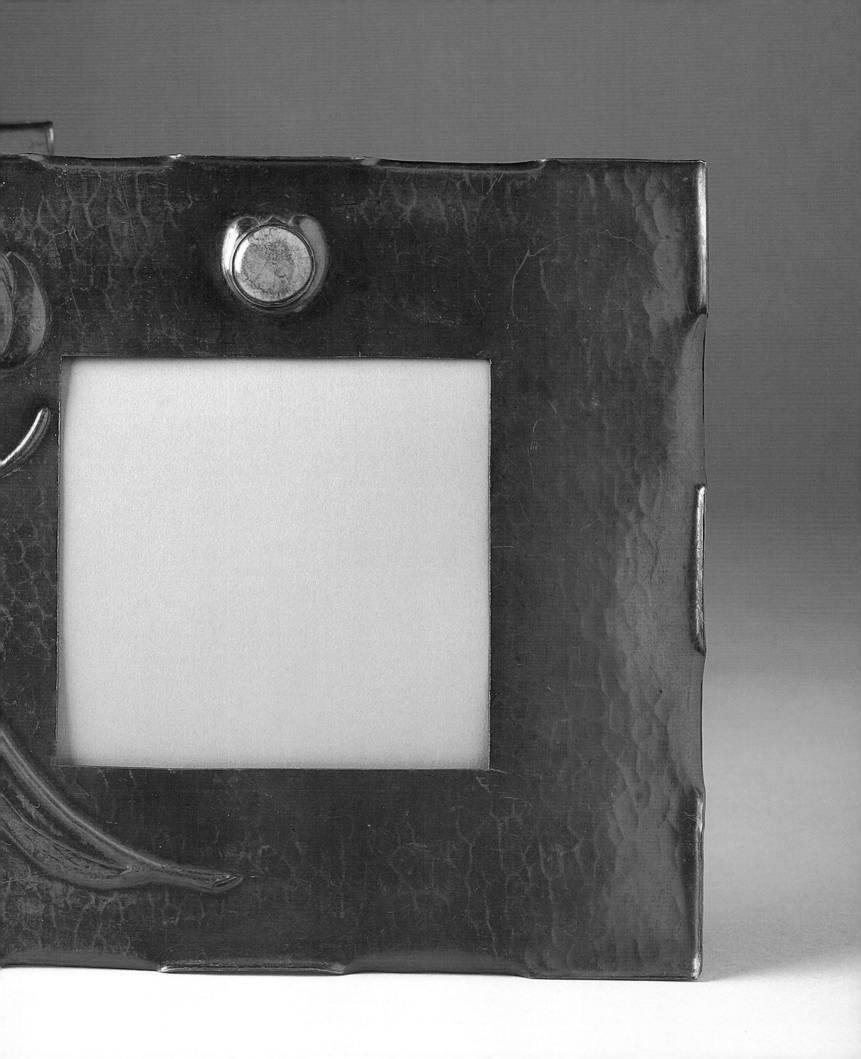

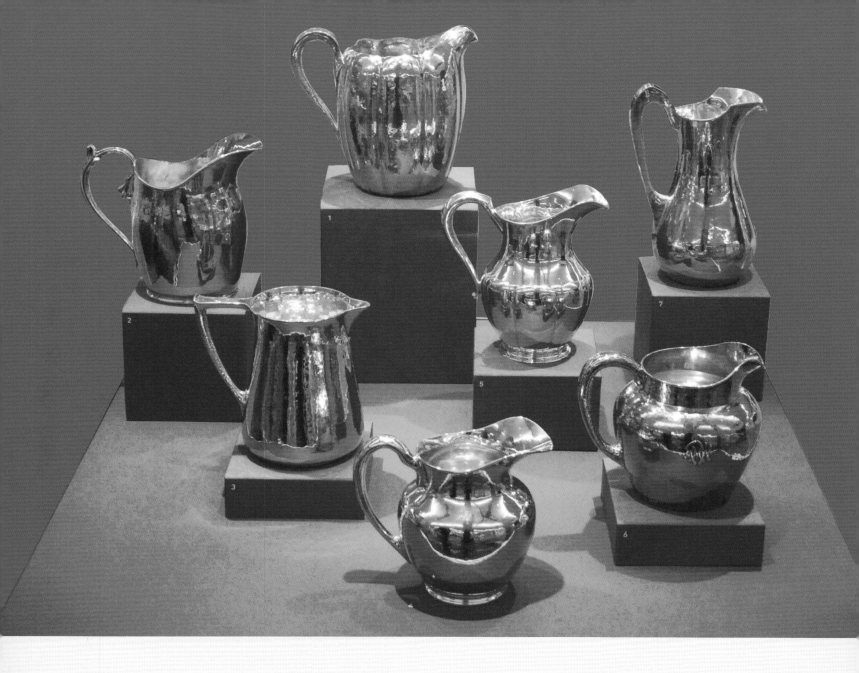

PITCHERS

The pitcher has long been a favorite form for silversmiths. Traditionally, the pitcher was the selected object by which journeyman silversmiths proved their mastery. While the function of a pitcher is obvious and limited, its design can be quite varied, even among those made in the Arts and Crafts period. These pitchers all reflect a favorite tenet of Arts and Crafts founder William Morris: "Have nothing in your house that you do not know to be useful, or believe to be beautiful."

William Durgin's pitcher (3) is an early and elegant example of the simple design and balanced proportion that characterizes the best work of early-twentieth-century silversmiths. The monogrammed pitchers of both Heinrich Eicher (7) and Chicago's *Lebolt & Co.* (6) display design

influences from the *Kalo Shop*, where Eicher had worked prior to establishing his workshop. *Cellini Craft*, in nearby Evanston, Illinois, produced a vessel that evokes classical design elements in its helmet form and stylized leaf and bead handle (2). Finnish-born Karl Leinonen crafted this smoothly finished pitcher (5) with a bulbous body of eight fluted panels in Boston. Bridgeport, Connecticut's, *Whiting Manufacturing Co.* produced a high-shouldered pitcher with heavy hammer marks on fluted sides (1) Swedish immigrant Franz Gyllenberg, working in Boston, was known for his colonial reproduction silver (4).

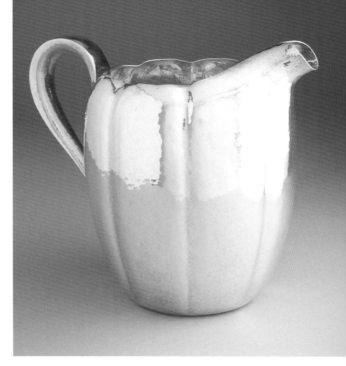

Pitcher (1917), Whiting Manufacturing Co., *Number 1*

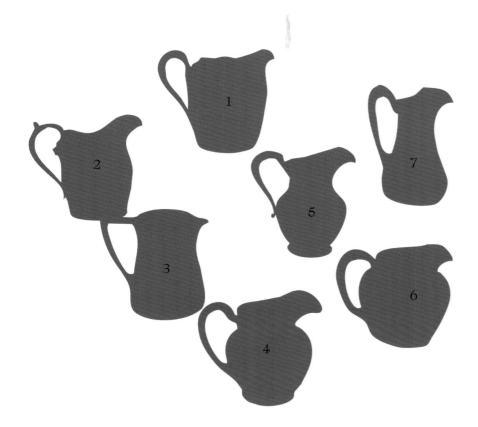

Case 16

1 **Pitcher** (1917)
Whiting Manufacturing Co. (1840–1926)
Bridgeport, Connecticut
sterling silver
P058S062

2 **Pitcher** (c. 1940)
Cellini Craft, Inc. (1934–1957)
Evanston, Illinois
sterling silver
P005061

3 **Pitcher** (c. 1903)
William B. Durgin (1833–1905)
Concord, New Hampshire
sterling silver
*2002.091.35

4 **Pitcher** (1926)
Franz Gyllenberg (active 1905–1929)
Boston, Massachusetts
sterling silver
*2002.091.09

5 **Pitcher** (c. 1925)
Karl F. Leinonen (1866–death date unknown)
Boston, Massachusetts
sterling silver
P010S064

6 **Pitcher** (c. 1925)
Lebolt & Co. (active c. 1912–1930)
Chicago, Illinois
sterling silver
*2002.091.30

7 **Pitcher** (c. 1920)
Heinrich Eicher (active c. 1900–1926)
Chicago, Illinois
sterling silver
*2002.091.26

*Courtesy of the Portland Art Museum,
The Margo Grant Walsh 20th Century
Silver and Metalwork Collection*

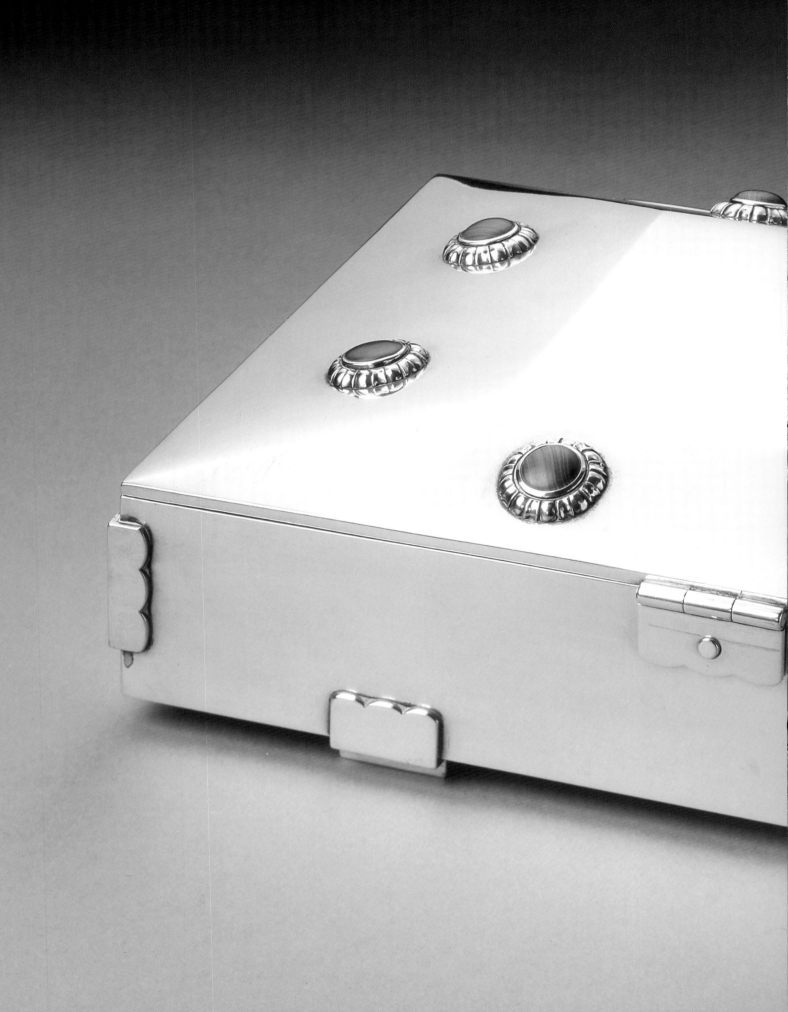

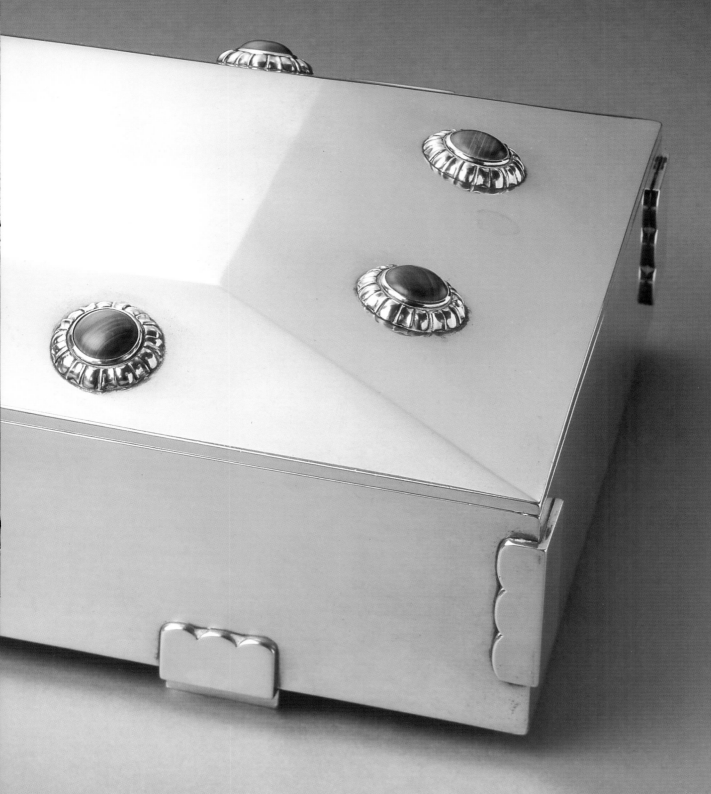

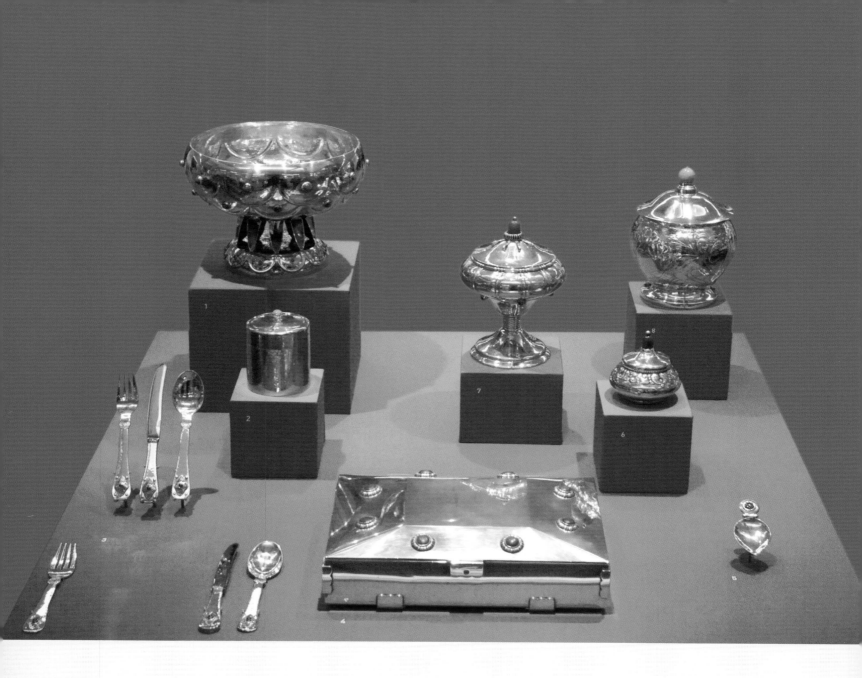

SILVER SET WITH STONE

The practice of using stone to decorate silver is nearly as old as silver-smithing itself. Medieval silversmiths incorporated a variety of precious and semiprecious stones in the design of vessels, weapons, and ceremonial pieces. Charles Ashbee's *Guild of the Handicraft* played a large role in making the combination of silver and stone popular again in the early twentieth century. Mixing materials requires accomplished technique on the part of the maker and has produced objects of beauty throughout the world—from the carnelian-decorated flatware designed for **Georg Jensen** (3) to this anonymously crafted box with bezel-set malachite (4).

John Pontus Petterson studied silversmithing in Norway prior to immigrating to the United States. He worked for *Tiffany & Co.*

in New York and the *Jarvie Shop* in Chicago before opening *The Petterson Studio* in 1912. Petterson's covered jar (2) is tastefully decorated with chased leaves and a bezel-set turquoise cabochon.

Largely self-taught, **Henry Petzal** discovered silversmithing while tinkering in his New Jersey garage in the late 1950s. He designed and made a variety of unique and well-proportioned silver pieces that are wonderfully modern while drawing on classical motifs. Petzal's heavy, covered vessel (8) is crafted from silver nearly twice the gauge of that which is normally used. The lid is topped with an amazonite ball and a seed pearl. Petzal never made more than eight versions of any design.

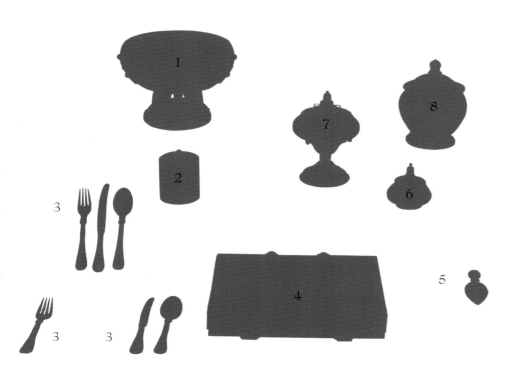

Container (1915), Grann & Laglye, *Number 6*

Case 17

1 **Raised bowl** (c. 1960)
unknown maker
Spain
sterling silver, green quartz
P115S050

2 **Container** (c. 1912–1914)
John Pontus Petterson (1884–1949)
Chicago, Illinois
sterling silver, turquoise cabochon
P116T005

3 **Dessert set** (c. 1979)
Georg Jensen, Inc. (1904–present)
Copenhagen, Denmark
sterling silver, carnelian
P114S056

4 **Box** (c. 1960)
unknown maker
silver, malachite
S057S057

5 **Caddy spoon** (1998)
Elizabeth Gage
(active late 20th century–present)
London, England
sterling silver, amethyst
P111N239

6 **Container** (1915)
Grann & Laglye (1906–present)
Copenhagen, Denmark
sterling silver, amber
S026S026

7 **Covered vessel** (1918)
Grann & Laglye (1906–present)
Copenhagen, Denmark
sterling silver, amber, lapis lazuli
P121S009

8 **Covered vessel** (1970)
Henry Petzal (b. 1912)
New Jersey
sterling silver, amazonite, seed pearl
P122S052

Box (c. 1960), by unknown maker, *Number 4*

Covered vessel (1918), Grann & Laglye, *Number 7*

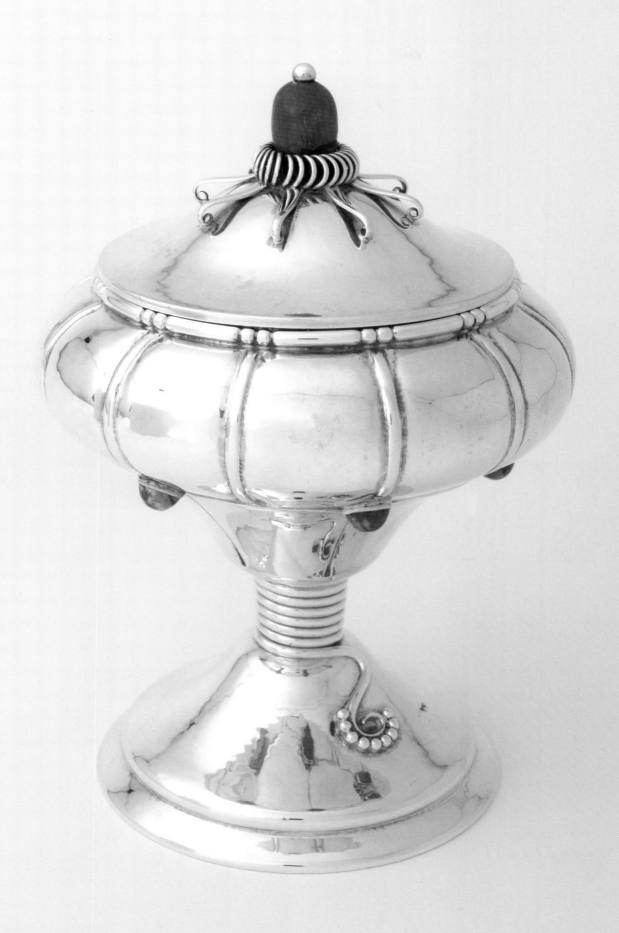

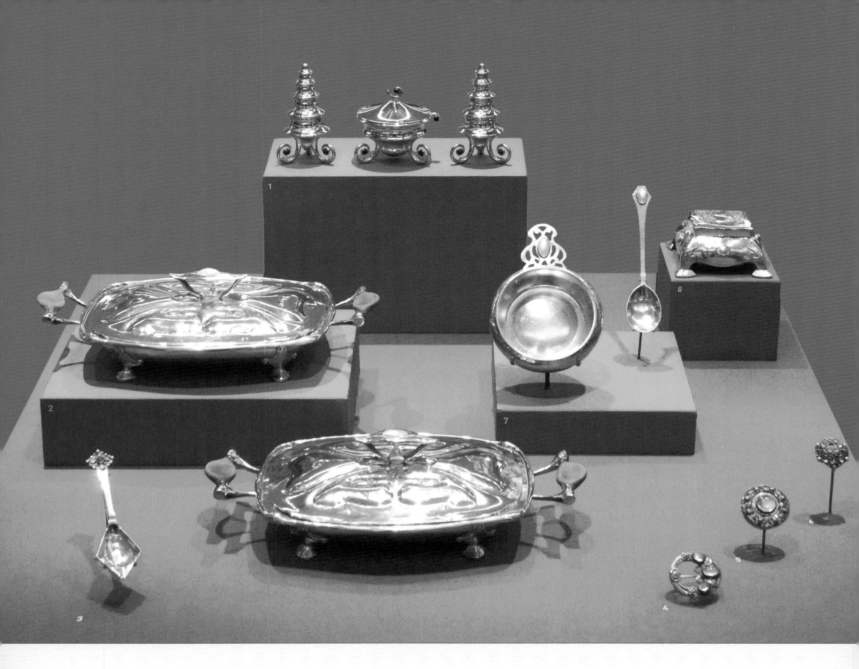

JEWELERY AND BLISTER PEARLS

Jeweled pieces were popular during the early Arts and Crafts period. New York's *Marcus & Co.* was one of the most prestigious jewelry firms at the turn of the twentieth century. Their holloware is not as well known but deserves the same reputation for quality and craftsmanship as their jewelry. The simple and elegant form of this porringer (7) is decorated with a large, bezel-set blister pearl in the center of its pierced handle.

Blister pearl was a popular decorative material for Arts and Crafts silversmiths and jewelers. Blister pearls form attached to the inside of a mollusk's shell and must be removed by cutting them, which results in their unusual shapes and contours. London silversmith **Frederick Courthope** used blister pearls to decorate the panels and lids of his Arts and Crafts period inkwell (8) and serving dishes (2).

Dorrie Nossiter and **Sybil Dunlop** were prominent among a group of jewelers and silversmiths working in the Arts and Crafts tradition from the 1920s to the 1950s. Known by their location in London as the *Notting Hill School*, their output of superbly designed and well-crafted pieces led a revival of Arts and Crafts jewelry making. Jewelry designs from the *Notting Hill School* frequently incorporated tightly scrolled wirework and stylized leaves (5, 6).

British designer **Karen Randall's** condiment set (1) is a fine example of the use of decorative stone in contemporary metalwork. Randall is heavily influenced by naturalistic forms and frequently incorporates cabochons in her work.

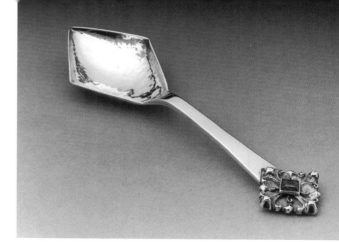

Caddy spoon (c. 1923), Sybil Dunlop, *Number 3*

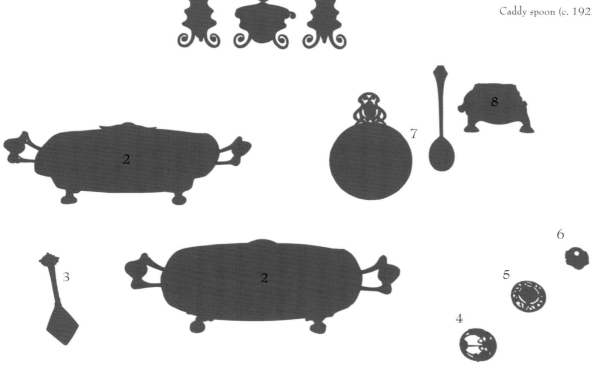

Case 18

1 Condiment set (1994)
Karen Randall (active c. 1980s–present) for
Garrard & Co. (1735–present)
London, England
sterling silver, stone
P101S138

2 Covered serving dishes (1921)
Frederick Courthope
(active late 19th–early 20th century)
London, England
sterling silver, blister pearls, hardwood
P104S059

3 Caddy spoon (c. 1923)
Sybil Dunlop (c. 1889–1968)
London, England
sterling silver, green quartz
S046S046

4 Brooch (c. 1920)
Mary Thew (1876-1953)
Scotland
silver, moonstone
N280N280

5 Brooch (c. 1930)
Sybil Dunlop (c. 1889–1968)
London, England
silver, moonstone, marcasites
N281N281

6 Brooch (c. 1920)
Dorrie Nossiter (1893–1977)
London, England
silver, carnelian, citrine, pearls
N282N282

7 Porringer with spoon (c. 1906)
Marcus & Co. (1880–1927)
New York, New York
sterling silver, blister pearl
P117S016

8 Inkwell (1900)
Frederick Courthope
(active late 19th–early 20th century)
London, England
sterling silver, stone, blister pearl
P105S010

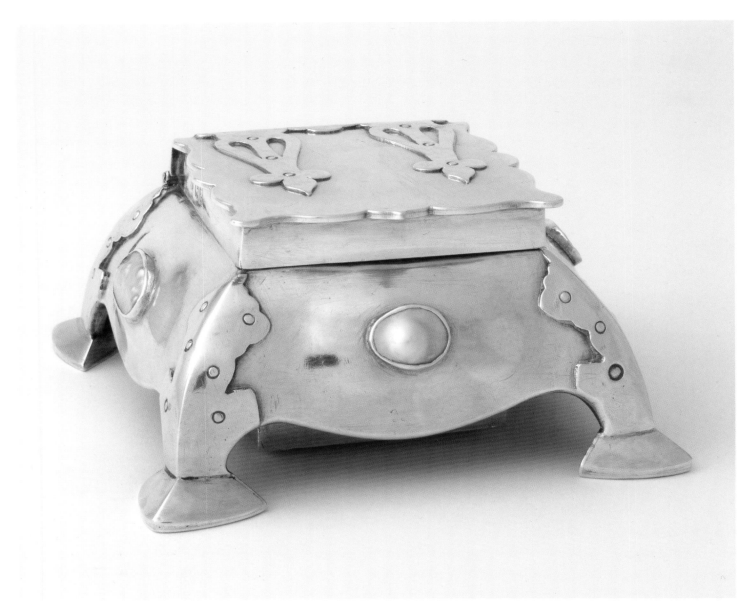

Inkwell (1900), Frederick Courthope, *Number 8*

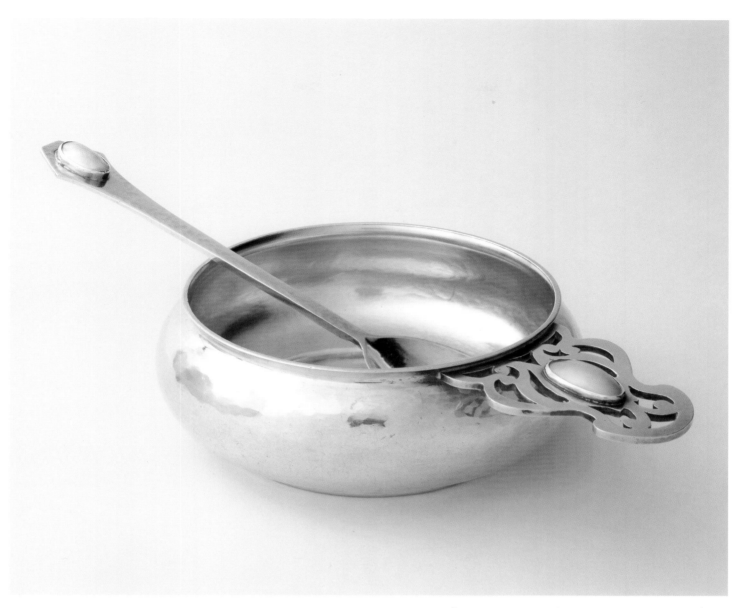

Porringer with spoon (c. 1906), Marcus & Co., *Number 7*

Charles Boyton and Caddy Spoons

London silversmith **Charles Boyton** broke from his family's venerable silver company in 1934 and began making modern silver, such as this hand-hammered condiment set (13) featuring an imaginatively pierced lid and nicely detailed finials and feet. After the Second World War, Boyton attempted to revive his business, but very few could afford fine silver in postwar England. Boyton produced this remarkable six-piece service (1) prior to closing his business in 1949.

The caddy spoon is an ordinary item intended to perform a very simple task—to transfer tea leaves from the tea caddy to the teapot. Upon this form, however, some of the finest craftsmen of the nineteenth and twentieth centuries have executed marvelous designs and expressed their artistry. Caddy spoons have been crafted in every part of the world in which tea is consumed. They serve as comparative examples for view-

ing the distinctive designs and craftsmanship of many different artists. **Albert Edward Jones** designed this spoon (4) with a simple, heart-shaped bowl and handle of interlaced wirework. **Robert Edgar Stone** trained at the *Central School of Arts and Crafts* in Birmingham, England. His beautiful and original designs often feature natural motifs such as the leaves on the handle of this caddy spoon (8). **Henry George Murphy**, once a teacher and principal at the *Central School of Arts and Crafts*, also favored naturalism in many of his designs (9).

Self-taught silversmith **Michael Bolton** began his career as a designer and maker of silver and jewelry in 1970. His hammering technique creates a distinctive finish on this stunning caddy spoon (11) with gilded bowl and silver handle that gives the appearance of having been set with a small pearl.

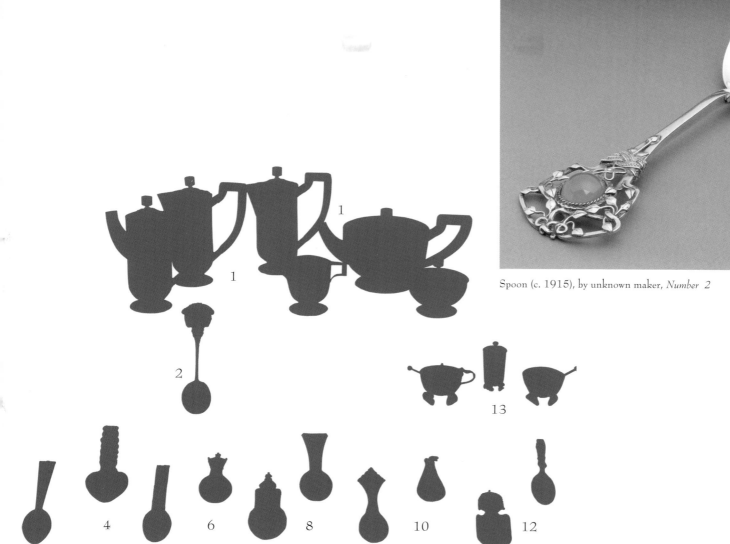

Spoon (c. 1915), by unknown maker, *Number 2*

Case 19

1 **Coffee, chocolate,
and tea service** (1947)
*Charles Boyton
(1885–1958)*
London, England
sterling silver, wood
M001M001

2 **Spoon** (c. 1915)
unknown maker
Great Britain
sterling silver,
moonstone
S047S047

3 **Caddy spoon** (1916)
*Sandheim Bros.
(1905–1920s)*
London, England
sterling silver
P193S038

4 **Caddy spoon** (1989)
*Designed by
Albert Edward Jones
(1879–1954)*
Birmingham, England
sterling silver
P196S043

5 **Caddy spoon** (1971)
unknown maker
London, England
sterling silver
P197S044

6 **Caddy spoon** (1934)
*Robert Edgar Stone
(1903–1990)*
sterling silver
N250N250

7 **Caddy spoon** (1910)
*Alfred Edward Bonner
(active c. 1905–1013)*
London, England
sterling silver
P194S041

8 **Caddy spoon** (1932)
*Robert Edgar Stone
(1903–1990)*
London, England
sterling silver
P192S034

9 **Caddy spoon** (1929)
*Henry George Murphy
(1884–1939)*
London, England
sterling silver
N235N235

10 **Caddy spoon** (1938)
unknown maker
sterling silver
N243N243

11 **Caddy spoon** (2002)
*Michael Bolton
(b. 1938)*
London, England
sterling silver
N236N236

12 **Caddy spoon** (1929)
*Amy Sandheim
(active early to
mid-20th century)*
London, England
sterling silver
P195S042

13 **Condiment set** (1935)
*Charles Boyton
(1885–1958)*
London, England
sterling silver, glass
P176S090

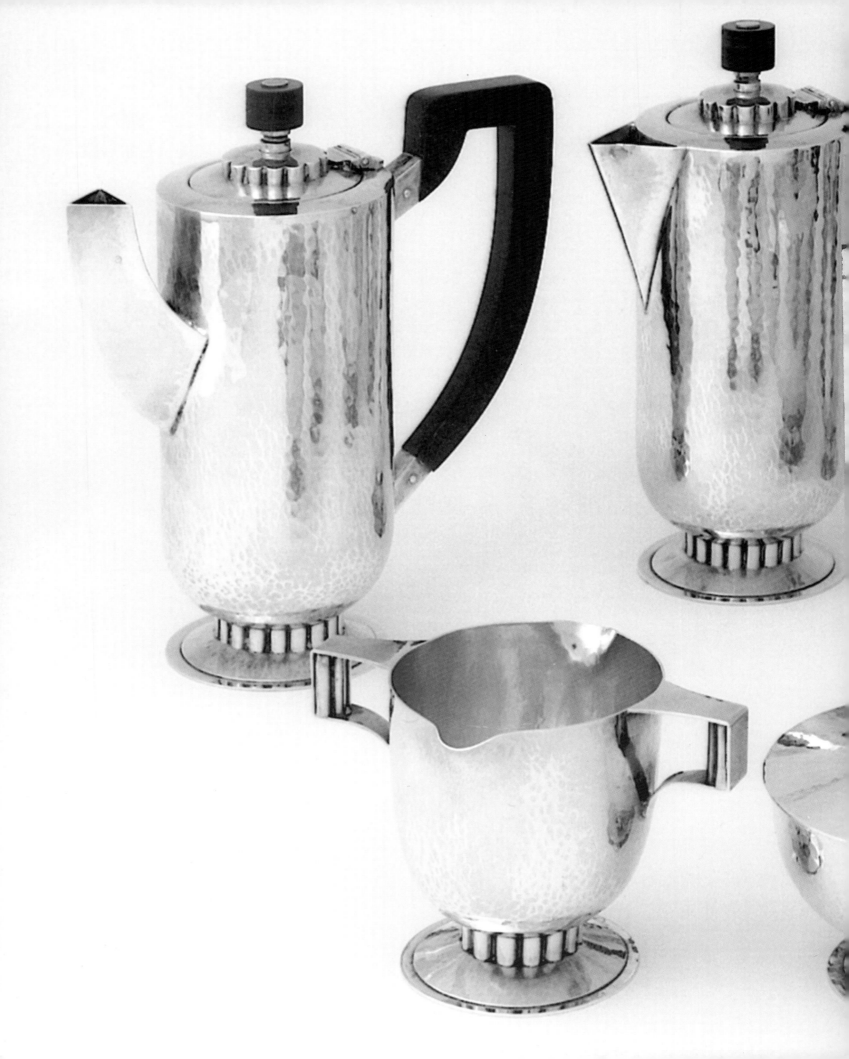

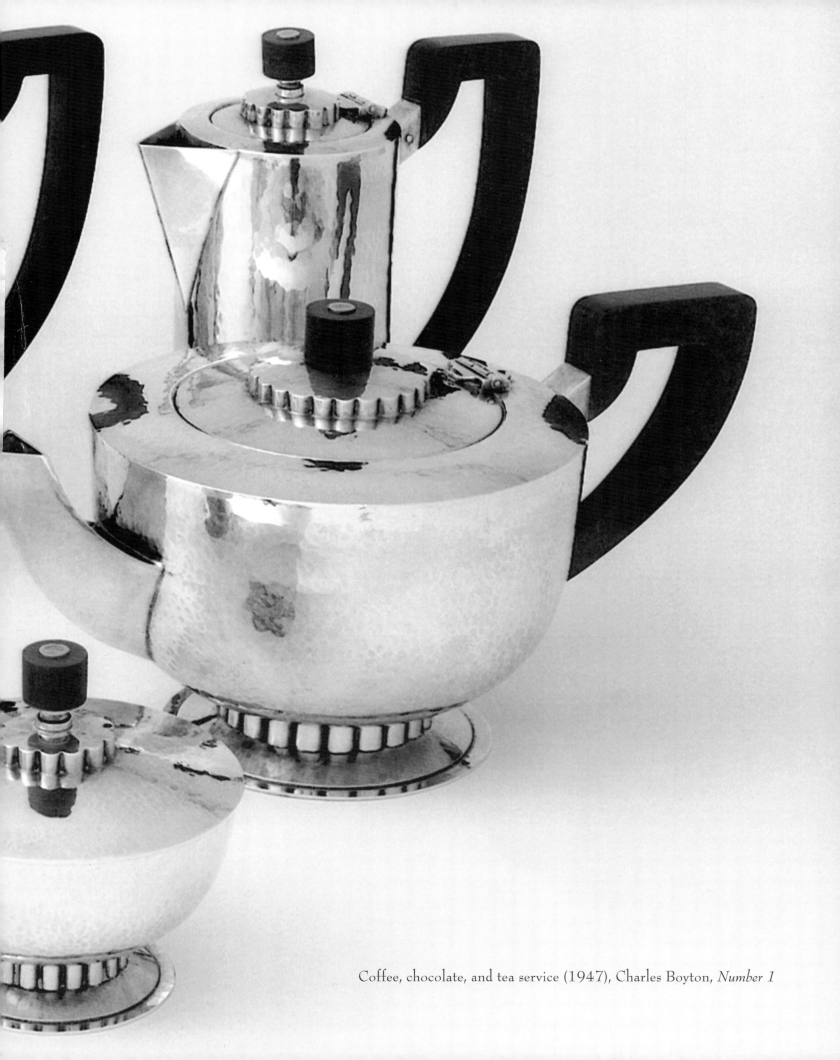

Coffee, chocolate, and tea service (1947), Charles Boyton, *Number 1*

SCANDINAVIAN STYLE

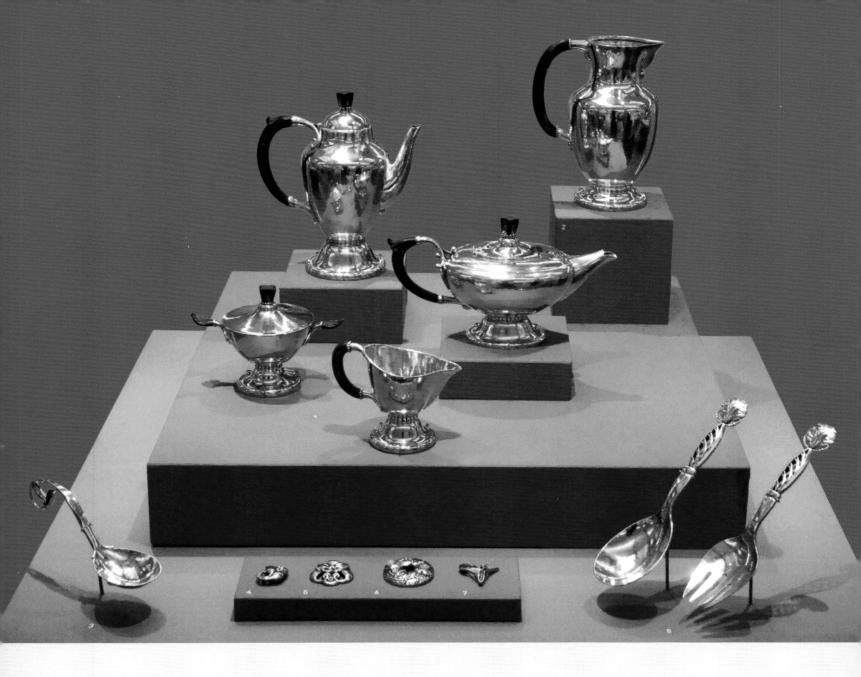

GEORG JENSEN

Georg Jensen apprenticed as a goldsmith in Copenhagen at the age of fourteen. Jensen's desire to be a sculptor led him to the *Danish Royal Academy of Fine Arts*. After graduating in 1892, Jensen found it difficult to earn a living as a sculptor and found work as a modeler in a small pottery workshop. In 1901 he returned to silversmithing and worked with Danish master **Mogens Ballin** until opening his own shop in 1904. Jensen combined his education in fine arts with his early formal training in metalsmithing to revive the tradition of the artist-craftsman.

Jensen initially produced a small range of silver jewelry masterfully set with semiprecious stones that quickly brought international acclaim. His background in sculpture may have contributed to his assured combination of materials and an ability to provide a sense of depth through relief and interlaced design. Jensen's distinctive and elegant work featured rounded shapes decorated with naturalistic motifs (4, 5, 6).

He extended his highly original style to holloware and flatware. Many of his forms are simple and sculptural with stylized wooden handles and finials (1). Georg Jensen's ladle (3) and serving set (8) feature the curvilinear design and naturalistic decoration that characterizes much of his work. At the time of his death in 1935, Jensen's renowned designs were produced by more than 250 workers in an international manufacturing and retail enterprise that continues today.

Henning Koppel was one of many brilliant designers that kept the name Georg Jensen at the forefront of original silverwork throughout the twentieth century. Koppel had never worked with silver prior to his hiring by the Jensen firm in 1945. He, like Jensen, was trained as a sculptor. Koppel's brooch (7) is a fine example of his abstract designs, which foretold the merging of jewelry and sculpture in the latter half of the twentieth century.

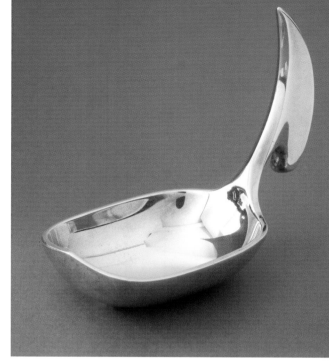

Caddy spoon (c. 1970), Karl Gustav Hansen, *Number 5 (see page 73)*

Case 20

1 **Tea and coffee service** (1915–1917)
Georg Jensen (1866–1935)
Copenhagen, Denmark
sterling silver, wood
M003M00S

2 **Pitcher** (1933–1934)
Georg Jensen (1866–1935)
Copenhagen, Denmark
sterling silver, wood
M003/M005

3 **Ladle** (1929)
Georg Jensen (1866–1935)
Copenhagen, Denmark
sterling silver
N140N140

4 **Brooch** (c. 1910)
Georg Jensen (1866–1935)
Copenhagen, Denmark
sterling silver
S110S110

5 **Brooch** (c. 1915)
Georg Jensen (1866–1935)
Copenhagen, Denmark
sterling silver
S109S109

6 **Brooch** (1945)
Georg Jensen, Inc. (1904–present)
Copenhagen, Denmark
sterling silver, stones
S108S108

7 **Brooch** (c. 1945)
Henning Koppel (1918–1982) for
Georg Jensen, Inc. (1904–present)
Copenhagen, Denmark
sterling silver
S107S107

8 **Serving set**
Georg Jensen, Inc. (1904–present)
Copenhagen, Denmark
sterling silver
N139N139

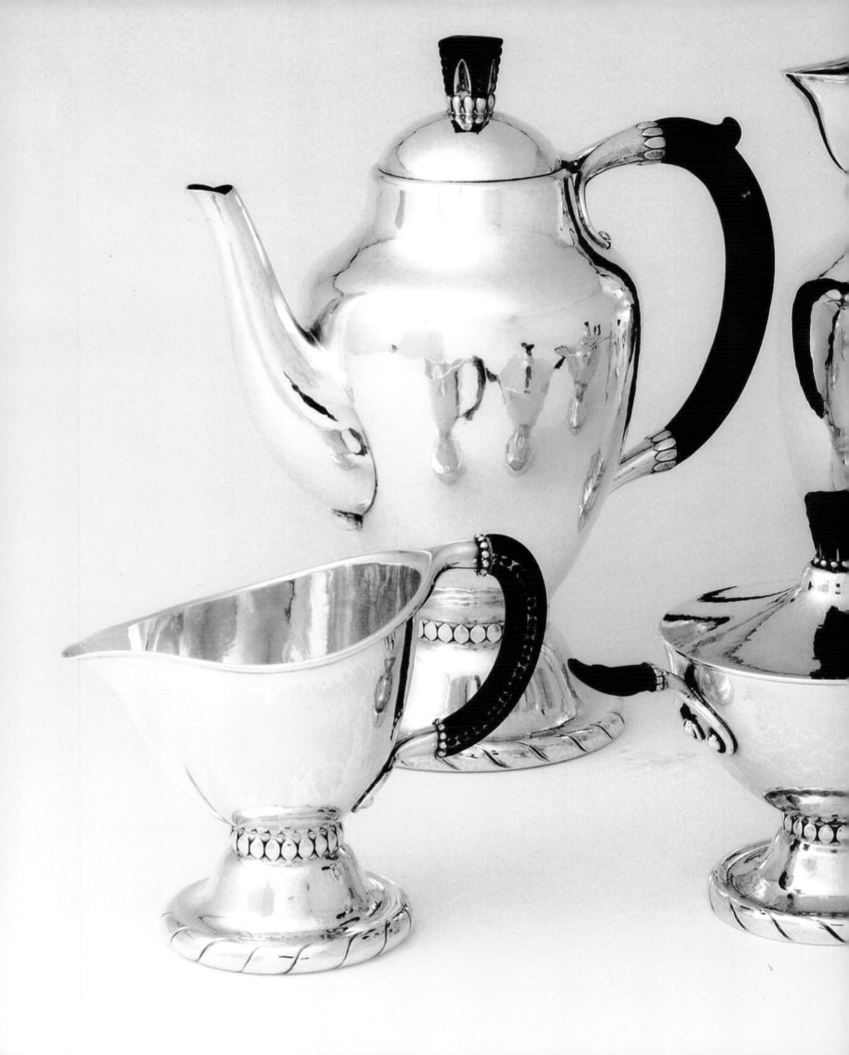

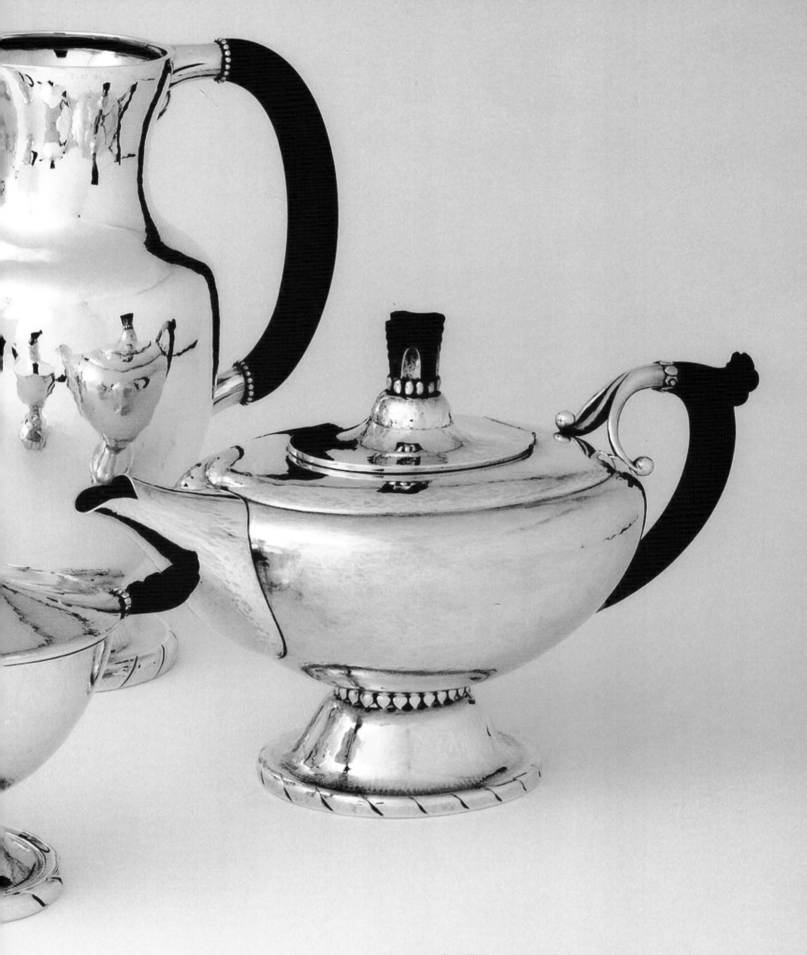

Tea and coffee service (1915–1917), Georg Jensen, *Number 1*

Danish design

Danish silversmiths have created magnificent works of beauty for several hundred years. However, Danish designs did not become internationally prominent until the twentieth century when a multitude of brilliant artists designed and crafted silver evoking the tasteful elegance that became closely associated with Danish work.

Georg Jensen is often credited as the originator of modern Danish silver design, but architect and designer Thorvald Bindesbøll, a pioneer of a variety of decorative arts, was designing silver as early as 1898. His imaginative and idiosyncratic designs were both simple and sophisticated. Bindesbøll was influenced by the English Arts and Crafts movement, Art Nouveau designs, and the recent introduction of Japanese decorative techniques to Europe. He created highly original designs for objects such as this brooch (2) made by master silversmith Evald Nielsen.

Mogens Ballin was formally trained as a painter. Inspired by the ideas of English Arts and Crafts founders William Morris and John Ruskin, Ballin taught himself silversmithing and opened a workshop in 1899

"to make everyday objects with a lovely form…which even the smallest purse can afford." His style, as seen in this beautiful box (6) tastefully decorated with a cabochon amethyst and applied leaf ornamentation, is distinct from English models and appears to be influenced by the designs of Bindesbøll.

Karl Gustav Hansen assumed control of his father's shop, the *Hans Hansen Silversmithy*, at the age of twenty-five when his father died in 1940. Under his direction, Hans Hansen became one of Denmark's most prominent makers of fine silver. Karl Gustav Hansen's tea service (1) features stout sculptural forms and ivory handles.

Kay Bojesen apprenticed for Georg Jensen prior to producing a distinctive body of work in his early career as a jeweler. His imaginative combination of carnelian stones and agate on this pendant necklace (8) from 1915 exemplifies the craftsmanship and originality that distinguish his jewelry from that of many of his contemporaries.

Brooch (c. 1910), designed by Thorvald Bindesbøll, made by Evald Nielsen,
Number 2

Case 21

1 **Tea service** (1958–1960)
Karl Gustav Hansen (1914–2002) for
Hans Hansen Silversmithy (1906–1992)
Kolding, Denmark
sterling silver, bone
M004M004

2 **Brooch** (c. 1910)
Designed by Thorvald Bindesbøll
(1846–1908), made by Evald Nielsen
(1879–1956)
Denmark
sterling silver, moonstone
S102S102

3 **Necklace** (c. 1980)
Hans Hansen Silversmithy (1906–1992)
Kolding, Denmark
sterling silver, enamel
N266N266

4 **Cup** (1988)
Karl Gustav Hansen (1914–2002) for
Hans Hansen Silversmithy (1906–1992)
Kolding, Denmark
sterling silver
N136N136

5 **Caddy spoon** (c. 1970)
Karl Gustav Hansen (1914–2002) for
Hans Hansen Silversmithy (1906–1992)
Kolding, Denmark
sterling silver
N246N246

6 **Box** (c. 1910)
Mogens Ballin (1871–1914)
Denmark
sterling silver, amethyst, wood liner
P118S001

7 **Brooch** (c. 1900)
Mogens Ballin (1871–1914)
Denmark
sterling silver, carnelian
S002S002

8 **Necklace** (c. 1915)
Kay Bojesen (1886–1958)
Copenhagen, Denmark
sterling silver, carnelian, agate
N212N212

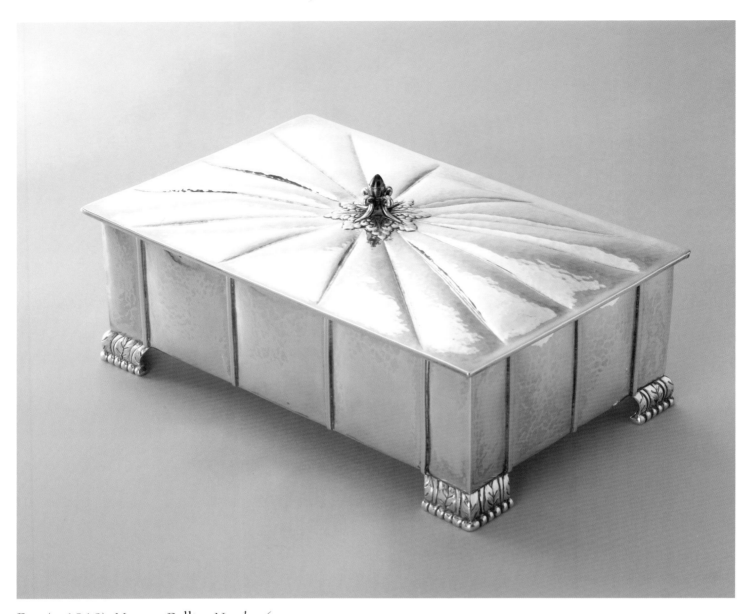

Box (c. 1910), Mogens Ballin, *Number 6*

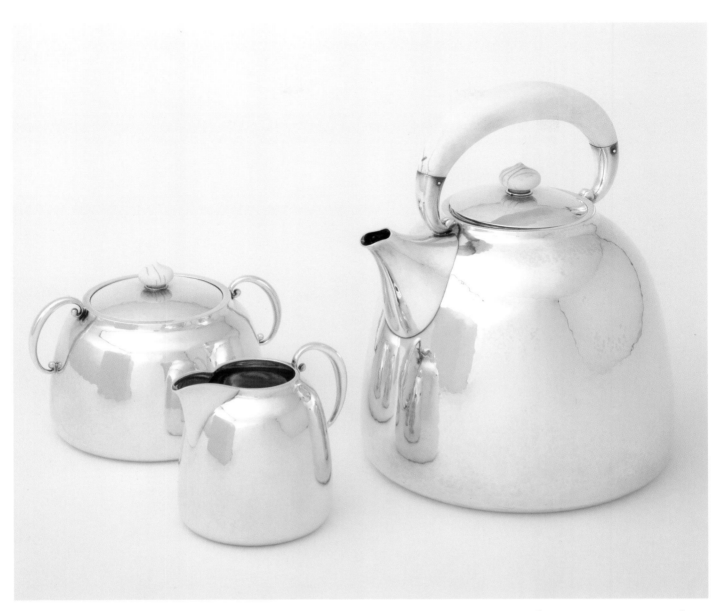

Tea service (1958-1960), Karl Gustav Hansen, *Number 1*

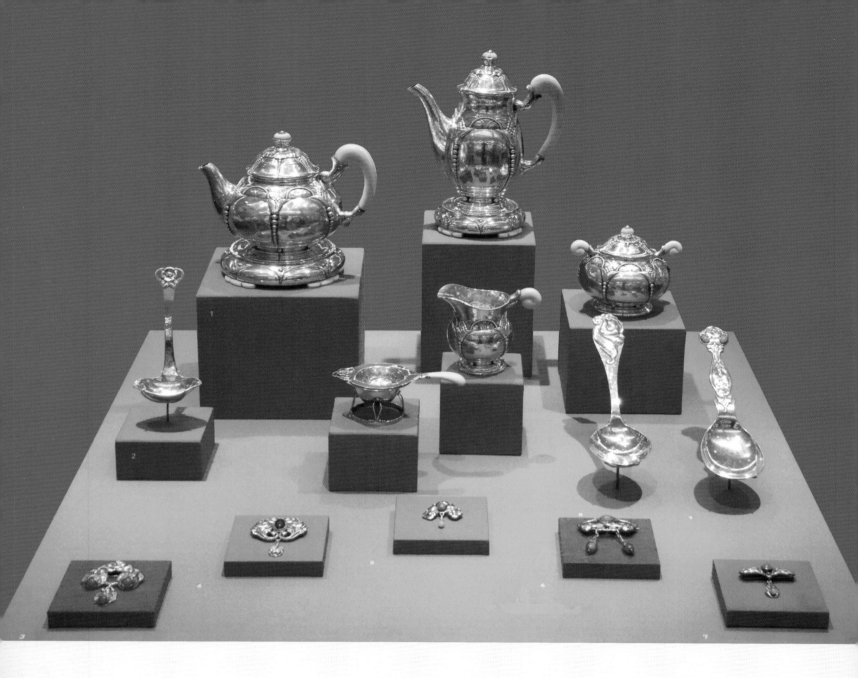

EVALD NIELSEN

Danish master **Evald Nielsen** developed his impressive skills as a chaser and engraver while serving an apprenticeship to a prominent Copenhagen goldsmith beginning in 1893. He traveled throughout France and Germany as a journeyman in the early 1900s. Nielsen began making his distinctively lavish jewelry upon returning to Copenhagen and establishing his shop in 1905. His style of setting semiprecious stones that appear to be emerging from flowers was emulated by many other contemporary jewelers (3). Nielsen exhibited extensively in world's fairs and his popular work was instrumental in popularizing the Danish Arts and Crafts style, called *skønvirke*. His stature was elevated to a level rivaled only by that of Georg Jensen.

Nielsen's flatware and holloware are equally elegant and distinctive. This remarkable tea and coffee service (1) decorated with ivory handles and finials is a fine example of his early work. It is designed to rest on pads rather than on a tray. Nielsen's successful career was characterized by constant improvement and innovation. When Nielsen died, he left his workshop to his son and provided a book of instructional maxims that included this statement: "It is wonderful to do work which is sad to sell."

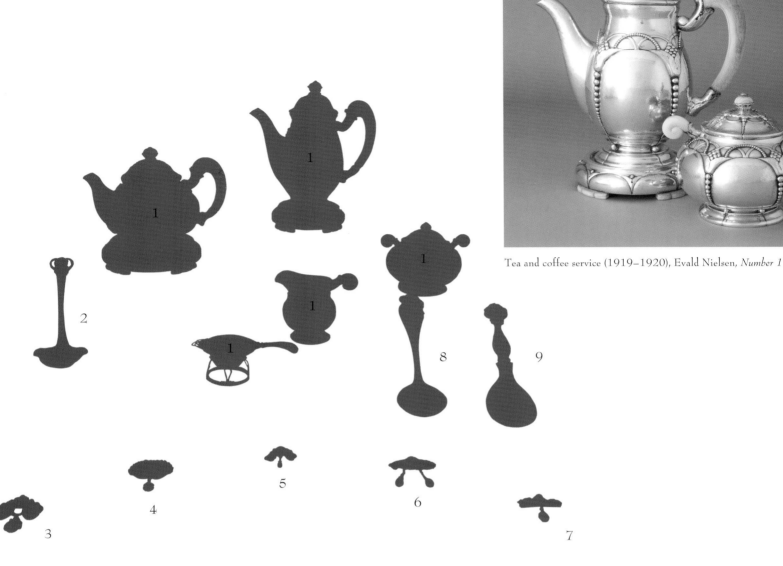

Tea and coffee service (1919–1920), Evald Nielsen, *Number 1*

Case 22

1 **Tea and coffee service** (1919–1920)
Evald Nielsen (1879–1956)
Copenhagen, Denmark
sterling silver, ivory
M002M002

2 **Ladle** (c. 1950)
Evald Nielsen (1879–1956)
Copenhagen, Denmark
silver
N143N143

3 **Brooch** (c. 1910–1920)
unknown maker
Denmark
silver, carnelian
S173S173

4 **Brooch** (c. 1910–1920)
unknown maker
Denmark
silver, agate
S174S174

5 **Brooch** (c. 1910–1920)
unknown maker
Denmark
silver, amber
S175S175

6 **Brooch** (c. 1910–1920)
unknown maker
Denmark
silver, amber
S176S176

7 **Brooch** (c. 1910–1920)
unknown maker
Denmark
sterling silver, carnelian
S177S177

8 **Serving spoon** (1931)
unknown maker
Denmark
sterling silver
N141N141

9 **Serving spoon** (c. 1910–1920)
unknown maker
silver, amber
N142N142

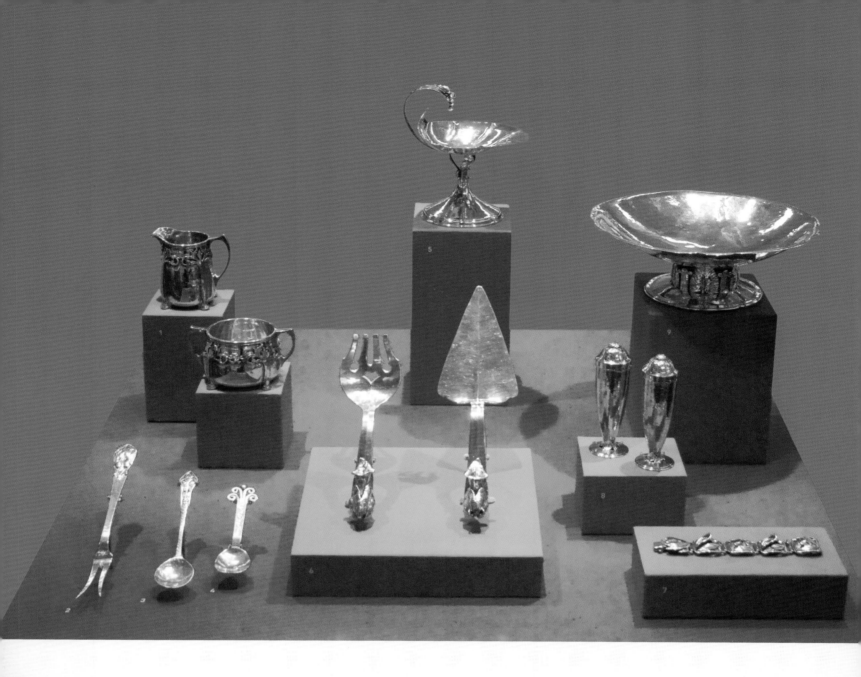

THE SMED FAMILY AND CARL POUL PETERSON

Peer Smed trained as a silversmith in his native Denmark. He worked for *Tiffany & Co.* in New York before establishing his own shop where he produced handwrought holloware and jewelry. Smed's finely crafted work and dramatic designs assured a steady stream of clients and earned him acclaim. Smed's design of flatware and holloware for New York's *Waldorf-Astoria Hotel* in 1931 featured the popular bead, scroll, and floral motif associated with the Scandinavian style in vogue at that time. His bracelet (7) features the calla lily, one of Smed's favorite motifs, in high relief.

After Peer Smed's death, his daughter, Lona P. Schaeffer, crafted similarly designed holloware and flatware throughout the 1940s. Very little is known of Schaeffer, and for much of the late twentieth century

her beautifully crafted silver was relatively unappreciated. Schaeffer's rare and imaginative output includes these heavy, handwrought fish servers (6) that feature the applied lily and leaf ornamentation her father favored.

Canadian silversmith Carl Poul Petersen's elegant compote (5) and deeply sculpted pickle fork (2) also reflect the Danish taste of Petersen's homeland. Petersen trained with Danish master Georg Jensen from the age of thirteen to age eighteen before marrying his daughter and immigrating to Montreal in 1929. He crafted a variety of modern silver pieces that advanced the popularity of Scandinavian design in Canada and throughout North America.

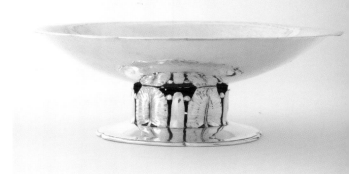

Centerpiece bowl (c.1945), Lona P. Schaeffer, *Number 9*

Case 23

1 Sugar and creamer (1919)
William Comyns & Sons (1885–1953) for Tiffany & Co. (1868–present)
London, England
sterling silver
S008S008

2 Pickle fork (c. 1915)
Carl Poul Peterson (1895–1977)
Montreal, Canada
sterling silver
N228N228

3 Spoon (c. 1940s–1950s)
unknown maker
silver
N198N198

4 Spoon (c. 1920s)
unknown maker
silver
N197N197

5 Compote (c. 1930)
Carl Poul Peterson (1895–1977)
Montreal, Canada
sterling silver
P092S125

6 Fish servers (c. 1945)
Lona P. Schaeffer (active 1940s)
Brooklyn, New York
sterling silver
P064S086

7 Bracelet (c. 1940)
Peer Smed (1878–1943)
Brooklyn, New York
sterling silver
*2002.091.34

8 Salt and pepper casters (1930s)
Peer Smed (1878–1943)
Brooklyn, New York
sterling silver
P061S069

9 Centerpiece bowl (c. 1945)
Lona P. Schaeffer (active 1940s)
Brooklyn, New York
sterling silver
P063S025

*Courtesy of the Portland Art Museum, The Margo Grant Walsh 20th Century Silver and Metalwork Collection

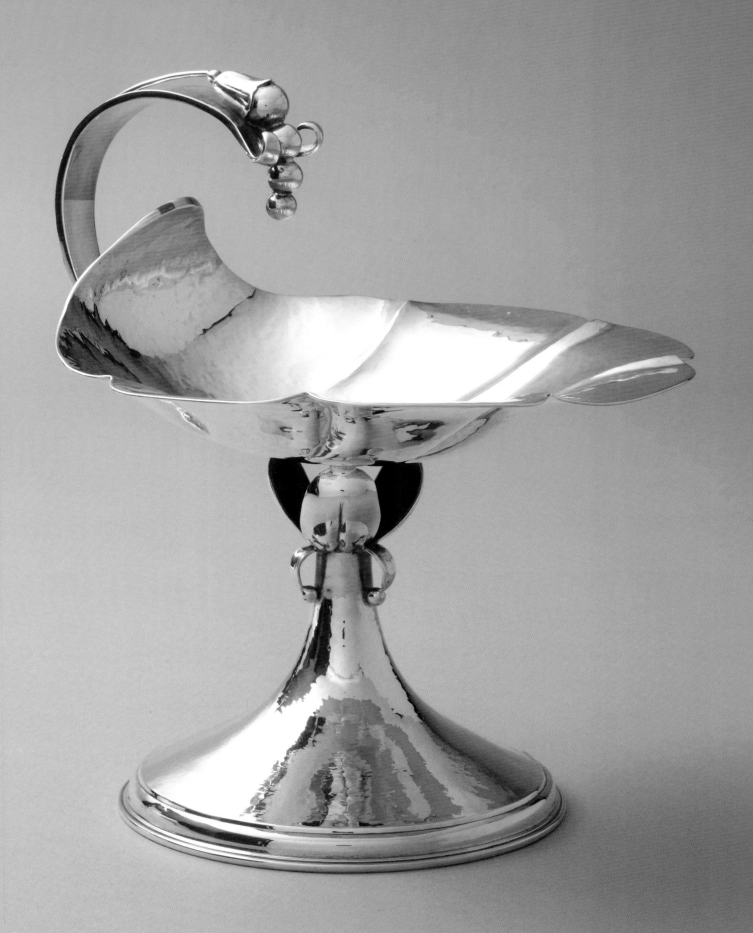

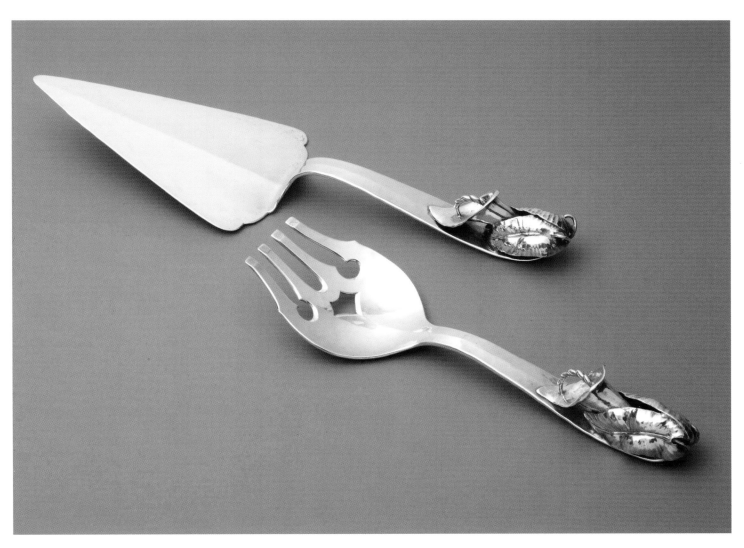

Fish servers (c. 1945), Lona P. Schaeffer, *Number 6*

Compote (c. 1930), Carl Poul Peterson, *Number 5*

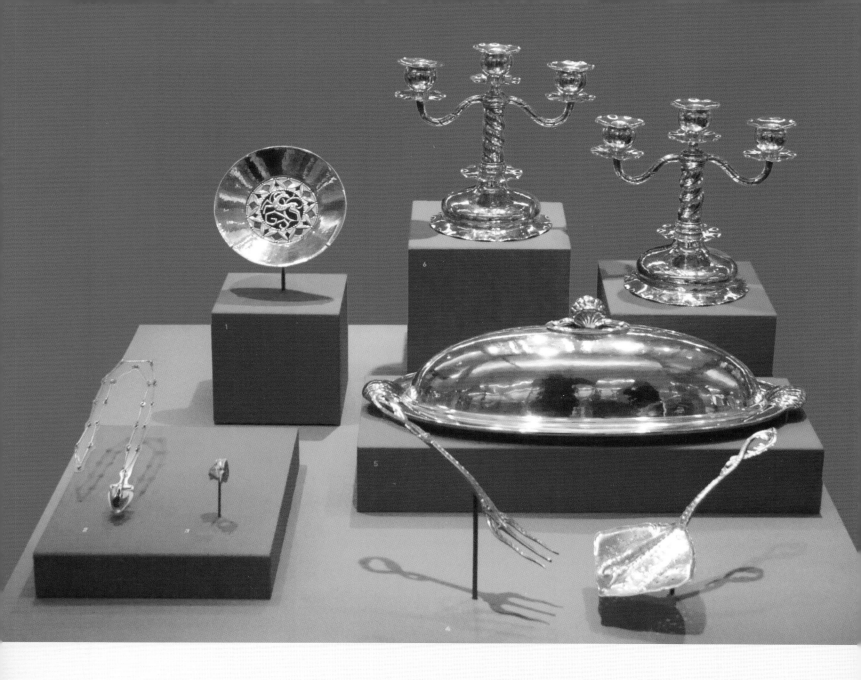

SCANDINAVIAN AND FINNISH DESIGN

Danish-born designer **Emile Hoye** created this whimsical but functional fish service in the form of sea creatures (4) for *Marius Hammer*, one of Norway's leading silversmithing firms. A skate and gar appear to have been transformed into silver in these imaginatively designed and remarkably well-executed pieces.

Designers at Finland's *Lapponia Jewelry* have been creating sculptural jewelry from silver, gold, and platinum since 1960. Sculptor and jewelry designer **Björn Weckström's** dramatic ring set with quartz (3) displays his preference for rendering gold in a matte finish that he finds to be warmer than the reflective brilliance of its conventional representation. Weckström often utilizes cast plaster models that create spontaneous elements in the forms of his jewelry, such as the surface texture of this abstract pendant necklace (2) set with an acrylic jewel.

Norwegian craftsmen first experimented with enamel on silver at the end of the nineteenth century. They earned a reputation for their original work at the Exposition Universelle in Paris in 1900, and Norwegian enamel work was promoted in catalogues by London's *Liberty & Co.* After enamel largely receded from use in the early twentieth century, Norwegian silversmiths returned to the use of brightly colored enamels in their silverwork. This flared dish (1) by Norway's silver company Thune features a stylized deer amidst embossed and enameled decoration. *Thune*, known for its elegant designs, is one of Norway's most venerable makers of silver.

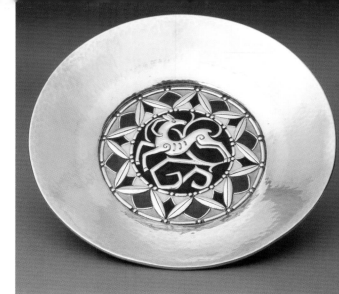

Dish (c. 1970), Thune, *Number 1*

Case 24

1 Dish (c. 1970)
Thune (1857–present)
Oslo, Norway
sterling silver, enamel
S096S096

2 Necklace (c. 1975)
Björn Weckström (b. 1935)
for Lapponia Jewelry (1960–present)
Helsinki, Finland
silver, lucite
N284N284

3 Ring (c. 1985)
Björn Weckstrom (b. 1935)
for Lapponia Jewelry (1960–present)
Helsinki, Finland
gold, quartz
N285N285

4 Fish servers (c. 1910)
Emile Hoye (1875–1958)
for Marius Hammer (1847–1927)
Bergen, Norway
sterling silver
N144N144

5 Fish platter with cover (1946)
Bratland
Copenhagen, Denmark
sterling silver
N087N087

6 Pair of candlestick holders (1931)
unknown maker
Stockholm, Sweden
sterling silver
N006N006

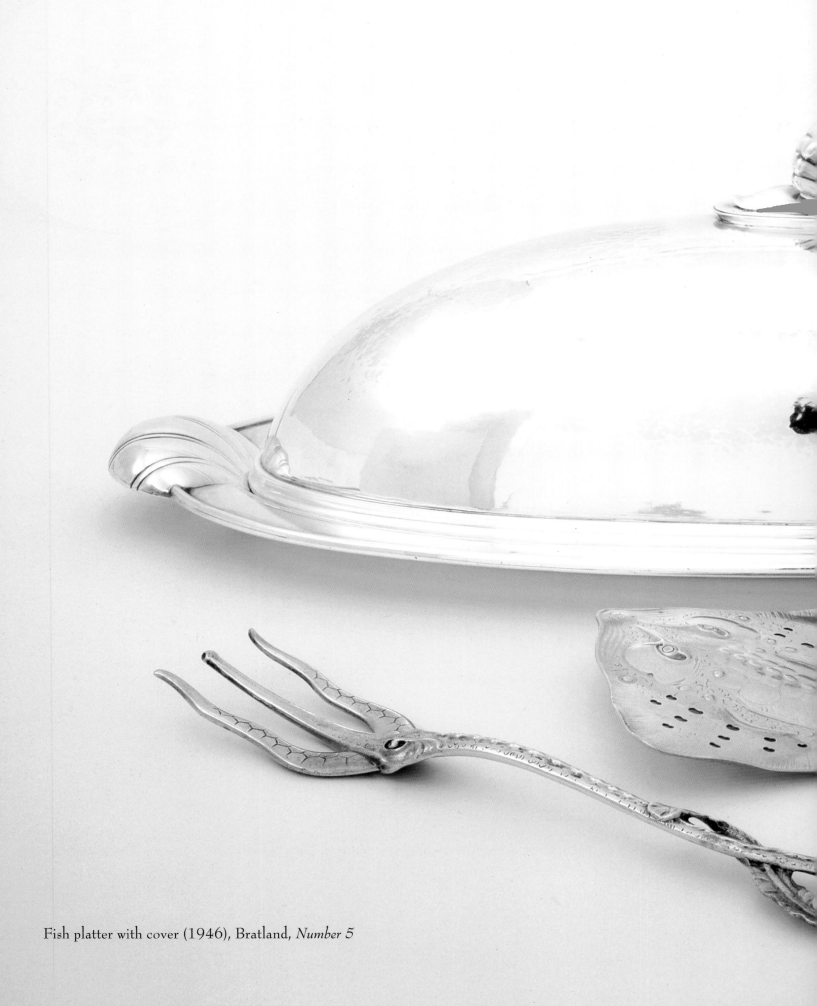

Fish platter with cover (1946), Bratland, *Number 5*

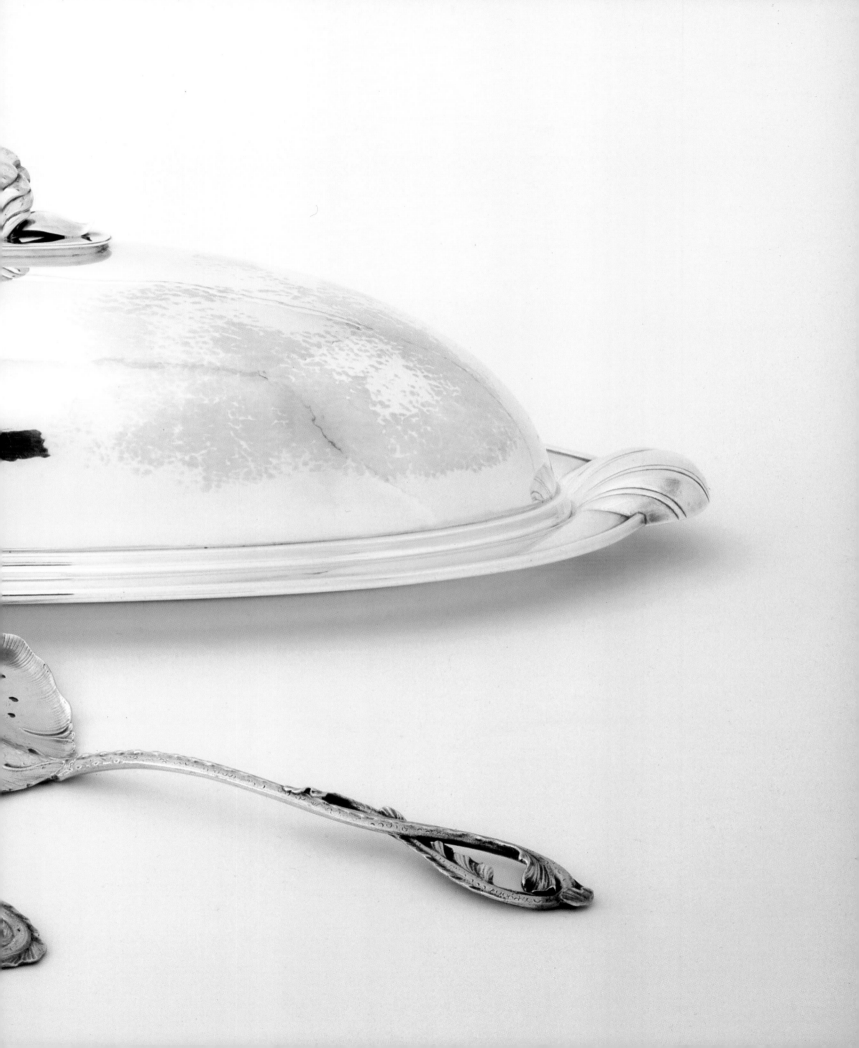

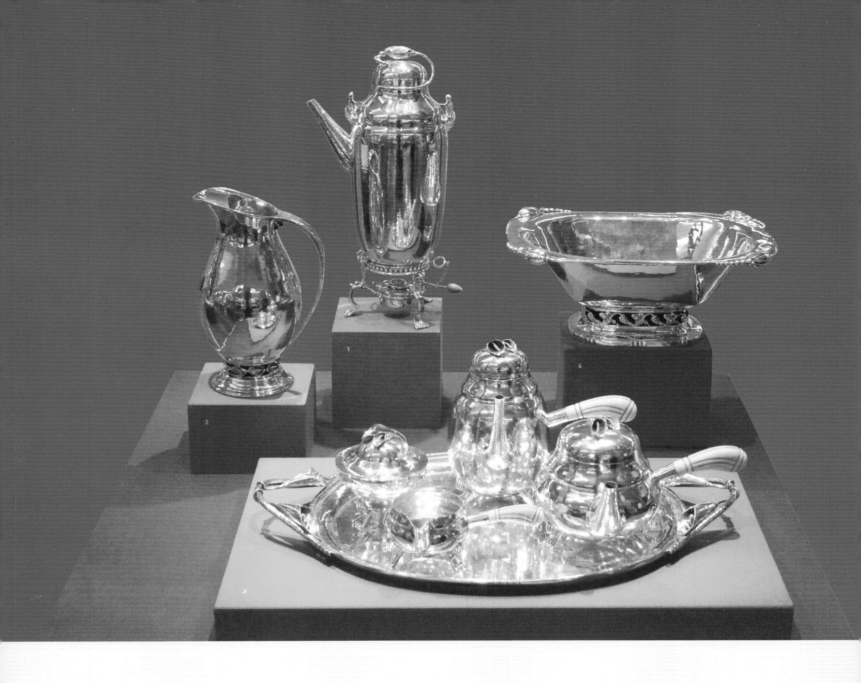

WILLIAM G. deMATTEO

William G. deMatteo immigrated to the United States from Italy as a young boy. Initially interested in pursuing a career in medicine, he was inspired to become a silversmith after visiting the *Georg Jensen* showroom in New York. Following an apprenticeship at *Reed & Barton* in New York, he started a small workshop in 1919 and subsequently moved to New Jersey, where he crafted exquisite handwrought silver and gold pieces until his retirement in 1968.

He was commissioned to produce designs for *Georg Jensen, Inc.* during the Second World War and continued to sell those designs until the end of his career. His prolific output included trays, bowls, tea sets, ecclesiastical work, and even custom-designed surgical instruments. Many of his holloware items, such as this tea and coffee service (3), match the elegance of those by Jensen. Whereas Jensen's favorite decorative motif was the magnolia flower bud, deMatteo's work is identified by his use of the lily. William deMatteo, under-appreciated for many years, is now considered one of the most important American silversmiths of the twentieth century. His son William L. deMatteo (1923–1988) became a master silversmith, and his grandson, Chip, continues to work in the tradition today.

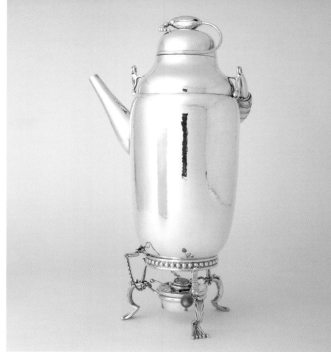

Coffee urn and warming stand (c. 1935), William G. deMatteo,
Number 1

Case 25

1 **Coffee urn and warming stand** (c. 1935)
William G. deMatteo (1895–1980)
Bergenfield, New Jersey
sterling silver, ivory
P080S129

2 **Pitcher** (c. 1939)
William G. deMatteo (1895–1980)
Bergenfield, New Jersey
sterling silver
P077S022

3 **Tea and coffee service** (c. 1945)
William G. deMatteo (1895–1980)
Bergenfield, New Jersey
sterling silver, ivory
M006M006

4 **Centerpiece bowl** (c. 1950)
William G. deMatteo (1895–1980)
Bergenfield, New Jersey
sterling silver
N023N023

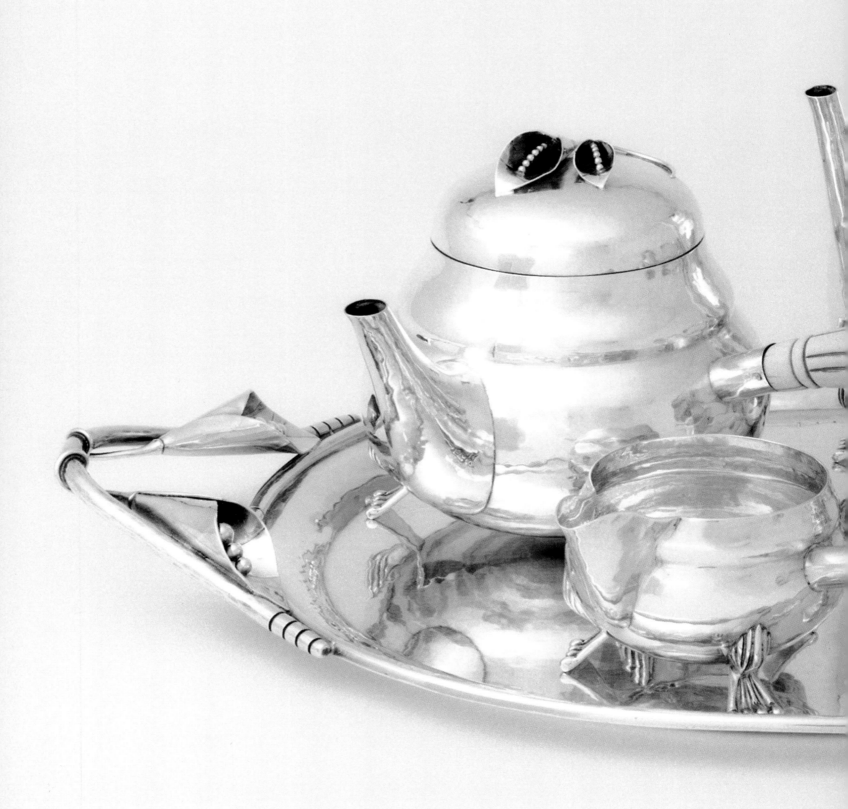

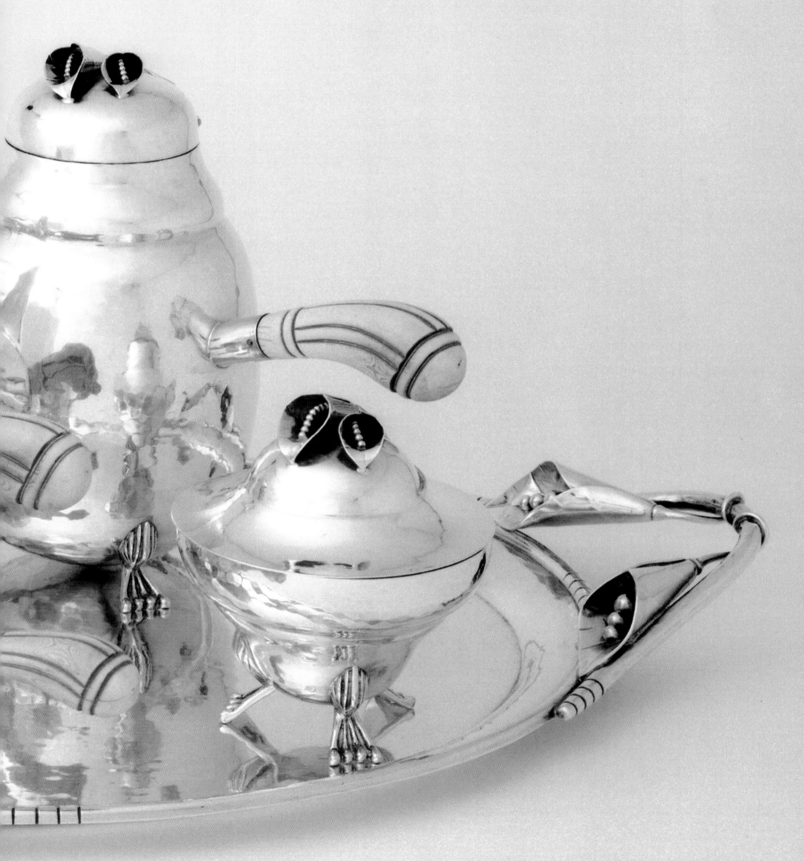

Tea and coffee service (c. 1945), William G. deMatteo, *Number 3*

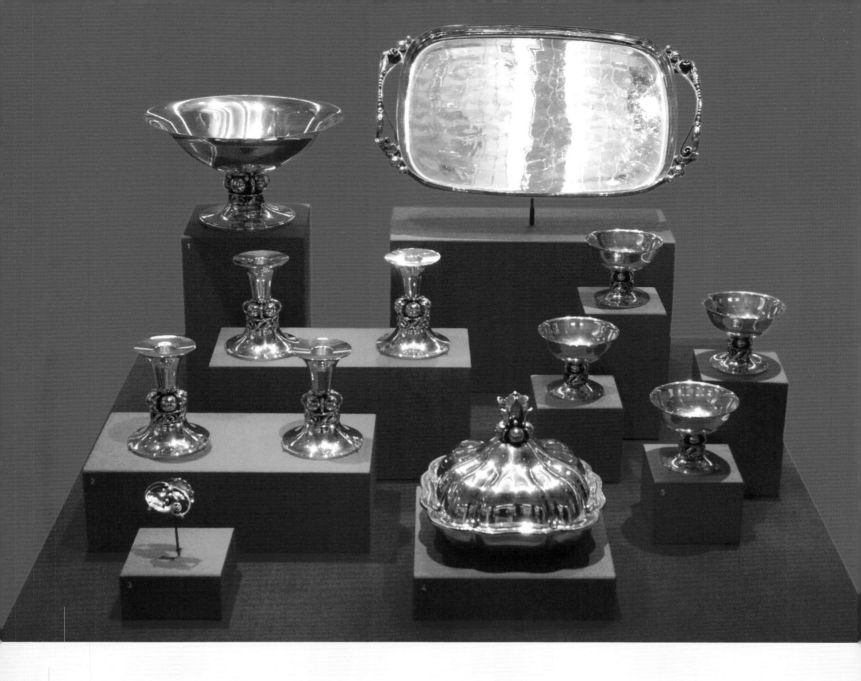

ALPHONSE LaPAGLIA

Alphonse LaPaglia designed a wide range of silver for *Georg Jensen, Inc.* in the 1940s when European goods were not available in the United States due to the Second World War. Like **William G. deMatteo**, LaPaglia skillfully reworked Jensen's signature motifs, including that of the magnolia blossom. Many of his pieces, such as this brooch (3), feature sculptural flower buds, leaves, and blossoms. LaPaglia had visited Rome in his youth and was inspired by the exuberant style of seventeenth-century Italian art and sculpture. His work tastefully incorporates similar elements in the sensuous decoration of his silver.

LaPaglia stopped designing for *Jensen* in 1948. He was designing silver out of a garage in New Jersey when *International Silver Co.*

decided to underwrite his work and established a studio for him in Connecticut in 1952. His work of this period reflects his fondness for Danish style and has a very strong signature in the form of heavy looped and spherical elements and decorative openwork in the feet (1, 2, 4, 5, 6). *International* marketed these well-made pieces of heavy gauge silver as a special prestige line. LaPaglia was able to enjoy only a year of success before his untimely death due to an accidental fall at his studio. *International* acquired his unique designs for further production.

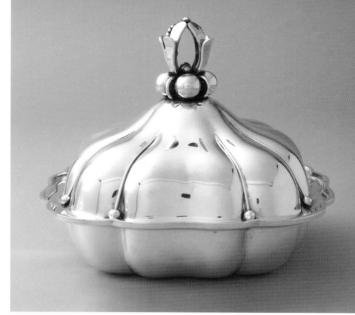

Covered dish with large finial (c. 1950), Alphonse LaPaglia, *Number 4*

Case 26

1 Centerpiece bowl (c. 1950)
Alphonse LaPaglia (active 1945–1953)
for International Silver Co. (1898–present)
Meriden, Connecticut
sterling silver
P074S135

2 Candlestick holders (c. 1950)
Alphonse LaPaglia (active 1945–1953)
for International Silver Co. (1898–present)
Meriden, Connecticut
sterling silver
*2003.051.01a–d

3 Brooch (c. 1945)
Alphonse LaPaglia (active 1945–1953)
for International Silver Co. (1898–present)
Meriden, Connecticut
sterling silver
N278N278

4 Covered dish with large finial (c. 1950)
Alphonse LaPaglia (active 1945–1953)
for International Silver Co. (1898–present)
Meriden, Connecticut
sterling silver
P072S095

5 Set of fruit bowls (c. 1950)
Alphonse LaPaglia (active 1945–1953)
for International Silver Co. (1898–present)
Meriden, Connecticut
sterling silver
P078S093

6 Tray (c. 1950)
Alphonse LaPaglia (active 1945–1953)
for International Silver Co. (1898–present)
Meriden, Connecticut
sterling silver
P075S000

*Courtesy of the Portland Art Museum,
The Margo Grant Walsh 20th Century
Silver and Metalwork Collection

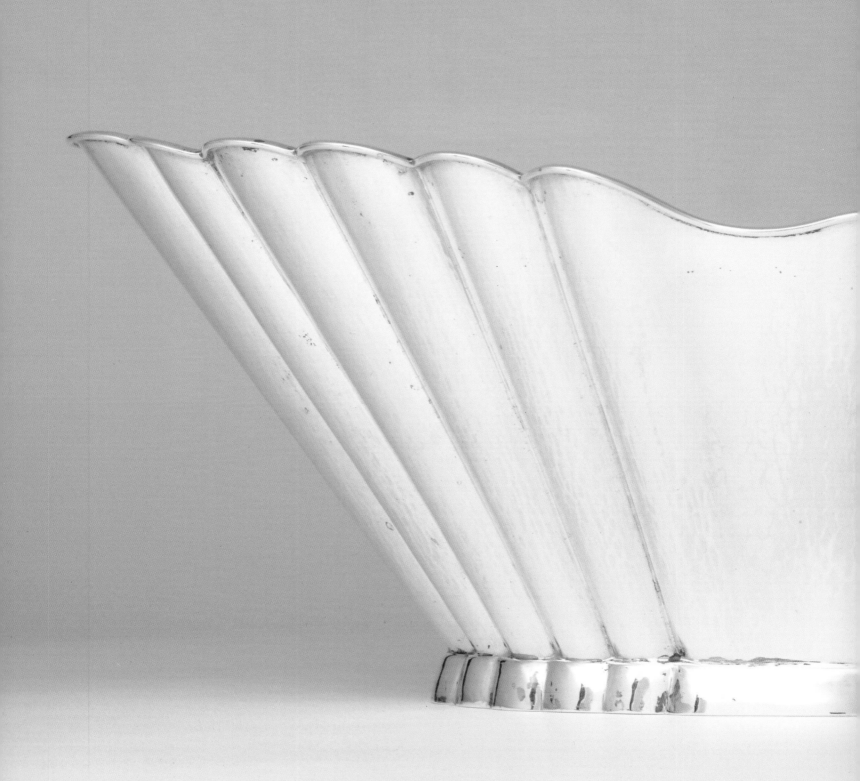

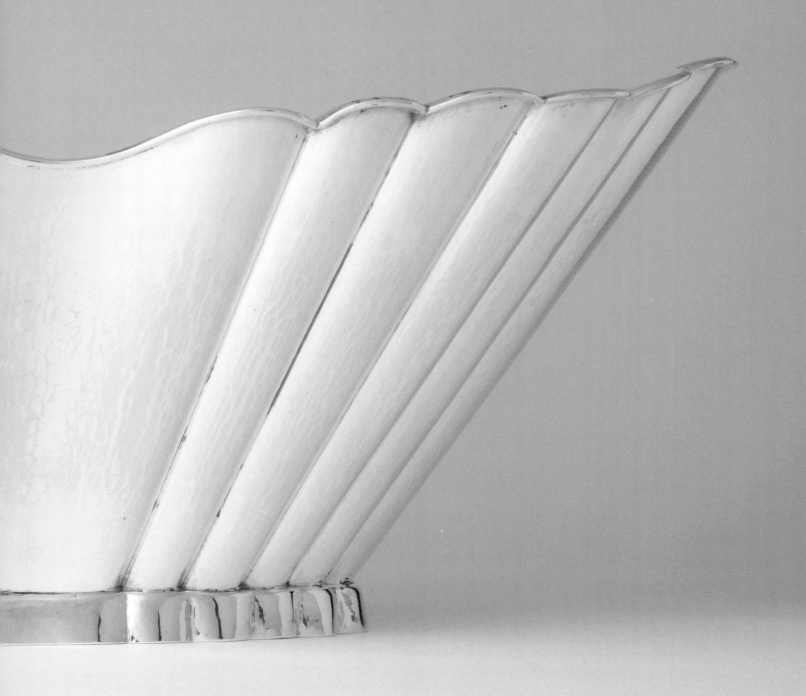

THE MODERNIST
IMPULSE

THE DARMSTADT COLONY AND WIENER WERKSTÄTTE

In 1899 a number of prominent Art Nouveau artists were invited by the Grand Duke Ernst Ludwig to live, work, and teach at a school on the outskirts of Darmstadt, Germany. Ludwig was inspired by the ideals of the English Arts and Crafts movement to create well-designed objects of beauty for industry. Over the course of several years and until the outbreak of the First World War, the Darmstadt artists' colony was an important source for new design ideas related to the Art Nouveau movement, known as *Jugendstil* (youth style) in Germany.

In 1897 a group of Vienna's most progressive artists and designers broke free from the conventional art establishment in Austria in a movement called *Secession*. Secession artists desired to transcend the perceived barriers between art, design, and craft. In 1903 Secession members began a cooperative enterprise called *Wiener Werkstätte* (Vienna Workshops) that was modeled on Charles Robert Ashbee's *Guild of Handicraft* in England. Architect and designer Josef Hoffmann was the primary force behind designs that brought *Wiener Werkstätte* acclaim for producing elegant and innovative metalwork in simplified forms, such as this iconic bowl with scalloped rim (3).

Detail of Mantle clock (c. 1910), Ludwig Hohlwein, *Number 6*

Case 27

1 **Pair of candlesticks** (c. 1910)
Wurttembergische Metallwarenfabrik (1853–present)
Wurtemburg, Germany
silver plate
N003N003

2 **Coffee service** (c. 1930)
unknown maker
Germany
silver, wood
N105N105

3 **Bowl** (c. 1920)
Josef Hoffmann (1870–1956) for Wiener Werkstätte (1903–1932)
Vienna, Austria
silver, gilt
N050N050

4 **Belt** (1910)
Turriet & Bardach
Austria
leather, metal, mother-of-pearl
N201N201

5 **Box** (c. 1900)
unknown maker
Germany
iron, wood liner
N016N016

6 **Mantle clock** (c. 1910)
Ludwig Hohlwein (1874–1949)
Germany
copper, brass, glass
N065N065

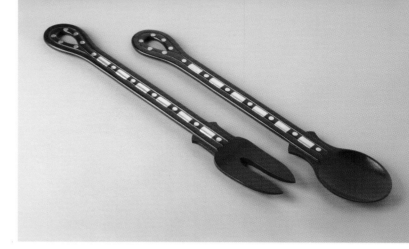

Salad servers (c. 1960), William Spratling, *Number 1*

Case 33

1 **Salad servers** (c. 1960)
William Spratling (1900-1967)
Taxco, Mexico
rosewood, silver
N117N117

2 **Bracelet** (c. 1945)
William Spratling (1900-1967)
Taxco, Mexico
sterling silver, azur-malachite
N120N120

3 **Pendant and chain** (1950s)
William Spratling (1900-1967)
Taxco, Mexico
silver, tortoiseshell
S114S114

4 **Coffee service** (c. 1964–67)
William Spratling (1900-1967)
Taxco, Mexico
sterling silver, rosewood
*2002.084.02A-D

5 **Dessert spoon** (c. 1945)
William Spratling (1900-1967)
Taxco, Mexico
sterling silver
N126N126

6 **Serving spoon** (c. 1945)
William Spratling (1900-1967)
Taxco, Mexico
sterling silver
N125N125

7 **Brooch** (c. 1950)
William Spratling (1900-1967)
Taxco, Mexico
sterling silver
S036S036

8 **Salad servers** (1944–1946)
William Spratling (1900-1967)
Taxco, Mexico
silver, ebony
N116N116

*Courtesy of the Portland Art Museum,
The Margo Grant Walsh 20th Century
Silver and Metalwork Collection

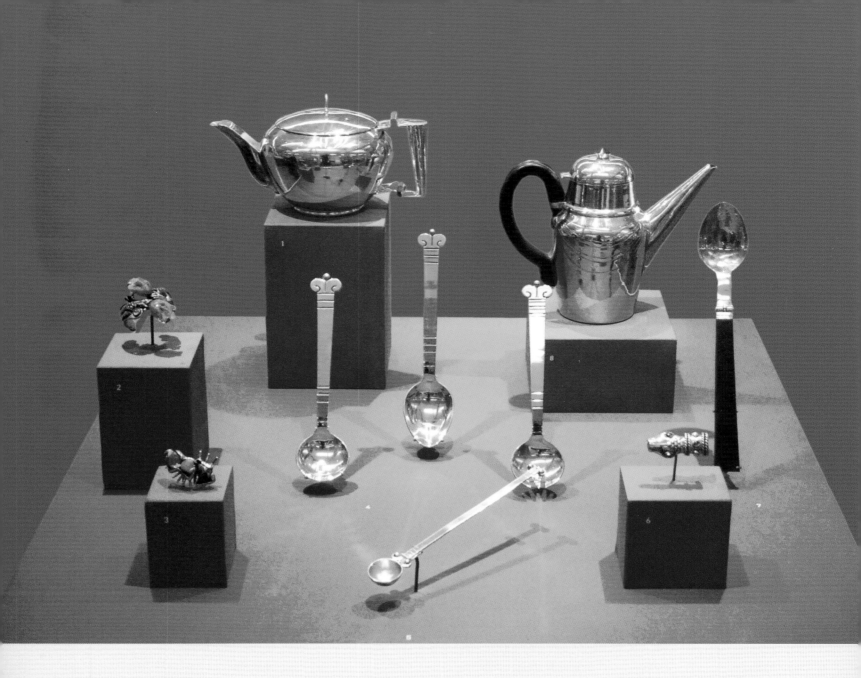

MEXICAN MASTERS

Spratling's success in Taxco helped revive interest in Mesoamerican design motifs and launched an industry that attracted a number of talented designers and craftsmen. Hector Aguilar was William Spratling's workshop manager prior to leaving with many of the shop's finest silversmiths and establishing the highly influential *Taller Borda* in 1939. Designs such as this iced tea spoon (5) draw from pre-Columbian motifs while revealing Aguilar's distinct sensibility.

Salvador Vaca Terán, one of the most avant-garde of the Taxco silversmiths, left Spratling's workshop in 1939 to open *Los Castillo* with his cousin, Antonio Castillo. In 1952 Terán opened his own workshop in Mexico City where he became known for imaginative and well-crafted jewelry featuring overlapping planes and sculptural shapes. His contributions to Modernist silverwork include this abstract brooch set with three colorful stones (3).

In 1940 Juvento Lopez Reyes crafted a very modern teapot (1) with a side-hinged lid to prevent unintended spills. The cylindrical handle is set with wooden components to insulate it from the heat of the pot. William Spratling used shallow incised lines to emphasize the form of this relatively unadorned coffeepot with a rosewood handle (8).

Spratling frequently incorporated a pair of hands as a design element in his work. This bracelet (2) features hands holding carved flowers of amethyst. Amethyst, regularly used in Mexican silver jewelry, varies from deep purple to pale violet and can be nearly transparent or opaque. The serpent, a symbol of pre-Columbian culture, was another favorite motif in Spratling's designs and appears in jewelry throughout Mexico (6).

Teapot (1940), Juvento Lopez Reyes, *Number 1*

Case 34

1 Teapot (1940)
Juvento Lopez Reyes
(active early to mid-20th century)
Taxco, Mexico
sterling silver, wood
N110N110

2 Bracelet (c. 1950)
William Spratling (1900-1967)
Taxco, Mexico
sterling silver, amethyst
S035S035

3 Brooch (c. 1950s–1960s)
Salvador Vaca Terán (1918–1974)
Mexico City
sterling silver, stones
N166N166

4 Salad servers (c. 1950s)
unknown maker
Taxco, Mexico
sterling silver
N122N122

5 Iced tea spoon (c. 1950s)
Hector Aguilar (1905–1986)
Taxco, Mexico
sterling silver
N124N124

6 Belt buckle (c. 1940s)
unknown maker
Mexico
sterling silver, amethyst
N170N170

7 Serving spoon (c. 1950)
William Spratling (1900–1967)
Taxco, Mexico
sterling silver, wood
N119N119

8 Coffeepot (c. 1962–1964)
William Spratling (1900–1967)
Taxco, Mexico
sterling silver, rosewood
N111N111

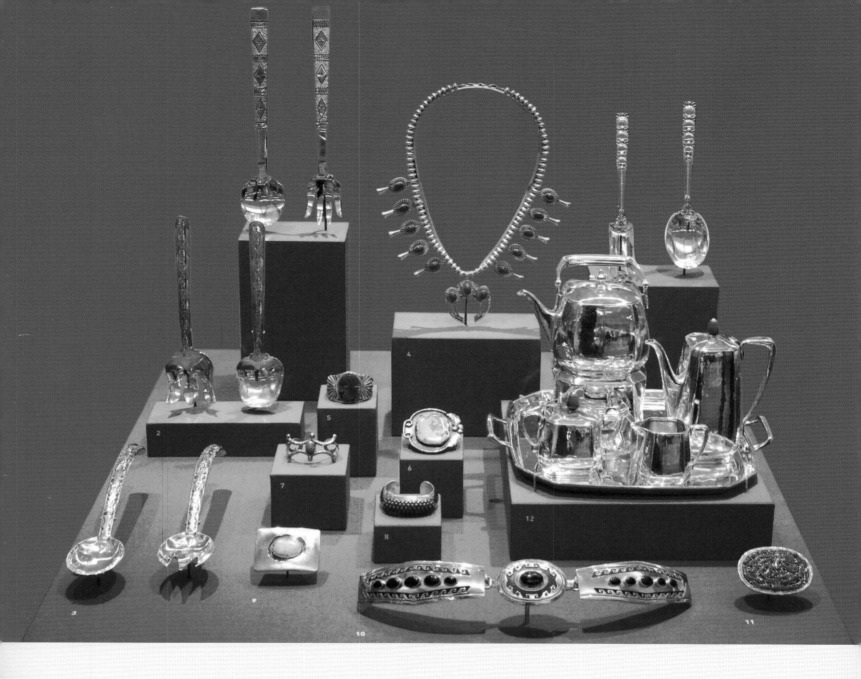

AMERICAN SIGNATURE

Although Native American jewelers in the southwestern United States used certain design motifs for several hundred years, they were only recently executed in silver. In the mid-nineteenth century, the Navajo learned silversmithing from the Mexicans and later introduced the art to Hopi and Zuni artisans. Today, Southwest Indian jewelry, such as Navajo silversmith **Thomas Jim's** squash blossom necklace (4), is recognized around the world as a distinctly American art form. The Navajo-made salad servers (1, 2, 3), similar in design to the set by *Tiffany & Co.* (13), have handles decorated to the base with raised detail that require a high level of technical skill by the maker.

New York's *Tiffany & Co.* was the signature American producer of fine silver at the beginning of the twentieth century. During the

Victorian era, *Tiffany*, and to a lesser extent, *Gorham Manufacturing Co.* in Providence, Rhode Island, were primarily responsible for bringing prestige to American craftsmanship through exhibitions held in Europe. In the United States, they were firmly established as the standard-bearers of fine silver craftsmanship. In the 1920s Arts and Crafts silver makers, like Chicago's *Kalo Shop* and *Lebolt & Co.*, were successfully selling their products in New York showrooms. *Tiffany & Co.* developed a special line of handwrought silver to compete with the simple and elegant forms that had become so popular. This unadorned tea and coffee service (12) is a fine example of *Tiffany's* very limited production of lightly hammered, heavy-gauge holloware.

Salad servers: *left set—see Number 3; center set—see Number 13; right set—see Number 2*

Case 35

1 Salad servers
(c. 1960s–1970s)
unknown maker, Navajo
Southwestern United States
sterling silver, coral
N179N179

2 Salad servers
(c.1960s–1970s)
Elmer Kee, Navajo
Southwestern United States
sterling silver
N128N128

3 Salad servers
(c. 1970s–1980s)
Thomas Jim, Navajo (b. 1955)
Flagstaff, Arizona
sterling silver
N129N129

4 Necklace (c. 1980s–1990s)
Thomas Jim, Navajo (b. 1955)
Flagstaff, Arizona
sterling silver, coral
N133N133

5 Bracelet (c. 1940s–1950s)
unknown maker
Southwestern United States
sterling silver, agate
N199N199

6 Pendant (c. 1940s–1950s)
unknown maker
Southwestern United States
silver, turquoise
N185N185

7 Bracelet (c. 1940s–1950s)
unknown maker
Southwestern United States
sterling silver, turquoise
N184N184

8 Bracelet (c. 1940s–1950s)
H. G. Gray
(active mid- to late 20th century)
Southwestern United States
sterling silver, coral
N132N132

9 Buckle (1959)
Singin Sam
(active mid- to late 20th century)
Jackson Hole, Wyoming
sterling silver, turquoise
N148N148

10 Buckle (c. 1970s–1980s)
T. Billy
(active mid- to late 20th century)
Southwestern United States
sterling silver, lapis lazuli
S105S105

11 Buckle (c. 1950s–1960s)
Evelyn Yazzie, Navajo
(active mid- to late 20th century)
Southwestern United States
sterling silver, coral
N146N146

12 Tea and coffee service (1928)
Tiffany & Co. (1837–present)
New York, New York
sterling silver, wood
N018N018

13 Salad servers (c. 1955)
Tiffany & Co. (1837–present)
New York, New York
sterling silver
N171N171

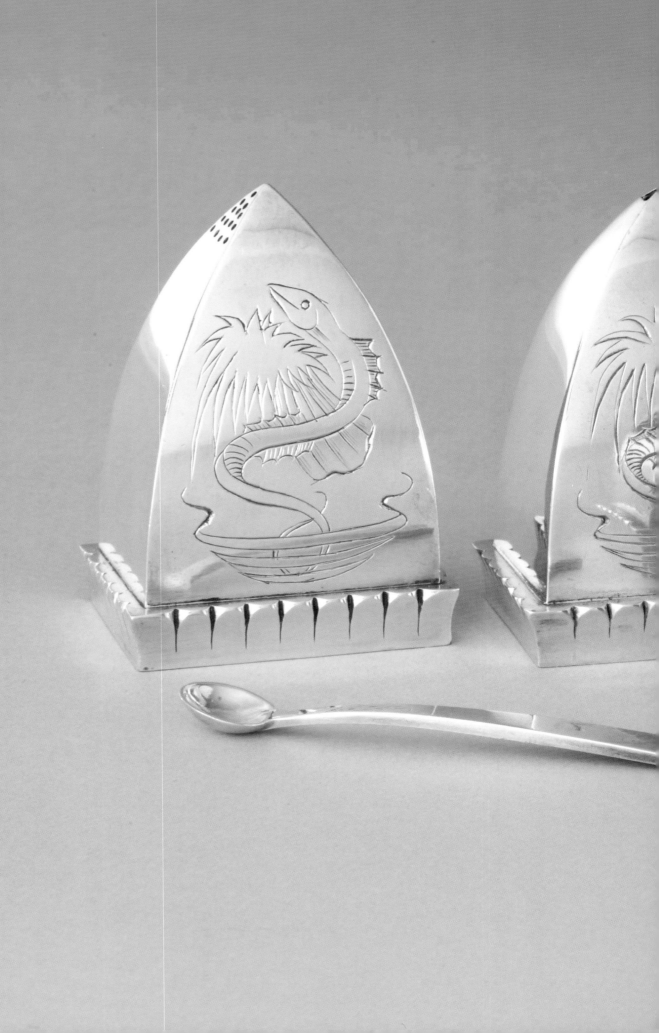

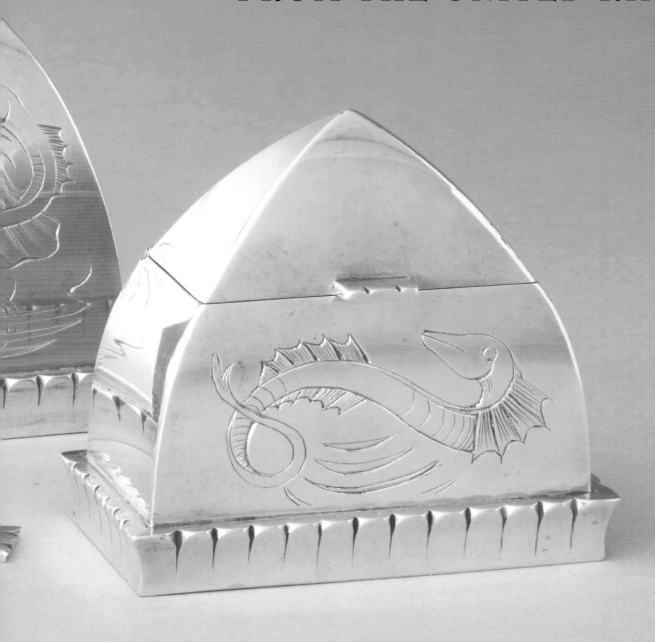

CONTEMPORARY SILVER
FROM THE UNITED KINGDOM

THE WORSHIPFUL COMPANY OF GOLDSMITHS

The Worshipful Company of Goldsmiths in London has maintained hallmarking standards and has supported metalworkers and jewelers working with gold, silver, and platinum since receiving its Royal Charter in 1327. Their deliberate and persistent patronage of innovative crafts-people has resulted in the production of beautiful and imaginative work by British artists in the second half of the twentieth century—a time when the practice of fine silversmithing became scarce in many parts of the world.

After graduating from London's *Central School of Arts and Crafts*, **Grant MacDonald** established a silversmithing workshop in 1969. In the ensuing decades, MacDonald embraced new technology and developed a technique of using lasers to cut and pierce precious metals. MacDonald's shop now employs twenty-five skilled artisans, and much of his output

consists of commissions for royal households in the Middle East. MacDonald's deeply fluted, star-shaped salt shaker (5) features a distinctive horizontal ribbed texture on its conical body.

In the 1960s British silversmith **Anthony Hawksley** developed a unique method of "acid etching" his work. His cylindrical caster made for the Queen's Silver Jubilee is decorated with a deep floriate relief and topped by a rose finial (4).

Mappin & Webb, founded in 1774, is one of England's most esteemed makers and retailers of fine jewelry and silverware. The company has maintained an innovative approach to design and craftsmanship as evidenced by this flatware service featuring highly textured and scalloped ripples (3).

Condiment set (1946), Central School of Arts & Crafts, *Number 2*

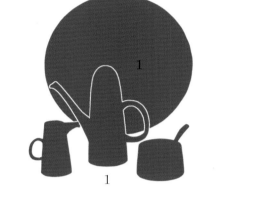

Case 36

1 **Coffee service** (1974)
Christopher Lawrence's House of Lawrian
(active late 20th century)
London, England
sterling silver
M005M005

2 **Condiment set** (1946)
Central School of Arts & Crafts
(1896–present)
London, England
sterling silver
P181S054

3 **Flatware** (1977)
Mappin & Webb, Ltd. (1774–present)
Sheffield, England
sterling silver
N033N033

4 **Sugar caster** (1977)
Anthony Paton Hawksley
(active c. 1960–present)
London, England
sterling silver
N260N260

5 **Salt shaker** (1973)
Grant MacDonald (b. 1947)
London, England
sterling silver
N377N377

6 **Pair of goblets** (1972)
Christopher Lawrence (b. 1936)
London, England
sterling silver
N265N265

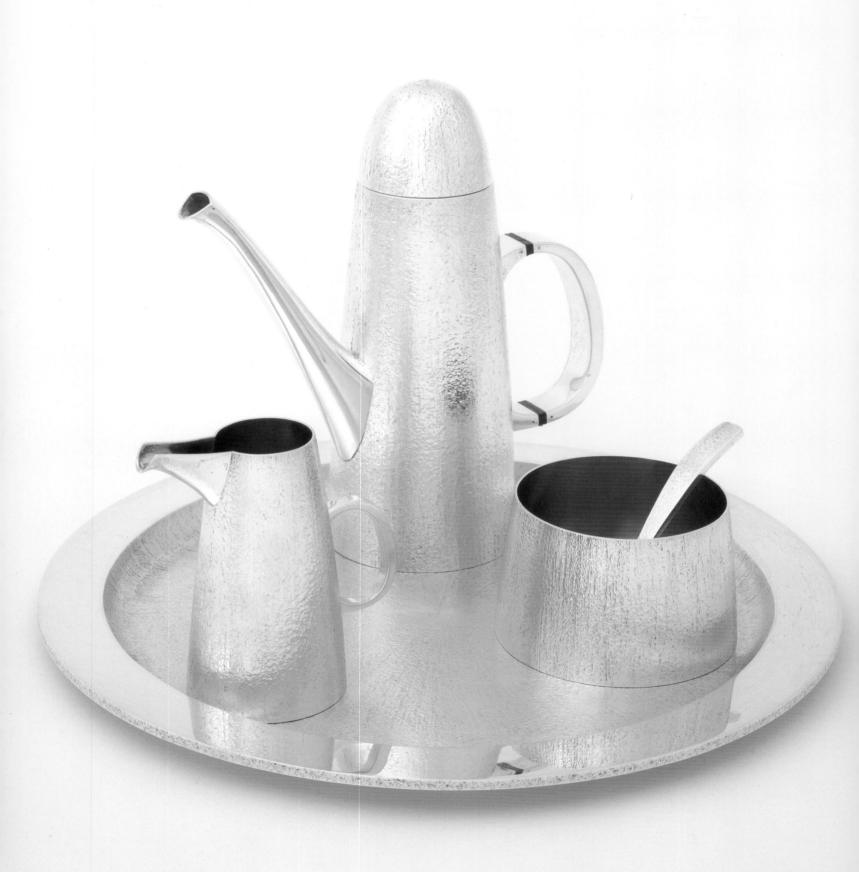

Left, Saltceller (1971), Christopher Lawrence, *Number 6*
Right, Brooch (1970), John Donald, *Number 7*

Coffee service (1974), Christoper Lawrence's House of Lawrian, *Number 1*

STUART DEVLIN AND GERALD BENNEY

In 1958 Australian **Stuart Devlin** received a scholarship to study silversmithing at the *Royal College of Art*, London. His student work brought him to the attention of **Graham Hughes**, the curator of *The Worshipful Company of Goldsmiths*, who awarded Devlin the first of many important commissions. Devlin produced dynamic designs, such as this hand-forged flatware with attenuated lines and gilt handles (5). His openness to modern technologies and materials has resulted in unique forms and finishes (1, 2, 8). Many attribute Devlin's imaginative work to his relative freedom from European traditions and customs during his formative years.

Gerald Benney's cigarette box (4) features the textured "bark" finish that characterizes much of this influential silversmith's output.

Benney invented the finishing technique accidentally while working on a cup in the 1960s. Someone had used his hammer to drive nails and scarred the surface of its peen. When Benney was raising the cup by hammer blow, the surface became ribbed and rippled like the bark of a tree. Benney, intrigued by the resulting texture, began experimenting with silver's surface by using modified hammers for gouging, oxidization, and enamel work. His innovative and richly textured pieces, often gilt, quickly gained favor with private, ecclesiastical, and commercial patrons who commissioned his work. His techniques, which were frequently imitated and rarely credited, changed the method by which modern English silver was smithed.

Container (1965), Stuart Devlin, *Number 2*

Case 37

1 **Pair of goblets** (1968)
Stuart Devlin (b. 1931)
London, England
sterling silver, parcel-gilt
N263N263

2 **Container** (1965)
Stuart Devlin (b. 1931)
London, England
sterling silver, gilt
S032S032

3 **Cup** (1974)
Leslie Durbin (1913–2005)
London, England
sterling silver, gilt
N264N264

4 **Cigarette box** (c. 1965)
Gerald Benney (b. 1930)
London, England
sterling silver, gilt
S028S028

5 **Flatware** (1971–1972)
Stuart Devlin (b. 1931)
London, England
sterling silver, gilt
N034N034

6 **Saltcellar** (1971)
Christopher Lawrence (b. 1936)
London, England
silver, gilt, glass liner
P000S119

7 **Brooch** (1970)
John Donald (active 1960s–present)
London, England
vermeil
S104S104

8 **Saltcellars and spoons** (1970)
Stuart Devlin (b. 1931)
London, England
gilt, sterling silver
S117S117

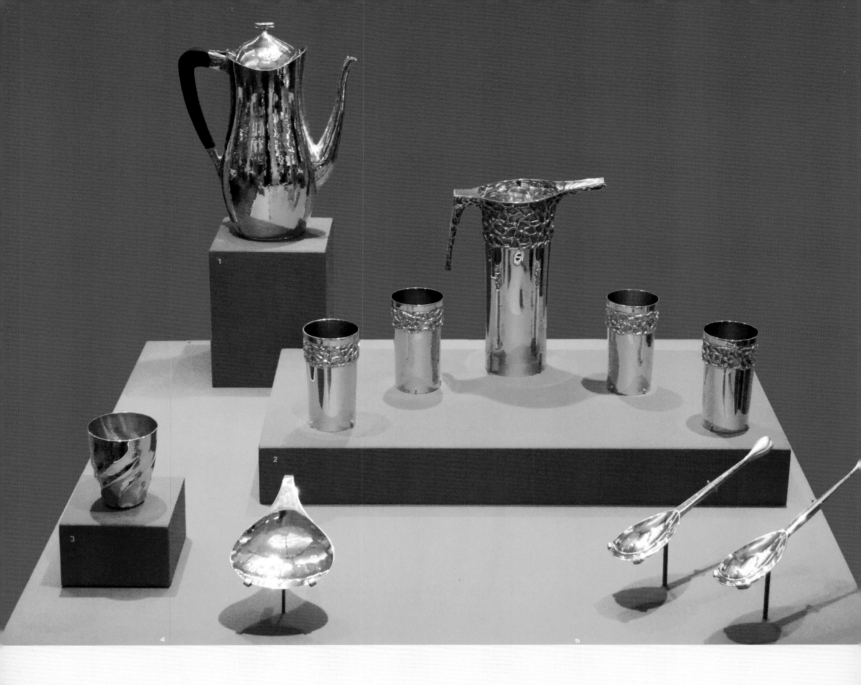

CHRISTOPHER LAWRENCE AND GRAHAM LEICHMAN STEWART

Christopher Lawrence studied at London's *Central School of Arts and Crafts* before working in Robert Edgar Stone's shop, where he learned the art of raising silver by hammer blow. Lawrence then managed Gerald Benney's workshop prior to establishing his own practice in the late 1960s. In 1973, he held a solo exhibition at Goldsmiths' Hall and dazzled visitors with his original designs and technical proficiency. His work has earned twenty-eight prizes in the Goldsmiths' competitions. His pieces often feature striking contrasts between burnished and textured surfaces. Lawrence's remarkable pitcher and beakers (2) are decorated with wide, deeply sculpted friezes lightly washed with gold.

The Worshipful Company of Goldsmiths conducts the annual Goldsmiths' Fair to exhibit the metalwork of contemporary jewelers and metalsmiths. It provides an opportunity for the public to meet more than ninety artists, view their work, and perhaps purchase their pieces. Each year, five students are given an opportunity to exhibit their designs. **Katey Felton's** parcel-gilt beaker with twisting fluted sides (3) was purchased at the 2004 Goldsmiths' Fair. The Fair is vital to the Company's goal of promoting awareness of fine metalwork and encouraging emerging artists.

Graham Leichman Stewart's unique serving spoons (5) and sommelier cup (4) were purchased at the Goldsmiths' Fairs in 2000 and 2001. Stewart, a second-generation silversmith from Scotland, crafts a wide range of innovative and beautiful metalwork—from traditional forms of flatware and holloware that are functional, to sculptural pieces commissioned for commemoration.

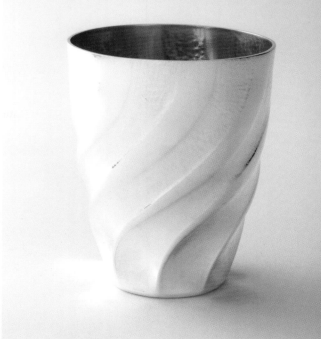

Beaker (2004), Katey Felton, *Number 3*

Case 38

1 **Coffee pot** (1964)
unknown maker
England
sterling silver, wood
N031N031

2 **Pitcher with four beakers** (1971)
Christopher Lawrence (b. 1936)
London, England
sterling silver, gilt
N089N089

3 **Beaker** (2004)
Katey Felton (b. 1978)
Sheffield, England
sterling silver, parcel-gilt
S029S029

4 **Sommelier cup** (2001)
*Graham Leichman Stewart
(active 1078–present)*
Scotland
sterling silver
S033S033

5 **Serving spoons** (2000)
*Graham Leichman Stewart
(active 1078–present)*
Scotland
sterling silver
N222N222

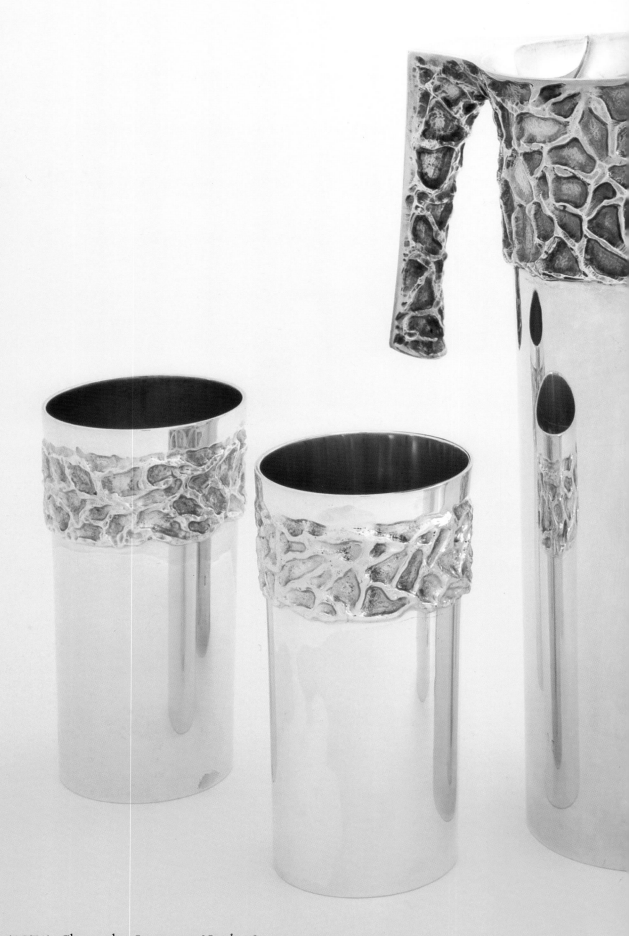

Pitcher with four beakers (1971), Christopher Lawrence, *Number 2*

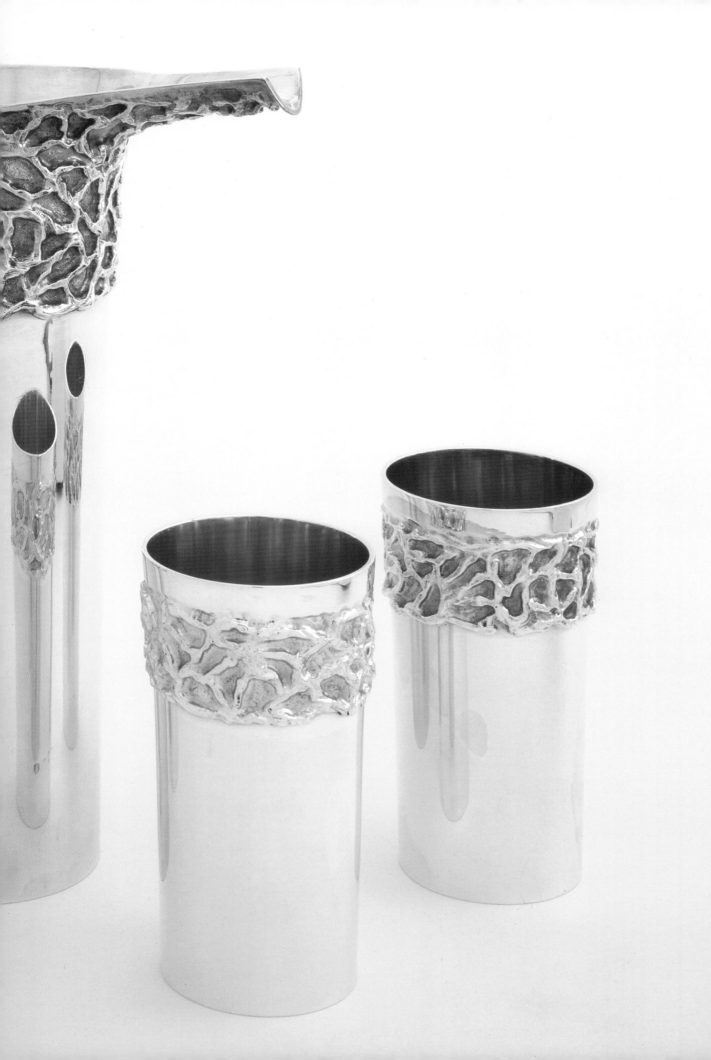

The Quest Continues

Alexander Fisher was very influential as a leading writer, sculptor, enameler, and silversmith of the English Arts and Crafts movement. After studying in France and Italy, Fisher taught at London's *Central School of Arts and Crafts* from 1896 to 1898. Fisher advocated that every object should be made as artwork—that it should be completely designed and crafted by one artist to express a particular idea. Fisher's silver casket (4) is an excellent example of his superb design and craftsmanship. A decorative frieze on the base of the lid alternates lizards with bezel-set moonstones. Naturalistic elements are tastefully incorporated in the locking clasp and upon the lid.

Wally Gilbert is a Freeman of the *Worshipful Company of Goldsmiths*. Gilbert produces jewelry, fine metalwork, and large-scale architectural cast iron. Gilbert's beaker (3) was designed and crafted in 2003 with surface ornamentation that reminds many of Arts and Crafts metalwork produced at the beginning of the twentieth century. Gilbert clarifies his inspiration in this personal statement— "...developments in design are cyclical rather than progressive and their concerns might echo mine; just as one may be startled by the 'modernity' of a piece of silver 3,000 years old and feel supported in one's search by makers widely separated in time and by culture."

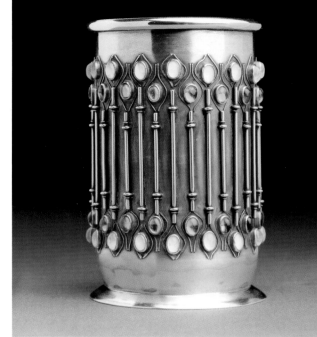

Beaker (2003), Wally Gilbert, *Number 3*

Case 39

1 **Pitchers** (c. 1970s–1980s)
Pampaloni (1902–present)
Florence, Italy
sterling silver
N027N027

2 **Pair of candlestick holders** (1942)
Edward Hermann Ronnebeck
(active early to mid-20th century)
London, England
sterling silver
N002N002

3 **Beaker** (2003)
Wally Gilbert (b. 1946)
Herefordshire, England
sterling silver, parcel gilt, moonstones
N088N088

4 **Casket** (c. 1900)
Alexander Fisher (1864–1936)
England
sterling silver, moonstones
S004S004

5 **Brooch** (c. 1910–1920)
unknown maker
Austria
silver, coral, gilt
N500N500

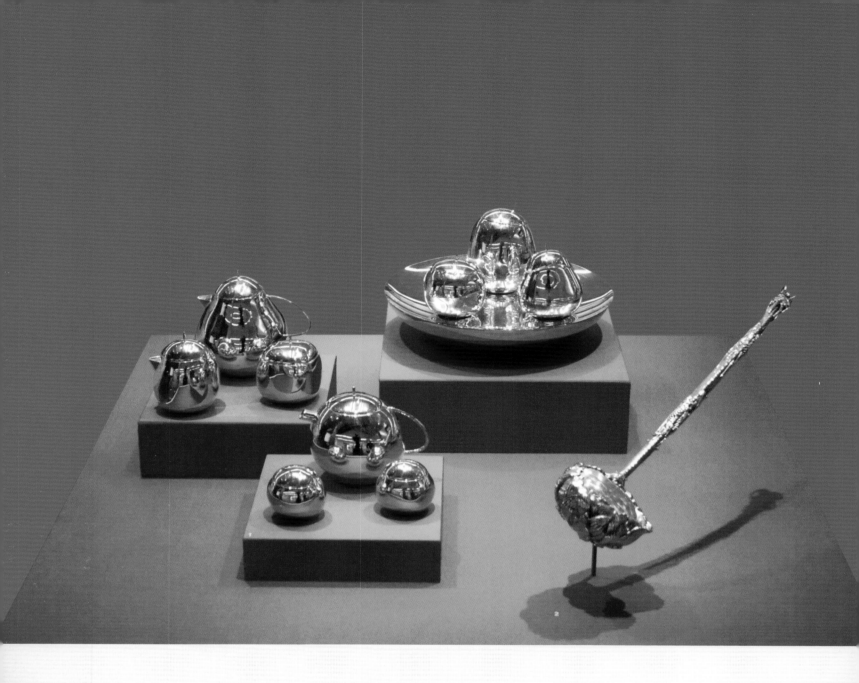

Kazuyo Sejima and Ryue Nishizawa

In 2002 the Italian design firm *Alessi* commissioned twenty of the world's most renowned and innovative architects to design tea and coffee services for an exhibition first viewed at the 2002 Venice Architecture Biennale. Tokyo-based architects **Kazuyo Sejima and Ryue Nishizawa** departed from the dominant theme of their building designs to create this voluptuous service (1). Sejima says she desired to "create a set that would make people happier at the table." The service's smooth, sculptural forms resemble pears and apples and invite the user to arrange them as one would the subjects of a still-life painting. They illustrate that great designers can produce works of art while meeting the challenges of space and function.

Following the opening of Japan to trade in the mid-nineteenth century, Japanese objects of art appeared throughout Europe and the United States. The originality of Japanese style and craftsmanship was popularly embraced during the Aesthetic movement of the 1860s and 1870s. Western silversmiths began to experiment with Japanese motifs of animals and plants, and explored techniques that incorporated a variety of metals in elaborate designs. Objects like this ladle (2), ornately decorated with leaves and a dragon, were produced for export and had tremendous influence on silver firms like *Gorham* and *Tiffany*, whose designers began to look East for inspiration.

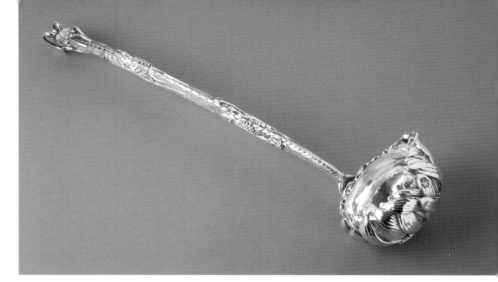

Ladle (c. 1880), Konoike, *Number 2*

Case 40

1 Tea and coffee service (2003)
*Kazuyo Sejima (b. 1966) and
Ryue Nishizawa (b. 1956)
for Alessi (1921–present)*
Omegna, Italy
sterling silver
*2005.084.01A–J

2 Ladle (c. 1880)
*Konoike
(active late 19th–early 20th century)*
Yokohama, Japan
sterling silver
N107N107

*Courtesy of the Portland Art Museum,
The Margo Grant Walsh 20th Century
Silver and Metalwork Collection

SOMMARIO / **CONTENTS**

Antonio Paolucci	Presentazione Presentation	VIII
Franca Falletti	Sull'Amore. Lettera a Michelangelo On Love. A letter to Michelangelo	XI
Richard Aste	Bartolomeo Bettini e la decorazione della sua "camera" fiorentina Bartolomeo Bettini and his Florentine 'chamber' Decoration	2
Jonathan Katz Nelson	La *Venere e Cupido* fiorentina: un nudo eroico femminile e la potenza dell'amore The Florentine *Venus and Cupid*: a Heroic Female Nude and the Power of Love	26
Roberto Leporatti	Venere, Cupido e i poeti d'amore Venus, Cupid and the Poets of Love	64
Leatrice Mendelsohn	«Come dipingere Amore»: fonti greche per la figura di Eros maligno nella pittura del Cinquecento "How to Depict Eros": Greek Origins of the Malevolent Eros in Cinquecento Painting	90
Roberto Bellucci *Cecilia Frosinini*	Un mito michelangiolesco e la produzione seriale: il cartone di *Venere e Amore* A Michelangelesque Myth and Production in Series: the *Venus and Cupid* Cartoon	109
	Catalogo / Catalogue	147
	Apparati / Appendices	229
APPENDICE I / APPENDIX I *Jonathan Katz Nelson*	Riferimenti nel Cinquecento ai dipinti di *Venere e Cupido* di Michelangelo-Pontormo e del Vasari Sixteenth-century References to the *Venus and Cupid* Paintings by Michelangelo-Pontormo and by Vasari	230
APPENDICE II / APPENDIX II *Jonathan Katz Nelson*	Copie e repliche della *Venere e Cupido* di Michelangelo e Pontormo Copies and Replicas of the Michelangelo-Pontormo *Venus and Cupid*	232
APPENDICE III / APPENDIX III *Roberto Leporatti*	Testi letterari Literary Texts	237
APPENDICE IV / APPENDIX IV *M. Materazzi, L. Pezzati, P. Poggi*	La riflettografia infrarossa Infrared Reflectography	244
APPENDICE V / APPENDIX V *Rossella Lari*	La *Venere e Cupido* di Michelangelo-Pontormo: Relazione di restauro The *Venus and Cupid* by Michelangelo-Pontormo: Restoration Report	249
Sabina Brevaglieri *Francesca Ciaravino* *Gabriele Rossi Rognoni*	Bibliografia generale / General Bibliography Indice dei nomi / Index of Names	255 264

Antonio Paolucci
Il Soprintendente al Polo Museale Fiorentino

PRESENTAZIONE

PRESENTATION

In questa estate degli Amori e delle Metamorfosi (*Europa* agli Uffizi, *Ganimede* a Casa Buonarroti) nel cuore dell'Accademia, accanto al *David*, campeggia la *Venere e Cupido* che Michelangelo disegnò e Pontormo dipinse per Bartolomeo Bettini, circa l'anno 1533, nella Firenze già medicea e autocratica.

Intorno a quel quadro, per intelligente iniziativa di Franca Falletti, abbiamo costruito una mostra. Abbiamo selezionato e ottenuto prestiti prestigiosi, promosso e finanziato restauri, invitato a collaborare i più autorevoli specialisti italiani e stranieri. Ed ecco la mostra e il catalogo che le mie righe introducono.

Dunque *Il Ratto di Ganimede* sta a Casa Buonarroti, *Venere e Cupido* è ospite dell'Accademia. Nella scelta dei miti è quasi una *par condicio* (opportuna in tempi di politicamente corretto) fra Amore omosessuale e Amore eterosessuale: idealizzati, idealizzatissimi – sia chiaro – l'uno e l'altro.

Il tutto – a Casa Buonarroti come all'Accademia – si colloca sotto l'epigrafe augusta del *divino* Michelangelo. Anzi sotto l'*Ombra del Genio*, se vogliamo usare il titolo della mostra grande e bellissima dedicata al Buonarroti e alla sua eredità fra Cinquecento e Seicento che occupa, in contemporanea, Palazzo Strozzi; Palazzo Strozzi finalmente restaurato, climatizzato, restituito alla sua funzione di luogo principe degli eventi espositivi di eccellenza. Quest'anno nessuno dirà – io spero – che l'estate fiorentina è povera di occasioni culturali importanti. Semmai, qui a Firenze, il problema è quello di un più efficace collegamento promozionale fra iniziative che discendono da uffici diversi. Il problema è di una politica cittadina che per essere più visibile e meglio competitiva dovrebbe puntare al coordinamento reale fra enti e istituzioni, al gioco di squadra più che al successo individuale. Ma questo è un altro discorso che ci porterebbe lontano. Conviene quindi chiuderlo subito.

In this summer of Cupids and Metamorphoses (*Europa* at the Uffizi, *Ganymede* at Casa Buonarroti), enthroned in the heart of the Accademia, next to the David, is the *Venus and Cupid* designed by Michelangelo and painted by Pontormo for Bartolomeo Bettini, in around 1533, in a Florence that was already Medicean and autocratic. Around this painting, through the intelligent initiative of Franca Falletti, we have constructed an exhibition. We have selected and obtained invaluable loans, promoted and financed restorations, invited the most authoritative experts, both Italian and international, to collaborate. And here is the show and the catalogue which I now present.

The Rape of Ganymede is at Casa Buonarroti, and the *Venus and Cupid* is a guest of the Accademia. In the choice of myths, there is a sort of "equal opportunity" (highly appropriate in these politically-correct days) for homosexual Love and heterosexual Love – idealized, idealized to the extreme, it must be said, both the one and the other.

The entire – at Casa Buonarroti and at the Accademia – is dominated by the noble epigraph of the *divine* Michelangelo. Or it might be said, by the *Shadow of the Genius*, to borrow the title of the splendid exhibition dedicated to Michelangelo and his heritage in the sixteenth and seventeenth centuries which occupies, contemporaneously, the Palazzo Strozzi; a Palazzo Strozzi finally restored, air-conditioned, and returned to its function of the chief site of exceptional exhibitions. This year no one can say – I sincerely hope – that the summer season in Florence is lacking in major cultural events. If anything, here in Florence, the problem is that of better promotional contacts between initiatives planned by different offices. The problem is that of a city-wide policy which, in order to be more visible and more competitive, should aim at efficient coordination between authorities and institutions, at teamwork rather than individual success. But this is another question that would lead us far away, and we will not address it here.

Torniamo al dipinto di Michelangelo e di Pontormo che è il fulcro della nostra mostra. Jonathan Nelson che della mostra è stato, con Franca Falletti, l'ideatore e il curatore scientifico, intitola il suo fondamentale e assai ben documentato saggio: *La "Venere e Cupido" fiorentina: un nudo eroico femminile e la potenza dell'Amore*.

Questo titolo mi affascina perché è una contraddizione in termini, quasi un ossimoro. Come fa, infatti, un nudo femminile *eroico* a scatenare la potenza dell'Amore? Dell'amore eterosessuale, intendo dire.

La potenza dell'Amore, nel XVI secolo, la scatenano le *Danae* e le *Baccanti* di Tiziano, le *Veneri* di Paolo Veronese che si portano a letto Marte con allegra impazienza, le cortigiane del Palma torpide e sontuose, la *Fornarina* di Raffaello con la sua docile consolante bellezza maliziosa quanto basta tuttavia per piacere a un uomo, persino la casta *Susanna* del timido Lotto. Gli esempi che ho citato (potrei continuare arrivando fino a Tiepolo a Boucher a Picasso) sono l'esatto contrario del nudo femminile *eroico*. Gli esempi che ho citato sono il nudo femminile *antieroico*; il nudo docile, morbido, disponibile nel quale l'*eroe-uomo* gloriosamente entrerà come in una città pavesata a festa. Nonostante l'opportunistico elogio di Pietro Aretino agli uomini non sono mai piaciuti «in corpo di femmina muscoli di maschio», né piacciono le atletiche virago che sembrano «imperiose contro loro stesse» (Pirro Ligorio).

I visitatori di questa mostra in Accademia hanno una opportunità unica. Potranno vedere la rappresentazione del corpo femminile nel dipinto di Michelangelo e Pontormo e nelle sue varianti implacabilmente terribilmente fiorentine (Vasari, Bronzino, Allori, Michele di Ridolfo), ma potranno anche vedere, contemporaneamente, la statua del *David*, il nudo maschile per eccellenza.

Giorgio Vasari che sapeva guardare e capire come nessuno, nel *David* loda il risultato eroico, la competizione vittoriosa con la classicità, la scultura che «ha tolto il grido a tutte le statue moderne e antiche o greche o latine che si fussero», ma ancora di più loda la sapienza e la "grazia" del modellato, i «contorni di gambe bellissime ed appiccature e sveltezze di fianchi divine... il posamento si dolce...».

Giorgio Vasari non lo dice né poteva dirlo ma aveva capito benissimo che quella "grazia" intatta e melodiosa che accarezza l'anatomia del *David*, «quel posamento sì dolce» potevano esserci soltanto lì, nella rappresentazione del nudo maschile, non certo nei donnoni superpalestrati della Sagrestia Nuova. Perché l'"affettuosa fantasia" del Divino Maestro – Vasari lo sapeva bene – andava in struggente deriva verso gli uomini non verso le donne.

Ed eccoci al cuore della questione. Alla tendenza cioè sottilmente pervicacemente omofila che attraversa l'arte fiorentina, prima e dopo Michelangelo; diciamo da Andrea del Sarto a Pier Dandini. Potrebbe essere, questo, l'argomento di uno di quei convegni fra psicologia e arte che organizza Graziella Magherini. Prendete un qualsiasi manuale di arte fiorentina del Cinquecento

Let us return, then, to the painting by Michelangelo and Pontormo which is the fulcrum of our show. Jonathan Nelson who has been, with Franca Falletti, the creator and curator, has entitled his fundamental and well-documented article: *The Florentine "Venus and Cupid": a heroic female nude and the power of Love*.

I find this title fascinating because it is a contradiction in terms, almost an oxymoron. How indeed can a *heroic* female nude trigger the power of Love? Of heterosexual love, that is. The power of Love, in the sixteenth century, was unleashed by the *Danae* and the *Bacchante* of Titian, the *Venuses* of Paolo Veronese who lead Mars to bed with joyful impatience, the languid, sumptuous courtesans of Palma, the *Fornarina* of Raphael with her docile, consoling beauty tinged with a hint of seductive allure, just enough to intrigue a man, and even the chaste *Susanna* of the timid Lotto. The examples I have given (and I could go on still further, as far as Tiepolo, Boucher and Picasso) are the exact contrary of the *heroic* female nude. The examples I have mentioned exemplify the *anti-heroic* female nude – the docile, soft, yielding nude into whom the *man-hero* will gloriously enter as into a city decked out for a festival. In spite of the opportunistic praise of Pietro Aretino, men have never liked "the muscles of the male in the body of the female", nor have they ever liked the athletic viragos who appear "imperious against themselves" (Pirro Ligorio).

The visitors to this show in the Accademia have a unique opportunity. They can see the representation of the female body in the painting by Michelangelo and Pontormo as well as in its implacably, terribly Florentine variations (Vasari, Bronzino, Allori, Michele di Ridolfo) but they can also see, at the same time, the statue of *David*, the male nude *par excellence*.

Giorgio Vasari, who knew how to look and understand like no one else, praises in the *David* the heroic effect, the victorious rivalry with classicism, the sculpture that "has eclipsed all other statues, both modern and ancient, whether Greek or Roman", but praises even more the skill and the "grace" of the modeling, the "extremely beautiful contours of the legs and the splendid articulations and grace of the divine flanks... the sweet and graceful pose...".

Giorgio Vasari does not say so, nor could he have said so, but he had clearly understood that the "grace", intact and harmonious, which caresses the anatomy of the David, "that sweet pose" could exist only there, in the representation of the male nude, and certainly not in the muscle-bound giantesses of the New Sacristy. Because the "affectionate fantasy" of the Divine Master – as Vasari was very well aware – was inexorably drawn to men and not to women.

And here is the heart of the matter – the tendency so subtly but obstinately homoerotic that runs through Florentine art, both before and after Michelangelo; from Andrea del Sarto to Pier Dandini, we may say. This could be the subject of one of those symposiums bringing together psychology and art that Graziella Magherini organizes. Glance through any handbook on

e vi accorgerete che mentre il nudo maschile è quasi sempre trattato con orgoglioso amore (il *David*, il *Perseo* di Benvenuto Cellini, il bellissimo inquietante *Giasone* del Francavilla recentemente acquistato per il Bargello) l'atteggiamento cambia quando a essere rappresentato è il nudo femminile; che è visto di solito con algido distacco, senza alcun palpito di "affettuosa fantasia". Verrebbe voglia di chiedersi perché mai nell'arte fiorentina le donne sono sempre così enigmatiche, inattingibili e tuttavia così allusive e coinvolgenti. Perché mai (anche nella *Venere di Botticelli*) le donne sono così tanto immagini di testa – cuore freddo e pensieri affilati come spade – e mai o quasi mai tepore di carne e di pelle. E quando i fiorentini affrontano l'argomento dell'erotismo eterosessuale, il risultato più alto è quel capolavoro inquietante, vero e proprio «dramma di isteria intellettuale» (Emiliani), che è l'*Allegoria* del Bronzino alla National Gallery di Londra. Quali le ragioni di tutto questo? Naturalmente non lo so e in ogni caso l'introduzione ad un catalogo non è il luogo per parlarne ma se una mostra d'arte antica invita e riflessioni di questo genere, vuol dire che è una buona mostra.

Florentine art of the sixteenth century and you will realize that the male nude is almost always treated with loving pride (the *David*, the *Perseus* by Benvenuto Cellini, the splendid, disturbing *Jason* by Francavilla recently acquired for the Bargello). This attitude changes when the female nude to be represented; she is usually viewed with cold detachment, with no quick surge of "affectionate fantasy". We may well wonder why in Florentine art the women are always so enigmatic, out of reach and yet so allusive and beguiling. Why is it (even in Botticelli's *Venus*) that the women are so clearly images of the mind – cold heart and thoughts as razor-sharp as swords – and never, or almost never, warm of flesh and skin. And when the Florentines do confront the question of heterosexual eroticism, their highest achievement is that true "drama of intellectual hysteria" (Emiliani) which is Bronzino's *Allegory* at the National Gallery in London. What reasons lie behind this? Obviously I do not know, and in any case the introduction to a catalogue is not the proper place to debate the question, but if an exhibition of ancient art arouses reflections of this kind, it means that it is a good exhibition.

Cat. 23

SULL'AMORE.
LETTERA A MICHELANGELO

ON LOVE.
A LETTER TO MICHELANGELO

Vorrei mi fosse concesso esporre brevemente alcuni leggeri pensieri in merito alla Vostra allegoria dell'Amore e ai saggi scritti dai moderni studiosi su di essa e sulle altre immagini di nudo femminile da Voi create in colori e in marmo. Secondo Voi l'Amore terreno è innanzitutto doppio, ma non solo, direi multiforme, volubile, (volatile?), infido, ingannevole, spavaldamente perverso. Lo diceva già il poeta Mosco nel II secolo avanti Cristo:

Dolce è qual mel sua voce, ma se grave
Ira l'infiamma, l'effrenata mente
Ben si può alhor veder tal quale el have:
Falsa, iniqua, mendace; e crudelmente
Scherza el crudel fanciul...

e così lo avete in effetti disegnato, colto nell'atto di arrampicarsi sul maestoso corpo della propria Madre, idolo immoto sospeso tra la terra e il cielo; tutto teso per portare a compimento il suo inganno, il falsamente innocuo fanciulletto protende con febbrile desiderio le labbra, mentre lascia scivolare lo sguardo verso le frecce acuminate, unico vero oggetto del suo interesse. Da un lato l'altare dell'Amore terreno con i suoi simulacri: l'arco e le maschere, attraverso cui si arriva al cuore della vittima, le rose e la figura distesa (idolo o uomo? ferito o morto?) simbolo, comunque, di tutto ciò che vi è di doloroso e caduco nell'Amore. Immagine carica, inquietante nella sua complessa ed ambigua significanza, dove il morbido modellato del busto della Venere non riesce a farsi apprezzare nella sua pur evidente sensualità, perché smaterializzato da un contesto pregno di intellettualistici ragionamenti, fisicamente bloccato entro il contorno incisivo del disegno, forza e vanto della scuola fiorentina. Certo, per Tiziano era invece un limite, lui che con la sua *Danae* mostrò a tutti come si sapeva fare a Venezia un nudo femminile, vero, palpitante, in quieta e diste-

I ask you to let me express some simple thoughts that have come to me about your allegory of Love and on the essays written by modern scholars on it and on the other images of the female nude you have created in colors and in marble. According to you, earthly Love is above all double, but not only; I would say multiform, voluble (volatile?), untrustworthy, deceptive and daringly perverse, already the opinion of the poet Moschus in the II century B.C.:

A voice sweet as honey, but when grave
Anger enflames him, then we can see well
The wild mind he possesses:
False, unjust, deceptive and wickedly
The cruel boy plays...

And this is just how you drew him, capturing him in the act of slithering up the majestic body of his own Mother, an immobile idol suspended between earth and the heavens; intent on carrying out his deception, the falsely innocuous boy pursess his lips with feverish desire, as his gaze falls on the sharpened arrows, the only object that really interests him. On one side, the altar of earthly Love with its simulacra: the bow and the masks, that reach the heart of the victim, the roses and the reclining figure (idol or man? wounded or dead?), in any case, symbol of all that is painful and transient in Love. A charged image, disquieting in its complex and ambiguous meaning. Here the softened modeling of Venus's torso, despite the evident sensuality, does not trigger admiration, because she has been dematerialized by a context filled with intellectualistic reasoning, physically blocked within the incisive contours of the design, strength and pride of the Florentine school. Certainly, for Titian this would be instead a limit, he who with his *Danae* showed us all how a female nude was portrayed in Venice: real and palpitating in quiet

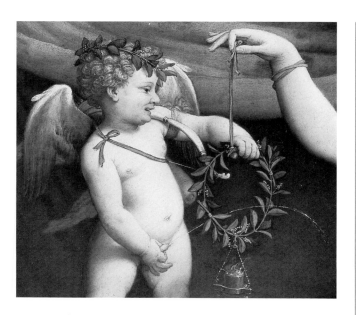

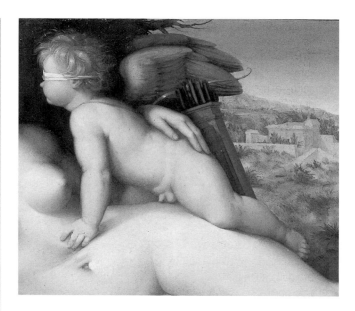

Cat. 11

sa armonia con la natura. Ma da sempre la natura a Firenze ha interessato poco, se non per penetrarla attraverso la ragione e asservirla all'uomo e mi sembra ora inutile rinfocolare una polemica durata già troppo a lungo.

Fino qui si sia o non si sia d'accordo con Voi, tutto questo lo sapevamo in molti.

Che poi esista anche un Amore ideale che dovrebbe essere immune dagli inganni dell'Amore terreno ci sarebbe di grande consolazione. E di fatto lo è stato in tutti i tempi per santi, filosofi, eroi. Ma ora anche questa certezza vacilla, sempre secondo le parole di Mosco (*et contro a me talhora, /Madre, el protervo arcier suoi stral' intende*), secondo le storie che ci narra Ovidio e secondo quanto anche da Voi rappresentato. Venere stessa, infatti talvolta viene colpita dalle frecce del suo stesso figlio, o quanto meno esposta ai suoi inganni, come se insito nella perfezione ci fosse un baco, un cancro, che dalle sue viscere esce e la minaccia, rendendola vulnerabile alla stregua di una comune mortale. Poco cambia se l'uomo che suscita il suo amore è Adone…

L'Amore ideale del neoplatonismo ficiniano non è più collocato in una dimensione chiusa, perfettissima e immobile che lo preserva intatto al di fuori dello spazio e del tempo; qualcosa si è rotto e la fonte limpida è stata contaminata: Venere è in pericolo. Sarà per questo che ha assunto una posa così contorta, tesa, da minaccioso guerriero pronto allo scontro? Eppure per Botticelli anche lo scontro era visto come abbandono, e giuoco. Ma ora non è tempo di giuochi: i Medici sono rientrati in Firenze, dopo un assedio, con la forza dell'inganno. Anche loro.

Avete ragione in questo e vi capisco, non è proprio tempo di giuochi.

and relaxed communion with nature. But nature has always been of little interest in Florence when it was not penetrated by reason and put to the service of man. Alas, it seems useless now to resume a debate that has gone on too long already. Whether we agreed with you or not, many of us were already aware of these things.

It would be a grand consolation to know that an ideal Love, immune from the deceptions of earthly Love, truly does exist. In truth, it has been an eternal comfort to saints, philosophers, and heroes. But now even this certainty vacillates, according to Moschus's verses once again (…and against me at times, / Mother, the arrogant archer casts his arrows…), according to the stories narrated by Ovid and represented by you. Venus herself is in fact struck by the arrows of her own son at times, or at the very least, victim of his deceptions; almost as though from within perfection harbors a worm, a cancer that emerges from the entrails, menacing her and rendering her vulnerable like a common mortal. Little does it matter that the man that prompts her love be Adonis…

Ideal Love in Ficino's neoplatonism is no longer relegated to an enclosed, perfect and immobile dimension that preserves it intact outside space and time; something has been broken and the limpid fount has been contaminated: Venus is in danger. Is this the reason that she has assumed such a contorted and tense pose, like a menacing soldier on the battlefield? And yet, for Botticelli, the battle was seen as abandonment and play. But now is no time for games: the Medici have returned to Florence after the siege, through the strength of their deception. They too.

You are correct about that, now is no time for games.

Serenamente inconsapevole, e perciò felice, è la vostra *Leda*, che accoglie il cigno dal lungo collo e dal morbido piumaggio senza riconoscere in lui il temerario (e davvero fantasioso) dominatore di tutti gli dèi. In realtà neppure Europa, e neppure Ganimede, e neppure Io, proprio nessuna delle vittime degli inganni di Giove mostra dispiacere o rabbia per il trattamento subìto, come se davvero per necessità di natura Amore dovesse essere ingannevole e la gioia venire solo dalla non percezione dell'inganno. Finché essa dura. Ma quando il rapimento finisce e Arianna/Europa si trova abbandonata su una spiaggia la sua disperazione non ha limiti e il suo corpo si inabissa ripiegato su se stesso, la testa reclinata sul petto, come l'immagine della *Notte*. Come viene l'autunno e l'inverno, come la vecchiaia e la morte. I cicli della vita ripercorrono quelli del giorno, quelli delle stagioni e quelli dell'Amore. Venere circondata da amorini sparge fiori sulla terra cavalcando un animale terrestre, quindi sollevata dalla terra per effetto di qualcosa (l'Amore ideale?) che ignora, e perciò riesce a infrangere, le leggi della natura. Ma non è anche la Primavera che riporta la vita dopo la sospensione dell'inverno, la lunga *Notte* dell'universo? E la curiosa contaminazione fra la *Notte* e la *Venere* dipinta da Michele di Ridolfo del Ghirlandaio per i Salviati non vuole significare che la Notte dell'Amore è l'Amore terreno con i suoi inganni da cui l'Amore ideale si leva cavalcando un capro e risvegliando il mondo?

Immagino che di queste cose ragionavate a Firenze quando Bartolomeo Bettini pensava alla decorazione della camera del suo nuovo palazzo con alcuni fra i più eminenti letterati e artisti del tempo, impegnandosi in un'impresa che gli guadagnò la stima di alcuni dei suoi contemporanei, ma non la memoria dei posteri: di lui non sappiamo quasi più nulla, nep-

Serenely unaware, and therefore happy, our *Leda* welcomes the long necked soft-feathered swan without recognizing him as the temerarious (and truly ingenious) dominator of all the gods. In truth, not even Europa or Ganymede, or Io, absolutely none of the victims of Jove's deceptions shows displeasure or anger for the treatment received. As though by nature's stipulation Love must be false and joy rise only from the non perception of a lie. For as long as it lasts. But when the passion is over and Ariadne/Europa finds herself abandoned on the beach, desperation knows no limits and the body sinks folding into itself, the head resting on the breast, as in the image of *Night*. Like the arrival of autumn and winter, old age and death. The cycles of life follow the cycles of day, of the seasons and of Love. Venus surrounded by *putti* spreads flowers over the earth riding a terrestial animal; she then is lifted from the earth by the power of something (ideal Love?) she ignores and for this reason she is able to break the rules of nature. But is not the Spring the renewal of life after the suspension of the winter, the long *Night* of the universe? And doesn't the curious contamination of *Night* and *Venus* painted by Michele di Ridolfo del Ghirlandaio for the Salviati mean that the Night of Love is earthly Love with its deceptions out of which ideal Love rises riding a goat and awakening the world?

I imagine that you discussed such matters in Florence when Bartolomeo Bettini conceived the decoration of the chamber for his new palace with some of the most eminent literary scholars of the time. He embarked upon a task that was admired by some of his contemporaries, but forgotten in the memory of those to follow: we know almost nothing about

CATALOGO, 13-a

ASTE, 12

pure quale fosse la sua abitazione, dove pur tuttavia tante energie intellettuali si erano concentrate. Costretto a fuggire a Roma per la riluttanza a sottomettersi al potere mediceo, sequestrato il suo gioiello dal duca Alessandro, di questo personaggio scomodo evidentemente non si dovette parlare molto più, ma come spesso accade ciò che viene represso scorre per vene sotterranee e si diffonde con tenace capillarità in un terreno dai confini sempre più vasti: così la *Venere e Cupido* commissionata da Bartolomeo Bettini divenne l'opera più copiata e replicata, con varianti o no, della moderna storia dell'arte e ancora oggi se ne ritrovano esemplari nei più lontani e differenti luoghi, mentre il riscoperto e rinnovato originale si mostra ai piedi del Gigante David.

Mi auguro che per Voi ci sia di che essere contento.

Franca Falletti

him, not even where the house that united so many intellectual interests was located. Forced to flee to Rome because of his reluctance to succumb to Medici power, his jewel confiscated by Duke Alexander, silence was evidently imposed on this undesirable individual. But as often happens, what is suppressed flows through underground channels and spreads with stubborn capillarity in a terrain of ever wider confines: thus the *Venus and Cupid* commissioned by Bartolomeo Bettini became the most copied and replicated work, with and without variations, in modern art history. Still today exemplars are found in the farthest and most diverse places, while the rediscovered and renovated original is on show at the foot of the Giant David.

I hope that for you this is cause for happiness.

Franca Falletti

«Et à Voi non devvrà esser discaro che non tanto il presento secolo, quanto quegli ancora che verranno, sappiano che la vita vostra, l'ingegno, i costumi, e le cortesie furono tali che non solamente tra i maggiori mercanti et i più degni preti ma appresso i miglior dottori, et i più eccelenti artefici, fu pregiato il nome vostro et tenuto caro».

Benedetto Varchi, *Due Lezzioni...*, Lorenzo Torrentino, Firenze 1550.

Dedica dell'editore "al molto magnifico et suo honoratissimo Messer Bartolomeo Bettini, Mercante Fiorentino in Roma".

"And you should not be displeased that not only the present century, but those still to come, will know that your life, intelligence, behavior, and courtesies were such that your name was valued and held dear, not only by the principal merchants and most worthy churchmen, but also by the best scholars and most excellent atists".

Benedetto Varchi, *Due Lezzioni...*, Lorenzo Torrentino, Firenze 1550.

Dedication by the publisher "to the most magnificent and honorable Messer Bartolomeo Bettini, Florentine merchant in Rome".

1. Giorgio Vasari-Jan van der Straet, *L'assedio di Firenze* / *The siege of Florence*,
Firenze, Palazzo Vecchio, Sala di Clemente VII.

Richard Aste

BARTOLOMEO BETTINI E LA DECORAZIONE DELLA SUA "CAMERA" FIORENTINA

BARTOLOMEO BETTINI AND HIS FLORENTINE 'CHAMBER' DECORATION

I. Bettini a Firenze nella scia dell'ultima Repubblica

Nel 1532 circa, due soli anni dopo la caduta della terza Repubblica di Firenze (fig. 1), il mercante e banchiere fiorentino Bartolomeo Bettini (m. 1551/1552)[1] commissionò ad Agnolo Bronzino, a Michelangelo Buonarroti e al Pontormo, la decorazione della "camera" della sua residenza cittadina a Firenze[2]. Il programma decorativo per la stanza alla fine fu abbandonato e la tavola più importante della "camera", *Venere e Cupido* (Cat. 23), dipinta da Pontormo su disegno di Michelangelo, fu acquisita «quasi per forza» da Alessandro de' Medici (fig. 2), primo duca di Firenze, nel 1534[3]. Bettini conservò il cartone originale di Michelangelo, lodato dal Vasari nel 1568 come «cosa divina; oggi appresso agli eredi in Fiorenza»[4]. Oggi ci restano solo due disegni preparatori superstiti per la decorazione della "camera", la *Venere e Cupido* di Michelangelo (Cat. 29) e la *Testa di Dante* del Bronzino (Cat. 25).

Le commissioni di Bettini vanno esaminate sullo sfondo della caduta della Repubblica fiorentina, di breve vita, tra il 1527 e il 1530, e dell'ambiente dispotico dei Medici che ne seguì. Dal canto suo Bettini ebbe un proprio ruolo in questo periodo intenso, dimostrandosi un simpatizzante della Repubblica. Nel 1527, dopo il Sacco di Roma per mano delle truppe dell'imperatore Carlo V e la conseguente perdita del potere a Roma e Firenze da parte dei Medici, a Firenze fu proclamata la terza Repubblica con a capo il gonfaloniere Niccolò Capponi. La costituzione della città fu sostenuta e difesa dai cittadini, che misero insieme una forte milizia sotto il comando di Malatesta Baglioni e Stefano Colonna[5]. Il 6 Aprile 1529, i Dieci della Guerra nominarono Michelangelo «governatore e procuratore generale sopra alla fabbrica e fortificazione delle mura della città di Firenze». L'artista fuggì dalla città in settembre, ma il 20 novembre vi fece ritorno e riprese i lavori ai bastioni intorno a San Miniato. Nonostante questi sforzi, il 29 giugno fu firmato il Trattato di Barcellona,

I. Bettini in Florence in the wake of the last Republic

In about 1532, only two years after the fall of Florence's third Republic (fig. 1), the Florentine merchant-banker Bartolomeo Bettini (d. 1551/1552)[1] commissioned first Agnolo Bronzino, then Michelangelo Buonarroti and Jacopo da Pontormo, to decorate a *camera* ('chamber') of his Florentine town house[2]. The room's decorative program was eventually abandoned, and the chamber's most important panel, *Venus and Cupid* (Cat. 23), painted by Pontormo on Michelangelo's design, was acquired "almost by force" by Alessandro de' Medici (fig. 2), first Duke of Florence, by 1534[3]. Bettini retained Michelangelo's original cartoon, praised by Vasari in 1568 as "a divine thing, which is now in the possession of Bettini's heirs in Florence"[4]. Today, only two preparatory drawings survive for the room decoration, Michelangelo's *Venus and Cupid* (Cat. 29) and Bronzino's *Dante* (Cat. 25).

Bettini's commissions must be examined against the background of the fall of the short-lived Florentine Republic, 1527-1530, and the autocratic milieu of the Medici which followed. Bettini himself played a role in this dramatic period, and showed himself to be a sympathizer of the Republic. In 1527, after the Sack of Rome by the troops of Emperor Charles V, and the resulting loss of Medici power in Rome and Florence, a third Republic was proclaimed in Florence under *gonfaloniere* Niccolò Capponi. The city's constitution was upheld and defended by her citizens, who raised a strong militia under the leadership of Malatesta Baglioni and Stefano Colonna[5]. On 6 April 1529, the *Dieci della Guerra* appointed Michelangelo "governor and procurator general of Florentine fortifications". The artist fled he city in September, but by 20 November he had returned and resumed work on the bastions around San Miniato. Despite these efforts, on 29 June, the Treaty of Barcelona was signed between France, England, and the Emperor, guaranteeing that the latter would suppress the Republic and reinstate the Medici in Florence. By 2 August

tra la Francia, l'Inghilterra e l'imperatore, che garantiva a que-
st'ultimo di poter sopprimere la Repubblica e reintegrare i
Medici a Firenze. Il 2 agosto 1530 il Baglioni aveva conse-
gnato Firenze nelle mani del papa Medici, Clemente VII, e del
principe d'Orange, e questo tradimento aveva condotto im-
mediatamente alla resa della città.

Durante la prima settimana di agosto del 1530, secondo Be-
nedetto Varchi, Bettini era entrato a fare parte dei Primi, quat-
trocento rampolli delle famiglie più aristocratiche, con incli-
nazioni repubblicane, che si erano riuniti in piazza Santo Spirito
contro le forze di occupazione dell'imperatore[6]. Questa milizia
sperimentale, istituita nel 1528, reclutava uomini tra i quindici
e i cinquant'anni, ma soltanto ai cittadini tra i diciotto e i tren-
tasei, quanti ne aveva Bettini, fu fatto prestare giuramento alle
armi[7]. Il 12 agosto 1530 la resa fu firmata negli alloggi di
Baccio Valori, incaricato del papa, e nel febbraio del 1531 il
comando assoluto su tutti i rami del governo fu conferito al
ventenne figlio illegittimo di papa Clemente VII, Alessandro de'
Medici. L'anno seguente l'imperatore proclamò Alessandro
«capo e principe di tutto lo Stato e governo», abolendo così la
costituzione e la Signoria, e concesse ad Alessandro sua figlia,
Margherita d'Austria, in sposa.

La fine della Repubblica fiorentina fu sottolineata, nel
1534, dalla costruzione, per volontà del duca Alessandro,
della Fortezza da Basso, un esplicito simbolo del controllo
dispotico e del potere assoluto dei Medici. Secondo lo stori-
co contemporaneo Bernardo Segni, la Fortezza fu innalzata
con l'intento da parte dei Medici «di mettere in sul collo de'
Fiorentini un aspro, e non mai più sopportato giogo di una
Cittadella, onde quei Cittadini perdessero interamente ogni
speranza di mai più poter vivere liberi»[8].

In questi tempi incerti, le famiglie fiorentine costantemente
provvedevano alla formazione della coscienza e delle posi-
zioni politiche dei giovani rampolli, assicurando il perpetuarsi
di un attento esercizio della vita pubblica e degli ideali nelle
future generazioni. Nel caso di Bettini – e, più in generale, di
ogni simpatizzante repubblicano che vivesse a Firenze imme-
diatamente dopo l'assedio – i sentimenti antimedicei erano
ereditati dalla famiglia. I Medici, una volta ristabilitisi al pote-
re, confiscarono le proprietà di molti simpatizzanti repubbli-
cani e li costrinsero all'esilio. Le convinzioni repubblicane di
Bettini avevano probabilmente portato all'acquisizione, da
parte del duca Alessandro, della *Venere e Cupido* di Miche-
langelo e alla condanna di Bettini all'esilio finale a Roma.
Secondo Vasari, «certi furagrazie, per far male al Bettino,
levata di mano di Iacopo quasi per forza e data al duca
Alessandro, rendendo il suo cartone al Bettino»[9].

Bettini fu uno dei dieci nuovi banchieri fiorentini che si
trasferirono a Roma sotto papa Paolo III Farnese (1534-
1549)[10] e sembra che lì abbia stabilito la sua definitiva resi-
denza dal 1536[11]. Si trovava certamente a Roma nel 1537
quando, dopo l'assassinio del duca Alessandro per mano di
suo cugino Lorenzino de' Medici, osò offendere il suo com-

2. Giorgio Vasari, *Ritratto del duca Alessandro de' Medici*
Portrait of Duke Alessandro de' Medici,
Firenze, Galleria degli Uffizi.

1530, Baglioni had betrayed Florence to the forces of the
Medici Pope, Clement VII, and the Prince of Orange, and this
treason led directly to the surrender of the city.

During the first week of August 1530, according to Benedetto
Varchi, Bettini joined four hundred scions from the *primi*, or
most noble Republican families who united in the Piazza Santo
Spirito against the Emperor's encroaching forces[6]. This experi-
mental militia, established in 1528, recruited men aged fifteen
to fifty, but only citizens between eighteen and thirty-six, like
Bettini, were ever sworn to arms[7]. On 12 August 1530, the
capitulation was signed at the quarters of papal commissioner
Baccio Valori, and by February 1531, absolute rule over all
branches of government was granted to Pope Clement VII's ille-
gitimate twenty-year-old son, Alessandro de' Medici. The fol-
lowing year, the Emperor proclaimed Alessandro "head and
prince of all the state and government", thereby abolishing the
constitution and the Signoria, and granted Alessandro his own
daughter, Margaret of Austria, as his wife.

The demise of the Florentine Republic was confirmed in
1534 by Duke Alessandro's construction of the Fortezza da
Basso, an overt symbol of Medici despotic control and absolute

BARTOLOMEO BETTINI E LA DECORAZIONE DELLA SUA "CAMERA" FIORENTINA
BARTOLOMEO BETTINI AND HIS FLORENTINE 'CHAMBER' DECORATION

5

pagno di esilio nonché artista medico, Benvenuto Cellini. L'autobiografia dell'artista ci fornisce l'unica descrizione nota di Bettini e persino una citazione diretta:

«un certo Baccio Bettini, il quale haveva un cappaccio come un corbello, et anchora lui mi dava la baia di questi duchi, dicendomi: noi gli abbiamo isducati, e non Harem piu duchi, e tu ce li volevi fare inmortali»[12].

È evidente come il nostro avesse attaccato Cellini per avere inserito l'immagine del duca nelle monete fiorentine, le prime della città a recare impresso il ritratto di un personaggio vivente[13]. Anche gli antenati della famiglia Bettini erano stati incarcerati o esiliati per la loro posizione antimedicea. In seguito all'esecuzione del frate domenicano Girolamo Savonarola nel 1498, molti dei *Piagnoni*, sostenitori antimedicei del frate, persero dei membri della propria famiglia. I Bettini, insieme con i Cambini, i Guidotti e gli Zati, erano tra le più eminenti famiglie che sopravvissero a queste avversità. Mentre molte altre famiglie si divisero politicamente dopo il 1498, i Bettini rimasero uniti con i *Piagnoni* e, di conseguenza, si opposero ai Medici, che lottarono per smantellare il movimento ispirato dal Savonarola, nel tentativo di raggiungere una solidità politica[14].

II. GLI ARTISTI DELLA "CAMERA" DI BETTINI ALL'INIZIO DEGLI ANNI TRENTA DEL CINQUECENTO

I drammatici sviluppi dei fatti fiorentini ebbero un forte impatto su Michelangelo, Pontormo e Bronzino, gli artisti che lavorarono alla "camera" di Bettini. Michelangelo, di solida fede repubblicana, nel novembre del 1530 fu perdonato da Clemente VII per le sue attività durante l'assedio, a condizione che si convincesse a riprendere il lavoro delle Cappelle Medicee e della Biblioteca Laurenziana; fu anche costretto a prendere indesiderate commissioni da amici influenti e sostenitori dei Medici[15]. Un tempo membro della intima cerchia di Lorenzo il Magnifico fino alla sua morte nel 1492, Michelangelo si ritrovò nuovamente legato alla famiglia e al nuovo Principato.

Non sorprende che in questo periodo fitto di impegni, egli stringesse relazioni professionali con il più giovane pittore fiorentino Pontormo, che trasferì su tavola e dipinse alcuni dei suoi cartoni. Due di questi erano il *Noli me tangere* (Tav. VIII/1; fig. 3) per Alfonso d'Avalos, marchese del Vasto[16], e la *Venere e Cupido* per Bettini (Cat. 23 e Tav. II/2; fig. 4)[17].

Ingaggiando Michelangelo solo un anno dopo il d'Avalos, Bettini doveva ben essere a conoscenza della riuscita collaborazione dell'artista con Pontormo per il *Noli me tangere* e, attraverso la sua amicizia con Michelangelo, il pragmatico mercante e banchiere potrebbe avere voluto attirare anche Pontormo – il più acclamato colorista della città – a lavorare per lui al progetto della sua "camera". Nonostante il perdono del papa, Michelangelo restò un nemico del duca Alessandro e temette

power. According to contemporary historian Bernardo Segni, the Fortezza was raised in order for the Medici "to place on the necks of the Florentines a yoke of a kind never experienced before: a citadel, whereby the citizens lost all hope of ever living in freedom again"[8].

In these stirring times, Florentine families invariably shaped the political consciousness and attitudes of their young family members, ensuring the perpetuation of thorough political training and beliefs in future generations. In the case of Bettini – and, on a larger scale, any Republican sympathizer living in Florence immediately after the Siege – anti-Medicean sentiments were passed down. The reinstated Medici confiscated the property of many Republican sympathizers, and forced them into exile. Bettini's ingrained Republican beliefs had probably led to Duke Alessandro's acquisition of the *Venus and Cupid* and to Bettini's eventual exile to Rome. According to Vasari, "certain tuft-hunters, in order to do Bettini an injury, took it [the *Venus and Cupid*] almost by force from the hands of Jacopo and gave it to Duke Alessandro, restoring the cartoon to Bettini"[9]. Bettini was one of ten new Florentine bankers who transferred to Rome under Pope Paul III Farnese (1534-1549)[10], and seems to have established permanent residence there by 1536[11]. He was certainly in Rome in 1537 when, after Duke Alessandro was assassinated by his own cousin, Lorenzino de' Medici, Bettini went to insult his fellow expatriate and Medici artist Benvenuto Cellini. The autobiography of the artist even provides a direct quote of Bettini: "...a certain Baccio Bettini [...] began to banter with me in the same way about dukes, calling out: 'We have dis-duked them, and won't have any more of them; and you were for making them immortal for us!' with many other tiresome quips of the same kind"[12]. Bettini evidently attacked Cellini for including the Duke's image on Florentine coins, the first in the city to include the portrait of a living person[13].

Earlier members of the Bettini family had also been imprisoned or exiled because of their anti-Medicean stance. Following the execution of Dominican friar Girolamo Savonarola in 1498, many of the *Piagnoni*, the anti-Medici supporters of the friar, lost family members. The Bettini, along with the Cambini, Guidotti, and Zati, were among eminent families who endured such hardships. While some families were divided politically after 1498, the Bettini stood united with the *Piagnoni*, and, consequently, opposed to the Medici, who fought to dismantle the Savonarolan movement in their quest for political consolidation[14].

II. THE ARTISTS OF THE BETTINI 'CHAMBER' IN THE EARLY 1530s

The dramatic developments in Florence also had a strong impact on Michelangelo, Pontormo, and Bronzino, the artists who worked on the Bettini *camera*. Michelangelo, a

per la sua vita durante il soggiorno a Firenze. Oppresso dal carico delle tante commissioni indesiderate e sconvolto per la morte del padre, avvenuta nel 1531, Michelangelo andò a passare dieci mesi a Roma, fra l'agosto del 1532 e il giugno del 1533; il 23 settembre 1534 stabilì la sua definitiva residenza a Roma per non fare mai ritorno nella sua città.

Il Pontormo aveva una posizione più sicura a Firenze come artista della corte medicea; ed essendo un artista meno interessato alla politica, a differenza di Michelangelo rimase attivo a Firenze fino alla morte, nel 1556, servendo indifferentemente sia committenti repubblicani che medicei[18]. Verso la fine degli anni Venti del Cinquecento il Pontormo aveva accettato commissioni per ritratti di personaggi repubblicani piuttosto in vista. Durante l'assedio aveva ritratto Francesco Guardi «in abito di soldato» (perduto)[19]. Due anni più tardi ritrasse Amerigo Antinori, subito prima dell'esilio di questi da Firenze (fig. 5)[20]. Dipinse anche un ritratto di Carlo Neroni (perduto)[21], per il quale Bronzino eseguì il *Martirio dei diecimila* (Firenze, Uffizi), derivato da un'opera del Pontormo sullo stesso soggetto (Firenze, Pitti)[22].

Il Pontormo rappresentava anche una scelta ideale per la decorazione della "camera" di Bettini, avendo riscosso successo con le tavole della *Storia di san Giuseppe* per la "camera" da letto di Pierfrancesco Borgherini, del 1515-1518 (si veda più avanti fig. 16)[23], e con una *Adorazione dei Magi* (Firenze, Pitti) per l'anticamera della residenza cittadina di Giovanni Benintendi, del 1518[24]. Ingaggiando il Pontormo, Michelangelo e Bronzino, Bettini si elevò al rango di grande committente e il programma da lui elaborato divenne uno dei più importanti progetti per decorazioni d'interni nella Firenze del primo Cinquecento. Nel 1532, al tempo stesso in cui attendeva a progetti per esponenti repubblicani, tra i quali la *Venere e Cupido*, il Pontormo fu incaricato da Clemente VII di completare il "salone" della Villa Medici di Poggio a Caiano[25]. E fu per farsi assistere nell'esecuzione di questa commissione che, nel 1532, il Pontormo richiamò Bronzino dalla corte Della Rovere a Pesaro. Dopo la vendita forzata della *Venere e Cupido* di Michelangelo-Pontormo al duca Alessandro, il Pontormo cominciò ad accettare da lui delle commissioni, tra cui un ritratto del duca in lutto (Filadelfia, Museum of Art)[26], dipinto alla fine del 1534, poco dopo la morte del padre, Clemente VII. Nel 1535-1536, portò avanti l'affresco della "loggia" della Villa Medici a Careggi, con figure allegoriche, oggi perdute, inneggianti alla glorificazione del governo di Alessandro[27], per quanto, secondo Vasari, cercasse di svincolarsi dal proprio ruolo di artista della corte dei Medici[28]. Nel 1534, il Pontormo compariva ufficialmente sul libro paga dei Medici[29] e rimase al loro servizio anche dopo l'assassinio di Alessandro, nel 1537. Avendo attivamente collaborato col Pontormo nel monastero della Certosa del Galluzzo[30], nella Cappella Capponi a Santa Felicita[31], e dipingendo il *Pigmalione e Galatea* sulla coperta del *Ritratto di Francesco Guardi*[31], il Bronzino ereditò lo stile lineare e le forme plastiche della

3. Pontormo, *Noli me tangere*,
Busto Arsizio (Varese), Collezione privata.

staunch Republican, was pardoned in November 1530 by Clement VII for his activities during the Siege, providing that the artist agreed to resume work at San Lorenzo on the Medici Chapel and Laurentian Library; he was also forced to take on unwanted commissions from the influential friends and sympathizers of the Medici[15]. Formerly a member of the inner circle of Lorenzo il Magnifico until his death in 1492, Michelangelo found himself bound once again to the family and to the new Principato. It is no wonder that in this busy period he developed a professional relationship with the younger Florentine painter, Pontormo, who transferred some of his cartoons to panel and painted them. Two of these were the *Noli me tangere* (Pl. VIII/1; fig. 3) for Alfonso d'Avalos, the Marchese del Vasto[16], and the *Venus and Cupid* for Bettini (Cat. 23 and Pl. II/2; fig. 4)[17]. Patronizing Michelangelo just one year after d'Avalos, Bettini must have been well aware of the artist's successful collaboration with Pontormo on the *Noli me tangere*, and through his friendship with Michelangelo, the savvy merchant-banker may have expected to attract Pontormo – the city's most acclaimed colorist – to work on his decorative project. In spite of his papal pardon, Michelangelo remained a foe of Duke Alessandro and feared for his life while living in Florence.

4. Michelangelo-Pontormo, *Venere e Cupido / Venus and Cupid*,
 Firenze, Galleria dell'Accademia.

intensa fase di michelangiolismo che il Pontormo ebbe all'inizio degli anni Trenta del Cinquecento[32]. D'altra parte, in netto contrasto con il suo maestro, entro il 1532 si era evoluto verso una tipologia di artista-gentiluomo e di vero cortigiano nell'abbigliamento, nei modi e nell'espressione pittorica. Vasari lo lodava come «dolcissimo e molto cortese amico, di piacevole conversazione, e in tutti i suoi affari è molto onorato»[34]. Catturata l'attenzione di Guidobaldo II della Rovere, duca di Urbino, era stato invitato a Pesaro nel 1530[35], dov'era vissuto nello stesso ambiente che aveva ispirato il *Cortegiano* di Baldassarre Castiglione (1528).

Nell'inverno o nella primavera del 1532, il Bronzino rientrò da un *wanderjahr* di successo nelle Marche[36]; al tempo della commissione di Bettini, l'artista ventinovenne stava appena cominciando a sviluppare una propria personalità professionale. Per quanto, infatti, avesse già ricevuto importanti commissioni indipendenti, fu a Pesaro che si sviluppò il suo vocabolario stilistico, in particolare nel campo della ritrattistica. Il *Ritratto del duca Guidobaldo* (fig. 6), per esempio, rivela l'influenza dei ritratti espressivi e pittorici della famiglia Della Rovere dipinti da Tiziano. L'anno seguente, a Firenze, lo stile dei suoi ritratti si spostò ancora verso un idioma più scultoreo, che riflette l'influenza dei *Momenti del giorno* di Michelangelo

Under the burden of unwanted commissions and distraught by the death of his father in 1531, Michelangelo spent ten months in Rome, between August 1532 and June 1533; by 23 September 1534 he established permanent residence in the city, never to return to his native Florence.

Pontormo had a more secure foothold in Florence as court artist to the Medici; and, unlike Michelangelo, the less-political artist remained active in Florence until his death in 1556, serving Republican and Medici patrons alike[18]. In the late 1520s Pontormo accepted commissions for portraits of prominent Republicans. During the Siege he painted Francesco Guardi "in the habit of a soldier" (now lost)[19]. Two years later, he portrayed Amerigo Antinori just before the sitter's Florentine exile (fig. 5)[20]. He also painted a portrait of Carlo Neroni (now lost)[21], for whom Bronzino executed the *Martyrdom of the Ten Thousand* (Florence, Uffizi), derived from Pontormo's painting of the subject (Florence, Pitti)[22].

Pontormo was also an ideal choice for the decoration of Bettini's 'chamber', having had success with the panels of the *Story of St. Joseph* for Pierfrancesco Borgherini's bedroom of 1515-1518 (see fig. 16)[23], and an *Adoration of the Magi* (Florence, Pitti) for the antechamber of Giovanni Benintendi's town house of 1518[24]. By patronizing Pontormo, Miche-

5. Pontormo, *Ritratto di Amerigo Antinori*
Portrait of Amerigo Antinori,
Lucca, Palazzo Mansi.

6. Agnolo Bronzino, *Ritratto di Guidobaldo II della Rovere*
Portrait of Guidobaldo II della Rovere,
Firenze, Palazzo Pitti, Galleria Palatina.

per le Cappelle Medicee (Catt. 14, 15). Il *Ritratto di Dante* (Cat. 22, Tav. II/1; fig 7), commissionato da Bettini per una delle lunette della sua "camera", è tipico dello stile maturo, lapidario, che l'artista impiegò dal principio alla fine della sua carriera per i ritratti di sofisticati personaggi contemporanei. Il Bronzino realizzò anche una copia del *Noli me tangere* di Michelangelo-Pontormo (Firenze, Casa Buonarroti; fig. 8), il cui cartone gli fu procurato dal Pontormo così che egli ne poté eseguire una seconda versione per Alessandro Vitelli, Capitano della Guardia Imperiale[37]. All'inizio degli anni Trenta, pertanto, il Bronzino era un pittore esperto, ingaggiato dal duca come dai ricchi repubblicani, e piuttosto versato nel nuovo linguaggio dell'arte di corte del Cinquecento. Eseguì tre dei poeti destinati alle lunette della "camera" di Bettini – *Dante* (Cat. 22), *Petrarca* e *Boccaccio* (entrambi perduti) – con raffinatezza ed eleganza eguagliata solo dal pezzo forte della stanza, la *Venere e Cupido* di Michelangelo-Pontormo (Cat. 23). Nel commissionare la decorazione per la sua "camera", Bettini rese possibile una complessa interazione tra lui stesso come mecenate, i suoi tre artisti e il pubblico designato. Già in passato le "camere private" erano state riccamente decorate a Firenze, per

langelo, and Bronzino, Bettini elevated his own *status* as patron, and his projected program became one of the most important interior decoration projects in early Cinquecento Florence. In 1532, at the same time as he was taking on Republican projects such as the *Venus and Cupid*, Pontormo was commissioned by Clement VII to complete the *salone* in the Medici Villa at Poggio a Caiano[25].

It was to assist in the execution of this commission that Pontormo called Bronzino back from the Della Rovere court at Pesaro in 1532. After the forced sale of the Michelangelo-Pontormo *Venus and Cupid* to Duke Alessandro, Pontormo began accepting commissions from him, including an intimate portrait of the Duke in mourning (Philadelphia, Museum of Art)[26], painted in late 1534 shortly after the death of Alessandro's father, Clement VII. In 1535-1536, Pontormo went on to fresco the loggia of the Medici Villa at Careggi with allegorical figures (now lost) glorifying Alessandro's rule[26]. However, according to Vasari, Pontormo struggled with his elevation to Medici court artist[27]. By 1534, he was officially on the Medici payroll[28], and he remained in their service after Alessandro's assassination in 1537.

BARTOLOMEO BETTINI E LA DECORAZIONE DELLA SUA "CAMERA" FIORENTINA
BARTOLOMEO BETTINI AND HIS FLORENTINE 'CHAMBER' DECORATION

9

esempio durante il governo del papa Leone X de' Medici (1513-1521) su desiderio dei sostenitori dei Medici come Borgherini e Benintendi, ma all'inizio degli anni Trenta, repubblicani come Bettini rischiavano la confisca delle proprietà e l'esilio per i loro orientamenti politici, cosa che ridusse inevitabilmente il mecenatismo artistico su vasta scala. La "camera" fiorentina, allora, fu un modo quasi sovversivo di esercitare il potere tra i mecenati delle arti, dopo l'assedio. In quest'arena di competizione, i raffinati modi di spendere denaro erano condizionati dalle usanze stabilite dai Medici, i più potenti committenti di opere d'arte della città. Bettini comprese il senso politico del patronato artistico nella Firenze medicea; e, mentre egli faceva opposizione alla famiglia dominante, la incompiuta decorazione per la sua "camera" ne emulava il mecenatismo in scala di grandezza, stile e raffinatezza. Riuscì a elevare il suo *status* sociale da mercante e banchiere a colto committente di arti visive attraverso le sue commissioni a Michelangelo, Pontormo e Bronzino; queste lo posero sullo stesso piano dei membri dell'élite fiorentina, quali i Salviati e, ciò che più conta, i Medici. Significativamente, tutti e tre gli artisti impegnati nel 1532 per la commissione di Bettini, più tardi furono impiegati dai Medici per commissioni sia private che pubbliche.

Having actively collaborated with Pontormo at the monastery of the Certosa at Galluzo[30], in the Capponi Chapel at Santa Felicita[31], and painting the *Pygmalian and Galatea* as the cover for the *Portrait of Francesco Guardi*[32], Bronzino inherited the linear style and plastic forms of Pontormo's intense phase of Michelangelism in the early 1530s[33]. But, by 1532, Bronzino had developed into a different kind of artist – a gentleman-artist and a true courtier in dress, manner, and artistic expression. Vasari praised him as a "most gentle and a very courteous friend, agreeable in his conversation and in all his affairs, and much honored"[34]. He caught the attention of Guidobaldo II della Rovere, Duke of Urbino, who invited him to Pesaro in 1530[35], where he had lived in the very milieu that had inspired Baldassare Castiglione's *Courtier* (1528).

By winter or spring of 1532, Bronzino returned from a successful *wanderjahr* in the Marches[36]; at the time of the Bettini commission, the twenty-nine year old artist was just coming into his own professionally. While he had already received independent commissions, it was in Pesaro that his own stylistic vocabulary developed, particularly in portraiture.

The *Portrait of Duke Guidobaldo* (fig. 6), for example, reveals the influence of Titian's expressive and painterly por-

7. Agnolo Bronzino (attr. a),
Ritratto di Dante / Portrait of Dante
Firenze, Collezione privata.

8. Agnolo Bronzino, *Noli me tangere*,
Firenze, Casa Buonarroti.

III. LA FAMIGLIA DI BETTINI,
IL QUARTIERE E LA RESIDENZA CITTADINA

I Bettini erano una nobile famiglia toscana, il cui ramo di Molezzano si era stabilito a Firenze nel 1351, ed è da questo ramo che discendeva Bartolomeo[38] (fig. 9). Come abbiamo visto, lo *status* della famiglia era confermato dal Varchi, che includeva Bartolomeo tra i nobili fiorentini che si erano uniti per mobilitarsi contro i Medici, nel 1530. Sfortunatamente non sappiamo dove Bartolomeo vivesse, ma i suoi antenati avevano costruito la loro casa nelle adiacenze del futuro sito di Palazzo Medici. Nel 1427 l'ingresso principale si apriva su Borgo San Lorenzo, al tempo il principale asse nord-sud di Firenze che conduceva alla Porta San Gallo, tuttavia il catasto del 1480 cita la casa dei Bettini in via Larga (fig.10), oggi via Cavour[39]. L'iniziativa di spostare l'entrata può rispecchiare un desiderio di vicinanza con il nuovo Palazzo Medici di via Larga, iniziato nel 1448.

Dunque gli avi di Bettini vivevano nel quartiere di San Giovanni – luogo di residenza di quindici tra le cento famiglie più ricche, tra cui gli Albizzi, i Medici, i Pazzi e i Valori – nel *gonfalone* Drago[40]. La residenza di un fiorentino in un particolare quartiere rifletteva la sua occupazione, ma coinvol-

traits of the Della Rovere family. The following year in Florence, Bronzino's portrait style shifted again towards a more sculptural idiom, reflecting the influence of Michelangelo's *Times of Day* for the Medici Chapel (Cats. 14, 15). Bronzino's *Dante* (Cat. 22, Pl. IV/1; fig. 7), commissioned by Bettini for one of his 'chamber' lunettes, is typical of the mature, lapidary style which the artist utilized for portraits of sophisticated contemporary sitters throughout his career. Bronzino also copied the Michelangelo-Pontormo *Noli me tangere* (Florence, Casa Buonarroti; fig. 8), the cartoon for which Pontormo provided him so that he could execute a second version for Alessandro Vitelli, Captain of the Imperial guard[37]. By the early 1530s Bronzino was thus an accomplished painter, patronized by the duke and by wealthy Republicans alike, and well-versed in the new vocabulary of Cinquecento court art. He executed three of the poet portraits destined for the lunettes of Bettini's 'chamber' – *Dante* (Cat. 22), *Petrarch*, and *Boccaccio* (both lost) – with sophistication and elegance rivaled only by the room's showpiece, the Michelangelo-Pontormo *Venus and Cupid* (Cat. 23).

In commissioning his 'chamber' decoration, Bettini made possible a complex interaction between himself as patron, his three artists, and his intended audience. Private *camere* had been elaborately decorated earlier in Florence, for example during the rule of the Medici Pope Leo X (1513-1521), by Medici sympathizers such as Borgherini and Benintendi, but in the early 1530s Republicans like Bettini risked confiscation of property and exile for their political beliefs, which inevitably restricted artistic patronage on a grand scale. The Florentine 'chamber', then, was an almost subversive way of wielding power among art patrons after the Siege. In this competitive arena, sophisticated methods of spending were conditioned by the established mores of the Medici, the city's most powerful patrons of art. Bettini understood the political agenda behind art patronage in Medici Florence; while he opposed the ruling family, his unfinished 'chamber' decoration emulated their patronage in scale, style, and sophistication. He succeeded in elevating his own *status* from that of

9. Stemma della famiglia Bettini / *Bettini's family arms*, Archivio di Stato di Firenze, Fondo Ceramelli Papiani, 471, c. 52

BARTOLOMEO BETTINI E LA DECORAZIONE DELLA SUA "CAMERA" FIORENTINA
BARTOLOMEO BETTINI AND HIS FLORENTINE 'CHAMBER' DECORATION

11

geva anche la sua identità e l'orgoglio civico⁴¹. I facoltosi mecenati del Quattrocento spesso rinunciavano ad alloggi confortevoli per case costruite negli "aviti quartieri", dove le famiglie nobili avevano risieduto per secoli. Queste zone della città erano arene politiche dove lo *status* di nobiltà era ottenuto e legittimato; tuttavia, a dispetto dei molti benefici del vivere in un quartiere di famiglia, il numero di famiglie che viveva nei luoghi aviti declinò con la fine del secolo⁴².

A uno spostamento di residenza deve essere riferita la mancanza di documentazione sui Bettini nel quartiere di San Giovanni, *gonfalone* Drago, dopo il 1480, quando la casa in via Larga fu venduta a Lionardo di Zanobi⁴³. Jacopo di Martello, il bisnonno di Bartolomeo, fu l'ultimo membro della famiglia la cui presenza nella zona del *gonfalone* Drago sia documentata. Così, nel periodo in cui Bartolomeo commissionò a Michelangelo, Pontormo e Bronzino la decorazione della sua "camera", nel 1532, la sua dimora e il suo quartiere avevano poco a che fare con i suoi antenati. L'assenza dal catasto e dal censimento del 1527 conferma un'interruzione del legame tra lui e il suo quartiere di famiglia, una tendenza alla quale i suoi parenti avevano dato inizio due generazioni prima⁴⁴. Il palazzo fiorentino,

merchant-banker to that of learned patron of the visual arts by his commissions to Michelangelo, Pontormo, and Bronzino; these aligned him with members of the Florentine elite such as the Salviati, and, most importantly, the Medici. Significantly, all three artists involved in Bettini's commission of 1532 were later employed by the Medici Dukes for both private and public commissions.

III. BETTINI'S FAMILY, NEIGHBORHOOD, AND TOWN HOUSE

The Bettini were a noble Tuscan family, the Molezzano branch of which had settled in Florence by 1351, and it is from this branch that Bartolomeo descended³⁸ (fig. 9). As we have seen, the family status was confirmed by Varchi, who included Bartolomeo among the *nobili fiorentini* who gathered to rally against the Medici in 1530.

Unfortunately we do not know where Bartolomeo lived, but his ancestors had built their house adjacent to the future site of the Palazzo Medici. In 1427 the main entrance was on Borgo San Lorenzo, then the major north-south axis of Florence leading to the Porta San Gallo; yet by 1480, the *cat-*

10. Francesco Granacci, Via Larga durante l'*Ingresso di Carlo VIII a Firenze*
Via Larga during the *Entry of Charles VIII into Florence*,
Firenze, Galleria degli Uffizi.

con le sue armi e imprese di famiglia, era un simbolo della resistenza passata, presente e futura, e della sopravvivenza politica[45].

Emulando la pratica dei membri più importanti delle grandi famiglie, i quali facevano costruire palazzi cittadini intesi a confermare lo *status*, la longevità e le relazioni sociali della famiglia, Bartolomeo Bettini, figura di successo ma anche personaggio relativamente minore nella Firenze del Cinquecento, progettò di decorare la sua residenza privata in maniera grandiosa, forse per compensare il suo difetto di nobiltà. Come Leon Battista Alberti sosteneva nella sua trattazione delle dimore private: «ma poi che tutti acconsentiamo di avere a lasciare appresso de' posteri fama e di savii e di potenti [...] Per il che ancora quando che non meno per onorare la patria e la casata nostra, che per dilicatezza adorneremo alcune cose nostre, chi sarà quello che non dica che ella è cosa da uomo da bene?»[46].

Essendo un mercante e banchiere che aspirava alla società nobile e intellettuale, può aver cercato di creare l'illusione di un passato più dignitoso ed appropriato se non attraverso una dimora avita, almeno per mezzo di una "camera" raffinatamente decorata. Nonostante ciò, quando fece dei tentativi per maritare una delle sue nipoti con il nipote di Michelangelo, Lionardo, nel 1549 l'artista scriveva a Lionardo che il banchiere era «uomo da bene e servente e d'assai, ma non è nostro pari, e tu ài la tua sorella in casa e' Guicciardini»[47].

IV. BARTOLOMEO BETTINI:
«MERCANTE E MECENATE DEI LETTERATI»

I banchieri come i Bettini – noti come "cambiatori", "banchieri" o "tavolieri" (dalla loro attività e postazione di lavoro) – erano riuniti in associazione sotto l'Arte del Cambio[48]. Essendo la maggior fonte di capitale in Europa, Firenze offriva significative opportunità commerciali e l'elezione di papa Leone X Medici nel 1513 fece progredire la posizione dei banchieri fiorentini a Roma rispetto a quella di qualsiasi altro gruppo straniero. Una bolla del 1515 garantiva esenzioni ai banchieri fiorentini, che divennero i nuovi amministratori della Zecca pontificia, e assicurava anche consistenti introiti sulle imposte, come il monopolio del sale. Come osservato precedentemente, molte banche fiorentine, tra le quali quella dei Bettini, si spostarono a Roma anche dopo la morte di Clemente VII, nel 1534. Il 19 gennaio 1542 Bartolomeo aveva fondato a Roma la società bancaria "Cavalcanti e Giraldi", attraverso la quale è provato che abbia trasferito denaro di Michelangelo alle conoscenze fiorentine dell'artista[49].

A Roma persisteva un certo livello di stabilità e opportunità per i mercanti e banchieri antimedicei, ragione per cui Paolo III, che con riluttanza aveva onorato i debiti del suo predecessore Medici, può aver accolto con piacere, o almeno non penalizzato, l'esule fiorentino.

asto (tax record) shows the Bettini house in via Larga, today via Cavour[39]. The decision to shift the entrance may reflect the desire for proximity to the new Palazzo Medici on via Larga (fig. 10), begun in 1448.

Bettini's ancestors thus lived in the *quartiere* of San Giovanni – home to fifteen of the one hundred wealthiest families, including the Albizzi, the Medici, the Pazzi, and the Valori – in the *gonfalone* Drago[40].

A Florentine's residence in a particular neighborhood reflected his trade, but also involved his identity and civic pride[41]. Wealthy patrons in the Quattrocento often sacrificed comfortable accommodations for houses built in "ancestral neighborhoods" where noble families had proudly resided for centuries. These neighborhoods were political arenas where noble status was attained and legitimized, yet despite the many benefits to living in a family *quartiere*, the number of families living in ancestral neighborhoods declined at the end of the century[42].

This shift may account for the lack of any documentation of a Bettini residence in San Giovanni, *gonfalone* Drago, after 1480, when the Bettini house in via Larga was sold to Lionardo di Zanobi[43]. Jacopo di Martello, Bartolomeo's great-grandfather, was the last family member documented in *gonfalone* Drago. Thus, by the time that Bartolomeo commissioned Michelangelo, Pontormo, and Bronzino to decorate his 'chamber' in 1532, his residence and neighborhood were scarcely ancestral. Bettini's absence in the *catasto* and census of 1527 confirms a termination of ties between himself and his family's *quartiere*, a trend that his relatives had begun two generations before[44].

The Florentine family *palazzo*, with its coat-of-arms and family *imprese*, was a symbol of past, present, and future endurance and political solvency[45]. Aspiring to the practice of prominent members of large families, who built urban homes that were intended to confirm the family's *status*, longevity, and social connections, Bartolomeo Bettini, a successful but relatively minor figure in Cinquecento Florence, planned to decorate his private residence in a grand manner that would perhaps compensate for his noble shortcomings. As Leon Battista Alberti argued in his discussion of private dwellings, "we decorate our property as much to distinguish family and country as for any personal display (and who would deny this to be the responsibility of a good citizen?)"[46].

Being a merchant-banker with aspirations for noble and intellectual society, Bettini may have tried to create the illusion of a more dignified and appropriate past – if not through an ancestral house, at the very least through an elegantly decorated 'chamber'.

When Bettini made efforts to marry off one of his nieces to Michelangelo's nephew, Lionardo, the artist wrote to Lionardo in 1549 that the banker was "a man of honor, able and obliging, but he is not our equal and your sister has married into the Guicciardini family"[47].

BARTOLOMEO BETTINI E LA DECORAZIONE DELLA SUA "CAMERA" FIORENTINA
BARTOLOMEO BETTINI AND HIS FLORENTINE 'CHAMBER' DECORATION

13

Un altro importante aspetto della vita di Bettini era costituito dal suo ambiente sociale e dalle sue amicizie. La distinzione tra amicizia e patronato politico era spesso resa nulla dalle aspirazioni a un avanzamento sociale: quando un personaggio promuoveva i propri interessi economici e politici, talvolta creava legami privati attraverso le reti del patronato. Gli amici non di rado appartenevano alle stesse organizzazioni, quali le confraternite laiche o "compagnie", che, a differenza delle prime gilde di mercanti, erano messe insieme da persone che esercitavano professioni diverse[50]. Gli incontri informali di queste "compagnie" aprirono la strada, per mercanti e banchieri come Bettini, ai contatti con i membri dell'élite fiorentina.

L'Accademia degli Umidi, trasformata in Accademia Fiorentina tre mesi dopo l'inizio della sua attività, il 1° novembre 1540, segnò un'evoluzione rispetto alla tradizione delle Confraternite di società[51]. Fondata sul principio di sostenere il primato della lingua toscana, l'Accademia all'inizio era composta da undici giovani uomini che si riunivano per leggere i sonetti di poeti toscani come Dante, Petrarca e Boccaccio; i membri erano tenuti a pubblicare prosa o poesia o a tradurre un'opera dal latino o dal greco in volgare. All'interno dell'Accademia uomini dalle più disparate carriere e formazioni – artisti, muratori, fabbricanti di panni di lana e potenti banchieri come i Medici – si mescolavano e scambiavano riflessioni sulla cultura toscana che stava fiorendo[52].

Quando viveva a Roma, dopo essere stato esiliato da Firenze intorno al 1536, Bettini ristabilì legami politici con la sua città natale grazie alla sua elezione alla carica di "console fiorentino" a Roma, nel 1544[53]. L'anno seguente, mantenendo sempre la residenza a Roma, entrò a far parte dell'Accademia Fiorentina il 29 settembre 1545. In qualità di membro di tale prestigiosa associazione, venne in contatto con uomini della corte di Cosimo I, come Varchi e Luca Martini (m. nel 1560)[54].

La stretta amicizia con il Varchi in particolare è confermata dalle lettere di Giovambattista Busini scritte a Varchi a riguardo dell'assedio di Firenze[55]. Nel ruolo di banchiere personale di Michelangelo, Bettini è anche citato in termini positivi in numerose lettere da e per l'artista[56]. Un dialogo inedito di Baccio Tasio, *Il Vespro*, immortala un dialogo tra alcuni soci dell'Accademia, Bettini, Martini e Alessandro Davanzati, sulla lingua toscana e su una rappresentazione teatrale intitolata il *Negromante*[57].

Martini, il committente dei *Sei poeti toscani* del Vasari, del 1544 (Cat. 24, Tav. IV/1), un dipinto che riflette le rappresentazioni dei poeti per la "camera" di Bettini, ebbe un ruolo di *liaison* tra la comunità artistica fiorentina e quella letteraria. Essendo il committente di artisti come Bronzino, Pierino da Vinci e Vasari, Martini fu anche di aiuto a Varchi nell'ottenere le lettere degli artisti sul paragone fra scultura e pittura pubblicate nelle *Due Lezzioni*[58]; inoltre, negli anni

IV. BARTOLOMEO BETTINI: "MERCANTE E MECENATE DEI LETTERATI"

Bankers like Bettini – known as *cambiatori*, *banchieri*, or *tavolieri* (after their trade or place of business) – were organized under the *Arte del Cambio*, the bankers' guild[48]. As a major source of capital in Europe, Florence offered significant commercial opportunities, and the election of the Medici Pope Leo X in 1513 improved the situation of the Florentine bankers in Rome more than any other foreign group. A bull of 1515 granted exemptions to Florentine bankers, who became the new directors of the papal mint, along with valuable tax incomes, such as the salt monopolies. As noted above, many Florentine banks, including Bettini's, moved to Rome even after the death of Clement VII in 1534. By 19 January 1542 Bettini was established in the Roman banking firm of "Cavalcanti and Giraldi", through which he is documented as transferring Michelangelo's funds to the artist's Florentine contacts[49].

In Rome there was a certain level of stability and opportunity for anti-Medici merchant-bankers. Paul III, who reluctantly honored the debts of his Medici predecessor, may have welcomed, or at least not penalized, the Florentine exile.

Another important aspect of Bettini's life was his social world and friendships. The distinction between friends and patrons was often blurred by the individual in his quest for advancement in society; as men advanced their economic and political interests, they often created intimate bonds through networks of patronage. Friends often belonged to the same organizations, such as *compagnie* (lay confraternities), which, in contrast to the earlier merchant guilds, were made up of men from different vocations[50]. Informal meetings of these *compagnie* paved the way for merchant-bankers like Bettini to interact with members of the Florentine élite.

The Accademia degli Umidi, transformed into the Accademia Fiorentina three months after its inception on 1 November 1540, grew from the tradition of social confraternities[51]. Founded on the principle of upholding the primacy of the Tuscan language, the Accademia began with eleven young men who gathered to read sonnets by Tuscan poets such as Dante, Petrarch, and Boccaccio; members were required to publish prose or poetry, or to translate a work from Latin or Greek into the vernacular. In the Accademia men of diverse careers and backgrounds – artists, masons, wool makers, and powerful bankers such as the Medici – could mingle together and exchange thoughts on the burgeoning Tuscan culture[52].

Living in Rome after his exile from Florence around 1536, Bettini reestablished political ties with his native city through his election as Florentine Consul in Rome in 1544[53]. The following year, while maintaining residence in Rome, he joined the Accademia Fiorentina on 29 September 1545. As a member, Bettini was in contact with men of the court of Cosimo I such as Varchi and Luca Martini (d. 1560)[54]. Bettini's close friendship with Varchi in particular is confirmed by the letters

Quaranta, la sua amicizia fu vantaggiosa per Bettini, come politico, accademico e mecenate delle arti. In amicizia anche con il Varchi, Bettini fu uno degli accademici più influenti e ben introdotti presso la corte dei Medici (vedi gli altri saggi di questo volume)[59]. Il mecenatismo di Bettini nei confronti del Varchi esemplifica il proseguire dell'avvicinamento del mercante e banchiere al ceto colto fiorentino. Attraverso questi rapporti, pubblicamente esplicitati nelle dedicazioni degli scritti del Varchi, Bettini mantenne i suoi contatti con il circolo di Michelangelo, Pontormo e Bronzino, i quali, tutti e tre con le loro lettere, contribuirono al dibattito di Varchi sul *paragone*.

V. Bettini e la sua "camera"

Una delle principali fonti sulla decorazione della "camera" di Bettini è costituita dal Vasari, le cui descrizioni possono essere ritenute particolarmente attendibili, dato che egli stesso aveva fatto da assistente al Bronzino, il 30 marzo 1533, per fornire i disegni per la Compagnia de' Negromanti[60]. Nella *Vita di Bronzino*, Vasari annotò che l'artista dipinse «a Bartolomeo Bettini, per empiere alcune lunette d'una sua "camera", il ritratto di Dante, Petrarca, e Boccaccio, figure dal mezzo in su, bellissime»[61]. Concepite come un tributo alla letteratura toscana, le lunette del Bronzino seguivano la tradizione rinascimentale delle decorazioni da "studiolo", particolarmente diffuse nei centri principeschi delle corti di Urbino e Mantova. Nella *Vita* di Pontormo, Vasari descriveva un ulteriore aspetto della decorazione per Bettini:

«Veggendosi adunque quanta stima facesse Michelangelo del Puntormo, e con quanta diligenza esso Puntormo conducesse a perfezzione e ponesse ottimamente in pittura i disegni e ' cartoni di Michelangelo, fece tanto Bartolomeo Bettini, che il Buonarruoti suo amicissimo gli fece un cartone d'una Venere ignuda con un Cupido che la bacia, per farla fare di pittura al Pontormo e metterla in mezzo a una sua "camera", nelle lunette della quale aveva cominciato a fare dipingere dal Bronzino Dante, Petrarca e Boccaccio, con animo di farvi gl'altri poeti che hanno con versi e prose toscane cantato d'amore»[62].

Vasari, dunque, rappresenta anche l'unico riferimento di quel tempo sulla commissione di Bettini al completo, mentre disponiamo di numerose descrizioni della *Venere e Cupido* di Michelangelo-Pontormo (si veda in Appendice II e nel saggio Nelson). Il programma decorativo è stato rivisitato dagli studiosi moderni, ma non ci rimane alcuno studio sulla "camera" in quanto tale.

La decorazione per Bettini fu commissionata come pezzo dimostrativo per i pochi privilegiati che si erano garantiti l'accesso alla sua "camera". Le "camere", nel Rinascimento, contenevano anche un letto, ma avevano molte funzioni che affiancavano quella di una camera da letto dei nostri giorni. Mentre l'espressione «camera sua» si riferiva sem-

of Giovambattista Busini to Varchi regarding the Siege of Florence[55]. As Michelangelo's private banker, Bettini is also mentioned in favorable terms in numerous letters to and from the artist[56]. An unpublished dialogue by Baccio Tasio, *Il Vespro*, records a discussion between fellow academicians Bettini, Martini, and Alessandro Davanzati over the Tuscan language and a theatrical piece entitled the *Negromante*[57].

Martini, the patron of Vasari's portrait of *Six Tuscan Poets* of 1544 (Cat. 24, Pl. IV/1), a painting which reflects the representations of poets in Bettini's 'chamber', acted as a liaison between Florence's artistic and literary communities. Patronizing artists such as Bronzino, Pierino da Vinci, and Vasari, Martini also helped Varchi obtain the letters from artists on the *paragone* or comparison between painting and sculpture, published in the *Due Lezzioni*[58]. The friendship with Martini in the 1540s was a most auspicious move for Bettini as politician, academician, and patron of the arts.

Bettini also befriended Varchi, one of the most influential and well-connected academicians at the Medici court (see the other essays in this volume)[59]. His patronage of Varchi exemplifies the merchant-banker's ongoing association with the Florentine intelligentsia. Through this relationship, publicly recognized in the dedications of Varchi's works, Bettini maintained his contact with the circle of Michelangelo, Pontormo, and Bronzino, all three of whom contributed letters to Varchi's debate on the *paragone*.

V. Bettini and his 'chamber'

A major contemporary account of Bettini's 'chamber' decoration is by Vasari, whose description may be taken as particularly reliable, given that he served as Bronzino's assistant on 30 March 1533 for set designs for the Compagnia de Negromanti[60]. In his life of Bronzino, Vasari noted that the artist painted "for Bartolomeo Bettini, to fill certain lunettes in a 'chamber', the portraits of Dante, Petrarch, and Boccaccio, half-length figures of great beauty"[61]. Conceived as a tribute to Tuscan literature, Bronzino's lunettes followed the Renaissance tradition of *studiolo* decorations, particularly in the princely court centers of Urbino and Mantua. In his life of Pontormo, Vasari described another aspect of Bettini's decoration:

"It thus became evident in what estimation Michelangelo held Pontormo, and with what diligence Pontormo carried to completion and executed excellently well the designs and cartoons of Michelangelo, and Bartolomeo Bettini so went to work that Buonarroti, who was much his friend, made for him a cartoon of a nude Venus with a Cupid who is kissing her, in order that he might have it executed in painting by Pontormo and place it in the center of a 'chamber' of his own, in the lunettes of which he had begun to have painted by Bronzino figures of Dante, Petrarch, and Boccaccio, with the intention of having there all the other poets who have sung of love in Tuscan prose and verse"[62].

BARTOLOMEO BETTINI E LA DECORAZIONE DELLA SUA "CAMERA" FIORENTINA
BARTOLOMEO BETTINI AND HIS FLORENTINE 'CHAMBER' DECORATION

15

pre alla camera da letto principale del proprietario, l'ambiente che ospitava i dipinti e gli arredi più preziosi, le prove a noi giunte non dimostrano che il dipinto di *Venere* e i ritratti dei poeti del Bettini fossero destinati alla sua camera da letto. Può essere stabilito uno stretto collegamento, comunque, tra la decorazione della "camera" di Bettini e i programmi decorativi delle camere da letto e anticamere, di cui si parlerà di seguito.

Molto prima che Bettini commissionasse la decorazione della sua "camera", i progetti per le "camere" erano un modo collaudato di mostrarsi alla moda, nella Firenze del Rinascimento[63]. Nella *Vita* del pittore fiorentino Dello Delli, Vasari citava gli arredi per le camere da letto del Quattrocento, come *cassoni, lettiere e spalliere* (fig. 11), che venivano decorati con dipinti profani, i cui soggetti celebravano eventi quali i matrimoni e le nascite, e servivano da talismani per la fertilità della famiglia e la prosperità[64]. Alberti raccomandava ai committenti che «quelle parti de la casa massime che hanno a stare in pubblico, e che hanno ad essere le prime, per ricevere gratamente quelli che vi verranno ad alloggiare, com' è la facciata de la casa, l'antiporto, e simili, sieno molto onoratissime…»[65]. Stanze come quelle di Bettini erano designate quali nuclei del palazzo cittadino, spesso funzionando tanto come ambienti di rappresentanza quanto come spazi privati. Per esempio, Isabella d'Este, marchesa di Mantova, mostrava i suoi tesori personali alle sue dame di corte, che vi erano invitate per cantare, suonare musica, leggere e raccontare storie nella «camera di Madama»[66].

Le lunette di Bettini con Dante, Petrarca e Boccaccio – i tre coronati della poesia toscana – e il dipinto, con Venere e suo figlio Cupido avrebbero costituito uno sfondo perfetto per intrattenere dei letterati fiorentini, che l'ambizioso mercante e banchiere sperava di impressionare e di attirare nel suo mondo.

Bettini, che doveva avere previsto la sua "camera" come celebrazione della sua florida condizione di mecenate delle arti, potrebbe essere stato anche spinto da un importante evento della sua vita a decorare le pareti e le lunette. Le

Vasari is also the only contemporary reference to Bettini's complete commission, in contrast to numerous descriptions of the Michelangelo-Pontormo *Venus and Cupid* (see Appendix II and Nelson essay). The decorative program has been revisited by modern scholars, but there remains no study of the room as such.

Bettini's decoration was commissioned as a demonstration piece for the privileged few who gained access to his *camera*. Chambers in the Renaissance always included a bed but served many functions besides that of a modern day bedroom. While the term *"camera sua"* often referred to the principal bedroom of the owner, the room which housed his most precious paintings and furniture, surviving evidence does not establish if Bettini's *Venus* painting and the poet portraits were made for his bedroom. A strong connection can be made, however, between the decoration of Bettini's *camera* and that of decorative programs for contemporary bedchambers and antechambers, discussed below.

Long before Bettini commissioned the decoration of his 'chamber', *camera* projects were an established mode of self-fashioning in Renaissance Florence[63]. In his life of Florentine painter Dello Delli, Vasari noted early Quattrocento bedroom furnishings such as *cassoni* (wedding chests; fig. 11), *lettiere* (beds), and *spalliere* (wall panels), which were adorned with secular paintings honoring marriage and childbirth and serving as talismans of family fertility and prosperity[64]. Alberti advised patrons to "make the parts [of the house] that are particularly public or are intended principally to welcome guests, such as the façade, vestibule, and so on, as handsome as possible"[65]. Rooms like Bettini's were designed as the nucleus of an urban *palazzo*, often functioning as reception rooms as well as intimate spaces. For example, Isabella d'Este, marchesa of Mantua, exhibited her private treasures to her ladies-in-waiting, who were invited to sing, play music, read, and tell stories in the *camera di Madama*[66].

Bettini's lunettes of Dante, Petrarch, and Boccaccio – the three crowns of Tuscan poetry – and his painting of Venus and her son Cupid, would have formed the perfect backdrop for

11. Lo Scheggia, cosiddetto / so-called *Cassone Adimari*,
 Firenze, Galleria dell'Accademia.

decorazioni delle camere, come i ritratti personali, erano in genere commissionati per celebrare i momenti fondamentali della vita: il raggiungimento dell'età adulta, il matrimonio o la nascita di un figlio[67].

I fiorentini investivano grandiosamente nel decorare e arredare le stanze private, durante il periodo in cui in famiglia ci sarebbe stato un matrimonio, essendo la "camera" il fulcro degli ornamenti e delle spese specifiche[68].

Una "camera" era così la vera sede del potere dinastico, l'origine del lignaggio familiare e l'indicazione del suo futuro. Infatti, Alberti, nel suo trattato di architettura, dava indicazione ai fiorentini di appendere «nelle camere dove i padri de le famiglie hanno a dormire con le lor mogli, ...volti di uomini o di donne bellissimi ed onorati, e dicono che questo importa grandemente quanto allo ingravidare de le matrone, e quanto alla bellezza de la futura progenie»[69].

Inoltre, l'importanza delle "camere" nell'Italia del Cinquecento, rendeva i programmi privati più visibili e pubblici di quanto non accadesse nel Quattrocento, quando Alberti vedeva le decorazioni per le camere come realizzazioni destinate solamente al piacere del committente e di sua moglie[70].

Come abbiamo visto, Bettini era entrato nell'età adulta difendendo la Repubblica nei giorni finali dell'assedio. Due anni più tardi, nel 1532, aveva l'età giusta per sposarsi e metter su famiglia, entrambe forti motivazioni per commissionare un programma decorativo, ma, sfortunatamente, non ci è giunta documentazione di un evento simile.

La *Venere e Cupido* di Bettini, il cui formato ricorda quello delle *spalliere*, apparteneva alla tradizione iconografica delle "camere" del Rinascimento, in cui Venere, la dea dell'amore e della bellezza, regnava sopra le giovani coppie

entertaining Florentine *letterati*, who the ambitious merchant-banker wished to impress and invite into his world. Bettini, who must have envisioned his 'chamber' as a celebration of his burgeoning status as a learned patron of the arts, may have also been prompted to decorate its walls and lunettes by an important event in his life. Chamber decorations, like private portraits, were typically commissioned to commemorate rites of passage – reaching adulthood, marriage, or the birth of a child[67]. Florentines invested greatly in the decoration and furnishing of private rooms at the time of a marriage in the family, the *camera* being the focus of ornamentation and specific accounts[68]. A 'chamber' was thus the true seat of dynastic power, the origin of a family's lineage, and the indicator of its future. Alberti, in his treatise on architecture, directed Florentines to hang, "wherever man and wife come together, [...] portraits of men of dignity and handsome appearance; for they say that this may have a great influence on the fertility of the mother and the appearance of future offspring"[69]. Moreover, the importance of *camere* in Cinquecento Italy made private, domestic programs more visible and public than those of the Quattrocento, when Alberti viewed 'chamber' decorations as commissioned solely for the pleasure of the patron and his wife[70]. As we have seen, Bettini had come into adulthood while defending the Republic in the final days of the Siege. Two years later, in 1532, he was of the right age to marry and begin a family, both strong motivations for commissioning a decorative program, but unfortunately there is no documentation of such an event.

Bettini's *Venus and Cupid*, whose format resembles that of *spalliere* panels, belonged to an iconographic tradition in Renaissance *camere*, where Venus, the goddess of love and

12. Sandro Botticelli, *Venere e Marte / Venus and Mars*, London, National Gallery.

BARTOLOMEO BETTINI E LA DECORAZIONE DELLA SUA "CAMERA" FIORENTINA
BARTOLOMEO BETTINI AND HIS FLORENTINE 'CHAMBER' DECORATION

17

come protettrice del matrimonio. I miti che circondavano Venere si prestavano come allegorie dell'amore, del matrimonio (quando la dea era rappresentata con Vulcano) e dell'infedeltà (quando era accanto a Marte). Venere come dea nuziale rappresenta un antico tema della tradizione letteraria della poesia matrimoniale o epitalamia[71].

Nelle arti visive, è spesso descritta al comando del suo dominio, distesa su un letto che somiglia a quelli che si potevano trovare nelle camere fiorentine, ed estende lo spazio fisico di un interno domestico in un mondo ideale, attraverso una albertiana finestra.

Prima di assumere un ruolo dominante all'interno delle decorazioni per le camere, come quella progettata per il palazzo di Bettini, Venere era entrata surrettiziamente nei *boudoir* fiorentini, nel periodo in cui si celebrava un matrimonio, tramite i *cassoni*. I predecessori dell'ampia tavola rettangolare di Bettini erano dei nudi femminili distesi, dipinti sulla faccia interna dei coperchi dei *cassoni nuziali* fiorentini della seconda metà del Quattrocento, ed erano affiancati da nudi maschili distesi, sulla faccia interna del *cassone pendant*.

In un esemplare del 1460 circa (Copenaghen, Statenmuseum for Kunst), Giovanni di Ser Giovanni, detto Lo Scheggia, dipinse eventi della storia romana, che alludevano alle virtù e al nobile carattere del suo committente, sul fronte e sui fianchi del *cassone nuziale*[71]. Sulla faccia inferiore del coperchio, dipinse un nudo femminile disteso davanti a uno sfondo neutro, una figura allusiva, concepita come immagine privata che avesse il potere di favorire la sessualità, e in ultimo la procreazione, a vantaggio del futuro della famiglia.

beauty, reigned over young couples as the patroness of marriage. Myths surrounding Venus lend themselves to allegories of love, marriage (when shown with Vulcan), and infidelity (when depicted with Mars). Venus as nuptial goddess is an antique theme seen in the literary tradition of marriage poetry, or ephithalamia[71]. In the visual arts, she is often depicted in command of her domain, reclining on a bed reflecting those found in Florentine bedrooms, and extending the physical space of the domestic interior through an Albertian window into an ideal world. Prior to taking on her leading role in 'chamber' decorations, as in the one planned for Bettini's *palazzo*, Venus entered the Florentine boudoir surreptitiously, at the time of a marriage, through *cassoni*. The precursors of Bettini's large, oblong panel are reclining female nudes painted on the inside lids of Florentine wedding chests from the second half of the Quattrocento, where they were paired with reclining male nudes on the inside lid of the pendant *'cassone'*.

In one example (c. 1460, Copenhagen, Statenmuseum for Kunst), Giovanni di Ser Giovanni (Lo Scheggia) depicted events in Roman history alluding to his patron's virtue and noble character on the sides and front of the wedding chest[72]. On the underside of the lid he painted a female nude reclining against a neutral background, a suggestive figure conceived as a private image with the power to encourage sexuality, and ultimately procreation, for the benefit of the family's future. Venus, the matriarch of the bedchamber, gained independence from the confines of *cassoni* in the late Quattrocento.

In Sandro Botticelli's *Venus and Mars* (see Pl. I/2 and fig. 12), painted for a marriage 'chamber' in a Florentine town house, Venus is united with her paramour and depicted as the ultimate victor over the god of war in a sheltered grove set before an idyl-

13. Piero di Cosimo, *Venere e Marte/ Venus and Mars*,
 Berlin, Staatliche Museen Gemäldegalerie.

Venere, la matriarca della camera da letto, si rese indipendente dai chiusi confini dei *cassoni* nel tardo Quattrocento. Nella *Venere e Marte* di Sandro Botticelli (Tav. I/2; fig. 12), dipinta per la camera matrimoniale di una residenza cittadina fiorentina, Venere è congiunta al suo amante e raffigurata come vincitrice finale contro il dio della guerra, in un boschetto riparato, ambientato davanti a un paesaggio idillico[73]. Ai piaceri fisici dell'amore – riferimenti al ruolo riproduttivo e dinastico della camera da letto – allude anche il sonno beato di Marte, mentre gli amorini giocano con le sue armi tradizionalmente offensive.

La *Venere e Marte* di Piero di Cosimo (Tav. I/1; fig. 13), che molto deve alla tavola del Botticelli, impiega lo stesso gruppo di personaggi che godono dei piaceri dell'amore consumato, nell'ambientazione di un paesaggio simile[74]. Piero, comunque, introdusse come figura principale in primo piano Cupido, simbolo, insieme con il suo coniglio, di lussuria e fertilità.

Nel primo Cinquecento, l'attrazione erotica tra Venere e Cupido (indipendente da Marte, Bacco e Vulcano) si diffuse nella pittura veneziana, a iniziare dalla *Venere dormiente* del 1510 circa (Dresda, Staatliche Gemäldegalerie) di Giorgione, forse commissionata in occasione di un matrimonio celebrato nel 1507[75]. Cupido (ridipinto nel 1837) era interpretato dal pubblico del Cinquecento come seduto ai piedi della madre, interessato all'allusivo uccello che tiene in mano.

La *Venere* di Giorgione, protettrice del matrimonio nell'Italia settentrionale, ispirò altri pittori veneziani ad adottarne il tema, mentre la *Venere e Cupido* di Palma il Vecchio, (fig. 14) allude al racconto di Ovidio su Cupido che ferisce con una freccia Venere, accendendo in lei il desiderio per Adone (*Metamorfosi*, X, 518-522)[76].

Il Cupido nella *Venere e Cupido* di Lorenzo Lotto (fig. 15), contrapponendosi al carattere più decoroso del personaggio del Palma, urina sul corpo della madre, attraverso una ghirlanda nuziale, come aperta celebrazione della fecondità e prosperità, all'interno della camera da letto[77].

Michelangelo poteva avere visto le immagini di *Venere e Cupido* di Giorgione, Palma il Vecchio e Lotto, durante il soggiorno a Venezia, nell'autunno del 1529. Il 21 settembre, tre settimane prima dell'assedio di Firenze, era fuggito a Venezia, via Ferrara, temendo gli eserciti combinati dell'imperatore Carlo V e di Clemente VII.

Due anni dopo, nel disegnare la sua *Venere e Cupido*, il Buonarroti potrebbe avere tradotto l'erotismo e la sensualità dei modelli settentrionali nel linguaggio acuto e complesso in uso presso i Medici, per la decorazione di un interno fiorentino, ovvero per quella della "camera" del suo «amicissimo» Bettini.

La decorazione della "camera" di Bettini rientra così in un nuovo tipo di mecenatismo del Cinquecento, in cui i progetti per le "camere" non erano visti semplicemente come il dono di ringraziamento di un gentiluomo per la dote della sposa[78], quanto piuttosto come estensione del carattere, della virtù e dell'orgoglio civico del committente.

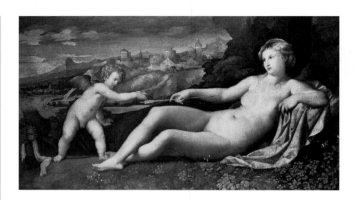

14. Palma il Vecchio, *Venere e Cupido / Venus and Cupid.* Cambridge, Fitzwilliam Museum.

lic landscape[73]. The physical pleasures of love – references to the procreative and dynastic role of the bedchamber – are also alluded to in Mars' blissful slumber as *amorini* play with his traditionally daunting arms. Piero di Cosimo's *Venus and Mars* (Pl. I/1 and fig. 13), indebted to Botticelli's panel, employs the same cast of characters who enjoy the pleasures of consummated love in a similar landscape setting[74]. Piero, however, introduced Cupid as a principal figure in the foreground, symbolizing, with the aid of his pet rabbit, lust and fertility. In the early Cinquecento the erotic interaction between Venus and Cupid (independent of Mars, Bacchus, and Vulcan) became popular in Venetian painting, beginning with Giorgione's *Sleeping Venus* (c. 1510, Dresden, Staatliche Gemäldegalerie), perhaps commissioned for a 1507 wedding[75]. Cupid (painted over by 1837) was seen by Cinquecento audiences as seated at his mother's feet and preoccupied with a suggestive *uccello* in his hand. Giorgione's *Venus*, the patroness of marriage in Northern Italy, inspired other Venetian painters to take up the theme. Palma il Vecchio's *Venus and Cupid* (fig. 14) alludes to Ovid's tale of Cupid wounding Venus with an arrow and igniting her desires for Adonis (*Metamorphoses*, X, 518-22)[76]. The Cupid in Lorenzo Lotto's *Venus and Cupid* (fig. 15), as opposed to Palma's more decorous character, urinates through a marriage wreath on his mother as an overt celebration of fecundity and prosperity in the bedroom[77]. Michelangelo may have seen the images of *Venus and Cupid* by Giorgione, Palma, and Lotto during a brief sojourn in Venice in the autumn of 1529. On 21 September, three weeks before the Siege of Florence, he had fled to Venice by way of Ferrara fearing the combined armies of the Emperor Charles V and Clement VII. Two years later, while designing his own *Venus and Cupid*, Michelangelo could have translated the eroticism and sensuality of the northern models into the Medici idiom of wit and complexity for a Florentine domestic decoration, namely that of his *amicissimo* Bettini.

Bettini's 'chamber' decoration belonged to a new kind of patronage in the Cinquecento, in which bedroom programs were no longer seen simply as a groom's counter-gift to his

BARTOLOMEO BETTINI E LA DECORAZIONE DELLA SUA "CAMERA" FIORENTINA
BARTOLOMEO BETTINI AND HIS FLORENTINE 'CHAMBER' DECORATION

19

Sebbene i soggetti religiosi continuassero ad adornare i primi programmi decorativi, nella Firenze del Cinquecento, come la *Storia di Giuseppe* per la camera nuziale dei Borgherini (fig. 16) o la *Vita di san Giovanni Battista* per l'anticamera dei Benintendi, i temi profani erano in quel momento molto graditi, legittimando i committenti come i veri eredi dell'antica *virtù* romana. Inoltre, le storie che celebravano l'amore erano ritenute soggetti particolarmente appropriati per i programmi decorativi delle "camere"; e i soggetti carichi di erotismo, come Cupido nell'atto di baciare Venere, mentre in definitiva alludevano alla fecondità della sposa e alla conseguente prosperità, erano idealmente adatti alla visione privata.

La "camera" dipinta di Bettini, sebbene mai compiutamente realizzata, avrebbe detto molto della ricchezza, raffinatezza e considerazione per Firenze del mercante e banchiere, in questa sua prima commissione di una certa importanza. A casa, nella propria "camera", Bartolomeo Bettini si sarebbe riposato tra opere d'arte dovute ai più richiesti pittori del suo tempo, che avevano arricchito la sua "camera" ed elevato il suo *status* al rango dei suoi vicini, sia repubblicani che medicei.

L'avere commissionato dipinti sul tema dell'amore ad artisti quali Michelangelo, Pontormo e Bronzino, diede accesso a Bettini alle pratiche sociali e alla raffinata cultura consumistica di quelle persone che egli più ammirava nella società fiorentina.

bride's dowry[78], but rather as an extension of the patron's character, virtue, and civic pride. Though religious subjects continued to adorn earlier bedroom programs in Cinquecento Florence, such as the *Story of Joseph* for the Borgherini bridal 'chamber' (fig. 16) and the *Life of St. John the Baptist* for the Benintendi *anticamera*, secular themes were now welcomed, legitimizing their patrons as the true heirs of ancient Roman *virtù*. Moreover, stories celebrating love were particularly appropriate subjects for 'chamber' programs, and sexually charged subjects such as Cupid kissing Venus, while ultimately alluding to the bride's fecundity and the family's subsequent prosperity, were ideally suited for private viewing. Bettini's painted *camera*, though never fully realized, would have spoken volumes of the merchant-banker's wealth, sophistication, and esteem for Florence in this his first major commission. At home in his *camera*, he would have relaxed among works of art by the most sought after painters of his day, enriching his *camera* while elevating his status to that of his wealthy neighbors – Republican and Medicean alike.

By commissioning paintings on the theme of love from Michelangelo, Pontormo, and Bronzino Bettini successfully gained access to the social practices and refined consumer culture of those he admired most in Florentine society.

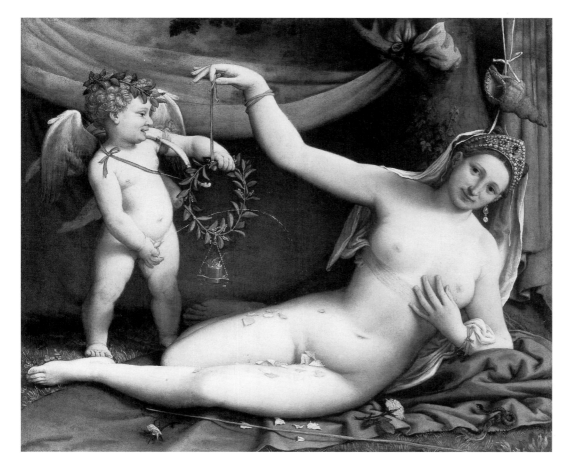

15. Lorenzo Lotto,
 Venere e Cupido
 Venus and Cupid,
 New York,
 The Metropolitan
 Museum of Art.

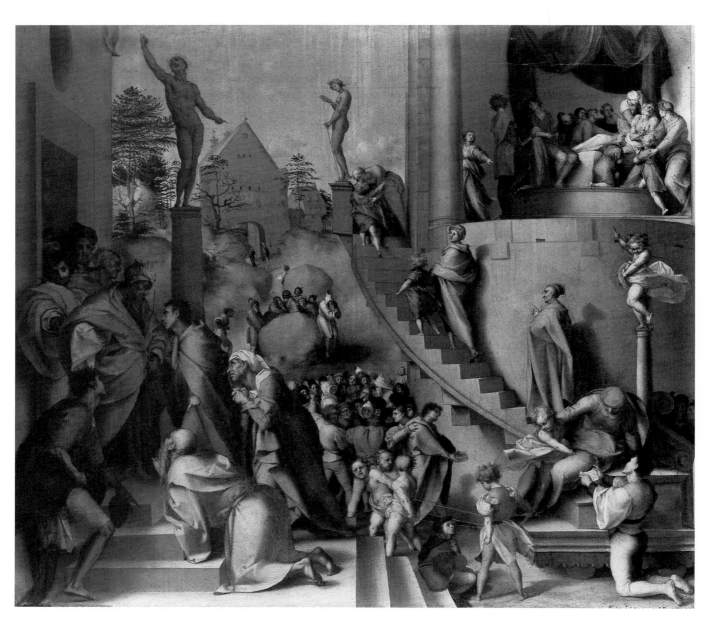

16. Pontormo, *Storia di Giuseppe/ Story of Joseph*,
London National Gallery.

BARTOLOMEO BETTINI E LA DECORAZIONE DELLA SUA "CAMERA" FIORENTINA
BARTOLOMEO BETTINI AND HIS FLORENTINE 'CHAMBER' DECORATION

21

Questo saggio si basa su parte della mia tesi di Ph.D, In Praise of Love: Paintings by Michelangelo, Pontormo, and Bronzino for Bartolomeo Bettini's Bedchamber (1532-1533 ca.), *discussa al Graduate Center of the City University di New York, di imminente pubblicazione. Per i loro suggerimenti e per il sostegno, sono grato alla mia relatrice, Janet Cox-Rearick, e a Jonathan Katz Nelson.*

This essay is based on parts of my Ph.D. dissertation, In Praise of Love: Paintings by Michelangelo, Pontormo, and Bronzino for Bartolomeo Bettini's Bedchamber (c. 1532-1533), *Graduate Center of the City University of New York, forthcoming.*
For their suggestions and support, I am grateful to my adviser, Janet Cox-Rearick, and to Jonathan Nelson.

[1] La data di nascita di Bettini rimane a tutt'oggi non documentata; tuttavia, la descrizione di lui che Benedetto Varchi fece nel 1530 come *giovane* (si veda oltre) suggerisce una datazione tra il 1494 circa e il 1512. In una lettera del 2 gennaio 1552, indirizzata a Michelangelo a Roma, Sebastiano Uberto si duole della recente scomparsa di Bettini, suo amico e notaio (MICHELANGELO BUONARROTI, *Il carteggio di Michelangelo*, 5 voll., a cura di Paola Barocchi e Renzo Ristori, Sansoni, Firenze 1965-1983, vol. 4, pp. 370-371). Per la vita di Bettini e i suoi contatti con artisti e letterati, cfr. LEATRICE MENDELSOHN, Paragone. Benedetto Varchi's "Due Lezzioni" and Cinquecento Art Theory, UMI Press, Ann Arbor 1982, pp. 23, 94, 162, 252, n. 31; e JONATHAN NELSON, Dante Portraits in Sixteenth Century Florence, "Gazette des Beaux- Arts", CXX, 1992, pp. 68-71.

[2] Giorgio Vasari, nella Vita di Pontormo, colloca la decorazione per la "camera" di Bettini tra il *Noli me tangere* per Alfonso d'Avalos, del 1531-1532, e il *Ritratto del Duca Alessandro*, del 1534, entrambi analizzati oltre; cfr. GIORGIO VASARI, Le vite de' più eccellenti pittori scultori ed architettori nelle redazioni del 1550 e 1568, a cura di Rosanna Bettarini, note di Paola Barocchi, 11 voll., S.P.E.S, Firenze 1966-1997, V, p. 326; PHILIPPE COSTAMAGNA, Pontormo, Electa, Milano 1994, catt. 69 e 71. Per la più accurata descrizione della camera da letto di Bettini, cfr. NELSON 1992, pp. 64-71. A questo ambiente, definito da Vasari "una sua camera", si farà riferimento lungo tutto lo svolgimento di questo studio come camera o stanza; per l'importanza della cosiddetta "camera mia", nel Rinascimento, cfr. JOHN KENT LYDECKER, Il patriziato fiorentino e la committenza artistica per la casa, in I ceti dirigenti nella Toscana del Quattrocento, a cura di Francesco Papafava, Papafava, Firenze 1987a, pp. 213-218.

[3] Per la vendita forzata cfr. VASARI 1568/1966-1997, V, p. 327. Egli asserisce che questo episodio avesse portato alla rottura dei rapporti di amicizia e collaborazione di Michelangelo con il Pontormo, e che il pagamento della Venere e Cupido da parte di Alessandro avesse consentito al Pontormo di costruirsi una casa in via Laura (oggi via della Colonna); a proposito della casa, costruita nel 1534, cfr. ELIZABETH PILLIOD, Pontormo Bronzino Allori. A Genealogy of Florentine Art, Yale University Press, New Haven-London 2001, p. 69, n. 17.

[4] VASARI 1568/1966-1997, vol. 6, p. 113.

[5] BENEDETTO VARCHI, Storia Fiorentina di Messer Benedetto Varchi, 5 voll., Società tipografica de' Classici Italiani, Milano 1803-1804, III, pp. 143-144 e IV, pp. 18-19.

[6] VARCHI 1803-1804, IV, pp. 241-243. Per l'assedio e la conseguente investitura di Alessandro de' Medici nel ruolo di duca, cfr. anche FRANCESCO DOMENICO GUERRAZZI, L'Assedio di Firenze, 2 voll., Le Monnier, Firenze 1859; CECIL ROTH, The Last Florentine Republic, Methuen & Co, London 1925; ERIC COCHRANE, Florence in the Forgotten Centuries, 1527-1800. A History of Florence and the Florentines in the Age of the Grand Dukes, University of Chicago Press, Chicago-London 1973, pp. 3-10; ELIZABETH CROPPER, Pontormo. Portrait of a Halberdier, Getty Museum Studies on Art, Los Angeles 1997.

[7] CROPPER 1997, p. 82.

[8] BERNARDO SEGNI, Storie fiorentine di Messer Bernardo Segni, gentiluomo fiorentino, dall'anno MDXXVII. al MDLV, 3 voll., Società tipografica de' Classici italiani, Milano 1805, II, p. 41.

[9] VASARI 1568/1966-1997, V, p. 327.

[10] MELISSA M. BULLARD, 'Mercatores Florentini Romanam Curiam Sequentes' in the early sixteenth century, "Journal of Medieval and Renaissance Studies", VI, 1976, pp. 57-59.

[11] Il 4 marzo 1536 Annibale Caro, scrivendo da Roma al suo amico Varchi a Firenze, afferma che il proprio debito «col Bettino» è stato estin-

[1] Bettini's birthdate remains undocumented; however, Benedetto Varchi's identification of him as a *giovane* in 1530 (see below) suggests a birthdate between about 1494 and 1512. In a letter of 2 January 1552 to Michelangelo in Rome, Sebastiano Uberto laments the recent loss of Bettini, his friend and notary (MICHELANGELO BUONARROTI, *Il carteggio di Michelangelo*, 5 vols., ed. Paola Barocchi and Renzo Ristori, Sansoni, Firenze 1965-1983, IV, pp. 370-371). For the life of Bettini and his contact with artists and *letterati*, see LEATRICE MENDELSOHN, Paragone. Benedetto Varchi's 'Due Lezzioni' and Cinquecento Art Theory, UMI Press, Ann Arbor 1982, pp. 23, 94, 162, 252, n. 31; and JONATHAN NELSON, Dante Portraits in Sixteenth Century Florence, 'Gazette des Beaux-Arts', CXX, 1992, pp. 68-71.

[2] GIORGIO VASARI, in the life of Pontormo, placed the Bettini 'chamber' decoration between the *Noli me tangere* for Alfonso d'Avalos of 1531-1532 and the *Portrait of Duke Alessandro* of 1534, both discussed below; see GIORGIO VASARI, Le vite de' più eccellenti pittori scultori ed architettori nelle redazioni del 1550 e 1568, ed. Rosanna Bettarini, notes by Paola Barocchi, 6 vols., S.P.E.S, Firenze 1966-1997, V, p. 326; PHILIPPE COSTAMAGNA, Pontormo, Electa, Milano 1994, cats. 69 and 71. For the most thorough account of Bettini's chamber, see NELSON 1992, pp. 64-71. This room, described by Vasari as 'una sua camera', will be referred to throughout this study as a 'chamber'; for the importance of the 'camera mia' in the Renaissance, see JOHN KENT LYDECKER, Il patriziato fiorentino e la committenza artistica per la casa, in I ceti dirigenti nella Toscana del Quattrocento, ed. Francesco Papafava, Papafava, Firenze 1987a, pp. 213-218.

[3] For the forced sale see VASARI 1568/1966-1997, V, p. 327. He claimed that this led to the collapse of Michelangelo's friendship and artistic collaboration with Pontormo, and that Alessandro's payment for the Venus and Cupid allowed Pontormo to construct his house on via Laura (today via della Colonna); for the house, built in 1534, see ELIZABETH PILLIOD, Pontormo Bronzino Allori. A Genealogy of Florentine Art, Yale University Press, New Haven-London 2001, p. 69, n. 17.

[4] GIORGIO VASARI, Lives of the Most Eminent Painters, Sculptors, and Architects, 10 vols, trans. Gaston C. Du Vere, Macmillan, London 1912-1915; reprint: AMS Press, New York 1976, IX, pp. 109-110; and VASARI 1568/1966-1997, VI, p. 113.

[5] BENEDETTO VARCHI, Storia Fiorentina di Messer Benedetto Varchi, 5 vols., Società tipografica de' Classici Italiani, Milano 1803-1804, III, pp. 143-144, and IV, pp. 18-19.

[6] VARCHI 1803-1804, vol. 4, pp. 241-243. For the Siege and the subsequent installation of Alessandro de' Medici as Duke, also see FRANCESCO DOMENICO GUERRAZZI, L'Assedio di Firenze, 2 vols., Le Monnier, Firenze 1859; CECIL ROTH, The Last Florentine Republic, Methuen & Co, London 1925; ERIC COCHRANE, Florence in the Forgotten Centuries, 1527-1800. A History of Florence and the Florentines in the Age of the Grand Dukes, University of Chicago Press, Chicago-London 1973, pp. 3-10; and ELIZABETH CROPPER, Pontormo. Portrait of a Halberdier, Getty Museum Studies on Art, Los Angeles 1997.

[7] CROPPER 1997, p. 82.

[8] BERNARDO SEGNI, Storie fiorentine di Messer Bernardo Segni, gentiluomo fiorentino, dall'anno MDXXVII. al MDLV, 3 vols., Società tipografica de' Classici italiani, Milano 1805, II, p. 41.

[9] GIORGIO VASARI (1568), Lives of the Most Eminent Painters, Sculptors, and Architects, trasl. by Gaston C. Du Vere, 10 vols., Macmillan, London 1912-1915; reprint: AMS Press, New York 1976, VII, p. 173.

[10] MELISSA M. BULLARD, 'Mercatores Florentini Romanam Curiam Sequentes' in the early sixteenth century, 'Journal of Medieval and Renaissance Studies', VI, 1976, pp. 57-59.

to; ANNIBALE CARO, *Lettere familiari*, a cura di Aulo Greco, 3 voll., Le Monnier, Firenze 1957-1961, I, pp. 31-34.

[12] BENVENUTO CELLINI, *La vita*, a cura di Carlo Cordiè, Riccardo Ricciardi Editore, Milano e Napoli 1996, pp. 193-194.

[13] NELSON 1992, p. 69.

[14] Tre fratelli Bettini – Luca, Domenico e Giovanni Maria – erano frati nel monastero domenicano di San Marco; cfr. LORENZO POLIZZOTTO, *The Elect Nation. The Savonarola Movement in Florence 1494-1545*, Clarendon, Oxford 1994, pp. 328, 394; e, a proposito di Luca, che morì in esilio nel 1527, cfr. *Dizionario Biografico degli Italiani*, 57 voll., Istituto della Enciclopedia italiana, Roma 1960- , IX, pp. 752-754.

[15] Tra queste c'erano un *David/Apollo* per Baccio Valori, un cartone per una pala d'altare commissionata da Matteo Malvezzi, e una copia del *Noli me tangere* per Alessandro Vitelli; cfr. CHARLES DE TOLNAY, *The Medici Chapel*, Princeton University Press, Princeton 1948, pp. 87-117. Per il periodo in questione, cfr. anche WILLIAM WALLACE, *Studies in Michelangelo's Finished Drawings, 1520-1534*, tesi di Ph.D., Columbia University, 1983; per le posizioni politiche di Michelangelo, cfr. GIORGIO SPINI, *Politicità di Michelangelo*, "Rivista storica italiana" LXXVI, 1964, pp. 557-600.

[16] Cfr. VASARI 1568/1966-1997, V, p. 326; e COSTAMAGNA 1994, cat. 69.

[17] A Pontormo potrebbe essere anche stato chiesto di affrescare una lunetta con la *Resurrezione*, su disegno di Michelangelo, sulla parete di fronte all'altare della Cappella Medici. Cfr. ANNY E. POPP, *Die Medici-Kapelle Michelangelos*, O. C. Recht, München 1922, pp. 158-163.

[18] DARIO TRENTO, *Pontormo e la corte di Cosimo I*, in *Kunst des Cinquecento in der Toskana*, a cura di Monika Cämmerer, Bruckmann, München 1992, pp. 139-144; COSTAMAGNA 1994, pp. 81-99; e PILLIOD 2001, pp. 11-42.

[19] VASARI 1568/1966-1997, V, p. 325; e COSTAMAGNA 1994, cat. 66. CROPPER 1997 lo ha identificato con il *Ritratto di un alabardiere* del Pontormo, al Getty Museum, Los Angeles.

[20] VASARI 1568/1966-1997, V, p. 327; e COSTAMAGNA 1994, cat. 67.

[21] VASARI 1568/1966-1997, V, p. 325; e COSTAMAGNA 1994, cat. 68.

[22] Si veda VASARI 1568/1966-1997, V, p. 325; e COSTAMAGNA 1994, catt. 65 e 65a.

[23] VASARI 1568/1966-1997, V, pp. 316-318; e COSTAMAGNA 1994, catt. 19-22.

[24] COSTAMAGNA 1994, Cat. 32.

[25] VASARI 1568/1966-1997, V, pp. 325-326; JANET COX-REARICK, *The Drawings of Pontormo. A Catalogue Raisonné with Notes on the Paintings*, 2 voll., II ed., Hacker Art Books, New York 1981, catt. 307-311.

[26] VASARI 1568/1966-1997, V, p. 327; e COSTAMAGNA 1994, Cat. 72.

[27] VASARI 1568/1966-1997, V, pp. 328-329; COX-REARICK 1981, catt. 312-320.

[28] Cfr. COSTAMAGNA 1994, pp. 74-75, 80, 86, 89, 92, 199, 252, e 259-260; e CROPPER 1997, pp. 53-58. Quando richiese ad Alessandro un compenso per il suo ritratto in lutto, il Pontormo propose di prendere solo quanto bastava a riscattare un cappotto che aveva precedentemente dato in pegno, ma il duca insistette per pagargli 50 scudi, in aggiunta a una *provvisione* annua; VASARI 1568/1966-1997, V, p. 327.

[29] PILLIOD 2001, pp. 14-23.

[30] VASARI 1568/1966-1997, VI, p. 231; COSTAMAGNA 1994, catt. 41-45.

[31] VASARI 1568/1966-1997, VI, p. 231; COSTAMAGNA 1994, catt. 50-53.

[32] VASARI 1568/1966-1997, V, p. 325; COSTAMAGNA 1994, Cat. 66a.

[33] Per le prime collaborazioni del Bronzino con il Pontormo, cfr. PILLIOD 2001, pp. 53-66.

[34] VASARI 1568/1966-1997, V, p. 238.

[35] VASARI 1568/1966-1997, vol. VI, p. 232; CRAIG HUGH SMYTH, *Bronzino Studies*, tesi di Ph.D., Princeton University 1955, Ann Arbor 1956, pp. 129-189; CHARLES MCCORQUODALE, *Bronzino*, Jupiter Books, London 1981, pp. 28-40.

[36] CRAIG HUGH SMYTH, *Bronzino as Draughtsman. An Introduction*, J.J. Augustin, Locust Valley (NY) 1971, pp. 55-56, n. 32.

[37] Cfr. VASARI 1568/1966-1997, V, p. 326; e COSTAMAGNA 1994, cat. 69a.

[38] Precedentemente denominati Ubaldini, il nome dei Bettini derivava dai

[11] On 4 March 1536 Annibale Caro, writing from Rome to his friend Varchi in Florence, states that his debt 'col Bettino' had been paid off; ANNIBALE CARO, *Lettere familiari*, ed. Aulo Greco, 3 vols., Le Monnier, Firenze 1957/1961, I, pp. 31-34.

[12] *The Autobiography of Benvenuto Cellini*, ed. Charles Hope and Alessandro Nova, trans. John Addington Symonds, Phaidon, Oxford 1983, p. 90.

[13] NELSON 1992, p. 69.

[14] Three Bettini brothers – Luca, Domenico, and Giovanni Maria – were friars in the Dominican monastery of San Marco; see LORENZO POLIZZOTTO, *The Elect Nation. The Savonarola Movement in Florence 1494-1545*, Clarendon, Oxford 1994, pp. 328, 394; and, for Luca who died in exile in 1527, see *Dizionario Biografico degli Italiani*, 57 vols., Istituto della Enciclopedia italiana, Rome 1960-, IX, pp. 752-754.

[15] These included a *David/Apollo* for Baccio Valori, an altarpiece cartoon for Matteo Malvezzi, and a copy of the *Noli me tangere* for Alessandro Vitelli; see CHARLES DE TOLNAY, *The Medici Chapel*, Princeton University Press, Princeton 1948, pp. 87-117. For this period, also see WILLIAM WALLACE, *Studies in Michelangelo's Finished Drawings, 1520-1534*, Ph.D. diss., Columbia University, 1983; for Michelangelo's political views, see GIORGIO SPINI, *Politicità di Michelangelo*, 'Rivista storica italiana', LXXVI, 1964, pp. 557-600.

[16] See VASARI 1568/1966-1997, V, p. 326; and COSTAMAGNA 1994, cat. 69.

[17] Pontormo may also have been assigned to fresco a *Resurrection* lunette after Michelangelo's designs on the wall opposite the altar of the Medici Chapel. See ANNY E. POPP, *Die Medici-Kapelle Michelangelos*, O.C. Recht, München 1922, pp. 158-163.

[18] DARIO TRENTO, *Pontormo e la corte di Cosimo I*, in *Kunst des Cinquecento in der Toskana*, ed. Monika Cämmerer, Bruckmann, München 1992, pp. 139-144; COSTAMAGNA 1994, pp. 81-99; and PILLIOD 2001, pp. 11-42.

[19] VASARI 1568/1966-1997, V, p. 325; and COSTAMAGNA 1994, cat. 66. CROPPER 1997, has identified this with Pontormo's *Portrait of a Halberdier* at the J. Paul Getty Museum, Los Angeles.

[20] VASARI 1568/1966-1997, V, p. 327; and COSTAMAGNA 1994, cat. 67.

[21] VASARI 1568/1966-1997, V, p. 325; and COSTAMAGNA 1994, cat. 68.

[22] See VASARI 1568/1966-1997, V, p. 325; and COSTAMAGNA 1994, cats. 65 and 65a.

[23] See VASARI 1568/1966-1997, V, pp. 316-318; and COSTAMAGNA 1994, cats. 19-22.

[24] COSTAMAGNA 1994, cat. 32.

[25] VASARI 1568/1966-1997, V, pp. 325-326; JANET COX-REARICK, *The Drawings of Pontormo. A Catalogue Raisonné with Notes on the Paintings*, 2 vols., II ed., Hacker Art Books, New York 1981, cats. 307-311.

[26] VASARI 1568/1966-1997, V, p. 327; and COSTAMAGNA 1994, cat. 72.

[27] VASARI 1568/1966-1997, V, pp. 328-329; COX-REARICK 1981, cats. 312-320.

[28] See COSTAMAGNA 1994, pp. 74-75, 80, 86, 89, 92, 199, 252 and 259-260; and CROPPER 1997, pp. 53-58. When asked for payment by Alessandro for his mourning portrait, Pontormo suggested only enough to repurchase a coat he had previously pawned, but the Duke insisted on paying him 50 *scudi* in addition to an annual *provvisione* (stipend); VASARI 1568/1966-1997, V, p. 327.

[29] PILLIOD 2001, pp. 14-23.

[30] VASARI 1568/1966-1997, VI, p. 231; COSTAMAGNA 1994, cats. 41-45.

[31] VASARI 1568/1966-1997, VI, p. 231; COSTAMAGNA 1994, cats. 50-53.

[32] VASARI 1568/1966-1997, V, p. 325; COSTAMAGNA 1994, cat. 66a.

[33] For Bronzino's early collaborations with Pontormo, see PILLIOD 2001, pp. 53-66.

[34] VASARI 1568/1976, X, p. 11.

[35] VASARI 1568/1966-1997, VI, p. 232; CRAIG HUGH SMYTH, *Bronzino Studies*, Ph.D. diss., Princeton University, 1955, Ann Arbor, 1956, pp. 129-189; and CHARLES MCCORQUODALE, *Bronzino*, Jupiter Books, London 1981, pp. 28-40.

[36] CRAIG HUGH SMYTH, *Bronzino as Draughtsman. An Introduction*, J. J. Augustin, Locust Valley (NY) 1971, pp. 55-56, n. 32.

[37] See VASARI 1568/1966-1997, V, p. 326; and COSTAMAGNA 1994, cat. 69a.

[38] Formerly Ubaldini, the Bettini name derived from the family's rela-

BARTOLOMEO BETTINI E LA DECORAZIONE DELLA SUA "CAMERA" FIORENTINA
BARTOLOMEO BETTINI AND HIS FLORENTINE 'CHAMBER' DECORATION

23

legami della famiglie con il Castel di Bettona. Sui Bettini, cfr. Eugenio Gamurrini, *Istoria genealogica delle famiglie nobili Toscane, & Umbre* (1679), 5 voll., Forni Editore, Bologna 1972, IV, pp. 15-19. Per la stirpe dei Bettini di Firenze, cfr. Archivio di Stato, Firenze (d'ora in avanti, ASF), *Ceramelli Papiani*, 655; e Biblioteca Nazionale Centrale, Firenze (d'ora in avanti, BNF), *Manoscritti Poligrafo Gargani*, 284-285. Sono grato a Giuseppe Biscione dell'Archivio di Stato per la sua assistenza che ha determinato il chiarimento che il nostro Bettini (Bartolomeo di Bettino di Bartolomeo Bettini) non è Bartolomeo di Girolamo di Francesco Bettini (1502-1537), per la cui dinastia cfr. ASF, *Ceramelli Papiani*, 654.20; e BNF, *Manoscritti Passerini*, 186.

39 Per i documenti delle tasse di Bettini del 1427, cfr. ASF, *Catasto*, 79, foglio 522r; per il 1457/1458, cfr. ASF, *Catasto*, 826, n. 360; e ASF, *Catasto*, 826, n. 400; per il 1480, cfr. ASF, *Catasto* 1019, foglio 78r; per il 1498, cfr. ASF, *Decima Repubblicana*, 29, fogli 27r, 678r, e 678v; e per il 1534, cfr. ASF, *Decima Granducale*, 3638, foglio 161. A seconda delle annate del catasto, i Bettini facevano capo alla parrocchia di San Lorenzo o di San Marco.

40 Per i Bettini di San Giovanni Drago, cfr. ASF, *Carte Pucci*, 593 (loro origini); ASF, *Cittadinario*, 2, foglio 24v (loro eleggibilità nel sistema elettorale); e ASF, *Raccolta Sebregondi*, 690 (esauriente resoconto e albero genealogico). Sulla storia e lo sviluppo demografico dei quartieri fiorentini, cfr. Samuel Cohn, *The Laboring Classes in Renaissance Florence*, Academic Press, New York 1980, pp. 115-128.

41 F. W. Kent, *Ties of Neighborhood and Patronage in Quattrocento Florence*, in *Patronage, Art, and Society in Renaissance Italy*, a cura di F. W. Kent e Patricia Simons, Clarendon, Oxford 1987, p. 80; e Ronald F. E. Weissman, *The Importance of Being Ambiguous: Social Relations, Individualism, and Identity in Renaissance Florence*, in *Urban Life in the Renaissance*, a cura di Susan Zimmerman e Ronald F. E. Weissman, Associated University Presses, London-Cranbury (NJ) 1989, pp. 269-280; e Louis Haas, *"Il mio buono compare": Choosing Godparents and the Uses of Baptismal Kinship in Renaissance Florence*, "Journal of Social History", XXIX, 1995, pp. 341-356.

42 Brenda Preyer, *Florentine Palaces and Memories of the Past*, in *Art, Memory and Family in Early Renaissance Florence*, a cura di Giovanni Ciappelli e Patricia Rubin, Cambridge University Press, Cambridge-New York 2000, pp. 176-180, specialmente p. 177.

43 Si vedano i registri delle tasse del 1480 (ASF, *Catasto*, 1019, foglio 78r) per la vendita della casa di via Larga da parte di Jacopo di Martello di Michele Bettini a Lionardo di Zanobi e ai suoi fratelli. I successivi documenti delle tasse non registrano la presenza dei Bettini nel "gonfalone del Drago".

44 Nessun Bettini appare nell'elenco del censimento fiorentino del 1527 (BNF, *MS Nuovi Acquisti*, 987).

45 Brenda Preyer, *The "casa overo palagio" of Alberto di Zanobi: A Florentine Palace of About 1400 and Its Later Remodeling*, "Art Bulletin", LXV, 1983, pp. 387-401, che cita la consapevole scelta si stare alla moda del banchiere fiorentino Bono Boni, per mezzo dei disegni per il suo palazzo urbano.

46 Leon Battista Alberti, *Della Architettura*, trad. Cosimo Bartoli, a cura di Stefano Ticozzi, A spese degli editori, Milano 1833, p. 304.

47 Michelangelo, lettera del 21 febbraio 1549 da Roma a suo nipote Lionardo di Buonarroto Simoni, in Firenze. Cfr. Buonarroti 1965-1983, IV, p. 314. Bettini aveva cercato di stabilire un accordo tra una delle sue nipoti e il nipote di Michelangelo sin dal 20 aprile 1545. Cfr. Ernst Steinmann, *Michelangelo e Luigi del Riccio*, Vallecchi Editore, Firenze 1932, pp. 51-53.

48 Richard Goldthwaite, *Local Banking in Renaissance Florence*, "Journal of European Economic History", XIV, 1985, pp. 5-55.

49 Si veda la lettera da Roma di Michelangelo del 1542 a suo nipote Lionardo, a Firenze (Buonarroti 1965-1983, p. 124).

50 La Compagnia di San Bastiano, per esempio, annoverava il Pontormo e il Bronzino tra i suoi membri. Cfr. Pilliod 2001, pp. 91-95. Per le confraternite italiane in generale, cfr. Ronald F. E. Weissman, *Ritual Brotherhood in Renaissance Florence*, Academic Press, New York 1981; Nicholas Terpstra, *The Politics of Ritual Kinship: Confraternities and Social Order in Early Modern*

tionship with the Castel di Bettona. See Eugenio Gamurrini, *Istoria genealogica delle famiglie nobili Toscane, & Umbre* (1679), 5 vols., Forni Editori, Bologna 1972, IV, pp. 15-19; Archivio di Stato, Firenze (hereafter, ASF), *Ceramelli Papiani*, 655; and Biblioteca Nazionale Centrale, Firenze (hereafter, BNF), *Manoscritti Poligrafo Gargani*, 284-285. I am grateful to Giuseppe Biscione of the Archivio di Stato for his assistance in determining that our Bettini (Bartolomeo di Bettino di Bartolomeo Bettini) is not Bartolomeo di Girolamo di Francesco Bettini (1502-1537), for whose lineage see ASF, *Ceramelli Papiani*, 654.20; and BNF, *Manoscritti Passerini*, 186.

39 For the Bettini tax records of 1427, see ASF, *Catasto*, 79, c. 522r; for 1457/1458, see ASF, *Catasto*, 826, no. 360; and ASF, *Catasto*, 826, no. 400; for 1480, see ASF, *Catasto* 1019, c. 78r; for 1498, see ASF, *Decima Repubblicana*, 29, folios 27r, 678r, and 678v; and for 1534, see ASF, *Decima Granducale*, 3638, c. 161. Depending on the year of the *catasto*, the Bettini belonged to either the parish of San Lorenzo or San Marco.

40 For the Bettini in San Giovanni, *gonfalone* Drago, see ASF, *Carte Pucci*, 593 (their origins); ASF, *Cittadinario*, 2, c. 24v (their eligibility in the electoral system); and ASF, *Raccolta Sebregondi*, 690 (comprehensive account and genealogical tree). On the history and demographics of Florentine neighborhoods, see Samuel Cohn, *The Laboring Classes in Renaissance Florence*, Academic Press, New York 1980, pp. 115-128.

41 F. W. Kent, *Ties of Neighborhood and Patronage in Quattrocento Florence*, in *Patronage, Art, and Society in Renaissance Italy*, ed. F. W. Kent and Patricia Simons, Clarendon, Oxford 1987, p. 80; Ronald F. E. Weissman, *The Importance of Being Ambiguous: Social Relations, Individualism, and Identity in Renaissance Florence*, in *Urban Life in the Renaissance*, ed. Susan Zimmerman and Ronald F. E. Weissman, Associated University Presses, London-Cranbury (NJ) 1989, pp. 269-280; and Louis Haas, *'Il mio buono compare': Choosing Godparents and the Uses of Baptismal Kinship in Renaissance Florence*, 'Journal of Social History', XXIX, 1995, pp. 341-356.

42 Brenda Preyer, *Florentine Palaces and Memories of the Past*, in *Art, Memory and Family in Early Renaissance Florence*, ed. Giovanni Ciappelli and Patricia Rubin, Cambridge University Press, Cambridge-New York 2000, pp. 176-180, esp. p. 177.

43 See the 1480 tax records (ASF, *Catasto*, 1019, c. 78r) for Jacopo di Martello di Michele Bettini's sale of the via Larga house to Lionardo di Zanobi and his brothers. Subsequent tax records do not record the Bettini in *gonfalone* of Drago.

44 No Bettini are listed in the Florentine census of 1527 (BNF, *MS Nuovi Acquisti*, 987).

45 Brenda Preyer, *The 'casa overo palagio' of Alberto di Zanobi: A Florentine Palace of About 1400 and Its Later Remodeling*, 'Art Bulletin', LXV, 1983, pp. 387-401, who cites Florentine banker Bono Boni's conscious self-fashioning through his urban palace designs.

46 Leon Battista Alberti, *On the Art of Building in Ten Books*, trans. Joseph Rykwert, Neil Leach and Robert Tavernor, MIT Press, Cambridge (Mass)-London 1988, p. 292.

47 Michelangelo, letter of 21 February 1549 from Rome to his nephew Lionardo di Buonarroto Simoni in Florence. See Michelangelo Buonarroti, *The Letters of Michelangelo*, 2 vols., ed. and trans. E. H. Ramsden, Stanford University Press, Stanford 1963, II, pp. 99-100. Bettini had been trying to procure an alliance between one of his nieces and Michelangelo's nephew since 20 April 1545. See Ernst Steinmann, *Michelangelo e Luigi del Riccio*, Vallecchi, Firenze 1932, pp. 51-53.

48 Richard Goldthwaite, *Local Banking in Renaissance Florence*, 'Journal of European Economic History', XIV, 1985, pp. 5-55.

49 See Michelangelo's 1542 letter from Rome to his nephew Lionardo in Florence (Buonarroti 1965-1983, p. 124).

50 The Compagnia di San Bastiano, for example, counted Pontormo and Bronzino among its members. See Pilliod 2001, pp. 91-95. For Italian confraternities in general, see Ronald F. E. Weissman, *Ritual Brotherhood in Renaissance Florence*, Academic Press, New York 1981; and Nicholas Terpstra, *The Politics of Ritual Kinship: Confraternities and Social Order in Early Modern Italy*, Cambridge University Press, Cambridge-New York 1999.

Italy, Cambridge University Press, Cambridge-New York 1999.

[51] Sulle origini dell'Accademia Fiorentina, cfr. MICHEL PLAISANCE, *Une pre-mière affirmation de la politique culturelle de Côme 1er: La transformation de l'Académie Florentine (1540-1542)*, in *Les écrivains et le pouvoir en Italie à l'époque de la Renaissance*, a cura di André Rochon, Université de la Sorbonne Nouvelle, Paris 1973, pp. 361-433; CLAUDIA DI FILIPPO BAREGGI, *In nota alla politica culturale di Cosimo I: L'Accademia Fiorentina*, "Quaderni storici", VII, 1973, pp. 527-574; e KAREN-EDIS BARZMAN, *The Florentine Academy and the Early Modern State. The Discipline of Disegno*, Cambridge University Press, Cambridge-New York 2000.

[52] PILLIOD 2001, p. 84.

[53] Per l'elenco dei Consoli fiorentini a Roma dal 1515 al 1620, cfr. JEAN DELUMEAU, *Vie économique et sociale de Rome dans la seconde moitié du XVIe siècle*, 2 voll., E. de Boccard, Paris 1957, I, pp. 208-210; per le loro mansioni, cfr. IRENE POLVERINI FOSI, *Il consolato fiorentino a Roma e il progetto per la chiesa nazionale*, "Studi romani", XXXVII, 1989, pp. 50-57; per le date e la durata dell'incarico di Bettini, cfr. Archivio della Arciconfraternita di San Giovanni dei Fiorentini, Roma, *Registri (parte III): hospitale consolato*, c. 535.

[54] PLAISANCE 1973, pp. 367-368

[55] GIOVAMBATTISTA BUSINI, *Lettere di Giovambattista Busini a Benedetto Varchi sopra l'Assedio di Firenze*, a cura di Gaetano Milanesi, Le Monnier, Firenze 1860, pp. 1, 3, 4, 23, 63, 68 e 74.

[56] BUONARROTI 1965-1983, vol. 4, pp. 124, 166, 168, 210-211, 222, 257, 273, 309, 314, 319-320, 323, 327, 330 e 370-371.

[57] Si veda saggio Leporatti, più avanti.

[58] Sull'amicizia di Martini con artisti e intellettuali, cfr. NELSON 1992, n. 3; e JONATHAN NELSON, *Creative Patronage: Luca Martini and the Renaissance Portrait*, "Mitteilungen des Kunsthistorisches Institutes in Florenz", XXIX, 1995, pp. 283-293.

[59] Per la carriera di scrittore del Varchi, teorico e accademico, cfr. UMBERTO PIROTTI, *Benedetto Varchi e la cultura del suo tempo*, Olschki, Firenze 1971. Sull'amicizia di Varchi con artisti e letterati dell'Accademia, cfr. ALESSANDRO CECCHI, *"Famose Frondi de cui santi honori..." un sonnetto del Varchi e il ritratto di Lorenzo Lenzi dipinto dal Bronzino*, "Artista, critica d'arte in Toscana", II, 1990, pp. 8-19; ALESSANDRO CECCHI, *Il Bronzino, Benedetto Varchi e L'Accademia Fiorentina: Ritratti di poeti, letterati e personaggi illustri della corte medicea*, "Antichità viva", XXX, 1-2, 1991, pp. 17-28; e FRANÇOIS QUIVIGER, *Benedetto Varchi and the Visual Arts*, "Journal of the Warburg and Courtauld Institutes", L, 1987, pp. 219-224.

[60] GIORGIO VASARI, *Il libro delle ricordanze di Giorgio Vasari*, a cura di Alessandro del Vita, Casa Vasari, Arezzo 1929, p. 20.

[61] VASARI 1568/1966-1997, VI, p. 232.

[62] VASARI 1568/1966-1997, V, p. 326.

[63] Per le decorazioni degli interni privati, cfr. CHARLES McCORQUODALE, *History of the Interior*, Vendome Press, New York-Paris 1983, pp. 55-84; JOHN KENT LYDECKER, *The Domestic Setting of the Arts in Renaissance Florence*, tesi di Ph.D. diss., Johns Hopkins University, Baltimore 1987b, pp. 9-79; e PETER THORNTON, *The Italian Renaissance Interior, 1400-1600*, Weidenfeld & Nicolson, London 1991.

[64] VASARI 1568/1966-1997, III, p. 38.

[65] ALBERTI 1833, p. 404.

[66] LODOVICO FRATI, *Giuochi ed amori alla corte d'Isabella d'Este*, "Archivio Storico Lombardo", IX, 1898, pp. 350-365.

[67] LYDECKER 1987a, pp. 213-218.

[68] Sull'importanza delle camere da letto personali, gli arredi pertinenti e i programmi decorativi, cfr. LYDECKER 1987a, pp. 217-221; e THORNTON 1991, pp. 285-295; per i resoconti, cfr. RICHARD A. GOLDTHWAITE, *Wealth and the Demand for Art in Italy 1300-1600*, The John Hopkins University Press, Baltimore-London 1993, pp. 224-243.

[69] ALBERTI 1833, p. 313.

[70] Cfr. LEON BATTISTA ALBERTI, *I primi tre libri della famiglia*, Sansoni, Firenze 1946, pp. 345-346.

[71] Cfr. JAYNIE ANDERSON, *Giorgione, Titian and the "Sleeping Venus"*, in *Tiziano e Venezia*, atti del convegno (Venezia 1976), a cura di Neri Pozza, Massimo Gemin e Giannantonio Paladini, Neri Pozza, Vicenza 1980, pp.

[51] On the origins of the Accademia Fiorentina, see MICHEL PLAISANCE, *Une première affirmation de la politique culturelle de Côme 1er: La transformation de l'Académie Florentine (1540-1542)*, in *Les écrivains et le pouvoir en Italie à l'époque de la Renaissance*, ed. Ancré Rochon, Université de la Sorbonne Nouvelle, Paris 1973, pp. 361-433; CLAUDIA DI FILIPPO BAREGGI, *In nota alla politica culturale di Cosimo I: L'Accademia Fiorentina*, 'Quaderni storici', VII, 1973, pp. 527-574; and KAREN-EDIS BARZMAN, *The Florentine Academy and the Early Modern State. The Discipline of Disegno*, Cambridge University Press, Cambridge-New York 2000.

[52] PILLIOD 2001, p. 84.

[53] For a list of Florentine Consuls in Rome from 1515 to 1620, see JEAN DELUMEAU, *Vie économique et sociale de Rome dans la seconde moitié du XVIe siècle*, 2 vols., E. de Boccard, Paris 1957, I, pp. 208-210; for their responsibilities, see IRENE POLVERINI FOSI, *Il consolato fiorentino a Roma e il progetto per la chiesa nazionale*, 'Studi romani', XXXVII, 1989, pp. 50-57; for the dates of Bettini's term, see Archivio della Arciconfraternita di San Giovanni dei Fiorentini, Roma, *Registri (parte III): hospitale consolato*, c. 535.

[54] PLAISANCE 1973, pp. 367-368.

[55] GIOVAMBATTISTA BUSINI, *Lettere di Giovambattista Busini a Benedetto Varchi sopra l'Assedio di Firenze*, ed. Gaetano Milanesi, Le Monnier, Firenze 1860, pp. 1, 3, 4, 23, 63, 68, and 74.

[56] BUONARROTI 1965-1983, IV, pp. 124, 166, 168, 210-211, 222, 257, 273, 309, 314, 319-320, 323, 327, 330, and 370-371.

[57] See the essay by Leporatti.

[58] On Martini's friendship with artists and intellectuals, see 1992, n. 3; and JONATHAN NELSON, *Creative Patronage: Luca Martini and the Renaissance Portrait*, 'Mitteilungen des Kunsthistorisches Institutes in Florenz', XXIX, 1995, pp. 283-293.

[59] For Varchi's career as writer, theorist, and academician, see UMBERTO PIROTTI, *Benedetto Varchi e la cultura del suo tempo*, Olschki, Firenze 1971. On Varchi's friendships with artists and *letterati* in the Accademia, see ALESSANDRO CECCHI, *'Famose Frondi de cui santi honori...' un sonnetto del Varchi e il ritratto di Lorenzo Lenzi dipinto dal Bronzino*, 'Artista, critica d'arte in Toscana', II, 1990, pp. 8-19; ALESSANDRO CECCHI, *Il Bronzino, Benedetto Varchi e L'Accademia Fiorentina: Ritratti di poeti, letterati e personaggi illustri della corte medicea*, 'Antichità viva', XXX, 1-2, 1991, pp. 17-28; and FRANÇOIS QUIVIGER, *Benedetto Varchi and the Visual Arts*, 'Journal of the Warburg and Courtauld Institutes', L, 1987, pp. 219-224.

[60] GIORGIO VASARI, *Il libro delle ricordanze di Giorgio Vasari*, ed. Alessandro del Vita, Casa Vasari, Arezzo 1929, p. 20.

[61] VASARI 1568/1976, X, p. 4.

[62] VASARI 1568/1976, VII, p. 172.

[63] On decorative programs for domestic interiors, see CHARLES McCORQUODALE, *History of the Interior*, Vendome Press, New York-Paris 1983, pp. 55-84; JOHN KENT LYDECKER, *The Domestic Setting of the Arts in Renaissance Florence*, Ph.D. diss., Johns Hopkins University, Baltimore 1987b, pp. 9-79; and PETER THORNTON, *The Italian Renaissance Interior, 1400-1600*, Weidenfeld & Nicolson, London 1991.

[64] VASARI 1568/1966-1997, III, p. 38.

[65] ALBERTI 1988, p. 299.

[66] LODOVICO FRATI, *Giuochi ed amori alla corte d'Isabella d'Este*, 'Archivio Storico Lombardo', IX, 1898, pp. 350-365.

[67] LYDECKER 1987a, pp. 213-218.

[68] On the importance of private bedchambers, their furnishings, and decorative programs, see LYDECKER 1987a, pp. 217-221; and THORNTON 1991, pp. 285-295; for accounts, see RICHARD A. GOLDTHWAITE, *Wealth and the Demand for Art in Italy 1300-1600*, The John Hopkins University Press, Baltimore-London 1993, pp. 224-243.

[69] ALBERTI 1833, p. 313.

[70] See LEON BATTISTA ALBERTI, *I primi tre libri della famiglia*, Sansoni, Firenze 1946, pp. 345-346.

[71] See JAYNIE ANDERSON, *Giorgione, Titian and the 'Sleeping Venus'*, in *Tiziano e Venezia*, Acts of Conference (Venezia 1976), ed. Neri Pozza, Massimo Gemin and Giannantonio Paladini, Neri Pozza, Vicenza 1980, pp. 337-342; and ARTHUR LESLIE WHEELER, *Tradition in the Epithala-*

337-342; e Arthur Leslie Wheeler, *Tradition in the Epithalamium*, "American Journal of Philology", LI, 1930, pp. 205-223.

[72] Cristelle L. Baskins, *Cassone Painting, Humanism, and Gender in Early Modern Italy*, Cambridge University Press, Cambridge-New York 1998, pp. 112-117, figg. 41 e 42.

[73] Ronald Lightbown, *Sandro Botticelli*, 2 voll., University of California Press, Berkeley-Oxford 1978, I, pp. 90-93. Sulla prima comparsa del soggetto della Venere nelle camere fiorentine, cfr. David Rosand, *So-and-so Reclining on her Couch*, in *Titian's "Venus of Urbino"*, a cura di Rona Goffen, Cambridge University Press, Cambridge-New York 1997, pp. 43-45.

[74] Cfr. Anna Forlani Tempesti-Elena Capretti, *Piero di Cosimo. Catalogo completo*, Cantini, Firenze 1996, cat. 10.

[75] Jaynie Anderson, *Giorgione. The Painter of 'poetic brevity'*, Flammarion, Paris-New York 1997, pp. 307-308; Rosand 1997, p. 43.

[76] Philip Rylands, *Palma il Vecchio. L'opera completa*, Mondadori, Milano 1988, cat. 67. Per un'altra interpretazione del dipinto vedi Cat. 29.

[77] Sylvie Béguin, *Lotto et Venise*, in *Le Siècle de Titien. L'âge d'or de la peinture à Venise*, a cura di Michel Laclotte e Giovanna Nepi Scirè, Réunion des Musées Nationaux, Paris 1993, cat. 154; per la datazione, cfr. Keith Christiansen, *Lorenzo Lotto and the Tradition of Epithalamic Paintings*, "Apollo", CXXIV, 1986, pp. 166-173; Rona Goffen, *Titian's Women*, Yale University Press, New Haven-London 1997, p. 43; e Peter Murphy, *Lorenzo Lotto*, Yale University Press, New Haven-London 1997, pp. 139-140.

[78] Richard Goldthwaite, *The Empire of Things: Consumer Demand in Renaissance Italy*, in *Patronage, Art, and Society in Renaissance Italy*, a cura di F. W. Kent e Patricia Simons, Clarendon, Oxford 1987, p. 170.

mium, 'American Journal of Philology', LI, 1930, pp. 205-223.

[72] Cristelle L. Baskins, *Cassone Painting, Humanism, and Gender in Early Modern Italy*, Cambridge University Press, Cambridge-New York 1998, pp. 112-117, figs. 41 and 42.

[73] Ronald Lightbown, *Sandro Botticelli*, 2 vols., University of California Press, Berkeley-Oxford 1978, I, pp. 90-93. On the first appearance of the Venus type in Florentine chambers, see David Rosand, *So-and-so Reclining on her Couch*, in *Titian's 'Venus of Urbino'*, ed. Rona Goffen, Cambridge University Press, Cambridge-New York 1997, pp. 43-45.

[74] See Anna Forlani Tempesti-Elena Capretti, *Piero di Cosimo. Catalogo completo*, Cantini, Florence 1996, cat. 10.

[75] Jaynie Anderson, *Giorgione. The Painter of 'poetic brevity'*, Flammarion, Paris-New York 1997, pp. 307-308; Rosand 1997, p. 43.

[76] Philip Rylands, *Palma il Vecchio. L'opera completa*, Mondadori, Milano 1988, cat. 67. For a different interpretation of this painting see Cat. 29.

[77] Sylvie Béguin, *Lotto et Venise*, in *Le Siècle de Titien. L'âge d'or de la peinture à Venise*, ed. Michel Laclotte and Giovanna Nepi Scirè, Réunion des Musées Nationaux, Paris 1993, cat. 154; for the dating see Keith Christiansen, *Lorenzo Lotto and the Tradition of Ephithalamic Paintings*, 'Apollo', CXXIV, 1986, pp. 166-173; Rona Goffen, *Titian's Women*, Yale University Press, New Haven-London 1997, p. 43; and Peter Murphy, *Lorenzo Lotto*, Yale University Press, New Haven-London 1997, pp. 139-140.

[78] Richard Goldthwaite, *The Empire of Things: Consumer Demand in Renaissance Italy*, in *Patronage, Art, and Society in Renaissance Italy*, ed. F. W. Kent and Patricia Simons, Clarendon, Oxford 1987, p. 170.

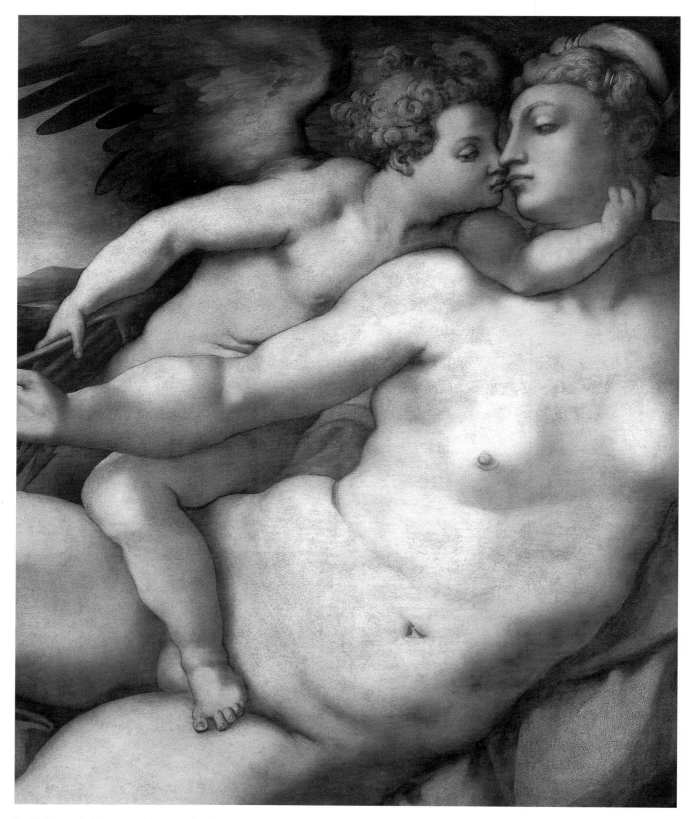

1. Michelangelo-Pontormo, *Venere e Cupido / **Venus and Cupid**, particolare/ detail.
 Firenze, Galleria dell'Accademia.

Jonathan Katz Nelson

LA "VENERE E CUPIDO" FIORENTINA: UN NUDO EROICO FEMMINILE E LA POTENZA DELL'AMORE

THE FLORENTINE 'VENUS AND CUPID': A HEROIC FEMALE NUDE AND THE POWER OF LOVE

I. TRE MODERNE RAGIONI PER NON INTERESSARSI A UN DIPINTO DEL RINASCIMENTO

Verso la metà degli anni Cinquanta del Cinquecento, diversi trattati e persino un sonetto (Cat. 30) descrivevano la *Venere e Cupido*, ora all'Accademia (Cat. 23, Tavv. II/2-III/1-3, fig. 1), come «disegnata da Michelangelo e colorita da Pontormo», ma oggi, nonostante il culto di Michelangelo e l'importanza del marketing legato al suo nome, anche le didascalie delle cartoline presentano proprio lo stesso dipinto come opera del solo Pontormo. La differenza tra le fonti rinascimentali e moderne rivela un mutamento nella comprensione della tematica sulla paternità del quadro, non un cambiamento di opinione sulla misura del contributo di Michelangelo. Ciò ci introduce a una delle tre ragioni principali per cui il dipinto, estremamente lodato dagli autori del XVI secolo (*Appendice I*), sia oggi scarsamente considerato dagli studiosi e praticamente ignorato dal grande pubblico. L'idea che due grandi pittori collaborassero a una stessa opera, urta la nostra sensibilità, in special modo quando entrambi gli artisti godono della ben nota reputazione di essere estremamente individualisti; nel nostro immaginario non è questo il modo in cui un dipinto del Rinascimento dovrebbe nascere.

Prima di rivolgere l'attenzione alle altre ragioni che ci allontanano dal dipinto dell'Accademia – in primo luogo la rappresentazione di una Venere muscolosa, lo stile marcatamente di maniera e l'iconografia criptica che lo contraddistinguono – potremmo riflettere sull'interesse, tipicamente moderno, nel voler isolare uno stile personale. Il desiderio di stabilire con esattezza chi materialmente abbia eseguito un dipinto rimane forte, in special modo tra gli esperti di arte italiana del Rinascimento, e si riflette in molte delle schede del presente catalogo. Ma la *Venere e Cupido* non mostra in modo diretto la "mano" di Michelangelo, e pertanto il dipinto raramente trova spazio nei libri che hanno la pretesa di coprire l'opera "completa" dell'artista. Inoltre, l'immagine familiare del genio solitario

I. THREE MODERN REASONS TO NEGLECT A RENAISSANCE PAINTING

In the mid 1550s, several treatises and even a sonnet (Cat. 30) described the *Venus and Cupid*, now in the Accademia (Cat. 23, Pls. II/2-III/1-3; fig. 1), as "designed by Michelangelo and colored by Pontormo", however today, in spite of the cult of Michelangelo and the importance of marketing his name, postcard captions present the very same painting as a work by Pontormo alone. The difference between these Renaissance and modern sources reflects a shift in the understanding of authorship, not a change in opinion about the extent of Michelangelo's contribution. This leads us to one of three principal reasons why the painting, highly praised by sixteenth-century authors (*Appendix I*), is rarely considered by scholars today and is virtually ignored by the general public. The idea that two major painters collaborated on a single work jars with our sensibilities, especially when both artists have a well-established reputation for being extremely individual; this is not, we feel, how a Renaissance painting should be made.

Before turning to other elements which distance us from the Accademia painting – primarily, the muscular representation of Venus, the markedly artificial style, and the cryptic iconography – we can reflect on the typically modern interest in isolating a personal style. The desire to establish exactly who materially executed a painting remains especially strong among connoisseurs of Italian Renaissance art, and is reflected in many of the following catalogue entries. However, the *Venus and Cupid* does not directly show the 'hand' of Michelangelo, and thus the painting rarely finds a place in books that purport to cover the 'complete' works of the artist. Moreover, the familiar image of the solitary genius, who worked alone on the Sistine ceiling, contrasts sharply with a historical reality: in the early 1530s, Michelangelo made two full-scale drawings or cartoons, now lost, which served as the basis for paintings of the *Venus and Cupid* and the *Noli me tangere* (Pl. VIII/1) by Pontormo.

che lavorava da solo alla volta della Sistina è in netto contrasto con una verità storica: all'inizio degli anni Trenta del Cinquecento, Michelangelo realizzò due cartoni a grandezza naturale, oggi perduti, che servirono come base per la *Venere e Cupido* e per il *Noli me tangere* (Tav. VIII/1) del Pontormo.

Lo stile di queste due opere documentate contribuisce a distinguerle dagli altri dipinti del Pontormo, per quanto, almeno, vengano menzionate nella maggior parte degli studi sull'artista. Il Vasari metteva in luce positivamente il loro sorprendente aspetto. Il *Noli me tangere* «fu stimata pittura rara per la grandezza del disegno di Michelagnolo e per lo colorito di Iacopo». Il cartone per quest'opera e per la *Venere e Cupido* «furono cagione che considerando il Puntormo la maniera di quello artefice nobilissimo, se gli destasse l'animo e si risolvesse per ogni modo a volere secondo il suo sapere imitarla e seguitarla»[1].

Il ruolo di collaboratore che ebbe il Pontormo in queste commissioni sembra del tutto estraneo alla personalità eccentrica che generalmente siamo soliti attribuire al pittore, il quale, mentre lavorava nella Cappella Capponi, si chiuse dentro e impedì a chiunque di vedere le sue creazioni. La sua interpretazione-trasformazione in dipinto, da un disegno in chiaroscuro, è argomento della trattazione della scheda a Cat. 23, la quale, in effetti, tenta di isolare il suo stile specifico.

I contemporanei toscani di Michelangelo e Pontormo non condividevano i nostri moderni preconcetti sull'idea di arte come espressione del genio individuale, e neppure erano gravati dalla nostra caratterizzazione di questi due artisti come isolati genii indipendenti. Certamente i committenti del Rinascimento riconoscevano l'incomparabile valore di un'opera interamente dovuta alla mano di Michelangelo, ma apprezzavano anche le collaborazioni artistiche. Secondo Vasari Alfonso d'Avalos, dopo avere ottenuto il cartone di Michelangelo per il *Noli me tangere*, si attenne alla raccomandazione dell'artista di assicurarsi i servigi di Pontormo come pittore. La decisione di Michelangelo di realizzare solo il cartone – sicuramente dettata, almeno in parte, dai suoi impegni nella Sagrestia Nuova – merita maggiore attenzione nel dibattito che mette in luce la crescente importanza del disegno nell'Italia del XVI secolo. La necessità aveva portato Michelangelo e Pontormo ad adottare un procedimento di lavoro innovativo, dando vita così a un dipinto che dovremmo considerare creato da entrambi gli artisti.

Il successo di questa collaborazione, proseguiva Vasari, ispirò la commissione del mercante e banchiere fiorentino Bartolomeo Bettini (di cui tratta il saggio di Aste). Al suo amico Michelangelo, Bettini richiese un cartone di «una Venere ignuda con un Cupido che la bacia», con l'intento di farne eseguire al Pontormo il dipinto. L'idea stessa di unire le forze di due artisti molto in vista, il più grande disegnatore e il maggiore "colorista" di Firenze, doveva affascinare Benedetto Varchi, teorico d'arte di primo piano e amico intimo di Bettini. Il dipinto costituì la risposta tutta fiorentina alla *Venere* veneziana. Questo "pedigree" certamente ci fornisce una spiegazione per la straordinaria fortuna di questa *Venere* fiorentina,

The style of these two documented works distinguish them from Pontormo's other paintings, though at least they are mentioned in most studies of the artist. Vasari presented their unexpected appearance in a positive light. The *Noli me tangere* was considered to be a "rare painting because of the grandness of the design of Michelangelo and the coloring of Jacopo". The cartoons for this work and for the *Venus and Cupid* "were the reason that Pontormo, considering the style of that most noble artist, gave over his soul to Michelangelo and resolved to imitate his style insofar as he was able"[1]. Pontormo's collaborative role in these commissions seems utterly removed from the eccentric personality we generally attribute to the painter who, when working in the Capponi chapel, locked himself in and refused to let anyone see his creations. His interpretation-transformation of a chiaroscuro drawing into a painting is discussed in entry Cat. 23, which, yes, attempts to isolate his unique style.

Tuscan contemporaries of Michelangelo and Pontormo did not share our modern preconception with the idea of art as an expression of personal genius, nor were they burdened by our characterizations of these two artists as isolated, independent geniuses. Of course, Renaissance patrons recognized the incomparable value of a work entirely by the hand of Michelangelo, but they also appreciated artistic collaborations. According to Vasari, after Alfonso d'Avalos obtained the *Noli me tangere* cartoon by Michelangelo, he followed the artist's recommendation and secured the services of Pontormo as a painter. Michelangelo's decision to carry out only the cartoon – surely dictated, at least in part, by his obligations in the New Sacristy – deserves greater attention in discussions about the increasing importance of *disegno* in sixteenth-century Italy. Necessity led to an innovative working procedure for Michelangelo and Pontormo, and thus to a painting we should consider as created by both artists.

The success of this collaboration, Vasari continued, inspired the Florentine banker and merchant, Bartolomeo Bettini (who is discussed in Aste's essay). From his friend Michelangelo, Bettini commissioned a cartoon of "a nude Venus and Cupid who kisses her", in order to have Pontormo carry out the painting itself. The very notion of uniting the forces of two preeminent artists, Florence's greatest draftsman and colorist, evidently appealed to Benedetto Varchi, a leading theoretician of art and close friend of Bettini. The painting constituted a local response to the Venetian Venus. This pedigree helps account for the extraordinary reception of the Florentine *Venus*, discussed in the closing section below; it was copied more often than any other panel painting by Michelangelo or Pontormo (*Appendix II*).

Interlocked, stylized poses and a plethora of mysterious objects make the Accademia painting much less accessible than the images of Venus by Titian or most other contemporary artists. This highly artificial quality constitutes a second obstacle to our appreciation of the work today. In a witty let-

di cui si tratterà oltre, nel paragrafo di chiusura: fu copiata più volte di qualsiasi altro dipinto su tavola di Michelangelo o del Pontormo (*Appendice II*).

Le pose intrecciate e stilizzate e una pletora di misteriosi oggetti rendono il dipinto dell'Accademia ancor meno accessibile delle immagini della *Venere* di Tiziano o della maggior parte degli altri artisti contemporanei. Questo attributo di estrema artificiosità, costituisce il secondo ostacolo all'apprezzamento dell'opera, oggi. Tuttavia, in una brillante lettera del 1542, il poeta Pietro Aretino lodava Michelangelo per la «elegante vivacità d'artifizio» di questo cartone (*Appendice I*). Le inconsuete posizioni assunte da Venere e da Cupido, i loro gesti stilizzati e gli oggetti sull'estrema sinistra, specialmente le maschere e la statuetta distesa, con la testa dalle sembianze umane, conferiscono alla *Venere e Cupido* di Michelangelo-Pontormo un'aria inquietante e una densità iconografica conturbante. Quest'opera severa, evidentemente esprime un messaggio allegorico sull'amore, ma non possiamo comprenderne il significato con facilità. Come suggerito oltre, nel terzo paragrafo, il contrasto tra l'ingannevole Cupido e la nobile Venere fa riferimento probabilmente alla familiare dicotomia tra l'amore terreno e quello celeste. Per molti, però, ogni spiegazione dequalifica il dipinto dall'elevata categoria della "grande arte"; secondo un'opinione oggi largamente diffusa, l'arte dovrebbe parlare in modo immediato, senza intermediazioni. Nel nostro immaginario, il linguaggio criptico della *Venere e Cupido* non è il modo in cui un dipinto dovrebbe comunicarci dei contenuti.

Bettini e la sua cerchia, il pubblico erudito al quale quest'opera era destinata, probabilmente furono deliziati da una simile complessità visiva e iconografica. In una lezione sul significato e sulla rappresentazione di Cupido (che Mendelsohn prende in esame nel suo saggio), Varchi indirizzava verso l'uso di figure enigmatiche per rendere oscuri i misteri dell'amore. Anche altri due amici di Bettini, Annibal Caro e Luca Martini, commissionarono opere d'arte cariche di simbolismo[2]. I gesti e gli oggetti presenti nei *Sei poeti toscani* del Vasari (Cat. 24, Tav. IV/1), realizzato per Martini, rivelano la posizione del committente circa la superiorità di Dante e l'importanza dei commentatori neoplatonici del poeta. La rappresentazione che il Vasari fece di Dante rimanda al ritratto dipinto dal Bronzino per Bettini. Egli commissionò quest'opera, insieme con i ritratti di tutti i «poeti che hanno con versi e prose toscane cantato d'amore», per le lunette della stessa camera alla quale era destinata la *Venere e Cupido* di Michelangelo-Pontormo. A lungo considerato perduto, il *Dante* può essere identificato, con buone probabilità, con un dipinto a forma di lunetta, recentemente riscoperto, qui esposto al di sopra della tavola dell'Accademia (Cat. 22, Tav. II/1). Sebbene non possiamo vedere queste opere con gli occhi del Rinascimento, e neanche in una camera del Rinascimento, l'allestimento adottato in mostra può far comprendere come la complessa iconografia della *Venere e Cupido* necessiti di essere capita in relazione ai ritratti dei poeti, presi in esame nel saggio di Leporatti. Questa *Venere*, insieme con il dipinto di

ter of 1542, however, the poet Pietro Aretino praised Michelangelo for the "elegant vivacity of artifice" in his cartoon. (*Appendix I*).

The odd positions held by Venus and Cupid, their highly stylized gestures, and the objects at the far left, especially the masks and the supine statuette with a seemingly human face, give the Michelangelo-Pontormo *Venus and Cupid* a disturbing air and an unsettling iconographic density.

This austere work evidently conveys an allegorical message about love, but we cannot easily comprehend the meaning. As suggested in section 3 below, the contrast between the deceptive Cupid and noble Venus probably refers to a familiar dichotomy between earthly and celestial love. For many, however, any explanation disqualifies the painting from the exalted category of "great art"; according to a belief widely held today, art should speak directly to viewers, without intermediaries. The cryptic language of the *Venus and Cupid* is not, we feel, how paintings should communicate with us.

Bettini and his circle, the erudite audience for whom this work was intended, probably delighted in such visual and iconographic complexities. In a lecture on the meaning and representations of Cupid, which Mendelsohn examines in her essay, Varchi specifically addressed the use of enigmatic figures to obscure the "mysteries of love". Two other friends of Bettini, Annibal Caro and Luca Martini, also commissioned works of art rich with symbolism[2]. The gestures and objects in Vasari's *Six Tuscan Poets* (Cat. 24, Pl. IV/1), made for Martini, indicate the patron's views about the superiority of Dante and the importance of the poet's Neo-Platonic commentators. Vasari's representation of Dante reflects a portrait painted by Bronzino for Bettini. He commissioned this work, together with portraits of "all the poets who sang of love in Tuscan verse and prose", for the lunettes of the same chamber where the Michelangelo-Pontormo *Venus and Cupid* was to hang. Long considered lost, the *Dante* can probably be identified with a newly discovered lunette painting exhibited here above the Accademia panel (Cat. 22, Pl. II/1). Though we cannot see these works with Renaissance eyes, or even in a Renaissance chamber, the display suggests that the complex iconography of the *Venus and Cupid* needs to be understood in relation to the poet portraits, discussed in Leporatti's essay.

The *Venus*, together with Michelangelo's painting of *Leda* (fig. 2) and his sculptures of the *Night* (fig. 3) and *Dawn* (fig. 4) – all four created in the 1520s and early 1530s, in what Vasari called the "modern style" – established a new and specifically Florentine type of reclining female nude, one strikingly different from those made by either ancient or modern artists in Rome, Florence, or Venice. The Michelangelo-Pontormo representation of Venus does not correspond to modern tastes regarding female beauty. As such it contrasts with works by, for example, Brescianino (Cat. 11, Pl. XVI/1) and Titian (Cat. 33), and even with other female nudes created or directly inspired by Michelangelo (Cats. 7-9). Most scholars,

2. da Michelangelo, *Leda / Leda*.
London, The National Gallery.

Michelangelo per la *Leda* (fig. 2) e le sculture della *Notte* (fig. 3) e dell'*Aurora* (fig. 4) – tutte e quattro create negli anni Venti e all'inizio degli anni Trenta del Cinquecento, in quella che Vasari chiamava la «maniera moderna» – fondarono un tipo nuovo, ed espressamente fiorentino, di nudo femminile disteso, notevolmente diverso da quelli elaborati dagli artisti antichi o dai moderni a Roma, Firenze o Venezia. La rappresentazione di Venere di Michelangelo-Pontormo non corrisponde ai gusti moderni in fatto di bellezza femminile. E perciò è in contrasto con opere, per esempio, del Brescianino (Cat. 11, Tav. XVI/1) e di Tiziano (Cat. 33), e anche con altri nudi femminili creati o direttamente ispirati da Michelangelo (Catt. 7-9). La maggior parte degli studiosi, studenti e turisti, trova il suo corpo troppo muscoloso, mentre Aretino elogiava Michelangelo per avere «fatto nel corpo di femmina i muscoli di maschio». Il nostro rifiuto di questo nuovo canone di bellezza femminile ideale, oggetto del paragrafo successivo, fornisce la motivazione principale della mancanza d'interesse, oggi, per la *Venere* dell'Accademia; nel nostro immaginario, non è così che la dea dell'amore e della bellezza dovrebbe essere dipinta.

II. «NEL CORPO DI FEMMINA I MUSCOLI DI MASCHIO»

«Per creare queste figure femminili, Michelangelo ha applicato dei seni sui corpi maschili». Variazioni sul genere di questa espressione trita e ritrita compaiono regolarmente nei testi eruditi così come nell'immaginario popolare, generalmente in riferimento alla *Notte* (fig. 3) il cui corpo presenta strette corrispondenze con il tipo della *Venere*[3]. Per abbattere questo mito e, di conseguenza, meglio comprendere le figure femminili di Michelangelo, possiamo analizzare queste due opere, insieme, e in relazione alle opinioni rinascimentali in fatto di donna ideale[4]. Sebbene la *Venere* e la *Notte* siano

students, and tourists find her body too muscular, though Aretino praised Michelangelo because he "made the muscles of male in the body of the female". Our rejection of this new canon of ideal female beauty, discussed in following section, provides the most important motivation for the lack of interest today in the Accademia *Venus*; this is not, we feel, how the Goddess of Love and Beauty should be depicted.

II. "THE MUSCLES OF THE MALE IN THE BODY OF THE FEMALE"

"To create his female figures, Michelangelo put breasts on men". Variations on this hackneyed explanation appear regularly in scholarly texts and in the popular imagination, usually in reference to the *Night* (fig. 3), whose body type corresponds closely to that of the *Venus*[3]. To dismantle this myth, and thus to better understand Michelangelo's female figures, we can consider these works together, and in relation to Cinquecento views about the ideal woman[4]. Though the *Venus* and the *Night* are very muscular, we cannot accurately describe their bodies as male; they do not correspond to Michelangelo's images of men and they have a number of feminine features. Many of these features are described in a wide range of Renaissance poems and treatises about women and beauty. This body of diverse texts presents a remarkably consistent canon of female beauty. Agnolo Firenzuola's *On the Beauty of Women*, completed in 1541, is only the most famous[5]. The author explains that legs should be "long, thin, but with calves as large as they need be... and as rounded as necessary" and hands should be "large and somewhat full" with "long, straight, and delicate" fingers[6]. More surprisingly, Firenzuola declares that "the foremost attraction of shapely naked women is wide hips"[7]. Precisely these features distinguish the *Venus*, the *Night*, and other female figures by Michelangelo. Firenzuola also devotes considerable attention to hair, which should be "blond, wavy, thick, abundant, and long"[8].

Michelangelo regularly used hairstyle as a sign of gender in his paintings and sculptures; his female figures usually have markedly feminine hairdos. This becomes particularly important when we cannot see other identifying features, as with some of the muscular *beate* in his *Last Judgment* (fig. 5). This visual sign plays a role analogous to an ancient and Renaissance literary trope involving female warriors wearing armor; no one could identify their gender until they took off their helmets, revealing their hair[9]. In Michelangelo's work, Venus wears only a white hairpiece, affixed to her blond tresses with a light brown ribbon; the *Night* has a long braid whose placement draws attention to her breasts. Both figures correspond to the Renaissance preference for women with large shoulders and a broad chest. For Firenzuola, however, the upper body should be "so plump that no sign of bones can be seen"[10]. As for the breasts themselves, Michelangelo made those of the *Night* unusually large, a choice probably related to his decision to

LA "VENERE E CUPIDO" FIORENTINA: UN NUDO EROICO FEMMINILE E LA POTENZA DELL'AMORE
THE FLORENTINE 'VENUS AND CUPID': A HEROIC FEMALE NUDE AND THE POWER OF LOVE

31

3. Michelangelo, Notte / *Night*.
Firenze, San Lorenzo, Sagrestia Nuova.

4. Michelangelo, *Aurora / Dawn*.
Firenze, San Lorenzo, Sagrestia Nuova.

estremamente muscolose, non possiamo esattamente descrivere i loro corpi come maschili: non corrispondono alle immagini degli uomini michelangioleschi e presentano un certo numero di connotati femminili. Molti di questi caratteri sono descritti in un'ampia gamma di poesie e trattati rinascimentali sulle donne e sulla bellezza. Questo insieme di testi, diversi tra loro, illustra un canone di bellezza femminile notevolmente costante; il testo di Agnolo Firenzuola, *Dialogo... delle bellezze delle donne*, terminato nel 1541, è soltanto il più famoso tra questi[5]. L'autore spiega che la gamba dovrebbe essere «lunga, scarsetta, e schietta nelle parti da basso, ma con le polpe grosse quanto bisogna», e la mano «grande, e un poco pienotta», con dita «lunghe, schiette, dilicate»[6]. Più sorprendentemente, Firenzuola asserisce che l'aspetto migliore «delle donne ignude formose» sia l'esser «ben fiancute»[7]. Esattamente queste connotazioni distinguono la *Venere*, la *Notte* e le altre figure femminili di Michelangelo.

Firenzuola dedica anche una considerevole attenzione ai capelli, che dovrebbero essere «biondi... crespi, spessi, copiosi e lunghi»[8]. Regolarmente Michelangelo si è servito delle capigliature per caratterizzare il genere sessuale, nelle sue pitture e sculture; le sue figure muliebri generalmente hanno acconciature accentuatamente femminili. Questo dato si rende particolarmente importante quando non riusciamo a distinguere nessun'altra connotazione riconoscibile, come nel caso di alcune muscolose *beate* del suo *Giudizio Universale* (fig. 5). Questo segno visivo gioca un ruolo analogo in un *topos* letterario sia antico che rinascimentale, riguardante donne guerriere che indossano armature; nessuno può riconoscere la loro identità sessuale finché non si tolgono l'elmo, svelando i capelli[9]. Nelle opere di Michelangelo, Venere indossa solo un copricapo bianco, fissato alle ciocche bionde con un nastro marrone chiaro; la *Notte* ha una lunga treccia, la cui posizione guida l'attenzione verso i suoi seni. Entrambe le figure rispondono alla preferenza

show the left breast as diseased[11]. Venus turns so that the viewer can see her healthy breasts, which conform to Renaissance tastes; according to Federico Luigini da Udine, also writing in the 1540s, ideal breasts should be "small, round, firm, and unripe, and in every way similar to two rotund and sweet apples"[12].

Michelangelo carefully arranged the *Venus and Cupid* composition so that the youth's leg partially blocks, but does not conceal, the goddess's *mons Veneris*. The recent restoration of the Accademia panel now allows us to appreciate Venus's full frontal nudity. The assertive display of her breasts and genitals brings to mind the dramatic question posed by Bradamante, the lady knight in *Orlando Furioso* (XXXII.102): "who will say, unless I undress myself completely, whether I am or am not what this woman is?"[13]. As for the *Venus* and the *Night*, their nudity leaves no doubt. Far from having male or sexually ambiguous bodies, they are immediately identifiable as female[14]. *Venus* and the *Night* differ from Renaissance ideals of beauty in their highly articulated musculature. The Venetian Ludovico Dolce harshly criticized this trait in his famous treatise on art. Written in 1557, this influential text celebrated Raphael and especially the Venetian Titian at the expense of the Florentine Michelangelo. Ironically, Dolce gave the words of castigation to the character called "Aretino", though that author had already praised Michelangelo's *Venus*. Here we read that, "Michelangelo is stupendous... but in only one mode, that is, at making a nude body muscular and elaborated, with foreshortenings and bold movements... he either does not know or does not want to observe those distinctions between the ages and sexes... in which Raphael is so admirable"[15].

A similar point was made a few years later by the Neapolitan architect Pirro Ligorio, in a little-known attack on an unnamed painter. In context, this reads as a thinly veiled criticism of Michelangelo's *Last Judgment*: "he made women with emo-

5. Michelangelo, *Giudizio Universale / Last Judgment*,
particolare / detail.
Città del Vaticano, Cappella Sistina.

del Rinascimento verso donne dalle spalle larghe e dall'ampio petto. Inoltre, per Firenzuola, il torso dovrebbe essere «sì carnoso, che sospetto d'osso non apparisce»[10]. Per quanto riguarda propriamente i seni, Michelangelo fece quelli della *Notte* sorprendentemente grandi, una scelta probabilmente legata alla sua decisione di mettere in evidenza il seno sinistro malato[11]. La *Venere* è girata in modo che lo spettatore possa vedere i suoi seni sani, conformi ai gusti del Rinascimento; secondo Federico Luigini da Udine, che scriveva anche lui negli anni Quaranta del Cinquecento, le forme ideali dei seni dovrebbero essere «piccole, tonde, sode e crudette, e tutte simili a due rotondi e dolci pomi»[12].

Michelangelo ha organizzato con dovizia la composizione della *Venere e Cupido*, in modo che la gamba del fanciullo nasconda parzialmente alla vista, ma senza occultare del tutto, il *mons Veneris* della dea. Il recente restauro della tavola dell'Accademia, ci consente oggi di apprezzare la nudità completamente frontale di Venere. Il manifestarsi deciso dei seni e dei genitali, riporta alla mente una domanda plateale posta da Bradamante, la donna-guerriero dell'*Orlando Furioso* (XXXII. 102) «ma chi dirà, se tutta non mi spoglio, s'io sono o s'io non son quel ch'è costei?»[13]. Quanto alla *Venere* e alla

tions and appearances that seem so far removed from feminine delicacy, with harsh muscles and breasts like citrons; and they are so muscular and done up so strangely that if they were really made this way by Nature, they would be imperious against themselves[16]".

For the ideal woman we can return to Firenzuola: she should be "plump and juicy, somewhere between lean and fat"[17]. The arms should be "fleshy and muscular, but with a certain softness, so that they seem to be not Hercules's arms when he squeezed Cacus"[18]. This critique could apply to both the *Venus* and the *Night*. The thighs, torso, arms, and shoulders ripple with tense and unusually large muscles, though less pronounced than those in Michelangelo's male figures, such as the *Day* (fig. 6). Female figures by other contemporary artists rarely if ever have such articulated musculature, though often, as in works by Giulio Romano and Marcantonio Raimondi (Cat. 10), women have extremely firm, athletic bodies. These examples recall ancient statues, but even the *Cesi Juno*, "which was praised by Michelangelo as the most beautiful object in all of Rome"[19], does not depict highly delineated muscles. Michelangelo had created a new type of female beauty.

Notte, le loro nudità non lasciano dubbi. Lungi dall'avere corpi maschili o sessualmente ambigui, sono identificabili immediatamente come femminili[14].

La *Venere* e la *Notte* si distaccano dall'ideale di bellezza del Rinascimento per la muscolatura, che appare molto articolata. Il veneziano Ludovico Dolce criticava aspramente questi tratti, nel suo famoso trattato sull'arte. Scritto nel 1557 questo testo influente elogiava Raffaello e specialmente il veneziano Tiziano, a scapito del fiorentino Michelangelo. Ironia della sorte, Dolce fece pronunciare parole di severa critica al personaggio che egli chiama "Aretino", quando fu proprio quell'autore a lodare già la *Venere* di Michelangelo. Qui leggiamo che: «Michel'Agnelo è stupendo… ma in una maniera sola, ch'è in fare un corpo nudo muscoloso e ricercato, con iscorti e movimenti fieri… egli o non sa, o non vuole osservar quelle diversità delle età e dei sessi… ne' quali è tanto mirabile Raffaello»[15].

Un simile punto di vista fu espresso, pochi anni dopo, dall'architetto napoletano Pirro Ligorio, in una critica poco nota a un imprecisato pittore. Nel suo insieme, può essere letto come una critica sottilmente velata al *Giudizio Universale* di Michelangelo: «…le donne l'ha fatte di tali sentimenti e effigie, che pareno lontane da quella dilicatezza ch'esse hanno, con l'aspri moscoli con le mammelle a usa di cetroni, e sono sì muscolose e sì stranamente acconcie, che se fossero così fatte dalla natura, sarebbono imperiose contra di loro istesse»[16].

A proposito della donna ideale, possiamo ritornare alle parole del Firenzuola: ella dovrebbe essere «tra 'l magro e 'l grasso, carnosa e succosa, in una proporzionale accomodata»[17]. Le braccia dovrebbero essere «carnose e musculose, ma con una certa dolcezza che non paian quelle d'Ercole quando stringe Caco»[18]. Questo appunto può essere rivolto sia alla *Venere* che alla *Notte*. Le cosce, il torso, le braccia e le spalle sono modulate per effetto di muscoli scattanti e insolitamente grandi, sebbene meno pronunciati che nelle figure maschili di Michelangelo, come per esempio il *Giorno* (fig. 6). Le figure muliebri di altri artisti contemporanei raramente, se mai accadeva, presentavano una muscolatura così articolata, sebbene spesso, come nelle opere di Giulio Romano e Marcantonio Raimondi (Cat. 10), le donne presentino corpi estremamente tonici e atletici. Questi esempi richiamano le statue antiche, ma neanche la *Giunone Cesi*, «la quale è stata da Mich'Angelo lodata, per la più bella cosa che sia in tutta Roma»[19], presenta muscoli molto delineati. Michelangelo aveva coniato un nuovo tipo di bellezza femminile.

Molti spettatori e studiosi moderni presentano l'innovazione di Michelangelo come uno sfortunato errore, motivato dal suo orientamento sessuale. Secondo questa discutibile teoria, Michelangelo avrebbe fatto sembrare uomini le donne, poiché era un omosessuale. Nella pubblicazione più diffusa negli Stati Uniti sull'artista, Hibbard sosteneva che la *Notte* ci dimostrerebbe «l'assenza, in Michelangelo, di passione sensuale per il corpo femminile… e tradisce la sua mancanza di interesse e anche di familiarità con il nudo femminile»[20].

Most modern viewers and scholars present Michelangelo's innovation as an unfortunate error, explained by his sexual orientation. According to this dubious theory, Michelangelo made women look like men because he was homosexual. In the most popular book on the artist in the United States, Hibbard claimed that the *Night* shows us "Michelangelo's lack of sensual feeling for the female body… and betrays his lack of interest in or even familiarity with the female nude"[20]. But several surviving sketches by Michelangelo and his immediate circle show the Virgin or Mary Magdalene without her clothes, and one drawing even shows a nude young girl drawn from life[21] (fig. 7). As Mary always appears dressed in finished works, these preparatory drawings reflect Michelangelo's attention to the female body. Moreover, nude or scantily clad women do appear regularly in his paintings and sculptures; often – as with the *Leda, Night*, and *Dawn* – the artist himself selected the subject. Regardless of Michelangelo's personal views about women, he strove to create beautiful images of them, and his Tuscan contemporaries enthusiastically praised and commissioned copies of these figures.

More importantly, we cannot simply impose our modern concept of homosexuality on the Cinquecento. The widespread view in Michelangelo's day was that any man could fall victim to – or enjoy – the charms of an attractive male youth. Recent studies of Renaissance legal documents, literature, and sermons have established that nearly all sexual relations between males involved what might be called pederasty today: an adult man with a boy between the ages of 12 and 19[22]. In his *Book on the Nature of Love* (1525), Mario Equicola identified "masculine Venus", an unnatural type of love, as the main cause for the desire of men to have sexual relations with boys[23].

The focus on this age group provides a context for understanding Michelangelo's interest in Tommaso Cavalieri. In his

6. Michelangelo, *Giorno / Day*.
Firenze, San Lorenzo, Sagrestia Nuova.

Ma diversi schizzi di Michelangelo e della sua stretta cerchia che sono giunti fino a noi, mostrano la Vergine, o la Maddalena, priva delle vesti, e un disegno mostra addirittura una fanciulla nuda ritratta dal vero (fig. 7)[21]. Poiché Maria, nelle opere finite, appare sempre vestita, questi disegni preparatori rivelano l'attenzione di Michelangelo per il corpo femminile. Inoltre, donne nude o poco coperte appaiono regolarmente nei suoi dipinti e nelle sue sculture; spesso, come per la *Leda*, la *Notte* e l'*Aurora*, fu l'artista stesso a scegliere il soggetto. A prescindere dal suo punto di vista personale a proposito delle donne, Michelangelo si sforzò di creare delle belle immagini femminili e i suoi contemporanei toscani entusiasticamente lodavano e commissionavano copie di queste figure.

Ciò che più conta è che non possiamo semplicemente attribuire il nostro concetto di omosessualità al Cinquecento. La posizione diffusa, al tempo di Michelangelo, era che ogni uomo sarebbe potuto cadere vittima – o godere – del fascino di un giovane maschio attraente. Recenti studi su documenti legali, testi letterari e sermoni del Rinascimento, hanno chiarito che praticamente tutte le relazioni sessuali tra persone di sesso maschile riguardavano quella che oggi può essere definita pederastia: un uomo adulto che abbia relazioni con un ragazzo di età compresa tra i dodici e i diciannove anni[22].

Nel suo *Libro sulla natura dell'amore* (1525), Mario Equicola riconosceva la «Venere mascula», un tipo di amore contro natura, come la causa principale del desiderio degli uomini di avere rapporti sessuali con i ragazzi[23]. L'attenzione verso questa fascia d'età ci fornisce il contesto per la comprensione dell'interesse di Michelangelo per Tommaso Cavalieri. Nella sua lezione del 1547, sulla poesia dell'artista, che egli lodava per essere piena «d'amore Socratico e di concetti Platonici», Varchi rimarcava come Michelangelo avesse inviato un sonetto d'amore a questo «giovane Romano nobilissimo»[24]. Gli studi moderni fanno solitamente riferimento a questa relazione; pochi, comunque, citano prove documentarie che il ragazzo avesse solo dodici anni nel 1532, quando Michelangelo fu colpito per la prima volta dalla sua bellezza[25]. Proprio lo stesso anno egli iniziò a lavorare alla *Venere e Cupido*. Senz'altro possiamo collegare il cartone di Michelangelo con la sua ricerca artistica e letteraria sull'amore, in questo periodo. Ma non disponiamo di basi per supporre di un collegamento tra l'interesse di Michelangelo per il ragazzo, di cui non esistono ritratti certi, e il suo rappresentare donne mascoline[26].

La poesia neoplatonica di Michelangelo e i suoi presunti desideri sessuali non possono spiegare perché egli abbia creato diverse tipologie di figure muliebri. Certamente non sembrano tutte uguali, altro preconcetto comune, già pronunciato dall'Aretino di Dolce, ma contraddetto dagli stessi commenti di Aretino sulla *Venere* e sulla *Leda*, approfonditi più avanti. Nella presente mostra, possiamo anche noi mettere a confronto queste opere, come la *Notte* e l'*Aurora*, rappresentate da copie di terracotta, in scala ridotta (Catt. 14, 15). I disegni e un modello in terracotta ci consentono tutta-

1547 lecture on the artist's poetry, which he praised as being "filled with Socratic love and Platonic concepts", Varchi noted that Michelangelo had sent a love sonnet to this "young and most noble Roman"[24]. Modern studies invariably mention this relationship; virtually no one, however, cites the documentary evidence that the boy was only 12 in 1532, when Michelangelo was first struck by his beauty[25]. The very same year, he began work on the *Venus and Cupid*. We have every reason to associate Michelangelo's cartoon with his artistic and literary investigations of love from this period. However, we have no grounds for positing a link between Michelangelo's interest in the boy, of whom we have no secure portraits, and his depiction of muscular women[26].

Michelangelo's Neo-Platonic poetry and reputed sexual desires cannot explain why he created different types of female figures. They certainly do not all look alike, another common misconception already expressed by Dolce's 'Aretino', but contradicted by Aretino's own comments about the *Venus* and the *Leda*, discussed below. In this exhibition we too can contrast these works, as well as the *Night* and the *Dawn*, represented by reduced-scale terracotta copies (Cats.

7. Michelangelo, *Studio per una Maddalena / Study for a Maddalena*, Paris, Musée du Louvre, Inv. 726.

via di valutare anche un altro tipo di corporatura, creato da Michelangelo, un nudo femminile più affusolato e sinuoso (Catt. 6, 7, 8), che appare anche nel suo famoso disegno degli *Arcieri* (fig. 8). Una visita alla Cappella Sistina rivela un'ampia varietà di tipi femminili, negli affreschi della volta e delle lunette: possenti o delicate, matronali o virginee, dalle ossa grandi o snelle (fig. 9). Questa galleria di donne copre tutte le fasce d'età, dalle infanti e le bambine fino alle giovani, mature e anziane[27]. A dispetto della sua reputazione, Michelangelo, tra tutti i suoi contemporanei, compreso Raffaello, aveva creato la più ricca gamma di tipi muliebri.

Molti autori moderni tentano di spiegare le donne muscolose di Michelangelo con una mancanza di modelle. Sebbene per lo più gli artisti del Rinascimento impiegassero modelli uomini, questo fatto non li portava a creare immagini mascoline di donne. Tutti potevano studiare le statue antiche di donne nude e, almeno alcuni pittori, avevano accesso a modelle-donne. Aretino scriveva che Sebastiano del Piombo, amico di Michelangelo, impiegava una prostituta, come modella per vari personaggi religiosi[28]. Nelle sue *Vite*, Vasari spiegava

14, 15). Drawings and a terracotta model allow us to consider yet another body type created by Michelangelo, a more elongated and sinuous female nude (Cats. 6, 7, 8), who also appears in this famous drawing of *The Archers* (fig. 8). A visit to the Sistine Chapel reveals a wide variety of female types in the ceiling and lunette frescoes: powerful and delicate, matronly and virginal, broad-boned and slender (fig. 9). This female gallery spans all ages, from infants and little girls to young, mature, and elderly women[27]. In spite of his reputation, Michelangelo created a greater range in female types than any of his contemporaries, even Raphael.

Many modern authors attempt to justify Michelangelo's muscular women by a lack of female models. Though most Renaissance artists used male models, this did not lead them to create masculine images of women. Everyone could study ancient statues of nude women and at least some painters had access to female models. Aretino wrote that Sebastiano del Piombo, Michelangelo's friend, used a prostitute as his model for various religious figures[28]. In his *Lives*, Vasari explained that the best way to acquire skill in drawing was "to sketch

8. Michelangelo, *Gli arcieri / Archers.*
London, The Royal Collection, Inv. RL 12778.

9. Michelangelo, *Figura femminile (Eva?) sotto il braccio del Dio Creatore*
Female figure (Eve?) under the arm of God the Creator, particolare / detail.
Città del Vaticano, Cappella Sistina.

che il modo migliore per acquisire destrezza nel disegno era di disegnare «gl'ignudi degli uomini vivi e femine»[29].

Possiamo davvero pensare che Michelangelo, il più famoso artista del suo tempo, avesse meno accesso dei suoi contemporanei alle modelle? I tipi di corporatura rintracciabili nelle sue opere non possono essere spiegati come errori commessi da un uomo gay, disinformato e disinteressato in merito all'aspetto di una donna nuda. Ciò non significa, tuttavia, che la *Venere* o la *Notte* riproducano fedelmente il corpo di una modella. L'abbondanza di dettagli realistici, in molte opere di Michelangelo, non ci deve indurre a prestare fede alla retorica rinascimentale che si tratti di imitazioni della Natura. Di questa, l'artista violò chiaramente le regole con la sua *Pietà*, al Vaticano, in cui diede un aspetto giovanile alla madre di un trentatreenne. Secondo Niccolò Martelli, mentre Michelangelo scolpiva le statue della Sagrestia Nuova (fig. 10): «...non tolse dal Duca Lorenzo né dal Sig. Giuliano il modello apunto come la nature li havea effigiati e composti, ma diede loro una grandezza, una proportione, un de-

men and women from life"[29]. Can we really believe that Michelangelo, the most famous artist of his day, had less access to female models than his contemporaries? The body types found in his works cannot be explained away as errors committed by a gay man who was ignorant about and uninterested in the appearance of nude women.

This does not mean, however, that either the *Venus* or the *Night* accurately reproduces the body of a model. The abundance of realistic details in many of Michelangelo's works should not lure us into believing the Renaissance rhetoric that they reproduce Nature. The artist clearly violated Her rules in the Vatican *Pietà*, in which he gave a youthful appearance to the mother of a thirty-three year old man. According to Niccolò Martelli, when Michelangelo carved the statues in the New Sacristy (fig. 10), "he did not use as his models Duke Lorenzo and Lord Giuliano as Nature had portrayed and composed them, but rather gave them a size, proportion, decorum, grace, and splendor which he thought would bring them more praise"[30].

coro, una gratia, uno splendore qual gli parea che più lodi loro arrecassero»[30]. Sia le figure maschili che quelle femminili appaiono significativamente dissimili dalla gente che possiamo osservare intorno a noi. Non possono essere descritte come naturalistiche, ma non disapproviamo la *Pietà* o i *Duchi* in San Lorenzo, per la bellezza che vediamo nei loro lineamenti anomali.

Di per se stessa, questa connotazione sovrumana delle possenti figure femminili di Michelangelo non costituiva un problema, nel Cinquecento. Piuttosto, il Dolce obiettava a Michelangelo di non avere rispettato le distinzioni tra le età e i sessi: le sue opere offendevano il senso del decoro del Rinascimento. Altri due autori non toscani espressero punti di vista simili. Il lombardo Gian Paolo Lomazzo criticava le figure di Michelangelo per «essere di proporzione uniforme»[31]. Inoltre il Lomazzo aveva la sensazione che Michelangelo mettesse in mostra dei muscoli eccessivi «in que' corpi nei quali la natura gli aveva assottigliati, come nel corpo di Cristo ed in simili»[32]. Ligorio condannava l'innominato pittore, nella summenzionata critica per avere rappresentato uomini, donne, bambini, angeli e diavoli, tutti in modo simile[33]. Nella loro muscolosità e nelle proporzioni, le vigorose figure di Michelangelo non rispettavano i confini tra maschile e femminile. Le distinzioni di genere, nell'aspetto e nel comportamento, assunsero particolare importanza nel Rinascimento, quando i confini biologici tra uomini e donne – che noi prendiamo per scontati – erano considerati molto più labili[34]. Molti, non solo credevano che la donna fosse inferiore all'uomo, ma che lo stesso corpo femminile fosse una variante imperfetta di quello maschile[35]. Durante la procreazione, diversi fattori – compreso il calore, la forza del seme, l'esatto punto di attacco all'utero – possono dare come risultato una donna mascolina, un uomo effeminato o anche un ermafrodito. Le possibilità di questo *continuum*, variano dall'ideale, all'imperfetto e al mostruoso. Nel primo Cinquecento, Agostino Strozzi sosteneva persino che i sessi fossero fisicamente pari, e riportava la convinzione di Avicenna che le donne, se si fossero esercitate come gli uomini, sarebbero diventate più robuste[36]. Le possenti donne di Michelangelo, nel realizzare il loro potenziale fisico, rappresentavano una possibile minaccia per gli spettatori del Rinascimento.

Nonostante le donne fossero lodate per molte virtù, guadagnandosi anche il titolo di "virago", dovevano tuttavia comportarsi e apparire come donne. Questo tema riecheggia in tutti i trattati e libri di consigli del Rinascimento, quali il *Dialogo della institution delle donne* (1545) di Ludovico Dolce[37]. Non sorprende che l'autore muova obiezioni alle figure di Michelangelo. Nel *Cortegiano* del Castiglione (III. 8), il duca Giuliano de' Medici sostiene fermamente ed esplicitamente di non volere che una signora si impegni in esercizi «robusti ed asperi»[38], incurante delle capacità di questa. In un saggio scritto tra il 1497 e il 1500, Vincenzo Calmeta ammoniva che, ove una donna si comporti in modo maschile, senza ritegno, «contrafà la sua natura, né più donna ma mostro si doveria appellare»[39]. Molti

10. Michelangelo, *Lorenzo de' Medici, duca di Urbino*
Lorenzo de' Medici, Duke of Urbino, particolare / detail.
Firenze, San Lorenzo, Sagrestia Nuova.

Both the male and female figures by Michelangelo differ significantly from the people we see around us. They cannot be described as naturalistic, but we don't object to the *Pietà* or the San Lorenzo *Dukes* because we find beauty in their abnormal features.

In and of itself, the superhuman quality of Michelangelo's powerful female figures did not constitute a problem in the Cinquecento. Rather, Dolce objected that Michelangelo did not respect the distinction between ages and sexes; his works offended the Renaissance sense of decorum. Two other non-Tuscan authors expressed similar views. The Lombard Gian Paolo Lomazzo criticized Michelangelo's figures for "being of uniform proportions"[31]. Moreover, Lomazzo felt that Michelangelo showed excessive muscles "in those bodies where Nature had attenuated them, as in the body of Christ and of others"[32]. Ligorio condemned the unnamed painter in his aforementioned critique for showing men, women, children, angels, and devils in a similar man-

testi descrivono così la condotta che si addice agli uomini e alle donne e questi comportamenti corrispondono alle variazioni presentate da Michelangelo nelle figure femminili e maschili. In un passaggio chiave, Firenzuola esprime il punto di vista diffuso che la donna si debba muovere con *leggiadria*. Con questo egli intende che le azioni e i movimenti debbano essere compiuti «con grazia, con modestia, con gentilezza, con misura»[40]. Nella Firenze del Cinquecento, sia Anton Francesco Doni che Francesco Bocchi, usavano proprio questa espressione per elogiare la *Notte*[41]. Possiamo descrivere la *Venere*, ma non le figure maschili di Michelangelo, come espressione di *leggiadria*. Circa un secolo prima, nel suo *Della Pittura*, Leon Battista Alberti aveva raccomandato agli artisti che, nei movimenti e nelle pose delle giovani fanciulle, «più tosto sia dolcezza di quiete che gagliardia»[42]. Quest'ultimo termine, spesso usato nel Cinquecento per esprimere un movimento vigoroso e incisivo[43], è più appropriato per molte delle figure maschili di Michelangelo, compreso il Cupido.

Aretino si dedica alla questione del ruolo attivo e della muscolosità al femminile, nella sua lettera sulla *Leda* e sulla *Venere* di Michelangelo. Per il modo in cui la seconda opera è concepita, il poeta loda «il prudente uomo» che «ha fatto nel corpo di femmina i muscoli di maschio». Pardo lega questa immagine a un suggestivo passaggio, nel *Dialogo d'amore* (1537) di Sperone Speroni: gli amanti, quando sono legati dal perfetto amore, sono congiunti in modo così totale che «diventino amendue un non so che terzo, non altramente che di Salmace e di Ermafrodito si favoleggi»[44]. In modo analogo, Goffen scrive delle braccia nude della Madonna del *Tondo Doni* (fig. 11), che «sdoppiando l'identità sessuale di lei, Michelangelo l'ha resa una *non-identità*... Lo spettatore afferra che questo essere androgino è una donna, ma di fatto essa non è maschio né femmina»[45]. Forse dovremmo dare più fiducia allo spettatore: la Venere e la Madonna non sono ermafroditi né androgini. Con segni pittorici, l'artista le ha rese riconoscibili come donne e come tali venivano descritte dai suoi contemporanei. Ma, ciò che più conta, come evidenziato da Aretino e da queste autrici contemporanee, i corpi di queste figure femminili di Michelangelo trascendono i limiti naturali del loro genere.

Aretino associa il fisico muscoloso della Venere con il ruolo di figura attiva, «*mossa* da sentimenti virili e donneschi», che «*diffonde* le proprietà sue nel desiderio dei due sessi». Al contrario, descrive la *Leda* come figura passiva, «dolce, piana e soave d'attitudine». In questo dipinto, la figura dominante, ancora una volta, è una divinità; come Zeus, in forma di cigno, «mentre stende il collo per basciarla, che le voglia essalare in bocca lo spirito de la sua divinità»[46]. Queste osservazioni, risalenti al Rinascimento, possono supportare il visitatore di questa mostra nel riconoscimento di importanti diversità tra la *Venere* e la *Leda*: una figura è più attiva e muscolosa, l'altra passiva e delicata. Inoltre, questo contrasto fornisce una chiave interpretativa per un altro paio di nudi femminili, di mano di Michelangelo, risalenti a questo perio-

ner[33]. In their muscularity and proportions, Michelangelo's brawny figures did not respect the boundaries between the male and female.

Gender distinctions in appearance and comportment took on particular importance in the Renaissance, when the biological boundaries between men and women – which we take for granted – were considered to be much more unstable[34]. Many believed not only that the woman was inferior to the man, but that the female body itself was an imperfect variant of the male[35]. During procreation, several factors – including heat, the strength of the seed, and the exact point where it attached to the womb – could result in a masculine woman, a feminine man, or even a hermaphrodite. The possibilities on this continuum ranged from the ideal to the flawed and the monstrous. In the early Cinquecento, Agostino Strozzi even argued that the sexes were physically equal, and cited Avicenna's belief that if women exercised like men, they would become more robust[36]. Michelangelo's powerful women, in realizing their physical potential, posed a potential threat for Renaissance viewers.

Though women could be praised for manly virtues, even earning the title *virago*, they should act and look like women. This theme reverberates throughout Renaissance treatises and advice books, such as Dolce's *Dialogue on the Instruction of Women* (1545)[37]. Not surprisingly, the author objected to Michelangelo's figures. In Castiglione's *The Courtier* (III. 8), Duke Giuliano de' Medici states unequivocally that regardless of her abilities, he does not want a lady to engage in "robust and strenuous manly exercises"[38]. In an essay written between 1497 and 1500, Vincenzo Calmeta warned that if a woman acted in a manly way, without restraint, "she is false to her nature, and should no longer be called a woman, but a new and monstrous creation"[39]. Several texts thus described behavior appropriate for men and women, and these actions correspond to the movements exhibited in Michelangelo's male and female figures. In one key passage, Firenzuola expressed the widespread view that woman should move with "*leggiadria*". By this he means that movements and actions should be "contained, composed, regulated, and graceful"[40]. In Cinquecento Florence, both Anton Francesco Doni and Francesco Bocchi used this very term to praise the *Night*[41]. We can also describe the *Venus*, but not Michelangelo's male figures, as expressing *leggiadria*. Roughly a century earlier, in his *On Painting*, Alberti had warned artists that in the movements and poses of young maidens there should be the "sweetness of quiet rather than strength [*gagliardia*]"[42]. The latter term, often used in the Cinquecento to express vigorous and robust movement[43], is most appropriate for many of Michelangelo's male figures, including the Cupid.

Aretino addresses the issues of female activity and muscularity in his letter about Michelangelo's *Leda* and *Venus*. For the conception of the latter work, the poet praises that "prudent man" who "made the muscles of the male in the body of the

11. Michelangelo, *Tondo Doni / Doni Tondo*,
particolare / *detail*.
Firenze, Galleria degli Uffizi.

do: la *Notte* e l'*Aurora*. Secondo una annotazione scritta dall'artista stesso, la *Notte* e il *Giorno* avrebbero portato a una morte prematura il duca Giuliano de' Medici[47]. Perciò, Michelangelo rappresenta la robusta figura femminile della *Notte*, addormentata, in una postura involuta; l'*Aurora*, al contrario, ha una muscolatura molto meno articolata e giace in posizione più rilassata. Questa immagine della *Notte*, insieme con Eva, nella *Tentazione* della Cappella Sistina, rivela come, per Michelangelo, la muscolosità indichi azione, o la potenzialità di compiere un'azione, buona o cattiva che sia.

Le caratteristiche maschili delle figure femminili non sono sempre associate con la virtù. La postura della *Venere* – che ricorda il famoso *Adamo* (Cappella Sistina), il *San Paolo* (Cappella Paolina) e in special modo il modello di un *Dio fluviale*, che Michelangelo aveva plasmato per la Sagrestia Nuova (fig. 12) – deriva, in definitiva, dalle antiche sculture di dèi fluviali, come quello rappresentato da Raffaello nel *Giudizio di Paride* (Cat. 10). Diversamente da questi modelli e precedenti, la *Venere* ha la spalla destra spostata in avanti e il braccio sinistro indietro, in modo da non poter essere visto[48]. Per quanto i suoi movimenti sembrino stilizzati e immobilizzati, il dinamismo bloccato della Venere contrasta con la languida tranquillità della *Leda*, la cui posa è mutuata da un prototipo antico alquanto differente (Cat. 20)[49].

Dunque, per Aretino, il ruolo di Venere ne giustifica la muscolosità. Non solo la dea è attiva, ma esercita anche il suo potere sia sugli uomini che sulle donne. Questa motivazione reca una forte analogia con una citazione dall'antiquario Vincenzo Cartari (1556), in riferimento a una bizzarra statua antica di una Venere barbuta, maschio dalla vita in su, e femmina per tutto il

female". Pardo compares this image with a fascinating passage in Sperone Speroni's *Dialogo d'amore* (1537): lovers, when united by perfect love, are so completely joined that they "become some third thing, not otherwise than is said in fables of Salmacis and Hermaphroditus"[44]. In a similar vein, Goffen writes of the muscular bare arms of the *Doni Tondo* Madonna (fig. 11) that "by doubling her sexual identity, Michelangelo makes it *non-identity*... The beholder realizes that this androgynous being is a woman, but in fact, she is neither male nor female"[45]. Perhaps we should give more credit to the beholder: the Venus and Madonna are neither hermaphrodites nor androgynes. With pictorial signs the artist identified them as female, and they were described as such by his contemporaries. But most importantly, as noted by Aretino and these modern authors, Michelangelo's female figures go beyond the natural limits of their gender.

Aretino associates the muscular physique of *Venus* with her role as an active figure "*moved* by masculine and feminine sentiments", who "*infuses* her qualities into the desire of the two sexes". In contrast, he describes the *Leda* as passive, "soft of flesh", and "suave in her manner". In this painting the dominant figure, once again, is a god; as Zeus, in the form of a swan, "stretches his neck to kiss her, it seems as if he wants to exhale into her mouth the very spirit of his own divinity"[46].

These Renaissance observations can help visitors to this exhibition to see important distinctions between *Venus* and *Leda*: one figure is more active and muscular, the other more passive and soft. Moreover, this contrast suggests a key to interpreting the other pair of female nudes made by Michelangelo during this period: the *Night* and the *Dawn*. According to a note written by the artist himself, the *Night* and the *Day* brought an early death to Duke Giuliano[47].

To this end, Michelangelo shows the robust female figure of *Night* as asleep in a convoluted pose; in contrast, the *Dawn* has far less articulated musculature and reclines in a more relaxed position. This image of the *Night*, together with the Eve in the Sistine Chapel *Temptation*, show that for Michelangelo muscularity indicates action, or the potential to carry out action, be it good or evil. Male characteristics in female figures cannot always be associated with virtue.

The pose of the *Venus* – reminiscent of the famous Adam (Sistine Chapel), the Saint Paul (Pauline Chapel), and especially the model of a *River God* (fig. 12) that Michelangelo made for the New Sacristy – ultimately derives from ancient sculptures of river gods, such as the one represented in Raphael's *Judgment of Paris* (Cat. 10). In contrast to these models and precedents, however, Venus shifts forward her right shoulder and pulls back her left arm so far that it cannot be seen[48]. Though her movements seem stylized and frozen, Venus's blocked dynamism contrasts with the languid serenity of the *Leda*, whose pose derives from a quite different ancient prototype (Cat. 20)[49]. For Aretino, then, Venus's role accounts for her muscularity. Not only is the goddess active, but she exercises her power on both men and women.

resto. «Questa Dea havesse l'insegna di maschio, & di femina, come quella, che alla universal generatione de gli animali era sopra»[50]. In questo brano Cartari rivela un interesse per la costituzione dei confini tra i generi; nel successivo passaggio, osserva che gli antichi diedero a tutti gli dèi sia un nome maschile che uno femminile, «come che fra quelli non sia la differenza di sesso, che è tra' mortali»[51]. La suggestione di queste distinzioni trapela anche nella lettera di Aretino, a proposito delle opere di Michelangelo, come correttamente notato da Jacobs. L'autrice affermava anche che questo dissolvimento delle categorie «mirava ad accrescere l'apprezzamento dello spettatore per mezzo… della fusione dell'identità sessuale»[52], ma non si può dare per certo che questa fosse l'intenzione dell'artista.

Indubbiamente, comunque, Michelangelo, con la *Venere* e la *Notte*, non intendeva riprodurre l'aspetto di donne reali. A prescindere dalla tematica della loro muscolosità, le teste piccole, in confronto al resto, attengono alle proporzioni dell'arte, non della natura[53]. Due autori del Rinascimento lodavano in particolare le proporzioni della *Notte*, quelle stesse proporzioni che colpiscono, in quanto inconsuete, lo spettatore d'oggi. Per Francesco Bocchi, questa caratteristica rendeva quella scultura una delle quattro opere d'arte perfette presenti a Firenze; di queste era l'unica dovuta a Michelangelo[54]. Anche Benedetto Varchi elogiava quelle proporzioni, nelle *Due Lezzioni*[55]. Questo volume fornisce anche una indicazione di come la *Venere* di Michelangelo, e il tipo michelangiolesco di corpo femminile, fosse inteso presso la cerchia di Bettini.

This motivation bear a striking similarity to one mentioned by the antiquarian Vincenzo Cartari (1556), in relation to a bizarre ancient statue of a bearded Venus, male from the waist up, and the rest female. "This Goddess had the signs of the male and the female, given that she oversaw the universal generation of animals"[50]. In this passage Cartari reveals an interest in the creation of gender boundaries; in the next line he observes that the ancients gave both a male and female name to all the gods, "as if there was no sexual difference between them, as there is among mortals"[51]. The fascination with such distinctions is also apparent in Aretino's letter about Michelangelo's works, as rightly noted by Jacobs. She even affirmed that this dissolution of categories "aimed at heightening the viewer's appreciation by… conflations of gender identity"[52], but we cannot assume that this was the artist's intention.

Certainly, however, Michelangelo did not intend to recreate the appearance of living women in the *Venus* and the *Night*. Aside from the issue of their muscularity, the comparatively small heads conform to the proportions of art, not nature[53].

Two Renaissance authors specifically praised the proportions of the *Night*, the same proportions that strike modern viewers as so odd. For Francesco Bocchi, this quality made the sculpture one of the four perfect works of art in Florence, and the only one by Michelangelo[54]. Benedetto Varchi also praised her proportions in his *Due Lezzioni*[55].

This volume also gives clues about how Michelangelo's *Venus* and the Michelangelesque female body type were understood in Bettini's circle.

12. Michelangelo, *Dio fluviale / River God*. Firenze, Casa Buonarroti.

III. LA *VENERE* NELLA CERCHIA DI BETTINI

Una serie di documenti della metà del Cinquecento ci dà l'impressione che Bettini, con le sue commissioni e amicizie, giocasse un ruolo importante nella cerchia dei principali artisti e letterati di Firenze[56]. Nella lettera dedicatoria del suo trattato sull'alchimia, Varchi sottolineava come Bettini, al pari di molti altri, godesse di una grande reputazione come mercante, ma avesse anche doti non comuni nel sapere spendere i suoi guadagni[57]. Nel 1546 una piacevole lettera di Niccolò Martelli, che chiaramente sperava di ottenere una commissione letteraria, definiva Bettini «un domestico del Petrarca e famigliar del Boccaccio»[58]. Molti dei suoi amici compaiono in un dialogo inedito tra Bettini, Martini e Alessandro Davanzati, a proposito di una rappresentazione teatrale che si era svolta nella casa di Bettini[59].

L'atmosfera culturale di quel luogo, probabilmente rassomigliava, o addirittura ispirò, quella che più tardi Martini avrebbe stabilito nel suo palazzo a Pisa, intrattenendovi Bronzino, Tribolo, Varchi e molti altri[60]. Diversi anni prima, in una lettera a Martini, nel 1539, Varchi chiedeva che la sua traduzione delle *Metamorfosi* di Ovidio (Libro XIII) venisse data al Bronzino e al Tribolo; nella lettera introduttiva, egli scrive che Dante e Petrarca avevano confermato le teorie classiche secondo le quali la pittura sarebbe poesia muta e la poesia pittura parlante[61]. Il *paragone*, o confronto, tra pittura, scultura e poesia, era l'argomento della famosa lezione del Varchi, che si tenne il 13 marzo 1547 all'Accademia Fiorentina, della quale anche Bettini,

III. THE *VENUS* IN BETTINI'S CIRCLE

A series of mid-Cinquecento documents give us the impression that Bettini, though his commissions and friendships, played an important role in a circle of major artists and *letterati* in Florence[56]. In the dedicatory letter to his treatise on alchemy, Varchi notes that Bettini, like many others, enjoyed an exalted reputation as a merchant, but was exceptional in knowing how to spend his earnings[57]. A delightful letter of 1546 from Niccolò Martelli, who clearly hoped to receive a literary commission, describes Bettini as "being at home with Petrarch and friendly with Boccaccio"[58]. Many of his friends appear in an unpublished dialogue between Bettini, Martini, and Alessandro Davanzati about a theatrical performance held in Bettini's house[59]. The cultural atmosphere there probably resembled, or even inspired, the one Martini later established in his palazzo in Pisa, where he entertained Bronzino, Tribolo, Varchi, and many others[60]. Several years earlier, in a 1539 letter to Martini, Varchi asks that his translation of Ovid's *Metamorphoses* (bk. XIII) be given to Bronzino and Tribolo; in his prefatory letter Varchi writes that Dante and Petrarch had demonstrated the classical notions of painting as mute poetry and poetry as speaking painting[61].

The *paragone*, or comparison, between painting, sculpture, and poetry was the subject of Varchi's famous lecture on 13 March 1547 to the Accademia Fiorentina, of which Bettini, Martini, Bronzino, and Michelangelo were also members in the 1540s. Varchi published this study in his *Due Lezzioni* (1550), with a dedication to Martini, together with a series of now-

13. da Michelangelo,
Venere e Cupido
Venus and Cupid.
Napoli, Museo
Nazionale
di Capodimonte.

Martini, Bronzino e Michelangelo erano membri, negli anni Quaranta del Cinquecento. Varchi pubblicò questo studio nelle *Due Lezzioni* (1550), con dedica a Martini, insieme a una serie di lettere, oggi famose, sul *paragone* tra vari artisti, tra cui Michelangelo, Bronzino e Pontormo. Presumibilmente Bettini sostenne finanziariamente la pubblicazione del volume, dato che a lui è dedicata la lettera dell'editore, con cui si apre il libro. La pubblicazione comprende anche la lezione del 6 marzo 1547, tenutasi all'Accademia, nella quale Varchi presentava un'interpretazione esplicitamente neoplatonica della poesia d'amore di Michelangelo. Martini aveva inviato a Michelangelo, che si trovava a Roma, questi *commentarii* tramite Bettini e il poeta, molto lusingato, aveva scritto a Martini le più alte lodi per Varchi[62]. I temi principali delle *Due Lezzioni* del Varchi – l'*amore* come forza ispiratrice e il *paragone* – caratterizzano anche la decorazione della "camera" di Bettini.

Forse Varchi aveva dato dei suggerimenti al suo amico su questo particolare programma, che fu per certo progettato fin dall'inizio. I ritratti di poeti di solito comparivano negli studi o nelle biblioteche, mai nelle "camere"[63]. Richiedendo immagini di «tutti i poeti che hanno con versi e prose toscane cantato d'amore», Bettini celebrava proprio gli autori i cui scritti d'amore stavano vivendo un *revival*, nella Firenze del tempo. Negli anni Quaranta sembra che Varchi avesse dato un consiglio al Tribolo, su un programma scultoreo per la villa Medici di Castello[64]. Inoltre, egli collaborò nel concepire il *Perseo* del Cellini e di certo scrisse gli epigrammi che vi compaiono sulla base[65]. Come dimostra Mendelsohn nel suo saggio, gli epigrammi illustrati erano in gran voga presso gli studiosi cinquecenteschi, specialmente il Varchi, che era intrigato dalla combinazione della prosa enigmatica con le immagini ispirate dall'antico. In una lezione sulla rappresentazione dell'amore, tenuta circa nel 1539, Varchi presenta un idillio greco di Mosco (analizzato nel saggio di Leporatti); in quest'opera, Venere stessa descriveva un Cupido del tutto simile a quello dipinto da Michelangelo e Pontormo.

Sebbene le testimonianze giunte fino a noi non siano sufficienti a provare che Varchi avesse collaborato all'ideazione delle decorazioni di casa Bettini, nei suoi scritti certamente egli ci fornisce indicazioni sul contesto culturale al quale queste appartenevano. Sfortunatamente, il committente non ricevette mai il dipinto della *Venere e Cupido*, poiché questo venne confiscato al Pontormo dal duca Alessandro de' Medici; finalmente, in occasione di questa mostra, è stato riunito con un ritratto di Dante, a forma di lunetta, verosimilmente la versione originale del Bronzino. Questo si vide probabilmente nella "camera" di Bettini, insieme con il cartone che fu dato al banchiere da Michelangelo, un'opera oggi perduta, ma ripresa in un disegno a tutta grandezza, a Napoli (Cat. 27; fig. 13).

Stando di fronte al *Dante* (Cat. 22, Tav. II/1; fig. 14) e alla *Venere e Cupido*, possiamo cercare di immaginare la reazione che una simile giustapposizione possa aver provocato tra gli amici di Bettini. Un indizio è rappresentato dall'animata conversazione descritta nei *Sei poeti toscani* (Cat. 24, Tav. IV/1), dipin-

14. attr. a Bronzino, *Ritratto di Dante / Portrait of Dante*, particolare / *detail*.
Firenze, Collezione privata.

famous letters on the *paragone* by various artists, including Michelangelo, Bronzino, and Pontormo. Bettini presumably helped finance the volume, given that it opens with a letter of dedication to him from the publisher. This also includes Varchi's 6 March 1547 lecture to the Accademia, in which he presented an explicitly Neo-Platonic interpretation of Michelangelo's love poetry. Martini sent this commentary to Michelangelo in Rome, in care of Bettini, and the poet, highly flattered, wrote back to Martini with the highest words of praise for Varchi[62].

The main themes of Varchi's *Due Lezzioni* – love as an inspirational force and comparisons between the arts – also characterize the decorations of Bettini's chamber. Perhaps Varchi gave some suggestions to his friend about the unique program, which was surely planned from the start. Poet portraits usually appear in studies or libraries, not chambers[63]. By requesting images of "all the poets who sang of love in Tuscan verse and prose", Bettini celebrated the very authors whose writings on love enjoyed a revival in Florence at the time. In the 1540s, it seems that Varchi gave Tribolo advice on the sculptural program at the Medici villa at Castello[64]. Moreover, Varchi probably helped devise the iconography of Cellini's *Perseus*, and he certainly wrote the epigrams which appear on its base[65]. As Mendelsohn shows in her essay, illustrated epigrams enjoyed a vogue among Cinquecento scholars, most notably Varchi, who were intrigued

15. Michelangelo, *Testa ideale (Zenobia?)* / *Ideal Head (Zenobia?)*,
Firenze, Galleria degli Uffizi,
Gabinetto Disegni e Stampe, Inv. 598E.

to dal Vasari per Martini[66]. Una varietà di *paragoni* sulla poesia e la filosofia dell'amore – e sulle pitture e sculture di Venere – può aver costituito una base per le discussioni. Prima di rivolgerci a queste questioni, comunque, possiamo valutare il commento del Varchi su una tipologia di corpo femminile, che faceva parte del suo assunto che pittori e artisti traessero scambievoli benefici, attraverso le reciproche opere.

Subito prima di spiegare come Michelangelo attinse da Dante, Varchi scriveva che «Zeusi, che fu tanto eccellente, faceva le donne grandi e forzose, seguitando in ciò Omero»[67]. Alberti (II. 44), riprendendo Quintiliano (XII. 10.5), aveva fatto la stessa osservazione su un antico scultore greco, le cui figure femminili avevano una «forma fatticcia»[68].

Questi brani ci danno indicazione di un "blocco" visivo, finora non riconosciuto, nella cultura dell'Italia del Rinascimento. A dispetto dell'autorità congiunta di un antico scultore e di un antico autore, praticamente nessun artista realizzava immagini di donne robuste[69]. Nel campo dell'architettura, Vitruvio distingueva fra i capitelli per i templi dedicati a differenti tipi di divinità maschili e femminili; questo fatto indusse Lomazzo a proporre diverse tipologie di corpi femminili ideali[70], che però non trovano riscontro nella pittura e nella scultura. Questa limitatezza dell'arte rinascimentale diventa anche più evidente, considerando le rappresentazioni di donne descrit-

by the combination of enigmatic prose and antique-inspired imagery. In a lecture about the representation of love, given in about 1539, Varchi presented a Greek idyll by Moschus, analyzed in Leporatti's essay; in this work, Venus herself describes a Cupid strikingly similar to the one depicted by Michelangelo and Pontormo. Though the surviving evidence does not amount to proof that Varchi helped plan the decorations in Casa Bettini, his writings certainly indicate the cultural context to which they belong. Unfortunately, the patron never received the *Venus and Cupid* painting, as it was confiscated from Pontormo by Duke Alessandro de' Medici; finally, on the occasion of this exhibition, it has been united with a lunette portrait of Dante, most likely the original version by Bronzino. This was probably seen in Bettini's chamber together with the cartoon he was given by Michelangelo, a work now lost but reflected in a full-scale drawing in Naples (Cat. 27; fig. 13).

Standing before the *Dante* (Cat. 22, Pl. II/1; fig. 14) and the *Venus and Cupid*, we can try to imagine the reaction that a similar juxtaposition sparked among Bettini's friends. One clue is the animated conversation depicted in the *Six Tuscan Poets* (Cat. 24, Pl. IV/1), painted by Vasari for Martini[66]. A range of *paragoni* about the poetry and philosophy of love – and about paintings and sculptures of Venus – could have provided the basis for discussions. Before turning to these questions, however, we can consider Varchi's comment about a female body type, which was part of his argument that painters and poets benefit from each others' work. Immediately before explaining how Michelangelo borrowed from Dante, Varchi writes that "Zeuxis, who was so excellent, made large and powerful women, and in this he followed Homer"[67]. Alberti (II. 44), drawing on Quintilian (XII. 10.5), had made the same observation about the ancient Greek sculptor, whose female figures had a robust appearance[68]. These passages indicate a hitherto unrecognized "blockage" in the visual culture of Renaissance Italy. In spite of the combined authority of an ancient sculptor and author, virtually no artist produced images of robust women[69]. In the realm of architecture, Vitruvius distinguished between the capitals for temples dedicated to different types of gods and goddesses, and this led Lomazzo to propose different ideal female body types[70], but they are not reflected in painting or sculpture.

This limitation in Renaissance art becomes even more striking if we consider the representations of women described as physically powerful. When artists illustrated *Orlando Furioso*, they showed Marfisa with a feminine physique, but in the one scene where she removes her clothes, Ariosto stated that she "resembles Mars in every part of her body except her face (XXVI. 80)"[71]. Painters regularly showed Amazons, such as Camilla, no differently from other beautiful women[72].

One notable exception to this disjunction between image and text may be Michelangelo's famous drawing of a nude woman (fig. 15) which provided the basis for a painting by Michele Tosini, called Michele di Ridolfo del Ghirlandaio (Cat. 12, Pl. IX/1). If we can accept the traditional identification as Zenobia,

te come fisicamente possenti. Quando gli artisti illustravano l'*Orlando Furioso*, mostravano Marfisa con un fisico femmineo, ma in quella scena in cui si toglie gli abiti, Ariosto affermava che ella «in ciascuna sua parte che nel viso, assomigliava a Marte» (XXVI. 80)[71]. I pittori abitualmente raffiguravano Amazzoni, come Camilla, non diversamente da ogni altra bella donna[72].

Un'eccezione rilevante a questo scollamento tra immagine e testo può essere rappresentata dal famoso disegno di una donna nuda (fig. 15), di Michelangelo, che ha fornito la base per il dipinto di Michele Tosini, detto Michele di Ridolfo del Ghirlandaio (Cat. 12, Tav. IX/1). Se ne accettiamo la tradizionale identificazione con "Zenobia", allora Michelangelo avrebbe seguito la descrizione della guerriera fatta dal Boccaccio (*De mulieribus claris*, C. 4-5) e descritta come fisicamente bella e tanto infaticabile e forte da superare gli uomini nella lotta. Anche se l'artista non sapeva personalmente delle eroiche donne omeriche, le citazioni in Varchi e Alberti dimostrano che il pubblico erudito del Cinquecento avrebbe potuto fare un collegamento tra le robuste donne di Zeusi e di Michelangelo.

Nel suo unico riferimento alla *Venere e Cupido*, Varchi la paragona all'opera di un altro antico scultore: questo brano compare come parte del dibattito «qual sia più nobile, o la scultura o la pittura». Varchi sottolinea che Plinio aveva fornito l'esempio dei dipinti realistici che avevano ingannato uccelli e cani, ma diceva anche di cavalli vivi tratti in inganno da versioni scolpite. Inoltre: «Non dice egli che gli uomini medesimi si sono innamorati delle statue di marmo, come avviene alla *Venere* di Prassitele? Benché questo stesso avviene ancora oggi tutto il giorno nella *Venere* che disegnò Michelangelo a M. Bartolomeo Bettini, colorita di mano di M. Jacopo Pontormo»[73].

then Michelangelo would have followed the description of the female warrior in Boccaccio (*De mulieribus claris*, C. 4-5) as physically beautiful and so hard and strong that she even surpassed men in wrestling. Even if the artist himself did not know about the heroic, Homeric women, the quotes in Varchi and Alberti indicate that learned viewers in the Cinquecento could have made the association between the robust women of Zeuxis and Michelangelo.

In his only mention of the *Venus*, Varchi compares it to the work of a different ancient sculptor. This passage appears as part of the debate "over which is more noble, sculpture or painting". He notes that Pliny gave examples of realistic paintings that fooled birds and dogs, but also told of live horses tricked by sculpted versions. Moreover, "Didn't he say that even men fell in love with marble statues, as happened with the Venus of Praxilities? Though the very same still occurs today, all day long, with the *Venus* that Michelangelo designed for M. Bartolomeo Bettini, colored by the hand of M. Iacopo Pontormo"[73].

This remarkably sculptural painting could even illustrate the comment in Michelangelo's famous letter on the *paragone*, "it seems to me that painting should be considered better the more it approaches relief"[74]. For Varchi, the great artist succeeded in giving the *Venus* painting the very quality that Pliny (XXXVI. 21) had observed in a statue. The scholar did recognize the verisimilitude and power of three-dimensional works, and in his sonnet to Bettini, also included in the volume, he cites the same story in Pliny to praise Michelangelo's *Night* and *Dawn*[75]. The *Venus and Cupid*, however, demonstrates that paintings can also cause men to fall in love. In the first of his two "lessons", Varchi explains that Love is the desire for beau-

16. Michelangelo, Venere e *Cupido Venus and Cupid*, schizzo preparatorio / preparatory sketch. London, The British Museum, Inv. 1859-6-25-553.

Questo dipinto estremamente scultoreo può illustrare anche il commento, nella famosa lettera di Michelangelo sul *paragone*: «la pittura mi par più tenuta buona quanto più va verso il rilievo»[74]. Per Varchi, il grande artista era riuscito a dare al dipinto della *Venere e Cupido* proprio la qualità che Plinio (XXXVI. 21) aveva notato in una statua. Lo studioso riconosceva la verosimiglianza e la potenza delle opere tridimensionali e in un sonetto dedicato a Bettini, inserito nel volume, egli citava la stessa storia di Plinio per lodare la *Notte* e l'*Aurora* di Michelangelo[75]. Comunque, la *Venere e Cupido* è la dimostrazione che anche le pitture possono essere causa di innamoramento per gli uomini. Nella prima delle sue "lezioni" Varchi spiega che l'amore è un desiderio di bellezza che ha origine divina. Un ristretto gruppo di persone, dalla sensibilità raffinata, «veduta alcuna bellezza materiale saglIono d'un pensiero in un altro a quella bellezza divina»[76].

Questo tema compare nella poesia di Michelangelo, il quale, come dimostrato da Summers, ne ha dato espressione visiva attraverso il *Sogno* (Cat. 41, Tav. XV/1 e Cat. 42, Tav. XIV/1).

A un livello più modesto, un sonetto anonimo (Cat. 30) afferma che le parole non possano esprimere «'l bello, et il buon» della dea dell'amore, del dipinto di Michelangelo-Pontormo. L'autore spiega che Cupido «piagato il core, si sforza, quant'ei può, baciar[e]» Venere. La bellezza della *Venere* di Michelangelo, come di quella di Prassitele, costringe all'innamoramento. Forse una fonte lontana di questo bacio inconsueto era nelle *Metamorfosi* di Ovidio (X. 525-528)[77]: nel baciare Venere, Cupido inconsapevolmente le ferisce leggermente il petto con una freccia; la ferita procura alla stessa dea le sofferenze dell'amore. Ma la posizione delle frecce e la caratterizzazione di Cupido, nel dipinto dell'Accademia, mostrano la distanza tra la concezione di Michelangelo e il testo antico.

ty, whose source is divine. A select group of people with refined sensibilities, "having seen some earthly beauty, rise from one thought to another to that divine beauty"[76]. This concept appears in the poetry of Michelangelo, who, as demonstrated by Summers, gave it visual expression in his drawing of the *Dream* (Cat. 41, pl. XV/1 and Cat. 42, Pl. XIV/1).

At a more modest level, an anonymous sonnet (Cat. 30) states that words cannot express the goodness and beauty of the Goddess of Love in the Michelangelo-Pontormo painting. The author explains that Cupid, "his heart wounded, strives as hard as he can to kiss" Venus. The beauty of Michelangelo's *Venus*, like that of Praxilities's, forces one to fall in love. Perhaps a distant source for this unusual kiss was Ovid's *Metamorphoses* (X. 525-528)[77]: when Cupid kissed Venus, he unwittingly grazed her breast with his arrow; the wound caused the Goddess herself to suffer the pains of love. But the placement of the arrows and the characterization of Cupid in the Accademia panel indicate the distance between the Michelangelo's conception and the ancient text.

Ovid's account also has no connection with Michelangelo's preparatory sketch (Cat. 29; fig. 16), interpreted most convincingly by Wilde as an image of Cupid aiming an arrow at his mother. This startling action, unprecedented in art, corresponds to a passage in Moschus's epigram about the "cruel" boy: the Goddess herself complains that "sometimes, the arrogant archer aims his arrows at me, his mother"[78]. The venerable origins of these Greek verses, and the very specificity of the description, must have also captured the attention of artists. In the Accademia panel, perhaps for the first time, this malevolent, nearly adolescent Cupid, discussed in Mendelsohn's essay, makes his appearance in Florentine painting.

17. Michelangelo, *Sansone e Dalila / Samson and Delilah*, Oxford, Ashmolean Museum, Inv. Parker II, 319.

Il racconto di Ovidio, fra l'altro, non ha punti di contatto con lo schizzo preparatorio di Michelangelo (Cat. 29; fig. 16), interpretato in modo più convincente da Wilde come immagine di Cupido che punta una freccia contro sua madre. Questa sorprendente azione, senza precedenti nell'arte, trova una corrispondenza con un passaggio dell'epigramma di Mosco, a proposito del fanciullo "crudele": la dea stessa si lamenta che «contra a me talora / Madre el protervo arcier suo' strali intende»[78].

Le venerande origini di questi versi greci, e la specificità della descrizione, devono pur avere catturato l'attenzione degli artisti. Nella tavola dell'Accademia, forse per la prima volta, questo malevolo Cupido quasi adolescente (di cui tratta il saggio di Mendelsohn) fece la sua apparizione nella pittura fiorentina. Cupido, in una posa contorta, impossibile da imitare, si protende in avanti e avanza, appoggiando il piede sulla coscia di Venere, rovesciando la faretra e spargendo le frecce. Queste sembrano colpire la gamba di Venere ma, ragionevolmente, data la prospettiva, esse devono cadere dietro la dea.

In questo punto decisivo, Michelangelo e Pontormo approfittano dell'ambiguità della profondità di campo[79]. Naso a naso con Venere, ma con lo sguardo rivolto alle sue frecce, Cupido avvicina a sé la testa della madre per darle, sulle labbra, un bacio privo di emozione. La dea impassibile è adagiata in una posa altrettanto improbabile, basata sui modelli antichi già analizzati. La particolarità dei gesti stilizzati delle mani di lei indica come gli stessi siano latori di significati simbolici. L'indice sinistro di Venere punta al suo petto privo di imperfezioni; questo particolare è da mettere in relazione con la sofferenza che le procurerebbero (o procureranno?) le ferite causate dalle frecce di Cupido. Proprio una di queste lei regge con la mano destra.

Alcuni studiosi hanno interpretato il suo gesto come il sottrarre a Cupido una freccia, altri come l'inserirla nella faretra, ma delle interpretazioni così narrative sembrano improprie. Michelangelo sicuramente avrebbe avuto le capacità di mostrare Venere che chiaramente tirava via o riponeva una freccia, se avesse voluto[80]. Invece, egli ha creato un gesto che, simultaneamente, dirige la nostra attenzione verso l'unica freccia che punta verso l'alto e indica un gruppo di oggetti con significato simbolico, all'estrema sinistra.

In una delle prime, e più influenti, interpretazioni del dipinto, Milanesi sosteneva che la Venere rappresentasse «la dea dell'amore sensuale e lascivo»[81]. Nella sua precisa lettura, comunque, notava come la Venere «grande e maestosa» richiamasse alla mente la Venere Urania. Milanesi spiegava questa «discordanza tra l'idea e la forma» con il desiderio di Michelangelo di descrivere la bellezza sempre in forma di grandiosità. Eppure le sue osservazioni sullo sguardo malizioso di Cupido e su quel corpo in qualche misura goffo, costituisce il punto di partenza per una interpretazione piuttosto diversa.

Gli autori successivi non hanno commentato le fondamentali differenze tra Venere e Cupido. Le più ovvie sono le pose e i gesti; il nobile portamento di lei contrasta nettamente con la torsione agitata di lui. La composizione reca forti analogie

In a contorted pose that defies imitation, Cupid leans forward as he steps over Venus's hip, overturning his quiver and spilling his arrows. These seem to strike the goddess's leg, but logically, given the perspective, they must fall behind her. At this crucial point, Michelangelo and Pontormo exploit the ambiguity of spatial depth[79]. Nose to nose with Venus, but looking back at his arrows, Cupid winds his left arm below the goddess's chin and pulls it closer to give his mother an emotionless kiss on the lips.

The impassive goddess reclines in an equally improbable pose, based on the ancient models discussed above. The specificity of her stylized hand gestures indicates that they convey symbolic meaning. Venus's left index finger points to her unblemished chest; this refers to the pain she would (or will?) feel from wounds caused by Cupid's arrows. One of these she holds with her right hand. Some scholars read her gesture as removing Cupid's arrow and others as inserting it in his quiver, but such narrative interpretations seem inappropriate. Michelangelo surely had the ability to show Venus as clearly pulling or pushing an arrow, had that been his intent[80]. Instead, he created a gesture that simultaneously brings our attention to the arrow and indicates a group of symbolic objects at the far left.

In one of the first and most influential interpretations of the painting, Milanesi argued that the Venus represents "the Goddess of sensual and lascivious love"[81]. In his sensitive reading, however, he noted that Venus, "grand and magisterial", recalls the Uranian Venus. Milanesi explained this "discordance between form and idea" by Michelangelo's desire to always show beauty in the form of greatness. However, his own observations of Cupid's malicious gaze and somewhat inelegant body provide the basis for a quite different interpretation. Subsequent authors have not commented on the fundamental differences between Venus and Cupid. Most obvious is the pose and gestures; her noble bearing contrasts sharply with his agitated twisting. The composition bears strong similarities to Michelangelo's drawing of *Samson and Delilah* (fig. 17)[82], where the writhing figure above represents the deceptive woman. Michelangelo also showed a small figure astride a larger one in the Sistine Ceiling, but there the graceful, virtuous David overpowers a clumsy Goliath. Michelangelo, the master of body language, used poses to express virtue and vice.

In his cartoon for Bettini, Michelangelo set up a contrast between the monumental, statuesque Venus and the sly, cunning Cupid[83]. With ivory white cheeks and carefully arranged hair, Venus looks directly at her son with pure, chaste love; significantly, her head is higher than his. With curly hair and an inflamed face – two features that correspond to Moschus's Cupid – he pushes his lips toward her but, at the same time, deceptively averts his gaze. If we, too, look at the arrows which are given such attention by Venus's gesture, we note that Cupid's point down as they fall toward the ground; only the arrow held by the Goddess of Love points upward.

con il disegno di Michelangelo per *Sansone e Dalila* (fig. 17)[82], dove la figura soprastante, in posa contorta, impersona la donna ingannevole.

Michelangelo aveva anche rappresentato una figura piccola a cavalcioni di una più grande, sulla volta della Sistina, ma lì l'aggraziato e virtuoso Davide sopraffà un goffo Golia. Michelangelo, maestro nel linguaggio del corpo, si è servito delle posture per esprimere virtù e vizio. Nel suo cartone per Bettini, il maestro ha messo su un contrasto tra la monumentale e statuaria Venere e l'astuto e smaliziato Cupido[83]. Con le guance bianco avorio e la capigliatura meticolosamente acconciata, Venere guarda dritto verso suo figlio, con amore puro e casto; significativamente la testa di lei è più in alto di quella di lui. Con i capelli ricci e il viso infiammato – due caratteristiche che corrispondono al *Cupido* di Mosco – lui spinge le labbra verso quelle di lei ma, allo stesso tempo, ingannevolmente distoglie lo sguardo. Se anche noi rivolgessimo lo sguardo alle frecce, verso le quali è attratta l'attenzione, per il gesto di Venere, noteremmo che l'occhio di Cupido punta verso il basso, dove quelle cadono a terra; solo la freccia retta dalla dea dell'amore punta verso l'alto.

Questo insieme di differenze indica una distinzione tra le figure, che trascende il loro ruolo generazionale e di genere sessuale. Ciò deve avere rammentato, a Bettini e ai suoi amici, il più elementare concetto della teoria rinascimentale sull'amore: la distinzione tra amore terreno e volgare – guidato dai sensi – che trascina l'uomo verso una vita voluttuosa, e l'amore celeste e nobile – che riflette il divino – che innalza l'uomo alla vita angelica e contemplativa.

This series of contrasts indicate a distinction between the figures, one that transcends their generational and gender roles. This must have reminded Bettini and his friends of the most elementary concept in Renaissance love theory: the differentiation between earthly, vulgar love – driven by the senses – which drags man down to the voluptuous life, and celestial, noble love – reflecting the divine – that raises man up to the angelic or contemplative life. The concept of the two Venuses, as developed by Ficino in the late Quattrocento and explored in erudite texts by Varchi and countless others, quickly became part of the cultural heritage of learned Europeans[84]. Michelangelo refers to this concept in a sonnet written for Cavalieri:

> *The love of which I speak aspires to the heights;*
> *Woman is too different, and its not worthy*
> *of a wise and manly heart to burn for her.*

> *The one [love] draws toward heaven, and the other draws*
> *to earth,*
> *one dwells in the soul, the other in the senses,*
> *and draws its bow at base and vile things*[85].

This imagery recalls Michelangelo's drawing of *The Archers* from about 1533 – perhaps made for an engraving (fig. 18) – in which all the idealized figures aim their arrows at the target, but the satyr holds his bow in the opposite direction, towards himself. The consideration of the woman in Michelangelo's sonnet echoes Pico della Mirandola's commentary, published posthumously in 1519, on a *canzone* by

18. da Michelangelo (Nicolas Béatrizet), *Saettatori / Archers*. Firenze, Galleria degli Uffizi, Gabinetto Disegni e Stampe, Inv. 969 st. sc.

Il tema delle due Veneri, sviluppato da Ficino nel tardo Quattrocento e indagato nei testi eruditi del Varchi e da innumerevoli altri, divenne presto parte del retaggio culturale degli europei colti[84]. Michelangelo fa riferimento a questo concetto, in un sonetto scritto per il Cavalieri:

L'amor di quel ch'io parlo in alto spira;
donna è dissimil troppo, e mal conviensi
arder di quella al cor saggio e virile.

L'un tira al cielo, e l'altro in terra tira;
nell'alma l'un, l'altr'abita ne' sensi,
e l'arco tira a cose basse e vile[85].

Questa immagine richiama il disegno di Michelangelo per *Gli Arcieri*, databile circa al 1533 – forse realizzato per un'incisione (fig. 18) – in cui tutte le figure idealizzate puntano le frecce verso il bersaglio, mentre il satiro impugna l'arco in senso opposto, verso se stesso.

La considerazione sulla donna nel sonetto di Michelangelo, fa eco al commento, pubblicato postumo, nel 1519, di Pico della Mirandola su una *canzone* di Girolamo Benivieni: «l'amore vulgare, cioè della bellezza corporale, più convenientemente è circa le donne che circa a' maschi; el celeste è il contrario»[86]. Se, in un solo dipinto, un artista del Rinascimento avesse voluto rappresentare sia l'amore sacro che l'amore profano, un'opzione sarebbe stata di rappresentare due immagini di Venere; una seconda sarebbe stata di creare una distinzione tra la dea dell'amore celeste ed Eros sensuale.

La Venere del dipinto dell'Accademia, sebbene femminile, possiede delle caratteristiche maschili precise. La sua monumentalità e la pronunciata muscolatura esprimono grandiosità, forza e solidità: la potenza dell'amore. Con il suo eroico fisico omerico – «contornata con maravigliosa rotondità di linee» (Aretino) – Venere non mostra alcuna debolezza o instabilità, tradizionalmente associate alle donne[87]. Invece, essa unisce i due tipi di bellezza, tra i quali fa distinzione Cicerone (*De Officiis*, I. XXXVI. 131-132), e che Firenzuola riprende: venustà e dignità, il primo un attributo della donna, il secondo dell'uomo. Le virtù maschili nobilitano così la rappresentazione della dea dell'amore e le conferiscono una bellezza ideale; per Bocchi, «ha la bellezza con quello che è forte e gagliardo stretta e grande amistà»[88]. Venere si dà all'osservatore e ai poeti d'amore. Per questi ultimi, come osservava Tolnay, rappresenta una musa[89]. Per noi, come spiegato da Mendelsohn, «il dipinto rende la bellezza accessibile, poiché è rappresentato in una forma visibile e corporea»[90]. La nostra contemplazione della bellezza dell'amore diventa il soggetto stesso del dipinto.

Michelangelo ci presenta le differenze di carattere tra Venere e Cupido, ma con attenzione li dispone in un raffinato equilibrio. Questo bel bilanciamento si differenzia dalla soluzione adottata per la *Leda*, dove il cigno e la donna sembrano fondersi in una unica figura, o anche per *Gli Arcieri* dove il satiro si tiene a di-

Girolamo Benivieni: "earthly love, that is, the love of corporeal beauty, is more properly directed toward women than toward men; and the reverse is true of heavenly love"[86]. If, in a single painting, a Renaissance artist wanted to represent both sacred and profane love, one option was to represent two images of Venus; another was to distinguish between the Goddess of Celestial Love and the sensual Eros. The Venus in the Accademia panel, though female, has selected male characteristics. Her monumentality and pronounced musculature express grandeur, strength, and firmness: the power of love. With her heroic, Homeric physique – "outlined with contours of a marvelous rotundity" (Aretino) – Venus shows none of the weakness and instability traditionally associated with women[87]. Instead, she unites the two kinds of beauty distinguished by Cicero (*De Officiis*, I. XXXVI. 131-132), and repeated by Firenzuola: loveliness [*venustas*] and dignity, the first an attribute of women, and the latter of men. Male virtues thus ennoble this representation of the Goddess of Love and bestow upon her an ideal beauty; for Bocchi, "beauty has a great and strong affinity with strength and sturdiness"[88]. Venus presents herself to the viewer and to the poets of love. For the latter, as Tolnay observed, she represents their muse[89]. For us, as Mendelsohn explained, "the painting renders divine beauty accessible, since it is represented in a visible, corporeal form"[90]. Our contemplation of the beauty of love becomes the very subject of the painting.

Michelangelo shows us the characterial differences between Venus and Cupid but carefully arranges them in a delicate equilibrium. This fine balance differs from the solution he used in the *Leda*, where the swan and woman seem to merge into one figure, or in *The Archers*, where the satyr stands off from the ideal figures. The compositional sketch for the *Venus and Cupid* even shows the two figures in opposition, but they are integrated in the painting. Venus gazes at Cupid and aims the arrow of true love toward him; he, inflamed, strives toward the higher form of love, and seems to wound the Goddess in his attempt to kiss her. Perhaps, Michelangelo is giving visual expression to the interrelationship of the two Venuses. Ficino explained in *On Love* (II. 7) that "the human soul... has within it two powers: that of understanding and of procreation. These two powers are two Venuses in us". Like Masaccio's *Trinity*, which represents three distinct parts within an indivisible whole, the Michelangelo-Pontormo painting shows two types of love within one compositional unit. More than a mere depiction of Venus and Cupid, the painting portrays the twofold nature of Love.

The mysterious objects at the far left must also refer to love. A pink ribbon ties the two masks to Cupid's bow, and allows them to dangle from a vase filled with roses, an attribute of Venus. In the *Dream* (Cat. 41, Pl. XV/1; fig. 19), many masks appear within a container, but the choice of only two in the *Venus and Cupid* (fig. 20) recalls Sebastiano del Piombo's portrait of Aretino, and Vasari's painting of Lorenzo the

19. Alessandro Allori, *Sogno / The Dream*, particolare / *detail*. Firenze, Galleria degli Uffizi.

20. Michelangelo-Pontormo, *Venere e Cupido* **Venus and Cupid**, particolare / *detail*. Firenze, Galleria dell'Accademia.

stanza dalle figure idealizzate. Lo schizzo compositivo per la *Venere e Cupido* mostra addirittura le due figure in opposizione, ma nel dipinto risultano integrate. Venere guarda Cupido e rivolge la freccia del vero amore verso di lui che, infiammato, si sforza di raggiungere la più elevata forma d'amore e sembra ferire la dea, nel suo tentativo di baciarla. Forse Michelangelo ci sta fornendo un'espressione visiva dell'interazione tra le due Veneri. Come spiegava Ficino ne *El libro dell'amore* (II. 7), «l'animo dell'uomo... ha due potentie in sé, la potentia del cognoscere e la potentia del generare: queste due potentie sono in noi due Venere». Come la *Trinità* di Masaccio, che rappresenta tre parti distinte in un tutto indivisibile, il dipinto di Michelangelo-Pontormo mostra due tipi di amore in una unità compositiva. Più che una mera raffigurazione di Venere e Cupido, il dipinto ritrae la duplice natura dell'amore.

Anche i misteriosi oggetti all'estrema sinistra, devono fare riferimento all'amore. Un nastro rosa lega le due maschere all'arco di Cupido, facendole pendere dal vaso pieno di rose, un attributo di Venere. Nel *Sogno* (Cat. 41, Tav. XV/1; fig. 19) molte maschere compaiono all'interno di un contenitore, ma la scelta di metterne solo due nella *Venere e Cupido* (fig. 20) rimanda al ritratto di Aretino di Sebastiano del Piombo e al dipinto del Vasari con *Lorenzo il Magnifico* (fig. 21). In una lettera del 1533, il Vasari spiegava che la «maschera bruttissima» e quella «pulita, bellissima», nel suo quadro, rappresentavano rispettivamente il vizio e la virtù[91]. Nelle tre opere citate, le maschere possono anche riferirsi alle diverse forme di poesia usate da Aretino, Lorenzo e Michelangelo: quella burlesca e quella amorosa che «guardano» in diverse direzioni[92]. Inoltre, maschere con sembianze di giovani uomini apparivano spesso negli spettacoli del XVI secolo, che trattavano di amore e di inganno, proprio i temi espressi dai gesti e dallo sguardo di Cupido[93]. Le maschere da satiro erano note fin dall'antichità, ma il viso della tavola dell'Accademia – sorprendentemente in carne e dotato di peluria – ha l'aspetto di una persona viva più di qualsiasi maschera nota attraverso la pittura o il teatro del Rinascimento.

21. Giorgio Vasari, *Ritratto di Lorenzo de' Medici, il Magnifico* *Portrait of Lorenzo de' Medici, the Magnificent*. Firenze, Galleria degli Uffizi.

Magnificent (fig. 21). In a letter of 1533, Vasari explains that he made the "very ugly" mask and the "clean, most beautiful" one to represent Vice and Virtue, respectively[91]. In these three works, the masks may also refer to the different poetic genres practiced by Aretino, Lorenzo and Michelangelo: the burlesque and amorous, which "look" in different directions[92]. Moreover, masks of young men often appeared in sixteenth-

Per di più, sembra guardare la Venere con atteggiamento lascivo, burlandosi della nostra contemplazione della dea della bellezza e dell'amore. Subito sotto, mezza nascosta dall'oscurità e dal drappo verde, giace una statuetta di giovane supino, con le mani levate verso l'alto[94]. Ha il corpo realizzato in pietra, paragonabile per colore e consistenza al contenitore di pietra serena, ma il viso dipinto a colori vividi, orlato dai capelli scompigliati, e i lineamenti tumefatti, sembrano decisamente umani. La posa e l'espressione indicano uno stato di sofferenza o morte; probabilmente, come suggeriva il Milanesi, vediamo i risultati dell'amore sensuale. La condizione ambigua di quell'oggetto, oscillante tra artificio e natura, lo rende ancora più disorientante, almeno per il pubblico moderno. Come le maschere e i gesti e le pose delle figure resi in maniera estremamente artefatta, la statuetta porta la nostra attenzione sull'artificio che trapela dalla *Venere e Cupido*, proprio l'aspetto lodato da Aretino[95].

IV. LA "VENERE" FUORI DELLA CERCHIA DI BETTINI

La *Venere e Cupido*, creata per essere vista insieme a una serie di ritratti di poeti nella "camera" di Bettini, prese una nuova strada dopo la sua confisca da parte del duca Alessandro. Insieme con la *Leda*, la *Notte* e l'*Aurora*, entrò a far parte di una categoria di nuova costituzione: belle figure femminili nude distese, di Michelangelo. Tutte e quattro appaiono in una serie di tavolette, probabilmente dipinte dall'allievo di Michele Tosini, Francesco Brina (*Appendice II*; figg. 22-25). La *Venere*, in particolare, assunse il ruolo di risposta fiorentina – unendo il disegno di Michelangelo con i colori del Pontormo – ai modelli veneziani, proposti da Tiziano. Il soggetto, la doppia paternità e l'accessibilità della *Venere e Cupido* facilitarono la divulgazione di questa immagine, «uno dei dipinti più copiati del Cinquecento toscano»[96]. Dopo che Michelangelo ebbe dato il dipinto e il cartone della *Leda* al suo assistente – che lo portò in Francia – la *Venere e Cupido* rimase l'unico dipinto profano, con il contributo di Michelangelo, presente in Italia.

Quando il cartone lasciò le mani dell'artista, fu a disposizione come oggetto di studio, nella casa di Bettini; anche Pontormo, probabilmente, ne ebbe una copia. Inoltre, i molti artisti che contribuirono a decorare Palazzo Vecchio, presumibilmente ebbero ampie opportunità di vedere il dipinto di Michelangelo-Pontormo, nella *guardaroba* dei Medici. Oggi le fotografie e le descrizioni ci consentono di identificare sedici dipinti che riproducono fedelmente la tavola dell'Accademia o, forse, il cartone perduto (*Appendice II*). Alcuni di questi dovrebbero coincidere con qualcuna delle sedici versioni della *Venere e Cupido*, nominate sia dalle fonti rinascimentali che dai più recenti inventari delle collezioni, ma molte copie ancora sono probabilmente andate perdute. Inoltre, vari artisti hanno dipinto delle variazioni sulla composizione della *Venere e Cupido*, assai similmente a come molti letterati tradussero e trasformarono l'idillio di Mosco su Cupido.

century spectacles about love and trickery, the very themes expressed by the gesture and gaze of Cupid[93]. Satyr masks were known since antiquity, but the face in the Accademia panel – surprisingly fleshy and hairy – is more life-like than any other mask known from Renaissance painting or theatre. It seems to leer at Venus, mocking our own contemplation of the Goddess of Beauty and Love.

Directly below, half hidden by the darkness and the green drapery, lies a statuette of a supine young man with upraised arms[94]. He has a stone body, comparable in color and texture to the *pietra serena* container, but a vividly painted face with wild hair and swollen features that seem positively human.

The pose and expression convey pain or death; probably, as suggested by Milanesi, we see the result of sensual love. The ambiguous status of the object, oscillating between artifact and nature, makes it even more disorienting, at least for the modern viewer. Like the masks, and the highly stylized gestures and poses of the figures, the statuette brings our attention to the artifice of the *Venus and Cupid*, the very feature praised by Aretino[95].

IV. THE 'VENUS' OUTSIDE OF BETTINI'S CIRCLE

The *Venus and Cupid*, created to be seen with a series of poet portraits in Bettini's chamber, took on a new life when Duke Alessandro confiscated it. Together with the *Leda*, the *Night* and the *Dawn*, she became part of a newly established category: beautiful, reclining, nude, female figures by Michelangelo. All four appear in a series of small panels, probably painted by Michele Tosini's student Francesco Brina (*Appendix II*; figs. 22-25). The *Venus* in particular took on the status of the Florentine response – uniting Michelangelo's *disegno* with Pontormo's colors – to the Venetian models proposed by Titian.

The subject, dual authorship, and accessibility of the *Venus and Cupid* facilitated the dissemination of this image, "one of the most copied Tuscan paintings of the sixteenth century"[96]. After Michelangelo gave his painting and cartoon of the *Leda* to his assistant – who brought them to France – the *Venus and Cupid* became the only secular painting in Italy with a contribution by Michelangelo.

When the cartoon left the artist's hands, it became available for study at Bettini's home; Pontormo, too, probably had a copy. In addition, the many artists who contributed to the Palazzo Vecchio decorations presumably had ample opportunity to see the Michelangelo-Pontormo painting in the Medici *guardaroba*. Today, photographs and descriptions allow us to identify sixteen paintings that faithfully reproduce the Accademia panel or, perhaps, the lost cartoon (*Appendix II*). Some of these must correspond to the sixteen versions of the *Venus and Cupid* named in both Renaissance sources and more recent inventories of collections, but many more copies are probably lost.

22. Francesco Brina (?), *Leda*.
Firenze, Casa Buonarroti.

23. Francesco Brina (?), *Venere e Cupido / Venus and Cupid*.
Firenze, Casa Buonarroti.

24. Francesco Brina (?), *Notte / Night*.
Firenze, Casa Buonarroti.

25. Francesco Brina (?), *Aurora / Dawn*.
Firenze, Casa Buonarroti.

Un certo numero di copie esistenti e quelle note dai documenti furono eseguite dal Vasari, o da artisti della sua cerchia (Catt. 28, 31). Dalla sua *Vita*, dalle *Lettere* e dai *Ricordi*, apprendiamo che Vasari fece quattro e forse più copie, due almeno delle quali abbinate con la *Leda*. Vasari ne dipinse una coppia nel 1542 per il suo più importante committente del tempo, Ottaviano de' Medici. È stato suggerito che questa *Venere e Leda* «acquistarono un doppio significato di adesione al pensiero di Michelangelo e di completamento... del discorso spirituale della cerchia di Ottaviano»[97]. Ma Michelangelo non aveva previsto che queste sue opere potessero essere viste insieme. Le aveva create in due circostanze molto diverse: la prima era un dono a un mercante fiorentino, per la sua camera privata, e la seconda era stata fatta per essere venduta – forse per ragioni diplomatiche[98] – al duca Alfonso d'Este, per il suo palazzo di Ferrara.

Moreover, several artists made variations on the *Venus and Cupid* composition, much like the many *letterati* who translated and transformed the idyll by Moschus about *Cupid*.

A number of the extant copies and those known from documents were executed by Vasari or artists of his circle (Cats. 28, 31). From his *Life*, letters, and *ricordi*, we know that Vasari made four and possibly more copies, at least two of which were paired with the *Leda*. Vasari painted one pair in 1542 for his most important patron at the time, Ottaviano de' Medici. It has been suggested that this *Venus* and *Leda* "took on a double significance: they adhere to Michelangelo's views, and complement... the spiritual discourse in Ottaviano's circle"[97]. But Michelangelo never expected these works to been seen together. He made them for two very different circumstances; the former was gift to a Florentine merchant

26. Giorgio Vasari, da / *after* Michelangelo, Venere e Cupido / *Venus and Cupid*.
London, Kensington Palace, The Royal Collection.

Sebbene Ottaviano possa avere dato un'interpretazione della *Venere* (fig. 26) e della *Leda* in termini filosofici, non era certamente così che le due opere venivano descritte, nelle lettere di Aretino e del Vasari. Il poeta scrive della *Leda* «che non si può mirar senza invidiare il cigno, che ne gode con affetto tanto simile al vero». Si tratta di un rimando all'*Eunuco* di Terenzio, ripetutamente citato dagli autori del Medioevo e del Rinascimento: un giovane, guardando un dipinto di *Giove e Danae*, si eccita sensualmente e si identifica con il dio[99]. L'anonimo autore di un sonetto in lode della *Venere e Cupido* (Cat. 30), sottolinea che l'amante della dea, Marte, «ben puossi, et con ragion, felice… anzi beato dir, fra gli altri dèi»[100].

In una divertente lettera del 1544, Vasari scriveva della sua «nuda Venere», presumibilmente simile a quella che aveva fatto per Ottaviano. Sembra che il pittore avesse delle difficoltà a spedire l'opera a Francesco Leoni, il suo intermediario a Venezia, e così buttava giù una sua fantasia erotica, ispirata alla figura: «La nuda Venere o per me o prima forse sarà portata; che ha auto tante fortune, che l'esercito di Dario non l'ebbe tante. L'è viva et è ancor vergine, con tutto che per esser buona roba, ci sia stato voluto far il bordello; tamen la madre l'ha auta

for his private chamber and the latter was to be sold – perhaps for diplomatic reasons[98] – to Duke Alfonso d'Este of Ferrara for his palazzo.

Though Ottaviano might have interpreted the *Venus* (fig. 26) and *Leda* in philosophical terms, they were certainly not described as such in the letters of Aretino and Vasari. The poet writes of the *Leda* "that one cannot look without envying the swan who enjoys her with such believable emotion". This recalls a passage in Terence's *The Eunuch*, repeatedly cited by Medieval and Renaissance authors: a young man, looking at a painting of Jupiter and Danae, becomes sexually aroused and identifies with the god[99]. The anonymous author of a sonnet praising the *Venus and Cupid* (Cat. 30) remarks that the Goddess's lover, Mars, may "be called the happy one, or better, blessed among the other gods"[100].

In an amusing letter of 1544, Giorgio Vasari wrote about his "nude Venus", presumably similar to the one he had made for Ottaviano. It seems that the painter had some difficulty in sending the work to Francesco Leoni, his intermediary in Venice, and so he dashed off this erotic *fantasia* inspired by the figure: "The nude Venus will be brought either by me, or perhaps

in custodia di sorte, che è libera dal puttanesimo per mia mani. Quando sarà con voi, bisognerà, ci haviate cura, che per essere di morbida maniera, non vi fussi levata su»[101].

Vasari descriveva una Venere decisamente terrena, persino disinibita. Nel suo dipinto del *San Girolamo*, nel 1541, sempre per Ottaviano de' Medici, raffigurava una Venere vestita[102], ma essa compare nuda nel dipinto inviato a Leoni. Questa figura vivida è *buona roba*; questo termine era impiegato da Shakespeare (*Henry IV*, III. II. 26) con il significato di prostituta e in tale senso fu definita da John Florio nel 1598[103]. Ma Vasari si compiace anche per le proprie doti; come il Pigmalione di Ovidio, egli aveva trasformato una figura statuaria in una delicata e desiderabile donna[104]. Anche le copie in mostra del dipinto dell'Accademia mostrano una figura meno austera e monumentale, posizionata in un'ambientazione più spaziosa e lussureggiante (Catt. 28, 31). La tensione tra le due figure è ridotta e, nella maggior parte delle versioni, Cupido guarda verso Venere; si individua persino una giocosa complicità tra i due nelle variazioni sulla composizione dovute ad Allori (Cat. 43, Tav. XV/2; fig. 27) e al Bronzino (Cat. 34, Tav. XI/1; fig. 28). Quest'ultima, in particolare, dimostra, da parte del pittore, la comprensione del prototipo, nella sua sofisticata re-interpretazione del tema. Invece di rappresentare frecce orientate in direzioni diverse, Bronzino seguì l'antica tradizione letteraria, rappresentandole come fatte di piombo oppure d'oro. In modo più comico, egli trasformò la maschera "brutta" in un satiro gioioso, che insinua il suo flauto di Pan tra le gambe della dea. Un satiro lascivo (e due maschere) compare anche in una variazione sulla *Venere e Cupido*, nota solo attraverso le fotografie (*Appendice II*; fig. 29). Forse Maarten van Heemskerck eseguì quest'opera all'inizio degli anni Quaranta del Cinquecento, data la forte somiglianza

27. Alessandro Allori, *Venere e Amore / Venus and Cupid*. Firenze, Galleria degli Uffizi.

sooner. She has had even more misfortunes than Darius's army had. She's alive and still a virgin and such hot stuff that they wanted to make a brothel out of her. But her mother keeps her more or less under surveillance, so that she escaped whoredom at my hands. She is so compliant that, when she's with you, you're going to have to be careful she isn't abducted"[101].

Vasari describes a decidedly earthly, even earthy Venus. In his painting of *St. Jerome* in 1541, also made for Ottaviano de' Medici, Vasari depicted Venus as clothed[102], but she appears as nude in the painting sent to Leoni. This lively figure is *buona roba*, literally "good stuff"; the term was used by Shakespeare (*Henry IV*, III. II. 26) to mean prostitute, and was so defined by John Florio in 1598[103]. But Vasari also praises his own skill; like Ovid's Pygmalion, he transformed a statuesque figure into a soft, desirable woman[104].

The copies of the Accademia painting on view also show a less austere and monumental figure, placed in a more spacious, lush setting. (Cats. 28, 31) The tension between the figures is reduced and in most versions Cupid looks toward Venus; there is even a playful complicity between them in the variations on the composition by Allori (Cat. 43, Pl. XV/2; fig. 27) and Bronzino (Cat. 34, Pl. XI/1; fig. 28).

The latter, in particular, demonstrates the painter's understanding of the prototype in his sophisticated reinterpretation of the theme. Instead of depicting arrows as pointing in different directions, Bronzino follows ancient literary tradition by representing them as made of lead or gold. Most amusingly, he transforms the "ugly" mask into a joyful satyr, who places his panpipes between the Goddess's legs.

A leering satyr (and two masks) also appear in a variation on the *Venus and Cupid* known only from photographs. (*Appendix II*; fig. 29). Perhaps Maerten van Heemskerk executed this fine work in the early 1540s, given that it exhibits strong similarities to the *Venus and Cupid* in Cologne, signed and dated by the Flemish master in 1545. The latter work, a hitherto unnoticed variation on the Michelangelo-Pontormo, helps document its immediate and international success[105].

A number of Vasari's copies of the *Venus* and *Leda* were brought to Venice, a bold invasion of Titian's domain. When Aretino praised these works in his promotional letter of 1542, he addressed the same Guidobaldo della Rovere who in 1538 had purchased the *Venus of Urbino*. Several recent studies have explored this competition and dialogue between the reclining female nudes by Michelangelo and Titian[106]. Michelangelo made the *Leda* for one of the most prominent patrons of Titian; the latter artist responded to the pose and composition of the *Leda*, and of the *Night*, in his painting of *Danae* (fig. 30), made in Rome for Ottavio Farnese in 1545-1546. In one of the best-known artistic confrontations in the Renaissance, Michelangelo himself visited Titian's studio. As recounted by Vasari in 1568, he praised Titian's coloring and style, but added: "It is a shame that in Venice they never

28. Agnolo Bronzino, *Venere, Cupido e Satiro / Venus, Cupid and a Satyr*. Roma, Galleria Colonna.

29. Maarten van Heemskerck (?), *Venere, Cupido e Satiro / Venus, Cupid and a Satyr*, Collezione ignota.

30. Tiziano, *Danae*. Napoli, Museo Nazionale di Capodimonte.

con la *Venere e Cupido* di Colonia, firmata e datata dal maestro fiammingo nel 1545. Quest'ultima opera, una variante passata finora inosservata, da Michelangelo-Pontormo, contribuisce a documentarne il successo immediato e internazionale[105].

Un certo numero di copie del Vasari della *Venere* e della *Leda*, fu portato a Venezia, un'ardita invasione del dominio di Tiziano. Quando Aretino elogiava queste opere, nella sua lettera propagandistica del 1542, si rivolgeva allo stesso Guidobaldo della Rovere che nel 1538 aveva acquistato la *Venere di Urbino*. Studi recenti hanno analizzato le forme di rivalità e il rapporto dialettico tra i nudi femminili distesi di Michelangelo e di Tiziano[106]. Michelangelo aveva realizzato la *Leda* per uno tra i committenti di Tiziano più in vista; Tiziano rispondeva alla posa e alla composizione della *Leda* e della *Notte* con la sua *Danae* (fig. 30), eseguita a Roma per Ottavio Farnese (1545-1546). In uno dei confronti artistici più noti del Rinascimento, lo stesso Michelangelo andò a far visita allo studio di Tiziano. Come riferito dal Vasari, nel 1568, il fiorentino aveva lodato Tiziano per il colore e la maniera, ma aveva aggiunto: «era un peccato che a Vinezia non s'imparasse da principio a disegnare bene, e che non avessono que' pittori miglior modo nello studio»[107].

Un importante aspetto del famoso brano del Vasari, merita un'ulteriore considerazione: l'incontro tra Michelangelo e Tiziano ebbe luogo nello stesso periodo in cui Vasari stava producendo delle copie dei nudi femminili di Michelangelo e stava cercando di venderli a Venezia. Il giudizio citato dal Vasari riflette probabilmente il punto di vista di Michelangelo, evidentemente condiviso

learned to design well from the beginning and that those painters did not have more order in their studies"[107].

One important aspect about Vasari's famous and influential passage deserves further consideration: the meeting between Michelangelo and Titian took place at the very time when Vasari was producing copies of Michelangelo's female nudes and trying to sell them in Venice.

The judgment recorded by Vasari probably reflects the view held by Michelangelo, and was evidently shared by Vasari himself. The *Leda* and the *Venus* show the majesty of Florentine *disegno* as applied to the female nude. Michelangelo carefully arranged the poses of both figures and their placement within the composition. The extant paintings show the firm, decisive drawing style that distinguished the Tuscan school and, especially, the works of Michelangelo. As suggested by Aretino, the *Venus and Cupid* seems to have an even more pronounced definition than the *Leda*, a "masculine" virtue that elevates the female Goddess. Moreover, both paintings show how Michelangelo studied and borrowed from ancient art.

For their highly designed and studied qualities, the *Leda* and the *Venus and Cupid* represent the ideal visual complement to Michelangelo's critique of Titian. These influential works showed the "correct" Tuscan depiction of the reclining female nude. As Freedberg observed of the *Venus*, the "fine-poised artifice, concordant with the stress on artificiality – and primacy – of form... were explicit precedents in Florence for Maniera"[108].

dal Vasari stesso. La *Leda* e la *Venere* dimostrano la maestosità del disegno fiorentino, applicato al nudo femminile. Michelangelo sistemò accuratamente le pose di entrambe le figure e la loro collocazione all'interno della composizione. I dipinti esistenti mostrano lo stile del disegno serrato e deciso che distingue la scuola toscana e in special modo le opere di Michelangelo. Come suggerito da Aretino, la *Venere e Cupido* sembra avere una definizione ancor più marcata rispetto alla *Leda*, una virtù "mascula" che eleva la divinità femminile. Inoltre, entrambe i dipinti dimostrano come Michelangelo studiò e attinse dall'arte antica.

Per il modo in cui sono disegnate e studiate, la *Leda* e la *Venere e Cupido*, rappresentano il complemento della critica che Michelangelo aveva mosso a Tiziano. Queste opere mostravano la "corretta" rappresentazione toscana del nudo femminile disteso. Come Freedberg ha osservato a proposito della *Venere*, «l'artificio ben equilibrato, consonante con lo sforzo dell'artificiosità – e la supremazia – della forma... crearono dei precedenti espliciti per la Maniera, a Firenze»[108].

Quando Vasari pubblicò il commento di Michelangelo su Tiziano, una generazione di artisti toscani più giovani stava lavorando in uno stile fortemente manierato, che aveva preso le mosse da dipinti come la *Venere e Cupido*. Verso la fine del Cinquecento il confronto, che Vasari aveva ambientato nello studio di Tiziano, ebbe luogo di nuovo attraverso i dipinti, altrove, a Roma. Naturalmente i Farnese possedevano ancora la *Danae* di Tiziano, che tenevano in mostra nel loro palazzo romano. Al secondo piano dello stesso edificio, il bibliotecario dei Farnese, Paolo Orsini, aveva messo insieme una sua collezione, che poi aveva lasciato ai suoi padroni, con il testamento del 1600. Questo documento aveva in elenco una *Venere e Cupido* di «Michelangelo», in realtà un disegno a tutta grandezza di mano di un anonimo artista[109] (Cat. 27). I visitatori del Palazzo Farnese poterono mettere così a confronto i nudi distesi dei due grandi maestri. L'aver ereditato questo disegno può avere incoraggiato i Farnese ad acquistare la versione dipinta, ora a Napoli (Cat. 28, Tav. V/2; fig. 31). Delle molte copie della *Venere e Cupido*, questa può vantare il più importante lignaggio: l'inventario di Palazzo Farnese, a Roma, del 1649, lo elenca tra le opere nella Sala dei Filosofi, come: «un quadro d'una Venere ignuda a giacere con un amorino che la bacia con due mascare, cornice di noce con prospettiva, intagliata con cortina di taffetà verde, e ferretto... disegno di Michel Angelo colorito dal Venusto in tavola»[110]. La stessa sala ospitava un busto in bronzo di Dante[111], una giustapposizione che potrebbe essere stata suggerita dalle *Vite* del Vasari.

Poco più di un secolo era passato da quando Michelangelo aveva creato questa particolarissima rappresentazione di Venere per la "camera" del Bettini. Forse per la prima volta, una dea dell'amore era riunita in un palazzo privato con un ritratto del grande poeta che ella aveva ispirato.

31. Cerchia di Giorgio Vasari (Hendrik Van den Broek), da Michelangelo, *Venere e Cupido / Venus and Cupid*. Napoli, Museo Nazionale di Capodimonte.

When Vasari published Michelangelo's comments about Titian, a younger generation of Tuscan artists was working in a highly mannered style, one that developed out of paintings like the *Venus and Cupid*. By the end of the Cinquecento, the confrontation that Vasari had staged in Titian's studio was reenacted with paintings elsewhere in Rome. Naturally, the Farnese still owned Titian's *Danae*, which they exhibited in their Roman palazzo. In the second floor of the same building, the Farnese librarian Paolo Orsini had installed his own collection, which he left it to his patrons in his will of 1600. This listed a *Venus and Cupid* by "Michelangelo", actually a full-scale drawing by an anonymous artist[109] (Cat. 27). Visitors to the Palazzo Farnese could thus compare the reclining nudes by the two great masters. The inheritance of this drawing may have encouraged the Farnese to acquire the painted version now in Naples (Cat. 28, Pl. V/2; fig. 31). Of the many copies of the *Venus and Cupid*, this enjoys the most exalted pedigree: the 1649 inventory of the Palazzo Farnese in Rome lists it in the Room of the Philosophers, as "a painting of a nude Venus, lying with a little Cupid who kisses her, with two masks, [in] carved walnut perspective frame, with green taffeta curtain, and small iron [fastenings?]... design by Michelangelo, colored on panel by Venusto"[110]. The same room contained a bronze bust of Dante[111], a juxtaposition that may have been suggested by Vasari's *Lives*. Just over a century had passed since Michelangelo created his unique representation of Venus for Bettini's 'chamber'. Perhaps for the first time, a painted version of this Goddess of Love was united in a private palace with a portrait of the great poet she had inspired.

[1] GIORGIO VASARI, *Le vite de' piu eccellenti pittori scultori ed architettori nelle redazioni del 1550 e 1568*, a cura di Paola Barocchi e Rosanna Bettarini, 11 voll., Sansoni, Firenze 1966-1997, V, p. 326.

[2] In una lettera del 10 maggio 1548, Caro richiedeva al Vasari un complesso dipinto di Venere e Adone, e aggiungeva: «Se non voleste far più di una figure, la Leda, e specialmente quella di Michelangelo, mi diletta oltre modo»; ANNIBAL CARO, *Lettere familiari*, a cura di Aulo Greco, 3 voll., Le Monnier, Firenze 1957-1961, II, pp. 62-64 n. 329.

[3] Per gli esempi: JAMES M. SASLOW, *Michelangelo: Sculpture, Sex, and Gender*, in *Looking at Italian Renaissance Sculpture*, a cura di Sarah Blake McHam, Cambridge University Press, New York-Cambridge 1998, p. 239, il «massive muscular body is clearly male, its breasts unconvincingly tacked on»; ROBERT S. LIEBERT, *Michelangelo: A Psychoanalytic Study of His Life and Images*, Yale University Press, New Haven-London 1983, p. 249, «only the strange breasts and absence of male genitalia are evidence of her femaleness».

[4] Il materiale di questo paragrafo sarà sviluppato in un libro, che al momento sto scrivendo, sul tema del corpo femminile nell'arte e nella poesia di Michelangelo.

[5] Per l'autore e la storia del testo di questo dialogo, cfr. AGNOLO FIRENZUOLA, *On the beauty of women*, tradotto e a cura di Konrad Eisenbichler e Jacqueline Murray, University of Pennsylvania Press, Philadelphia 1992, pp. XIII-XLIV. Per la letteratura sulla bellezza femminile nell'Italia del Cinquecento, si vedano i saggi in *Concepts of Beauty in Renaissance Art*, a cura di Francis Ames-Lewis e Mary Rogers, Ashgate, Aldershot 1998, in particolare quelli di ELIZABETH CROPPER, pp. 1-11; MARY ROGERS, pp. 93-106, con riferimento ai loro precedenti e fondamentali studi; NAOMI YAVNEH, *The Ambiguity of Beauty in Tasso and Petrarch*, in *Sexuality and Gender in Early Modern Europe. Institutions, texts, images*, a cura di James Grantham Turner, Cambridge University Press, Cambridge-New York 1993, pp. 133-157.

[6] AGNOLO FIRENZUOLA, *Opere*, a cura di Adriano Seroni, Sansoni, Firenze 1958, pp. 591 e 594.

[7] FIRENZUOLA 1958, p. 590.

[8] FIRENZUOLA 1958, p. 573.

[9] DEANNA SHEMEK, *Ladies Errant. Wayward Women and Social Order in Early Modern Italy*, Duke University Press, Durham-London 1998, p. 96; in corso di pubblicazione una traduzione italiana (Edizioni Tre Lune, Mantova).

[10] FIRENZUOLA 1958, p. 590. Il suo contemporaneo Agostino Nifo, usava simili termini ed aggiungeva che, in una donna ideale, «il busto si avvicina alla forma di una pera capovolta, ma schiacciata»; *De Pulchro et Amore*, (1529), in *Scritti d'arte del Cinquecento*, a cura di Paola Barocchi, 3 voll., Ricciardi, Milano-Napoli 1971-1977, II, p. 1648. Questo passaggio è stato frainteso e interpretato come riferimento al seno, da MARILYN YALOM, *A History of the Breast*, Ballantine Books, New York 1997, p. 55.

[11] JONATHAN NELSON-JAMES STARK, *The Breasts of 'Night': Michelangelo as Oncologist?*, lettera all'editore, "New England Journal of Medicine", CCCXLIII. 21, 23 novembre, 2000, pp. 1577-1578; si tratta dell'argomento di un articolo di prossima pubblicazione. Questi segni fisici del cancro sono ancora una volta visibili nella copia dipinta da Michele Tosini, alla quale, nel recente restauro, sono stati tolti i panni del XIX secolo (Cat. 13).

[12] YAVNEH 1993, p. 138. Sulla misura ideale del seno, si veda anche YALOM 1997, pp. 49-90.

[13] Per la trattazione, cfr. SHEMEK 1998, p. 99.

[14] Nel 1548 Aretino scriveva a "La Zufolina", una cortigiana che egli descrive come davvero ambigua, a tal punto che il duca Alessandro volle praticare del sesso con lei, con il fine di scoprire se si trattasse veramente di un ermafrodito; cfr. FEDERIKA H. JACOBS, *Aretino and Michelangelo, Dolce and Titian: Femmina, Masculo, Grazia*, "Art Bulletin", LXXXII, 2000, p. 60. È interessante aggiungere che lo stesso duca fece confiscare la *Venere e Cupido* al Pontormo; forse questa muscolosa figura femminile intrigava particolarmente Alessandro.

[15] *Dialogo della pittura di m. Lodovico Dolce, intitolato L'Aretino*, Venezia 1557, p. 44, ristampato in MARK W. ROSKILL, *Dolce's Aretino and Venetian art theory of the Cinquecento*, New York University Press, New York 1968, p. 170.

[1] GIORGIO VASARI, *Le vite de' più eccellenti pittori scultori ed architettori nelle redazioni del 1550 e 1568*, ed. Paola Barocchi and Rosanna Bettarini, 11 vols., Sansoni, Firenze 1966-1997, V, p. 326.

[2] In a letter of 10 May 1548, Caro asked Vasari for a complex painting of Venus and Adonis, and added: "Se non voleste far più di una figure, la Leda, e specialmente quella di Michelangelo, mi diletta oltre modo"; ANNIBAL CARO, *Lettere familiari*, ed. Aulo Greco, 3 vols., Le Monnier, Firenze 1957-1961, II, pp. 62-64 n. 329.

[3] For examples: JAMES M. SASLOW, *Michelangelo: Sculpture, Sex, and Gender*, in *Looking at Italian Renaissance Sculpture*, ed. Sarah Blake McHam, Cambridge University Press, New York-Cambridge 1998, p. 239, the "massive muscular body is clearly male, its breasts unconvincingly tacked on"; ROBERT S. LIEBERT, *Michelangelo: A Psychoanalytic Study of His Life and Images*, Yale University Press, New Haven-London, 1983, p. 249, "only the strange breasts and absence of male genitalia are evidence of her femaleness".

[4] The material in this section will be developed in a book I am currently writing on the female body in Michelangelo's art and poetry.

[5] For the author and textual history see AGNOLO FIRENZUOLA, *On the beauty of women*, trans. and edited by Konrad Eisenbichler and Jacqueline Murray, University of Pennsylvania Press, Philadelphia 1992, pp. XIII-XLIV. On the literature about female beauty in Cinquecento Italy see the essays in *Concepts of Beauty in Renaissance Art*, ed. Francis Ames-Lewis and Mary Rogers, Ashgate, Aldershot 1998, especially those by ELIZABETH CROPPER, pp. 1-11; MARY ROGERS, pp. 93-106, with references to their earlier, fundamental studies; NAOMI YAVNEH, *The Ambiguity of Beauty in Tasso and Petrarch*, in *Sexuality and Gender in Early Modern Europe. Institutions, texts, images*, ed. James Grantham Turner, Cambridge University Press, Cambridge-New York 1993, pp. 133-157.

[6] AGNOLO FIRENZUOLA 1992, pp. 65, 65, 67.

[7] FIRENZUOLA 1992, p. 63.

[8] FIRENZUOLA 1992, p. 46.

[9] DEANNA SHEMEK, *Ladies Errant. Wayward Women and Social Order in Early Modern Italy*, Duke University Press, Durham-London 1998, p. 96; an Italian translation is forthcoming (Edizioni Tre Lune, Mantova).

[10] FIRENZUOLA 1992, p. 63. His contemporary, Augustinus Niphus (Nifo), used similar terms and added that in an ideal woman, "il busto si avvicina alla forma di una pera capovolta, ma schiacciata", *De Pulchro et Amore* (1529) in *Scritti d'arte del Cinquecento*, ed. Paola Barocchi, 3 vols., Ricciardi, Milano-Napoli 1971-1977, II, p. 1648. This passage was misunderstood as a reference to the breast in MARILYN YALOM, *A History of the Breast*, Ballantine Books, New York 1997, p. 55.

[11] JONATHAN NELSON-JAMES STARK, *The Breasts of "Night": Michelangelo as Oncologist?*, letter to the editor, 'New England Journal of Medicine', CCCXLIII. 21, November 23, 2000, pp. 1577-1578; this will be the subject of a forthcoming article. These physical signs of cancer are visible once again in painted copy by Michele Tosini, whose 19th century clothes were removed in the recent restoration (Cat. 13).

[12] YAVNEH 1993, p. 138. On the ideal breast size, also see YALOM 1997, pp. 49-90.

[13] For translation and discussion, see SHEMEK 1998, p. 99.

[14] In 1548 Aretino wrote to 'La Zufolina', a courtesan he described as truly ambiguous, so much so that Duke Alessandro wanted to have sex with her in order to discover if she was really a hermaphrodite; see discussion in FEDERIKA H. JACOBS, *Aretino and Michelangelo, Dolce and Titian: "Femmina, Masculo, Grazia"*, 'Art Bulletin', LXXXII, 2000, p. 60. It is interesting to add that the same Duke confiscated the *Venus and Cupid* from Pontormo; perhaps, this muscular female figure had a special appeal for Alessandro.

[15] *Dialogo della pittvra di m. Lodovico Dolce, intitolato L'Aretino*, Venice 1557, p. 44, reprinted in MARK W. ROSKILL, *Dolce's Aretino and Venetian art theory of the Cinquecento*, New York University Press, New York 1968, p. 170, with a slightly freer English translation on p. 171.

[16] PIRRO LIGORIO, *Trattato di alcune cose appartenente alla nobiltà dell'antiche arti e massimamente de la pittura de la scoltura e dell'architettura*, in BAROCCHI 1971-1977, II, p. 1436. Michelangelo's repre-

[16] Pirro Ligorio, *Trattato di alcune cose appartenente alla nobiltà dell'antiche arti e massimamente de la pittura de la scoltura e dell'architettura"*, in Barocchi 1971-1977, II, p. 1436. La rappresentazione del *Giudizio Universale* di Michelangelo, si differenzia dalle altre raffigurazioni dello stesso soggetto poiché, tra i dannati, non mostra chiaramente le rappresentazioni di donne, come osservato da Bernadine Barnes, *Michelangelo's "Last Judgment". The Renaissance Response*, University of California Press, Berkeley-Los Angeles-London 1998, p. 44. Sembra piuttosto improbabile che questa scelta sia da mettere in rapporto con il pubblico esclusivamente maschile, al quale il dipinto era destinato, come suggerito dall'autrice.

[17] Firenzuola 1958, p. 576.

[18] Firenzuola 1958, p. 594. Evidentemente aveva in mente la scultura di *Ercole e Caco* del Bandinelli, che era appena stata installata di fronte a Palazzo Vecchio. Per la critica inerente a quest'opera, senza menzione del Firenzuola, cfr. Louis A. Waldman, *"Miracol novo et raro": Two Unpublished Contemporary Satires on Bandinelli's "Hercules" and "Cacus"*, "Mitteilungen des Kunsthistorischen Institutes in Florenz", XXXVIII, 1994, pp. 419-27.

[19] Ulisse Aldrovandi, *Delle Statue Antiche, che per tutta Roma, in diversi luoghi, et case si veggono*, in Lucio Mauro, *Le Antichità della Città di Roma...* (1556), Venezia 1558, p. 122; Phyllis Pray Bober-Ruth Rubinstein, *Renaissance Artists and Antique Sculpture. A Handbook of Sources*, Oxford University Press, London-Oxford 1986, p. 55 n. 8.

[20] Howard Hibbard, *Michelangelo*, 2ª ed., Penguin, London-New York, 1985, p. 191. Cfr. Yael Even, *The Heroine as Hero in Michelangelo's Art*, "Woman's Art Journal", XI, 1990, p. 29, «the viraginous women who appear in his paintings and sculptures are, to some extent, the product of his homoerotic preference».

[21] Charles de Tolnay, *Corpus dei disegni di Michelangelo*, 4 voll., Istituto Geografico De Agostini, Novara 1975-1980, I, nn. 23v (Paris, Louvre: *Madonna che allatta*), 31r (Paris, Louvre: *Fanciulla nuda; Studio per una Maddalena*); II, nn. 248 (London, British Museum: *Madonna che allatta*), 303r (Firenze, Casa Buonarroti: *Maddalena in piedi*); III, n. 389bis (Oxford, Ashmolean Museum: *Madonna in piedi*).

[22] Michael Rocke, *Forbidden Friendships: Homosexuality and Male Culture in Renaissance Florence*, Oxford University Press, Oxford-New York 1996.

[23] Mario Equicola, *Libro di natura d'amore*, Lorio, Venezia 1525, p. 120; Stephen Kolsky, *Mario Equicola: the real courtier*, Librairie Droz, Genève, 1991, p. 29.

[24] Benedetto Varchi, *Due Lezzioni...*, Lorenzo Torrentino, Firenze, 1549/1550, in *Opere*, 2 voll., Sezione letterario-artistica del Lloyd austriaco, Trieste 1858-1859, II, pp. 624, 626. Nella sua trattazione su Michelangelo, non manca di lodarlo per i «costumi suoi onestissimi». La lezione si tenne il 6 marzo 1546, secondo il calendario fiorentino, e la dedica dell'editore a Bettini è datata 12 gennaio 1549, ovvero rispettivamente 1547 e 1550, per il calendario moderno.

[25] Gerda Panosky-Soergel, *Postscriptum to Tommaso Cavalieri*, in *Scritti di storia dell'arte in onore di Roberto Salvini*, Sansoni, Firenze 1984, pp. 399-406.

[26] Leonardo e Sodoma che, secondo le fonti rinascimentali, avevano relazioni sessuali con dei giovani, facevano raffigurazioni delicate, persino effeminate, sia di figure maschili che femminili.

[27] Creighton Gilbert, *The Proportion of Women*, in *Michelangelo on and off the Sistine Ceiling. Selected Essays*, Braziller, New York 1994, pp. 59-114. Anche Even 1990 faceva distinzioni tra tipi femminili di Michelangelo.

[28] Pietro Aretino, *Sei giornate...*, a cura di Giovanni Aquilecchia, Laterza, Bari 1969, p. 311; questo brano è citato da Robert Gaston, *Sacred Erotica: The Classical Figura in Religious Painting of the Early Cinquecento*, "International Journal of the Classical Tradition", II. 2, 1995, p. 244 n. 19.

[29] Vasari 1568/1966-1997, I, p. 114.

[30] *Il primo libro delle lettere di Nicolo Martelli*, Firenze 1546, pp. 48v-49r, lettera del 28 luglio 1544 a Domenico Rugasso, servatore del S. Orazio Farnese.

[31] Lomazzo, in Barocchi 1971-1977, II, p. 1851. Per un affascinante esempio di come Michelangelo facesse distinzioni tra tipologie di corporature, si veda la sequenza di quattro schizzi (Tolnay 1975-1980, III, n.

sentation of the *Last Judgment* differs from others by showing no clearly depicted women among the damned, as noted by Bernadine Barnes, *Michelangelo's 'Last Judgment'. The Renaissance Response*, University of California Press, Berkeley-Los Angeles-London 1998, p. 44. It seems most unlikely that this decision is related to the all-male audience, as she suggests.

[17] Firenzuola 1992, p. 49.

[18] Firenzuola 1992, p. 67. Evidently he had in mind Bandinelli's *Hercules and Cacus*, which had just been installed in front of the Palazzo Vecchio. For critiques of this work, without mention of Firenzuola, see Louis A. Waldman, *'Miracol' novo et raro': Two Unpublished Contemporary Satires on Bandinelli's 'Hercules' and 'Cacus'*, 'Mitteilungen des Kunsthistorischen Institutes in Florenz', XXXVIII, 1994, pp. 419-27.

[19] Ulisse Aldrovandi, *Delle Statue Antiche, che per tutta Roma, in diversi luoghi, et case si veggono*, in Lucio Mauro, *Le Antichità della Città di Roma...* (1556), Venezia 1558, p. 122; Phyllis Pray Bober-Ruth Rubinstein, *Renaissance Artists and Antique Sculpture. A Handbook of Sources*, Oxford University Press, London-Oxford 1986, p. 55 n. 8.

[20] Howard Hibbard, *Michelangelo*, 2nd ed., Penguin, London-New York 1985, p. 191. See Yael Even, *The Heroine as Hero in Michelangelo's Art*, 'Woman's Art Journal', XI, 1990, p. 29, "the viraginous women who appear in his paintings and sculptures are, to some extent, the product of his homoerotic preference".

[21] Charles de Tolnay, *Corpus dei disegni di Michelangelo*, 4 vols., Istituto Geografico De Agostini, Novara 1975-1980, I, nos. 23v (Paris, Louvre: *Nursing Madonna*), 31r (Paris, Louvre: *Nude girl, study for Magdalene*); II, nos. 248 (London, British Museum: *Nursing Madonna*), 303r (Firenze, Casa Buonarroti: *Standing Magdalene*); III, n. 389bis (Oxford, Ashmolean Museum: *Standing Madonna*).

[22] Michael Rocke, *Forbidden Friendships: Homosexuality and Male Culture in Renaissance Florence*, Oxford University Press, Oxford-New York 1996.

[23] Mario Equicola, *Libro di natura d'amore*, Lorio, Venezia 1525, p. 120; Stephen Kolsky, *Mario Equicola: the real courtier*, Librairie Droz, Genève 1991, p. 29.

[24] Benedetto Varchi, *Due Lezzioni...*, Lorenzo Torrentino, Firenze 1549/1550, in *Opere*, 2 vols., Sezione letterario-artistica del Lloyd austriaco, Trieste 1858-1859, II, pp. 624, 626. In his discussion about Michelangelo, Varchi also made a point of praising "costumi suoi onestissimi". The lecture was given on 6 March 1546, according to the Florentine calendar, and the dedication letter from the publisher to Bettini is dated 12 January 1549, thus they date 1547 and 1550, respectively, in the modern calendar.

[25] Gerda Panosky-Soergel, *Postscriptum to Tommaso Cavalieri*, in *Scritti di storia dell'arte in onore di Roberto Salvini*, Sansoni, Firenze 1984, pp. 399-406.

[26] Leonardo and Sodoma, who, according to Renaissance sources, had sexual relationships with youths, depicted both male and female figures as soft, even feminine.

[27] Creighton Gilbert, *The Proportion of Women*, in *Michelangelo on and off the Sistine Ceiling. Selected Essays*, Braziller, New York 1994, pp. 59-114. Even 1990 also distinguished between Michelangelo's female types.

[28] Pietro Aretino, *Sei giornate....*, ed. Giovanni Aquilecchia, Laterza, Bari 1969, p. 311; this passage is mentioned in Robert Gaston, *Sacred Erotica: The Classical Figura in Religious Painting of the Early Cinquecento*, 'International Journal of the Classical Tradition', II. 2, 1995, p. 244 n. 19.

[29] Vasari 1568/1966-1997, I, p. 114.

[30] *Il primo libro delle lettere di Nicolo Martelli*, Firenze 1546, pp. 48v-49r, letter of 28 July 1544 to Domenico Rugasso 'servatore del S. Orazio Farnese'.

[31] Lomazzo, in Barocchi 1971-1977, II, p. 1851. For a fascinating example of how Michelangelo did distinguish between body types, see the sequence of four sketches (Tolnay 1975-1980, III, n. 408r; Wien, Albertina) where he transforms a muscular male nude to a softer, rounder, female figure.

408r; Wien, Albertina) dove trasforma un nudo maschile muscoloso in una figura femminile più morbida e rotondeggiante.

[32] Come riportato in GIORGIO VASARI, *La Vita di Michelangelo della redazione del 1550 e del 1568*, a cura di Paola Barocchi, 5 voll., Ricciardi, Milano-Napoli 1962, p. 126.

[33] LIGORIO, in BAROCCHI 1971-1977, II, p. 1436.

[34] Lo studio rivoluzionario di THOMAS LAQUEUR, *Making Sex: Body and Gender from the Greeks to Freud*, Harvard University Press, Cambridge 1990, dovrebbe essere letto congiuntamente alla recensione critica di KATHARINE PARK-ROBERT A. NYE, *Destiny in Anatomy*, "The New Republic", 18 febbraio 1991, pp. 53-57, e uno studio esemplare di JOAN CADDEN, *Meanings of Sex Difference in the Middle Ages*, Cambridge University Press, Cambridge-New York 1993, in particolare pp. 201-227.

[35] I testi di medicina, per esempio, spiegavano che la vagina era un pene rovesciato; in certe circostanze, quali un'attività faticosa, i "malformati" genitali femminili potevano venir fuori dal corpo, trasformando così la donna in un uomo; cfr. PATRICIA PARKER, *Gender Ideology, Gender Change: The Case of Marie Germain*, "Critical Inquiry", 1993, pp. 337-64.

[36] Per la *Defensio mulierum* (1501 ca.) dello Strozzi, cfr. PAMELA JOSEPH BENSON, *The Invention of the Renaissance Woman. The Challenge of Female Independence in the Literature and Thought of Italy and England*, Pennsylvania State University Press, University Park (Penn) 1992, p. 49.

[37] Per questo e due altri testi simili del Dolce, cfr. RONNIE H. TERPENING, *Lodovico Dolce, Renaissance man of letters*, University of Toronto Press, Toronto-Buffalo-London 1997, pp. 134-145.

[38] Per la trattazione cfr. BENSON 1992, p. 81.

[39] VINCENZO COLLI CALMETA, *Della ostentazione*, in *Prose e lettere edite e inedite*, a cura di Cecil Grayson, Commissione per i testi di lingua, Bologna 1959, pp. 40-41, citato e argomentato da SHARON FERMOR, *Movement and gender in sixteenth-century Italian painting*, in The Body Imaged. The Human Form and Visual Culture since the Italian Renaissance, a cura di Kathleen Adler e Marcia Pointon, Cambridge University Press, Cambridge-New York 1993, pp. 133-134.

[40] FIRENZUOLA 1958, p. 61. Per il termine, cfr. FERMOR 1993, pp. 129-146; e SHARON FERMOR, *Poetry in motion: beauty in movement and the Renaissance concept of leggiadrìa*, in AMES-LEWIS e ROGERS 1998, pp. 124-133.

[41] FRANCESCO BOCCHI, *Le bellezze della città di Fiorenza...* (1591), Gregg, Farnborough 1971, p. 268; per la lettera di Doni, del 12 gennaio 1543, a Michelangelo, cfr. *Il carteggio di Michelangelo*, a cura di Paola Barocchi e Renzo Ristori, Sansoni, Firenze 1965-1983, IV, pp. 160-163 n. MVI.

[42] LEON BATTISTA ALBERTI, *Della pittura*, a cura di Luigi Malle, Sansoni, Firenze 1950, II, 44, p. 97.

[43] Cfr. FERMOR 1993.

[44] SPERONE SPERONI, *Dialogo d'amore* (1537), in *Trattatisti del Cinquecento*, a cura di Mario Pozzi, Ricciardi, Milano 1978, p. 514, come citato e sviluppato da MARY PARDO, *Artifice as Seduction in Titian*, in TURNER 1993, p. 77.

[45] RONA GOFFEN, *Mary's Motherhood According to Leonardo and Michelangelo*, "Artibus et historiae. An art anthology", XL, 1999, p. 51. Analogamente, EVEN 1990, p. 29, si riferisce alle «cross-gender images» di Michelangelo, e, a proposito della *Sibilla Libica*, scrive: «More masculine than feminine, she attains an heroic stature that enables her to join "the higher order" of her two male counterparts».

[46] La caratterizzazione della *Leda*, in Aretino, contrasta spiccatamente con quella di RONA GOFFEN, *Titian's Women*, Yale University Press, New Haven-London 1997, p. 234, «Michelangelo's *Night / Leda* is muscular exertion and sculptural clarity».

[47] MICHELANGELO BUONARROTI, *Rime*, a cura di Enzo Noè Girardi, Laterza, Bari 1960, n. 14. I primi versi recitano: «el Dì e la Nocte parlano, e dicono: /– noi abbìano col nostro veloce corso condotto alla morte el duca Giuliano; / è ben giusto che e' ne facci vendetta come fa». Cfr. anche ANTHONY HUGHES, *A Lost Poem by Michelangelo?*, "Journal of the Warburg and Courtauld Institutes", XLIV, 1981, pp. 202-206; egli sostiene convincentemente che questi versi rappresentino una bozza di una spiegazione dell'iscrizione che Michelangelo aveva progettato per la tomba.

[48] Non ci sono segni che indichino la presenza di un lembo di tessuto o

[32] As cited in GIORGIO VASARI, *La Vita di Michelangelo della redazione del 1550 e del 1568*, ed. Paola Barocchi, 5 vols., Ricciardi, Milano-Napoli 1962, p. 126.

[33] LIGORIO, in BAROCCHI 1971-1977, II, p. 1436.

[34] The groundbreaking study by THOMAS LAQUEUR, *Making Sex: Body and Gender from the Greeks to Freud*, Harvard University Press, Cambridge 1990, should be read in conjunction with a critical review by KATHARINE PARK-ROBERT A. NYE, *Destiny in Anatomy*, 'The New Republic', 18 February 1991, pp. 53-57, and an exemplary study by JOAN CADDEN, *Meanings of Sex Difference in the Middle Ages*, Cambridge University Press, Cambridge-New York 1993, esp. pp. 201-227.

[35] Medical texts, for example, explained that the vagina was an inverted penis; under certain circumstances, such as strenuous activity, a woman's "malformed" genitals could emerge from her body, thus transforming her into a man; see PATRICIA PARKER, *Gender Ideology, Gender Change: The Case of Marie Germain*, 'Critical Inquiry', 1993, pp. 337-364.

[36] For Strozzi's *Defensio mulierum*, c. 1501, see PAMELA JOSEPH BENSON, *The Invention of the Renaissance Woman. The Challenge of Female Independence in the Literature and Thought of Italy and England*, Pennsylvania State University Press, University Park (Penn) 1992, p. 49.

[37] For this and two related works by Dolce see RONNIE H. TERPENING, *Lodovico Dolce, Renaissance man of letters*, University of Toronto Press, Toronto-Buffalo-London 1997, pp. 134-145.

[38] For discussion see BENSON 1992, p. 81.

[39] VINCENZO COLLI CALMETA, *Della ostentazione*, in *Prose e lettere edite e inedite*, ed. Cecil Grayson, Commissione per i testi di lingua, Bologna 1959, pp. 40-41, as quoted and discussed in SHARON FERMOR, *Movement and gender in sixteenth-century Italian painting*, in *The Body Imaged. The Human Form and Visual Culture since the Italian Renaissance*, ed. Kathleen Adler and Marcia Pointon, Cambridge University Press, Cambridge-New York 1993, pp. 133-134.

[40] FIRENZUOLA 1992, p. 34; For the term see FERMOR 1993, pp. 129-146; and SHARON FERMOR, *Poetry in motion: beauty in movement and the Renaissance concept of leggiadrìa*, in AMES-LEWIS and ROGERS 1998, pp. 124-133.

[41] FRANCESCO BOCCHI, *Le bellezze della città di Fiorenza...* (1591), Gregg, Farnborough 1971, p. 268; for Doni's 12 January 1543 letter to Michelangelo see *Il carteggio di Michelangelo*, ed. Paola Barocchi and Renzo Ristori, Sansoni, Firenze 1965-1983, IV, pp. 160-163 n. MVI.

[42] LEON BATTISTA ALBERTI, *On Painting*, trans. and ed. by John R. Spencer, Yale University Press, New Haven-London 1966, p. 80.

[43] See FERMOR 1993.

[44] SPERONE SPERONI, *Dialogo d'amore* (1537), in *Trattatisti del Cinquecento*, ed. Mario Pozzi, Ricciardi, Milano 1978, p. 514, as cited and discussed in MARY PARDO, *Artifice as Seduction in Titian*, in TURNER 1993, p. 77.

[45] RONA GOFFEN, *Mary's Motherhood According to Leonardo and Michelangelo*, 'Artibus et historiae. An art anthology', XL, 1999, p. 51. Similarly, EVEN 1990, p. 29, refers to Michelangelo's "cross-gender images", and writes of the *Libyan Sibyl*, "More masculine than feminine, she attains an heroic stature that enables her to join 'the higher order' of her two male counterparts".

[46] Aretino's characterization of the *Leda* contrasts markedly with the one in RONA GOFFEN, *Titian's Women*, Yale University Press, New Haven-London 1997, p. 234, "Michelangelo's *'Night/Leda'* is muscular exertion and sculptural clarity".

[47] MICHELANGELO BUONARROTI, *Rime*, ed. Enzo Noè Girardi, Laterza, Bari 1960, n. 14. The first lines read "Day and Night speak, and they say: / We have with our swift course led Duke Giuliano to his death, / and it is only just that he has his revenge for it, as he does", as translated by ANTHONY HUGHES, *A Lost Poem by Michelangelo?*, 'Journal of the Warburg and Courtauld Institutes', XLIV, 1981, pp. 202-206. He argues convincingly that these verses are the draft of an explanation of the inscription Michelangelo had planned for the tomb.

[48] There is no indication of drapery or flesh between the left hand and shoulder of the Accademia panel, according to the restorer Rossella Lari,

un tratto di pelle, tra la mano e la spalla sinistra, nella tavola dell'Accademia, secondo il giudizio della restauratrice, Rossella Lari, e neppure nelle altre versioni dipinte e disegnate. L'unica eccezione è rappresentata dal disegno a tutta grandezza di Napoli (Cat. 27), che vi introduce un drappeggio; si può presumere che l'anonimo copista avesse rielaborato il prototipo.

⁴⁹ Il rilievo antico più vicino alla *Leda* di Michelangelo è riprodotto in GUSTAVE MENDEL, *Musée Impérial Ottoman. Catalogue des Sculptures Grecques, Romaines et Byzantines*, Constantinopoli 1914, pp. 21-22, cat. 820. Sono grato a Leo Steinberg per questa osservazione.

⁵⁰ VINCENZO CARTARI, *Le immagini degli dèi*, a cura di Caterina Volpi, De Luca, Roma 1996, pp. 593-594. La storia di questa statua, basata sul *Lexicon* di Suidas (970 ca.), è citata anche nel *Hieroglyphicorum* (1556), di Valeriano, e poteva essere ben nota precedentemente, dato che Valeriano aveva lavorato per i Medici, a Firenze, all'inizio degli anni Venti del Cinquecento.

⁵¹ CARTARI 1996, pp. 593-594.

⁵² JACOBS 2000, p. 51. Per questo interesse sui confini tra i generi sessuali, Jacobs cita anche molti altri testi sull'argomento, compreso quello di Dolce e la lettera di Aretino a "La Zufolina" (cfr. nota 14), ma non il Cartari.

⁵³ Secondo GEORGE L. HERSEY, *The Evolution of Allure: Sexual Selection from the Medici Venus to the Incredible Hulk*, MIT Press, Cambridge (Mass) 1996, pp. 79-80, l'altezza della *Notte* misura otto teste, e la lunghezza delle gambe è pari a quattro. Nel suo manuale delle arti, del 1395, Cennino Cennini trascura le vere proporzioni del corpo femminile poiché non le ritiene perfette; cfr. PHILIP SOHM, *Gendered Style in Italian Art Criticism from Michelangelo to Malvasia*, "Renaissance Quarterly", XLVIII, 1995, pp. 778-779.

⁵⁴ THOMAS FRANGENBERG, *The notion of beauty in Francesco Bocchi's Bellezze della città di Fiorenza*, I, in AMES-LEWIS e ROGERS 1998, p. 194.

⁵⁵ BENEDETTO VARCHI, *Lezzione della maggioranza delle arti*, Firenze 1549/1550, in BENEDETTO VARCHI-VINCENZO BORGHINI, *Pittura e scultura nel Cinquecento*, a cura di Paola Barocchi, Sillabe, Livorno 1998, p. 47.

⁵⁶ Per le lettere a Bettini (o che lo nominano) scritte da Martelli, Busini, il Lasca, Caro e Varchi, cfr. JONATHAN NELSON, *Dante Portraits in Sixteenth-Century Florence*, "Gazette des Beaux-Arts", CXIX, 1992, pp. 59-77; e MASSIMO FIRPO, *Gli affreschi di Pontormo a San Lorenzo: eresia, politica e cultura nella Firenze di Cosimo I*, Einaudi, Torino 1997, pp. 173 n. 73; pp. 177-178.

⁵⁷ BENEDETTO VARCHI, *Questione sull'alchimia*, Magheri, Firenze 1827, p. XIII, dedica datata 11 novembre 1544.

⁵⁸ NICCOLÒ MARTELLI, *Dal primo e dal secondo libro delle lettere*, a cura di Cartesio Marconcini, Carabba, Lanciano 1916, pp. 98-120.

⁵⁹ Cfr. saggio di Leporatti in questo volume.

⁶⁰ Per Martini si veda JONATHAN NELSON, *Creative Patronage: Luca Martini and the Renaissance Portrait*, "Mitteilungen des Kunsthistorischen Institutes in Florenz", XXIX, 1995, pp. 282-305; e ID., *Luca Martini, dantista, and Pierino da Vinci's Relief of the 'Death of Count Ugolino della Gherardesca and His Sons'*, in *Pierino da Vinci*, atti del convegno (Vinci 1990) a cura di Marco Cianchi, Becocci, Firenze 1995, pp. 24-32. In un dialogo di Alessandro Allori (1560), il personaggio "Bronzino" annunciava che Varchi e Martini sarebbero arrivati per cena, «e sentirai forse trattare di alcuni passi sopra il nostro stupendissimo poeta Dante», in BAROCCHI 1971-1977, II, p. 1965.

⁶¹ BENVENUTO VARCHI, *"Delle trasformazioni" di Publio Ovidio Nasone, libro XIII tradotto da lingua latina in volgare fiorentino in versi sciolti*, in *Opuscoli inediti di celebri autori toscani...*, 2 voll., Stamperia di Borgo Ognissanti, Firenze 1809, II, pp. 167-189.

⁶² BUONARROTI 1965-1983, IV, pp. 257-258 n. MLXXVI, scritto alla fine di marzo o all'inizio dell'aprile 1547; Martini evidentemente aveva inviato una versione manoscritta del testo. Poco tempo dopo la pubblicazione, Michelangelo citava il libro in una lettera dell'inizio del 1550; IV, pp. 339-340 n. MCXLIIII. Ancora una volta, l'artista esprime il suo compiacimento e quello di Cavalieri.

⁶³ L'originaria funzione della "camera" di Bettini non è chiara; per la tradizione delle camere decorate, cfr. saggio di Aste in questo volume.

⁶⁴ CRISTINA ACIDINI LUCHINAT, *La fucina artistica di Castello*, in *Le ville e giardini di Castello e Petraia a Firenze*, a cura di Cristina Acidini Luchinat e Giorgio Galletti, Pacini, Pisa 1992, p. 42.

⁶⁵ JOHN POPE-HENNESSY, *Cellini*, Abbeville Press, New York 1985, p. 175.

and none is visible in the the painted and drawn versions. The only exception is the full-scale drawing in Naples (Cat. 27), which shows some drapery; presumably, the anonymous copyist elaborated on the prototype.

⁴⁹ The ancient relief closest to Michelangelo's *Leda* is reproduced in GUSTAVE MENDEL, *Musée Impérial Ottoman. Catalogue des Sculptures Grecques, Romaines et Byzantines*, Constantinopoli 1914, pp. 21-22, cat. 820. I thank Leo Steinberg for this observation.

⁵⁰ VINCENZO CARTARI, *Le immagini degli dèi*, ed. Caterina Volpi, De Luca, Roma 1996, pp. 593-594. The story of this statue, based on Suidas' *Lexicon* (c. 970), was also cited in Valeriano's *Hieroglyphicorvm* (1556), and may well have been known earlier, given that Valeriano had worked for the Medici in Florence in the early 1520s.

⁵¹ CARTARI 1996, pp. 593-594.

⁵² JACOBS 2000, p. 51. For this interest in gender boundaries Jacobs also cites many other relevant texts, including Dolce, and Aretino's letter to 'La Zufolina' (see note 14), but not Cartari.

⁵³ According to GEORGE L. HERSEY, *The Evolution of Allure: Sexual Selection from the Medici Venus to the Incredible Hulk*, MIT Press, Cambridge (Mass) 1996, pp. 79-80, the height of the *Night* is equal to eight heads, and the length of her legs is four. In his 1395 art manual, Cennino Cennini disregards the true proportions of women because they are not perfect; see discussion in PHILIP SOHM, *Gendered Style in Italian Art Criticism from Michelangelo to Malvasia*, 'Renaissance Quarterly', XLVIII, 1995, pp. 778-779.

⁵⁴ THOMAS FRANGENBERG, *The notion of beauty in Francesco Bocchi's Bellezze della città di Fiorenza*, I, in AMES-LEWIS and ROGERS 1998, p. 194.

⁵⁵ BENEDETTO VARCHI, *Lezzione della maggioranza delle arti*, Firenze 1549/1550, in BENEDETTO VARCHI-VINCENZO BORGHINI, *Pittura e scultura nel Cinquecento*, ed. Paola Barocchi, Sillabe, Livorno 1998, p. 47.

⁵⁶ For letters to Bettini (or which mention him) written by Martelli, Busini, il Lasca, Caro and Varchi, see JONATHAN NELSON, *Dante Portraits in Sixteenth-Century Florence*, 'Gazette des Beaux-Arts', CXIX, 1992, pp. 59-77; and MASSIMO FIRPO, *Gli affreschi di Pontormo a San Lorenzo: eresia, politica e cultura nella Firenze di Cosimo I*, Einaudi, Torino 1997, pp. 173 n. 73; pp. 177-178.

⁵⁷ BENEDETTO VARCHI, *Questione sull'alchimia*, Magheri, Firenze 1827, p. XIII, dedication dated 11 November 1544.

⁵⁸ NICCOLÒ MARTELLI, *Dal primo e dal secondo libro delle lettere*, ed. Cartesio Marconcini, Carabba, Lanciano 1916, pp. 98-120.

⁵⁹ See the essay by Leporatti in this volume.

⁶⁰ For Martini see JONATHAN NELSON, *Creative Patronage: Luca Martini and the Renaissance Portrait*, 'Mitteilungen des Kunsthistorischen Institutes in Florenz', XXIX, 1995, pp. 282-305; and ID., *Luca Martini, dantista, and Pierino da Vinci's Relief of the 'Death of Count Ugolino della Gherardesca and His Sons'*, in *Pierino da Vinci*, Arts of Conference (Vinci 1990) ed. Marco Cianchi, Becocci, Firenze 1995, pp. 24-32. In a dialogue by Alessandro Allori (1560), the 'Bronzino' character announced that Varchi and Martini would come for dinner, "e sentirai forse trattare di alcuni passi sopra il nostro stupendissimo poeta Dante", in BAROCCHI 1971-1977, II, p. 1965.

⁶¹ BENVENUTO VARCHI, *Delle trasformazioni di Publio Ovidio Nasone libro XIII tradotto da lingua latina in volgare fiorentino in versi sciolti*, in *Opuscoli inediti di celebri autori toscani...*, 2 vols., Stamperia di borgo Ognissanti, Firenze 1809, II, pp. 167-189.

⁶² BUONARROTI 1965-1983, IV, pp. 257-258 n. MLXXVI, written in late March or early April 1547; Martini evidently send a manuscript version of the text. Soon after it was published, Michelangelo mentioned the book in a letter of early 1550; IV, pp. 339-340 n. MCXLIIII. Once again, the artist expressed his pleasure, and that of Cavalieri.

⁶³ The original function of Bettini's *camera* is not clear; for the tradition of bedroom decorations, see the essay by Aste in this volume.

⁶⁴ CRISTINA ACIDINI LUCHINAT, *La fucina artistica di Castello*, in *Le ville e giardini di Castello e Petraia a Firenze*, ed. Cristina Acidini Luchinat and Giorgio Galletti, Pacini, Pisa 1992, p. 42.

[66] Una vivace conversazione tra personaggi seduti è anche il soggetto di un curioso dipinto pontormesco, a Londra (National Gallery, Inv. 3941), che forse corrisponde ad un'opera citata nell'inventario di Benedetto Gondi, nel 1609, come «quadro non finito, di una Accademia di litterati, di mano di Iacopo da Pontormo»; GINO CORTI, *Two Early Seventeenth-Century Inventories Involving Giambologna*, "The Burlington Magazine", CXVIII, 1976, p. 633.

[67] VARCHI 1549/1550, in VARCHI 1998, pp. 56-57.

[68] ALBERTI 1950, II, 44, p. 97.

[69] Per questa espressione, ringrazio Deanna Shemek che ha sviluppato il concetto del "blocco" visivo nella letteratura del Rinascimento, in SHEMEK 1998, p. 83. Cinzio Giraldi, nel suo *Discorso intorno al comporre de i romanzi* (1554, p. 31), avvertiva che sarebbe improprio per i suoi contemporanei seguire l'esempio di Omero, che scriveva di una principessa che andò con le sue donne a lavare i panni al fiume.

[70] GIAN PAOLO LOMAZZO, in BAROCCHI 1971-1977, II, pp. 1853-1855; GERALD MARTIN ACKERMAN, *The Structure of Lomazzo's Treatise on Painting*, tesi di Ph.D., Princeton University, 1964, p. 95.

[71] Per la trattazione cfr. DEANNA SHEMEK, *Of Women, Knights, Arms, and Love: the "Orlando Furioso" and Ariosto's "Querelle des Femmes"*, "MLN (Modern Language Notes)" , CIV. 1, 1989, pp. 68-97.

[72] Per le rappresentazioni rinascimentali di Amazzoni, cfr. CRISTELLE L. BASKINS, *Cassone Painting, Humanism, and Gender in Early Modern Italy*, Cambridge University Press, Cambridge-New York 1998, pp. 75-102.

[73] VARCHI 1549/1550 in VARCHI 1998, p. 45.

[74] BUONARROTI 165-1983, IV, pp. 265-266, n. MLXXXII, scritta in aprile-giugno 1597; VARCHI 1549/1550 in VARCHI 1998, p. 84

[75] VASARI/BAROCCHI 1962, p. 1021; trattazione in LEATRICE MENDELSOHN, *Paragone. Benedetto Varchi's "Due Lezzioni" and Cinquecento Art Theory*, UMI Press, Ann Arbor 1982, p. 162.

[76] VARCHI 1549/1550, in VARCHI 1858-1859, II, p. 626.

[77] WILLIAM KEACH, *Cupid disarmed or Venus wounded. An Ovidian Source for Michelangelo and Bronzino*, "Journal of the Warburg and Courtauld Institutes", XLI, 1978, pp. 327-331. A proposito del bacio, cfr. anche i saggi di Leporatti e Mendelsohn, in questo volume.

[78] Traduzione del Benivieni in italiano dal latino, tradotto dal greco dal Poliziano; cfr. qui saggio Leporatti.

[79] In modo analogo, la collocazione ambigua delle figure nel *Noli me tangere*, dà quasi l'impressione che Cristo tocchi Maria Maddalena; cfr. WILLIAM E. WALLACE, *Il "Noli me tangere" di Michelangelo tra sacro e profano*, "Arte cristiana", LXXVI, 1988, pp. 443-450.

[80] Per lo stesso motivo, gli storici dell'arte argomentano circa il gesto di Maria nel *Tondo Doni* – la Madonna porge o riceve il Bambino? – ma nessuna madre premurosa reggerebbe un infante in questo modo. Michelangelo creò non tanto una posa naturalistica quanto estremamente stilizzata.

[81] GAETANO MILANESI, *Della "Venere baciata da Cupido", dipinta dal Pontormo sul cartone di Michelangiolo Buonarroti*, in *Le opere di Giorgio Vasari*, a cura di Gaetano Milanesi, 9 voll., Sansoni, Firenze 1878-1885, VI, pp. 291-295. Per un compendio della maggior parte delle più importanti interpretazioni precedenti il 1960, compreso il Milanesi, cfr. VASARI 1568/1962, pp. 1941-1943. Per le interpretazioni più recenti, cfr. FRANCESCO GANDOLFO, *Il "dolce tempo": mistica, ermetismo e sogno nel Cinquecento*, Bulzoni, Roma 1978, p. 114, che interpreta Venere come «semplice *voluptas* che travia Eros, l'amore, riducendolo dal suo stato spirituale e sublimante a quello carnale e terreno»; ANGELA NEGRO, *"Venere e Amore" di Michele di Ridolfo del Ghirlandaio. Il mito di una "Venere" di Michelangelo fra copie, repliche e pudiche vestizioni*, Campisano, Roma 2001, p. 32: «Il tema reale del dipinto... è quindi *Venere che seduce Cupido disarmandolo*»; Joannides nel Cat. 29; Mendelsohn nel suo saggio, e gli autori citati di seguito. L'interpretazione sostenuta in questo saggio è stata elaborata in stretta collaborazione con Roberto Leporatti, al quale sono molto grato per la sua assistenza e per i suggerimenti.

[82] Cfr. scheda di Cat. 29.

[83] In modo simile, Michelangelo contrappone i beati ai dannati nei suoi affreschi della Cappella Sistina, nel *Giudizio Universale* e nel *Miracolo del serpente di bronzo*.

[84] Volendo citare un esempio per tutti, si veda il fugace riferimento alla

[65] JOHN POPE-HENNESSY, *Cellini*, Abbeville Press, New York 1985, p. 175.

[66] A lively conversation among seated men is also the subject of a curious, Pontormesque painting in London (National Gallery, Inv. 3941), perhaps identifiable with a work listed in the 1609 inventory of Benedetto Gondi as "un quadro non finito, di una Accademia di litterati, di mano di Iacopo da Pontormo"; GINO CORTI, *Two Early Seventeenth-Century Inventories Involving Giambologna*, 'The Burlington Magazine', CXVIII, 1976, p. 633.

[67] VARCHI 1549/1550, in VARCHI 1998, pp. 56-57.

[68] ALBERTI-SPENCER 1966, p. 80.

[69] For this term I thank Deanna Shemek who discusses a "blockage" in Renaissance literature in SHEMEK 1998, p. 83. Cinzio Giraldi, in his *Discorso intorno al comporre de i romanzi* (1554, p. 31), warned that it would be improper for his contemporaries to follow the example of Homer, who wrote that a Princess went with her maids to wash clothes in the river.

[70] GIAN PAOLO LOMAZZO, in BAROCCHI 1971-1977, II, pp. 1853-1855; GERALD MARTIN ACKERMAN, *The Structure of Lomazzo's Treatise on Painting*, Ph.D. diss., Princeton University, 1964, p. 95.

[71] For discussion see DEANNA SHEMEK, *Of Women, Knights, Arms, and Love: the 'Orlando Furioso' and Ariosto's 'Querelle des Femmes'*, 'MLN (Modern Language Notes)', CIV. 1, 1989, pp. 68-97.

[72] For Renaissance depictions of Amazons, see CRISTELLE L. BASKINS, *Cassone Painting, Humanism, and Gender in Early Modern Italy*, Cambridge University Press, Cambridge-New York 1998, pp. 75-102.

[73] VARCHI 1549/1550, in VARCHI 1998, p. 45.

[74] BUONARROTI 1965-1983, IV, pp. 265-266, n. MLXXXII, written in April-June 1547; VARCHI 1549/1550 in VARCHI 1998, p. 84.

[75] VASARI 1568/1962, p. 1021; discussion and English translation in LEATRICE MENDELSOHN, *Paragone. Benedetto Varchi's 'Due Lezzioni' and Cinquecento Art Theory*, UMI Press, Ann Arbor 1982, p. 162.

[76] VARCHI 1549/1550, in VARCHI 1858-1859, II, p. 626.

[77] WILLIAM KEACH, *Cupid disarmed or Venus wounded. An Ovidian Source for Michelangelo and Bronzino*, 'Journal of the Warburg and Courtauld Institutes', XLI, 1978, pp. 327-331. On the kiss also see the essays by Leporatti and Mendelsohn in this volume.

[78] I translate from Benivieni's Italian translation of Poliziano's Latin translation of the Greek; see Leporatti's essay.

[79] Analogously, the ambiguous placement of the figures in the *Noli me tangere* almost give the impression that Christ touches Mary Magdalene; see WILLIAM E. WALLACE, *Il 'Noli me tangere' di Michelangelo tra sacro e profano*, 'Arte cristiana', LXXVI, 1988, pp. 443-450.

[80] By the same token, art historians debate about Mary's gesture in the *Doni tondo* – does she give or receive the Christ Child? – but no caring mother would ever hold an infant in this way. Michelangelo created a highly stylized pose, not a naturalistic one.

[81] GAETANO MILANESI, *Della 'Venere baciata da Cupido', dipinta dal Pontormo sul cartone di Michelangiolo Buonarroti*, in *Le opere di Giorgio Vasari*, ed. Gaetano Milanesi, 9 vols., Sansoni, Firenze 1878-1885, VI, pp. 291-295. For a summary of most major interpretations before 1960, including Milanesi, see VASARI 1568/1962, pp. 1941-1943. For more recent interpretations see FRANCESCO GANDOLFO, *Il 'dolce tempo': mistica, ermetismo e sogno nel Cinquecento*, Bulzoni, Roma 1978, p. 114, who interprets Venus as "semplice *voluptas* che travia Eros, l'amore, riducendolo dal suo stato spirituale e sublimante a quello carnale e terreno"; ANGELA NEGRO, *'Venere e Amore' di Michele di Ridolfo del Ghirlandaio. Il mito di una 'Venere' di Michelangelo fra copie, repliche e pudiche vestizioni*, Campisano, Roma 2001, p. 32: "Il tema reale del dipinto... è quindi *Venere che seduce Cupido disarmandolo*"; Joannides, in Cat. 29; Mendelsohn, in her essay; and authors cited below. The interpretation presented in this essay was developed in close collaboration with Roberto Leporatti, to whom I am most grateful for his assistance and suggestions.

[82] See Cat. 29.

[83] In a similar fashion, Michelangelo contrasts the blessed and damned in his Sistine Chapel frescoes, in the *Last Judgment*, and in the *Miracle of the Brazen Serpent*.

«Venere santa e non quella lasciva», in *Descrizione del convito e delle feste fatte in Pesaro per le nozze di Costanzo Sforza e di Cammilla d'Aragona nel maggio del 1475*, a cura di Marco Tabarrini, Barbèra, Firenze 1870, p. 20.

[85] BUONARROTI 1960, n. 260. In un altro sonetto Michelangelo distingueva l'amore nobile dalla lussuria: «Voglia sfrenata è il senso, e non amore / che l'alma uccide» (BUONARROTI 1960, n. 105; BUONARROTI 1980, n. 103).

[86] *Commento dello Illustrissimo Signor Conte Joanni Pico Mirandolano sopra una canzone de Amore composta da Girolano Benivieni*, in *De hominis dignitate, Heptaplus, De ente et uno e scritti vari*, a cura di Eugenio Garin, Vallecchi, Firenze 1942, p. 537; Pico spiega perché Benivieni, parlando d'amore si rivolge a un carattere maschile ("Amor"), mentre Cavalcanti si rivolgeva ad uno femminle (la sua "Donna"). Secondo Ficino (*Dell'amore*, VII. IX.2), le donne che mostrino un certo carattere mascolino possono più facilmente attrarre gli uomini.

[87] Per l'associazione tra disegno e virtù "virili", cfr. SOHM 1995, in part. pp. 782-784. Questo concetto è stato applicato in modo appropriato alle figure femminili di Michelangelo, da GOFFEN 1997, p. 233.

[88] BOCCHI 1591, p. 184, trattato in ROBERT WILLIAMS, *The notion of beauty in Francesco Bocchi's "Bellezze della città di Fiorenza"* I, in AMES-LEWIS e ROGERS 1998, p. 202.

[89] CHARLES DE TOLNAY, *Michelangelo*, 5 voll., Princeton University Press, Princeton 1943-1960, III, *The Medici Chapel*, Princeton University Press, Princeton 1948, pp. 108-109, 194-196. Egli esprime anche lo strano concetto secondo il quale il dipinto raffigurerebbe il momento prima della differenziazione tra amore spirituale e sensuale.

[90] MENDELSOHN 1982, p. 121.

[91] Per la lettera del Vasari, cfr. MATTHIAS WINNER, *Michelangelo's "Il Sogno" as an Example of an Artist's Visual Reflection in His Drawings*, in *Michelangelo Drawings*, a cura di Craig Hugh Smyth, National Gallery of Art, Washington 1992, p. 241 n. 34, che la mette in collegamento con il ritratto di Aretino. Nel disegno di Venere del Salviati, la dea stessa indossa una maschera; cfr. Cat. 9. JACOBS 2000, p. 59, osserva la «Venus's curiously masklike face» nel dipinto di Napoli, Cat. 28; questo particolare effetto, causato dalla presenza della zona scura sotto all'orecchio della dea, praticamente scompare quando si osserva il quadro con un'illuminazione appropriata.

[92] Negli anni Venti del Cinquecento, Michelangelo scrisse delle ottave burlesche, sulla scia della tradizione della *Nencia da Barberino* di Lorenzo. (BUONARROTI 1960, n. 20). Un contadino loda la sua donna con una serie di rozzi paragoni, per esempio: «Quand'io ti veggo, in su 'n ciascuna poppa/ mi paion duo cocomer in un sacco». In un sonetto del 1507 ca. (BUONARROTI 1960, n. 4), Michelangelo descrive il piacere di un vestito stretto che fascia il petto della sua donna; il nastro «che preme e tocca il petto ch'egli allaccia» ne sembra deliziato.

[93] ALLARDYCE NICOLL, *Masks, Mimes, and Miracles*, Cooper Square, New York 1963, p. 234.

[94] La linea di contorno del drappeggio è ora visibile con maggiore facilità in un disegno fedele, conservato al Louvre, probabilmente dovuto alla bottega di Alessandro Allori; cfr. *Appendice II*, e qui in *Catalogo* fig 28-a).

[95] Il saggio di PAUL BAROLSKY su *Art as Deception*, in *The faun in the garden: Michelangelo and the poetic origins of Italian Renaissance art*, Pennsylvania State University Press, University Park (Penn) 1994, pp. 107-118, fissa il contesto per la comprensione dell'importanza dell'artificio – e del ruolo delle maschere e della statuetta – nei dipinti della *Venere*. JOHN T. PAOLETTI, *Michelangelo's Masks*, "Art Bulletin", LXXIV, 1992, pp. 438-439, collega la maschera a satiro con la perduta scultura di una testa di satiro di Michelangelo, e pertanto funge da surrogato della presenza dell'artista.

[96] ALESSANDRO CONTI, *Pontormo*, Jaca Book, Milano 1995, p. 51.

[97] ANNA MARIA BRACCIANTE, *Ottaviano de' Medici e gli artisti*, S.P.E.S., Firenze 1984, p. 89.

[98] WILLIAM E. WALLACE, *Michelangelo's Leda: the diplomatic context*, "Renaissance Studies", XV, 2001, pp. 473-499.

[99] CARLO GINZBURG, *Tiziano, Ovidio e i codici della figurazione erotica del Cinquecento*, "Paragone", 339, 1978, pp. 3-24. Cfr. anche DIANE WOLFTHAL, *Images of Rape. The "Heroic" Tradition and its Alternative*, Cambridge University Press, Cambridge-New York 1999, p. 23; e DAVID FREEDBERG, *The*

[84] To cite but one example, see the passing reference to "Venere santa e non quella lasciva" in *Descrizione del convito e delle feste fatte in Pesaro per le nozze di Costanzo Sforza e di Cammilla d'Aragona nel maggio del 1475*, ed. Marco Tabarrini, Babèra, Firenze 1870, p. 20.

[85] BUONARROTI 1960, n. 260. This translation is based on Michelangelo Buonarroti, *Complete Poem and Selected Letters*, trans. by Creighton Gilbert, II ed., Princeton University Press, Princeton 1980, n. 258. In another sonnet Michelangelo distinguished noble love from lust: "Unreigned desire, not love, our senses are, / Killing the soul" (BUONARROTI 1960, n. 105; BUONARROTI 1980, n. 103).

[86] *Commento dello Illustrissimo Signor Conte Joanni Pico Mirandolano sopra una canzone de Amore composta da Girolano Benivieni*, in *De hominis dignitate, Heptaplus, De ente et uno e scritti vari*, ed. Eugenio Garin, Vallecchi, Firenze 1942, p. 537; GIOVANNI PICO DELLA MIRANDOLA, *Commentary on a canzone of Benivieni*, translated by Sears Jayne, Lang, New York 1984, p. 133. Pico explains why Benivieni, when he discusses love, addresses a male figure ("Amor"), whereas Cavalcanti addressed a female one (his "Donna"). According to Ficino (*Dell'amore*, VII. IX. 2), women who display a certain masculine character can more easily attract men.

[87] For the association between *disegno* and "manly" virtues see SOHM 1995, esp. pp. 782-784. This concept was righly applied to Michelangelo's female figures by GOFFEN 1997, p. 233.

[88] BOCCHI 1591, p. 184, as translated and discussed in ROBERT WILLIAMS, *The notion of beauty in Francesco Bocchi's 'Bellezze della città di Fiorenza'*, I, in AMES-LEWIS and ROGERS 1998, p. 202.

[89] CHARLES DE TOLNAY, *Michelangelo*, 5 vols., Princeton University Press, Princeton 1943-1960, III, *The Medici Chapel*, Priceton University Press, Princeton 1948, pp. 108-109, 194-196. He also expresses the odd notion that the painting shows the moment before the differentiation of spiritual and sensual love.

[90] MENDELSOHN 1982, p. 121.

[91] For Vasari's letter see MATTHIAS WINNER, *Michelangelo's 'Il Sogno' as an Example of an Artist's Visual Reflection in His Drawings*, in *Michelangelo Drawings*, ed. Craig Hugh Smyth, National Gallery of Art, Washington 1992, p. 241 n. 34, who associates it with the portrait of Aretino. In Salviati's drawing of Venus, the Goddess herself wears a mask; see Cat. 9. JACOBS 2000, p. 59, notes "Venus's curiously masklike face" in the Naples painting, Cat. 28; this characteristic, caused by the dark area under the Goddess's ear, virtually disappears when the panel is viewed with proper lighting.

[92] In the 1520s, Michelangelo wrote a burlesque octave stanza in the tradition of Lorenzo's *Nencia da Barberino* (BUONARROTI 1960, n. 20; BUONARROTI 1980, n. 18). A peasant praises his Lady with a series of rustic comparisons, e.g. "When I look upon you and each breast, / I think they're like two melons in a satchel". In a sonnet from ca. 1507 (BUONARROTI 1960, n. 4; BUONARROTI 1980, n. 4), Michelangelo describes the pleasure enjoyed by the tight dress that binds his Lady's chest; the ribbon seems delighted "to press and touch the breast that it has yolked".

[93] ALLARDYCE NICOLL, *Masks, Mimes, and Miracles*, Cooper Square, New York 1963, p. 234.

[94] The outline of the drapery is now most easily seen in an accurate drawing in the Louvre, probably from the workshop of Alessandro Allori; see *Appendix II* and in the catalogue, fig. 23-a.

[95] PAUL BAROLSKY's essay on *Art as Deception*, in *The faun in the garden: Michelangelo and the poetic origins of Italian Renaissance art*, Pennsylvania State University Press, University Park (Penn) 1994, pp. 107-118, establishes a context for understanding the importance of artifice – and the role of the masks and the statuette – in the *Venus* paintings. JOHN T. PAOLETTI, *Michelangelo's Masks*, 'Art Bulletin', LXXIV, 1992, pp. 438-439, associates the satyr mask with Michelangelo's lost statue of a satyr head, which thus functions as a surrogate of the artist's presence.

[96] ALESSANDRO CONTI, *Pontormo*, Jaca Book, Milano 1995, p. 51.

[97] ANNA MARIA BRACCIANTE, *Ottaviano de' Medici e gli artisti*, S.P.E.S., Firenze 1984, p. 89.

[98] WILLIAM E. WALLACE, *Michelangelo's Leda: the diplomatic context*, 'Renaissance Studies', XV, 2001, pp. 473-499.

[99] CARLO GINZBURG, *Tiziano, Ovidio e i codici della figurazione erotica*

Power of Images. Studies in the History and Theory of Response, University of Chicago Press, Chicago-London 1989, pp. 317-344, per l'eccitazione sessuale prodotta dalle immagini.

[100] Un'altra similitudine con la lettera di Aretino è rappresentata dall'importanza data al bacio divino (quello di Giove o quello di Venere). I parallelismi dimostrano che questi testi riflettono punti di vista e modalità di espressione paragonabili. Esiste la possibilità che l'anonimo autore conoscesse la lettera di Aretino; Vasari certamente aveva tutto l'interesse a far circolare simili lodi.

[101] CARL FREY, *Der Literarische nachlass Giorgio Vasaris*, 3 voll., Georg Müller, München 1923-1940, I, p. 132.

[102] Un Cupido ha uno strumento simile a quello che si vede nella *Venere* del Brescianino (Cat. 11); per le varie versioni del dipinto del Vasari, cfr. LAURA CORTI, *Vasari. Catalogo completo*, Cantini, Firenze 1989, p. 38 n. 21.

[103] JOHN FLORIO, *A Worlde of Wordes*, 1598, «Buonarobba, as we say, good stuffe, a good wholesome plump-cheeked wench», come riportato nell'*Oxford English Dictionary*, p. 156-380 (*bonaroba*). Walter Kaiser mi ha fornito gentilmente il riferimento su Shakespeare e mi ha assistito nella traduzione della lettera.

[104] Ringrazio Paul Barolsky per questo e altri suggerimenti; per il *Pigmalione e Galatea* di Bronzino (Firenze, Galleria degli Uffizi), cfr. PHILIPPE COSTAMAGNA, *Pontormo*, Electa, Milano 1994, cat. 66a, che lo data al 1530 ca.

[105] Per il dipinto di Colonia (Wallraf-Richartz-Museum, Inv. n. 875), con un'iscrizione latina che parla di come Venere disapprovi Cupido, cfr. JEFFERSON CABEL HARRISON JR., *The paintings of Maerten van Heemskerck: a catalogue raisonné*, 2 voll., tesi di Ph.D., University of Virginia, 1987, pp. 599-610 n. 66; e *Venus, Vergeten Mythe. Voorstellingen van een godin van Cranach tot Cézanne*, a cura di Ekkehard Mai, catalogo della mostra (Köln-München-Antwerp), Koninklijk Museum voor Schone Kunsten, Antwerp 2001, p. 284 n. 27; entrambi senza fare accenno a Michelangelo.

[106] Cfr. PARDO 1993, pp. 73-82; GOFFEN 1997, pp. 233-35; JACOBS 2000; WALLACE 2001, pp. 483-485.

[107] VASARI 1568/1966-1997, VI, p. 165; commento in SOHM 1995, p. 785.

[108] S. J. FREEDBERG, *Painting in Italy 1500-1600*, II ed., Penguin, London 1983, p. 178.

[109] Sembra che questo disegno non sia mai stato usato come cartone di lavoro, ovvero per trasferire la composizione; fu probabilmente realizzato come documentazione visiva del cartone originale di Michelangelo. Se così fosse, quest'opera e il disegno a tutta grandezza della *Leda* (Cat. 17) dovrebbero essere tra i più precoci disegni di grandi dimensioni, realizzati per i collezionisti, come opere d'arte a sé stanti, e non come disegni preparatori per dei dipinti (vedi saggio Bellucci-Frosinini).

[110] *Raffaello, Michelangelo e bottega: i cartoni farnesiani restaurati*, a cura di Rossana Muzii, catalogo della mostra (Napoli), Electa, Napoli 1993, pp. 22, 26. Questo saggio comprende un eccellente resoconto delle attribuzioni, delle interpretazioni, delle copie e delle provenienze del dipinto e del disegno, e fa notare come nel 1832 fossero stati conservati nel "Gabinetto de' quadri osceni".

[111] Napoli, Museo Nazionale di Capodimonte, n. 10516; cfr. BRUNO MOLAJOLI, *Notizie su Capodimonte: catalogo delle gallerie e del museo*, 5ª ed., L'arte Tipografica, Napoli 1964, p. 111, fig. 145, come fiorentina, XVI secolo; e NELSON 1992, p. 77 n. 83. Per l'inventario del 1649, cfr. CHRISTINA RIEBESELL, *Die Sammlung des Kardinal Alessandro Farnese: ein 'studio' für Künstler und Gelehrte*, "Acta Humaniora", Weinheim (VCH) 1989. Una versione preliminare del materiale che costituisce l'ultimo paragrafo è stata presentata nel 1987 come "term paper" a Kathleen Weil-Garris Brandt, che ringrazio per i suoi utili suggerimenti.

del Cinquecento, 'Paragone', 339, 1978, pp. 3-24. Also see DIANE WOLFTHAL, *Images of Rape. The "Heroic" Tradition and its Alternative*, Cambridge University Press, Cambridge-New York 1999, p. 23; and DAVID FREEDBERG, *The Power of Images. Studies in the History and Theory of Response*, University of Chicago Press, Chicago-London 1989, pp. 317-344, for sexual arousal by images.

[100] Another similarity with Aretino's letter is the importance given to the divine kiss (Jupiter's or Venus's). The parallels show that these texts reflect comparable ways of viewing and modes of expression. The possibility exists that the anonymous author knew Aretino's letter; Vasari certainly had every incentive to circulate such praise.

[101] CARL FREY, *Der Literarische nachlass Giorgio Vasaris*, 3 vols., Georg Müller, München 1923-1940, I, p. 132.

[102] One of the Cupids has an instrument like that found in Brescianino's *Venus* (Cat. 11); for the various versions of Vasari's painting see LAURA CORTI, *Vasari. Catalogo completo*, Cantini, Firenze 1989, p. 38 n. 21.

[103] JOHN FLORIO, *A Worlde of Wordes*, 1598, "Buonarobba, as we say, good stuffe, a good wholesome plump-cheeked wench", as cited in the *Oxford English Dictionary*, p. 156/380 (*bonaroba*). Walter Kaiser kindly gave me the Shakespearean reference and assisted me in translating the letter.

[104] I thank Paul Barolsky for this and many other suggestions; for Bronzino's *Pigmalian and Galatea* (Firenze, Galleria degli Uffizi), see PHILIPPE COSTAMAGNA, *Pontormo*, Electa, Milano 1994, cat. 66a, as c. 1530.

[105] For the Cologne painting (Wallraf-Richartz-Museum, Inv. n. 875), with a Latin inscription about how Venus criticized Cupid, see JEFFERSON CABEL HARRISON JR., *The paintings of Maerten van Heemskerck: a catalogue raisonné*, 2 vols., Ph.D. diss., University of Virginia, 1987, pp. 599-610 n. 66; and *Venus, Vergeten Mythe. Voorstellingen van een godin van Cranach tot Cézanne*, ed. Ekkehard Mai, exh. cat. (Köln-München-Antwerp), Koninklijk Museum voor Schone Kunsten, Antwerp 2001, p. 284 n. 27; both without mention of Michelangelo.

[106] See PARDO 1993, pp. 73-82; GOFFEN 1997, pp. 233-35; JACOBS 2000; WALLACE 2001, pp. 483-485.

[107] VASARI 1568/1966-1997, VI, p. 165; translation and commentary in SOHM 1995, p. 785.

[108] S. J. FREEDBERG, *Painting in Italy 1500-1600*, II ed., Penguin, London 1983, p. 178.

[109] It seems that this drawing was never used as a cartoon, i.e. to transfer the composition; it was probably made as a visual record of Michelangelo's original cartoon. If so, this work and the full-scale drawing of the *Leda* (Cat. 17) must be among the earliest large drawings made as works of art, for collectors, and not as preparatory for paintings (see essay by Bellucci-Frosinini).

[110] *Raffaello, Michelangelo e bottega: i cartoni farnesiani restaurati*, ed. Rossana Muzii, exh. cat. (Napoli), Electa, Napoli 1993, pp. 22, 26. This essay includes an excellent account of the attributions, interpretations, copies, and provenance of the painting and drawing, and notes that in 1832 they were kept in the "Gabinetto de' quadri osceni".

[111] Naples, Museo Nazionale di Capodimonte, n. 10516; see BRUNO MOLAJOLI, *Notizie su Capodimonte: catalogo delle gallerie e del museo*, V ed., L'arte Tipografica, Napoli 1964, p. 111, fig. 145, as Florentine, sixteenth-century; and NELSON 1992, p. 77 n. 83. For the 1649 inventory see CHRISTINA RIEBESELL, *Die Sammlung des Kardinal Alessandro Farnese: ein 'studio' für Künstler und Gelehrte*, Acta Humaniora, Weinheim (VCH) 1989. A preliminary version of the material in this last section was presented in a 1987 term paper to Kathleen Weil-Garris Brandt, who I thank for her useful suggestions.

1. Giorgio Vasari, *Sei poeti toscani / Six Tuscan Poets*.
 Minneapolis, Institute of Arts.

Roberto Leporatti

VENERE, CUPIDO
E I POETI D'AMORE

VENUS, CUPID
AND THE POETS OF LOVE

L'immagine più viva di Bartolomeo Bettini e della sua cerchia di amici ci è restituita da un dialogo inedito, intitolato *Il Vespro*, scritto da Baccio Tasio[1], in cui il banchiere e mecenate fiorentino compare come interlocutore insieme ad Alessandro Davanzati e Luca Martini, l'altro protagonista della vita letteraria e artistica di quegli anni, studioso di Dante e occasionale poeta[2]. Vi si discute della recente rappresentazione di una commedia, intitolata il *Negromante*, tenuta, pare alla presenza del duca, in casa del Bettini. È probabile che non si tratti di quella dell'Ariosto, ma di un'opera per il momento non identificata[3]. I riferimenti non coincidono nel contenuto, e a un certo punto il Bettini elogia l'autore perché ha cambiato il titolo in omaggio alla Compagnia de' Negromanti che l'ha rappresentata: (rivolgendosi al Martini) «per più honorare quegli che la facevono, fra ' quali et tu et io eravamo, finse il nome alla Comedia Negromante de' Negromanti; cosa non più fatta: per gl'altri sempre, o dalle persone della comedia, o dal subbietto di quella, le hanno denominate». Non è chiaro se quel «fra ' quali et tu et io eravamo» alluda alle responsabilità per l'organizzazione e l'allestimento dello spettacolo, o se preveda addirittura una loro partecipazione diretta come attori. Potrebbe trattarsi della stessa Compagnia de' Negromanti che nel marzo 1533 in casa Antinori rappresentò una commedia, ricordata dal Vasari nel *Libro delle ricordanze*, che per l'occasione aiutò il Bronzino a dipingere una prospettiva[4]. Nel dialogo la discussione è guidata da Luca Martini, che non ha apprezzato lo spettacolo e può esporre così le sue opinioni sul genere commedia e in particolare sulla struttura e la lingua di quella rappresentata. Il gruppo di artisti e intellettuali, fra i quali oltre a quelli appena nominati avrà fatto la sua comparsa anche il giovane Benedetto Varchi che ad essi rimase sempre legato, non si dilettava soltanto di passare il tempo «in ispassi, in bei tempi et in Comedie», ma si riuniva spesso anche per leggere e commentare i grandi scrittori, in particolare di materia amorosa. Probabilmente proprio

The most vivid image of Bartolomeo Bettini and his circle of friends passed down to us is that found in the unpublished dialogue entitled *Il Vespro* written by Baccio Tasio[1]. The banker and Florentine patron appears as an interlocutor together with Alessandro Davanzati and Luca Martini, the other protagonist of literary and artistic life of the time, a scholar of Dante and occasional poet[2]. The discussion centers on the recent performance of a comedy entitled the *Negromante*. This was probably not Ariosto's, given that the content does not correspond, but another as yet unidentified work[3]. It was put on in Bettini's house and, it seems, in the presence of the Duke. At a certain point Bettini praises the author for his change in title in homage to the Company of the *Negromanti* that had performed the comedy. He says to Martini: "he named the comedy *Negromante* of the *Negromanti* more in honor of those producing it, you and I among them; something never again done, for others have always been named after the personages in the comedy or after its subject". Whether the "you and I among them" alludes to the responsibility of Martini and Bettini for the organization and presentation of the spectacle or to their direct participation in it as actors remains unclear. The Company of *Negromanti* may be the same that staged a production of a comedy in Casa Antinori in March 1533; this was mentioned in the *ricordi* of Vasari, who for the occasion helped Bronzino design a stage prop[4]. In the dialogue Luca Martini, who apparently did not enjoy the spectacle, leads the discussion professing his views on the genre of comedy and in particular on the structure and the language adopted in the one represented. Besides the personages already mentioned we must include the young Benedetto Varchi, who was constantly in contact with this circle of artists and intellectuals. They not only took pleasure in "pastimes, good times, and Comedies", but also met often to read and comment on great

2. Giorgio Vasari, *Sei poeti toscani / Six Tuscan Poets*, particolare / detail, Minneapolis, Institute of Arts.

per accogliere discussioni come queste il Bettini aveva immaginato, secondo la testimonianza del Vasari, la sua "camera" decorata con una galleria di ritratti con i maggiori poeti che «hanno con versi e prose toscane cantato d'amore», con al centro la tavola con *Venere e Cupido* disegnata da Michelangelo e dipinta dal Pontormo.

Rimasta incompiuta e smembrata la decorazione di questa "camera", l'unico documento organico che rifletta, anche se in modo originale, lo spirito di quel progetto rimane la tavola dei cosiddetti *Sei poeti toscani* di Giorgio Vasari (Cat. 24, Tav. IV/1; figg. 1-3), commissionata da Luca Martini nel luglio 1543 e consegnata circa un anno dopo. Nonostante in proposito siano confuse e contraddittorie le testimonianze del Vasari nei *Ricordi* e del Giovio in una lettera in cui ne chiedeva una copia con «Guido Cavalcanti e Guiton d'Arezo e[n] cambio di Ficino e del Landino»[5], si è d'accordo nel ritenere questa la tavola commissionata dal Martini. Vi si riconoscono i ritratti di Dante, Petrarca, Boccaccio, Cavalcanti (fig. 2), e di due autorevoli commentatori e traduttori delle loro opere, il letterato e umanista Cristoforo Landino e il filosofo platonico Marsilio Ficino (fig. 3)[6]. Se comparato ai giudizi di valore che si erano ormai imposti in tutta Italia a quasi metà Cinquecento, si vede che la tavola ripropone una gerarchia, con Dante in veste di assoluto protagonista, e un canone, con l'aggiunta essenziale rispetto alle tre corone del solo Cavalcanti, che risalgono a modelli lontani, in un certo senso arcaici, come il *Comento de' miei sonetti* di Lorenzo de' Medici e i *Nutricia* del Poliziano[7]. L'inclusione in abiti moderni dei due umanisti quattrocenteschi accentua ancor di più questa interpretazione: il Landino vi è richiamato come autore del fortunatissimo commento alla *Commedia* (1481), il Ficino

writers, particularly those who had written on questions of Love. It must have been just this type of discussion that Bettini envisioned when he devised the decoration of his chamber. According to Vasari, this was to include a gallery of portraits of the major poets who "with their Tuscan verses and prose have sung the praise of love", and to have as its center the *Venus and Cupid* panel designed by Michelangelo and painted by Pontormo.

The only vestige that reflects, albeit in an original manner, the spirit of the chamber's incomplete and dismantled decorative scheme is Vasari's so-called *Six Tuscan Poets* (Cat. 24, Pl. IV/1; figs. 1-3). Despite the confused and contradictory comments Vasari himself makes on this painting in his book of *ricordi* and those contained in a letter by Paolo Giovio, who requested a copy with "Guido Calvacanti and Guiton d'Arezo in exchange for Ficino and Landino"[5], the work is generally held to be the one commissioned from Vasari by Martini in July of 1543 and completed about a year later. The portraits depict Dante, Petrarch, Boccaccio, Calvacanti (fig. 2), and two authoritative commentators and translators of their works: the man of letters and humanist Cristoforo Landino, and the platonic philosopher Marsilio Ficino (fig. 3)[6].

This group does not reflects the system of values in vigor in the mid-sixteenth century Italy; clearly the painting represents a hierarchical configuration that places Dante in the role of absolute protagonist. Moreover, it presents a literary canon that – with the single and essential addition of Guido Cavalcanti to the three crowns – finds its origin in earlier and, in a certain sense, archaic models, such as Lorenzo the Magnificent's *Comment on my sonnets* [*Comento de' miei sonetti*] and Angelo Poliziano's *Nutricia*[7]. The inclusion of the two

come traduttore della *Monarchia* di Dante (1468), ma anche come riscopritore del Cavalcanti, a cui riserva in quanto poeta-filosofo un posto secondo solo a Platone nel suo *Commentarium in Convivium Platonis de amore*, da lui stesso volgarizzato e intitolato *El libro dell'Amore* (1469).[8]

Con la pubblicazione a Venezia delle *Prose della volgar lingua* nel 1525, Pietro Bembo aveva imposto per la letteratura volgare due modelli possiamo dire esclusivi: Petrarca per la poesia, Boccaccio per la prosa[9]. La proposta aveva incontrato forti resistenze a Firenze, dove non andava a genio l'idea di abbandonare nella scrittura il rapporto vitale con la lingua d'uso. In generale però, o almeno negli ambienti legati al committente della tavola, Luca Martini, la proposta era stata nella sostanza recepita[10]. Concorda con questo giudizio, e definisce «il Petrarca molto più che ciascun altro toscano lucido e terso», anche la più autorevole risposta fiorentina alle *Prose* del Bembo, la cosiddetta *Giuntina di rime antiche*, pubblicata nel 1527, una raccolta dei più antichi rimatori toscani finora inediti[11]: Dante con le sue sole *Rime*, Cavalcanti, Cino da Pistoia, Guittone d'Arezzo e altri minori; ossia, con l'ideale aggiunta delle altre due corone, proprio il canone, di ascendenza petrarchesca[12], imposto dal Giovio nella sua variante non sopravvissuta dei *Sei poeti*. Il Bembo, che esalta soprattutto il Petrarca come campione di eleganza poetica e proprietà linguistica, parlando di Dante, scrive che «sarebbe stato più lodevole che egli di meno alta e meno ampia materia posto si fosse a scrivere»[13]. Quello che per la tradizione fiorentina determinava il primato della *Commedia*, ossia l'altezza morale e religiosa e la vastità enciclopedica dei suoi contenuti, diveniva per lui un peso, persino un impaccio per chi scrive versi. Per l'umanista veneto un'«alta e ampia materia» spetta al teologo, al filosofo, allo scienziato, non al poeta che ha come obiettivo primario l'eleganza della parola. Era invece proprio sull'impegno dei contenuti che, nella tradizione dell'umanesimo volgare e civile fiorentino, si era fondato il successo del poema dantesco[14]: proprio quei caratteri messi tanto in evidenza dagli strumenti scientifici ostentati in primo piano nella tavola del Vasari.

Questo orientamento ha le sue radici nella cultura dell'età di Lorenzo il Magnifico (fig. 4). Fondamentale è la riscoperta promossa dal Ficino della poesia stilnovistica, maturata a Firenze alla fine del Duecento, e di cui ormai da tempo si era perso memoria. La *Commedia* non era più presentata come un fatto isolato, ma tornava a essere vista come il frutto più alto di tutta una tradizione di opere letterarie di impronta filosofica e scientifica. Vengono rilette le opere minori di Dante, come la *Vita nova* e il *Convivio*, in cui la poesia amorosa viene sottilmente commentata dall'autore stesso e nel secondo caso si presta a una trattazione di tipo addirittura enciclopedico. Insieme al Dante minore viene riscoperto anche il suo «primo amico» Guido Cavalcanti, autore di un manipolo di poesie di grande impegno filosofico, tra le quali una canzone, *Donna me prega perch'eo voglio dire*, in cui dà una sua interpretazione dell'a-

3. Giorgio Vasari, *Sei poeti toscani Six Tuscan Poets*, particolare detail, Minneapolis, Institute of Arts.

fifteenth-century humanists in modern dress lays further emphasis on this interpretation. Landino was the author of the extremely popular commentary on the *Divine Comedy* (1481); Ficino was the translator of Dante's *Monarchia* (1468), but also as the re-discoverer of Cavalcanti. This poet-philosopher earns a place second only to Plato in Ficino's *Commentarium in Convivium Platonis de amore*, a volume translated into the vernacular by the author himself with the title *On Love* (1469)[8].

With the publication in Venice of the *Prose della volgar lingua* in 1525, Pietro Bembo furnished two possible and practically exclusive models for vernacular literature: Petrarch for poetry and Boccaccio for prose[9]. The proposal encountered strong resistance in Florence, where there was little interest in the idea of abandoning the vital rapport between spoken and written language. In general, however, Bembo's proposal had been basically accepted, at least in the circles tied to Martini, the patron of the *Six Tuscan Poets*.[10] Even the most authoritative Florentine response to Bembo's *Prose*, the so-called Giuntina edition of "antique rhymes" concurred with this judgment, defining "Petrarch much more lucid and clear than other Tuscans". Published in 1527, the compilation included the most ancient and hitherto unpublished Tuscan poetic compositions[11]: Dante (with only his rhymes), Cavalcanti, Cino da Pistoia, Guittone d'Arezzo and other minor figures. This was precisely the canon of Petrarchan origin[12] that — with the ideal integration of the other two crowns, Petrarch and Boccaccio — Giovio applied to his copy, now lost, of Vasari's *Six Tuscan Poets*.

Bembo above all exalted Petrarch as the champion of poetic elegance and linguistic command; the scholar maintained

4. Scuola di Giorgio Vasari,
*Lorenzo il Magnifico
fra i filosofi e i letterati
del suo tempo*
*Lorenzo the Magnificent
with the philosophers
and 'letterati' of his time*
Firenze, Palazzo Vecchio.

more in termini scientifici e fisiologici, come passione che porta all'autodistruzione, e che fu commentata da alcuni dei più celebri medici e filosofi del suo tempo, come Dino del Garbo[15]. Il protagonista di questo recupero, come si è detto, fu Ficino, che nell'ultima orazione del suo *Libro dell'amore*, la VII, conclude parlando proprio di «Guido filosofo, diligente tutore della Patria sua e nelle sottigliezze di logica nel suo secolo superiore a tutti». Vi afferma addirittura che quanto è esposto nell'intero libro lo si può ritrovare già mirabilmente racchiuso nelle sue rime: «Costui seguitò lo Amore socratico in parole e in costumi. Costui con gli suoi versi brevemente conchiuse, ciò che da voi di Amore è detto»[16].

Il recupero della poesia stilnovistica non rispondeva a esigenze archeologiche, ma era una proposta viva, rivolta dal Ficino ai poeti contemporanei perché riprendessero il filone da troppo tempo abbandonato di una poesia amorosa di orientamento filosofico, s'intende aggiornata alle nuove dottrine neoplatoniche da lui stesso elaborate. Il primo a raccogliere il suo invito fu proprio Lorenzo il Magnifico, che si rese subito conto di come l'affermazione del primato di una tradizione tipicamente fiorentina oltre quella ormai nazionale di Dante, Petrarca e Boccaccio, poteva giovare alle sue aspirazioni a un primato anche politico. Si diede così alla composizione di poesie amorose improntate ai principî del neoplatonismo ficiniano, una parte delle quali dotò anche di prose esplicative tese a enfatizzare il loro spessore filosofico e scientifico nel *Comento de' miei sonetti*. Anche gli altri maggiori poeti della sua cerchia fecero altrettanto. Angelo Poliziano, la cui raffinata educazione umanistica si univa a una

that Dante "would have been more praiseworthy had he concentrated on less lofty and vast material in his writings"[13]. That which had determined the primacy of the *Divine Comedy* in the Florentine tradition – its moral and religious heights, and the encyclopedic vastness of content – became a weight for Bembo, even an obstacle to the writing of verse. The Venetian humanist believed that "lofty and vast subject matter" was the business of theologians, philosophers, and scientists, not poets, whose primary objective was elegance of expression. Nevertheless, it was precisely the depth of content that had established the success of the *Divine Comedy* in the Florentine tradition of vernacular and civic humanism[14]. These very qualities are given so much emphasis by the scientific instruments displayed in the foreground of Vasari's painting.

These convictions found their origin in the culture of the age of Lorenzo (fig. 4). Here Ficino promoted the fundamental rediscovery of the *stilnovisti* poets who had flourished at the end of the Duecento, and whose memory had been forgotten. The *Divine Comedy* was no longer presented as an isolated incident, but seen once again as the noblest fruit of a full harvest of literary creations, philosophical and scientific in nature.

Attention was given to some minor works by Dante, such as the *Vita nova* and *Convivio*, in which the author himself subtly comments his own amorous verses; the latter text even lent itself to an encyclopedic type of analysis. Together with this 'minor' Dante, the poet's "first friend", Cavalcanti, was also rediscovered. He was the author of a numerous poems deep

profonda conoscenza della tradizione poetica toscana, nelle sue rime e nelle preziose allegorie neoplatoniche delle *Stanze*, arieggia spesso Dante e Cavalcanti. Girolamo Benivieni (fig. 5) compose un canzoniere, pervaso da un'intensa adesione ai principî amorosi ficiniani[17], e scrisse anche una canzone d'amore «secondo la mente e opinione de' platonici», che fu ampiamente commentata da Pico della Mirandola, come una sorta di risposta a quella di Cavalcanti e dei suoi commentatori: «Di questi dua amori hanno tractato specificamente dua Poeti in lingua Toscana. Dello amore vulgare Guido Cavalcanti in una sua canzona. Dell'altro, cioè del celeste, el Poeta nostro [Benivieni] nell'opera presente».[18]

Nasce in età laurenziana anche la tradizione delle indagini sulla topografia dell'oltremondo dantesco, che miravano a dimostrare la precisione dei riferimenti matematici e astrologici nella *Commedia*, confermandone anche da questo punto di vista l'alto valore scientifico[19]. L'iniziatore fu l'architetto e matematico Antonio di Tuccio Manetti, appassionato cultore di Cavalcanti e dedicatario della traduzione della *Monarchia* dantesca e del *Libro dell'Amore* del Ficino. Le sue ricerche sul «sito, forma e misura dello 'nferno dantesco» furono per la prima volta esposte in forma compendiosa dal Landino nel proemio al suo commento alla *Commedia*[20]. Girolamo Benivieni nella

5. Ridolfo del Ghirlandaio, *Ritratto di Girolamo Beniveni*
Portrait of Girolamo Beniveni
London , National Gallery.

in philosophical meaning, such as the *canzone* "Donna me prega perch'eo voglio dire"; this was commented on by some of the most famous doctors and Aristotelian philosophers of his time, such as Dino del Garbo[15].

In these works Cavalcanti professed his interpretation of love in scientific and physiological terms as a passion that leads to self destruction. Ficino, as we have seen, was the protagonist of this revival; he concluded the seventh and last speech of his *On Love* with a mention of "Guido the philosopher, the diligent mentor of his fatherland, superior to all of his time in the refinement of Logic". Ficino even went so far as to affirm that everything expressed in his entire book was already admirably stated in Cavalcanti's rhymes: "A follower of Socratic love in words and costume, his verses contain in brief all you have stated about love"[16].

The recovery of the *stilnovisti* poetry was not an archeological process but a vital resumption. Ficino proposed this to his contemporaries as an invitation to renew a form of poetry that had been abandoned for too long: Love poetry with a philosophical orientation, naturally brought up to date with the neo-Platonic doctrines Ficino himself had recently elaborated. The first to respond to the summons was Lorenzo the Magnificent. He immediately grasped that affirming the primacy of a typically Florentine tradition – beyond that of Dante, Petrarch, and Boccaccio, which by then had become national – could assist his aspirations for a political primacy. Thus he dedicated himself to the composition of amorous verse imbued with the principles of Ficino's neo-Platonism. In Lorenzo's *Comment on my sonnets*, some of his writings were furnished with explanatory prose aimed at emphasizing their philosophical and scientific depth. The other poets of his circle did much the same. Poliziano, whose refined training as a humanist complemented a perfect knowledge of the Tuscan poetic tradition, often echoed Dante and Ca-valcanti in his rhymes and in the precious neo-platonic allegories of his *Stanze*.

Girolamo Benivieni (fig. 5) composed a *Canzoniere* pervaded with an intense adhesion to Ficino's principles of love[17]. He also wrote a *canzone* of love, "following the mind and opinion of the Platonics"; this was fully glossed by Pico della Mirandola as a response to Cavalcanti and his commentators. "[T]wo poets have fully treated these two types of love in the Tuscan language: on earthly love, Guido Cavalcanti in his *canzone*; on the other type, that is celestial love, our Poet [Benivieni] in the present work"[18].

The investigation of the topography of Dante's otherworld was also initiated in the Laurentian era. Aimed at demonstrating the precision of the mathematical and astrological references in the *Divine Comedy*, it confirmed the work's scientific value from this point of view[19]. The instigator of these studies was the architect and mathematician Antonio di Tuccio Manetti, a passionate scholar of Cavalcanti and the person to whom Ficino dedicated his translation of the Dan-

sua edizione del poema dantesco, pubblicata nel 1506 in polemica risposta all'edizione aldina curata dal Bembo quattro anni prima, allega in appendice un suo *Dialogo di Antonio Manetti circa al sito, forma et misure dello "Inferno" di Dante Alighieri*[21]. Sulla loro scia torneranno sull'argomento Bernardo Giambullari in una lezione letta all'Accademia nel 1541, Luca Martini, di cui ci rimangono alcuni disegni ma sappiamo che aveva realizzato anche dei modelli in rilievo particolarmente apprezzati dal Varchi, i *Dialogi* del Giannotti, in cui protagonista è Michelangelo in veste di esperto dantista, e poi ancora il Borghini e Galileo Galilei[22].

Sulla base di queste coordinate generali, diventa forse meglio leggibile, nonostante le sue lacune, anche il progetto della "camera" del Bettini. L'affermazione del Vasari che il Bronzino vi dipinse Dante, Petrarca e Boccaccio con l'intenzione di raffiguravi anche «gli altri poeti che hanno con versi e prose toscane cantato d'amore», può far pensare a una galleria più vasta e variegata rispetto alla ristretta selezione presentata dalla tavola del Vasari, tanto più nella versione-Martini. Al limite l'espressione «con versi e prose toscane», non designa necessariamente poeti di nazionalità toscana, ma sembra mettere l'accento piuttosto sulla lingua, che ormai da tempo era dominio dei letterati di tutta Italia, e potrebbe far pensare anche a un allargamento della rassegna oltre la cerchia cittadina e regionale[23]. Ma, attenendoci a ciò che del progetto ci è pervenuto, ci sono molti aspetti che ci aiutano a interpretarne il senso e le finalità complessive. Delle tre lunette realizzate, l'unica di cui ci è rimasto l'originale, secondo la proposta qui avanzata (Cat. 22, Tav. II/1 e Cat. 25), è quella di Dante (Cat. 28; fig. 6). La dettagliata rappresentazione del Purgatorio sullo sfondo della lunetta – purtroppo oggi meglio leggibile nella copia, probabilmente non autografa, di Washington (Tav. IV/2; fig. 7) –, riflette le discussioni sulla topografia dell'aldilà, avviate dal Manetti e riprese dal Landino e dal Beniveni. C'è evidentemente un preciso richiamo al dipinto di Domenico di Michelino (fig. 8) in Santa Maria del Fiore (1465), e il fatto ha anche una sua importante valenza civile, trattandosi in quel caso di un'opera pubblica, destinata a tutta la città nella sua più alta sede spirituale. Il Bronzino, che allude solo con dei bagliori luminosi all'Inferno e al Paradiso, appunta tutta la sua attenzione sul Purgatorio e anticipa così le successive ricerche del Giambullari, del Martini e del Giannotti, che rispetto ai precedenti quattrocenteschi estenderanno le loro indagini anche alla struttura del sito della seconda Cantica. Straordinaria è poi la scelta di squadernare davanti allo spettatore, nella visione da sotto in su del poeta finalmente coronato del desiderato «cappello», la corona d'alloro, un *in folio* della *Commedia* aperto sull'esordio del Canto XXV del *Paradiso*, con i versi in cui Dante si mostra più consapevole del proprio primato e della propria identificazione con la cultura della città, dalla quale è escluso, visibile in basso a sinistra sotto la protezione della sua mano. È inevitabile cogliere anche in questo un significato politico, a pochi mesi dalla caduta della Repubblica, in un suo atti-

te's *Monarchia* and his own *On Love*. Manetti's research on the "site, form and measure of Dante's Inferno" was published for the first time by Landino, in the form of a *compendium* in the preface of his *Divine Comedy* commentary[20]. Beniveni added his *Dialogue of Antonio Manetti on the site, form and measurements of the "Inferno" of Dante Alighieri* as the appendix to his edition of Dante's poem; this was published in 1506 as a polemic response to Bembo's Aldine edition of the *Divine Comedy* edited four years earlier[21].

Following up on these studies of Dantesque topography were Bernardo Giambullari, in a lesson read at the Florentine Academy in 1541; Luca Martini who left us a few drawings, but was also known to have made relief models praised in particular by Varchi; Donato Giannotti who in his *Dialogues* portrayed Michelangelo as a Dante scholar; and later still Borghini and Galileo Galilei[22].

With these general coordinates in mind, the project for Bettini's chamber becomes more comprehensible, in spite of its fragmentary surviving elements. Vasari's affirmation that Bronzino painted Dante, Petrarch, and Boccaccio, and also intended to portray "the other poets who have with their Tuscan verse and prose sung the praises of love", indicates a gallery of portraits; this must have been vaster and more varied in content than the restricted selection in Vasari's painting, especially the version made for Martini. The phrase "with Tuscan verse and prose" does not necessarily limit this selection to poets of Tuscan nationality; rather, it puts the emphasis on the language itself. By that time, Tuscan language was widely in use in literary circles throughout all of Italy, thus pointing to a widening of the survey beyond the confines of the city or region[23]. If we limit ourselves to the surviving elements of the project, various factors help in deciphering its meaning and overall objectives.

Of the three lunettes executed by Bronzino, the only surviving one – according to the proposal advanced in this exhibition (Cat. 22, Pl. II/1 and Cat. 25) – is the portrait of Dante (Cat. 25; fig. 6). Here we find a reflection of the debate underway in regards to the topography of the Dantesque cosmos, begun by Manetti and continued by Landino and Beniveni. The detailed representation of *Purgatory* in the background (unfortunately more legible today in the Washington copy (Pl. IV/2; fig. 7), probably not by the master himself), is an evident reference to the painting of Dante in Santa Maria del Fiore by Domenico di Michelino (1465, fig. 8); it thus carries the implication of civic pride, inasmuch as the latter work was a public commission destined for the entire populace in the most prestigious religious site of Florence.

Bronzino limits his allusions to the Inferno and Paradise to their luminous glow. Instead, the artist focuses his attention on Purgatory, anticipating the subsequent research of Giambullari, Martini and Giannotti; these authors, in respect to the earlier commentators in the Quattrocento, extend their re-

6. Agnolo Bronzino,
 Testa di Dante
 Head of Dante,
 München, Staatliche
 Graphische Sammlung,
 Inv. 2147.

7. Cerchia del Bronzino,
 Ritratto di Dante
 Portrait of Dante,
 Washington, National
 Gallery of Art.

8. Domenico di Michelino,
 Ritratto di Dante
 Portrait of Dante,
 Firenze, Santa Maria
 del Fiore.

vo sostenitore come il Bettini, che vive nel timore di dover con-dividere quella sorte, e che di fatto passerà il resto dei suoi anni, pur senza una rottura definitiva con il regime mediceo, da cui anzi più tardi riceverà riconoscimenti anche importanti, per lo più lontano da Firenze. Infine, altro aspetto interessante della lunetta, è l'accurata trascrizione del testo (ben 48 versi, oltre un terzo del canto!), esemplata sull'edizione aldina della *Commedia* del 1515[24], su cui lavoreranno con impegno il Martini, il Varchi e altri loro amici negli anni seguenti[25].

Il senso dell'ambizioso progetto del Bettini si capisce me-glio tenendo presente anche l'altro documento che possiamo valutare e verificare, e cioè la tavola di Michelangelo e Pon-tormo con *Venere e Cupido*, che avrebbe dovuto campeggia-re «in mezzo» alla "camera". La scelta di affidare quest'opera a Michelangelo, che sicuramente è il responsabile della sua "invenzione", è importante e rappresenta una precisa scelta di campo. Francesco Berni nel suo famoso capitolo, composto prima della morte di papa Clemente VII (1534) e dunque pro-prio nel periodo in cui matura il progetto della "camera", per primo elabora il fortunato mito di Michelangelo «nuovo Apelle e nuovo Apollo», ponendo l'accento sulla sua statura di poeta, non minore di quella dell'artista, e sottolineando, in contrap-posizione alle «parole» della retorica petrarchista, le «cose», i contenuti filosofici dei suoi versi: «Ho visto qualche sua com-posizione: Sono ignorante, e pur direi d'avelle Lette tutte nel mezzo di Platone»[26]. Sono lodi che oggi si possono conside-rare anche iperboliche, ma è questo il giudizio che di quelle rime ne davano il Bettini e i suoi contemporanei, e queste fu-rono le ragioni che lo indussero ad affidare all'amico Miche-langelo, esperto tanto nell'una come nell'altra arte, il compito di tradurre in immagini quell'ideale di amore cantato dai poeti ritratti. Se, nel complesso, comuni sono i contenuti filosofici della sua poesia, tutt'altro che convenzionali, nel petrarchi-smo dilagante, sono i modi in cui essi venivano espressi. Quel-l'«assillo d'osservazione del reale, e quasi fissità ragionativa su certi dati sperimentali, interni o esterni, che determinano un sofferto manierismo della speculazione», secondo quanto ne scrive il suo più recente commentatore[27], hanno le loro ra-dici nella poesia fiorentina tardo-quattrocentesca, e soprattut-to in quei poeti che restituiscono della filosofia neoplatonica un'interpretazione più tormentata, persino esasperata al limi-te dell'ermetismo, come Girolamo Benivieni e magari lo stes-so Pico della Mirandola[28].

Benedetto Varchi, specie a partire dal suo soggiorno pado-vano, si espresse nettamente a favore delle soluzioni lingui-stiche proposte dal Bembo. In un testo d'occasione ma im-portante (pubblicato postumo nel 1584), una mascherata in ottave destinata alla recitazione, immagina che Francesco Petrarca, accompagnato da un silenzioso Dante che resta in secondo piano, si rivolga ai poeti fiorentini accusandoli di essere responsabili del decadimento linguistico delle patrie lettere, e indica nel Bembo la sola guida che può consentire la rinascita dell'antica gloria: «Ben venne, ha già molt'anni un sag-

search to the structure of the site of the second *Cantica*. Bronzino shows Dante as if from below, and the poet is final-ly crowned with laurel, the "cap" he so desired. Extraordi-narily, the artist includes an *in folio* page of the *Divine Comedy* opened to the beginning of *Paradise* XXV. These are the very verses in which Dante most clearly pronounces his awareness of his own primacy and recognition within the cul-ture of the city from which he had been excluded: Florence, visible on the lower left under his protective hand.

The political significance, just a few months after the fall of the Republic, is inescapable; Bettini, an active partisan, lived in fear of being forced to share in Dante's same fate. Although the banker never definitely broke with the Medici regime — from which he later received recognition, even of some importance — he would in fact pass the rest of his life large-ly far from his native city. Another point of interest in the lunette is the transcription of the text (as many as 48 verses, over a third of the Canto!) taken from the Aldine edition of the *Divine Comedy* of 1515[24]; in the years to follow, Martini, Varchi, and their friends would be seriously engaged in stu-dies on the text of this very volume[25].

The sense of the Bettini's ambitious program is better un-derstood after considering the other document available for evaluation: the *Venus and Cupid* panel by Michelangelo and Pontormo, the "centerpiece" of the chamber. The choice of commissioning the work from Michelangelo, who certainly was responsible for its 'invention', is of great significance and represents a precise orientation. Francesco Berni was the first to elaborate on the popular myth of Michelangelo as the "new Apelles and new Apollo".

In his famous verses composed before the death of Clement VII (1534), and therefore in exactly the same period Bettini's project was underway, Francesco Berni emphasized Miche-lan-gelo's stature as a poet no less than an artist. He underscored, in contrast to the "words" of the Petrarchan rhetoric, the "things" — the philosophical content — of Michelangelo's poet-ry. "I've seen some of his compositions: I am ignorant and yet I could swear I have read them all in the midst of Plato"[26]. Today such praise may seem hyperbolic, but this was the interpreta-tion that Bettini and his contemporaries adopted.

These were the reasons that led the patron to give his friend Michelangelo, an expert in one art as well as the other, the task of translating into images the ideal of love sung by the poets adorning the chamber. If, on the whole, the philoso-phical tenets of Michelangelo's poetry were commonplace, his way of expressing them proved to be anything but con-ventional, in the midst of rampant Petrarchan modes.

His literary work evince an "assault of observations taken directly from reality, and the almost rational fixation on cer-tain experimental data, interior and exterior, that determine the tormented mannerism of speculation", to use the words of his most recent commentator[27]. This finds its roots in late Quattrocento Florentine poetry, especially writers like Be-

gio, ed ebbe Di voi pietade, e ne mostrò la strada»[29]. Detto questo però la funzione decisiva svolta dal Varchi, e soprattutto dopo il suo rientro a Firenze nel 1543 e la ripresa del vivace dialogo con i suoi amici più cari, fu piuttosto quella di promuovere un compromesso tra la cultura, per così dire, nazionale e quella cittadina. In una lettera al giovane Carlo Strozzi scritta da Padova, insieme ai classici greci (Demostene e Omero) e latini (Virgilio e Cicerone), indicava nei soli Petrarca e Boccaccio i modelli da imitare, «tanto che sei autori solamente basteriano in queste tre lingue». Al tempo stesso però insisteva anche su un aspetto che è invece, come abbiamo visto, tipico della tradizione più genuinamente fiorentina, e cioè l'impegno dei contenuti anche in un'opera letteraria: «ingegnatevi di conoscere quello dove è tutto l'utile, cioè il vivere civilmente et credete che Virgilio in latino, et Homero in greco, seppero et insegnarono ogni cosa forse meglio ch'Aristotele… E il medesimo fa Dante et il Petrarca»[30]. Un rapido confronto tra l'attività svolta dal Varchi presso le due Accademie di Padova e Firenze, è significativo. Nell'Accademia padovana risulta nel complesso più separata la gestione dei suoi interessi speculativi da quelli letterari: da una parte legge e commenta magari l'*Etica Nicomachea* di Aristotele, dall'altra si addentra in sottili indagini linguistiche e retoriche nell'analisi dei sonetti di Petrarca, Bembo o Giovanni della Casa[31]. Nell'Accademia fiorentina, questi suoi interessi si compenetrano; il testo è ridotto sempre più quasi a pretesto per lunghe dissertazioni scientifiche e filosofiche: per esempio nel 1543 la lezione sul Canto XXV del *Purgatorio* diventa l'occasione per un vero e proprio trattato «sulla generazione del corpo umano» e la «creazione dell'anima razionale».

L'esempio più significativo ai nostri fini è naturalmente quello delle *Due lezzioni*, recitate all'Accademia nel 1547, e pubblicate con grande successo tre anni dopo[32]. Anche solo guardando al sistema delle dediche e dei richiami interni ne è chiaro l'orientamento: l'intero volumetto è dedicato dallo stampatore al Bettini che probabilmente finanziò una parte delle spese per la sua pubblicazione; la seconda lezione sul paragone delle arti (pittura e scultura, ma anche arte e poesia, è bene tenerlo sempre presente) è dedicata a Luca Martini, che vi è elogiato esplicitamente per la sua attività di dantista. Alla fine sono accolti due sonetti, uno dei quali è indirizzato ancora al Bettini, sulle sculture della *Notte* (fig. 9) e dell'*Aurora* (fig. 10), i nudi femminili delle Cappelle Medicee, che risale a pochi anni dopo la progettata "camera".

Nella lezione è ricordata anche con alti elogi la *Venere e Cupido* di Michelangelo e Pontormo, in quel momento già nelle Collezioni medicee[33]. È insomma ancora una volta l'espressione del nostro gruppo di amici e non fa che riproporre in forma scritta quell'ideale di una collaborazione tra arti e lettere già immaginato in forma figurativa per la "camera" del Bettini. Viene ribadita di quel progetto anche la centralità di Michelangelo, perfetta incarnazione dell'artista-letterato. La prima lezione è infatti un commento al suo sonetto *Non ha l'ottimo artista alcun con-*

nivieni and perhaps even Pico, who restored to neo-Platonic philosophy a more tortured, even exasperated interpretation bordering on hermetism[28].

Varchi, especially from the time of his Paduan sojourn, clearly expressed his approval of the linguistic proposals advanced by Bembo. In an ephemeral but important literary composition, a masquerade in octave stanzas intended for the stage (published posthumously in 1584), he imagined Petrarch, accompanied by a silent Dante who remains in the background, addressing Florentine poets and accusing them of being responsible for the linguistic decay of the city's literary tradition. Moreover, Varchi indicated Bembo as their sole guide in actuating the rebirth of its ancient glory: "happily, some years ago, a wise man came and took pity on you, showing the way"[29]. With this said, however, Varchi's decisive role after his return to Florence in 1543 and his renewal of a vivacious dialogue with his dearest friends, was to promote a compromise between two cultures, the Florentine and what we might consider the national one.

In a letter to the young Carlo Strozzi written in Padua, Varchi indicated Petrarch and Boccaccio as the only models to follow, together with classical Greek authors (Demozsthenes and Homer) and Latin ones (Virgil and Cicero), and thus "six authors suffice for these three languages". At the same time, however, he insisted on an aspect that, as we have seen, is instead typical of the most genuine Florentine tradition: a depth of content also in literary works. "[M]ake an effort to know where all value lies, that is, in living civilly and believe that Virgil in Latin and Homer in Greek knew and taught everything even better perhaps than Aristotle... and the same holds true for Dante and Petrarch"[30].

A rapid comparison of Varchi's activity in the academies of Florence and Padua proves significant. In the latter, the development of his speculative interests seem to be, on the whole, kept more separate from his literary interests. On the one hand, Varchi read and commented on Aristotle's *Nicomachean Ethics* while, on the other, he engaged in subtle linguistic and rhetorical inquiries in the analysis of the sonnets of Petrarch, Bembo or Giovanni della Casa[31].

In Florence, these interests merged; the text functioned increasingly more as a mere pretext for long scientific and philosophic disquisition. For example, in 1543, Varchi's lesson on *Purgatory* XXV gave rise to an actual treatise "on the generation of the human body" and the "creation of the rational soul".

The most meaningful example in this sense naturally remains the *Two Lessons* given at the Academy in 1547 and published with great success three years later[32]. Simply by surveying the system of dedications and internal references, the approach becomes clear: in its entirety, the small volume is dedicated by the publisher to Bettini, who probably financed a portion of the expense for its publication; the second lesson on the *paragone*, or comparison, of the arts (paint-

9. Michelangelo, *Tomba di Giuliano de' Medici, duca di Nemours*
Tomb of Giuliano de' Medici, Duke of Nemours,
Firenze, San Lorenzo, Sagrestia Nuova.

cetto (Girardi 151), e nasce nel periodo in cui Luigi del Riccio (morto nel 1546) e Donato Giannotti erano attivissimi nell'aiutare il maestro a raccogliere una scelta delle sue rime per un'edizione che non sarà mai realizzata[34]. A questo stesso anno appartengono anche i *Dialogi* del Giannotti, a differenza delle *Lezioni* del Varchi rimasti inediti, che presentano Michelangelo in veste di dantista e dove sono citate anche alcune sue rime. Sono gli anni quindi in cui si stava preparando un lancio di Michelangelo poeta in grande stile, ed era un evento attesissimo a Firenze. Molte rime di Michelangelo avevano circolato e continueranno a circolare manoscritte, ma la lezione del Varchi resta la più ampia antologia a stampa fino alla famigerata edizione del pronipote (1623), che come è noto le riscriverà adeguandole al gusto del suo tempo[35]. Alla fine della lezione il Varchi indica nel sonetto *Non vider gli occhi miei cosa mortale* (Girardi 105), dedicato a Tommaso Cavalieri, il più rappresentativo della sua poesia amorosa, nel quale culmina tutta quella tradizione, che si è cercato fin qui di illustrare, che mira filosoficamente alla trasfigurazione della bellezza sensibile in bellez-

ing and sculpture and, not to be forgotten, art and poetry) is dedicated to Luca Martini with explicit praise for his activity as a Dante scholar. Two sonnets are included at the end, one, dealing with the sculptures of *Night* (fig. 9) and *Dawn* (fig. 10), the female nudes in the Medici Chapel, addressed again to Bettini and dating to just a few years after the chamber project. In the lesson, much praise is given to the Michelangelo-Pontormo *Venus and Cupid*, by then also in the Medici collections[33].

Once again, in sum, the lesson is a perfect expression of our group of friends; it does no more than reproduce, in written form, the ideal of collaboration of the arts and literature already imagined in figurative form in Bettini's chamber. Likewise, the *Two Lessons* emphasizes the centrality of Michelangelo as the perfect incarnation of the artist and poet. The first lesson is in fact a comment on his sonnet "Non ha l'ottimo artista alcun concetto" (Girardi 151); Varchi elaborated on this during the very period that Luigi del Riccio (who died in 1546) and Donato Giannotti were actively involved in helping Michelangelo compile a selection of his rhymes for an edition which was never published[34].

The same year, Giannotti composed his *Dialogues*, which unlike Varchi's lessons remained unpublished; in that work Michelangelo is presented as a Dante scholar and some of his poetry cited. These are years in which there is an attempt to launch Michelangelo as a poet, an event followed with interest by the Florentines. Many of Michelangelo's rhymes had been circulating and continued to circulate as manuscripts, but Varchi's lesson remained the largest printed anthology up to the time of the infamous edition of Michelangelo's great nephew (1623) who, as is known, rewrote the verses adapting them to the tastes of his time[35]. At the end of the first lesson, Varchi indicated the sonnet *Non vider gli occhi miei cosa mortale* (Girardi 105), dedicated to Tommaso Cavalieri, as being the most representative of Michelangelo's love poetry, and the culmination of the entire tradition that here we have tried to illustrate: the philosophical transfiguration of physical beauty into divine beauty[36]. Michelangelo was presented as "excellent, even unique in poetry and in the true art of loving". Just before this passage, Varchi had been careful to specify the type of love he was referring to: "and this art is not that of Ovid in his *Art* who, in truth, wrote basely of it, but Plato in his most divine *Symposium*"; this is the art "our judicious and loving Poet wanted to teach us in this learned and marvelous sonnet". Varchi concluded: "And that our Poet understood this art and this love is manifest not only in his age and very honest behavior but in all of his compositions full of Socratic love and platonic concepts"[37]. Citing word for word Ficino's *On Love*, printed for the first time just a few years earlier by Giambullari (1544)[38], Varchi held Michelangelo to be the new Cavalcanti of contemporary amorous poetry.

Turning more specifically to Michelangelo-Pontormo painting of *Venus and Cupid*, that constituted the symbolic

za divina[36]. Michelangelo viene presentato come «eccellente, anzi singolare nella poesia e nella vera arte dell'amante». Poco prima il Varchi si era premurato di precisare di quale amore si tratta: «E questa arte è quella, la quale seguitando, non Ovidio nella sua *Arte*, il quale di vero ne scrisse plebeamente, ma Platone nel suo *Convito* divinissimo, ci voleva insegnare il giudizioso ed amorevole Poeta nostro in questo dotto e maraviglioso sonetto». E infine conclude: «E che il Poeta nostro intendesse di questa arte e di questo amore, lo mostrano manifestissimamamente, oltre l'età e costumi suoi onestissimi, tutti i componimenti di lui pieni d'Amore Socratico e di concetti Platonici»[37]. Citando alla lettera il *Libro dell'amore* del Ficino, da poco stampato per la prima volta dal Giambullari (1544),[38] il Varchi propone Michelangelo come il nuovo Cavalcanti della poesia amorosa contemporanea.

Venendo più specificamente alla tavola con la *Venere e Cupido* di Michelangelo e Pontormo, che costituisce il centro simbolico del progetto decorativo del Bettini, restano da spiegare le ragioni della scelta di questo soggetto per illustrare la poesia amorosa coltivata dai poeti ritratti nelle lunette circostanti, e la sua nuovissima impostazione. Proporrei di appuntare l'attenzione su un caso preciso, la traduzione di un testo greco, ovviamente nel quadro più generale del culto rinascimentale per la letteratura classica[39], che offre precisi spunti iconografici a Michelangelo e alla tradizione che la sua tavola inaugura, con importanti implicazioni soprattutto se considerato nel suo contesto storico-culturale. L'interesse intorno a questo testo, almeno in àmbito fiorentino, riemerge ogni volta che anche in pittura torna di moda il soggetto di Venere e Cupido. Si tratta di un idillio presente nell'*Antologia greca* (IX, 440), l'*Amor fuggitivo*, del poeta bucolico Mosco di Siracusa, vissuto nel II secolo a.C.[40] (Appendice III,a). Protagonista è Venere che, in cerca di Cupido sfuggito alla sua sorveglianza, si precipita per strada a chiedere a tutti sue notizie, e lo descrive minutamente, perché tutti possano riconoscerlo e riportarglielo, o almeno guardarsi dai suoi malefici effetti. Si tratta dunque della più antica descrizione di Cupido, completa in ogni dettaglio, che ci sia pervenuta in poesia, in cui l'autore fa a gara con le celebrate rappresentazioni di Eros nell'arte sua contemporanea.

Per l'interpretazione della tavola di Michelangelo e Pontormo rinvio al saggio di Nelson. Qui basti richiamare, fra gli elementi che Michelangelo potrebbe aver tenuto presenti dall'idillio di Mosco, gli spunti più originali rispetto alle tradizionali raffigurazioni di Cupido, sia fisici, come la corporatura da adolescente, l'acceso rossore delle guance, i capelli crespi (fig. 11), sia soprattutto psicologici, come la sua predilezione per gli scherzi crudeli, la dolcezza delle sue apparenze e parole che nasconde un'interna malizia: nella tavola, mentre il fanciullo si sforza di baciare la madre, guarda dalla parte opposta le frecce che gli pendono minacciosamente dalla faretra. Nella sua descrizione Venere confessa che Cupido talvolta non esita a scagliare le sue frecce anche contro di lei. Per le possibili fonti letterarie della Venere colpita da Cupido, di solito si richiama-

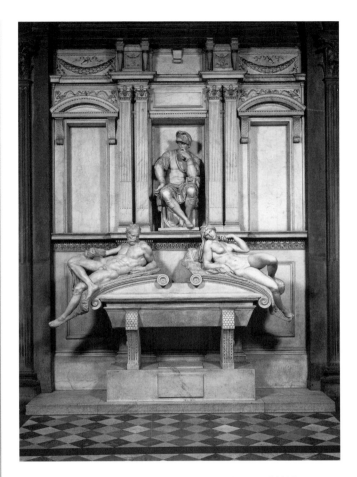

10. Michelangelo, *Tomba di Lorenzo de' Medici, duca di Urbino*
Tomb of Lorenzo de' Medici, Duke of Urbino,
Firenze, San Lorenzo, Sagrestia Nuova.

center of Bettini's decorative program, we still need to understand the choice of this subject to illustrate the amorous verses of the poets portrayed in the surrounding lunettes, and the highly original formula adopted by Michelangelo. I suggest, obviously within the more general context of the Renaissance cult for classical literature, that we focus our attention on a particular case: the translation of a Greek text[39], an idyll contained in the *Greek Anthology* (IX, 440), the *Runaway Love* by the bucolic poet Moschus of Syracuse, who lived in the II century B.C.[40] (Appendix III,a). The composition offered Michelangelo, and the tradition that his painting inaugurates, precise iconographic stimuli with important implications if considered his historical-cultural environment. In Florentine circles at least, interest in this text reemerged every time that the subject of Venus and Cupid returned in vogue, also in the figurative arts. The protagonist of the piece is Venus who, searching for Cupid who has escaped her surveillance, runs to the streets asking everyone for news of him. She describes him minutely in

no le *Metamorfosi* (X, 525-528)[41]; nell'episodio ovidiano, tuttavia, pochi versi funzionali all'aggancio della storia principale di Venere e Adone, Cupido è ancora il tradizionale bambino inconsapevole dei propri atti, che colpisce la madre involontariamente (*inscius*). In Mosco al contrario il giovane dio è ben consapevole dei propri poteri, e cerca di esercitarli nel modo più subdolo possibile, colpendo *volontariamente*, come le altre vittime, anche la madre. Ciò potrebbe aiutare a decifrare il sommario schizzo preparatorio di Michelangelo per la *Venere e Cupido* (Cat. 29), prima che a una riconsiderazione più meditata si risolvesse per il più sottile contrappunto del cartone definitivo.

La scoperta dell'idillio di Mosco risale alla Firenze laurenziana. La prima notizia che abbiamo di un'attenzione al testo al di fuori della fortuna, peraltro recente anch'essa, dell'*Antologia greca*[42], è in un Codice in cui Ficino ha raccolto i "materiali" tenuti presenti per la composizione del *Libro dell'Amore*: la sua trascrizione del *Simposio*, estratti da altre opere platoniche, inni ad Afrodite e testi greci che hanno come soggetto Eros[43]. È probabile che sia stato il Ficino stesso a esortare i suoi amici poeti alla traduzione, per rendere il testo accessibile a un pubblico il più vasto possibile, compresi gli artisti che spesso non conoscevano le lingue classiche e che potevano essere molto interessati alla conoscenza di un testo simile. Nell'impresa si cimentò il maggior poeta del tempo, Angelo Poliziano, che intorno al 1473 lo volse in esametri latini. Lo seguì a ruota Girolamo Benivieni, che dalla versione latina dell'amico tradusse l'*Amor fuggitivo* in volgare. Quest'ultimo incluse nel suo *Canzoniere* il proprio volgarizzamento, con a fronte la traduzione del Poliziano, certo perché sentiti come omogenei alla propria poe-

11. Michelangelo-Pontormo, *Venere e Cupido*
Venus and Cupid, particolare/ detail,
Firenze, Galleria dell'Accademia.

order that all can recognize him and bring him back to her or, at least, protect themselves against his mischievous doings. This is the most ancient description of Cupid that has come down to us in poetry; it is complete in every detail, and so the author competes with the celebrated representations of Eros in the figurative art of his own time.

The essay by Nelson in this volume discusses the interpretation of the Michelangelo-Pontormo painting; for our purposes, it suffices to recall, among the elements that may have influenced Michelangelo, the more original ideas in Moschus with respect to traditional portrayals of Cupid. Some are physical – the adolescent body, the bright red cheeks, the curly hair (fig. 11) – and others psychological – his predilection for cruel jokes, the sweetness of his appearance and words that conceal a hidden cunning. In the Michelangelo-Pontormo painting, as the youth strains to kiss his mother, he glances the other way at the arrows that hang menacingly from the quiver. In the Moschus poem, Venus confesses that Cupid sometimes does not hesitate to launch his arrows even at her. For the possible literary sources of Venus being struck by Cupid, the reference is usually the *Metamorphoses* (X, 525-528)[41]; however, in the Ovidian episode – a few lines functioning as a link with the story of Venus and Adonis – Cupid is still portrayed as the traditional child, unaware of his own doings who strikes his mother involuntarily (*inscius*). In Moschus, conversely, the young god is well aware of his powers and tries to exercise them in the most subtle way possible, striking his mother voluntarily, as with other victims. This may help explain the rough preparatory sketch Michelangelo did for the *Venus and Cupid* (Cat. 29), before a more meditated reconsideration brought him to the subtle counterpoint of the final cartoon.

The discovery of the Moschus's idyll goes back to the Florence of Lorenzo the Magnificent. The first mention of the interest afforded to the text outside the general, and also recent popularity of the *Greek Anthology*[42] can be found in a codex containing the "material" that Ficino gathered while composing his *On Love*: his transcription of the *Symposium*; passages from other platonic works; hymns to Aphrodite; and Greek texts dealing with Eros[43]. Probably Ficino himself encouraged his poet friends to translate Moshcus's idyll to make it accessible to as vast a public as possible. This naturally included artists, who often were not familiar with classical languages, but were nonetheless very interested in texts of this type. Poliziano, the major poet of the period, took up the challenge: in about 1473 he translated the verses into Latin hexameters. Benivieni followed in his footsteps, and translated his friend's Latin version into Italian. In his *Canzoniere*, Benivieni included his vernacular translation alongside Poliziano's Latin one, certainly because they were in harmony with his own poetics, and the full expression of the milieu in which Moschus's work had been rediscovered[44].

12. Verrocchio, *Venere e Cupido / Venus and Cupid*,
 Firenze, Galleria degli Uffizi, Gabinetto Disegni e Stampe, Inv. 212E.

tica e piena espressione dell'ambiente nel quale erano stati riscoperti[44]. Il testo ebbe una immediata fortuna nella cerchia ficiniana, come dimostrano i riflessi che si trovano anche in opere originali, sia letterarie che artistiche. Per primo il Poliziano stesso, proprio negli anni in cui sta traducendo Mosco, ne riprende subito alcuni spunti nelle *Stanze per la giostra*, descrivendo l'«arcer frodolente» con parole che richiamano la versione in volgare del Benivieni: «dolce in sembianti, in atti acerbo e fello» (I. 122-124); «tutto protervo nel lascivo aspetto Si strinse a Marte, e colli strali ardenti Della faretra gli ripunse il petto E colle labra tinte di Veleno Baciollo, e 'l fuoco suo gli misse in seno» (II. 1; cfr. in *Appendice III,*a la versione del Benivieni ai vv. 11-12, 18-19, 30, 40-42)[45]. Per il versante figurativo si può richiamare invece il disegno del Verrocchio qui riprodotto (fig. 12), forse preparatorio a uno stendardo per la stessa giostra cantata dal Poliziano, dove fa la sua prima comparsa questa tipologia di Cupido: il fanciullo alato coglie di sorpresa una Venere assopita, spuntando da un canneto dietro le sue spalle, e cerca di slacciarle maliziosamente la veste sul petto, per pungerla forse con la freccia che tiene in mano pronta all'uso[46].

Il successo di queste traduzioni, specie dopo la stampa delle opere del Poliziano, dove è incluso anche il suo Mosco, a cominciare dall'aldina del 1498, divenne addirittura euro-

The text was immediately acclaimed within the circles of Ficino, as seen by reflections of it found in original works of both literary and artistic nature. Poliziano himself, at the time of his translation of Moshcus, was the first to draw immediately from it in his *Stanze per la giostra*, describing the "fraudulent archer" with words that recall the vernacular version of Benivieni: "sweet in semblance and sharp and wicked in act" (I.122-124); "arrogant in his lustful manner he drew near Mars and with his arrows burning from the quiver he pricked his breast again and with his lips wet with poison kissed him" (II.1; for Benivieni's version see *Appendix III*,a, lines 11-12, 18-19, 30, 40-42)[45].

In the world of images, this type of Cupid makes his first appearance in a drawing by Verrocchio (fig. 12), perhaps a preparatory study for a banner for the same joust for which Poliziano composed his verses. The winged boy surprises a sleeping Venus; he suddenly appears from a bunch of canes behind her, and mischievously attempts to untie the garment covering her breast. Perhaps he plans to prick her with the arrow he holds, ready for use[46].

The success of these translations spread not only throughout Italy but also Europe, especially after the publication of Poliziano's works, including his version of Moschus, beginning with the Aldine edition of 1498[47]. They were stimulus for

peo e stimolò altre traduzioni alternative[47]. Fra queste il caso più importante è quello di Iacopo Sannazaro, che inserì una versione in volgare dell'*Amor fuggitivo* in una delle sue farse, rappresentate alla Corte aragonese intorno al 1484[48]. Si inaugura così un altro importante filone di questo successo: la sua fortuna teatrale, che culminerà nell'*Aminta* del Tasso[49]. La farsa del Sannazaro si apre con un prologo in cui un attore annuncia l'«argumento della istoria» davanti a una scenografia che rappresenta un "palazzo di Venere"; seguono poi, recitate da un altro attore in costume, le «Parole di Venere», ossia l'idillio di Mosco.

Con la morte di Lorenzo il Magnifico, a Firenze seguì un lungo periodo di grave instabilità politica: i Medici furono cacciati dalla città; seguirono l'avventura tragica del Savonarola e le vicende tormentate della Repubblica, prima della faticosa riaffermazione di un saldo regime mediceo, che potrà dirsi realizzato solo con Cosimo I nel 1537. Tutti i protagonisti di quella stagione morirono: Lorenzo (1492), Pico e Poliziano (1494), Landino (1498) e Ficino (1499). Solo il Benivieni sopravvisse, e anche lui fu conquistato dalla predicazione del Savonarola, di cui divenne uno dei più stretti collaboratori. In conformità alla dottrina del frate, con la sua violenta avversione al classicismo laurenziano, ripudiò il passato mediceo. Dopo la morte del Savonarola, riprese e pubblicò una parte delle sue rime, ma riscrivendole radicalmente e dotandole di un ampio commento che ne reinterpretava l'acceso neoplatonismo in chiave cristiana (*Commento* 1500)[50]. Con il rientro dei Medici a Firenze nel 1512 il Benivieni tornò a guardare con un atteggiamento meno intransigente alla propria produzione passata e la recuperò con larghezza nell'importante e fortunata edizione delle sue *Opere* pubblicata nel 1519 e ristampata a Venezia nel 1522 e 1524[51]. Vi incluse finalmente la canzone d'Amore col commento del Pico, rimasti fino ad allora inediti, le egloghe, le laudi, le frottole, con le loro invettive politiche e il linguaggio diretto e corposo. Al centro di un libro così composto il Benivieni raccolse un gruppo di testi lirici, tra cui quelli dedicati a Lorenzo stesso, a Pico, a Simonetta Vespucci, amata da Giuliano de' Medici, e anche la versione da Mosco. Con questo volume egli intese riaffermare il proprio prestigio di patriarca delle lettere cittadine: non erano molti a quella data che potevano vantare di aver corrisposto in versi con Lorenzo, di avere collaborato con Poliziano e Pico della Mirandola. Con il trattato del Pico e le sue poesie neoplatoniche, il volume si proponeva anche di rilanciare quell'ideale di poesia amorosa e filosofica maturata ai tempi di Lorenzo e Ficino, corretto però, reso più sofferto e spiritualmente profondo, dal filtro della non rinnegata esperienza savonaroliana. Un libro – non era sfuggito al Panofsky – che è stato fondamentale per Michelangelo[52]. L'*Amor fuggitivo* vi è accompagnato da una versione della prima parte (vv. 1-12) dell'altro testo cardine della letteratura classica relativa all'iconografia di Cupido: l'elegia II.12 di Properzio (*Appendice III*,b)[53]. Alla parte finale dell'elegia, in cui Properzio passa a parlare dell'esperienza amorosa personale (vv. 13-ss.), il Benivieni sostituisce una coda moralistica: «O feli-

other alternative versions, the most important of which was Jacopo Sannazaro's. He includes his own vernacular translation of *Runaway Love* in a farce performed at the Aragonese court in around 1484, which remained unpublished until the nineteenth century[48]. This begins another important vein in the diffusion of the text: its theatrical popularity, culminating in Tasso's *Aminta*[49]. Sannazaro's farce opens with a prologue in which an actor, standing in front of a scenography representing the 'palace of Venus', announces the "argument of the story"; another actor in costume then recites the "Words of Venus", that is, the idyll of Moschus.

With the death of Lorenzo the Magnificent, Florence entered a long period of instability: the Medici exile from the city was followed by the tragic episode of Savonarola and the tormented events of the Republic; the difficult process of the re-establishment of a strong Medici government ended only with Cosimo I in 1537. All of the protagonists of the earlier season had passed away: Lorenzo (1492), Pico and Poliziano (1494), Landino (1498) and Ficino (1499).

Benivieni, the only survivor, had been conquered by the preaching of Savonarola and became one of the friar's closest collaborators. In conforming to this doctrine that professed violent adversity to Laurentian classicism, Benivieni had repudiated his Medicean past. After the death of Savonarola, he took some of his rhymes in hand again and published them after a radical revision. Benivieni also added an ample commentary that reinterpreted the fervent neo-Platonism in a Christian key (*Commento*, 1500)[50].

With the reentry of the Medici in Florence in 1512, the poet began to look upon his past production with less severity, recovering much of it for the important edition of his *Opere* published in 1519, and reprinted in Venice in 1522 and 1524[51]. Therein he finally included the previously unpublished *canzone* of love with Pico's comment, the eclogues, the lauds, and the *frottolas*, with their political invectives and direct and corpulent language.

At the center of a book so composite in nature, Benivieni gathered a group of lyrical texts, including those dedicated to Lorenzo himself, to Pico della Mirandola, to the Simonetta Vespucci loved by Giuliano de' Medici, and also his translation of Moschus. In this volume Benivieni intended to reaffirm his prestige as a patriarch of Florentine letters: not many at that time could boast having corresponded in verse with Lorenzo and collaborated with Poliziano and Pico. With the treatise by Pico and the Neoplatonic poetry of Benivieni, the volume proposed to re-launch the ideal of philosophical and amorous poetry that had flourished at the time of Lorenzo and Ficino. This was corrected, however, by the filter of his Savonarolan experience, which Benivieni never rejected, into something more fervent and spiritually profound.

This book proved to be fundamental for Michelangelo, a fact which did not escape Panofsky's notice[52]. In the volume, the *Runaway Love* is accompanied by a portion of the first

ce colui, se è alcun che scorga / L'insidie e ' lacci pria che 'l cieco seno / Agli amorosi stral denudi et porga!», ecc. In questo modo i due testi, Mosco e Properzio, concorrono a una decisa condanna di Cupido come simbolo dell'amore sensuale, in netto contrasto con la concezione alta e spirituale descritta nelle rime circostanti, soprattutto quelle per Pico della Mirandola, che in sostanza sono rime d'amore «socratico» che prefigurano quelle che Michelangelo dedicherà al Cavalieri.

Nell'olimpico ideale ficiniano il cammino dell'anima dalla bellezza sensibile a Dio era un processo impegnativo ma naturale nella sua gradualità; l'amore nell'accezione più volgare, che porta l'uomo alla morte morale, era considerato certo, ma alla stregua di una degenerazione, una malattia in senso strettamente fisiologico. Già per Pico, ma soprattutto per Benivieni gli ostacoli che l'anima incontra in questo suo percorso verso il divino si moltiplicano; l'amore per il corpo, e in generale per i beni terreni, più che il primo necessario gradino, da superare al più presto, per salire a forme d'amore più nobili e disinteressate, è sentito come connaturato alla condizione terrena, un peso che quotidianamente trattiene l'anima nel suo slancio verso Dio. Un tema persino ossessivo nella poesia di Michelangelo è proprio quello dell'anima imprigionata nel corpo da cui anela di essere liberata, come l'Idea dalla pietra, e la consapevolezza della propria indegnità rispetto all'ideale perseguito con accanimento: «contraria ho l'arte al disïato effetto», come si legge nel sonetto commentato dal Varchi (Girardi 151). È uno stato d'animo che porta all'ostentazione della propria condizione di peccatore, fino a rasentare talvolta l'autofustigazione, e che dà luogo in arte a quei veri o presunti autoritratti deformi, come la spoglia in mano a San Bartolomeo nel *Giudizio Universale* (fig. 13) (e c'è chi ha voluto vedere un'allusione all'autore stesso anche nella maschera di satiro della *Venere e Cupido*; fig. 14)[54]. Questo concetto agonistico, per cui il raggiungimento del bene è sempre il frutto di una drammatica lotta, e il rapporto tra anima e corpo, parte materiale e parte spirituale, conflitto e lacerazione, è lo stesso che ritroviamo in Michelangelo. È da queste premesse che nasce l'idea di rappresentare Venere e Cupido, la prima simbolo di un amore contemplativo astratto da ogni passione terrena, il secondo proteso con tutto il suo essere al conseguimento del piacere materiale, come due forze intimamente legate, come madre e figlio, ma in perenne contrapposizione tra loro. L'idea è già implicita nel testo di Mosco, in cui è Venere che, svelando davanti a tutti la reale natura di Cupido, se ne dissocia, proponendosi come rappresentante di un ideale alternativo di amore[55]. E questo trova pieno riscontro nella realizzazione della tavola, in collaborazione con un Pontormo che rinuncia a tutto il suo incanto coloristico, per dar vita a una severa allegoria, senza alcuna concessione all'aneddoto e alla decorazione.

Dopo il rilancio della versione del Benivieni, l'*Amor fuggitivo* di Mosco trova a Firenze un rinnovato successo nei decenni successivi. Sarà volgarizzato da Luigi Alamanni, Agnolo

13. Michelangelo, *Giudizio Universale / Last Judgment*, particolare / detail, Città del Vaticano, Cappella Sistina.

14. Michelangelo-Pontormo, *Venere e Cupido / Venus and Cupid*, particolare / detail
Firenze, Galleria dell'Accademia.

Firenzuola[56], e soprattutto da Benedetto Varchi. Quest'ultimo, che lo traduce anche in latino, tornerà su questo testo in più occasioni e con finalità diverse[57]. Si può forse supporre che anche la versione da Mosco fosse tra quei suoi componimenti composti in gioventù per l'apprendimento delle lingue classiche, di cui ha parlato nella lettera di dedica al Tribolo e al Bronzino della sua versione delle *Metamorfosi* di Ovidio[58]. Il testo fu comunque ripreso dal Varchi e allegato in appendice a una sua lezione, probabilmente tenuta a Padova[59], sulla «pittura d'Amore», concentrando l'analisi sui testi poetici più rappresentativi nelle tre culture: il *Trionfo d'Amore* di Petrarca (I, vv. 22-30) per la volgare, Mosco per la greca, Properzio per la latina[60], riproponendo per i classici lo stesso accostamento del Benivieni.

Nella Firenze di Cosimo I il soggetto di *Venere e Cupido* trova un suo rinnovato impiego anche nell'arte. Nelle tre tavole del Bronzino, Cupido (Cat. 34, Tav. XI/1; Tav. XII/1, fig. 15; tav XXII/2 rimane il giovane sessualmente maturo, malizioso, ma a differenza dell'austera simbologia di Michelangelo e Pontormo, gli corrisponde una Venere non meno conturbante di lui, che gioca pericolosamente con le sue frecce e ricambia le effusioni del figlio con baci tutt'altro che materni: Mosco è riletto con un occhio ad Apuleio, tra l'altro in quegli anni tradotto anche dal Firenzuola[61]. Oppure si ripresenta la botticelliana *Primavera-Venere*, casta e benefica, come nell'arazzo della *Primavera* (Cat. 36, Tav. XIII; fig. 16). Nello stesso dise-

15. Bronzino, *Allegoria di Venere / Allegory of Venus* particolare / detail. London, The National Gallery.

part (lines 1-12) of the other basic text in classical literature dealing with the iconography of Cupid: Propertius's *Elegy* II.12 (cf. *Appendix III,b*)[53].

At the end of the elegy, where Propertius tells of his personal experience in love (lines 13-ff.), Benivieni substituted a moralistic appendage: "O happy the one, if there be such a one, who sees the insidious traps and ties before he bears / his blind breast and offers it to love's arrows", etc. In this way the two texts, by Moschus and Propertius, agree in a determined condemnation of Cupid as a symbol of sexual love. This type of love stands in net contrast to the lofty and spiritual conception described in the other rhymes by Benivieni, especially those for Pico which we can describe as "Socratic" love poems, and that prefigure the ones Michelangelo later dedicated to Cavalieri.

In Ficino's Olympic ideal, the pathway of the soul from physical beauty to God was a difficult but natural process in its gradualness; love in its basest form brought man to a moral death; it was certain and similar to a degeneration, a sickness in a strictly physiological sense. Already Pico, and above all Benivieni, envisioned multiple obstacles along the path towards the divine. Love of the body and, in general, of earthly goods are seen less as the first and necessary step in the process of rising as soon as possible to nobler and more disinterested forms of love. Rather, that lower type of love is inextricably part of the earthly condition, a weight that day by day prevents the soul from ascending towards the divine. A theme present almost obsessively in Michelangelo's writings is precisely that of the soul imprisoned in the body – like the Idea in stone – from which it longs to escape.

This is combined with Michelangelo's sense of his own unworthiness with respect to an ideal he searched for with passion; as we read in his sonnet (Girardi 151), the subject of Varchi's commentary, "my skill works against the wished effect". It is a state of the soul that leads to the exhibitionism of one's own condition as a sinner, to the point of resembling self-punishment at times. It gives rise in art to those deformed self-portraits, actual or presumed, like St. Bartholomew's skin in the *Last Judgment* (fig. 13). (And there are those who would like to see an allusion to the author himself in the satyr mask of the *Venus and Cupid*; fig. 14)[54].

This concept of struggle – where the attainment of good is always the fruit of a dramatic battle, and the rapport between body and soul, material and spiritual, a conflict and laceration – is the same that we find in Michelangelo. The idea of representing Venus and Cupid rests on these premises: the former, the symbol of a contemplative love detached from all earthly passion; the latter, tending with his whole being towards the fulfillment of material pleasure. Two forces are intimately tied one to the other, like mother and son, but in perennial conflict. The idea is already implicit in Moschus's text, when Venus unveils the real nature of Cupid to all, dissociating herself from him, proposing herself as the alternative ideal of love[55]. All this finds full expression in the

16. Agnolo Bronzino-Jan Rost, *Primavera-Venere,
Primavera-Venus*, particolare / detail.
Firenze, Palazzo Pitti, Deposito Arazzi.

gno del Pontormo (Cat. 38) a cui il Bronzino si ispira nel cartone per l'arazzo, probabilmente per un progetto commissionato da Cosimo I e dunque con un fine celebrativo della dinastia medicea, resiste la formula dell'abbraccio da dietro, quasi "contronatura", tra Cupido e Venere come nella tavola di Michelangelo e Pontormo, ma il rapporto tra madre e figlio è affettuoso, di piena complicità, come tra una madre protettiva e il suo piccolo.

Lo stesso si può dire delle tante copie ricavate dalla tavola o dal cartone di Michelangelo, spesso poco fedeli allo spirito dell'originale, come quella di Napoli (Cat. 28, Tav. V/2). Non sono più ormai la rappresentazione per immagini di una "filosofia" d'Amore, concepita per fare da cornice alle discussioni di un libero consesso di cittadini cultori di arti e lettere, bensì i simboli celebrativi di fecondità e rinnovamento nel quadro del ristabilito regime medìceo di Cosimo I. In questi complessi apparati allegorici prevale ormai quella dimensione carnevalesca, teatrale e decorativa, sulla quale ha giustamente insistito la Mendelsohn[62]. Non si dovrebbero infatti dimenticare gli apparati per feste, a cominciare da quello meglio documentato di

painting done in collaboration with a Pontormo who renounces all of his chromatic skills to give expression to the severe alle-gory, where no concession to anecdote or ornament is allowed.

In the decades following Benivieni's reissue of Moshcus's *Runaway Love*, the poem encountered a renewed success in Florence. It was translated into the vernacular by Luigi Alamanni, Agnolo Firenzuola[56] and, notably, Varchi. The latter also translated it into Latin, and returned to the text on several occasions for different purposes[57]. In the dedication to Tribolo and Bronzino of his version of Ovid's *Metamorphoses*, Varchi mentioned the verses he had written to learn the classical languages, and perhaps his version of Moschus is one of these youthful exercises[58]. Whatever the case, he added the text as an appendix to a lecture on the "painting of Love" that he probably gave in Padua[59].

This focused on the analysis of the most representative poetic texts of three cultures: Petrarch's *Triumph of Love* (I.22-30) for the vernacular; Moschus for Greek; Propertius for Latin[60], thus reiterating for the same juxtaposition of the classics proposed by Benivieni. In the Florence of Cosimo I, the subject of *Venus and Cupid* found a new interpretation in art. In three panels by Bronzino, Cupid (Cat. 34, Pl. XI/1; fig. 15, Pl. XII/1; Pl. XII/2) remains the sexually mature, teasing youth but, in contrast to the austere symbolism of Michelangelo and Pontormo, the corresponding Venus is no less provoking than her son: she plays dangerously with his arrows and responds to his effusions with kisses that are anything but maternal. Moschus was re-read with a eye on Apuleius, translated at that time by Firenzuola[61]. On the other hand, the Botticellian Venus-Primavera is presented again, cast and salubrious, as in Bronzino's tapestry of the Primavera (Cat. 36, Pl. XIII; fig. 16); this was probably made for a project commissioned by Cosimo I and, therefore, with a intent to celebrate the Medicean dynasty. In the drawing by Pontormo (Cat. 38) that inspired Bronzino, we find the embrace from behind, almost 'against nature', as in the Michelangelo-Pontormo *Venus and Cupid* painting. In the later work, however, the rapport between the mother and son is affectionate and fully reciprocate, like a protective mother and her young offspring.

The same can be said for the many copies deriving from the painting and the Michelangelo's cartoon, often unfaithful to the spirit of the original, as in the work from Naples (Cat. 28, Pl. V/2). These images no longer represent a philosophy of love, conceived as a frame for discussions amongst a spontaneous gathering of lovers of the arts and letters. Within the complexity of the allegories, the carnevalesque, theatrical and decorative dimension prevails, as Mendelsohn has rightly underscored[62]. Apparatus for festivities like the well-documented marriage of Francesco with Giovanna d'Austria should not be forgotten. For this celebration, Bronzino prepared a production dedicated to Hymen (with paintings ded-

Francesco con Giovanna d'Austria, dove proprio il Bronzino prepara l'apparato di Imeneo (con dipinti dedicati alla Grazie, una statua della Venere genitrice ecc.) e il suo allievo Alessandro Allori dipinge una tela con i maggiori poeti toscani[63]. Nella commedia che fu rappresentata nella stessa occasione, ispirata alla favola di Amore e Psiche, vi sono intermedi in cui cantano anche Venere e Cupido.

L'ultimo lavoro del Varchi intorno alla sua versione da Mosco va in questa direzione. Ritroviamo infatti l'*Amor fuggitivo* in un codice in cui ha raccolto le sue opere che, per la loro natura declamatoria o dialogata come egloghe e mascherate varie, si prestavano alla recitazione e al canto[64]. Un copista ha trascritto il testo nella lezione nota (*Appendice III,c*), ma successivamente l'autore è intervenuto di suo pugno, per sostituire le prime due terzine con una nuova, in cui Venere prende subito la parola: «Alcuno è qui tra voi, chiaro e gradito Drappel, che veduto habbia il figliuol mio, che s'è da me, né so dove, fuggito?» La variante non è altro, quindi, che un adattamento della versione letteraria a una destinazione teatrale. In un'altra mascherata in ottave composta dal Varchi e trascritta nello stesso codice è invece Cupido a parlare[65] (*Appendice III,d*). A prima vista il dio sembrerebbe esprimere i più onesti propositi, visto che si propone di rendere gli ascoltatori-amanti «non Di saggi stolti, ma di stolti saggi»; alla fine però i suoi versi si rivelano una tradizionale invocazione a «cogliere la rosa», a godere della giovinezza prima che sia troppo tardi, senza troppi scrupoli morali. Nell'ottava 6 arriva persino a scagliarsi contro i più grandi poeti d'amore: «E questi sei, via più saggi e migliori Di quanti fusser mai dentro il mio regno»[66]. L'autore non poteva certo condividere un simile giudizio. Queste «parole di Cupido» rispondono dunque a un'ottica rovesciata. È come se il Varchi ci mostrasse il giovane dio sfuggito alla sorveglianza della madre, che cerca con tutta la sua malizia di adescare nuove vittime, confermando ciò che lei dice nell'*Amor fuggitivo*[67]: «Dolci parole ha 'l mio vezzoso figlio, Ma la mente è fallace».

I due testi in un certo senso si richiamano e avrebbero potuto benissimo costituire un dittico da recitare in una stessa occasione[68]. È notevole infine che i poeti siano sei, come nella tavola del Vasari. In questa rappresentazione, non sappiamo se realizzata o soltanto immaginata dal Varchi, avranno fatto corona intorno a Cupido sei attori mascherati da Dante, Petrarca, Boccaccio e altri tre fra i «poeti che hanno in versi e prose toscane cantato d'Amore», oppure una galleria di ritratti dipinti dagli amici pittori che così volentieri si prestavano in qualità di scenografi in occasione di questi spettacoli, come quelli appunto fatti a richiesta e più volte copiati dal Bronzino, dal Vasari, da Alessandro Allori. È comunque la prova di come vivo fosse ancora nella memoria del Varchi e dei suoi amici il progetto decorativo della "camera" del Bettini, con riuniti i simboli del duplice Amore, celeste e terreno, Venere e/versus Cupido, sotto lo sguardo severo dei grandi poeti-filosofi toscani.

icated to the Graces, a statue of Venus genetrix, etc.) and his pupil Allori painted a canvas with the major Tuscan poets[63]. In the comedy that was performed for the same occasion, inspired by the fable of Cupid and Psyche, there were intermezzos in which Venus and Cupid sang.

The last of Varchi's works involving his version of Moschus is similar in nature (*Appendix III,c*). *Runaway Love* appears in a codex in which the author gathered works that, for their declamatory nature or dialogue form, were intended to be recited or sung: eclogues and various masquerades[64]. A copyist transcribed the Moschus text as we know it (*Appendix III, a*), but subsequently Varchi intervened personally. He substituted the first two triplets with a new one, in which Venus is immediately given the stage: "Is there any among you honest and welcome crowd that has seen my son who has escaped from me, nor do I know where he has gone?" This variation was nothing but an adaptation of the familiar literary version to a theatrical piece.

In another masquerade in octaves, transcribed in the same codex, Cupid speaks instead[65] (*Appendix III,d*). At first sight the god would seem to express the sincerest intentions, given that he proposes to transform his listener-lovers "not from wise men to idiots, but from idiots to wise men".

In the end, however, Cupid's verses reveal themselves to be a traditional invocation to 'pick the rose', to enjoy youth before it is too late, without too many moral scruples. In octave 6 he goes so far as to attack the greatest poets of love: "And these six, wiser and better than any of them have been within my reign"[66].

Varchi, the author, certainly did not share this opinion. These 'words of Cupid' thus correspond to an intentional reversal. It is as though Varchi shows us Cupid, who has escaped his mother's surveillance; the young god is trying his very best to capture new victims with his enticements, confirming what Venus says in *Runaway Love*[67]: "My precious son speaks sweet words but his mind is deceptive". The two poems refer to one another in a certain sense and could well have been performed as a diptych on the same occasion[68].

In the representation that may possibly have been performed, or perhaps merely imagined by Varchi, the poets are significantly six, as in Vasari's painting. Perhaps six actors – masked as Dante, Petrarch, Boccaccio, and three other "poets that in their Tuscan verses and prose have sung the praises of Love" – formed a crown around Cupid.

Alternatively, he could have been surrounded by a gallery of portraits painted by artist friends who willingly prepared scenography for these spectacles, like those requested and copied on numerous occasions by Bronzino, Vasari, Allori. Whichever the case, it is clear that in the minds of Varchi and his friends the decorative program of Bettini's chamber was a vivid memory, with its symbols of twofold Love, earthly and celestial, Venus and/vs. Cupid, united under the severe gaze of the greatest Tuscan poet-philosophers.

Ringrazio per i preziosi consigli e commenti sul presente lavoro Domenico De Robertis, Bruce Edelstein, Walter Kaiser e Giuliano Tanturli. Anche se a mio nome, il lavoro è il frutto della collaborazione con Jonathan Nelson.

[1] JONATHAN KATZ NELSON, *Creative Patronage: Luca Martini and the Renaissance Portrait*, "Mitteilungen des Kunsthistorischen Institutes in Florenz", XXXIX, 1995, pp. 282-305, alla p. 300, n. 9, segnala il ms. 2550 della Biblioteca Riccardiana di Firenze, cc. 152r-168v. Il dialogo si trova anche nei codici Magliabechiano VI 238 (secolo XVII) della Biblioteca Nazionale di Firenze, cc. 128r-148v, seguito dal *Trattato dell'Archimia del Varchi scritto d'ordine del Duca Cosimo,=* e Cart. 105 (XIV, N 39) della Biblioteca Civica di Orvieto. Ne uscirà presto un'edizione per mia cura in uno dei prossimi numeri della rivista "Per leggere". Per il momento non sono riuscito a trovare altre notizie sull'autore, "Bacciotto del Sevaiolo detto Baccio Tasio". Posso solo segnalare nel codice Magl. VII 877 (secolo XVI), un suo *Capitolo in dispregio dell'Arte della Medicina: Se voi vedessi caro Benedetto*, cc. 31r-35v, seguito da un altro *Capitolo di Vincentio Danti [1530-1576] scultore Perugino in dispregio dell'Archimia*; altri codici fiorentini gli attribuiscono alcuni carmi latini.

[2] Sul Martini, oltre allo studio citato alla nota 1, vedi anche di JONATHAN NELSON, *Luca Martini "dantista", and Pierino da Vinci's relief of the "Death of Ugolino della Gherardesca and his Sons"*, in *Pierino da Vinci*, atti del convegno (Vinci 1990), a cura di Marco Cianchi, Becocci, Firenze 1995, pp. 39-46.

[3] L'autore della commedia non è mai nominato nel dialogo. L'argomento, che riguarda le comiche vicissitudini di un vecchio innamorato come già nella *Clizia* del Machiavelli, fa pensare a un'opera affine a *L'errore* di Giambattista Gelli, pubblicata nel 1556.

[4] *Il libro delle ricordanze di Giorgio Vasari*, a cura di Alessandro del Vita, Casa del Vasari, Arezzo 1929, p. 20 (citato da Aste, nel suo saggio).

[5] Il Vasari, nei suoi *Ricordi* parla sempre di Dante, Petrarca, Boccaccio, Cavalcanti, Guittone e Cino, sia per la tavola del Martini (CARL FREY, *Giorgio Vasari. Der Literarische Nachlass*, 3 voll., Müller, München 1923-1940, II, n. 144, p. 861 e GIORGIO VASARI *Le vite de' più eccellenti pittori, scultori ed architetti nelle redazioni del 1550 e 1568*, a cura di Rosanna Bettarini-Paola Barocchi, 11 voll., Sansoni, Firenze 1966-1997, VI, p. 384) sia per quella del Giovio (FREY 1923-1940, II, n. 178, p. 867). Il Frey riporta anche il testo della lettera in cui il Giovio richiede una copia con varianti della tavola del Martini (I, n. 87, p. 175), trascrivendolo così: «con Guido Cavalcanti e Guiton d'Arezo e Cambio di Ficino e del Landino»; in nota tuttavia propone di leggere il testo nel modo qui adottato. Anche il Giovio dunque si era confuso perché Cavalcanti c'era già nella tavola probabilmente appartenuta al Martini.

[6] Si veda JONATHAN NELSON, *Dante Portraits in Sixteeenth Century Florence*, "Gazette des Beaux-Arts", 6-CXX, 1992, pp. 59-77 e DEBORAH PARKER, *Vasari's "Portrait of six Tuscan Poets": a visibile literary history*, "Lectura Dantis. A forum for Dante research and interpretation", XXII-XXIII, 1998 [*Visibile Parlare. Dante and the Art of the Italian Renaissance*], pp. 45-62 con bibliografia.

[7] LORENZO DE' MEDICI, *Comento de' miei sonetti*, a cura di Tiziano Zanato, Olschki, Firenze 1991, pp. 147-148; *Nutricia*, vv. 720-725, in ANGELO POLIZIANO, *Silvae*, a cura di Francesco Bausi, Olschki, Firenze 1996, pp. 246-247.

[8] CRISTOFORO LANDINO, *Comedia del divino poeta Dante Alighieri, con la dotta e leggiadra spositore di Christophoro Landino*, Nicholo di Lorenzo della Magna, Firenze 1481; si può leggere ora in CRISTOFORO LANDINO, *Comento sopra la Comedia*, a cura di Paolo Procaccioli, Salerno, Roma 2001. Per il *Commentarium* si veda MARSILIO FICINO, *Commentaire sur le Banquet de Platon*, a cura di Raymond Marcel, Les Belles Lettres, Paris 1956; e per la versione in volgare MARSILIO FICINO, *El libro dell'Amore*, a cura di Sandra Niccoli, Olschki, Firenze 1987.

[9] PIETRO BEMBO, *Prose e rime*, a cura di Carlo Dionisotti, UTET, Torino 1960, in particolare le pp. 128-132 e *passim*.

[10] Per esempio anche il Lasca (Anton Francesco Grazzini), uno dei fon-

For their precious suggestions and comments on this essay I thank Domenico De Robertis, Bruce Edelstein, Walter Kaiser and Giuliano Tanturli. Even though it is written in my name, this work is the fruit of a collaboration with Jonathan Nelson.

[1] JONATHAN KATZ NELSON, *Creative Patronage: Luca Martini and the Renaissance Portrait*, "Mitteilungen des Kunsthistorischen Institutes in Florenz", 39, 1995, pp. 282-305, at p. 300 n. 9, indicates ms. 2550 of the Biblioteca Riccardiana, Firenze, cc. 152r-168v. The dialogue is also found in the codex Magliabechiano VI 238 (XVII cent.) of the Biblioteca Nazionale, Firenze, cc. 128r-148v, followed by the *Trattato dell'Archimia del Varchi scritto d'ordine del Duca Cosimo*, and Cart. 105 (XIV n. 39) of the Biblioteca Civica of Orvieto. I am presently working on an edition that will be published in one of the upcoming issues of the periodical 'Per leggere'. For the moment, I have been unable to find ulterior information on the author, 'Bacciotto del Sevaiolo detto Baccio Tasio'. I can only indicate the codex Magliabechiano. VII 877 (XVI cent.) in which his *Capitolo in dispregio dell'Arte della Medicina: Se voi vedessi caro Benedetto*, cc. 31r-35v, can be found, followed by another *Capitolo di Vincentio Danti [1530-1576] scultore Perugino in dispregio dell'Archimia*; other Florentine codexes attribute to him some Latin poems.

[2] On Martini, besides the study cited in n. 1, see also JONATHAN NELSON, *Luca Martini 'dantista', and Pierino da Vinci's relief of the 'Death of Ugolino della Gherardesca and his Sons'*, in *Pierino da Vinci*. Acts of Conference (Vinci 1990), ed. Marco Cianchi, Becocci, Firenze 1995, pp. 39-46.

[3] The author of the comedy is never named in the dialogue. The argument deals with the comical vicissitudes of an old man in love, as in the earlier *Clizia* by Machiavelli, brings to mind a work similar to *The Error* by Giambattista Gelli, published in 1556.

[4] *Il libro delle ricordanze di Giorgio Vasari*, ed. Alessandro del Vita, Casa del Vasari, Arezzo 1929, p. 20 (see the essay by Aste, in this volume).

[5] Vasari, in his *Ricordi*, always mentions Dante, Petrarch, Boccaccio, Cavalcanti, Guittone and Cino, in regards to both the panel for Martini (CARL FREY, *Giorgio Vasari. Der Literarische Nachlass*, 3 vols., Müller, München 1930, II, n. 144, p. 861 e Giorgio Vasari, *Le vite de' più eccellenti pittori scultori ed architetti nelle redazioni del 1550 e 1568*, ed. Rosanna Bettarini-Paola Barocchi, 11 vols., Sanson, Firenze 1966-1997, VI, p. 384) and the one for Giovio (FREY 1923-1940, II, n. 178, p. 867). Frey also transcribes the text of the letter in which Giovio asks for a copy with variations of the Martini's panel (I, n. 87, p. 125) in the following way: «con Guido Cavalcanti e Guiton d'Arezo e Cambio di Ficino e del Landino»; in the notes however he proposes a reading of the text like the one adopted here. Whichever the case, Giovio was certainly confused because Cavalcanti was already included in the panel that probably belonged to Martini.

[6] See JONATHAN NELSON, *Dante Portraits in Sixteenth Century Florence*, 'Gazette des Beaux-Arts', 6-CXX, 1992, pp. 59-77 e DEBORAH PARKER, *Vasari's 'Portrait of six Tuscan Poets': a visibile literary history*, 'Lectura Dantis. A forum for Dante research and interpretation', XXII-XXIII, 1998 [*Visibile Parlare. Dante and the Art of the Italian Renaissance*], pp. 45-62, with further bibliography.

[7] LORENZO DE' MEDICI, *Comento de' miei sonetti*, ed. Tiziano Zanato, Olschki, Firenze 1991, pp. 147-148; *Nutricia*, vv. 720-725, in ANGELO POLIZIANO, *Silvae*, ed. Francesco Bausi, Olschki, Firenze 1996, pp. 246-247.

[8] CRISTOFORO LANDINO, *Comedia del divino poeta Dante Alighieri, con la dotta e leggiadra spositore di Christophoro Landino*, Nicholo di Lorenzo della Magna, Firenze 1481; can be read now in CRISTOFORO LANDINO, *Comento sopra la Comedia*, ed. Paolo Procaccioli, Salerno, Roma 2001. For the *Commentarium* see MARSILIO FICINO, *Commentaire sur le Banquet de Platon*, ed. Raymond Marcel, Les Belles Lettres, Paris 1956, and for the version in vernacular MARSILIO FICINO, *El libro dell'Amore*, ed. Sandra Niccoli, Olschki, Firenze 1987.

[9] PIETRO BEMBO, *Prose e rime*, ed. Carlo Dionisotti, UTET, Torino 1960, in particular pp. 128-132 and *passim*.

[10] For example also Lasca (Anton Francesco Grazzini) — one of the

datori dell'Accademia degli Umidi e amico, oltre che del Martini e del Bettini, di Benedetto Varchi, quando parla, citando il Bembo, del «tosco maggiore», intende Petrarca, non Dante. Cfr. MICHEL PLAISANCE, *Une première affirmation de la politique culturelle de Côme I*er*: la transformation de l'Académie des "Humidi" en Académie Florentine*, in *Les écrivains et le pouvoir en Italie à l'époque de la Renaissance (Première série)*, a cura di André Rochon, Université de la Sorbonne nouvelle, Paris 1973, pp. 361-433, alla p. 395. Il richiamo è alla definizione di Petrarca come «maggior Tosco» in PIETRO BEMBO, *Stanze*, ottava 22, in BEMBO 1960, p. 660.

[11] *Sonetti e canzoni di diversi antichi autori toscani*, Giunti, Firenze 1527. Se ne può vedere la ristampa anastatica: vol. I, *Introduzione e indici* a cura di Domenico De Robertis, II, *Testo*, Le Lettere, Firenze 1977, e per il rapporto con le *Prose* del Bembo, la recensione all'ed. De Robertis di GUGLIELMO GORNI, in *Il nodo della lingua e il verbo d'Amore*, Olschki, Firenze 1981, pp. 217-241.

[12] Cino e Guittone sono accostati a Dante in Petrarca, *Canzoniere* 287 e nel *Triumphus Cupidinis* IV. 31; la canzone d'amore del Cavalcanti è richiamata in *Canzoniere* 70.20. La sostituzione, se così si può dire, di Cavalcanti, caro alla cultura laurenziana, con Cino da Pistoia, come principale mediatore nel passaggio tra Dante e Petrarca, è promossa anch'essa soprattutto dal Bembo.

[13] PIETRO BEMBO, *Prose della volgar lingua*, II, 20, in BEMBO 1960, p. 178.

[14] Seguo le coordinate ricostruite da Giuliano Tanturli nel suo saggio *La Firenze laurenziana davanti alla propria storia letteraria*, in *Lorenzo il Magnifico e il suo tempo*, a cura di Gian Carlo Garfagnini, Olschki, Firenze 1992, pp. 1-38.

[15] GUIDO CAVALCANTI, *Rime, con le rime di Iacopo Cavalcanti*, a cura di Domenico De Robertis, Einaudi, Torino 1986. Per la canzone di Cavalcanti e i suoi numerosi commenti si veda ENRICO FENZI, *La canzone d'amore di Guido Cavalcanti e i suoi antichi commenti*, Melangolo, Genova 1999.

[16] MARSILIO FICINO 1987, p. 177.

[17] Il canzoniere, intitolato *Canzoni e sonetti di Girolamo Benivieni Fiorentino*, è inedito, e conservato soltanto in due codici settentrionali, il Sessoriano 413 della Biblioteca Nazionale di Roma, cc. 413r-435r, e il Parmense 3070 della Biblioteca Palatina di Parma, cc. 2r-17r. Un'edizione critica per mia cura è di prossima pubblicazione. Per informazioni generali sull'opera si deve ricorrere ancora alla biografia di CATERINA RE, *Girolamo Benivieni fiorentino. Cenni sulla vita e sulle opere*, Lapi, Città di Castello 1906, pp. 157-193 e alla voce di CESARE VASOLI, in *Dizionario Biografico degli italiani*, VIII, 1966, pp. 150-155:

[18] *Opere di Hieronymo Benivieni*, Giunti, Firenze 1519, p. 40r.

[19] Cfr. GIOVANNI AGNELLI, *Topo-cronografia del viaggio dantesco*, Hoepli, Milano 1891 e GIOVANNI BUTI-RENZO BERTAGNI, *Commento astronomico della "Divina Commedia"*, Sandron, Firenze 1966.

[20] Si può leggere in CRISTOFORO LANDINO, *Scritti critici e teorici*, a cura di Roberto Cardini, 2 voll, Bulzoni, Roma 1974, I, pp. 155-164.

[21] *Commedia di Dante insieme con uno dialogo circa el sito forma et misure dello Inferno*, Giunti, Firenze 1506.

[22] Per gli studi di Giambullari (la cui lezione è pubblicata per la prima volta in *Lettioni d'Accademici Fiorentini sopra Dante*, Doni, Firenze 1547, pp. 82-96), Martini, Borghini e Galilei, vedi *Studi sulla Divina Commedia di Galileo Galilei, Vincenzio Borghini e altri*, a cura di Ottavio Gigli, Le Monnier, Firenze 1855 (per il Martini si tenga conto anche delle osservazioni e rettifiche di NELSON 1990, pp. 39-40). Su Donato Giannotti, cfr. *Dialoghi de' giorni che Dante consumò nel cercare l'Inferno e 'l Purgatorio*, a cura di Deoclecio Redig De Campos, Sansoni, Firenze 1939.

[23] Nel 1960 Andrea Emiliani (*Il Bronzino*, Bramante, Busto Arsizio 1960, p. 63) aveva segnalato un ritratto dell'Ariosto, conservato in una collezione privata, derivato da un originale del Bronzino, a suo parere presumibilmente connesso con le lunette del Bettini. Un omaggio del Bronzino e del suo *entourage* a un grande letterato, non toscano ma molto amato a Firenze, è possibile, anche se riesce difficile immaginare l'Ariosto celebrato come poeta d'amore, condizione che, almeno stando al Vasari, sembrerebbe essenziale per l'inclusione nella galleria della "camera".

[24] *Dante col sito, et forma dell'Inferno tratta dalla istessa descrittione del poeta*, nelle case d'Aldo et d'Andrea d'Asola, Venezia 1515. Il testo è

founders of the Accademia degli Umidi and friend, not only of Martini and Bettini but also Benedetto Varchi – when, citing Bembo, he speaks of the "tosco maggiore", intends Petrarch, not Dante. Cf. MICHEL PLAISANCE, *Une première affirmation de la politique culturelle de Côme I*er*: la transformation de l'Académie des "Humidi" en Académie Florentine*, in *Les écrivains et le pouvoir en Italie à l'époque de la Renaissance (Première série)*, ed. André Rochon, Université de la Sorbonne Nouvelle, Paris 1973, pp. 361-433, on p. 395. For the definition of Petrarch as "maggior Tosco" see PIETRO BEMBO, *Stanze*, octave 22, in BEMBO 1960, p. 660.

[11] *Sonetti e canzoni di diversi antichi autori toscani*, Giunti, Firenze 1527. The facsimile edition of the work can be found in: vol. I, *Introduzione e indici*, ed. Domenico De Robertis, vol. II, *Testo*, Le Lettere, Firenze 1977, and in regards to the relation to the *Prose* by Bembo, see the review of the De Robertis edition by Guglielmo Gorni in *Il nodo della lingua e il verbo d'Amore*, Olschki, Firenze 1981, pp. 217-241.

[12] Cino and Guittone are associated with Dante in PETRARCH, *Canzoniere* 287 and in *Triumphus Cupidinis* IV.31; the canzone of love by Cavalcanti is recalled in *Canzoniere* 70.20. Bembo was also the main promoter of the substitution, if it can be called so, of Cavalcanti, dear to Laurentian circles, with Cino da Pistoia as the principal mediator in the passage between Dante and Petrarch.

[13] PIETRO BEMBO, *Prose della volgar lingua*, II.20, in BEMBO 1960, p. 178.

[14] I follow the arguments as presented in Giuliano Tanturli's essay *La Firenze laurenziana davanti alla propria storia letteraria*, in *Lorenzo il Magnifico e il suo tempo*, ed. Gian Carlo Garfagnini, Olschki, Firenze 1992, pp. 1-38.

[15] GUIDO CAVALCANTI, *Rime, con le rime di Iacopo Cavalcanti*, ed. Domenico De Robertis, Einaudi, Torino 1986. For the canzone by Cavalcanti and the texts of his numerous commentaries see ENRICO FENZI, *La canzone d'amore di Guido Cavalcanti e i suoi antichi commenti*, Melangolo, Genova 1999.

[16] MARSILIO FICINO 1987, p. 177.

[17] The *canzoniere*, entitled *Canzoni e sonetti di Girolamo Benivieni Fiorentino*, is unpublished, and only preserved in two northern codexes, the Sessoriano 413 of the Biblioteca Nazionale, Roma, cc. 413r-435r, and the Parmense 3070 of the Biblioteca Palatina, Parma, cc. 2r-17r. A critical edition edited by me is forthcoming. For general information on his production, reference must still be made to the biography by CATERINA RE, *Girolamo Benivieni fiorentino. Cenni sulla vita e sulle opere*, Lapi, Città di Castello 1906, pp. 157-193 and CESARE VASOLI, *Dizionario Biografico degli Italiani*, VIII, 1966, pp. 150-155.

[18] *Opere di Hieronymo Benivieni*, Giunti, Firenze 1519, p. 40r.

[19] Cf. GIOVANNI AGNELLI, *Topo-cronografia del viaggio dantesco*, Hoepli, Milano 1891 and GIOVANNI BUTI-RENZO BERTAGNI, *Commento astronomico della 'Divina Commedia'*, Sandron, Firenze 1966.

[20] See CRISTOFORO LANDINO, *Scritti critici e teorici*, ed. Roberto Cardini, 2 vols, Bulzoni, Roma 1974, I, pp. 155-164.

[21] *Commedia di Dante insieme con uno dialogo circa el sito forma et misure dello Inferno*, Giunti, Firenze 1506.

[22] For the studies of Giambullari (whose lesson is published for the first time in *Lettioni d'Accademici Fiorentini sopra Dante*, Doni, Firenze 1547, pp. 82-96), Martini, Borghini e Galilei, see *Studi sulla Divina Commedia di Galileo Galilei, Vincenzio Borghini e altri*, ed. Ottavio Gigli, Le Monnier, Firenze 1855 (for Martini see also the observations and rectifications of NELSON 1990, pp. 39-40). For Donato Giannotti, see *Dialoghi de' giorni che Dante consumò nel cercare l'Inferno e 'l Purgatorio*, ed. Deoclecio Redig De Campos, Sansoni, Firenze 1939.

[23] In 1960 Andrea Emiliani (*Il Bronzino*, Bramante, Busto Arsizio 1960, p. 63) indicated the existence of a portrait of Ariosto, in a private collection, a derivation of an original by Bronzino that, in his opinion, was presumably connected to the lunettes for Bettini. It is possible that Bronzino and his *entourage* paid this homage to the great literary figure, who, although not Tuscan, was well loved in Florence. Nonetheless, it is difficult to imagine Ariosto celebrated as a poet of love, a condition that, at least as Vasari indicates, would seem to have been the prerequisite for an inclusion in the gallery of the chamber.

piuttosto danneggiato nella lunetta, mentre è perfettamente leggibile nella copia di Washington, se anche non autografa comunque con ogni probabilità uscita dalla bottega del Bronzino. Là dove è possibile confrontare i due testi, si possono osservare nella copia alcune varianti non attestate nelle edizioni correnti in quegli anni, una delle quali particolarmente interessante: al v. 7 invece di «Con altra voce homai con altro vello Ritornerò poeta» si legge «Con altra penna homai con miglior vello…».

[25] Si veda il *Riscontro e scelta delle varianti di sette manoscritti della "Divina Commedia" fatto sopra il testo d'Aldo del 1515 nella Pieve di S. Gavino in Mugello da Baccio Valori, Benedetto Varchi, Luca Martini… in Studi…* 1855, pp. 321-358. Una bibliografia più dettagliata si può trovare in NELSON 1990.

[26] Il capitolo fu pubblicato per la prima volta in FRANCESCO BERNI, *I capitoli del Berni in terza rima, nuovamente con somma diligentia stampate*, Navo, Venezia 1538. Si può leggere ora come n. XXVIII nell'edizione commentata di Silvia Longhi in *Poeti del Cinquecento*. Tomo I: *Poeti lirici, burleschi e didascalici*, a cura di Guglielmo Gorni, Massimo Danzi e Silvia Longhi, Ricciardi, Milano-Napoli 2001, pp. 799-803.

[27] GUGLIELMO GORNI, in *Poeti…* 2001, p. 576.

[28] Alludo, oltre che al filosofo, anche al poeta, per cui si veda GIOVANNI PICO DELLA MIRANDOLA, *Sonetti*, a cura di Giorgio Dilemmi, Einaudi, Torino 1994. Nella biografia scritta dal nipote Antonio Benivieni, conservata nell'Archivio di Stato di Firenze, Manoscritti Gianni 43 alla c. 25, si racconta che il giovanissimo Girolamo durante un banchetto di Lorenzo de' Medici indicò proprio in Michelangelo allora tredicenne l'artista «che sarà atto a vincere di maestria e di forma molti e molti accozzati insieme». Vi sarà in questa profezia del Benivieni molto senno del poi, come giustamente rileva il Parronchi, ma è comunque significativa della sua grande ammirazione per l'artista (ALESSANDRO PARRONCHI, *Opere giovanili di Michelangelo*, vol. III, *Miscellanea Michelangiolesca*, Olschki, Firenze 1981, pp. 221-222).

[29] Pubblicata per la prima volta nel *Primo volume della scielta di stanze raccolte da M. Agostino Ferentilli*, Bernardo Giunti, Venezia 1584, pp. 191-193 (ripubblicato in BENEDETTO VARCHI, *Opere*, 2 voll., a cura di Antonio Racheli, Dalla sezione letterario-artistica del Lloyd austriaco, Trieste, 1858-1859, II, p. 584). In BENEDETTO VARCHI, *Saggio di rime inedite estratte dai manoscritti originali della Biblioteca Rinucciniana*, a cura di Giuseppe Aiazzi, Firenze, 1837, pp. 15-18, è intitolata *Mascherata di Dante e del Petrarca nelle nozze di Cosimo I de' Medici con Eleonora di Toledo*, supponendo che l'autore l'abbia inviata a Firenze da Padova in quell'occasione. Ma il 1539 è data forse troppo precoce per pensare a un riavvicinamento del Varchi al regime mediceo; è un omaggio a Cosimo e Eleonora, che vi sono nominati, ma non necessariamente per il loro matrimonio. MICHEL PLAISANCE, *Culture et politique à Florence de 1542 à 1551: Lasca et les Humidi aux prises avec l'Académie Florentine*, in *Les écrivains et le pouvoir en Italie à l'époque de la Renaissance*, a cura di André Rochon, Université de la Sorbonne Nouvelle, Paris 1974, pp. 149-242; alla p. 195, più prudentemente, ritiene la mascherata composta prima del 1547 (data di morte del Bembo, a cui il Varchi si riferisce come ancora vivo).

[30] La lettera è discussa in PLAISANCE 1973, pp. 373-375 e citata per intero in appendice alle pp. 433-434.

[31] Anche a questo proposito si veda quanto ne scrive PLAISANCE 1973, p. 394; 1974, p. 162.

[32] *"Due Lezzioni" di M. Benedetto Varchi, nella prima delle quali si dichiara un sonetto di M. Michelagnolo Buonarroti, nella seconda si disputa quale sia più nobile arte, la scultura o la pittura…*, Torrentino, Firenze 1550; per l'edizione moderna vedi *Trattati d'arte del Cinquecento, fra Manierismo e Controriforma*, 3 voll. a cura di Paola Barocchi, I, Laterza, Bari 1960-1962, da cui cito.

[33] BAROCCHI 1960-1962, I, p. 538.

[34] Vedi MICHELANGELO BUONARROTI, *Rime*, a cura di Enzo Noè Girardi, Laterza, Bari 1967, pp. 487-489.

[35] *Rime di Michelangelo Buonarroti. Raccolte da Michelagnolo suo Nipote*, Giunti, Firenze 1623.

[36] Il sonetto è emblematico fin dal primo verso: il richiamo è a Dante, *Donne ch'avete intelletto d'amore*, la canzone-manifesto della *Vita nova* e dello stilnuovo, che scrive di Beatrice: «Dice di lei Amor: "Cosa mortale

[24] *Dante col sito, et forma dell'Inferno tratta dalla istessa descrittione del poeta*, nelle case d'Aldo et d'Andrea d'Asola, Venezia 1515. The text is rather damaged in the lunette but perfectly legible in the copy in Washington, which is probably not an original by Bronzino but may be a product of his workshop. When the two texts can be compared, a few variations not present in contemporary editions can be noted in the copy. One of these is particularly interesting: at v. 7 instead of «Con altra voce homai con altro vello Ritornerò poeta» we read «Con altra penna homai con miglior vello…».

[25] See the *Riscontro e scelta delle varianti di sette manoscritti della 'Divina Commedia' fatto sopra il testo d'Aldo del 1515 nella Pieve di S. Gavino in Mugello da Baccio Valori, Benedetto Varchi, Luca Martini… in Studi…* 1855, pp. 321-358. A more detailed bibliography can be found in NELSON 1990.

[26] The chapter was published for the first time in FRANCESCO BERNI, *I capitoli del Berni in terza rima, nuovamente con somma diligentia stampate*, Navo, Venezia 1538. It can now be consulted as n. XXVIII in a commentated edition by Silvia Longhi in *Poeti del Cinquecento*. Tomo I. *Poeti lirici, burleschi e didascalici*, ed. Guglielmo Gorni, Massimo Danzi and Silvia Longhi, Ricciardi, Milano-Napoli 2001, pp. 799-803.

[27] GUGLIELMO GORNI, in *Poeti…* 2001, p. 576.

[28] In addition to the philosopher, I allude to the poet, for which see GIOVANNI PICO DELLA MIRANDOLA, *Sonetti*, ed. Giorgio Dilemmi, Einaudi, Torino 1994. In the biography written by the nephew Antonio Benivieni, now in the State Archives, Florence, Manoscritti Gianni 43, c. 25, it is said that the young Girolamo during a banquet given by Lorenzo de' Medici indicated precisely Michelangelo, then thirteen, as the artist "che sarà atto a vincere di maestria e di forma molti e molti accozzati insieme". There must be much hindsight in this prophecy by Benivieni, as Parronchi rightly underscored, but it is nonetheless indicative of his great admiration for Michelangelo (ALESSANDRO PARRONCHI, *Opere giovanili di Michelangelo*, vol. III, *Miscellanea Michelangiolesca*, Olschki, Firenze 1981, pp. 221-222).

[29] Published for the first time in *Primo volume della scielta di stanze raccolte da M. Agostino Ferentilli*, Bernardo Giunti, Venezia 1584, pp. 191-193 (republished in BENEDETTO VARCHI, *Opere*, 2 vols., ed. Antonio Racheli, Dalla sezione letterario-artistica del Lloyd austriaco, Trieste 1858-59, II, p. 584). In BENEDETTO VARCHI, *Saggio di rime inedite estratte dai manoscritti originali della Biblioteca Rinucciniana*, ed. Giuseppe Aiazzi, Piatti, Firenze 1837, pp. 15-18, it is entitled *Mascherata di Dante e del Petrarca nelle nozze di Cosimo I de' Medici con Eleonora di Toledo*, suggesting that the author sent it from Padua to Florence on that occasion. But 1539 is perhaps too early a date for Varchi's reconciliation with the Medici regime; although definitely a homage to Cosimo and Eleonora, who are mentioned in it, it was not necessarily composed for their marriage. MICHEL PLAISANCE, *Culture et politique à Florence de 1542 à 1551: Lasca et les Humidi aux prises avec l'Académie Florentine*, in *Les écrivains et le pouvoir en Italie à l'époque de la Renaissance*, ed. André Rochon, Université de la Sorbonne nouvelle, Paris 1974, pp. 149-242, on p. 195, more prudently maintains that the masquerade was composed before 1547 (the year Bembo dies and to whom Varchi refers as still living).

[30] The letter is discussed in PLAISANCE 1973, pp. 373-375 and entirely transcribed in the appendix on pp. 433-434.

[31] On this subject see once again PLAISANCE 1973, p. 394; 1974, p. 162

[32] *'Due Lezzioni' di M. Benedetto Varchi, nella prima delle quali si dichiara un sonetto di M. Michelagnolo Buonarroti, nella seconda si disputa quale sia più nobile arte, la scultura o la pittura…*, Torrentino, Firenze 1550; for the modern edition see *Trattati d'arte del Cinquecento, fra Manierismo e Controriforma*, 3 vols. ed. Paola Barocchi, I, Laterza, Bari 1960-1962, used here.

[33] BAROCCHI 1960-1962, I, p. 538.

[34] See MICHELANGELO BUONARROTI, *Rime*, ed. Enzo Noè Girardi, Laterza, Bari 1967, pp. 487-489.

[35] *Rime di Michelangelo Buonarroti. Raccolte da Michelagnolo suo Nipote*, Giunti, Firenze 1623.

[36] The sonnet is emblematic from the first line: the reference is to Dante, *Donne ch'avete intelletto d'amore*, the 'canzone-manifesto' of

Come esser può sì adorna e sì pura?"». Il motivo è ripreso dalle altre due corone: PETRARCA, *Canzoniere* 90: «Non era l'andar suo cosa mortale Ma d'angelica forma… Uno spirto celeste, un vivo sole Fu quel ch'i' vidi…», e BOCCACCIO, *Filostrato*, I. 11. 3-5 «la quale Sì bella e sì angelica a vedere Era, che non parea cosa mortale». L'immagine arriva infine a Michelangelo (per cui cfr. anche il sonetto 78) attraverso il recupero e la mediazione del neoplatonismo quattrocentesco: si veda in particolare uno dei sonetti più programmatici in senso filosofico di Girolamo Benivieni, in apertura del *Commento*… 1519, I, II, c. VIII*r-v*: «La donna mia non è cosa mortale / Che si possa veder sensibilmente, / Né imaginar, che nostra inferma mente, / Nostro concepto human tanto non sale».

37 VARCHI 1858-1859, II, p. 626.

38 MARSILIO FICINO, *De Amore*, a cura di Neri Dortelata [Cosimo Bartoli e Pierfrancesco Giambullari] Torrentino, Firenze 1544.

39 Si veda in proposito il saggio di Mendelsohn.

40 *The Greek Bucolic Poets*, trad. di John Maxwell Edmonds, The Loeb Classical Library, London 1912, pp. 422-425.

41 «Namque pharetratus dum dat puer oscula matri, Inscius extanti destrinxit harundine pectus: Laesa manu natum dea reppulit…»; «e infatti un giorno il fanciullo [quello con la faretra] dava dei baci a Venere sua madre, quando senza volere le scalfì il petto con una freccia che sporgeva. Sentendosi pungere, la dea scostò con la mano il figlio…» (trad. di Piero Bernardini Marzolla, Einaudi, Torino 1979).

42 JAMES HUTTON, *The Greek Anthology in Italy to the Year 1800*, Cornell University Press, Ithaca 1935.

43 *Marsilio Ficino e il ritorno di Platone. Mostra di manoscritti stampe e documenti*, catalogo della mostra (Firenze) a cura di Sebastiano Gentile, Sandra Niccoli e Paolo Viti, Le Lettere, Firenze 1984, scheda n. 45.

44 La traduzione del Benivieni, insieme a quella del Poliziano, è pubblicata in *Poesie volgari inedite e poesie latine e greche edite e inedite di Angelo Ambrogini Poliziano*, a cura di Isidoro Del Lungo, Barbèra, Firenze 1867, pp. 527-528. Nei due mss. di *Canzoni e Sonetti* (cfr. nota 17), si trova, nel codice della Biblioteca Nazionale di Roma, Sessoriano 413, alle cc. 431*r*-432*v*, nel codice della Biblioteca Palatina di Parma, Parmense 3070, alla c. 15*r-v*.

45 Per l'importanza della versione di Mosco nell'opera di Poliziano si veda IDA MAÏER, *Ange Politien. La formation d'un poète humaniste (1469-1480)*, Droz, Genève 1966, in particolare alle pp. 107-115, 255-256, 314-315 e ALESSANDRO PEROSA, *Studi sulla tradizione delle poesie latine del Poliziano*, in *Studi in Onore di Ugo Enrico Paoli*, Le Monnier, Firenze 1954, pp. 539-562, alle pp. 555-556.

46 Cfr. *Il disegno fiorentino del tempo di Lorenzo il Magnifico*, catalogo della mostra (Firenze), a cura di Annamaria Petrioli Tofani, Silvana, Cinisello Balsamo 1992, scheda n. 7.5, a cura di Gianvittorio Dillon con bibliografia. DARIO COVI, *Four new documents concerning Andrea del Verrocchio*, "The Art Bullettin", XLVIII, 1966, pp. 99 e 103, ha rinvenuto in un inventario dei beni posseduti dall'artista alla sua morte, fra altri libri, un «Moscino in forma» (da leggere Mosc[h]ino), da lui interpretato come un'edizione di Mosco di cui però non abbiamo notizia a questa data (in nota riferisce anche di alcune proposte alternative di Panofky e Kristeller). Da un controllo sul documento (Archivio di Stato di Firenze, Tribunale della Mercanzia, 1539, cc. 301*r*-302*v*) a me pare si possa leggere anche «Mesc[h]ino», che darebbe credito all'ipotesi che mi è stata suggerita oralmente da Giuliano Tanturli, e cioè che possa trattarsi di *Guerino il Meschino*, il popolare romanzo di Andrea da Barberino più volte stampato nel corso del Quattrocento. Sulla scorta di questa segnalazione di Covi, avevano richiamato l'idillio di Mosco, a proposito del disegno del Verrocchio, LUISA VERTOVA, *Maestri toscani del Quattro e primo Cinquecento*, Istituto Alinari, Firenze 1981, pp. 49-51; a proposito di una tavola di Lorenzo di Credi con la *Storia di Afrodite e Adone* di collezione privata, GIGETTA DALLI REGOLI, *Precisazioni sul Credi*, "Critica d'Arte", n. s. 18, 1971, pp. 67-80 (interessante esempio di precoce contaminazione tra l'idillio greco e il mito ovidiano).

47 *Omnia opera Angeli Politiani*…, Aldo Manuzio Venezia 1498. Nelle successive edizioni la versione dell'*Amor fuggitivo* del Poliziano, compare sia tra i carmi latini, sia in una redazione più tarda in una lettera inviata ad Antonio Zenoe raccolte nelle sue *Epistole*. Fra la fine del Quattrocento e gli inizi del Cinquecento l'idillio fu tradotto in latino anche dagli umanisti

the *Vita nova* and of the Stilnovisti. It describes Beatrice as follows: "Dice di lei Amor: 'Cosa mortale Come esser può sì adorna e sì pura?'". The motif is taken up again by the other two crowns: PETRARCH, *Canzoniere* 90: "Non era l'andar suo cosa mortale Ma d'angelica forma… Uno spirto celeste, un vivo sole Fu quel ch'i' vidi…" and BOCCACCIO, *Filostrato*, I 11.3-5: "la quale Sì bella e sì angelica a vedere Era, che non parea cosa mortale". The image finally makes its way to Michelangelo (see also sonnet 78) through the recovery and mediation of fifteenth century neo-Platonism: see in particular one of the most philosophically programmatic sonnets by Girolamo Benivieni, at the beginning of the *Commento*... 1519, I II, c. VIII*r-v*: "La donna mia non è cosa mortale / Che si possa veder sensibilmente, / Né imaginar, che nostra inferma mente, / Nostro concepto human tanto non sale".

37 BENEDETTO VARCHI, *Opere*, II, p. 626.

38 MARSILIO FICINO, *De Amore*, ed. Neri Dortelata [Cosimo Bartoli and Pierfrancesco Giambullari], Torrentino, Firenze 1544.

39 See on this subject the essay by Mendelsohn in this volume.

40 *The Greek Bucolic Poets*, translated by John Maxwell Edmonds, The Loeb Classical Library, London 1912, pp. 422-425.

41 "Namque pharetratus dum dat puer oscula matri, Inscius extanti destrinxit harundine pectus: Laesa manu natum dea reppulit…"; "and in fact one day the boy (the one with the quiver) was kissing his mother Venus when inadvertently he scratched her breast with an arrow that was sticking out. Feeling the prick, the goddess pushed her son away with her hand".

42 JAMES HUTTON, *The Greek Anthology in Italy to the Year 1800*, Cornell University Press, Ithaca 1935.

43 *Marsilio Ficino e il ritorno di Platone. Mostra di manoscritti stampe e documenti*, exh. cat. (Firenze), ed. Sebastiano Gentile, Sandra Niccoli and Paolo Viti, le Lettere, Firenze 1984, entry no. 45.

44 Benivieni's translation, with that of Poliziano, is published in *Poesie volgari inedite e poesie latine e greche edite e inedite di Angelo Ambrogini Poliziano*, ed. Isidoro Del Lungo, Barbèra, Firenze 1867, pp. 527-528. For the two *Canzoni e Sonetti*, mss. (cf. note 17), it is found on cc. 431*r*-432*v* in the cod. of the Biblioteca Nazionale, Roma, Sessoriano 413, and on c. 15*r-v* in the cod. of the Biblioteca Palatina, Parma, Parmense 3070.

45 For the significance of the version of Moschus within the works of Poliziano see IDA MAÏER, *Ange Politien. La formation d'un poète humaniste* (1469-1480), Droz, Genève 1966, in particular on pp. 107-115, 255-256, 314-315 and ALESSANDRO PEROSA, *Studi sulla tradizione delle poesie latine del Poliziano*, in *Studi in Onore di Ugo Enrico Paoli*, Le Monnier, Firenze 1954, pp. 539-562, on pp. 555-556.

46 Cf. *Il disegno fiorentino del tempo di Lorenzo il Magnifico*, exh. cat. (Firenze), ed. Annamaria Petrioli Tofani, Silvana, Cinisello Balsamo 1992, entry no. 7.5, by Gianvittorio Dillon with bibliography. DARIO COVI, *Four new documents concerning Andrea del Verrocchio*, 'The Art Bullettin', XLVIII, 1966, pp. 99 and 103, found among the artist's books inventoried at the time of his death a "Moscino in forma" (to be read as Mosc[h]ino), that he thought was an edition of Moschus of whom however there is no documentation at the time (in note he refers to other interpretations by Panofsky e Kristeller). After direct examination of the document (Archivio di Stato di Firenze, Tribunale della Mercanzia, 1539, cc. 301*r*-302*v*), I believe that it could be read as "Mesc[h]ino"; this would support the hypothesis, suggested to me by Giuliano Tanturli, that the volume was Andrea da Barberino's *Guerino il Meschino*, a popular romance published repeatedly in the Quattrocento. Following Covi's indication, LUISA VERTOVA, *Maestri toscani del Quattro e primo Cinquecento*, Istituto Alinari, Firenze 1981, pp. 49-51, made reference to the poem by Moschus in regards to the drawing by Verrocchio, and GIGETTA DALLI REGOLI, *Precisazioni sul Credi*, 'Critica d'Arte', n. s., 18, 1971, pp. 67-80 in reference to a painting by Lorenzo di Credi with *Stories of Aphrodite and Adonis* in a private collection (an interesting example of the early contamination between the Greek idyll and the Ovidian myth).

47 *Omnia opera Angeli Politiani*..., Aldo Manuzio, Venezia 1498. In the subsequent editions, Poliziano's version of *Amor fuggitivo* appears among the Latin poems and in a slightly different version in a letter sent to Antonio Zeno collected in his *Epistles*. Between the end of the Quattrocento and the beginning of the Cinquecento, the idyll was translated into Latin by the

Antonio Pelotti, milanese (CARLO CORDIÈ, *L'umanista Antonio Pelotti tradut-tore dell'Amor fuggitivo di Mosco*, "Rendiconti dell'Istituto Lombardo di scienze e lettere", 83, 1950, pp. 425-438), e da Francesco Maturanzio, perugino (GIOVAN BATTISTA VERMIGLIOLI, *Memorie per servire alla vita di Fran-cesco Maturanzio, oratore e poeta perugino*, Baduel, Perugia 1807). Per la fortuna europea, a prescindere dalle edizioni di Mosco e di Teocrito a partire soprattutto dal Seicento, l'*Amor fuggitivo* fu tradotto in Francia da Clement Marot, in Inghilterra da Barnabe Barnes in *Parthenophil and Parthenope* (1593); Ben Jonson in *The Haddington Masque, vv. 85-156* (rappresentata nel 1608) e Richard Crashaw nel *Cupid's Crye* (*The Delights of the Muses*, 1646); la versione del Poliziano è richiamata, per la raffigu-razione di Cupido, anche nel mese di marzo nel *Shepheardes Calender* di Edmund Spenser.

[48] Fu pubblicata da GIOSUÈ CARDUCCI in *Scritti di letteratura e d'istruzione. Strenna del giornale* "La Gioventù", Firenze 1863, e ora anche in IACOPO SANNAZARO, *Opere volgari*, a cura di Alfredo Mauro, Laterza, Bari 1961, pp. 257-260. La farsa è testimoniata da un solo codice, Paris, Bibliothèque Nationale, it. 1563, secolo XV, cc. 115r-116v (e in una sua probabile par-ziale copia fiorentina conservata a Firenze, Biblioteca Nazionale, II II 75, secolo XV) compilato nel 1495-1496 a Milano per volontà di Lodovico il Moro, per raccogliere il meglio della produzione letteraria della sua corte, dove trovano ampia ospitalità anche poeti fiorentini come Lorenzo de' Medici, Poliziano, Benivieni, Pico della Mirandola, delle cui rime è il princi-pale testimone.

[49] La commedia pastorale del Tasso infatti, composta intorno al 1573, si apre con un prologo in cui parla Amore sfuggito alla madre e camuffa-to da contadino (ispirato all'altro epigramma di Mosco presente nel-l'*Antologia* di Massimo Planude, IV, 200, e tradotto anch'esso da Poli-ziano in "Amorem arantem"), e si conclude con una libera versione del-l'*Amor fuggitivo* in alcune stampe a partire da quella di Vittorio Baldini, Ferrara 1581. Si veda TORQUATO TASSO, *Aminta*, edizione critica a cura di Bartolo Tommaso Sozzi, Liviana, Padova 1957, con le osservazioni di PAOLO TROVATO, *Per una nuova edizione dell'"Aminta"*, in *Torquato Tasso e la cultura estense*, a cura di Gianni Venturi, Olschki, Firenze 1999, III, pp. 1003-1027.

[50] *Commento di Hieronymo Benivieni sopra a più sue canzone e sonetti dello Amore e della Bellezza divina*, Tubini, Firenze 1500.

[51] Cfr. nota 18.

[52] ERWIN PANOFSKY, *The Neoplatonic Movement and Michelangelo*, in *Studies in Iconology*, Oxford Univesity Press, New York 1939; trad. italia-na Einaudi, Torino 1975, alla p. 247 segnala anche importanti riscontri let-terali tra la canzone d'amore del Benivieni e il sonetto n. 260 di Miche-langelo nell'ed. Girardi citata (su cui cfr. saggio NELSON).

[53] BENIVIENI 1519, pp. 121r-122r, *Amore fugitivo di Mosco poeta graeco tradocto in lingua latina per M. Agnolo Poliziano e di latina in toscana per Hyeronymo Benivieni*; a p. 122r-v, *Descriptione del medesimo amore tra-dutta da una Elegia di Propertio*.

[54] Cfr. JOHN T. PAOLETTI, *Michelangelo's Masks*, 'Art Bulletin', LXXIV.3 , 1992, pp. 423-440.

[55] L'idea è già sviluppata dal Sannazaro nel *Prologo* della sua farsa cit. a nota 48, che è anche una sottile interpretazione dell'idillio di Mosco: ai vv. 52-57 Venere, ben consapevole della malizia del figlio («Ella, sì come avvista in li soi mali Ve dirà i segnali del suo figlio»), è presentata al con-trario come dea benigna, guida alla virtù e all'onore («perché è fra gli altri Dei la più benigna, E chi segue sua insigna, onore e gloria E trionfo e vit-toria al fine acquista»).

[56] La versione del Firenzuola (1493-1543), *Vener, cercando il figlio che da lei*, fu stampata per la prima in *Rime di M. Agnolo Firenzuola Fiorentino*, Giunti, Firenze 1549, p. 38r-v (per un'edizione moderna vedi AGNOLO FIRENZUOLA, *Opere*, a cura di Adriano Seroni, Sansoni, Firenze 1958, pp. 910-912). La versione di Luigi Alamanni (1464-1528), *Venere il figlio amor cercando giva*, fu pubblicata per la prima volta dal Cartari, *Imagini dei Dei degli Antichi*, fin dalla prima edizione, Marcolini, Venezia 1556, pp. CIVv-CVr; (a p. CIVv sono citati anche i vv. 1-18 della traduzione di Properzio del Benivieni citata alla nota 53). La si legge anche in LUIGI ALAMANNI, *Versi e prose*, a cura di Pietro Raffaelli, 2 voll., Le Monnier, Firenze 1859, II, pp.

humanists Antonio Pelotti from Milan (see CARLO CORDIÈ, *L'umanista Antonio Pelotti traduttore dell'Amor fuggitivo di Mosco*, in 'Rendiconti dell'Istituto Lombardo di scienze e lettere', 83, 1950, pp. 425-438), and Francesco Maturanzio from Perugia (GIOVAN BATTISTA VERMIGLIOLI, *Memorie per servire alla vita di Francesco Maturanzio, oratore e poeta perugino*, Baduel, Perugia 1807). In regards to its diffusion throughout Europe, besides the editions of Moschus and Theocritus published in the Seicento, the *Amor fuggitivo* was translated in France by Clement Marot, in England by Barnabe Barnes in *Parthenophil and Parthenope* (1593), Ben Jonson in *the Haddington Masque*, lines 85-156 (represented in 1608) and by Richard Crashaw in his *Cupid's Crye* (*The Delights of the Muses*, 1646); the version by Poliziano is mentioned for the Cupid, also in *March* of the *Shepheardes Calendar* of Edmund Spenser.

[48] It was published by GIOSUÈ CARDUCCI in *Scritti di letteratura e d'istru-zione. Strenna del giornale* 'La Gioventù', Firenze 1863, and more recently in IACOPO SANNAZARO, *Opere volgari*, ed. Alfredo Mauro, Laterza, Bari 1961, pp. 257-260. The farce is contained in only one codex, Paris, Bibliothèque Nationale, it. 1563, cent. XV, cc. 115r-116v (and in a probable copy of it found in Firenze, Biblioteca Nazionale, II II 75, cent. XV ex.) compiled in 1495-1496 in Milan on a request of Lodovico il Moro to gather the best of the literary production of his court, that included an ample number of Florentine poets such as Lorenzo de' Medici, Poliziano, Benivieni, Pico della Mirandola, for whose poetry it constitutes the main documentation.

[49] In effect, the pastoral comedy by Tasso, composed about 1573, opens with a prologue with a recitation by Amor who has escaped from his mother disguised as a peasant (inspired by the other epigram by Moschus present in the Planudian *Anthology*, IV, 200, also translated by Poliziano in 'Amorem arantem'), and it ends with a loose version of *Amor fuggiti-vo* in a few editions following the one in Baldini, Ferrara 1581. See TORQUATO TASSO, *Aminta*, critical edition ed. Bartolo Tommaso Sozzi, Liviana, Padova 1957, with the comments of PAOLO TROVATO, *Per una nuova edizione dell'"Aminta"*, in *Torquato Tasso e la cultura estense*, ed. Gianni Venturi, Olschki, Firenze 1999, III, pp. 1003-1027.

[50] *Commento di Hieronymo Benivieni sopra a più sue canzone e sonetti dello Amore e della Bellezza divina*, Tubini, Firenze 1500.

[51] Cf. note 18.

[52] ERWIN PANOFSKY, *The Neoplatonic Movement and Michelangelo*, in *Studies in Iconology*, Oxford University Press, New York 1939; Italian trans-lation Einaudi, Torino 1975, on p. 247 he also mentions important literary affinities between Benivieni's canzone of love and the sonnet no. 260 by Michelangelo (ed. Girardi), on which see also Nelson's essay in this volume.

[53] BENIVIENI 1519, pp. 121r-122r, *Amore fuggitivo di Mosco poeta graeco tradocto in lingua latina per M. Agnolo Poliziano e di latina in toscana per Hyeronymo Benivieni*; on p. 122r-v, *Descriptione del medesimo amore traducta da una Elegia di Propertio*.

[54] Cf. JOHN T. PAOLETTI, *Michelangelo's Masks*, 'Art Bulletin', LXXIV.3, 1992, pp. 423-440.

[55] The idea is already developed by Sannazaro in the Prologue of his farce cit. in note 48, which also is a refined interpretation of the idyll by Moschus: in vv. 52-57 Venus, well aware of her son's mischief ("Ella, sì come avvista in li soi mali Ve dirà i segnali del suo figlio"), is presented conversely as the beneficent goddess, guide to virtue and honor ("perché è fra gli altri Dei la più benigna, E chi segue sua insigna, onore e gloria E trïonfo e vittoria al fine acquista").

[56] Firenzuola's version (1493-1543), *Vener, cercando il figlio che da lei*, was first published in *Rime di M. Agnolo Firenzuola Fiorentino*, Giunti, Firenze 1549, p. 38r-v (for a modern edition see AGNOLO FIREN-ZUOLA, *Opere*, ed. Adriano Seroni, Sansoni, Firenze 1958, pp. 910-912). Luigi Alamanni's version (1464-1528), *Venere il figlio amor cercando giva*, was first published by Vincenzo Cartari, *Imagini dei Dei degli Antichi*; from the time of the first edition, Marcolini, Venezia 1556, pp. CIVv-CVr (on p. CIVv, vv. 1-18 of Benivieni's translation of Propertius cited in note 53 are quoted). It can be read also in Luigi Alamanni, *Versi e prose*, ed. Pietro Raffaelli, 2 vols., Le Monnier, Firenze 1859, II, pp. 137-138. For the manuscript tradition see the codex Magl. VII 1206 (cent. XVI), where on cc. 172v-173r Alamanni's version follows that of

137-138. Per la tradizione ms. posso segnalare il codice Magl. VII 1206 (secolo XVI), dove alle cc. 172v-173r la versione dell'Alamanni segue quella del Varchi; la trovo segnalata anche nel codice Cors. 45 C 12 c. 73v, della Biblioteca Corsiniana, dell'Accademia dei Lincei di Roma.

57 La versione del Varchi, *Mentre la bella dea che Cipri honora*, è presente in numerosi manoscritti, ed è a stampa a partire dall'Ottocento (v. *Amore fuggitivo, idillio di Mosco tradotto da Benedetto Varchi*, Curti, Venezia 1810, pp. I-III). La traduzione in latino si trova nella raccolta dei suoi carmi, codice II VIII 141 della Biblioteca Nazionale di Firenze, cc. 71v-72v (pubblicata in *Liber Carminum Benedicti Varchii*, a cura di Aulo Graeco, Abete, Roma 1969, pp. 112-113, con qualche errore di trascrizione). Fra carte appartenute al Varchi, riunite nel codice II I 397 della Nazionale di Firenze, a c. 179r-v, mi pare notevole che si trovi una copia autografa di Girolamo Benivieni della sua versione dell'*Amor fuggitivo*.

58 Biblioteca Nazionale di Firenze, Magl. VII 730, cc. 15r-16v. La lettera è stata recentemente pubblicata in DEBORAH PARKER, *Bronzino: Renaissance Painter as Poet*, Cambridge University Press, Cambridge 2001, pp. 171-172, da cui cito: «Luca Martini, cui dopo la partita mia [1537] discosti rimasero coi libri molti scritti e componimenti, e fra quelli alcune cose tradotte di greco e di latino nella lingua nostra così in versi come in prosa fatte da me, più per esercitarmi nel comporre e per acquistare meglio l'intelligenza delle lingue che per altro, mi scrive d'avere tra esser ritrovato e trascritto il principio del tredicimo libro delle trasformazioni d'Ovidio…».

59 Si trova nel codice BNF II IX 78, pp. 253-288; vedi VARCHI 1858-1859, II, pp. 489-496. Il Racheli ritiene la lezione «letta nello studio fiorentino». A p. 494 si legge: «…dolore e letizia, delle quali favellammo già lungamente sopra la sposizione di quel dottissimo sonetto del reverendissimo Bembo». Il Varchi allude, alla lezione tenuta a Padova sopra il sonetto del Bembo, *A questa fredda tema, a questo ardente*, si direbbe di fronte allo stesso uditorio, e che fu stampata nel volume con *La seconda parte delle lezzioni di M. Benedetto Varchi…*, Giunti, Firenze 1561, pp. 64v-80v. Infine è il taglio stesso della lezione, di tipo più filologico con continui richiami tra testi affini, che sembra rinviare al periodo padovano. Per un'analisi più approfondita della lezione si veda il saggio della Mendelsohn in questo volume.

60 A differenza del VARCHI 1858-1859, II, p. 490, che riporta solo il primo verso dell'elegia, nel mss. i vv. 1-12 vi sono trascritti per esteso.

61 *Apulejo, dell'Asino d'Oro, tradotto per M. Agnolo Firenzuola Fiorentino*, Giolito, Venezia 1550. Ma su questa e altre versioni da Apulieo nel Cinquecento cfr. il saggio della Mendelsohn.

62 LEATRICE MENDELSOHN, *L'allegoria di Londra del Bronzino e la retorica del Carvenale*, in *Kunst des Cinquecento in der Toscana, Italienische forschungen*, herausgegeben des Kunsthistorisches Institut in Florenz, vol. 17, a cura di Monika Cämmerer, Bruckmann, München 1992, pp. 152-167.

63 *Descrizione dell'apparato fatto in Firenze per le nozze dell'Illustrisimo ed eccellentisimo don Francesco de' Medici Principe di Firenze e di Siena e della serenissima Regina Giovanna d'Austria*, in GIORGIO VASARI, *Le Vite dei più eccellenti pittori, scultori ed architettori scritte da M. Giorgio Vasari*, Giunti, Firenze 1568, con nuove annotazioni e commenti di Gaetano Milanesi, 9 voll., Sansoni, Firenze 1878-1885, VIII, pp. 517-622, alle pp. 527-528.

64 *[…] et varie traduzzioni et componimenti parte colle rime et parte senza di M. Benedetto Varchi*, Biblioteca Nazionale Centrale di Firenze, II, VIII 146, cc. 18r-19v.

65 *Ivi*, cc. 83r-85v.

66 Il riferimento è ai versi famosi di Dante in cui designa la scuola dello stilnuovo, l'esperienza che è alla radice della tradizione poetica amorosa fiorentina, quando si rivolge al suo capostipite, Guido Guinizzelli, defindendolo (*Purgatorio*, XXVI 97) «il padre Mio e delli altri miei miglior che mai Rime d'amor usar dolci e leggiadre».

67 È la stessa soluzione del Tasso (vedi nota 49), che poteva conoscere questi componimenti del Varchi (un verso della I ottava del *Cupido*, «Son qui disceso a mostrarvi l'errore *Del vulgo cieco, che tien cieco Amore*», è ripreso alla lettera alla fine del Prologo di Cupido del Tasso: «cui cieco a torto il cieco vulgo appella»). Può darsi che al Varchi sia venuta in modo autonomo l'idea di destinare alla recitazione sua versione

Varchi. I have found it catalogued also in cod. Cors. 45 C 12 c. 73v, in the Biblioteca Corsiniana of the Accademia dei Lincei, Roma.

57 The version by VARCHI, *Mentre la bella dea che Cipri honora*, is present in numerous manuscripts, with publications beginning in the nineteenth century (see *Amore fuggitivo, idillio di Mosco tradotto da Benedetto Varchi…*, Curti, Venezia 1810, pp. I-III). The Latin translation is found in his collection of poems, codex II VIII 141 in the Biblioteca Nazionale, Firenze, cc. 71v-72v (published in *Liber Carminum Benedicti Varchii*, ed. Aulo Greco, Abete, Roma 1969, pp. 112-113, with a few errors in transcription). Among the papers once belonging to Varchi, gathered in the cod. II I 397 of the Biblioteca Nazionale, Firenze, worthy of mention on c. 179r-v is the presence of an autograph copy by Girolamo Benivieni of his own version of *Amor fuggitivo*.

58 Biblioteca Nazionale, Firenze, Magl. VII 730, cc. 15r-16v. The letter dated 1539 has recently been published by Deborah Parker in *Bronzino: Renaissance Painter as Poet*, Cambridge University Press, Cambridge-New York 2001, pp. 171-172, quoted here: "Luca Martini, cui dopo la partita mia [1537] discosti rimasero coi libri molti scritti e componimenti, e fra quelli alcune cose tradotte di greco e di latino nella lingua nostra così in versi come in prosa fatte da me, più per esercitarmi nel comporre e per acquistare meglio l'intelligenza delle lingue che per altro, mi scrive d'avere tra esser ritrovato e trascritto il principio del tredicimo libro delle trasformazioni d'Ovidio…".

59 Found in cod. BNF II IX 78, pp. 253-288; see VARCHI 1858-1859, II, pp. 489-496. Racheli thinks the lesson was "letta nello studio fiorentino". On p. 494 it reads: "…dolore e letizia, delle quali favellammo già lungamente sopra la sposizione di quel dottissimo sonetto del reverendissimo Bembo". Varchi alludes to the lesson held in Padua on the sonnet by Bembo, *A questa fredda tema, a questo ardente*, presumably in front of the same audience, and that was published in the volume with *La seconda parte delle lezzioni di M. Benedetto Varchi…*, Giunti, Firenze 1561, pp. 64v-80v. Finally, the manner in which the lesson was delivered, of a philological type with continuous comparisons between related texts points to the Paduan period. For a more in depth analysis of the lesson see the essay by Mendelsohn in this volume.

60 VARCHI 1858-1859, II p. 490, transcribes only the first verse of the elegy, while in the mss. vv. 1-12 are reported in their entirety.

61 *Apulejo, dell'Asino d'Oro, tradotto per M. Agnolo Firenzuola Fiorentino*, Giolito, Venezia 1550. But on this and other versions of Apuleius in the Cinquecento cf. Mendelsohn.

62 LEATRICE MENDELSOHN, *L'allegoria di Londra del Bronzino e la retorica del Carvenale*, in *Kunst des Cinquecento in der Toskana*, ed. Monika Cämmerer, Bruckmann, München 1992, pp. 152-167.

63 *Descrizione dell'apparato fatto in Firenze per le nozze dell'Illustrisimo ed eccellentisimo don Francesco de' Medici Principe di Firenze e di Siena e della serenissima Regina Giovanna d'Austria*, in GIORGIO VASARI, *Le vite dei più eccellenti pittori, scultori ed architettori scritte da M. Giorgio Vasari*, Giunti, Firenze 1568, ed. Gaetano Milanesi, 9 vols., Sansoni, Firenze 1878-1885, VIII, pp. 517-622, on pp. 527-528.

64 *[…] et varie traduzzioni et componimenti parte colle rime et parte senza di M. Benedetto Varchi*, Biblioteca Nazionale Centrale, Firenze, II VIII 146, cc. 18r-19v.

65 *Ivi*, cc. 83r-85v.

66 The reference is to the famous verses by Dante in which he describes the school of the Stilnovisti – the experience at the roots of the Florentine tradition of amorous verse – when he turns to its founder, Guido Guinizzelli, defining him (*Purgatorio*, XXVI. 97) "il padre Mio e delli altri miei miglior che mai Rime d'amor usar dolci e leggiadre".

67 Tasso adopted this same solution (see note 49) and could have learned of these compositions from Varchi (a verse of the I octave of *Cupido*, "Son qui disceso a mostrarvi l'errore *Del vulgo cieco, che tien cieco Amore*" is cited to the letter at the end of the Prologue of Cupid in Tasso: "cui cieco a torto il cieco vulgo appella"). It is possible that Varchi came up with the idea of designing his version of Moschus for recitation autonomously, but more probably he was inspired by the precedents. It cannot be excluded that he had gotten wind of the present day codex BNF

da Mosco, ma è probabile che sia stato ispirato dai precedenti. Non si può escludere che avesse notizia dell'attuale codice BNF, II II 75, che era a Firenze, dove si trova la farsa del Sannazaro (cfr. nota 48). Certamente conobbe la versione dell'*Amor fuggitivo* di Tommaso Castellani, pubblicata nella fortunatissima antologia a cura di Lodovico Domenichi, *Rime diverse di molti eccelletiss. auttori nuovamente raccolte. Libro primo con nuove additione ristampato*, appresso Gabriel Giolito di Ferrarii, in Venezia 1546. È la prima versione in ottave sicuramente databile e il testo di Mosco è incorniciato tra due ottave in cui l'autore si rivolge alle donne, facendo pensare che il testo era destinato alla recitazione. Il Castellani poi era stato attivo soprattutto a Milano presso la corte di Francesco II Sforza e lì facilmente poteva aver conosciuto la farsa del Sannazaro.

[68] Nel codice della Biblioteca Nazionale di Firenze, Magl. VII 1206, citato alla nota 57, un ms. compilato in un ambiente molto vicino al Varchi, le ottave con le «Parole di Cupido» e la versione da Mosco (seguite anche da quella dell'Alamanni) sono trascritti l'uno di seguito all'altro alle cc. 169r-172r, segno che il loro avvicinamento, se anche non realizzato dall'autore, era evidente.

II II 75, that was in Florence, where the farce by Sannazzaro is found (cf. note 48). Certainly he was familiar with the version of *Amor fuggitivo* by Tommaso Castellani, published in the very popular anthology edited by LODOVICO DOMENICHI, *Rime diverse di molti eccelletiss. Auttori nuovamente raccolte. Libro primo con nuove additione ristampato*, appresso Gabriel Giolito di Ferrarii, in Venezia 1546. It is the first version in octave stanzas that can be dated with certainty and the text by Moschus is framed by two octaves in which the author addresses women, suggesting that the text was intended for recitation. Castellani moreover had been active mainly in Milan at the court of Francesco II Sforza, and there he could have easily had access to the farce by Sannazaro.

[68] In the cod. of the Biblioteca Nazionale, Firenze, Magl. VII 1206, cited at n. 57, a ms. compiled in a cultural climate very close to Varchi's, the octave stanzas with the "Words of Cupid" and the version by Moschus (followed also by that of Alamanni) are copied one after the other on cc. 169r-172r, a sign that their affinity, even if unacknowledged by the author, was nonetheless apparent.

1. da Lisippo, *Eros di Tespia / Eros from Thespia*,
 Venezia, Museo Nazionale Archeologico, Inv. 121.

Leatrice Mendelsohn

«COME DIPINGERE AMORE»: FONTI GRECHE PER LA FIGURA DI EROS MALIGNO NELLA PITTURA DEL '500

"HOW TO DEPICT EROS": GREEK ORIGINS OF THE MALEVOLENT EROS IN CINQUECENTO PAINTING

I. INTRODUZIONE

La figura di Eros (Greco), Amor (Latino) o Cupido (Latino italianizzato) a guisa di adolescente ingannatore e seducente fece il suo ritorno nell'arte italiana nel corso della quarta decade del XVI secolo (fig. 1)[1]. Il Cupido nella *Venere e Cupido* di Michelangelo-Pontormo è un valido esempio di una fase nell'evoluzione di questo personaggio, che ebbe la propria genesi nell'emulazione rinascimentale dell'epigrammatica, della scultura e della maniera greca. Nel Quattrocento e prima, gli idoli pagani venivano rappresentati in pittura mediante statue di un avvenente adolescente di sesso maschile, a significare implicitamente la natura pericolosa per la Cristianità del giovane dio[2]. L'evoluzione della sua immagine proseguì nel Cinquecento, principalmente in dipinti commissionati dai signori delle corti minori del Centro e Nord d'Italia. Dopo successive trasformazioni, l'immagine maligna dell'adolescente maschio perse potenza con il sopraggiungere della repressione legata alla Controriforma[3]. Il soggetto conobbe poi nuova vita nella Roma secentesca, allorché Caravaggio dipinse il suo *Amor Omnia Vincit*, in cui l'Amore Carnale (*Amor Volgare*) trionfa (fig. 2). A quell'epoca le caratteristiche di Eros erano ormai stabilmente codificate nelle forme di un giovane seducente e furbo. Nella sua ultima reincarnazione, Eros venne identificato con il significato stesso dell'arte[4].

II. EMBLEMI ED EPIGRAMMI

Nello stesso periodo in cui questa nuova icona faceva la sua comparsa, venne pubblicata nel 1531 la prima edizione dell'*Emblematum liber* dell'Alciati[5]. Ristampata in numerose edizioni in tutta Europa durante il resto del secolo, quest'opera di "emblemi illustrati" utilizzò le stesse fonti greche che ispirarono la rinascita pittorica di Eros, quindi, statue ed epi-

I. INTRODUCTION

Eros (Greek), Amor (Latin) or Cupido (Italianized Latin), in the guise of a deceitful, seductive adolescent, made an artistic comeback in Italy during the 1530's (fig. 1)[1]. The Cupid in the Michelangelo-Pontormo *Venus and Cupid* exemplifies a stage in the evolution of this persona that had its genesis in the Renaissance emulation of Greek epigrams, statuary and style. In the fifteenth century and earlier, pagan idols were represented in paintings by statues of a beautiful adolescent male, implying that the youthful god was a danger to Christianity[2]. His image continued to evolve in the sixteenth century, primarily in paintings commissioned by rulers of the smaller northern and central Italian courts. After undergoing several transformations, images of the malevolent, adolescent male declined in the wake of Counter-Reformation repression[3]. The subject was revived in Rome during the seventeenth century when Caravaggio produced his *Amor Omnia Vincit* in which Carnal Love (*Amor Volgare*) triumphs (fig. 2). By that time, the persona of Eros was firmly established in the form of a slyly seductive youth. In his later reincarnations, Eros became identified with the meaning of art itself[4].

II EMBLEMS AND EPIGRAMS

Contemporaneous with the appearance of this new icon, the first illustrated edition of Alciati's *Emblematum liber* was published in 1531[5]. Reprinted in numerous editions throughout Europe during the rest of the century, this book of illustrated emblems utilized the same Greek sources that inspired the pictorial rebirth of Eros: statues and epigrams. Certain Cinquecento paintings termed "emblematic" share significant stylistic characteristics with Alciati's *Emblematum liber*. Originally intended as source books for artists, emblem books now validate the post-modern scholar's search for the multiple mean-

2. Caravaggio, *Amor Omnia Vincit*,
Berlin, Staatliche Museen, Gemäldegalerie.

grammi. Alcuni dipinti cinquecenteschi detti "emblematici" condividono significative caratteristiche stilistiche con l'*Emblematum liber* di Alciati. Intesa in origine per essere codice di riferimento a uso di artisti, questa raccolta di emblemi viene a convalidare la ricerca degli studiosi postmoderni sui molteplici significati della pittura allegorica. La relazione tra la cinquecentesca teoria degli emblemi e lo stile allegorico nell'arte è comunque reciproca e furono i punti di contatto tra i due generi che dettero forma alla rappresentazione pittorica di Eros, e possono perciò spiegarla.

La prima edizione illustrata dell'*Emblematum liber* di Alciati include dodici emblemi con l'immagine di Eros[6]. In ciascuno di essi, Eros è rappresentato come un fantolino alato, una figura vicina a quella dell'antico *putto*[7]. Due volte egli appare insieme a sua madre, Venere. In una delle prime illustrazioni (n. 111), si vedono due figure di Eros, una delle quali di aspetto più maturo. Questa figura è qui indicata in greco con il nome di *Anteros*, o *Amore virtuoso*, e ha legato Cupido, una figura più infantile, che appare bendato (fig. 3)[8]. Poiché in questo contesto *Anteros* rappresenta l'amore spirituale, gli emblemi di Alciati potrebbero a prima vista

ings of allegorical paintings. The relationship between Cinquecento "emblem theory" and allegorical painting style is, however, reciprocal. Points of contact between the two genres shaped, and can therefore explain, paintings of Eros.

The first illustrated edition of Alciati's *Emblematum liber* included 12 emblems with images of Eros[6]. In all of these, Eros is represented as a small winged child resembling an antique *putto*[7]. Twice he appears with his mother Venus. In one early illustration (No.111), two Eros figures are shown, one of which appears older. He is labeled in Greek, Anteros, or virtuous love, and has tied up the more childlike Cupid who is blindfolded (fig. 3)[8]. Since in this context Anteros represents the more spiritual love, Alciati's emblems might at first glance appear not to be the source for the wicked, adolescent Cupid. In subsequent editions, however, the younger mischievous child gradually grew in size to equal his virtuous brother, Anteros (fig. 4). The growth of Eros from *putto* to *fanciullo* to *giovane*, argues for the significance of the illustrated *Emblematum* in shaping the more negative image of Eros.

Alciati's interest in inscriptions had previously led him to undertake a census of antique tombs with inscribed bases in Lombardy[9]. Similar to an artist's notebook, the visual recording of collections was combined with a reverence for antiquity that verged on idolatry. The relationship of image to text on the emblem page reflects this antiquarian orientation. The title or motto above the emblem's image, often enigmatic in form, is analogous to a displaced inscription from an ancient tomb, while the expanded epigram (or *argumentum*) became competitive with the image above it. By recording their inscriptions, antiquarians believed they could preserve lost statues or reliefs from oblivion[10]. So too, emblematic paintings, in reminding the reader that in the future, the present becomes the past, bear witness to the mortality of things while immortalizing them[11].

The importance of the *anticaglie* to which many of the epigrams refer has, inexplicably, been neglected in emblem studies. Even when a painting does not directly imitate an emblem illustration, painting and emblem will often refer to the same antiquity, identified through a surviving Roman copy, a literary reference, or a notebook sketch. By referring to known statues by famous sculptors, the emblems gained *auctoritas* and became *memoriale* of the past. Allegedly written to confer praise on the recipient and not on the author, an epigram beneath a statue of Venus that says: «Phidias fashioned me», implies a *paragone* in which the poet basks in the sculptor's fame.

The Renaissance relationship between statues and emblems may derive from Plotinus who recognized common elements in hieroglyphs, idealized statues of the gods, and Plato's intelligible forms[12]. In the *Enneads*, the word *agalma* describes not only a statue, but the idea in the mind of the sculptor that it embodies, as well as the enigmatic writing of the Egyptians. Thus the "idea" like is transmitted from the artist's memory, in an occult condensed form, to a statue. By means of gestures and poses they could serve as receptacles for ancient concepts[13]. In enriching

«COME DIPINGERE AMORE»: FONTI GRECHE PER LA FIGURA DI EROS MALIGNO NELLA PITTURA DEL CINQUECENTO
"HOW TO DEPICT EROS": GREEK ORIGINS OF THE MALEVOLENT EROS IN CINQUECENTO PAINTING

93

sembrare non essere l'origine di Cupido come adolescente perverso. Nelle edizioni che seguirono, tuttavia, il fanciullo più piccolo e maligno crebbe gradualmente in misura fino a eguagliare il suo virtuoso fratello Anteros (fig. 4). La crescita di Eros da *putto* a *fanciullo* a *giovane* ben indica quanto significative fossero le illustrazioni dell'*Emblematum liber* nel modellare l'immagine più negativa di Eros.

L'interesse di Alciati per le iscrizioni l'aveva in precedenza condotto a compilare un censimento di antiche tombe lombarde, con iscrizioni sulle basi[9]. Simile a un taccuino d'artista, questa raccolta mescolava ai dettagli visivi una reverenza per l'antichità che rasentava l'idolatria. Il rapporto tra immagine e testo nelle pagine degli emblemi riflette questo orientamento verso lo studio delle antichità. Il titolo, o motto, sopra l'immagine dell'emblema, spesso in forma enigmatica, è analogo a un'iscrizione rimossa da un'antica tomba, mentre il più esteso epigramma (o *argumentum*) entra in competizione con l'immagine soprastante. Raccogliendo tali iscrizioni, gli appassionati dell'antichità ritenevano di preservare dall'oblio statue o bassorilievi ormai perduti[10]. Così la pittura emblematica, a sua volta rammentando a chi guarda che in futuro il presente diventerà il passato, testimonia, nell'atto stesso di immortalarle, la caducità delle cose[11].

L'importanza delle *anticaglie* a cui molti degli epigrammi si riferiscono è stata inesplicabilmente trascurata negli studi sull'emblematica. Perfino quando un dipinto non imita direttamente l'illustrazione di un emblema, tanto dipinto che emblema si riferiscono spesso alla medesima opera antica identificata tramite una copia romana sopravvissuta, un rimando letterario o uno schizzo su taccuino. Il riferimento a statue note di artisti famosi conferì agli emblemi *auctoritas* e ne fece un memoriale del passato. Dichiaratamente scritto in lode del soggetto cui è rivolto e non dell'autore, un epigramma che, posto sotto la statua di Venere, recita: «Fidia mi datto forma», contiene un implicito *paragone* in cui il poeta partecipa della fama dello scultore.

La relazione che il Rinascimento istituì tra statue ed emblemi potrebbe derivare da Plotino, che individua elementi comuni tra i geroglifici, le statue idealizzate degli dèi e le forme intelligibili di Platone[12]. Nelle *Enneadi*, la parola *agalma* descrive non solo una statua, ma l'idea nella mente dello scultore cui essa dà corpo come l'enigmatica scrittura degli Egizi. In questo modo "l'idea" è trasmessa dalla memoria dell'artista, in forma occulta e sintetica, alla statua. Mediante il gesto e la posa le statue assumono dunque la funzione di contenitore di antichi concetti[13]. Arricchendo il suo libro con immagini di statue, Alciati stava sicuramente sfruttando la loro efficacia[14].

Nella prima edizione degli *Emblemata*, furono riportati, tradotti alla lettera o parafrasati da Alciati, quaranta epigrammi tratti dall'*Antologia Greca*. Di questi, un numero sproporzionato si riferisce al dio Eros. Nella stessa *Antologia*, alcune poesie di argomento omoerotico paragonano l'amato a Eros in modo che la statua del dio, tanto lodata che vituperata, diviene surrogato

3. *Anteros o Amore virtuoso / Anteros* or *Virtuous Cupid*, da Andrea Alciati, *Emblematum liber*, ill. n. 111.

4. *Eros e Anteros / Eros and Anteros*, da Andrea Alciati, *Emblematum liber*, Paris 1534, p. 141.

5. da Lisippo, *Cupido che tende l'arco / Cupid stringing his Bow*, Venezia, Museo Nazionale Archeologico, Inv. 170.

6. Parmigianino, *Cupido che intaglia l'arco / Cupid carving his Bow*, Wien, Kunsthistorisches Museum.

dell'amato del poeta[15]. Giulio Cesare Scaligero, nel suo cinquecentesco trattato sulla poetica, descrive tali componimenti come «pieni di pathos erotico [*affectus in se amatoria continentia*]»[16]. Essi vengono detti *vivida*, cioè pieni d'animazioni e molto vivi, come quadri. In maniera analoga, gli epigrammi che descrivono Eros partecipano anche del suo carattere: colmi di bellezza, crudeli, beffardi e ingannatori. Poesia e pittura, come arti, condividono con Eros queste licenziose qualità.

III. STATUE DI EROS E STATUE PARLANTI

Furono due versioni di una statua perduta di *Cupido che tende l'arco* che contribuirono alla rinascita del soggetto (fig. 5)[17]. Queste statue, basate su originali del IV secolo, opera dello scultore greco Lisippo e menzionate da Pausania, erano visibili nel palazzo della famiglia Grimani a Venezia, che ne fece pubblico lascito. Le statue rimasero così a Venezia, nel Museo nazionale Archeologico[18].

Una versione servì da modello al Parmigianino per la figura di *Cupido che intaglia l'arco* (Wien, Kunsthistorisches Mu-

his book with images of statues, Alciati was surely exploiting their efficacy[14]. In the first edition of the *Emblemata*, forty epigrams from the *Greek Anthology* were translated verbatim or paraphrased by Alciati. A disproportionately high number of these refer to the god Eros. In the anthology itself, homoerotic poems compare the beloved to Eros so that the statue, whether praised or blamed, becomes a surrogate for the poet's lover[15]. Joseph Scaligero, in his sixteenth-century literary treatise, describes such poems as "full of erotic sentiments [*affectus in se amatoria continentia*]"[16]. They are called "vivida", that is, animated and lively like pictures. Similarly, epigrams that describe Eros also partake of his character in being beautiful, pitiless, mocking, and deceptive. Poetry and painting, as arts, share these "licentious" qualities.

III. STATUES OF EROS AND SPEAKING STATUES

Two versions of a lost statue of *Cupid stringing his Bow* contributed to the renewal of the subject (fig. 5)[17]. Based on fourth century originals by the Greek sculptor Lysippos, men-

seum), come si vede dalla torsione del busto visto da tergo, il complesso angolo delle gambe, la curva delle braccia nell'atto dell'intaglio e, cosa più importante, lo sguardo diretto con cui Cupido, voltandosi a guardare sopra la spalla, si rapporta con l'osservatore (fig. 6).

Il secondo tipo (fig. 1) trova corrispondenza nelle figure di Correggio e Giulio Romano, anche se queste sembrano talvolta una commistione di entrambi i tipi (fig. 7). Un terzo tipo di Eros, ora perduto, ma conosciuto tramite i cammei e i sigilli, fu da Pausania attribuito a Prassitele e lodato in epigrammi[19]. La riscoperta di epigrammi greci e delle statue di Lisippo e Prassitele fu sintomatica della rinascita di un occultismo tardo-ellenistico proveniente da ambienti padovani. Un gusto

tioned by Pausanias, the statues were accessible in the palace of the Grimani family in Venice. Given to the public as a bequest by the family, they remain in Venice, in the Museo Nazionale Archeologico[18]. One version served as Parmigianino's model for the figure of *Cupid Carving his Bow* (Vienna, Kunsthistorisches Museum), as seen by the twist of the body observed from the rear, the complex angle of the legs, the curves of the arms holding the carving knife, and most importantly, the directness of the gaze with which Cupid, turning to glance over his shoulder, confronts the spectator (fig. 6). The second type (fig. 1) finds a correspondence in figures by Correggio and Giulio Romano, although they sometimes appear to be a fusion of both types (fig. 7).

7. Giulio Romano, *Venere e Adone* **Venus and Adonis** Mantova, Palazzo Te.

antiquariale di questo genere aveva influenzato Donatello nelle opere padovane un secolo avanti[20].

Gli epigrammi possono dichiarare l'intenzione dell'artista, articolando le parole di un anonimo poeta-osservatore che può rivolgersi alla statua o, in alternativa, a chi guarda come se la statua stessa parlasse. Spesso un epigramma dà spiegazioni o interroga in forma dialogica una statua; altre volte il messaggio scritto va a sommarsi all'immagine con un "detto" morale. In tutti i casi si stabilisce un rapporto di scambio tra poeta e osservatore, un inespresso discorso verbale parallelo a quello visivo tra testo e immagine[21]. Uno scambio di questo genere sembra avere luogo tra Venere, Cupido e l'osservatore nel cartone michelangiolesco per *Venere e Cupido*. Le statue avevano fama di possedere le qualità umane di moto ed emozione, vale a dire un'anima. Di conseguenza esse possono sollecitare una risposta empatica.

Quando Benedetto Varchi accostò il dipinto di Pontormo alla *Venere* di Prassitele come esempio di *agalmatofilia*, non faceva che trasferire alla Venere dipinta il potere dell'antica statua di eccitare il desiderio[22]. E vengono così in mente i sonetti scritti direttamente alla statua di Michelangelo, *La Notte*, cui lo scultore rispose con un epigramma.

Un uso meno polemico, ma parimenti politico di aggiunta verbale furono i versi del Varchi incisi sotto le quattro statuette di bronzo rappresentanti alcuni dèi nelle nicchie alla base della statua di *Perseo* del Cellini[23]. Ciascuna delle figure, Giove, Minerva, Danae con Perseo fanciullo e Mercurio, si rivolge ostentatamente al Perseo trionfante, garantendogli protezione divina. Il vero destinatario delle loro parole è invece il committente, il duca Cosimo I de' Medici.

La metafora letteraria della statua che parla in forma epigrammatica fu resuscitata nel Rinascimento dal costume di attaccare a due statue romane, *Pasquino* e *Marforio*[24], dei componimenti poetici.

Si trattava di satire poetiche o erotiche (o entrambe le cose) indirizzate a personaggi famosi. In una lettera datata 1537, Pietro Aretino – difendendo le incisioni del Raimondi per i disegni salaci di Giulio Romano intitolati *I Modi* – scrisse a un amico romano una apologia; qui fa riferimento ai sonetti che apparivano sulla base «di una statua in marmo con un satiro che tenta di violare un giovinetto»[25].

Aretino, i cui stessi lavori erano considerati pornografici, nella sua difesa di Giulio Romano attacca il moralismo della Chiesa. Nella forma in cui sopravvivono nelle incisioni, i disegni di Giulio Romano intitolati *I Modi* includono Eros solo occasionalmente, ma il suo spirito irriverente vive nei testi aggiunti dall'Aretino all'edizione pubblicata. In posizione di autore e mediatore tra artisti e committente, l'Aretino promosse il gusto per l'arte erotica nel Veneto, nelle corti del Nord Italia, in Francia e Spagna. La tendenza antiromana e antipapalina che emerge dai suoi scritti, in specie nelle pasquinate, si riflesse nelle immagini che egli promosse. E le più importanti di esse sono le immagini di Eros[26].

A third type of Eros, now lost though known through cameos and seals, was attributed to Praxiteles by Pausanias and lauded in epigrams[19]. The re-discovery of Greek epigrams and the Lysippan/Praxitelian statues signalled a revival of late Hellenistic occultism emanating from the Paduan milieu. A similar type of antiquarianism had influenced Donatello's Paduan works a century earlier[20].

Epigrams can state the artist's intention, articulated in the words of an anonymous poet-spectator addressing the statue or, alternatively, can address the spectator as though the statue itself speaking. Often an epigram explains or questions a statue in dialogue form; at other times the message augments the image with a moral dictum. In all cases, an exchange is assumed between the poet and the viewer, an unspoken verbal discourse that parallels the visual one between text and image[21]. Such an exchange appears to take place between Venus, Cupid, and the spectator in Michelangelo's cartoon of *Venus and Cupid*. Statues had a history of possessing human powers of emotion and motion, that is to say, a soul. Consequently they could elicit an empathetic response. When Benedetto Varchi likened Pontormo's painting to Praxiteles's *Venus* as an example of *agalmatophilia,* he was transferring to this painted Venus the ancient statue's power to arouse desire[22]. One is reminded of the sonnets written directly to Michelangelo's statue of the *Night* to which Michelangelo wrote an epigrammatic reply. A less polemical, but equally political, usage of verbal attachments were Varchi's verses inscribed beneath the four bronze statuettes of gods in niches on the base of Cellini's statue of *Perseus*[23]. Each of the figures: Jupiter, Minerva, Danae with the infant Perseus, and Mercury ostensibly speak to the triumphant Perseus, granting him divine protection. The true recipient of their words is the patron, Duke Cosimo I de' Medici.

The literary metaphor of statues that spoke in the form of epigrams was revived in the Renaissance in the custom of attaching poems to two Roman statues, the *Pasquino* and the *Marforius*[24]. These were political or erotic satires (or both) directed at famous persons. In a letter dated 1537, Pietro Aretino – in defense of Raimondi's engravings of Giulio Romano's salacious drawings of *I Modi* – wrote an *apologia* to a Roman friend; here he refers to the sonnets on the base of "a marble Satyr who attempts to violate a young boy"[25].

Aretino, whose own writings were considered pornographic, attacks the Church's morality police in his defense of Giulio. As they survive in engravings, Giulio's *I Modi* drawings only occasionally include Eros, but the god's irreverent spirit resides in the texts added by Aretino to the published edition. Acting as both author and go-between for artists and patrons, Aretino promoted the taste for erotic art in the Veneto, in northern Italian courts, in France, and in Spain. The anti-Roman, anti-papal attitude expressed in his writings, especially the pasquinades, is reflected in the images he promoted. Most important of these are the images of Eros[26].

IV. L'Eros di Benedetto Varchi

La prima edizione dell'*Antologia Greca*, data alle stampe nel 1494 includeva un lungo idillio del poeta ellenistico Mosco intitolato *Amor fugitivus*[27] (*Appendice III,a*). In questo componimento, Venere offre a Cupido in ricompensa per il suo ritorno «un bacio e altro», e ammonisce il lettore a guardarsi da lui[28]. Nel 1530 erano ormai disponibili numerose traduzioni italiane della poesia di Mosco. Una di esse forma un'appendice a una lezione su Petrarca, tenuta da Varchi presso l'Accademia degli infiammati di Padova intorno al 1539[29]. La lezione si apre con la discussione dello scopo dell'allegoria, perché i «misteri d'amore, non si divessero al volgo manifestare». Nella sua lezione, Varchi decostruisce la descrizione di Amore che Petrarca fa nel *Triumphus Cupidinis*. Nominando gli attributi del dio così come ricorrono altrove nella poesia toscana, egli li spiega come significanti di Eros definendo il dio per mezzo della descrizione. Così facendo, Varchi ci fornisce un saggio di lettura delle immagini che a sua volta diventa programma per la rappresentazione pittorica di Amore[30]. Le due maggiori questioni che egli pone sono: «Per qual cagione amore si dipinga garzone ovvero fanciullo» e «Perché si dipinga cieco o velato gli occhi». Egli spiega che la sua età «nasconde la verità delle cose», ha cioè funzione ingannatrice. In maniera antitetica, Amore è rappresentato come bello perché egli è il desiderio di ogni bellezza; nondimeno da lui dipendono ogni vizio così come ogni virtù: «Amore in diversi tempi sia ora piacevole e quando crudele, o piuttosto abbia in sé sempre una piacevolezza crudele, cioè che sotto velame di volere giovare, noccia, e allora più inganni quando meno il dimostra; e questo nell'Amor virtuoso non può aver luogo»[31]. Varchi ci dice che Petrarca sfrutta gli aspetti di Eros come una sorta di travestimento[32]. «Si dipinga nudo», secondo Varchi, «...per dinotare che egli ne spoglia gli amanti di tutti i beni così come interiori come esteriori» e «per mostrare che cuopre la mente per meglio ingannare altrui».

Varchi e i pittori del Cinquecento sono d'accordo su un aspetto importante: la vista limpida di Amore. Al contrario, le illustrazioni quattrocentesche per i *Trionfi* del Petrarca ritraevano solitamente Cupido bendato, anche quando egli era mostrato con le sembianze di un adolescente, come nella tavola del Pesellino ora all'Isabella Stewart Gardner Museum di Boston[33] (fig. 8). Questo particolare, come gli altri consueti attributi, è esaminato nell'emblema 114 di Alciati. La descrizione è significativa sia per la definizione letteraria di *Amor volgare* che per la sua rappresentazione pittorica. I dipinti che ritraggono l'adolescente Amore, come l'idillio di Mosco, non lo rappresentano bendato perché egli sa molto bene quel che sta facendo. «Coloro che cieco lo dipingono», aggiunge il Varchi, «intendendo più del viso interiore che dell'esteriore, cioè degli occhi della mente e non di quegli del corpo».

Nei dipinti della metà del Cinquecento, gli attributi esteriori di Eros sono resi minuziosamente. Un tratto ricorrente dell'aspetto di Cupido sono i boccoli biondi. Questi capelli, propriamente

8. Pesellino, *Il Trionfo di Amore, Castità e Morte / The Triumphs of love, Chastity and Death*, particolare dell'*Amore* / detail of *Love*, Boston, Isabella Stewart Gardner Museum.

IV. Varchi's 'Eros'

The first printed edition of the *Greek Anthology* of 1494 included a long idyll by the Hellenistic poet Moschus entitled *Amor fugitivus* or *The Runaway Cupid*[27] (*Appendix III,a*).

In the poem, Venus offers a reward of "a kiss and more" for Cupid's return and cautions the reader to beware of him[28]. By 1530, several Italian translations of Moschus's poem were available. One such translation forms an appendix to a lecture on Petrarch, delivered by Varchi to the Accademia degli Infiammati in Padua about 1539[29]. The lecture opens by discussing the purpose of allegory, which is "to hide the truth of the mysteries of love from the ignorant".

In his lecture, Varchi deconstructs Petrarch's description of Amor in the *Triumphus Cupidinis*. Naming the god's attributes as they occur in other Tuscan poems, he explicates them as signifiers of Eros, defining the god through description. In doing so, Varchi provides a lesson in the "reading" of images that, in turn, becomes a program for painting Amor[30].

The two most important questions he asks are: "Why is Amor depicted as a young boy or adolescent?" and "Why is he painted blind or blindfolded?" The reason given for his age is "to hide the truth of things", i.e. to deceive. Antithetically,

9. Agnolo Bronzino, *Allegoria di Venere / Allegory of Venus*, particolare / detail, London, National Gallery.

descritti da Varchi, sono accuratamente resi nella lucente e liscia, quasi metallica capigliatura nell'*Allegoria di Venere* del Bronzino, dipinta intorno al 1546 e ora a Londra (fig. 9), un'opera che prende le mosse dalla *Venere e Cupido* del Pontormo[34]. La bellezza artificiale di Amore, da cui emana il suo potere ingannatore, si rispecchia nell'artifizio eccessivo del pittore.

In entrambi i dipinti, lo stile o il trattamento pittorico della figura e dei suoi attributi è un modo di visualizzare un *concetto*, il significato centrale della personificazione. Varchi sottolinea con forza che né Petrarca né Boccaccio usano il nome Cupido, e oltre a ciò, egli dice, «...nel XVI secolo noi tuscani non abbiamo mai descritto Amore se non come dotato di doppia forma, proprio come esiste una doppia Venere; un Amore è buono e probo, virtuoso ed è detto *celestiale*, l'altro è malvagio, disonesto, maligno, ed è detto *volgare*». Ma Eros, come lo si trova dipinto in Mosco, Varchi e nell'arte figurativa, è celestiale o volgare? Dall'aspetto con cui si presenta, osserva il Varchi, l'*amor volgare* non sempre è distinguibile dalla sua celestiale controparte e, come abbiamo visto negli esempi scultorei e letterari sopra considerati, il dio e la sua immagine sono incostanti.

Per Varchi è l'aspetto esteriore di Amore che camuffa il vero senso del dio. L'enfasi sulla manifestazione del senso è importante tanto per l'esegesi poetica del Petrarca come per la spiegazione del contenuto del dipinto di Michelangelo-Pontormo. Nella teoria degli emblemi, l'elemento figurativo

"Love is represented as beautiful because he is the desire for all beauty; nevertheless all vice as well as virtue depends on him". Amor is both pleasing and rude, hence of a "pleasurable rudeness. A cruel pleasure, that under the veil of appearing youthful is noxious: the better he disguises his deceit, the more deceitful he is"[31]. Varchi tells us that Petrarch exploits the features of Eros as "a kind of disguise"[32]. "Love is depicted nude", according to Varchi, to show that he "strips all lovers of goodness, interior as well as exterior", and "to demonstrate that he obscures the mind and so better deceives others".

Varchi and the Cinquecento painters are in agreement on one important aspect: the clear-sightedness of Amor. Fifteenth century illustrations of Petrarch's *Triumph of Love* usually depict Cupid blindfolded, even when he is shown as an adolescent as in Pesellino's panel from the Isabella Stewart Gardner Museum in Boston[33] (fig. 8).

This detail, like his other standard attributes, is questioned in Alciati's emblem 114. The description is significant for both the literary definition of *Amor volgare* and its pictorial representations. Paintings of the adolescent Amor, like the idyll by Moschus, do not depict him blind because "he knows very well what he is doing". Those who show Amor blind, says Varchi, are attempting to show his inner being rather than his outward appearance, that is, "the eye of the mind and not that of the body".

External attributes are meticulously rendered in mid-Cinquecento paintings of Eros. Cupid's blond curls are a common aspect of his appearance. The metallic quality of his hair, specifically described by Varchi, is accurately rendered in the smooth and polished hair in Bronzino's London *Allegory,* of c. 1546 (fig. 9) a work that depends on Pontormo's *Venus and Cupid*[34]. The artful beauty of Amor, from which his power to deceive emanates, is mirrored in the excessive artifice of the painter's style.

In both paintings, the style, that is the pictorial treatment of a figure and its attributes, is a mean of visualizing the *concetto,* or central meaning of the personification. Varchi makes the point that neither Petrarch nor Boccaccio used the name Cupid. Furthermore, he says, "...in the sixteenth century, we Tuscans never describe Amor except as having two forms, just as there are two Venuses; one Amor is good, honest, and virtuous and called *celestial*; the other is bad, dishonest, and evil and called *volgare*".

Is the Eros, as "depicted" by Moschus, Varchi, and the painters, celestial or vulgar? In actual appearance, Varchi observes, *amor volgare* is not always distinguishable from his celestial counterpart and, as we have seen in the sculptural and literary examples noted above, the god and his image are inconstant.

For Varchi, it is the external appearance of Amor that disguises the god's true meaning. The emphasis on externalization of meaning is as important to the poetic exegesis of

(l'illustrazione) di un emblema è una chiave di lettura, ma può anche apparire in contraddizione con il messaggio dell'epigramma. Al pari degli emblemi, i messaggi allegorici contenuti nei dipinti possono offrirsi a una lettura che va in senso opposto all'illustrazione cui sono collegati[35]. Nella sua descrizione di Eros, Varchi insistette soprattutto sull'idea dell'inganno e aggiunse dettagli a suo sostegno che non comparivano nell'originale greco di Mosco[36] (si veda in *Appendice III*). Anche se mantenne il sentimento bucolico dell'originale, Varchi ne rinforzò le allusioni sessuali. L'espressione *risa finta* che si trova nell'ultima riga della traduzione italiana, non compare nel testo greco. La frase adoperata per descrivere la «voce di miele e il cuore di fiele di Eros», tratta ancora da un altro epigramma, è rappresentata nell'*Allegoria* del Bronzino.

Petrarch as it is to the elucidation of content in the Michelangelo-Pontormo painting. In emblem theory, the figurative member (the illustration) of an emblem is a key to its reading, but it may also appear to contradict the message of the epigram. Like emblems, allegorical messages attached to paintings could be read in opposition to their illustrations[35].

In his description of Eros, Varchi stressed above all else the idea of deception and added details to support it that were not present in the original Greek by Moschus[36]. Although he retains the bucolic feeling of the original, Varchi reinforces the sexual innuendoes. The "*risa finta*" or "false smile" found in the last line of his Italian translation, do not appear in the Greek.

The phrase used to describe Eros's "voice of honey... heart of gall", taken from still another epigram, is depicted in Bronzino's *Allegory*.

10. Correggio, *Leda / Leda*,
Berlin, Staatliche Museen, Gemäldegalerie.

V. Statue dipinte

I testi erotici e le antiche statue di Cupido erano noti in Italia sin dalla fine del XV secolo. Cosa fu che innescò un improvviso moto d'interesse in questo nuovo tipo di Eros, e perché verso il 1530 questo sembrò impossessarsi delle corti dell'Italia settentrionale? Perché solo *dopo* il sacco di Roma gli artisti trasformarono il marito tradito di Psiche di Raffaello in un adolescente seduttivo e ingannatore? Tutte le tarde rappresentazioni del tema, inclusa la *Venere e Cupido* di Michelangelo-Pontormo e la sua vasta progenie, dovrebbero essere considerate allegoriche. Mentre l'immagine può alludere a una storia, il concetto è incapsulato in un momento singolo, condensando il suo significato come un emblema o un geroglifico.

Tra il 1528 e il 1530, Giulio Romano, che aveva lavorato con Raffaello alla Farnesina, decorò per Federigo Gonzaga, signore di Mantova, il Palazzo del Tè. In tutte le stanze decorate Giulio dipinse Cupidi di tutte le grandezze: infanti, adolescenti e pienamente sviluppati, ma non emerge nessuna chiara identità del dio[37]. Poco tempo dopo, tra il 1530 e il 1532, anche Correggio dipinse per Federigo Gonzaga – destinate però alla corte di Carlo V – scene tratte dagli *Amori degli dei*. In questa serie appaiono figure di Cupido adolescente, tanto nella *Leda* (fig. 10) che nella *Danae*, dove il dio assiste da *voyeur* alla relazione tra donne mortali e Giove. Questo Eros più grande, di solito accompagnato da una coppia di paffuti putti, attesta la familiarità del Correggio con il modello lisippeo. Le figure di Giulio Romano e Correggio derivano dal *Cupido* di Raffaello, eppure nessuno di questi artisti assegna ai propri giovani *aides-de-camp* un carattere apertamente negativo. Uno dei più autorevoli di questi adolescenti compare nel disegno *Marte e Venere* eseguito da Rosso Fiorentino per l'Aretino, e inviato, probabilmente su suo consiglio, a Francesco I a Fontainebleau (fig. 11)[38]. In questo disegno, e nella decorazione di Fontainebleau che ne risultò, un Marte insolitamente giovanile è spalleggiato da un eccessivo, quasi comico Eros. In un altro dipinto di Rosso, oggi perduto, la figura di Cupido fu particolarmente ritenuta degna di lode dal Vasari. Egli magnificò la grande abilità di Rosso nell'immaginare: «...un putto di dodici anni, ma cresciuto e di maggiori fattezze che di quella età non si richiede, e in tutte le parti bellissimo»[39]. Eros è qui raffigurato come un giovane sessualmente maturo e di bellezza ideale, il ritratto del protagonista di numerosi epigrammi dell'*Antologia Greca*.

Grosso modo contemporaneo della *Venere e Cupido* di Michelangelo-Pontormo è il *Cupido che intaglia un arco*, dipinto dal Parmigianino intorno al 1531-1532, dipinto cui di sovente viene dato l'epiteto di "emblematico"[40]. Come lo sguardo di Cupido, il suo messaggio basato su di un epigramma è diretto all'osservatore. Un putto forza la mano dell'altro, riluttante, a toccare il corpo marmoreo, ma nondimeno sensuale di Cupido. Sydney Freedberg vide nei due putti Anteros e Liseros

11. Pierre Milan da Rosso Fiorentino,
Marte e Venere / Mars and Venus, incisione,
Paris, Bibliothèque Nationale de France, BA 12.

V. Painted Statues

Erotic texts and antique statues of Cupid were known in Italy from the end of the fifteenth century. What sparked the sudden rise in interest in this new type of Eros and why did it seem to take hold in the Northern courts around 1530? Only *after* the sack of Rome did artists transform Raphael's betrayed husband of Psyche into a deceitful, seductive, adolescent. All later depictions of the theme, including the Michelangelo-Pontormo *Venus and Cupid* and its numerous progeny, should be considered allegorical. While the image may allude to a story, the *concetto* is encapsulated in a single moment, condensing its meaning like an emblem or hieroglyph.

Between 1528 and 1530, Giulio Romano, who had worked with Raphael at the Farnesina, decorated the Palazzo del Te for Federigo Gonzaga, ruler at the court of Mantua. Throughout the decorated rooms, Giulio painted Cupids in all sizes: childlike, adolescent, and full-grown, but no clear identity for the god emerges[37]. Shortly after, between 1530 and 1532, Correggio also painted episodes from the *Loves of the Gods* for Federigo Gonzaga, (destined, however, for the court of Charles V). Adolescent Cupids appear in both the *Leda* (fig. 10) and *Danae* from this series where they are voyeurs to the liaisons between mortal women and the god Jupiter. This

che si bisticciano, un riferimento alla distinzione Platonica tra Amor Sacro e Amor Profano[41]. La figura agonistica di Eros, cui l'epigramma è indirizzato, è dipinta sopra un bassorilievo mostrante *Eros e Anteros che si contendono la palma della vittoria*, ora al Museo Archeologico di Napoli (cfr. fig. 12). Questo Eros più giovane che punta i piedi e si protende verso la palma può avere ispirato la posa più contorta assunta da Cupido nel dipinto del Pontormo, compressa come se fosse su un bassorilievo[42]. La relazione equivoca dell'immagine statuaria con il testo moraleggiante negli *Emblemata* riflette la persistente

12. Copia del XVI secolo di *Eros e Anteros si contendono la palma della Vittoria* / XVI century copy of *Eros and Anteros wrestling for the palm of Victory*, Erreux, Musée.

ambivalenza del Rinascimento verso le statue pagane. La stessa ambivalenza è trasferita alle statue che nei dipinti rappresentano Eros. Il divieto della Chiesa controriformata di usare immagini mitologiche e nudità in contesti religiosi spinse a usare soggetti pagani nei luoghi privati, ma non eliminò del tutto il contenuto spirituale collegato ai miti.

Ma la statuaria antica era meramente una base per vari significati morali oppure il motto moraleggiante intendeva legittimare la trasgressività della scultura? La domanda va ripetuta rispetto alla pittura. Il testo emblematico, moraleggiante, si pone come abbiamo notato comodamente accanto al messaggio omoerotico che emana dall'epigramma originale. Come può chi osserva distinguere tra il messaggio inviato e "il velo"? I commentari morali, che avevano lo scopo di rendere accettabili ai lettori e ai fruitori d'arte cristiani gli dei e la poesia pagani, furono istituzionalizzati in testi come *Ovide Moralisé* e *Ovidius moralizatus*[43]. In questi testi, episodi erotici vengono glossati con commentari che trasformavano il mito letterario in un'accettata allegoria cristiana. Di fatto, le parole "cristiano" e "allegoria" erano sovente lette come sinonime. Ciò che avvenne in letteratura si verificò anche nella pittura di tema mitologico, ma in questo caso il commentario era silente e, nel sostenere l'immagine, la lasciava in posizione dominante. Le statue di Eros erano come sinuose colonne ricoperte di uno strato di significato che non ne celava

older Eros, usually accompanied by a pair of chubby putti, attests to Correggio's familiarity with the lysippan source. Giulio and Correggio's figures derive from Raphael's Cupid and none of these painters endowed their youthful aides-de-camp with an overtly negative *persona*.

One of the most influential of these adolescents appears in the *Mars and Venus* drawing executed by Rosso Fiorentino for Aretino and sent, probably on his advice, to Francois I at Fontainebleau (fig. 11)[38]. In this drawing, and the resulting decoration for Fontainebleau, an uncharacteristically youthful Mars is supported by a straining, almost comic, Eros. In another, now lost, painting by Rosso, the figure of Cupid was singled out for special praise by Vasari. Rosso is said to show very great skill "...because he imagined a putto aged twelve, but developed, and with larger features than expected for his age and in all parts most beautiful"[39]. Eros here is refigured as a sexually mature, ideally beautiful boy, a portrait of the protagonist of numerous epigrams from the *Greek Anthology*.

Roughly contemporary with the Pontormo-Michelangelo *Venus and Cupid*, is Parmigianino's *Cupid carving a bow* c. 1531-1532, the painting most frequently given the epithet "emblematic"[40]. Like Cupid's glance, its message based on an epigram is directed to the observer. One putto forces the hand of the reluctant other to touch the marble-like, yet sensual body of Cupid. Sydney Freedberg saw the two small putti as Anteros and Liseros fighting among themselves as a reference to the platonic distinction between Sacred and Profane love[41]. This agonistic Eros, about whom epigrams were written, is depicted on a relief showing *Eros and Anteros wrestling for the palm of victory*, now in the Museo Archeologico, Naples (cf. fig. 12). The younger Eros bracing his feet and leaning towards the palm may have inspired the more contorted pose assumed by Cupid in Pontormo's painting, compressed as if in a relief[42]. The equivocal relationship of statue image to moralizing text in the *Emblemata* reflects the persistent ambivalence of the Renaissance toward pagan statues. The same ambivalence is transferred to painted statues depicting Eros. The Counterreform Church's ban on the use of mythological images and nudity in a religious context fostered pagan subjects in private but did not eliminate all spiritual content attached to the myths.

Were antique statues merely a base for various moral meanings or did the moral sayings sanction transgressive sculpture? The question bears repeating with respect to painting. The moralizing, "emblematic" text, as we have noted, rests comfortably beside the homoerotic message issuing from the original epigrams. How was the viewer to distinguish between the intended message and its "veil"? Moral commentaries, intended to make the pagan gods and poetry acceptable to Christian readers and viewers, were institutionalized in such texts as the *Ovide Moralisé* and the *Ovidius moralizatus*[43]. Erotic episodes were glossed with commentary that transformed the literary myth into accepted

le forme sensuali. La risposta istintiva, come compresero gli ico-
noclasti, si rivolse alle forme: più esse erano seducenti, più si fis-
savano nella memoria[44]. Nel passato, gli studiosi optarono per
indicare, in immagini erotiche, come dominante il messaggio
morale, ma è ormai chiaro che più spesso la morale era un mero
pretesto per una situazione promiscua. Pur nascosto, un mes-
saggio morale poteva giustificare un'immagine non censurata.
Ciò che tuttavia era gradito al committente, non necessaria-
mente lo era al censore, in particolare dopo il Concilio di Trento.
Quantunque la *Lezione* del Varchi sul Petrarca fornisca alla
moderna iconografia un mezzo per un'interpretazione in senso
opposto, non si hanno prove che la lezione abbia mai fornito un
esplicito programma per un dipinto. Né suggerirei che il poema
di Mosco sia la fonte d'ispirazione primaria, o l'unica, delle imma-
gini di Eros maligno, o che quella relazione biunivoca tra descri-
zione visiva e testuale del dio esista sempre. Mi limito a usare il
testo greco, come fece il Varchi, come guida all'uso della
metafora nella pittura della metà del Cinquecento. Le immagini
derivanti dal cartone di Michelangelo espressero il loro messag-
gio allegorico in modi concreti, ma spesso camuffati. L'attività
letteraria dell'artista, con scritti poetici e satirici, lo aveva allena-
to a trasferire il processo verbale/retorico alla produzione di
immagini visive. Così facendo, Bronzino, Rosso, Vasari e altri
seguirono la guida di Pontormo e del suo mentore, lo scultore-
poeta Michelangelo. Nell'imitare la descrizione greca di Mosco
di un seduttore maligno, questi pittori aderiscono alle regole
tracciate dal Varchi per l'allegoria. Proprio come gli emblemi for-
nirono per i dipinti di Eros un moderno equivalente alle antiche
fonti testuali, le qualità scultoree delle figure del cartone miche-
langiolesco divennero un modello pseudo-antico da cui scaturi-
rono le numerose variazioni sul tema *Venere e Cupido*. Al pari
dell'umanista Alciati, i pittori entravano in competizione non solo
con gli antichi epigrammi, ma con le statue perdute descritte in
testi greci e latini. Il procedimento di replicare in pittura l'antichità
usando la *Venere* di Michelangelo fu comunque un atto di riani-
mazione piuttosto che di imitazione.

VI. Il dipinto di "Venere e Cupido"

È stata avanzata l'ipotesi che la *Venere e Cupido* di Miche-
langelo-Pontormo illustri un episodio delle *Metamorfosi* di Ovidio
(Libro X): Cupido nell'atto di ferire Venere, facendo così precipi-
tare la sua tragica attrazione per Adone[45]. La prova della validità
di tale idea risiede nel bacio, e in come questo fu successiva-
mente reso nell'*Allegoria* del Bronzino, che si presume derivi dal
cartone di Michelangelo. Il bacio di Bronzino è più esplicitamen-
te erotico e la sua Venere non indica la propria ferita, ma la sua
azione è focalizzata sul sottrarre la freccia che la produrrebbe[46].
L'azione della coppia centrale del Bronzino, e per associazione
di quella del Pontormo, può essere parimenti accostata a un
altro bacio di dubbia fama che precede la storia di Amore e
Psiche. Mi riferisco alla storia nella storia che compare

Christian allegory. Indeed, the words "Christian" and "allegory"
were often read as synonyms. The literary process also took
place in mythological painting but with a silent commentary
that, in supporting the image, let it rule. Statues of Eros were
like serpentine columns sheathed with a veneer of meanings
that did not obscure their sensuous forms. The instinctive
response, as iconoclasts understood, was to the forms; the
more seductive they were, the more fixed in the memory[44]. In
the past, scholars opted for the moral message as the dominant
one in erotic images, but it has become clear that more often,
the moral was merely a pretext for promiscuity. Even when hid-
den, a moral text could justify an uncensored image. What
pleased the patron, however, did not necessarily please the cen-
sor, particularly after the Council of Trent.

Although Varchi's *Lezzione* on Petrarch provides a means of
reverse interpretation for the modern iconographer, there is
no evidence that the lecture ever provided an explicit program
for a painting. Nor would I suggest that the Moschus poem is
the primary or only textual source for paintings of a malevo-
lent Eros, or that a one-to-one relationship between verbal
and visual descriptions of the god always exists. I merely use
the Greek texts, as Varchi did, as a guide to the use of
metaphor in mid-Cinquecento painting.

The pictures deriving from Michelangelo's cartoon expressed
their allegorical messages in concrete but often disguised, ways.
The artist's activity as a poet and satirist in his own right prepared
him to transfer this verbal/rhetorical process to the making of
actual pictures. In doing so, Bronzino, Rosso, Vasari, and others
followed the lead of Pontormo and his mentor, the sculptor-poet,
Michelangelo. In imitating Moschus's Greek description of a
malevolent seducer, these painters adhere to Varchi's rules for
allegory. Just as the emblems provided a modern equivalent for
an ancient textual source for the Eros paintings, the sculptural
quality of the figures in Michelangelo's cartoon became a pseu-
do-antique model from which the numerous variations of the
Venus and Cupid derived. Like the humanist Alciati, painters
were competing not only with the ancient epigrams, but with the
lost statues described in Greek and Latin texts. The process of
replicating antiquity in paint, using Michelangelo's *Venus* was,
however, an act of re-animation, rather than imitation.

VI. The "Venus and Cupid" Painting

It has been proposed that the Michelangelo-Pontormo
Venus and Cupid illustrates a narrative episode from Ovid's
Metamorphoses (Bk. X): the act of Cupid wounding Venus
that precipitates her tragic attraction to Adonis[45]. Evidence for
the validity of the idea lies in the kiss and its subsequent ren-
dering in Bronzino's *Allegory*, presumed to derive from the
Michelangelo cartoon. Bronzino's kiss is more explicitly erot-
ic and his Venus does not point to her wound, instead she is
focused on stealing the implicated arrow[46]. The actions of

nell'*Asino d'Oro* di Apuleio, noto anche come *Metamorfosi*, un'estensione di Ovidio[47]. Nel proemio della storia di Psiche (IV. 30), scrive Apuleio, Venere: «Chiama subito quel suo figliolo alato e audace non poco, che è maestro di cattivi costumi e ha in spregio la pubblica moralità. Egli, armato di saette infocate, di notte va correndo per le dimore altrui e, seminando zizzania tra gli sposi, causa impunemente gravissimi scandali e insomma non fa mai niente di buono». Invia quindi Amore a punire Psiche, la fama della cui bellezza ha reso la dea violentemente gelosa. Impartisce a Cupido l'ordine di vendicarla e «Così, parlò la dea, e dolcemente, con le labbra semiaperte, impresse al figlio un lungo bacio» (IV. 31). La *Venere* del Bronzino descrive con esattezza il bacio narrato da Apuleio, rivelando la lingua di Venere. Il bacio del Pontormo è meno esplicito, ma rimane il punto focale del dipinto. Apuleio, in una scena introduttiva alla storia di Psiche, si collega alla descrizione del bacio tra Lucio e Photis nell'episodio centrale dell'*Asino d'Oro*. In maniere tra loro in contrasto, entrambi i baci fanno riferimento all'ascesa dell'anima.

Non solo dal Veneto si diffusero gli epigrammi e le statue dell'antica Grecia, che fornirono una fonte per questi dipinti di *Venere e Cupido*, ma anche lo stile letterario di Apuleio, tanto nell'originale latino che in edizioni vernacolari italiane[48]. Mentre però la lingua originale dell'*Asino d'Oro* è un latino colloquiale, l'autore insiste sulla propria grecità: l'eroe è greco e la storia ha luogo in Grecia. Apuleio usa nella storia di Psiche un fiorito stile "asiatico", per contrastare lo stile "basso" del corpo narrativo principale, che è più sessualmente esplicito. Gli studiosi di letteratura vedono Amore come l'alter ego di Lucio, lo studente greco che alla conclusione del libro viene iniziato al sacerdozio di Iside. L'aspetto celestiale di Amore/Cupido fa da contraltare alle avventure terrestri ed erotiche di Lucio. I passaggi della trasformazione di Lucio da asino a essere umano e poi a sacerdote narrano di un'ovvia ascensione dal profano verso il sacro[49].

La versione che Apuleio dà del cammino dell'anima verso l'immortalità fu importante per la rappresentazione pittorica della mitologia popolare nel primo Rinascimento, come in Raffaello. Dopo il 1530 l'aspetto maligno dello sposo di Psiche assume in pittura un ruolo più pronunciato. Nei dipinti di *Venere e Cupido* qui presi in considerazione, il *concetto* dell'ascesa continua a vivere *solo* nella memoria dell'osservatore. In dipinti derivanti dal cartone di Michelangelo, come quello del Bronzino, il comportamento lascivo del figlio (colto nell'atto di rubare la corona alla madre nel mentre la sta accarezzando) è una deliberata inversione del ruolo madre-figlio incarnata dalla Sacra Famiglia, della quale il dipinto del Bronzino è una parodia[50]. Il dipinto riecheggia lo spirito satirico con cui Apuleio tratta un soggetto spirituale. Alla fine dell'*Asino d'Oro*, Giove sancisce l'unione di Amore e Psiche e garantisce a Psiche (l'anima) l'immortalità. Apuleio termina il suo racconto con la notizia che, a suo tempo, la coppia aveva avuto un bambino di nome Desiderio (*Voluptas*).

Se il dipinto del Pontormo non esprime il tono satirico di Apuleio in maniera così forte come nel Bronzino è perché nel disegno di Michelangelo la leggenda popolare pagana è un'al-

Bronzino's central pair, and by association Pontormo's, can be similarly linked to another infamous kiss, one that precedes a version of the Cupid and Psyche story. I refer to the text within a text from *The Golden Ass* by Apuleius, also known as the *Metamorphoses*, an expansion of Ovid[47].

In the *proemio* to the Psyche story (IV.30), according to Apuleius, Venus sends for her son: "that wicked and headstrong boy who with his bad character and his disdain for law and order, goes running about at night through other folk's houses armed with flames and arrows, ruining everyone's marriages and committing the most shameful acts with impunity".

She then dispatches Cupid to punish Psyche whose fame as a beauty has made the goddess intensely jealous. After giving Cupid the order to revenge her, "so saying she kissed her son long and intensely with parted lips" (IV.31). Bronzino's Venus, revealing her tongue, accurately portrays the kiss described in Apuleius's text. Pontormo's kiss is less explicit but remains the focus of the painting. In the scene that introduces the celestial Psyche story, Apuleius parallels his description of the profane kiss between Lucius and Photis in the central plot of *The Golden Ass*. In contrasting ways, both kisses refer to the soul's ascent.

Not only Greek epigrams and statues issuing from the Veneto provided sources for these paintings of *Venus and Cupid*, but also the literary style of the Apuleian version of the myth, in its Latin original and Italian vernacular editions[48]. While colloquial Latin is the original language of *The Golden Ass*, the author insists on its Greekness: the hero is Greek and the story takes place in Greece. Apuleius uses the "Asiatic" florid style in the Psyche text, to contrast with the more sexually explicit and "crude" style of the central narrative. Literary scholars see Cupid as the alter ego of Lucius, the Greek student who is initiated into the priesthood of Isis at the book's conclusion. Cupid's celestial aspects parallel the earthly, erotic, escapades of Lucius. The stages of Lucius's conversion from an ass to a human being to a priest narrate an obvious ascension from the profane to the sacred[49].

Apuleius's version of the soul's path to immortality was important for earlier Renaissance depictions of the folk-tale such as Raphael's. After 1530, the malevolent aspect of Psyche's husband assumes a more pronounced role in painting. In the paintings of *Venus and Cupid* considered here, the *concetto* of ascent persists *only* in the memory of the viewer. In paintings deriving from Michelangelo's cartoon such as Bronzino's, the lascivious behavior of the son (in the act of stealing his mother's crown while caressing her) is a deliberate inversion of the mother – son relationship embodied in the Holy Family, of which Bronzino's painting is a parody[50]. It echoes the Apuleian satirizing of a spiritual subject. At the end of *The Golden Ass*, Jupiter sanctions the union of Cupid and Psyche and grants Psyche (the soul) immortality. Apuleius ends his tale with the news that, in due time, a child named Desire (*Voluptas*) was born to the couple.

legoria spirituale. Altrove ho proposto che per Michelangelo la ferita di Venere allude alla ferita delle Vergine davanti alla Crocifissione[51]. L'empatia della Vergine con il Cristo al momento della morte è riflessa nell'adorazione dello spettatore per Venere, e nella sua identificazione con le ferite di lei. Possiamo leggere sia il dipinto del Pontormo che quello del Bronzino come il ritratto del pregnante momento che precede il matrimonio di Amore e Psiche, e fa riferimento anche al ciclo di nascita e morte, come narrato da Ovidio nella storia di Adone. Complemento al bacio sono gli emblematici ornamenti di un altare a forma di tomba, maschere, e un vaso con fiori, allusione al carattere transeunte della vita mortale e dell'amore[52].

Venere e suo figlio non sono mere rappresentazioni delle due divinità dell'amore che si abbracciano, ma esemplificano l'inevitabilità dell'umana sofferenza d'amore[53]. La seduzione operata su un osservatore di sesso maschile da una scultorea Venere distesa rappresenta la prima fase della sua assimilazione al dio. Nelle basi neoplatoniche della storia di Psiche, il desiderio dell'amante di identificare la bellezza con le forme dell'amata è una metafora dell'eterno desiderio maschile di unirsi al divino. Se l'osservatore/amante riesce a identificarsi in pieno con l'amata (come spesso non accade nei sonetti di Michelangelo), egli diviene tutt'uno con il dio. L'osservatore di Pontormo, ignoto e non visto, è, al pari di Venere e di Psiche, perseguitato da Eros. Attraverso le sofferenze causate da Amore, l'osservatore-amante raggiunge la salvazione. La posa della Venere distesa è vicina al modello michelangiolesco, adesso alla Casa Buonarroti, eseguito per il mai completato *Dio Fiume*[54]. La porzione superiore del torso e la testa sembrano tratti da un bassorilievo romano, utilizzato da Giulio Romano e altri, in cui Venere (collocata vicino a Marte) fa gesti indirizzati alla sua sinistra, al di sopra del seno[55]. Nell'antichità, tale gesto era un riferimento al cuore come sede di amore e sofferenza, mentre nel periodo Barocco era un segno di fede[56]. Nell'assimilare queste fonti, lo scopo di Michelangelo non era illustrare un'antica storia, ma esprimere un moderno concetto sull'interrelazione tra amore, morte, e immortalità. Come abbiamo visto, il concetto dipende da una miscela di fonti aristoteliche, platoniche, neoplatoniche e occultiste. Intorno al 1530, i temi religiosi potevano ancora essere rappresentati facendo uso di figure mitologiche senza tema di inquinare il messaggio cristiano. Di fatto, la presenza di dei pagani rende più intenso il messaggio voluto. Allo stesso modo in cui testi come quelli di Ovidio subirono interventi moralizzatori, le statue greche, sovente associate a culti mistici, furono cristianizzate. Non è necessario aggiungere che c'è un ampio iato tra il desiderio suscitato da immagini come quelle de *I Modi* di Giulio Romano e quello che ispira il casto bacio scambiato da Venere e Cupido nell'opera del Pontormo. Malgrado le differenze, la figura del bell'adolescente in veste di icona del desiderio parla sia del culto dell'amore maschile esistente nel mondo sociale e politico della cultura italiana alla metà del Cinquecento[57], sia del movimento di riforma religiosa che sancì e promosse il libero arbitrio nella doppia forma della licenza poetica e personale.

If Pontormo's painting does not convey the satirical tone of Apuleius as strongly as the Bronzino, it is because in Michelangelo's *disegno* the pagan folk tale is a spiritual allegory. Elsewhere I have proposed that for Michelangelo, the wound of Venus alludes to the wound of the Virgin at the Crucifixion[51]. The Virgin's empathy with Christ at the moment of death is mirrored in the spectator's adoration of Venus and his identification with her wounds. We can read both the Pontormo and the Bronzino paintings as depicting the pregnant moment that precedes the marriage of Cupid and Psyche, while also referring to the cycle of birth and death as related in Ovid's tale of Adonis. The kiss is complemented by the emblematic ornaments of a tomb-like altar, masks, and a vase with flowers that allude to the transience of mortal life and love[52].

Venus and her son do not merely represent the two gods of love embracing, but exemplify the inevitability of human suffering because of love[53]. The male spectator's seduction by a sculptural, reclining Venus represents the first phase of his assimilation to God. In the Neo-platonic basis for the Psyche tale, the desire of the lover to identify with beauty in the form of his beloved is a metaphor for man's eternal desire to unite with God. If the spectator-lover succeeds in fully identifying with the beloved (as often, in Michelangelo's sonnets, he does not), he becomes one with God. Pontormo's spectator, unknown and unseen, is persecuted, like Venus and Psyche, by Eros. Through the suffering caused by Love, the spectator-lover achieves salvation.

The pose of the reclining Venus is close to Michelangelo's model now in the Casa Buonarroti, made for a never completed River God[54]. Her upper torso and head seem to be drawn from a Roman relief utilized by Giulio Romano and others, in which Venus (positioned near Mars) gestures towards her left side above her breast[55]. In antiquity, the gesture referred to the heart as the source of love and pain, and in the Baroque period, was a sign of faith[56]. In assimilating these sources, Michelangelo's goal was not to illustrate an ancient story, but to express a modern *concetto* about the interrelation of love, death, and immortality. As we have shown, the *concetto* depended on a mixture of Aristotelian, Platonic, Neo-platonic and occult sources. In the 1530s, religious themes could still be represented using mythological figures without fear of polluting the Christian meaning. In fact, the presence of pagan gods intensified the desired message. In the same way that texts such as Ovid were "moralized", Greek statues, often associated with mystical cults, were "Christianized". It is hardly necessary to add that there is a wide gap between the desire excited by images such as Giulio Romano's *I Modi* and the desire inspired by the chaste kiss exchanged between Pontormo's Venus and Cupid. Despite differences, the figure of the beautiful male adolescent as an icon of desire spoke both to the cult of male love that existed in the social and political worlds of mid-Cinquecento Italian culture[57], and to the religious reform movement that sanctioned and promoted free will in the binary form of poetic and personal license.

Alcuni aspetti di questo saggio sono stati presentati al Congresso della Renaissance Society of America, tenutosi a New York nel 1995 e alla Emblem Society in Pittsburgh nel 1993. Vorrei ringraziare la Folger Shakespeare Library e la Gladys Krieble Delmas Foundation, per le borse di studio conferitemi.

[1] Riguardo le distinzioni tra *puer, fanciullo e giovane*, cfr. KONRAD EISENBICHLER, *The Boys of the Archangel Raphael. A Youth Confraternity in Florence, 1411-1785*, University of Toronto Press, Toronto-Buffalo-London 1998, pp. 18-22 e MICHAEL ROCKE, *Forbidden Friendships, Homosexuality and Male Culture in Renaissance Florence*, Oxford University Press, New York-Oxford 1996, p. 284 n. 36, che nota l'ambiguità di questi termini latini in riferimento all'età e alla condizione legale: tutte e tre le parole possono indicare ragazzi fino all'età di diciotto anni.

[2] Si vedano i disegni di Jacopo Bellini, *Soldato che attacca un idolo e Tempio poligonale con idolo pagano*, dal suo *Album degli schizzi*, c. 48, Louvre, Cabinet des Dessins (R. F. 1516/153). Il modello antico cui Bellini si ispirò per la figura che regge un arco fu sicuramente un Eros di tipo lisippeo; si veda oltre.

[3] JEAN SEZNEC, *The Survival of the Pagan Gods*, trad. Barbara Sessions, Harper & Row, New York 1961, pp. 263-264.

[4] Si veda HERWARTH RÖTTGEN, *Caravaggio der Irdische Amor oder Der Sieg der Fleischlichen Liebe*, Fischer, Frankfurt am Main 1992.

[5] *Andreae Alciati Emblematum Fontes Quatuor* (rist. anast. di Augsburg 1531, Parigi 1534, Venezia 1546, a cura di Henry Green, Brothers, Manchester 1870. Sono anche ricorsa ad *Andreas Alciatus, The Latin Emblems, Indexes and lists*, a cura di Peter M. Daly, Virginia W. Callahan e Simon Cuttler, 2 voll, University of Toronto Press, Toronto-Buffalo-London 1985.

[6] Gli emblemi di Eros nella edizione di Augsburg del 1531 sono: n. 106 *Potentissimus affectus amor (Vis amoris)*; 107 *Potentia Amoris* (si veda come Eros, un ragazzino inciso su una gemma...); 108 *Vis Amoris* (la forza d'amore... un fuoco più potente del fuoco); 110/111 *Anteros: Amor virtutis alium Cupidinem superano* (Nemesi ha dipinto un Eros alato ostile a un Eros alato); 112 *Dulcia quandoque amara fieri* (Cupido si lamenta con Venere per una puntura d'ape); 113 (*idem*); 114 *In statuam Amoris* (lunga poesia su una statua di Eros); 155 *De Morte et Amore* (la Morte viene raggiunta dal suo compagno Amore); 156 *In formosam fato praereptam* (Eros addormentato con la Morte); 196 *Mulieris famam non formam vulgata esse oportere* («Fidia mi ha modellato cosi»); 207 *Malus Medica* (Venere e Cupido).

[7] Il più grande numero di *putti* di dimensione simile, rappresentati in una varietà di pose utilizzabili, lo si trova in bassorilievi su sarcofagi e troni. Il *Trono di Saturno*, a Venezia dalla metà del XIV secolo, fu trasferito nel 1532 da una collezione privata a Santa Maria dei Miracoli, collocazione profetica e probabilmente importante per i futuri adattamenti delle sue figure di Eros. Si veda PHYLLIS PRAY BOBER-RUTH RUBENSTEIN, *Renaissance Artists and Antique Sculpture*, Harvey Miller, London 1986, nn. 52-54, pp. 90-91.

[8] Sul significato greco di *anteros* come "amore reciproco", che *non* significa né amore "virtuoso" né "negativo", si veda ERWIN PANOFSKY, *Blind Cupid*, in *Studies in Iconology, Humanistic Themes in the Art of the Renaissance*, Icon Editions, Boulder-Oxford 1972, p. 126.

[9] Il manoscritto inedito *Antiquitates mediolenses* (1508) prende le forme di una silloge; cfr. PIERRE LAURENS-FLORENCE VUILLEMIER, *De l'archéologie à l'emblème: la genèse du "Liber Alciat"*, "Revue de L'Art", CI, 1993, pp. 86-95. Sulle collezioni veneziane: PATRICIA FORTINI BROWN, *Venice & Antiquity, The Venetian Sense of the Past*, Yale University Press, New Haven-London 1996.

[10] Si veda ANNEGRIT SCHMITT, *Antiken kopien und künstlerische Selbstverwirklichung in der Frürenaissance: Jacopo Bellini auf den Spuren römischer Epitaphien*, in *Antikenzeichnung und Antikenstudium in Renaissance und Frübarock*, atti del convegno (Coburg 1986), a cura di Richard Harprath e Henning Wrede, Ph. von Zabern, Mainz am Rhein 1989, pp. 1-20.

[11] DANIEL RUSSELL, *Emblematic Structures in Renaissance French Culture*, University of Toronto Press, Toronto-Buffalo-London 1995, p. 5, definisce

Aspects of this essay were presented at the meetings of the Renaissance Society of America in New York, 1995 and at the Emblem Society in Pittsburgh, 1993. For their fellowships I would like to thank the Folger Shakespeare Library and the Gladys Krieble Delmas Foundation.

[1] For the distinctions between *puer, fanciullo* and *giovane* see KONRAD EISENBICHLER, *The Boys of the Archangel Raphael. A Youth Confraternity in Florence, 1411-1785*, University of Toronto Press, Toronto-Buffalo-London 1998, pp. 18-22 and MICHAEL ROCKE, *Forbidden Friendships, Homosexuality and Male Culture in Renaissance Florence*, Oxford University Press, New York-Oxford 1996, p. 284 n. 36, who notes the ambiguity of these Latin terms with regard to age and legal status. All three as legal terms may refer to boys up to the age of eighteen.

[2] Jacopo Bellini's, *Soldier's attacking an Idol,* and *Polygonal Temple with Pagan Idol*, from his *Sketchbook*, c. 48, Louvre, Cabinet des Dessins (R. F. 1516/153). Bellini's model for the figure holding a bow was undoubtedly a Lysippan type Eros, discussed below.

[3] JEAN SEZNEC, *The Survival of the Pagan Gods*, trans. Barbara Sessions, Harper & Row, New York 1961, pp. 263-264.

[4] HERWARTH RÖTTGEN, *Caravaggio der Irdische Amor oder Der Sieg der Fleischlichen Liebe*, Fischer, Frankfurt am Main 1992.

[5] *Andreae Alciati Emblematum Fontes Quatuor*, facsimile of Augsburg 1531, Paris 1534 and Venezia 1546, ed. Henry Green, Brothers, Manchester 1870; *Andreas Alciatus, The Latin Emblems, Indexes and Lists*, ed. Peter M. Daly, Virginia W. Callahan and Simon Cuttler, 2 vols., University of Toronto Press, Toronto-Buffalo-London 1985.

[6] The emblems of Eros in the 1531 Augsburg edition are: nos.106 *Potentissimus affectus amor (Vis amoris)*; 107 *Potentia Amoris* (see how Eros, a little boy engraved on a gem...); 108 *Vis Amoris* (force of love... a fire stronger than fire); 110/ 111 *Anteros: Amor virtutis alium Cupidinem superano* (Nemesis has painted a winged Eros hostile to a winged Eros); 112 *Dulcia quandoque amara fieri* (Cupid complains to Venus of a bee sting); 113 (same); 114 *In statuam Amoris* (long poem on a statue of Eros); 155 *De Morte et Amore* (Death joined by his companion Love); 156 *In formosam fato praereptam* (Eros asleep w. Death); 196 *Mulieris famam non formam vulgata esse oportere* ("Phidias fashioned me thus"); 207 *Malus Medica* (Venus and Cupid).

[7] The largest number of *putti* of similar size, represented in a variety of adaptable poses are found on sarcophagi and throne reliefs. The *Throne of Saturn*, in Venice from the mid-fourteenth century was transferred in 1532 from a private collection to the Church of Sta.Maria dei Miracoli, a prophetic and possibly influential location for future adaptations of its Eros figures. See PHYLLIS PRAY BOBER-RUTH RUBENSTEIN, *Renaissance Artists and Antique Sculpture*, Harvey Miller, London 1986, nos. 52-54, pp. 90-91.

[8] On the Greek meaning of *anteros* as "reciprocal love", and *not* as signifying either "virtuous" or negative love, see ERWIN PANOFSKY, *Blind Cupid*, in *Studies in Iconology, Humanistic Themes in the Art of the Renaissance*, Icon Editions, Boulder-Oxford 1972, p. 126.

[9] The unpublished manuscript *Antiquitates mediolenses* (1508) takes the form of a sylloge; see PIERRE LAURENS-VUILLEMIER, *De l'archéologie à l'emblème: la genèse du 'Liber Alciat'*, 'Revue de L'Art', CI, 1993, pp. 86-95. On Venetian collections, see PATRICIA FORTINI BROWN, *Venice and Antiquity, The Venetian Sense of the Past*, Yale University Press, New Haven-London 1996.

[10] ANNEGRIT SCHMITT, *Antiken kopien und künstlerische Selbstverwirklichung in der Frürenaissance: Jacopo Bellini auf den Spuren römischer Epitaphien*, in *Antikenzeichnung und Antikenstudium in Renaissance und Frübarock*, Acts of Conference (Coburg 1986), ed. Richard Harprath and Henning Wrede, Ph. von Zabern, Mainz am Rhein 1989, pp. 1-20.

[11] DANIEL RUSSELL, *Emblematic Structures in Renaissance French Culture*, University of Toronto Press, Toronto-Buffalo-London 1995, p. 5, defines the emblematic painting as "one that can be detached from its setting with no loss of meaning to the argument it is illustrating".

un dipinto emblematico quando questo «può essere staccato dalla sua ambientazione senza che l'argomento illustrato perda di significato».

[12] RUSSELL 1995, pp. 113-124.

[13] L'idea della statua come contenitore mediante cui si può vedere l'inconcepibile bellezza si trova in PLATONE, *Simposio* (210E-212B) e PLOTINO, *Enneadi* (I.6).

[14] L'edizione francese di Alciati curata nel 1534 da Christian Wechel codificò molte delle illustrazioni. Sebbene prima di quello di Alciati esistessero già molti testi illustrati, la relazione tra immagine e testo non era stata ancora fissata. Le illustrazioni per i *Trionfi* del Petrarca, precedenti i libri con emblemi, sono un esempio di ciò.

[15] *The Greek Anthology*, 5 voll., trad. di William Roger Paton, Heinemann, London 1956-1960, IV, XII, epigramma 56, p. 309.

[16] GIULIO CESARE SCALIGERO, *Poetices liber septem*, J. Crespin, Genova 1561, p. 431 (VI, III, CXXVI). L'associazione del riso con il gioco sessuale è ribadito dal gioco di parole, visto che "riso" o "risa" indica nella lingua maccheronica dell'italiano volgare la sodomia. Si veda JEAN TOSCAN, *Le Carnavale du Language*, 4 voll., Université de Lille, Lille 1981.

[17] *Eros Grec: Amour des Dieux et des Hommes*, catalogo della mostra (Athènes-Paris), Ministère de la Culture de Grèce-Réunion des Musées Nationaux, Athènes-Paris 1989, pp. 54-55; *Lisippo: l'Arte e La Fortuna*, catalogo della mostra (Roma), a cura di Paolo Moreno, Fabbri, Milano 1995.

[18] MARILYN PERRY, *The Statuario Publico of the Venetian Republic*, in *Saggi e Memorie di Storia dell'Arte*, VIII, 1972, pp. 75-150. Questo tipo di *Eros*, nella Collezione Grimani dal 1523, può essere stato noto già in precedenza, poiché appare in un disegno di Dürer [Wien, Albertina] eseguito a Venezia intorno al 1500.

[19] Menzione della statua di Amore di Prassitele la si trova in cinque epigrammi in *The Greek Anthology*, nn. 203, 204 e 205.

[20] DOUGLAS LEWIS, *Rehabilitating a Fallen Athlete: Evidence for a date of 1453/1454 in the Veneto for the Bust of a Platonic Youth by Donatello*, in *Small Bronzes in the Renaissance*, a cura di Debra Pincus, The National Gallery of Art, Washington (D.C.), Yale University Press, New Haven-London 2001, pp. 33-53.

[21] Si veda LEONARD BARKAN, *The Beholder's Tale: Ancient Sculpture, Renaissance Narratives*, "Representations", XLIV, 1993, pp.133-166 e LEONARD BARKAN, *Unearthing the Past: Archeology and Aesthetics in the Making of Renaissance Culture*, Yale University Press, London-New Haven 1999, pp. 210-211, 220, 222.

[22] LEATRICE MENDELSOHN, *Paragoni: Benedetto Varchi's "Due Lezzioni" and Cinquecento Art Theory*, UMI Research Press, Ann Arbor 1982, p. 120.

[23] JOHN POPE-HENNESSY, *Cellini*, Abbeville Press, New York 1985, pp. 174-175.

[24] Su Pasquino, cfr. BARKAN 1999, pp. 210-231.

[25] PIETRO ARETINO, *Lettere sull'Arte*, a cura di Ettore Camesasca, 3 voll., Ed. Del Milione, Milano 1957-1960, I, n. LXVIII, indirizzata a Battista Zatti da Brescia, 19 dicembre 1537. Per datazione e discussione si veda BETTE TALVECCHIA, *Taking Positions, On the Erotic in Renaissance Culture*, Princeton University Press, Princeton 1999, pp. 13, 85, 86, 233 n.24 e 256 n. 1 e JAMES SASLOW, *Ganymede in the Renaissance, Homosexuality in Art and Society*, Yale University Press, New Haven-London 1986, p. 72. Negli *Amori degli dèi*, iniziato da Rosso Fiorentino e completato da Perin del Vaga, un giovane e perspicace Eros viene chiaramente distinto da Amore, lo sposo di Psiche (TALVECCHIA 1999, fig. 53, p. 155). Nella rappresentazione più moderata di Perino degli *Amori degli dèi*, incisa da Jacopo del Caraglio in una serie di 20, Eros assiste di quando in quando gli amanti.

[26] MARIANTONIETTA ACOCCELLA, *L'Asino d'oro nel Rinascimento: dai volgarizzamenti alle raffigurazioni pittoriche*, Longo, Ravenna 2001, pp. 135-136.

[27] *The Greek Anthology*, vol IV, libro IX, n. 440, pp. 245-246.

[28] Sul poema di Mosco, si veda il saggio di Leporatti.

[29] BENEDETTO VARCHI, *Lezione sopra quei versi del "Trionfo d'Amore" del Petrarca, "Quattro destrier via piu che neve bianchi…"*, in *Lezioni sul Dante e prose varie di Benedetto Varchi la maggior parte inedite*, 2 voll., Società

[12] RUSSELL 1995, pp. 113-124.

[13] The idea of the statue as a receptacle through which one can "see the inconceivable beauty" is found in PLATO, *Symposium* (210 E-212 B), and PLOTINUS, *Ennead* (I. 6).

[14] Christian Wechel's 1534 French edition of Alciati codified many of the illustrations. Although many illustrated texts existed before Alciati's the relation of image to text was not fixed. Illustrations to Petrarch's *Triumphs* that preceded the emblem books are an example of this.

[15] *The Greek Anthology*, 5 vols, trad. William Roger Paton, Heinemann, London 1956-1960, vol. IV, bk. XII, *epigram 56*, p. 309.

[16] GIULIO CESARE SCALIGERO, *Poetices liber septem*, J. Crispin, Genova 1561, p. 431 (VI, III, CXXVI). The association of laughter with sexual play is reaffirmed by the wordplay, since "riso" or "risa" signifies sodomy in the macaronic language of the Italian *volgare*. See JEAN TOSCAN, *Le Carnavale du Language*, 4 vols, Université de Lille, Lille 1981.

[17] *Eros Grec: Amour des Dieux et des Hommes*, exh. cat. (Athènes-Paris), Ministère de la Culture de Grèce-Réunion des Musées Nationaux, Athènes-Paris 1989, pp. 54-55; *Lisippo: l'Arte e La Fortuna*, exh. cat. (Roma), ed. Paolo Moreno, Fabbri, Milano 1995.

[18] MARILYN PERRY, *The Statuario Publico of the Venetian Republic*, in *Saggi e Memorie di Storia dell' Arte*, VIII, 1972, pp. 75-150. This type of Eros, in the Grimani collection by 1523, may have been known earlier, since it appears in a drawing by Dürer (Wien, Albertina) made in Venice, c. 1500.

[19] Mention of Praxiteles statue of Love is found in five epigrams in *The Greek Anthology*, nos. 203, 204 and 205.

[20] DOUGLAS LEWIS, *Rehabilitating a Fallen Athlete: Evidence for a date of 1453/1454 in the Veneto for the Bust of a Platonic Youth by Donatello*, in *Small Bronzes in the Renaissance*, ed. Debra Pincus, The National Gallery of Art, Washington (D.C.), Yale University Press, New Haven-London 2001, pp. 33-53.

[21] LEONARD BARKAN, *The Beholder's Tale: Ancient Sculpture, Renaissance Narratives*, Representations, XLIV, 1993, pp. 133-166; and LEONARD BARKAN, *Unearthing the Past: Archeology and Aesthetics in the Making of Renaissance Culture*, Yale University Press, London-New Haven 1999, pp. 210-211, 220, 222.

[22] LEATRICE MENDELSOHN, *Paragoni: Benedetto Varchi's "Due Lezzioni" and Cinquecento Art Theory*, UMI Research Press, Ann Arbor 1982, p. 120.

[23] JOHN POPE-HENNESSY, *Cellini*, Abbeville Press, New York 1985, pp. 174-175.

[24] On the Pasquino, see BARKAN 1999, pp. 210-231.

[25] PIETRO ARETINO, *Lettere sull'Arte*, ed. Ettore Camesasca, 3 vols, Ed. Del Milione, Milano 1957-1960, I, no. LXVIII, addressed to Battista Zatti da Brescia, December 19, 1537. For dating and discussion see BETTE TALVECCHIA, *Taking Positions, On the Erotic in Renaissance Culture*, Princeton University Press, Princeton 1999, pp. 13, 85, 86, 233 n. 24 and 256 n. 1 and JAMES SASLOW, *Ganymede in the Renaissance, Homosexuality in Art and Society*, Yale University Press, New Haven-London 1986 p. 72. In the *Loves of the Gods*, begun by Rosso Fiorentino and completed by Perin del Vaga, a young, observant Eros is clearly distinguished from Cupid the husband of Psyche (TALVECCHIA 1999, fig. 53, p. 155). In Perino's more moderate representation of the *Loves of the Gods*, engraved by Jacopo del Caraglio in a series of 20, Eros occasionally assists the lovers.

[26] MARIANTONIETTA ACOCCELLA, *L'Asino d'oro nel Rinascimento: dai volgarizzamenti alle raffigurazioni pittoriche*, Longo, Ravenna 2001, pp. 135-136.

[27] *The Greek Anthology*, IV, IX, no. 440, pp. 245-246.

[28] On the Moschus poem, see the essay by Leporatti.

[29] BENEDETTO VARCHI, *Lezione sopra quei versi del 'Trionfo d'Amore' del Petrarca, 'Quattro destrier via piu che neve bianchi…'*, in *Lezioni sul Dante e prose varie di Benedetto Varchi la maggior parte inedite*, 2 vols., Società Editrice delle "Storie" del Nardi e del Varchi, Firenze 1841, II, pp. 17-38, and published elsewhere with the title, *Come dipingere Amor*.

[30] LINA BOLZONI, *La stanza della Memoria*, Einaudi, Torino 1995, trans. Jeremy Parzen, *The Gallery of Memory. Literary and Iconographic*

Editrice delle "Storie" del Nardi e del Varchi, Firenze 1841, II, pp. 17-38, altrove pubblicato con il titolo *Come dipingere Amor*.

[30] LINA BOLZONI, *La stanza della Memoria*, Einaudi, Torino 1995, trad. Jeremy Parzen, *The Gallery of Memory, Literary and Iconographic Models in the Age of the Printing Press*, University of Toronto Press, Toronto 2002, p. XXI.

[31] L'uso che Varchi fa dell'ossimoro è rinvigorito in *The Greek Anthology*, una pratica che si ritrova anche in Petrarca come in testi medievali quali lo *Anticlaudianus* di Alano da Lilla.

[32] L'esempio citato è il sonetto, «ma poi ch'amor di me vi fece accorta, / fur i biondi capegli allor velati, / a l'amoroso sguardo in se raccolto».

[33] LUISA VERTOVA, *Cupid and Psyche in Renaissance Painting before Raphael*, "Journal of the Warburg and Courtauld Institutes", XLII, 1979, pp. 104-121.

[34] VARCHI 1841, pp. 28, 30, «dipingono dunque amore flavio, cioè coi capelli biondi e di più crespi, non come quegli che chiamiamo oggi ricciuti, ma inanellati e tali naturalmente quali si fanno dall'arte col ferro». Si comparino anche i versi di Mosco tratti dal suo poema: «i crini ha in capo inanellati ed irti…»

[35] ARISTOTELE, *Rhetoric*, III, x.5; *Rettorica et Poetica d'Aristotile. Tradocta di Greco in Lingua Volgare Fiorentina da Bernardo Segni*, Torrentino, Firenze 1549, p. 122, «…quanto ell'è fatta piu brevemente, e piu oppostamente; tanto ha ella più del piacevole; per la cagione che nel parlare opposto s'impara più; e nel parlar ' breve s'apprende piùtosto… gli enigmi approvati hano del piacevole, per che e ' vi si impara dentro: et son ' detti in metafora».

[36] TOSCAN 1981, come la nota 16.

[37] Sui soffitti della Sala dei Venti e nel successivo Camerino dei Falconi (1530-1536), così come nella precedente Sala di Psiche, appaiono adolescenti in pose tributarie di antiche statue di Eros. La Sala di Psiche, contiene comunque implicazioni erotiche, a quanto pare per illustrare la relazione di Federigo Gonzaga con la sua amante Isabella Boschetti.

[38] Louvre, Cabinet des Dessins, Inv. 1575. Sull'incisione (BARTSCH 51, come Caraglio), si veda Susan Borsch in *The French Renaissance in Prints from the Bibliothèque Nationale de France*, catalogo della mostra (Los Angeles), Gardner Lithograph, Buena Park California 1994, pp. 303-307, come Pierre Milan.

[39] GIORGIO VASARI, *Le vite dei più eccellenti pittori, scultori ed architettori scritte da M. Giorgio Vasari*, Giunti, Firenze 1568, con nuove annotazioni e commenti di Gaetano Milanesi, 9 voll., Sansoni, Firenze 1878-1885, V, p. 168.

[40] Wien, Kunsthistorisches Museum, Inv. 275. Si veda MARIO DI GIAMPAOLO, *Parmigianino, catalogo completo*, Cantini, Firenze 1991, p. 114.

[41] SYDNEY J. FREEDBERG, *Parmigianino, His Works in Painting*, Harvard University Press, Cambridge 1950.

[42] Nel dipinto, la scaramuccia è tuttavia tra Cupido e Venere, non tra sacro e profano.

[43] SASLOW 1986, p. 42 e RUSSELL 1995, pp. 34-37, 55.

[44] BOLZONI 2002, pp. 145-151.

[45] WILLIAM KEACH, *Cupid Disarmed, or Venus Wounded? An Ovidian source for Bronzino and Michelangelo*, "The Journal of the Warburg and Courtauld Institutes", XLI, 1978 pp. 327 -331.

[46] LEATRICE MENDELSOHN, *L'Allegoria di Londra del Bronzino e la retorica del carnevale*, in *Kunst des Cinquecento in der Toskana*, a cura di Monika Cämmerer, XVII, Bruckmann, München 1992, pp. 152-167.

[47] APULEIO, *Le metamorfosi o l'asino d'oro* (IV.28), trad. di Claudio Annaratone, testo latino a fronte, Rizzoli, Milano 1994.

[48] REMIGIO SABBADINI, *Le scoperte dei codici latini e greci ne' secoli XIV e XV*, a cura di Eugenio Garin, 2 voll., Sansoni, Firenze 1967. Uno dei manoscritti su cui si basò la traduzione originale in volgare apparteneva a Ercole d'Este, due versioni del principale manoscritto latino sono nella Biblioteca Laurenziana di Firenze (68.2, 29.2), una versione latina fu pubblicata nel 1521 da Giunti e nel 1525 fu stampata a Venezia un'edizione italiana, seguita da edizioni del 1527, 1529 e 1535. La prima volgarizzazione fu attribuita a Niccoló Leonicino. Il "lucianismo" fu tuttavia introdotto in Italia in tempi anteriori da Erasmo ed esiste un commentario illustrato del Boiardo risalente al 1518. Una traduzione di Firenzuola fu pubblicata nel 1550.

[49] NANCY SHUMATE, *Crisis and Conversion in Apuleius' Metamorphoses*,

Models in the Age of the Printing Press, University of Toronto Press, Toronto 2002, p. XXI.

[31] Varchi's use of oxymorons is reinvigorated by *The Greek Anthology*, a practice found in Petrarch as well as in medieval texts such as the *Anticlaudianus* of Alain de Lille.

[32] The example given is the sonetto, "ma poi ch'amor di me vi fece accorta, / fur i biondi capegli allor velati, / a l'amoroso sguardo in se raccolto".

[33] LUISA VERTOVA, *Cupid and Psyche in Renaissance Painting before Raphael*, 'Journal of the Warburg and Courtauld Institutes', XLII, 1979, pp. 104-121.

[34] VARCHI 1841, pp. 28, 30, "dipingono dunque amore flavio, cioè coi capelli biondi e di più crespi, non come quegli che chiamiamo oggi ricciuti, ma inanellati e tali naturalmente quali si fanno dall'arte col ferro". Compare also the lines of Moschus from his poem: "i crini ha in capo inanellati ed irti".

[35] See ARISTOTLE, *Rhetoric*, III, x. 5; *Rettorica et Poetica e'Aristotile. Tradocta di Greco in Lingua Volgare Fiorentina da Bernardo Segni*, Torrentino, Firenze 1549, p. 122, "…quanto ell'è fatta più brevemente, e più oppostamente; tanto ha ella più del piacevole; per la cagione che nel parlare opposto s'impara più; e nel parlar ' breve s'apprende piùtosto… gli enigmi approvati hano del piacevole, per che e ' vi si impara dentro: et son ' detti in metafora".

[36] TOSCAN 1981, as in note 16.

[37] On the ceilings of the Sala dei Venti and the later Camerino dei Falconi (1530-1536), as well as in the earlier Sala di Psiche, adolescents appear in poses dependent on ancient statues of Eros. The Sala di Psiche, however, contains erotic implications and was said to illustrate the relationship of Federigo Gonzaga to his mistress Isabella Boschetti.

[38] Louvre, Cabinet des Dessins, Inv. 1575. On the engraving (BARTSCH 51, as Caraglio), see Suzanne Borsch in *The French Renaissance in Prints from the Bibliothèque Nationale de France*, exh. cat. (Los Angeles), Gardner Lithograph, Buena Park California 1994, pp. 303-307, as Pierre Milan.

[39] GIORGIO VASARI, *Le vite dei più eccellenti pittori, scultori ed architettori scritte da M. Giorgio Vasari*, Giunti, Firenze 1568, ed. Gaetano Milanesi, 9 vols., Sansoni, Firenze 1878-1885, V, p. 168.

[40] Wien, Kunsthistorisches Museum, Inv. 275; see MARIO DI GIAMPAOLO, *Parmigianino, catalogo completo*, Cantini, Firenze 1991, p. 114.

[41] SYDNEY J. FREEDBERG, *Parmigianino. His Works in Painting*, Harvard University Press, Cambridge 1950.

[42] In the painting, however, the "contest" is between *Cupid and Venus*, not between the sacred and profane.

[43] See both SASLOW 1986, p. 42 and RUSSELL 1995, pp. 34-37, 55.

[44] BOLZONI 2002, pp. 145-151.

[45] WILLIAM KEACH, *Cupid Disarmed, or Venus Wounded? An Ovidian source for Bronzino and Michelangelo*, 'The Journal of the Warburg and Courtauld Institutes', XLI, 1978, pp. 327-331.

[46] LEATRICE MENDELSOHN, *L'"Allegoria" di Londra del Bronzino e la retorica del carnevale*, in *Kunst des Cinquecento in der Toskana, Italienische Forschungen*, ed. Monika Cämmerer, XVII, Bruckmann, München 1992, pp. 152-167.

[47] APULEIUS, *Metamorphoses*, IV. 28, trans. J. Arthur Hanson, Harvard University Press, Cambridge (Mass.)-London 1996.

[48] REMIGIO SABBADINI, *Le scoperte dei codici latini e greci ne' secoli XIV e XV*, ed. Eugenio Garin, 2 vols., Sansoni, Firenze 1967. One of the manuscripts on which the translations into *volgare* were based originally belonged to Ercole d'Este, two versions of the principal Latin manuscript are in the Biblioteca Laurenziana in Florence (68.2, 29.2), a Latin version was published in 1521 by Giunti and in 1525 an Italian edition was printed in Venice, followed by editions of 1527, 1529 and 1535. The first volgarization was attributed to Niccolò Leonicino. "Lucianismo" in Italy was introduced earlier by Erasmus, however, and an illustrated commentary by Boiardo dates from 1518. A translation by Firenzuola was published in 1550.

[49] NANCY SHUMATE, *Crisis and Conversion in Apuleius' Metamorphoses*,

University of Michigan Press, Ann Arbor 1996.

[50] MENDELSOHN 1992. Nel dipinto del Pontormo il bacio è una parodia dell'amor filiale.

[51] LEATRICE MENDELSOHN, *Der Florentine Kreis: Michelangelos Sonett an Vittoria Colonna, Varchis Lezzioni und Bilder der Reformation*, in *Vittoria Colonna, Dichterin und Muse Michelangelos*, catalogo della mostra (Wien), a cura di Silvia Ferino-Pagden, Skira, Milano 1994, pp. 265-273. Sicuramente il mito di Adone fu considerato una prefigurazione della morte di Cristo. Il dipinto di Sebastiano del Piombo rappresentante la *Morte di Adone* ha simili sfumature religiose ed è stato messo in relazione con il Pontormo passando per un disegno di Michelangelo sul medesimo soggetto.

[52] ECKHARD LEUSCHNER, *Personae, Larva, Maske, ikonologische Studien aus zum 16 bis frühen 18 Jahrhundert*, P. Lang, Frankfurt am Main-New York 1997.

[53] MENDELSOHN 1982, p. 99.

[54] Un disegno conservato alla Biblioteca Ambrosiana ritenuto uno studio di un torso frammentario di *Eracle* suggerisce una fonte diretta per la *Venere* di Michelangelo. MAURO LUCCO, *L'Opera completa di Sebastiano del Piombo*, Rizzoli, Milano 1980, p. 102, n. 34. Non è verosimile che solo per pura coincidenza sul *verso* di questo foglio compaia uno studio di *Venere* dalla *Morte di Adone* di Sebastiano del Piombo, ora agli Uffizi: *Ibidem*, n. 34.

[55] BOBER-RUBENSTEIN 1986, p. 24, n. 23.

[56] BOLZONI 2002, pp. 151-161.

[57] ROCKE 1996.

University of Michigan Press, Ann Arbor 1996.

[50] MENDELSOHN 1992. In Pontormo's painting, the kiss is a parody of filial love.

[51] LEATRICE MENDELSOHN, *Der Florentine Kreis: Michelangelos Sonett an Vittoria Colonna, Varchis Lezzioni und Bilder der Reformation*, in *Vittoria Colonna, Dichterin und Muse Michelangelos*, exh. cat. (Wien), ed. Silvia Ferino-Pagden, Skira, Milano 1994, pp. 265-273. Certainly there is evidence that the myth of Adonis was considered a prefiguration of the death of Christ. The painting by Sebastiano del Piombo of the *Death of Adonis*, has similar religious overtones and has been connected to the Pontormo via a related drawing by Michelangelo.

[52] ECKHARD LEUSCHNER, *Personae, Larva, Maske, ikonologische Studien aus zum 16 bis frühen 18 Jahrhundert*, P. Lang, Frankfurt am Main-New York 1997.

[53] MENDELSOHN 1982, p. 99.

[54] A drawing in the Ambrosiana, said to be a study of a fragmentary torso of Hercules, suggests a direct source for Michelangelo's Venus. MAURO LUCCO, *L'Opera Completa di Sebastiano del Piombo*, Rizzoli, Milano 1980, p. 102, no. 34. It is unlikely to be coincidental that the verso of this sheet bears a study for the Venus from Sebastiano's *Death of Adonis*, now in the Uffizi; *Ibid.*, no. 34.

[55] BOBER-RUBENSTEIN 1986, p. 24, n. 23.

[56] BOLZONI 2002, pp. 151-161.

[57] ROCKE 1996.

Roberto Bellucci-Cecilia Frosinini

(Opificio delle Pietre Dure e Laboratori di Restauro)

UN MITO MICHELANGIOLESCO
E LA PRODUZIONE SERIALE:
IL CARTONE DI "VENERE E CUPIDO"

A MICHELANGELESQUE MYTH
AND PRODUCTION IN SERIES:
THE 'VENUS AND CUPID' CARTOON

Lo studio delle repliche di *Venere e Cupido* realizzate ipoteticamente nel corso di alcuni decenni del Cinquecento a partire da un cartone di Michelangelo, secondo il racconto fattone da Vasari nelle *Vite*, risulta particolarmente interessante anche per la possibilità che offre di approfondimento sulla storia del cartone come tipologia di lavoro, come oggetto artistico e come modello di riferimento.

Inoltre, il fatto di condurre tale studio sulla base dell'indagine riflettografica consente un ulteriore allargamento del tema, a considerazioni sulla vera natura dell'*underdrawing* in relazione al cosiddetto "disegno preparatorio".

Naturalmente le osservazioni cui siamo giunti non hanno affatto la presunzione di essere definitive: questo deve essere premesso non solo per onestà di metodo, ma anche per la semplice ragione che lo studio è stato affrontato soltanto su cinque dei possibili 32 esemplari (tra repliche effettive e derivazioni) testimoniatici dalle fonti.

Proprio per la frequenza di utilizzo di una terminologia spesso impropria, possibile fonte di molti equivoci in fase di interpretazione dei dati, è opportuno chiarire subito alcuni concetti sia linguistici che tecnici di base. È probabile che la fonte dell'equivoco stia nel modo in cui Vasari utilizza il termine *cartone* in una accezione già compiutamente cinquecentesca, vale a dire cioè, in un contesto in cui la terminologia, l'oggetto in sé e la sua metodica di utilizzo si erano già sovrapposti nella mentalità comune. Bisogna invece risalire al Cennini[1] e alle fonti e i documenti quattrocenteschi per capire la genesi della vicenda. Sarebbe errato pensare che la pratica di trasferire un'immagine da un supporto cartaceo alla superficie definitiva da dipingere (fosse essa muro o tavola) sia stata un'invenzione del tardo Quattrocento. Studi tecnici sempre più approfonditi e attente disamine della documentazione scritta sopravvissuta stanno finalmente facendo luce sull'argomento.

Based on what is reported by Giorgio Vasari, in his *Lives of the Artists*, it can be hypothesised that during the 1500's – at least for a few decades – replicas of the *Venus and Cupid* taken from a cartoon by Michelangelo were quite popular. The study of these replicas is particularly interesting because they offer the possibility to further our knowledge about the cartoon as an artistic object, as a reference model and as a working method. Additionally, with the assistance of the reflectographic analysis further considerations relative to the true nature of the underdrawing, as related to the so-called 'preparatory drawing', can be made. Naturally, the observations we make do not presume to be definitive: this premise is obligatory, not only for honesty of method, but also for the simple reason that this study has focused upon only five of the possible thirty-two examples (the true replicas, as well as the derivations) attested to by the literary sources.

Due to the frequent use of often improper terminology – leading to possible misunderstandings when interpreting the data – some of the linguistic as well as basic technical concepts should be clarified from the start. It is probable that the source of the basic confusion stems from the fact that Vasari uses the term 'cartoon' *(cartone)* in a sense that is already clearly 16th century in connotation. That is, the term is used in a context where the object and its use were already well-impressed in a common mentality. It is necessary to go back to Cennini[1], to the documents and sources from the 1400's in order to understand the genesis of the situation. It would be wrong to think that the practice of transferring an image from a paper support to the final surface to be painted (be it wall or wood panel) was an invention of the late 1400's. Increasingly careful, in-depth technical studies in disagreement with the surviving written documentation are finally shedding some light on the subject. The purchase of paper by Giottino and Giovanni da Milano[2] in the Vatican Chapel is only

L'acquisto di carta nel cantiere della Cappella Vaticana da parte delle maestranze di Giottino e Giovanni da Milano[2] è solo uno dei molti esempi che si potrebbero citare per cominciare a riflettere su quanto poco, in realtà, sappiamo della conduzione del lavoro in un cantiere trecentesco. Come, in modo altrettanto significativo, va preso atto della sicura pratica dell'utilizzo di *patroni*, sia su muro che su tavola: ulteriore prova della minuziosa pianificazione a parte dell'idea compositiva, spesso nei suoi dettagli, fatta dal pittore, e della necessità di trasferirla poi sul supporto definitivo. Una concezione del lavoro che nessuno spazio lasciava all'invenzione estemporanea con cui, spesso acriticamente e anacronisticamente, abbiamo tentato di interpretare le epoche passate. Cennini stesso parla, sia pure in un contesto di decorazioni minori, dell'utilizzo di *spolverazzi* per riportare il disegno attraverso carta traforata. E la lunga spiegazione tecnica che riserva alla realizzazione di carta lucida, da utilizzare per ricavare modelli dall'opera di buoni maestri, sembrerebbe una traccia importante da seguire, alla ricerca delle origini dello sviluppo della tecnica. In Cennini la terminologia autorizza a credere che originariamente *cartone* sia soltanto un accrescitivo della parola *carta* e che quindi indichi un supporto costituito da più carte aggiunte per raggiungere la misura di superficie desiderata. La necessità di usare questo supporto come mezzo intermedio di trasferimento del disegno sulla superficie da dipingere, sia per mezzo di un traforo delle linee di contorno, sia attraverso il ricalco o addirittura l'incisione, non consente evidentemente di pensare a un supporto di spessore e rigidezza maggiore a quello della carta stessa, come la sovrapposizione con il vocabolo identico dell'italiano moderno indurrebbe equivocamente a credere. Ulteriore confusione in questa direzione hanno senz'altro ingenerato le modalità collezionistiche attraverso cui i disegni (ivi compresi i cartoni) sono giunti fino a noi: controfondati, irrigiditi dall'incollaggio su carte rigide o addirittura su tela.

Il fatto che la sopravvivenza di questi disegni da trasporto su carta sia pressoché nulla per tutto il Trecento e buona parte del Quattrocento, oltre a essere dovuto alla perdita più sensibile di documentazione (anche di altro genere) dimostra soltanto la diversa ricezione che se ne aveva da parte del pubblico. Il disegno preparatorio da riporto (= il cartone) era considerato soltanto un mezzo di lavoro e come tale non si sentiva nessuna necessità di conservarlo: l'utilizzo diretto su intonaco bagnato, l'inevitabile annerimento da carbone dovuto alla pratica dello spolvero, oppure ancora l'indiscriminata lacerazione della superficie segnata dalle incisioni creavano, ovviamente, problemi notevoli a una eventuale conservazione di tipo collezionistico. Per la quale, inoltre, sembra non ci fosse alcuna richiesta: sono invece giunti fino a noi, in grande quantità, i raffinatissimi disegni a punta metallica su carta preparata: siano essi riferibili (parzialmente) a opere definitive o no, costituiscono una precisa attestazione di gusto che,

one of the many examples that could be cited when one begins to consider how truly little we know about how work was carried out in a 14th century artistic work-site. Also significant is that most assuredly the use of transfer patterns – both on the wall and the wood panel – were used. This is further proof of the very minute planning of the compositional idea by the painter – a composition that was often very detailed – and therefore the need to transfer it in its entirety onto the final surface. A work concept that left no space to extemporaneous invention and which in past eras we have tried to acritically and anachronistically interpret. Often, Cennini speaks of the use of the pouncing technique (*spolverazzi*) – albeit in the context of minor decorations – to transfer a drawing by pouncing charcoal dust through the holes of a drawing on paper. The long explanation that Cennini gives us for making tracing paper – in order to get a copy of the work of good masters to use as a model – seems to be an important thread to follow in the search for the origins of the development of this technique. The terminology used by Cennini allows us to surmise that the term 'cartoon' (*cartone* – literally large *carta* or paper) was simply an enlargement of the word *carta*, thereby indicating a drawing support that was made up of multiple pieces of paper attached together to create the surface-size required. Whatever means was used to transfer the drawing from the large paper to the surface to be painted – pinholes in the contour lines, charcoal transfer tracing, or incising over the drawn outline – it is obvious that the paper support could not have been as rigid or thick as the modern day Italian implies in the use of the term *cartone* (cardboard). Further confusion in this sense is certainly due to the habits of collectors and the way drawings (including cartoons) have reached us today: they are backed and stiffened by means of gluing them onto cardboard or even canvas.

The fact that the survival of these transfer drawings on paper from the 1300's and a good part of the 1400's is practically non-existent simply demonstrates the different way they were received by the public. The preparatory transfer drawing (= cartoon) was considered only a work instrument, and as such there was no reason to save it. Its direct use on wet plaster, the inevitable blackening from the carbon dust used for the pouncing, or even the indiscriminate lacerations on the surface from the incising, obviously created a major problem for the conservation – in terms of collectionism – of the paper cartoon. Additionally, from a collector's or collection point of view, there did not seem to be any request for the conservation of these works. Instead, the refined metal-point drawings on prepared paper, from the same period, have reached us in large quantities. Whether these can be referred to as definitive works – either totally or partially – they do constitute a precise attention to taste and refinement. This attention diminishes enormously – if not altogether – with the growing affirmation in time of the *ben finito cartone* ('well finished cartoon') as an element of taste and collection piece.

UN MITO MICHELANGIOLESCO E LA PRODUZIONE SERIALE: IL CARTONE DI "VENERE E CUPIDO"
A MICHELANGELESQUE MYTH AND PRODUCTION IN SERIES: THE 'VENUS AND CUPID' CARTOON

111

1-a.

1-b.

1-c.

1-d.

1a-d. Dettagli comparati della mano della Venere con griglia spaziale
comparison of the details of Venus's hand with spatial grid:

a. *Venere e Cupido / Venus and Cupid*,
Firenze, Galleria dell'Accademia.
b. *Venere e Cupido / Venus and Cupid*, Firenze, Gallerie Fiorentine,
in deposito a Pisa, Scuola Normale Superiore.
c. *Venere e Cupido / Venus and Cupid*, Roma, Galleria Colonna.
d. *Venere e Cupido / Venus and Cupid*, tavola / panel, Napoli,
Museo Nazionale di Capodimonte.

non a caso, viene a diminuire sensibilmente, per poi cessare quasi del tutto, in concomitanza dell'affermarsi del *ben finito cartone* quale elemento di gusto e oggetto da collezione.

Del periodo tra Trecento e prima metà del Quattrocento si sono conservati anche diversi disegni a carbone matita o pennello, che sembrerebbero poter rientrare nella categoria dei *disegni dimostrativi*: redazioni in piccolo, cioè, dell'opera che avrebbe dovuto essere fatta e che servivano all'artista stesso per studiarne l'effetto compositivo generale, e/o al committente per una preliminare valutazione. Esempi come il celebre *cartonetto* di Paolo Uccello, con le sue due redazioni successive (parallele alla nota vicenda documentaria delle due redazioni in affresco del medesimo cenotafio dipinto per Giovanni l'Acuto, la prima rifiutata dall'Opera del Duomo di Firenze) e la quadrettatura certamente finalizzata a trarne i successivi cartoni di lavoro ingranditi, pare un'ottima esemplificazione di questo genere.

La terminologia più tarda, pienamente cinquecentesca, invece, ci ha trasmesso una accezione del termine "cartone" equivoca, in cui spesso l'oggetto di lavoro si sovrappone o viene sostituito ad un altro oggetto, un *ben finito cartone*, per usare l'espressione dell'Armenini, che certamente era uno stadio intermedio del progetto, un disegno preparatorio a grandezza pressoché naturale rispetto all'opera definitiva, da mostrare al committente, e anche, in seguito, da collezione in se stesso.

La trasformazione del cartone come strumento di lavoro in un oggetto di fruizione pubblica, di dimostrazione di perizia artistica e quindi di oggetto degno di collezione si ha certamente a partire dalla trasformazione del concetto stesso dell'artista e dell'arte di cui l'Accademia di San Luca è portatrice. E la grande eminenza grigia della trasformazione è senz'altro Vasari. Che in maniera sciente retrodata la trasformazione all'inizio del Cinquecento, facendola risalire alla triade di geni del Rinascimento, Leonardo, Raffaello e, soprattutto, Michelangelo. Niente vieta infatti di pensare che al di là dell'episodica esposizione dei cartoni della *Sant'Anna* di Leonardo, o di quella delle battaglie di Michelangelo e Leonardo divenuti scuola di apprendimento dell'arte, la trasformazione dello strumento di lavoro in pezzo di bravura stia nelle scelte di metodo e nelle diatribe nate in seno all'Accademia stessa. La grande operazione culturale che Vasari opera attraverso le *Vite* acquista sempre più senso se ci si allontana dalla lettura meramente biografica che se ne faceva in passato per riportarle alla più realistica dimensione di promozione di idee e contenuti. Ormai riconosciuto come il vero creatore del mito dell'affresco, Vasari può a buon diritto essere considerato anche l'inventore del mito e della fortuna del cartone.

Un mito che si afferma in brevissimo tempo, tanto che già nell'Armenini, nel 1586, si legge che:

«Hora ci resta a trattare dei cartoni, i quali appresso di noi si tiene essere l'ultimo et il più perfetto modo di quello che per artificio di disegno si vede»[3].

During the period between 1300 and the first half of the 1400, a number of charcoal, pencil or brush drawings are conserved. These would enter into the category of 'demonstrative drawings', that is, small scale drawings representing the way the finished work would look. These were used by the artist in order to study the general compositional effect and/or to show to the patron for a preliminary evaluation. An example of this use is the famous 'small cartoon' *(cartonetto)* by Paolo Uccello, with its two subsequent versions – relating to the two well-documented fresco versions of the same cenotaph painted for Sir John Hawkwood, the first of which was refused by the Opera del Duomo in Florence – and the squaring off of the drawing with the purpose of creating subsequent cartoons of the enlarged work.

Instead, the later 16th century terminology has transmitted to us a meaning for the term 'cartone' that is incorrect, one in which the object of the work is overlapped or even substituted by another object – to use Armenini's expression a *ben finito cartone*: an object that certainly represented an intermediate stage of the project, a preparatory drawing of basically the same size as the finished work, one to show to the patron, and later, an object of collection in itself. The transformation of the cartoon as a working tool into an object of public scrutiny, a demonstration of artistic ability and therefore an object worthy of being in a collection, certainly springs from the transformation brought about by the Academy of St. Luke in terms of the concept of art and the artist himself. And without doubt, the great grey-haired eminence behind this transformation is Giorgio Vasari. In an erudite manner, this transformation is pushed back to the beginning of the 1500's, to the triad of Renaissance geniuses: Leonardo da Vinci, Raphael and above all, Michelangelo. Nothing however prohibits thinking that apart from the episodic exposition of the *Saint Anne* cartoons by Leonardo, or those of the battles of Michelangelo and Leonardo – a school in themselves of artistic education – the transformation of the working tool into a piece of bravura lies in the choice of method and in the diatribes born within the Academy itself. The important cultural operation that Vasari completes by means of his *Lives* makes more sense if we distance ourselves from the mere biographical reading of the work and view its more realistic dimension of promoting the ideas that it contains. Known as the true creator of the myth of the fresco, Vasari has all the right to be also considered the inventor of the myth of the cartoon.

A myth that in very short time was well affirmed; so much so, that in 1586 we read in Armenini: "Now we must discuss cartoons, which we believe to be the highest and most perfect manner that is seen in the artifice of drawing"[3].

From a purely utilitarian and subordinated use, the cartoon becomes almost the highest artistic expression of the Renaissance. Naturally, Vasari's operation did not spring extemporaneously from his mind. Necessarily it put down roots in both a cultural and a social humus that was ready to receive it. The exaltation of the drawing as a foundation and center point in Florentine pictorial tradition has historical roots dating certainly at least

2a.

2b.

2c.

2d.

2 a-d. Dettagli comparati del piede della Venere con griglia spaziale
comparison of the details of Venus's foot with spatial grid:

 a. *Venere e Cupido / Venus and Cupid*,
 Firenze, Galleria dell'Accademia.
 b. *Venere e Cupido / Venus and Cupid*, Firenze, Gallerie
 Fiorentine, in deposito a Pisa, Scuola Normale Superiore.
 c. *Venere e Cupido / Venus and Cupid*, Roma, Galleria Colonna.
 d. *Venere e Cupido / Venus and Cupid*, tavola / panel, Napoli,
 Museo Nazionale di Capodimonte.

3 a-b. Dettagli del volto della Venere e Cupido /
details of the faces of Venus and Cupid:

 a. *Venere e Cupido / Venus and Cupid*,
 Firenze, Galleria dell'Accademia.
 b. *Venere e Cupido / Venus and Cupid*,
 Roma, Galleria Colonna.

3a.

3b.

Da un uso puramente utilitaristico e sussidiario, il cartone diventa quasi la più alta espressione artistica del Rinascimento. Naturalmente l'operazione di Vasari non fu soltanto il parto estemporaneo della sua mente, ma necessariamente affondava le sue radici in un *humus* culturale e sociale pronto alla ricezione.

L'esaltazione del disegno come fondamento e cardine della tradizione pittorica fiorentina ha radici storicamente certe almeno a partire dalla codificazione fattane da Cennino Cennini che dedica diversi capitoli del suo *Libro dell'Arte* all'educazione al disegno del suo ipotetico discepolo di bottega [«El fondamento dell'arte, e di tutti questi lavorii di mano il principio, è il disegno e 'l colorire», Cennini inizio del XV secolo, cap. III]. La creazione dell'Accademia non fa altro che dare voce a un'istanza e una ricerca precisa dell'ambiente artistico, che Vasari ha il merito di esaltare e codificare anche nella costruzione polemica dell'antagonismo culturale-campanilistico con Venezia.

Già durante la vita stessa di Michelangelo i cartoni dell'artista avevano anche un valore commerciale e quindi è più che verosimile che se ne traessero copie, sia disegnate che dipinte. Vasari ricorda, nella *Vita del Pontormo*, delle due copie che Jacopo trae da un cartone di Michelangelo rappresentante il *Noli me tangere*, subito prima della vicenda di *Venere e Cupido*. Nel 1532, nel *Carteggio* di Michelangelo, si ritrova una lettera del Mini in cui l'uomo afferma di avere l'intenzione di trarre 3 dipinti dal cartone della *Leda* che Michelangelo gli ha donato: «Sappiatte che di quello chartone n'arò a fare 3 delle Lede»[4].

E anche nella vicenda del cartone di *Venere e Cupido*, Vasari si dilunga sul guadagno che ne ebbe il Pontormo e sulla avidità del Bettini, amico di Michelangelo e proprietario del cartone, che ne voleva fare speculazione. È dunque estremamente probabile che la ragione delle così numerose repliche e derivazioni di *Venere e Cupido* possa essere anche una motivazione economica legata senz'altro alla idolatria nei confronti di Michelangelo, ma anche al valore monetario in cui era facile trasformarla. Se percorriamo questa ipotesi di lavoro è interessante considerare come già nel Quattrocento siano attestate fortunate produzioni di serie di repliche di modelli illustri cui presumibilmente erano addirittura dedicate intere botteghe[5].

È interessante notare, a questo proposito, come dai documenti cinquecenteschi sia più volte registrato l'utilizzo di maestranze specifiche, all'interno delle botteghe o dei cantieri pittorici, dedicate a operare il trasferimento dei cartoni su supporto definitivo. Ne parla, per esempio, un documento del 1572 relativo ai lavori della cupola nell'àmbito della bottega del Vasari[6]. E dell'uso di tali maestranze riferisce anche il *Trattato* del Carducho (1633)[7].

A sostegno di un'ipotesi del genere starebbero innegabili identità del *ductus* dell'*underdrawing* di alcune delle repliche di *Venere e Cupido* (Roma, Galleria Colonna; Napoli,

from the codification by Cennino Cennini. Cennini dedicates various chapters of his book *Il Libro dell'Arte* to the training in drawing that his hypothetical workshop disciple receives "The basis of the profession, and the very beginning of all these manual operations, is drawing and painting". The creation of the Academy simply provides a voice to that moment and to the precise search in the artistic environment that Vasari can be credited with exhalting and codifying even in light of cultural polemics with Venice.

Even during Michelangelo's life his cartoons had commercial value. It is more than likely that both drawn and painted copies were made of his cartoons. In the *Life of Pontormo*, Vasari recalls the two copies that Pontormo took from a cartoon by Michelangelo depicting *Noli me tangere*, immediately before that of the *Venus and Cupid*. In 1532, in Michelangelo's *Carteggio*, there is a letter from Mini, wherein this artist affirms that he intends to make three paintings from the cartoon of Leda that Michelangelo had given him: "You should know that from that cartoon, I will make 3 Ledas"[4]. Even in the circumstance of the cartoon for *Venus and Cupid*, Vasari dwells on the amount that Pontormo earned because of it, and on the greed shown by Michelangelo's friend Bettini, who was the owner of the cartoon and who speculated heavily on it. It is therefore extremely probable that the reason for the many replicas and derivations of *Venus and Cupid* is tied to an economic motivation based on idolatry for Michelangelo, but also to the monetary value in which the work was easily transformed. If we follow this working hypothesis, it is interesting to consider that already in the 1400's there was a successful production of a series of illustrious models to which even entire workshops were dedicated[5].In this regard it is interesting to note from 16th century documents, that more than once specifically skilled hands were called from either within the workshop itself or from pictorial work-sites specialised in the transfer of the cartoons to the final artistic support. For example, a document dating from 1572 relating to the work on the cupola in Florence tells of this practice within Vasari's workshop[6]. This dedicated use of a specific skill is also referred to in the *Treatise* by Carducho (1633)[7].

In support of this hypothesis, the *ductus* of the underdrawing of a couple of the Venus and Cupid replicas (Roma, Galleria Colonna; Napoli, Museo e Gallerie Nazionali di Capodimonte) proves to be exactly the same, under examination using infrared reflectography. Not only are the underdrawings identical in terms of the pictorial transposition, but the same hand also executed the minor details, not tied to the need for a reference cartoon.

The co-existence of so many replicas leads to questions about the practicality of using one single original cartoon for the transposition of the drawing. These are general questions, given the scarcity of knowledge about the actual technical use of cartoons as a working method. There are specific questions related to the existence of one of the *Venus and Cupid* cartoons at the Museo di Capodimonte in Naples: could this be the original by Michelangelo — once in Bettini's possession — or is it a later replica, exactly in the same way as the paintings?

4 a-b. Dettagli dell'arco / details of the bow:

 a. *Venere e Cupido / Venus and Cupid*,
 cartone / cartoon, Napoli, Museo
 Nazionale di Capodimonte.
 b. *Venere e Cupido / Venus and Cupid*,
 Firenze, Galleria dell'Accademia.

4a.

4b.

5a.

5b.

5c.

Museo e Gallerie Nazionali di Capodimonte) esaminate attraverso la riflettografia IR. Identità anche di dettagli assolutamente ininfluenti alla vera e propria trasposizione pittorica, quindi verosimilmente non legati alla necessità di un cartone di riferimento ma alla stessa mano che li ha tracciati.

La coesistenza di tante repliche porta di necessità alcune domande circa la praticabilità di utilizzo di un originale unico per la trasposizione. Domande generali, dato che scarse sono le conoscenze in merito alla reale tecnica di utilizzo del cartone come metodo di lavoro. E domande specifiche, data l'esistenza ancor oggi di un cartone con *Venere e Amore*, presso il Museo di Capodimonte, a Napoli: se cioè questo possa essere l'originale di Michelangelo, già posseduto dal Bettini, o non sia piuttosto una ulteriore replica, esattamente allo stesso modo dei dipinti.

La tecnica di trasposizione del disegno preparatorio sul supporto definitivo tramite l'utilizzo di un disegno preparatorio in scala 1:1 rispetto all'originale poteva servirsi di diverse metodiche: incisione indiretta (uno strumento a punta dura, metallica, che ripassava le linee principali del disegno, lasciando attraverso la carta interposta una traccia sul gesso della preparazione); spolvero (bucherellando fittamente le linee del disegno preparatorio e poi facendo passare attraverso questa trama del carbone in polvere che lasciava così una traccia puntinata sul gesso del supporto definitivo); ricalco (il disegno preparatorio veniva sul retro tinto di carbone cosicché, una volta appoggiato il foglio sul gesso e ripassati i tratti del disegno, il carbone lasciava una traccia in corrispondenza della pressione). Evidentemente tutte queste tecniche comportavano un utilizzo "pesante" del disegno originale e dopo le operazioni sopradescritte sembrerebbe pressoché impossibile che questo ne uscisse in condizioni da essere conservato e riutilizzato molte volte di seguito, vuoi per la lacerazione del supporto, vuoi per la sua pesante sporcatura.

5a-c. Dettagli delle maschere / details of the masks:

 a. *Venere e Cupido / Venus and Cupid*, tavola / panel, Napoli, Museo Nazionale di Capodimonte.
 b. *Venere e Cupido / Venus and Cupid*, cartone / cartoon, Napoli, Museo Nazionale di Capodimonte.
 c. *Venere e Cupido / Venus and Cupid*, Roma, Galleria Colonna.

The technique of transferring the preparatory drawing onto the final painting support by means of a one-to-one scale preparatory drawing could be accomplished by various methods: indirect incising (a hard, pointed, metallic tool is used to trace over the principal lines of the drawing and through the paper leaves the incision of the line on the gesso ground of the support); pouncing (pinholes pricked along the lines of the preparatory drawing and then charcoal dust pounced onto the

6a.

6b.

6 a-b. Dettagli del paesaggio / details of the landscape:

 a. *Venere e Cupido / Venus and Cupid*, Firenze, Gallerie Fiorentine,
 in deposito a Pisa, Scuola Normale Superiore.
 b. *Venere e Cupido / Venus and Cupid*, Roma, Galleria Colonna.

Naturalmente potevano darsi casi in cui si provvedeva a una sorta di "restauro" dell'esemplare per conservarlo (ripulitura dal carbone, spianatura dal retro dei bordi slabbrati dell'incisione e loro colmatura dal davanti con una ripassatura di segno, controfondatura del retro). Ma si tratta di casi molto speciali e certo non comuni. La pratica doveva essere invece quella del trarre dal *ben finito cartone* un cosiddetto "cartone sostitutivo"[8], cioè un disegno preparatorio puramente sussidiario da utilizzare secondo le pratiche usuali, senza doversi curare della sua conservazione, lasciando quindi intatto per tutti gli altri scopi, collezionistici, espositivi, didattici ma anche di modello per repliche successive, il *ben finito cartone* che ne era stato all'origine.

Questa è stata presumibilmente anche la vicenda del cartone originale di Michelangelo di *Venere e Cupido*. Già Pontormo, se dobbiamo dare fede al racconto vasariano, dovette trarne un mezzo intermedio di lavoro, dato che poi il cartone di Michelangelo torna in possesso del Bettini. Di questi cartoni sostitutivi dovettero essercene molti, successivi nel tempo gli uni agli altri e si presume eseguiti da mani diverse. Ciò dà conto delle leggere o maggiori varianti che si osservano sui dipinti derivati, che è possibile raggruppare tra loro anche sulla base di alcune di queste varianti.

Un altro aspetto da prendere in considerazione, tra i numerosi sollevati dal problema, è quello delle misure: le misure delle tante varianti, infatti, non sono identiche tra loro e questo apre il problema della loro relazionalità reciproca e nei confronti dell'originale *ben finito cartone* di Michelangelo. La possibilità di ottenere dall'indagine in infrarosso delle immagini riflettografiche dell'*underdrawing* geometricamente identiche all'originale (come spiegato in dettaglio nel saggio dell'Istituto Nazionale di Ottica Applicata: v. *Appendice IV*) ci dà infinite possibilità di comparazione fra loro degli interi e dei particolari, dettaglio per dettaglio. E certamente assai stimolante sarebbe poter proseguire lungo questo filone di ricerca ed esaminare con la stessa tecnica di indagine tutte le sopravvissute repliche.

Ma anche soltanto rimanendo allo stato attuale delle ricerche, le considerazioni fatte permettono di esprimerci, per esempio, a favore di un'ipotesi di cartone sussidiario fatto in pezzi separati e non della grandezza dell'intera composizione. Infatti, le numerose testimonianze sia documentarie che letterario-trattatistiche, che parlano inequivocabilmente di cartoni a grandezza uguale al supporto definitivo, di operazioni di giuntura tra i vari fogli durate anche molti giorni, per finire con le sopravvivenze (quale il grande cartone della *Scuola d'Atene* oggi all'Ambrosiana di Milano), verosimilmente si riferiscono al *ben finito cartone* che, come già visto, era cosa ben diversa dal mezzo reale di lavoro.

È certo verosimile in base a considerazioni di ordine pratico che dal *ben finito cartone* siano stati tratti diversi pezzi separati di "cartone sostitutivo", ognuno di essi relativo a

surface of the drawing, leaving the traces of charcoal on the gesso ground in correspondence to the pinholes); transferred tracing (the back of the preparatory drawing was entirely tinted with charcoal. When the cartoon was placed on the gessoed support and the lines of the drawing traced over, the charcoal leaves a mark in correspondence to the pressure). Evidently, all these techniques required the 'heavy' use of the original drawing. After the above-described operations, it would seem almost impossible that the cartoon could still be in condition to be used over and over again – due mainly to either lacerations in the paper or the heavily soiled conditions.

Naturally, there could be cases when a sort of 'restoration' may have been performed on the particular cartoon in order to preserve it (cleaning off of the charcoal, smoothing out of the incision lines from the back, the filling in of the line from the front, the application of a backing). But these were very special instances and certainly not commonplace. The habitual practice must have been that of making a 'substitute cartoon'[8] from the well-finished one. In essence, a preparatory drawing that was supplementary, and meant to be used according to the normal practice, without having to worry about its conservation, and leaving intact the well-finished cartoon for the uses for which it was meant: collections, exhibitions, training, and also from which to make subsequent replicas. Presumably, this was also what happened with Michelangelo's original cartoon of the *Venus and Cupid*. If we can rely upon Vasari's telling of the story, Pontormo must have used the Michelangelo cartoon as intermediary means of work, given the fact that the original cartoon was returned to Bettini's possession. Naturally, these substitute cartoons must have been fairly numerous, being made one after the other over time and presumably executed by different hands. This explains the slight or major variations that can be seen on the paintings derived from them, and it is possible to group these among themselves based on some of these variations.

Another aspect – among the many raised by the problem – to take into consideration, deals with the measurements of the variations. In fact the dimensions are not identical with one another, and the problem of relating them to the original well-finished cartoon by Michelangelo is raised. The possibility of obtaining images of the underdrawing, by means of infrared reflectographic analysis, which are geometrically identical to the original gives us the possibility to make comparisons between the drawing as a whole and the individual details. It would certainly be fairly stimulating to be able to follow this line of research and with the same analytical technique examine all the surviving replicas. But returning to the current state of study, the considerations we have made permit us to embrace the hypothesis of a substitute cartoon made in separate pieces and not the size of the entire composition. Numerous sources, documents and literary-treatises, unequivocally speak about cartoons that are the size of the final painting support, and about the work of often many days needed to join together the single sheets. The survivors of this process (the large-size cartoon in the Ambrosiana in Milan of the

una porzione diversa dell'immagine, più semplici da maneggiare, preparare per il trasferimento del disegno, posizionare sul supporto definitivo, usare per il riporto dell'immagine. L'ipotesi che siano stati utilizzati vari pezzi di cartone sostitutivo darebbe una spiegazione logica anche del fatto che su alcuni dipinti si riscontrano sovrapponibilità quasi assolute di parti dell'immagine, ma al contempo un disallineamento o una spaziatura diversa delle stesse parti nell'area del supporto intero.

Nel cercare di studiare la genesi storica delle varie repliche, altro passaggio importantissimo sarebbe lo studio comparato delle metodologie dell'*underdrawing* con la tecnica costruttiva dei vari supporti lignei. È interessante, infatti, avere notato che nel caso della replica dell'Accademia di Firenze e di quella oggi a Pisa, la costruzione dei supporti presenta analogie notevoli (caratteristiche fisiche del legno che autorizzano a pensare a una stessa partita di assi; dimensioni delle assi; chiodi come elemento di collegamento dell'asse inferiore a quella immediatamente superiore, non utilizzati in altra zona; sistema di traversatura), tanto da dover suggerire con forza di prendere in considerazione l'ipotesi di una loro realizzazione nell'àmbito di una stessa bottega di legnaiolo, in epoca ravvicinata se non contemporanea.

L'insieme dei dati tecnici, quindi, avrebbe necessità di essere sviluppato ulteriormente, prima di poter giungere a risultati cronologici e attributivi certi, se mai essi saranno possibili in un gruppo di opere che nasce con intenzionalità ben precise di riferimento voluto e controllato, di replica. Ma mentre l'esame del dato stilistico dovrà sempre tenere in debito conto il fatto che le varie botteghe impegnate nella realizzazione delle opere dovettero, verosimilmente, produrre "repliche" e non esemplari stilisticamente autonomi e quindi attenuare eventuali specificità individuali, l'esame dei dati materiali avrà senz'altro da offrire una diversa chiave di lettura. Le pratiche di bottega, infatti, quello che di materiale e tradizionale e ripetitivo c'è all'interno di uno specifico ambito, si riproduce in modo certo, con il valore quasi di un'impronta digitale.

Qui si metteva in atto un apprendimento assolutamente primario del mestiere, quello che può corrispondere all'abbecedario per uno scolaro, assimilabile alla grafia individuale di una persona. Una grafia che per la sua intrinseca veridicità può essere usata, come in tribunale la perizia calligrafica, col valore di prova.

School of Athens) seem to refer to the 'well-finished cartoon' type and, as we have already seen, constitute something quite different from the working piece.

It is certainly possible that due to practical considerations, different separate pieces of the 'substitute cartoon' were taken from the well-finished cartoon, each of these from a different portion of the image. These were easier to handle, easier to prepare the drawing for transfer, easier to position it on the final pictorial support. The hypothesis that various pieces of substitute cartoons were used would also provide a logical explanation to the fact that in some paintings the image can be almost exactly overlain, but at the same time there is a misalignment or different use of surrounding space over the rest of the painted support. When attempting to study the historic genesis of the various replicas, another very important passage would be the comparative study of the methods used for the underdrawing with the construction techniques used for the various wood supports. In fact, it is interesting to see that in the Florentine Accademia replica and the one in Pisa, the construction of the support elements is very similar (physical characteristics of the wood that allow us to hypothesise the use of the same batch of planks; the size of the planks; nails joining the lower plank to the one immediately above it while not used in other areas of the panel; system of battens). There are enough similarities to strongly conjecture the close, if not almost contemporary, construction of the two panels within the same carpentry workshop.

This series of technical data would need to be further developed before reaching secure chronological and attributive conclusions; these will ever be is possible when dealing with a group of works made precisely with the intention of being replicas. The examination of the stylistic data should always take into due account the fact that the various workshops involved in the production of the paintings were producing 'replicas', and not pieces that were stylistically autonomous, with elements specifically individual. However, the examination of the materials will undoubtedly offer another angle of interpretation. In fact, workshop production takes place within a specific environment, one based on the use of materials that is traditional and repetitive. The production of the object is done in a certain way, with identifiable characteristics; almost artistic 'finger prints'. There was an absolutely primary learning aspect to the trade, one that could correspond to a schoolboy's primer, and similar to an individual's handwriting. A handwriting, that because of its intrinsic truthfulness, can be used as proof – just as handwriting analysis is used in the courtroom.

[1] Cennino Cennini (*Il Libro dell'arte*, inizio del xv secolo, a cura di Franco Brunello, Neri Pozza, Vicenza 1972) enumera il disegno a stilo (cap. VIII, pp. 9-10), a penna (cap. XIII, pp. 14-15), a carboncino (cap. XXX, pp. 29-32), a grafite (cap. XXXIV, p. 34), ad inchiostro acquerellato (capp. XXXI e XXXII, pp. 30-32), il lucido (capp. XXIII-XXVI, pp. 24-26). Venendo poi a parlare del vero e proprio disegno preparatorio, per la pittura su muro parla di spartizione degli spazi con corda battuta e seste, di disegno a mano libera a carbone, di acquerellatura a ocra del segno e delle ombre, di disegno a sinopia (cap. LXVII, pp. 73-75). Sul disegno preparatorio per dipinti su tavola il Cennini indica l'uso di carboncino, poi raffermato a inchiostro, di ombreggiature ad acquerello (cap. CXXII, pp. 126-127), di incisione per separare tra loro i campi da dorare e quelli da dipingere (cap. CXXIII, p. 128). Ci sono anche alcuni brevi cenni alla tecnica dello spolvero, ma riferiti solo a motivi decorativi (cap. CXLI, pp. 143-144; cfr. anche capp. IV, CV, CXLII).

[2] J. SHEARMAN, *A note on the early history of cartoons*, "Master Drawings", XXX, 1992, pp. 5-8.

[3] GIOVANNI BATTISTA ARMENINI, *De' veri precetti della pittura* (1586), libro III, a cura di Marina Gorreri, Einaudi, Torino 1988, p. 99.

[4] MICHELANGELO BUONARROTI, *Il carteggio di Michelangelo*, a cura di Paola Barocchi-Renzo Ristori, ed. postuma di Giovanni Poggi, Sansoni, Firenze 1965-1983, III, pp. 380-381.

[5] LISA VENTURINI, *Modelli fortunati e produzione di serie*, in *Maestri e botteghe. Pittura a Firenze alla fine del Quattrocento*, catalogo della mostra (Firenze), a cura di Mina Gregori-Antonio Paolucci-Cristina Acidini Luchinat, Silvana editrice, Milano 1992, pp. 147-167.

[6] Bibliografia in CARMEN C. BAMBACH, *Drawing and Painting in the Italian Renaissance Workshop*, Cambridge University Press, Cambridge-New York 1999, nota 9, pp. 373-374.

[7] Bibliografia in BAMBACH 1999, nota 10, p. 374.

[8] BAMBACH 1999, pp. 283-295.

[1] Cennino Cennini (*Il Libro dell'arte*, ed. Franco Brunello, Neri Pozza, Vicenza 1972) lists drawing with a stylus (chapt. VIII, pp. 9-10), with a pen (chapt. XIII, pp. 14-15), with charcoal (chapt. XXX, pp. 29-32), with graphite (chapt. XXXIV, p. 34), with ink washes (chapts. XXXI and XXXII, pp. 30-32), with the use of tracing paper (chapts. XXIII-XXVI, pp. 24-26). He then speaks about the preparatory drawing, for wall painting he discusses the partitioning of the space with snapped plumb lines, drawn free-hand with charcoal, ochre wash for the contours and shadows, sinopia drawing (chapt. LXVII, pp. 73-75). For the preparatory drawing for paintings on wood panel, Cennini indicates the use of charcoal, reinforced with ink, and shaded with washes (chapt. CXXII, pp. 126-127), and the use of incising to separate the areas to be gilded from those to be painted (chapt. CXXIII, p. 128). There is also the brief mention of the pouncing technique, but only in relation to decorative motifs (chapt. CXLI, pp. 143-144; see also chapts. IV, CV, CXLI).

[2] J. SHEARMAN, *A note on the early history of cartoons*, 'Master Drawings', XXX, 1992, pp. 5-8.

[3] GIOVANNI BATTISTA ARMENINI, *De' veri precetti della pittura* (1586), bk. III, ed. Marina Gorreri, Einaudi, Torino 1988, p. 99.

[4] MICHELANGELO BUONARROTI, *Il carteggio di Michelangelo*, ed. Paola Barocchi-Renzo Ristori, ed. posth. Giovanni Poggi, Sansoni, Firenze 1965-1983, III, pp. 380-381.

[5] LISA VENTURINI, *Modelli fortunati e produzione di serie*, in *Maestri e botteghe. Pittura a Firenze alla fine del Quattrocento*, exh. cat. (Firenze) ed. Mina Gregori-Antonio Paolucci-Cristina Acidini Luchinat, Silvana, Cinisello Balsamo 1992, pp. 147-167.

[6] Bibliography in CARMEN C. BAMBACH, *Drawing and Painting in the Italian Renaissance Workshop*, Cambridge University Press, Cambridge-New York 1999, note 9, pp. 373-374.

[7] Bibliography in BAMBACH 1999, note 10, p. 374.

[8] BAMBACH 1999, pp. 283-295.

Venere e Cupido

Firenze, Galleria dell'Accademia
cm 128,5 x 193
(Cat. 23, Tavv. II/2 e III/1-3)

Supporto composto di 3 assi in orizzontale;
l'asse in basso è molto piccola (cm 5-8 di altez-
za) rispetto alle dimensioni delle altre due (55 cm
la seconda; 65-68 la terza). Spessore 3,5 cm
(medio). Le due assi superiori sono incollate tra
loro e collegate da 3 ranghette con perni lignei.
L'asse in basso è invece incollata e inchiodata
con 6 chiodi. La struttura presenta un sistema
originale di traversatura, costituito da 2 traverse
verticali entrambe rastremate verso il basso.
Assenza di tela negli strati preparatori.
Il disegno è stato tracciato utilizzando sia incisioni
che carbone secco poi ripassato a pennello. Le
incisioni riguardano solo i contorni delle figure di
Venere e Amore e non sono comunque rilevabili
sul completo dell'estensione dei corpi. La ripas-
satura a pennello riguarda anche questa soltanto
i corpi delle figure principali.
La differenza di spessore del tratto a carbone
secco tra le figure e la zona degli elementi alle-
gorici sulla sinistra trova una spiegazione tecnica
nel fatto che quando si operava una ripassatura a

pennello, parte del tratto a carbone veniva can-
cellato. Il tratto a carbone secco (dove non ripas-
sato a pennello e quindi alleggerito) ha le carat-
teristiche di un ricalco, per la durezza e la rigidità
del *ductus*.
La riflettografia IR non rivela tracce di disegno
nella zona del paesaggio.
Nelle linee generali l'*underdrawing* dà conto di
una sovrapponibilità completa delle varie parti
della composizione rispetto alle altre repliche
esaminate.

Venus and Cupid

Firenze, Galleria dell'Accademia
128.5 x 193 cm
(Cat. 23, Pls. II/2 and III/1-3)

The wood support is made of three horizontal
planks; the lowest plank is very small (5-8 cm
high) with respect to the other two (55 cm
middle and 65-68 cm the top plank). The
width of the wood planks is 3.5 cm (average).
The two top-most planks are glued together
and internally supported by three wooden

plates pegged across the joins. Instead, the
lowest plank is glued and nailed to the other
with six nails. The structure retains its original
batten system, and is made of two vertical bat-
tens tapered toward the bottom.
There is no cloth used in the preparatory layers.
The drawing was made with both incised lines
and dry charcoal, passed over with a brush.
The incised areas are only found around the fig-
ures of Venus and Cupid, and are not found over
the entire body area. The reinforcement of the
drawing with a brush wash is limited to the bod-
ies of the two main figures. The difference of the
thickness of the dry charcoal line found in the
figures and that in the allegorical elements on
the left are explained technically in that when
the line was reinforced with the brush wash,
part of the charcoal was erased. The charcoal
line where the brush did not pass over – and
therefore was not partially erased – retains the
characteristic line of a transferred tracing as
seen in the rigid, hard line of the *ductus*.
The IR reflectography does not show any trace
of drawing in the landscape area.
In terms of the various parts of the composi-
tion, the general lines of the underdrawing can
be completely overlaid with the other replicas
examined.

7. (*pagina accanto*) Intero IR del dipinto di Firenze.
 (*opposite*) Infrared reflectogram of the Florence painting.

8. (*in alto*) Radiografia X; (*in basso*) IR, particolare.
 (*above*) X-ray; (*below*) IR, detail.

Venere e Cupido

Firenze, Gallerie Fiorentine
(in deposito a Pisa, Scuola Normale Superiore)
cm 134 x 194,2
(Cat. 31, Tav. XIV/2)

Supporto composto di 5 assi in orizzontale; l'asse in basso è molto piccola (cm 5,5 di altezza) rispetto alle dimensioni delle altre due (28,1 cm la seconda; 32,2 la terza; 54 la quarta; 14,2 la quinta). Spessore medio 3,2. L'asse in basso è incollata e inchiodata con 4 chiodi alla superiore. Le altre assi sono incollate tra loro senza altri elementi di collegamento.

La struttura presenta un sistema originale di traversatura, costituito da 2 traverse verticali, una rastremata verso il basso e una verso l'alto. Assenza di tela negli strati preparatori. Anche in questo caso si riscontrano alcune incisioni verosimilmente riferibili al trasporto del disegno preparatorio. L'*underdrawing* rivela solo l'uso di un tratto sottile di punta secca, senza alcuna ripassatura a pennello. Il disegno è molto dettagliato, sia nei contorni che nei particolari interni, quali per esempio la minuzia delle notazioni anatomiche delle figure. L'impossibilità di leggere il disegno nella zona del paesaggio è dovuta alla non trasparenza all'infrarosso dei pigmenti utilizzati e quindi è non è possibile dire se in realtà un disegno ci sia o no.

Venus and Cupid
Firenze, Gallerie Fiorentine
(in deposit to Pisa, Scuola Normale
Superiore)
134 x 194.2 cm
(Cat. 31, Pl. XIV/2)

The wood support is made of five planks placed horizontally; the lowest is very small (5.5 cm high) with respect to the dimensions of the other four (28.1 cm the second; 32.2 the third; 54 the fourth; 14.5 the fifth). The average width of the planks is 3.2 cm. The lowest plank is glued and nailed to the one above it with four nails. The other planks are glued together without other joining elements.

The structure has a unique batten system, made up of two vertical battens, one tapered toward the bottom, the other tapered toward the top. There is no cloth used in the preparatory layers. Again, in this case there are some incised lines that can most likely be identified with the transfer of the preparatory drawing. The underdrawing reveals only a thin, dry-point line that is not gone over with a brush.

The drawing is very detailed in both the outlines as well as the internal details, as can be seen for example, in the minute anatomical passages of the figures. Drawing in the landscape areas is impossible to verify due to the non-transparency in the infrared bands of the pigments used in that area, therefore making it difficult to say whether there is or is not an underlying drawing.

9. (*pagina accanto*)
Radiografia del dipinto
delle Gallerie Fiorentine,
in deposito a Pisa, Scuola
Normale Superiore.
(*opposite*)
X-ray of the Gallerie
Fiorentine painting,
in deposit to Pisa, Scuola
Normale Superiore.

10. (*in questa pagina*)
Particolari IR del dipinto
delle Gallerie Fiorentine,
in deposito a Pisa, Scuola
Normale Superiore.
(*in this page*)
Details of the Gallerie
Fiorentine painting,
in deposit to Pisa, Scuola
Normale Superiore,
in infrared reflectography.

Venere e Cupido

Roma, Galleria Colonna

cm 134,5 x 193

(Tav. X/1)

Supporto composto di quattro assi in orizzontale. L'asse inferiore misura cm 30-29,5; la seconda 32-29; la terza 31-33; la quarta 41-42. Le assi sono incollate tra loro senza altri elementi di collegamento.

La struttura presenta un sistema originale di traversatura, costituito da due traverse verticali, una rastremata verso il basso e una verso l'alto. Presenza di strisce di tela negli strati preparatori in corrispondenza delle giunzioni delle tavole e sui nodi del legno.

La riflettografia a IR rivela un continuo utilizzo di punta secca per il disegno, senza ripassature a pennello. Il disegno è realizzato con tratto molto sottile e fluido, quasi da disegno a mano libera.

Il dettaglio è molto accurato per quanto riguarda i contorni esterni delle figure, minore nei particolari interni.

Si rileva disegno anche nella zona del paesaggio, grazie alla trasparenza dei pigmenti utilizzati alla radiazione infrarossa.

Venus and Cupid

Roma, Galleria Colonna

134.5 x 193 cm

(Pl. X/1)

The wood support is made up of four horizontal planks. The lowest plank is 30-29.5 cm; 32-29 cm the second; 31-33 cm the third; 41-42 cm the fourth. The planks are glued together without any additional elements. The structure retains its original batten system, and is made of two vertical battens tapered toward the bottom.

There is the presence of cloth strips in the preparatory layers corresponding to the joins in the individual planks and covering the knots on the wood surface.

The IR reflectography reveals the use of drypoint for the drawing, without going over the lines with a brush.

The line of the drawing is very thin and fluid, almost done in free-hand.

The detail is very carefully executed in the outer contours of the figures, and there is less attention to the internal details. In the landscape area, the drawing can be seen, as a result of the transparency to infrared radiation of the pigments in that area.

11. (*pagina accanto*) Radiografia del dipinto di Roma.
 (*opposite*) X-ray of the Rome painting.

12. (*in alto*) Particolare IR del dipinto di Roma.
 (*above*) Detail of the Rome painting in infrared reflectography.

Venere e Cupido
Napoli, Museo Nazionale di Capodimonte
cm 135,9 (media) x 192,7 (media)
(Cat. 28, Tav. V/2)

Supporto composto di 3 assi in orizzontale
(cm 41,8-40,5 quella in basso; 46 cm la secon-
da; 47.6-46,5 la terza). Spessore 3,5-3,7.
Le assi sono collegate tra loro da ranghette e
incollate. La struttura presenta un sistema origi-
nale di traversature, costituito da due traverse
verticali, una rastremata verso il basso e una
verso l'alto.
Assenza di tela negli strati preparatori. La rifletto-
grafia IR rivela un tipo di disegno e un *ductus*
estremamente analogo a quello della replica della
Galleria Colonna di Roma, tanto da renderli prati-
camente sovrapponibili, non solo dimensional-
mente ma anche nei particolari singoli.

Venus and Cupid
Napoli, Museo Nazionale di Capodimonte
135.9 (average) x 192.7 (average) cm
(Cat. 28, Tav. V/2)

The wood support is made up of three horizon-
tal planks (41.8-40.5 cm the lowest; 46 cm the
second; 47.6-46.5 cm the third). The width of
the planks is 3.5-3.7 cm. The planks are glued
together and internationally supported by
wooden plates.
The structure retains its original batten system,
and is made of two vertical battens tapered
toward the bottom. There is no cloth used in the
preparatory layers.
The IR reflectography reveals a type of drawing
and a *ductus* that is extremely analogous to the
Galleria Colonna, Rome, replica.
This correspondence is so close, in fact, that
the two can practically be overlain exactly, not
only in the dimensions, but also in the single
details.

13. (*pagina accanto*)
Radiografia X del dipinto di Napoli.
(*opposite*)
X-ray of the Napoli painting.

14. (*in questa pagina*)
Particolari IR del dipinto di Napoli.
(*in this page*)
Details of the Naples painting
in infrared reflectography.

15. Intero IR del cartone di Napoli.
 Infrared reflectogram of the Napoli cartoon.

Venere e Cupido
Napoli, Museo Nazionale di Capodimonte
Disegno
cm 127,7 x 182,3
(Il cartone è comunque marginato).
(Cat. 27)

Supporto composto di 19 fogli. Il disegno non rivela tracce di un utilizzo né per incisione né per spolvero. Naturalmente sarebbe necessario completare un giudizio del genere potendolo osservare dal retro, ma, come è noto, l'opera è controfondata. La presentazione attuale è quella tipica da *ben finito cartone*, con dettaglio di ombreggiature e regolarizzazione dei bordi, fatto che di per sé non esclude la possibilità di un utilizzo dei singoli pezzi, poi ripuliti e ricomposti ai fini della conservazione. Le singole parti del disegno sono sovrapponibili all'*underdrawing* delle repliche dipinte, ma operando una traslazione nello spazio dato che la presente ricomposizione dei singoli fogli copre un'area, nel suo insieme, più piccola dei dipinti e quindi consente meno spazio all'alloggiamento delle figure.

Venus and Cupid
Napoli, Museo Nazionale di Capodimonte
Drawing
127.7 x 183.3 cm
(The cartoon has been trimmed at the edges).
(Cat. 27)

The drawing shows no signs of having been used either for incising or pouncing. Naturally, a complete examination of the back of the drawing would be necessary in order to corroborate this statement however, as is known, the work has a backing. The current presentation of the work is typical of a well-finished cartoon complete with shading and trimmed up, aligned edges. This fact does not however preclude the possibility of having used the single pieces, cleaned them up and put them together in order to better conserve the whole. The single parts of the drawing can not be overlaid with the painted replicas. The actual recomposition of the single sheets covers an area that is smaller than the paintings in the comparison and therefore there is less space for the placing of the figures.

Tav. I/1
PIERO DI COSIMO, *Venere e Marte / Venus and Mars*, 1490 ca.
Berlin, Staatliche Museen Gemäldegalerie.

Tav. I/2
BOTTICELLI, *Venere e Marte / Venus and Mars*, 1483 ca.
London, National Gallery.

Tav. II/1 (Cat. 22)
attr. a BRONZINO,
*Ritratto di Dante / Portrait
of Dante*, 1532-1533.
Firenze, Collezione privata.

Tav. II/2 (Cat. 23)
MICHELANGELO-PONTORMO, *Venere e Cupido / Venus and Cupid*, 1533 ca. Firenze, Galleria dell'Accademia.

Tav. III/1-3 (Cat. 23)
Michelangelo-Pontormo
Venere e Cupido / Venus and Cupid
(particolari / details), 1533 ca.
Firenze, Galleria dell'Accademia.

Tav. IV/1 (Cat. 24)
GIORGIO VASARI
Sei poeti toscani
Six Tuscan Poets
1544.
Minneapolis,
Institute of Arts.

Tav. IV/2
CERCHIA DEL
BRONZINO
Ritratto di Dante
Portrait of Dante
post 1533.
Washington, National
Gallery of Art.

Tav. V/1
GIORGIO VASARI, da MICHELANGELO, *Venere e Cupido / Venus and Cupid*, 1541-1544 (?)
London, Kensington Palace, The Royal Collection.

Tav. V/2 (Cat. 28)
CERCHIA DI GIORGIO VASARI (HENDRIK VAN DEN BROEK), da MICHELANGELO, *Venere e Cupido / Venus and Cupid*
seconda metà del XVI secolo. Napoli, Museo Nazionale di Capodimonte.

Tav. VI/1a-b (Cat. 7)
MICHELANGELO, *Nudo femminile (La Terra?)* / *Female Nude (Earth?)*, 1530-1535 ca.
Firenze, Casa Buonarroti.

Tav. VII/1 (Cat. 8)

attr. a **MICHELANGELO**
*Figura femminile
stante (Venere?)*
*Standing female
nude (Venus?)*
1527 (?) ca.
Firenze, Galleria
degli Uffizi, Gabinetto
Disegni e Stampe.

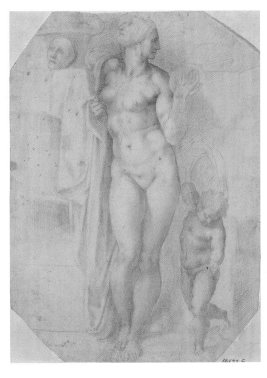

Tav. VII/2 (Cat. 9)

FRANCESCO SALVIATI
Venere e Cupido (?)
Venus and Cupid (?)
1539 (?)
Firenze, Galleria
degli Uffizi, Gabinetto
Disegni e Stampe.

Tav. VII/3 (Cat. 14)

IL **TRIBOLO**,
DA **MICHELANGELO**
Aurora / Dawn
1534-1537
Firenze, Museo
Nazionale
del Bargello.

Tav. VIII/1
MICHELANGELO-
PONTORMO
Noli me tangere
1531-1532.
Busto Arsizio (Varese),
Collezione privata.

Tav. VIII/2 (Cat. 16)
ARTISTA DEL NORD ITALIA (?), da MICHELANGELO, *Leda,* quarto-quinto decennio del XVI secolo. Venezia, Museo Correr.

**Tav. IX/1
(Cat. 12)**
MICHELE DI RIDOLFO
DEL GHIRLANDAIO,
da MICHELANGELO
*Testa ideale
(Zenobia?)*
***Ideal Head
(Zenobia?)***
1540 ca.
Firenze, Galleria
dell'Accademia.

Tav. IX/2
MICHELANGELO
*Testa ideale
(Zenobia?)*
***Ideal Head
(Zenobia?)***
1524 ca.
Firenze, Galleria
degli Uffizi,
Gabinetto
Disegni e Stampe.

Tav. IX/3 (Cat. 17)
attr. a ROSSO FIORENTINO, da MICHELANGELO, *Leda*, 1533-1538 ca., London, Royal Academy of Arts.

Tav. X/1
MICHELE DI RIDOLFO DEL GHIRLANDAIO, da MICHELANGELO
Venere e Cupido / Venus and Cupid, 1565 ca., Roma, Galleria Colonna.

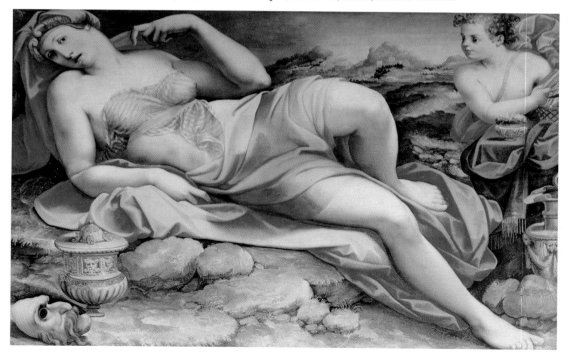

Tav. X/2
MICHELE DI RIDOLFO DEL GHIRLANDAIO, *Aurora / Dawn*, 1565 ca., Roma, Galleria Colonna.

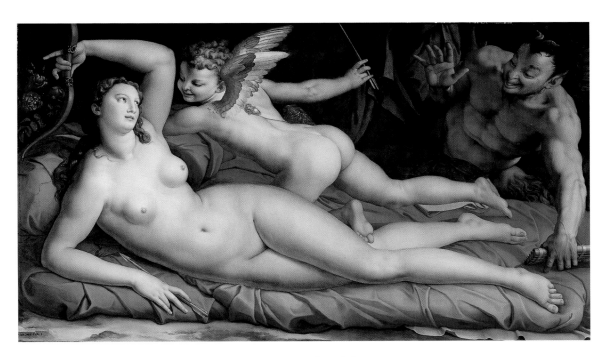

Tav. XI/1 (Cat. 34)
AGNOLO BRONZINO, *Venere, Cupido e Satiro / Venus, Cupid and a Satyr*, 1553-1554 ca.
Roma, Galleria Colonna.

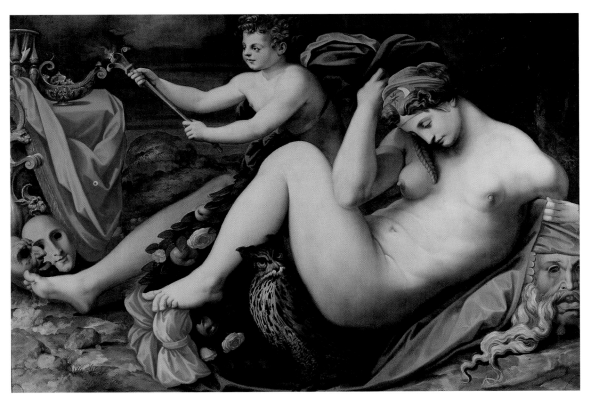

Tav. XI/2 (Cat. 13)
MICHELE DI RIDOLFO DEL GHIRLANDAIO, *Notte / Night*, 1565 ca., Roma, Galleria Colonna.

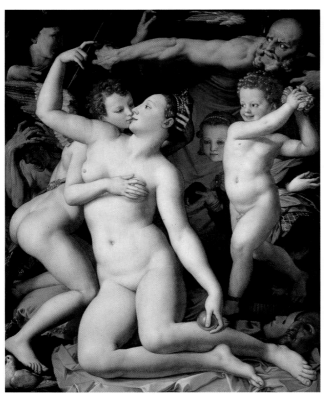

Tav. XII/1
AGNOLO BRONZINO
Allegoria di Venere
Allegory of Venus
1544-1545 ca.
London,
National Gallery.

Tav. XII/2
AGNOLO BRONZINO
Venere, Cupido
e Gelosia
Venus, Cupid
and Jealousy
1550 ca.
Budapest,
Szépmüvészeti
Múzeum.

Tav. XIII (Cat. 36)
AGNOLO BRONZINO-JAN ROST, *Primavera-Venere / Primavera-Venus*, 1545-1546.
Firenze, Palazzo Pitti, Deposito Arazzi.

Tav. XIV/1 (Cat. 42)
ALESSANDRO ALLORI (?)
Il Sogno
The Dream
1570-1575 ca.
New York,
Collezione privata.

Tav. XIV/2 (Cat. 31)
CERCHIA DI GIORGIO
VASARI,
da MICHELANGELO
Venere e Cupido
Venus and Cupid
seconda metà XVI secolo.
Firenze, Gallerie Fiorentine
(in deposito a Pisa,
Scuola Normale
Superiore).

Tav. XV/1 (Cat. 41)
ALESSANDRO ALLORI
Il Sogno
The Dream
1570-1575 ca.
Firenze, Galleria
degli Uffizi.

Tav. XV/2 (Cat. 43)
ALESSANDRO ALLORI
Venere e Cupido
Venus and Cupid
1570 ca.
Firenze, Galleria
degli Uffizi.

Tav. XVI/1 (Cat. 11)
ANDREA DEL BRESCIANINO, *Venere, Cupido e un putto / Venus, Cupid and a putto*, 1525-1527 ca.
London, Collezione privata.

Tav. XVI/2 (Cat. 32)
IL POPPI, *Danae*, 1570 ca., Firenze, Collezione privata.

CATALOGO
CATALOGUE

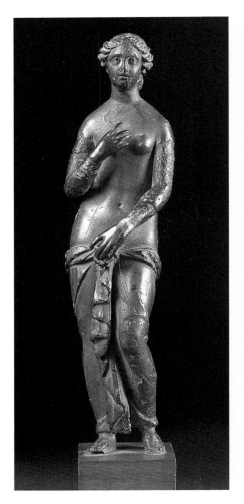
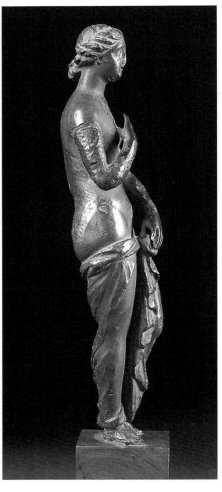

zo e in terracotta soprattutto nelle produzioni di età romana d'oltralpe dove le contraddizioni formali si mostreranno ancora più evidenti: si vedano gli esempi di Trier (MENZEL 1966, pp. 37-39, tav. 38, n. 80) da Augst, Svizzera (SCHWARZ 1963, p. 74, tavv. 8-9) e una rozza statuetta in terracotta da Pompei (LEVI 1926, p. 189, n. 829).

Il bronzo di Firenze è sicuramente appartenuto alle Collezioni Medicee; è presente infatti negli Inventari del 1704, n. 2925 (Archivio Galleria degli Uffizi, Man. 82), ma non compare tra gli oggetti collocati nella Tribuna.

Nell'Inventario del 1676 al n. 34 dei bronzi, è menzionata, senza le misure, «Venere seminuda con panno tra le cosce», che forse potrebbe, con le dovute cautele, essere identificato con il nostro bronzo (*Inventario di medaglie, cammei, intagli, metalli, statute, teste e iscrizioni che si trovano nella Galleria 1676:* Archivio Galleria degli Uffizi, Man. 78). Proprio in quegli anni confluiscono nelle raccolte di antichità, varie collezioni, non ultima quella del cardinale Leopoldo de' Medici: nell'Appendice alla *Guardaroba 826* si menzionano, per esempio, diverse Veneri per dimensioni vicine alla nostra e *«una figura di una femmina mezza nuda di bronzo alta 6 soldi»* (FILIERI 1991, p. 118). Nel 1777 Luigi Lanzi ne *«Il Gabinetto dei Bronzi Antichi eretto nella Real Galleria di Firenze per ordine di S. A. R. l'Arciduca d'Austria e G. D. di Toscana Pietro Leopoldo. Breve descrizione e spiegazione delle antichità che vi si contengono»*, lo menziona ancora nella *Guardaroba Medicea* (Venere, Ninfe, Amorini, Marte, Eroi Guerrieri. Archivio Galleria degli Uffizi Man. 105, n. 21, foglio 57 dell'Armadio 2), da cui poi confluisce, alla fine del 1800, nelle Collezioni del Museo Archeologico di Firenze.

Cat. 1

Venere

Da un originale di età ellenistica metà del II secolo a.C.
Bronzo fuso e lamina d'argento
Altezza cm 16,8; base di legno cm 2,8
Firenze, Museo Archeologico Nazionale, Inv. 2561

Questo bronzo fa parte della ricca serie di Veneri, tanto care al collezionismo mediceo fin da Cosimo I: un pezzo simile compare anche sullo sfondo del *Ritratto d'uomo* del Bronzino (1550-1555 ca., Ottawa, National Gallery of Canada; fig. 1-a). Derivato dal tipo della *Pudica Capitolina-Dresda, Medici,* e quindi diversa dalla *Venere* discendente, pur nelle diversità, dalla Cnidia creata da Prassitele (Cat. 2, 3, 4, 5), il nostro bronzo appartiene a una variante con panneggio creata in età ellenistica a Rodi che trova molte repliche in età romana soprattutto in marmo.

Si presenta integro, con le braccia e le mani riattaccate da un restauro; si nota un foro di trapano nella parte inferiore dell'*himation*-mantello. Lo schema dell'acconciatura e un certo allungamen-

to della figura farebbero pensare, per il nostro esemplare, con molta cautela, a una datazione in età antonina. L'originale del tipo va sicuramente posto dopo la seconda metà del II secolo a. C., anche se per la datazione ci sono ancora divergenze tra gli studiosi (la questione è riassunta in *LIMC* 1984, p. 82). Se nella grande plastica in marmo il tipo trova un ripetuto riscontro di copie, anche grazie all'ampio uso decorativo di queste statue, poche sono le repliche in bronzo di piccole dimensioni: oltre il nostro, esemplari da Tortosa in Siria già nella Collezione De Clercq (DE RIDDER 1904-1905, p. 39-40, nn. 34-36, tav. V) e al British Museum di Londra (GORI 1738, vol. I, tav. 94; BERNOULLI 1873, p. 261, n. 18).

La grande varietà di Afroditi create in età ellenistica e la capacità dei copisti di età romana di elaborare "variazioni sul tema", dovettero contribuire, molto presto, a molte alterazioni e snaturamenti al tipo della *Pudica* che in molti casi ripete le forme della *Afrodite Anadiomene* semipanneggiata (DENTI 1985, pp. 140 sgg.), con atteggiamenti diversi delle braccia, protese in alto a strizzarsi i capelli piuttosto che celare le nudità.

Ed è proprio la fortuna del tipo che contribuirà a una vasta produzione di piccola plastica in bron-

Venus

After an original from the Hellenistic age
mid II century B. C.
Cast bronze and silver lamina
Ht. 16.8 cm; wooden base 2.8 cm
Firenze, Museo Archeologico Nazionale, Inv. 2561

This bronze statue is one of a rich series of *Venuses*, very dear to the collectors of the Medici family from the time of Cosimo I: a similar piece appears in the background of the *Portrait of a Man* by Bronzino (Ottawa, National Gallery of Canada, fig. 1-a).

Deriving from the *Dresden-Capitoline type* of the 'modest Venus' and thus a descendant, with changes, from the *Cnidian Venus* studied by Michelangelo (Cats. 2, 3, 4, 5), our bronze statuette belongs to a draped variation dating from the Hellenistic period in Rhodes, copied extensively in Roman times, especially in marble. The statue is intact, the arms and the hands reattached during a restoration; a hole has been

1-a. Bronzino, *Ritratto di uomo / Portrait of a Man*.
Ottawa, National Gallery of Canada.

contaminations of the 'modest Venus' type. In many cases, this was a replica of the forms of the half-draped Aphrodite Anadynomene (Denti 1985, pp. 140 ff.), distinguished by a different positioning of the arms, stretched up in the act of ringing out her hair rather than hiding her nudity. And it is exactly the popularity of the type that will contribute to the vast production of bronze and terracotta statuettes particularly during the Roman era beyond the Alps where formal anomalies become ever more evident: the replica of Trier (Menzel 1966, pp. 37-39, pl. 38 no., 80) from Augst, Switzerland (Schwarz 1963, p. 74, pl. 8-9) and a coarse terracotta statue from Pompei suffice as examples (Levi 1926, p. 189, no. 829). The bronze statuette from Florence surely belonged to the Medici collections; it is in fact mentioned in the inventories of 1704 n. 2925 (Archives of the Galleria degli Uffizi, Man. 82), but does not appear among the objects contained in the Tribune. In the 1676 inventory of the bronzes, no. 34 is listed as a "semi-nude Venus with a drapery between her thighs" without any indication of its size; this may possibly be our bronze statuette, an assumption made with due caution (*Inventario di medaglie, cammei, intagli, metalli, statute, teste e iscrizioni che si trovano nella Galleria 1676*: Archives of the Galleria degli Uffizi, Man. 78). At precisely that same moment, various collections were incorporated into the larger group of antiquities, not the least of which that belonging to Cardinal Leopoldo de' Medici: in the appendix of the *Guardaroba 826* various Venuses near in size to our exemplar are listed as well as a "figure of a woman half naked in bronze 6 'soldi' high" (Filieri 1991, p. 118).

In 1777 Luigi Lanzi in "*Il Gabinetto dei Bronzi Antichi eretto nella Real Galleria di Firenze per ordine di S. A. R. l'Arciduca d'Austria e G. D. di Toscana Pietro Leopoldo. Breve descrizione e spiegazionte delle antichità che vi si contengono*" mentions the statue as still within the *Medici Guardaroba* (*Venere, Ninfe, Amorini, Marte, Eroi Guerrieri* – Archives of the Galleria degli Uffizi Man. 105, no. 21, sheet 57 in Armoir 2), from where it moves to the collections of the Museo Archeologico of Florence at the end of the 1800s.

Mario Cygielman

drilled in the lower part of the *himation*-mantle. The type of coiffeur and a certain elongation of the figure encourage a cautious chronological placement of this exemplar within the age of the Antonines.

Despite the many disagreements among scholars (the various opinions are summarized in *LIMC* 1984, p. 82), the original prototype surely can be dated to after the second half of the II century B.C. Although the large marble sculptural version was widely diffused, also due to the popularity of

these statues as decorative objects, few small size replicas in bronze exist: besides this exemplar, one from Tortosa in Syria once part of the De Clerq Collection (De Ridder 1904-1905, pp. 39-40, nos. 34-36, pl. V) and another in the British Museum in London (Gori 1738, I, pl. 94 and Bernoulli 1873, p. 261, n. 18). Very early on, the large variety of Aphrodites created in the Hellenistic age and the capacity of the Roman copyists to elaborate "variations on the theme" must have contributed to many alterations and

Cat. 2, 3, 4, 5

MICHELANGELO BUONARROTI
(Caprese 1475-Roma 1564)

*Quattro studi di antica statua
frammentaria di Venere*

1520 ca.
2. Matita nera
mm 200 x 147
Firenze, Casa Buonarroti, Inv. 41F
3. Matita nera
mm 130 x 80 (in foglio di mm 147 x 100)
Firenze, Casa Buonarroti, Inv. 16F
4. Matita nera
mm 256 x 180
London, British Museum, 1859-6-25-570
5. Matita nera
mm 202 x 110
London, British Museum, 1859-6-25-571

I quattro fogli presi in considerazione presentano studi in matita nera di un antico torso frammentario di Venere visto da angolazioni differenti. Come per primo osservò Wilde (1953), in origine facevano probabilmente tutti e quattro parte dello stesso foglio. I fogli Wilde 43 e 44 del British Museum, entrambi acquistati nel 1859 dalla famiglia Buonarroti mostrano rispettivamente il torso dal davanti e dal retro. Il foglio 41F di Casa Buonarroti lo mostra sotto il profilo destro e sotto il profilo sinistro, mentre il piccolo disegno (Inv. 16F), sempre di Casa Buonarroti, ne dà una veduta da tergo di tre quarti, leggermente scorciata, con il punto di vista all'altezza delle natiche. L'ultimo, che è stato scontornato, era una volta unito a Wilde 43, al di sotto e ad angolo retto con esso. Questi due disegni, e forse gli altri, furono probabilmente separati l'uno dall'altro già da Michelangelo, che tagliava spesso i fogli con i disegni, ma non può escludersi che la cosa sia invece accaduta al

momento della vendita nel 1859. In questi disegni Michelangelo torna a una sua vecchia usanza. Aveva studiato un torso simile, ma non identico, intorno al 1505, facendone una veduta da tergo e un profilo sinistro nel suo grande disegno a penna al Musée Condé di Chantilly (Inv. 29r) e altre da almeno tre punti di vista in un altro disegno, perduto, eseguito circa nello stesso periodo, noto per le copie e le derivazioni dell'Ashmolean Museum di Oxford (PARKER 1956, II, p. 412) e della Casa Buonarroti (Inv. 28F).
Come tutti gli studiosi hanno notato, il prototipo è quello della *Venere di Cnido* di Prassitele, ma la gamba sinistra sollevata e in avanti presente in tutti questi disegni suggerisce che essi siano basati su una variante di quella figura, in qualche modo più in movimento rispetto al prototipo. Wilde notava che un torso simile è rappresentato nel *Ritratto d'uomo* del Bronzino custodito nella National Gallery of Canada, a Ottawa (Cat. 1, fig. 1-a), ma non si tratta chiaramente della scultura copiata da Michelangelo, dato che conserva la maggior parte delle braccia ed è parzialmente drappeggiata. Tolnay (1976) suggerì che i disegni di Michelangelo fossero stati fatti non su un originale in marmo, ma su una copia in gesso plausibilmente di proprietà dell'artista stesso.
Poco si sa di ciò che si trovava all'interno della bottega di Michelangelo, ma è più che verosimile che vi fossero presenti calchi e copie in gesso di sculture antiche e contemporanee di suo interesse. Wilde dedusse che il torso era usato da Michelangelo per lo studio delle forme femminili e che questi disegni furono fatti nel periodo in cui stava lavorando al modello a grandezza naturale per l'*Aurora*. Più nello specifico, egli li metteva in relazione col modello di Michelangelo di nudo femminile della Casa Buonarroti (Cat. 7), probabilmente concepito per una delle figure allegoriche femminili in piedi poste alla sinistra di chi guarda in una delle tombe dei duchi nella Sacrestia Nuova.

Sembra plausibile, dopo un periodo in cui Michelangelo era stato occupato esclusivamente nell'esecuzione di statue maschili, che egli desiderasse rifare l'occhio alla forma femminile nella sua rappresentazione classica prima di cominciare a delineare le sue proprie figure, così come aveva schizzato antiche forme architettoniche attingendo al *Codice Coner* ora al Soane Museum di Londra mentre preparava la facciata di San Lorenzo.
Sebbene in questi disegni il tratto largo della matita metta in risalto la superficie modellata della figura e suggerisca un lavoro preparatorio per una scultura, Michelangelo sfruttò questo antico frammento per altre possibilità. I due disegni del British Museum sono concepiti più con una sensibilità di superficie, quello di Casa Buonarroti (Inv. 41F) più con senso della struttura volumetrica, con la veduta del profilo sinistro tracciata in una maniera che deliberatamente sovverte la forma ideale antica. Quest'ultima veduta è ripresa con variazioni minime sul *verso* di un frammento di foglio conservato presso il Département des Arts Graphiques al Musée du Louvre (Inv. 725). Il *recto* dello stesso frammento mostra un adattamento della *Venere* vista da dietro, leggermente allungata, e con le anche inclinate in direzione opposta rispetto al modello antico.
Sempre al Louvre (Inv. 710) esiste un altro frammento, più ampio, dello stesso foglio ricostruito per primo da Tolnay (1967, pp. 193-200). Il *recto* di questa porzione più grande contiene il profilo sinistro a figura intera di una donna nuda, anziana ed emaciata. Si pensa che, prima che il foglio fosse smembrato, questa figura fosse in posizione leggermente arretrata rispetto a quella di Venere di Inv. 725.
Non è chiaro il contesto di cui le due donne fanno parte, ma il fatto che l'anziana sorregga una viola da braccio potrebbe ipoteticamente suggerire quello della *Morte di Orfeo*. Che tale soggetto

fosse previsto per un rilievo in una prima versione della tomba del Magnifico è noto dalla copia di un disegno custodita agli Uffizi (Inv. 607E; v. JOANNIDES 1991). Sia o no corretta questa interpretazione, risulta ovvio che Michelangelo aveva in mente un contrasto tra senilità e giovinezza e sugli effetti della vecchiaia sul corpo femminile. Non è un caso perciò che il torso della donna anziana riecheggi il disegno del profilo sinistro di torso di Casa Buonarroti (Inv. 41F). Questo insieme di connessioni dimostra il passaggio di motivi tra differenti progetti e la maniera in cui, nell'idea di Michelangelo, la ricerca finalizzata a un progetto in un determinato materiale potesse risultare produttiva per un'opera in un altro. Inoltre sottolinea il suo particolare interesse in quel periodo per l'anatomia femminile, da adoperare in una varietà di contesti spesso intrecciati: allegorici, narrativi, erotici.

MICHELANGELO BUONARROTI
(Caprese 1475-Roma 1564)

Four Studies of a Fragmentary Antique Statue of Venus
c. 1520

2. Black chalk
200 x 147 mm
Firenze, Casa Buonarroti, Inv. 41F
3. Black chalk
130 x 80 mm (laid into a sheet 147 x 100 mm)
Firenze, Casa Buonarroti, Inv. 16F
4. Black chalk
256 x 180 mm (made up)
London, British Museum, 1859-6-25-570
5. Black chalk
202 x 110 mm
London, British Museum, 1859-6-25-571

The four sheets under consideration carry black chalk studies of a fragmentary antique torso of Venus seen from different angles.

As Wilde (1953) first observed, all four were in all probability once parts of the same sheet. Wilde 43 and 44 in the British Museum, both acquired from the Buonarroti family in 1859, show the torso from, respectively, the front and the rear. Casa Buonarroti (Inv. 41F) shows it in right and left profile and the smaller drawing also in Casa Buonarroti (Inv. 16F), places it in left three-quarter view from the rear, shallowly foreshortened from a viewpoint level with the buttocks. The last, which has been silhouetted, clearly once adjoined Wilde 43, beneath it and at right angles to it.

These two – and perhaps the others – were probably separated from one another early on by Michelangelo, who often cut up sheets of drawings, but it is not to be excluded that this occurred at the time of the 1859 sale.

In these drawings Michelangelo was recalling an old practice. He had studied a similar but not identical torso c. 1505 from the rear and in left profile in his large pen drawing in the Musée Condé, Chantilly (Inv. 29*r*) and from at least three viewpoints in another lost drawing made around the same time, known in copies or derivations in the Ashmolean Museum, Oxford (PARKER 1956, II, p. 412) and Casa Buonarroti (Inv. 28F).

The prototype, as all scholars have noted, is that of the Cnidian *Venus* of Praxiteles, but the raised and advanced left leg, seen in all these drawings, suggests that they were based on a variant of that figure somewhat more mobile than the prototype.

Wilde noted that a similar torso is represented in Bronzino's *Portrait of a Man* in the National Gallery of Canada, Ottawa (Cat. 1, fig. 1-a), but it is clearly not the sculpture copied by Michelangelo since it retains more of the arms and is partially draped. Tolnay (1976) suggested that Michelangelo's drawings may have been made not from a marble original, but from a plaster reduction, conceivably one owned by Michelangelo himself. Little is known about Michelangelo's studio equipment but it is more than likely that it contained plaster casts and reductions of the antique and modern sculptures that interested him.

Wilde argued that the torso was used by Michelangelo to study the female form and that these drawings were made at the time that he was working on the full-size clay model for the *Dawn*.

More specifically, he linked them with Michelangelo's clay model of a female nude in Casa Buonarroti (Cat. 7), probably intended for one of the female allegorical figures to stand in the tabernacle to the viewer's left of one of the Dukes in the New Sacristy tombs.

It does seem likely, after a period in which Michelangelo had been exclusively occupied in executing male statues, that he wished to re-fresh his eye for the female form as represented in antiquity before beginning to design his own figures, much as he had sketched antique architectural forms through the intermediary of the *Codex Coner* in the Soane Museum, London, while preparing the facade of San Lorenzo.

Although the broad handling of the chalk in these drawings emphasizes the surface modelling of the figure, and suggests preparation for sculpture, Michelangelo exploited this antique fragment for other possibilities.

The two drawings in the British Museum are concerned more with epidermis, Casa Buonarroti (Inv. 41F) with structure, with the view in left profile registered in a manner that deliberately undermines the idealism of the antique form. This last view is repeated with minimal variation on the *verso* of a fragmentary sheet in the Département des Arts Graphiques, Musée du Louvre (Inv. 725).

The *recto* of this same fragment shows an adaptation of the Venus, in rear view, somewhat elongated, and with her hips canted in the opposite direction to those in the antique. Another, larger fragment of the same sheet, which was first reconstructed by Tolnay (1967, pp. 193-200), is also in the Louvre (Inv. 710). The *recto* of this larger portion contains a full-length figure of an elderly and emaciated nude woman in left profile. Before the sheet was dismembered, she would have stood a little behind the 'Venus' figure on Inv. 725.

The context in which the two women took part is unclear, but that the old woman holds a *viol de braccia* might conjecturally suggest the *Death of Orpheus*; and that an Orpheus subject was planned as a relief on an early version of the Magnifici tomb is known from a copy drawing in the Uffizi (Inv. 607E; see JOANNIDES 1991). But whether or not this interpretation is correct, it is obvious that Michelangelo planned a contrast between youth and age, and the effects of age upon the female body. It is not by chance therefore that the torso of the old woman echoes the drawing of the torso's left profile on Casa Buonarroti (Inv. 41F).

This nexus of connections demonstrates the transfer of motifs among different projects and the way in which, in Michelangelo's mind, research for a project in one medium could be productive for work in another. It stresses also his particular interest in the nude female body in this period, to be used in a variety of – often intersecting – contexts: allegorical, narrative, erotic.

Paul Joannides

BIBLIOGRAFIA / BIBLIOGRAPHY
2. BAROCCHI 1962, n. 70; TOLNAY 1975-1980, n. 231.
3. BAROCCHI 1962, n. 70; TOLNAY 1975-1980, n. 234.
4. WILDE 1953, n. 43; TOLNAY 1975-1980, n. 232.
5. WILDE 1953, n. 44; TOLNAY 1975-1980, n. 233.

Cat. 6

attr. a MICHELANGELO BUONARROTI
(Caprese 1475-Roma 1564)

Figura femminile in piedi
1524-1525 ca. (?)
Matita rossa
mm 353 x 242
Firenze, Casa Buonarroti, Inv. 53F

La figura principale è modellata nel tratteggio ampio e leggero talvolta impiegato da Michelangelo nel corso degli anni Venti del Cinquecento, un tratto che sembra scorrere con andamento discontinuo sulla superficie della forma. Sebbene applicata con più delicatezza, questa tecnica è paragonabile a quella dei disegni a matita nera in Cat. 2, 3, 4, 5 e quella dei grandi fogli riempiti su ambo i lati, ora smembrati, conservati al Louvre (Inv. 710 e 725). Questo stile potrebbe essere stato appositamente attivato per evocare la superficie del corpo femminile.

Come esposto in Cat. 8, la morfologia del corpo qui mostrata, allungata, sinuosa e ondulata era stata sperimentata da Michelangelo già molti anni prima nei suoi disegni ora al Musée Condé di Chantilly (Inv. 29r). Era l'ideale per le figure allegoriche femminili erette, da collocare nelle strette nicchie poste a fianco delle figure sedute dei duchi nelle tombe della Sacrestia Nuova. Le figure per la Tomba di Giuliano de' Medici, duca di Nemours, come sappiamo dagli appunti di Michelangelo stesso (Casa Buonarroti, Inv. 10A *recto*), dovevano rappresentare il *Cielo* alla sinistra di chi guarda e la *Terra* sulla destra, sovrastanti le figure della *Notte* e del *Giorno,* rispettivamente. Come si vede nel modello eseguito nel 1521 da Michelangelo per la Tomba di Giuliano

(Paris, Louvre, Inv. 838), queste figure sono drappeggiate e atteggiate in una posa netta e semplice. Non sono munite di attributi. La Tomba di Lorenzo de' Medici, duca di Urbino, di faccia, avrebbe certamente contenuto figure improntate allo stesso stile. Michelangelo non ha lasciato tracce circa la loro identità, ma tra i vari suggerimenti avanzati, il più plausibile è che le figure rappresentassero *Acqua* e *Fuoco.* Anch'esse avrebbero dovuto, nell'idea iniziale, avere un aspetto corrispondente a quelle loro opposte.

Se il modello in terracotta di Casa Buonarroti (Cat. 7) è correttamente identificato come *Cielo / Aria,* o la corrispondente figura dell'*Acqua* sulla Tomba del duca Lorenzo, è allora chiaro che, mentre l'iconografia generale può non avere subìto cambiamenti, le forme della sua rappresentazione ne subirono, da vestite a nude, e da pose semplici ad altre sinuose. Questa terracotta è spesso messa in relazione con quelle che Michelangelo preparò nel 1533 per il Tribolo, ma sarebbe stata senza dubbio più accurata, ed è probabilmente databile intorno al 1525, a dimostrazione che Michelangelo previde con largo anticipo il cambiamento.

Suggerire che la presente figura, come era implicito in Wilde (1953), fosse disegnata in preparazione per uno degli *Elementi* è un'ipotesi accattivante. Ma, se il braccio sinistro alzato e il destro abbassato e le forme indecifrabili che esse sostengono e il copricapo a cono rovescio non escludono del tutto tale ruolo, sembrano tuttavia inadeguate per esso. Gli orientamenti dei progetti scultorei di Michelangelo, inoltre, in quel periodo andavano verso la semplificazione e l'eliminazione di attributi, non verso un loro aumento. Il disegno potrebbe essere in relazione con qualche progetto di cui non si hanno altre notizie.

Il *recto* contiene anche tre piccole composizioni. Eseguite in mero profilo, senza pretese, offrono tuttavia un saggio di grande abilità ed esperienza nel disegno. Esse ritraggono il *Letto di Policleto,* una fonte di ispirazione frequente per Michelangelo (e copiato anche da Antonio Mini), un "uomo che porta un tagliere" (WILDE 1953, Inv. 54v), forse per un *Banchetto di Erode* e un *Ercole e Anteo,* un gruppo che Michelangelo aveva in mente nel 1524-1525, oppure tratto da essi. Furono probabilmente tracciati come modelli schematici per Antonio Mini che, senza dubbio, fu responsabile della *Testa di Satiro* (fig. 6-a) sul *verso,* ripresa da un foglio di studi di teste conservato nello Staedelsches Kunstinstitut di Frankfurt (Inv. 392), un lavoro a quattro mani di Michelangelo e del suo allievo eseguito all'incirca nello stesso periodo.

Meller (1974) suggerì che il disegno principale sul *recto,* che egli attribuiva con qualche incertezza a Pierino da Vinci, fosse stato fatto in preparazione di una gettata in bronzo, nel qual caso le linee interne rappresenterebbero i perni e le prese d'aria. Ma, a parte il fatto che non c'è giustificazione per togliere l'attribuzione a Michelangelo, tali linee non sembrano sufficientemente sistematiche per tale scopo. A ogni buon conto,

non sembra verosimile che Michelangelo nella seconda decade del XVI secolo avesse in mente statue di nudi in bronzo, tanto per la Sacrestia Nuova che per altri progetti. Esse più probabilmente rappresentano i puntelli o l'armatura di sostegno di un modello in creta o cera. Ad affermare tale ipotesi c'è il fatto che una figura in tal modo sostenuta la si trova in un foglio riempito sui due lati nel Département des Arts Graphiques del Louvre (Inv. 694), un foglio che dev'essere una replica di uno perduto di Michelangelo. Nel presente disegno l'ovale che lo circoscrive potrebbe rappresentare la sagoma del blocco di marmo che avrebbe dovuto alla fine essere ordinato, o un contenitore destinato a proteggere un modello fragile, nel qual caso l'orizzontale dietro le spalle e le cosce della figura indicherebbe delle barre di sostegno. Anche se sarebbe conveniente collegare questo disegno con le tombe ducali, chi scrive trova difficile ignorare le forti somiglianze morfologiche, formali e della posa tra la figura principale del *recto* e Catt. 8 e 9. Esse suggeriscono almeno che un progetto scultoreo di Michelangelo fu all'origine del suo disegno omaggio. Ma prospettano anche la possibilità che Michelangelo progettasse, per qualche contesto secolare, una statua o statuetta in cui una figura di Venere doveva essere mostrata come emblema della Vanità. Sembra verosimile che questo disegno o quello Uffizi Inv. 251F (Cat. 8) fosse conosciuto da Andrea Brescianino: la sua *Venere* alla Galleria Borghese (Cat. 11, fig. 11-a) sembra inconcepibile senza avere conosciuto uno dei due.

6-a. Antonio Mini da/after Michelangelo,
Testa di Satiro / Head of a Satyr.
Firenze, Casa Buonarroti, Inv. 53F v.

attr. to MICHELANGELO BUONARROTI
(Caprese 1475-Roma 1564)

Standing Female Figure

c. 1524-1525 (?)
Red chalk
353 x 242 mm
Firenze, Casa Buonarroti, Inv. 53F

The main figure is modeled in the widely-spaced, lightly-touched hatchings sometimes employed by Michelangelo during the 1520s, ones that seem to skip across the surface of the form. Although more delicate in application, the handling is comparable to that of the black chalk drawings discussed in Cat. 2, 3, 4, 5 and those on the large double-sided sheet, now dismembered, in the Louvre (Inv. 710 and 725). This style may have specifically been geared to evoking the surfaces of the female body.

As noted in Cat. 8 the body-type shown here, elongated, sinuous and undulating had been tried by Michelangelo many years before in his drawing in the Musée Condé, Chantilly (Inv. 29*r*). It was ideal for the standing female allegories to be situated in the narrow tabernacles flanking the seated Dukes in the New Sacristy tombs. The figures for the Tomb of Giuliano de' Medici, Duke of Nemours, were, as we know from Michelangelo's own inscription on Casa Buonarroti Inv. 10A *recto*, to represent *Cielo* as heaven-sky-air to the viewer's left and *Terra* to the viewer's right, standing, respectively, above the reclining figures of *Notte* and *Giorno*. As shown in Michelangelo's *modello* of 1521 for Giuliano's Tomb (Paris, Louvre, Inv. 838), these figures are draped, and simple and clear in pose. They are not equipped with attributes. The facing Tomb of Lorenzo de' Medici, Duke of Urbino, would certainly have contained matching figures. Michelangelo left no record of their identities but among various suggestions advanced, the most likely is that

they were to represent *Aqua* and *Fuoco*. They too, presumably would initially have corresponded in type to those opposite. If the terracotta model in Casa Buonarroti (see Cat. 7) is rightly identified as *Cielo / Aria*, or the corresponding figure, probably *Acqua*, on the tomb of Duke Lorenzo, then it is clear that while the general iconography may not have changed, the forms of representation had, from clothed to nude and from simple to serpentine poses. This terra-cotta is often linked with those Michelangelo prepared for Tribolo in 1533, but they would surely have been more detailed, and it is probably of the mid-1520s, indicating that Michelangelo envisaged the change early.

It is tempting to suggest that the present figure, as Wilde implied (1953), was drawn in preparation for one of the Elements. However, while the raised left and lowered right arms, the indecipherable forms that they hold, and the inverted-cone headdress do not entirely rule out such a role, they seem inappropriate for it. Furthermore, Michelangelo's progression in his sculptural designs of this period was usually towards simplification and the elimination of attributes, not their increase. The drawing may rather be connected with some project of which we have no other knowledge. The *recto* also carries three small figure drawings. Made in pure outline, utterly unpretentious, they evince great draughtsmanly skill. They depict the *Bed of Polycleitus*, a frequent source for Michelangelo (and copied also by Antonio Mini), a man carrying a trencher (WILDE 1953, Inv. 54*v*), perhaps for or after a *Feast of Herod*, and *Hercules and Antaeus*, a group that Michelangelo was planning in 1524-1525. They were probably drawn as diagrammatic models for Antonio Mini who, no doubt, was responsible for the *Head of a Satyr* (fig. 6-a) on the *verso*, repeated from a sheet of head studies in the Staedelsches Kunstinstitut, Frankfurt (Inv. 392), a joint product of Michelangelo and his pupil of around the same date.

Meller (1974) suggested that the main recto drawing, which he tentatively assigned to Pierino da Vinci, was made in preparation for bronze casting, the internal lines representing pins and air-vents. But, apart from the fact that there is no justification for removing the drawing from Michelangelo, these lines seem insufficiently systematic for such a purpose. In any case, it seems unlikely that Michelangelo planned nude statues in bronze during the 1520s, either for the New Sacristy or other projects. They more probably represent the struts or armature employed to sustain a clay or wax model. In favour of this view is that a figure thus supported is found on a double sided sheet in the Département des Arts Graphiques in the Louvre (Inv. 694), a sheet which must replicate a lost one by Michelangelo. In the present drawing the enclosing oval might indicate the shape of a marble block that was finally to be ordered; or a container designed to protect a fragile model, in which case the horizontal at the figure's shoulders and hips would be holding bars.

While it would be convenient to link this drawing with the Ducal Tombs, this writer finds it difficult to ignore the strong similarities of type, form and pose between the main recto figure and Cats. 8 and 9. At the least they suggest that a sculpture projected by Michelangelo fertilised his presentation drawings. But they also raise the possibility that Michelangelo planned for some secular context a statue or statuette in which a Venusian figure was to be shown as an emblem of Vanity. It seems likely that either this drawing or Uffizi, Inv. 251F (Cat. 8) was known to Andrea Brescianino: his *Venus* in Galleria Borghese (Cat. 11, fig. 11-a) seems inconceivable without knowledge of one or the other.

Paul Joannides

BIBLIOGRAFIA / BIBLIOGRAPHY
DELACRE 1938, p. 529; WILDE 1953, pp. 80, 88; DUSSLER 1959, n. 438; BAROCCHI 1962, n. 174; MELLER 1974, pp. 271-272, TOLNAY 1975-1980, n. 229bis.

Cat. 7 (Tav. VI/1)

MICHELANGELO BUONARROTI
(Caprese 1475- Roma 1564)

Nudo femminile (La Terra?)
1530-1535 ca.
Terracotta
Altezza cm 35
Firenze, Casa Buonarroti, Inv. 193

Questo dinamico modello preparatorio è l'unica rappresentazione tridimensionale di un nudo femminile in piedi di Michelangelo. Sorprendentemente questa terracotta ha suscitato poca attenzione, forse a causa delle opinioni stereotipate sulla rappresentazione della donna in Michelangelo, che non lasciano spazio a queste figure piuttosto femminili e anche sensuali. Il nuovo allestimento della Sala dei bozzetti a Casa Buonarroti permette ai visitatori di apprezzare le graziose curve e la complessa torsione che la caratterizzano.
Wilde (1953) formulava come ipotesi plausibile che i disegni di Michelangelo su una *Venere antica* (Cat. 2, 3, 4, 5), potessero essere servite a sviluppare idee per questo modello. La figura ricorda l'*Aurora* nella Sagrestia Nuova, soprattutto come appare nella ridotta replica in terracotta del Tribolo (Cat. 14). L'allegoria di *Fiesole* (Firenze, Museo Nazionale del Bargello) del Tribolo, e probabilmente la sua statua della *Terra*, ora perduta ma basata su modello di Michelangelo, rispecchiano la posa e l'ideale di bellezza femminile riscontrabile nella terracotta di Casa Buonarroti.

La maggior parte degli studiosi giustamente accetta l'attribuzione a Michelangelo fatta da Wilde, ma qualcuno pone in discussione la sua proposta di datare l'opera ai primi anni Trenta del Cinquecento in base a un'associazione con due modelli documentati, realizzati per la Sagrestia Nuova. In un disegno autografo (Firenze, Casa Buonarroti Inv. 10A; TOLNAY n. 201) Michelangelo buttò giù delle annotazioni relative alla Tomba del duca Giuliano, e indicò *Cielo* e *Terra*, rispettivamente negli spazi in alto a sinistra e a destra. Vasari spiegava che «volle Michelangelo che il Tribolo facesse due statue nude, che avevano a metter in mezzo quella del duca Giuliano che già aveva fatta egli; l'una figurata per la Terra, coronata di cipresso, che dolente et a capo chino piangesse con le braccia aperte la perdita del Duca Giuliano».
Tribolo completò un grande modello di terracotta della *Terra* ma scolpì solo il lato frontale della scultura in marmo (VASARI, 1568/1966-1997, V, pp. 204-205). In una lettera del 15 ottobre 1533, Michelangelo scriveva di avere quasi finito «dua modelli picoli» per il Tribolo (BUONARROTI 1965-1983, IV, 55, n. 186). Weinberger (1967), basandosi sulle osservazioni Wilde, propone che Michelangelo abbia realizzato il modello della Casa Buonarroti per la *Terra* del Tribolo. In un recente studio sulla Sagrestia Nuova, tuttavia, Balas identifica erroneamente la *Notte* con la *Terra* e attribuisce il modello della Casa Buonarroti al Tribolo (1995, p. 72). Thode (1913, VI, p. 280, n. 583), seguito più cautamente da Myssok (1999), associa la terracotta con le figure delle *Vittorie* che Michelangelo aveva progettato per la Tomba di Giulio II.
La *Terra* del Tribolo può essere verosimilmente identificata con una statua di marmo incompiuta, un tempo agli Uffizi, come dimostrato da Parronchi basandosi su descrizioni scritte e in special modo su un disegno di Tommaso Arrighetti (1981, pp. 105-110; 1992, pp. 41, 50-52; fig. 7-a). Il foglio fa parte del primo volume della *Galleria di Firenze* (corridoi 1-2), preparato sotto la direzione di Benedetto de Greyss e finito entro il 1759. Mostra una figura femminile, completamente nuda, nella quale la testa reclinata, il gesto del braccio aperto e l'espressione del viso, concorrono a esprimerne il senso di lutto; nella posa e nelle proporzioni richiama alla mente l'allegoria di *Fiesole* del Tribolo. Questa, unica statua incompiuta, corrisponde a un'opera citata nella *Guida degli Uffizi* di Giuseppe Bianchi del 1759, come segue: «un marmo abbozzato per figurare una donna a cui (nonostante che nulla di certo rappresenti) fu dato luogo fra le [statue] finora descritte per esser lavoro del Buonarroti». Giuseppe Bencivenni scriveva nel 1779 che l'incendio degli Uffizi, nel 1762, aveva distrutto il marmo nonfinito «di Michelangelo». Un secolo prima, Giovanni Cinelli aveva notato nel museo una scultura abbozzata di mano di Michelangelo. Cinelli era convinto che il maestro avesse scolpito la statua per una nicchia nella Sagrestia Nuova, e aggiungeva come questa era rimasta nella cap-

pella per molti anni; ciò nonostante, in una lettera del 1563, Vasari descrisse tutte le nicchie esistenti prive di statue (1923-1940, I, pp. 719-721). Sebbene Parronchi non associ la *Terra* con la terracotta della Casa Buonarroti, che egli descrive come una *Vittoria* (1981, p. 30), il modello mostra significative similitudini con la statua che compare nel disegno di Arrighetti. Entrambe le figure sono rappresentate in piedi con il peso appoggiato sulla gamba sinistra, che risulta flessa, e ruotano verso sinistra il bacino e il torso. Nel modello, la posizione delle spalle indica che entrambe le braccia dovevano essere abbassate e la parte superiore del braccio destro è allungata diritta verso il basso, come nel perduto marmo degli Uffizi. In quest'ultima, tuttavia, la gamba portante è leggermente ruotata verso l'esterno. Questo particolare, insieme con il ridotto effetto di torsione, fa sembrare molto più statica la statua perduta. Inoltre questa appare più frontale, come sarebbe più appropriato per la figura destinata a una nicchia. Queste differenze potrebbero suggerire che il Tribolo possa avere adattato il piccolo modello della Casa Buonarroti nel realizzare una scultura più grande ed equilibrata. In alternativa, come proposto da Joannides (Cat. 6), la mancanza di definizione della terracotta potrebbe indicare che Michelangelo avesse fatto un abbozzo per sé, non un modello definitivo per un altro scultore. Se il disegno di Arrighetti fosse approssimativamente in scala, il marmo perduto avrebbe circa la stessa altezza del duca Giuliano e, se la figura fosse posizionata con la spalla destra leggermente in avanti, come è quella di lui, le mani di lei si allungherebbero oltre lo spazio della nicchia, come succede per il ginocchio e il piede sporgenti di lui.

MICHELANGELO BUONARROTI
(Caprese 1475-Roma 1564)

Female Nude (*Earth?*)

Early 1530s (?)
Terracotta
Height, 35 cm
Firenze, Casa Buonarroti, Inv. 193

This dynamic preparatory model is Michelangelo's only three-dimensional representation of a standing female nude.

This terracotta has attracted surprisingly little attention, perhaps because the stereotypical views of Michelangelo's depictions of women leave no place for this rather feminine, even sensual figure. Its new display in the Casa Buonarroti now allows viewers to appreciate its graceful curves and complex torsion.

Wilde plausably suggested that Michelangelo's drawings after an ancient Venus (Cat. 2, 3, 4, 5), may have been made to develop ideas for this model. The figure recalls the *Dawn* in the New Sacristy, especially as seen in Tribolo's reduced terracotta replica Cat. 14).

Tribolo's *Fiesole* (Firenze, Museo Nazionale del Bargello), and probably his lost statue of the *Earth*, the latter based on a model by Michelangelo, reflect the pose and ideal of female beauty found in the Casa Buonarroti terracotta. Most scholars rightly accept Wilde's attribution of this work to Michelangelo, but some question his proposal for a date in the early 1530s, in association with two documented models for the New Sacristy.

On an autograph drawing (Firenze, Casa Buonarroti, Inv. 10A; TOLNAY n. 201) Michelangelo jotted down some notes related to the Tomb of Duke Giuliano, and indicated *Cielo* (Heaven) and *Terra* (Earth), respectively, in the upper left and right. Vasari explained that "Michelangelo wished Tribolo to make two nude statues to stand on either side of that of Duke Giuliano [...] one of which was to represent Earth crowned with cypress, mourning and lamenting with bowed head and outstretched arms the loss of Duke Giuliano". Tribolo completed a large clay model of the *Earth* but carved only the front face of the marble sculpture (VASARI, 1568/1966-1997, V, pp. 204-205). In a letter of 15 October 1533, Michelangelo wrote that he had nearly completed "two small models" for Tribolo (BUONARROTI 1965-1983, IV, 55, n. 186). Weinberger (1967), building on Wilde's observations, argued that Michelangelo made the Casa Buonarroti model for Tribolo's *Earth*. In the most recent study of the New Sacristy, however, Balas incorrectly identified the *Night* as the *Earth*, and attributed the Casa Buonarroti model to Tribolo (1995, p. 72). Thode (1913), followed more tentatively by Myssok (1999), associated the terracotta with the *Victory* fig-

ures Michelangelo had planned for the Tomb of Pope Julius II. Tribolo's *Earth* can probably be identified with a marble statue once in the Uffizi; the association was established by Parronchi on the basis of written descriptions and especially a drawing by Tommaso Arrighetti (1981, pp. 105-110; 1992, pp. 41, 50-52; fig. 7-a). The drawing forms part of the first volume of the *Galleria di Firenze* (corridors 1-2), prepared under the direction of Benedetto de Greyss and completed by 1759.
It shows a female figure, completely nude, whose lowered head, open-arm gesture, and facial expression all express her grief; her pose and proportions recall Tribolo's *Fiesole*. This work, the only unfinished in the volume, corresponds to one listed in Giuseppe Bianchi's 1759 guide to the Uffizi as: "a marble roughed out to represent a woman (though who she represents is uncertain) [...] by Buonarroti." Giuseppe Bencivenni wrote in 1779 that the 1762 fire in the Uffizi had destroyed the unfinished marble "by Michelangelo."
A century earlier, Giovanni Cinelli had noted a roughed-out sculpture by Michelangelo in the museum. He believed the master had made the statue for a niche in the New Sacristy, and added that it remained in the chapel for many years, though in a letter of 1563, Vasari described all the niches in the chapel as missing statues (1923-1940, I, pp. 719-721).
Though Parronchi did not associate the *Earth* with the Casa Buonarroti terracotta, which he described as a *Victory* (1981, p. 30), the model exhibits significant parallels to the statue

seen in Arrighetti's drawing. Both figures stand with their weight on their left leg, right leg bent, and their hips and torso rotated to the left. The shoulders of the model indicates that both arms are lowered, and the right upper arm extends straight down, as in the lost Uffizi marble. In the latter, however, the supporting left leg turns slightly out. This detail, together with the reduced torsion, makes the lost statue seem much more static. Moreover, it appears more frontal, as would be appropriate for a niche figure.
These differences may suggest that Tribolo adapted the small Casa Buonarroti model when he carved a larger, more stable sculpture. Alternatively, as proposed by Joannides (Cat. 6), the lack of detail in the terracotta may indicate that Michelangelo made it for himself and not as a final model for another sculptor. If Arrighetti's drawing is roughly to scale, the lost marble would be about the same height as the statue of Duke Giuliano, and if placed with her right shoulder slightly forward, like his, her hands would extends beyond the niche, as do his protruding knee and foot.

Jonathan Katz Nelson

BIBLIOGRAFIA / BIBLIOGRAPHY
THODE 1913, VI, p. 280, n. 583; WILDE 1953, p. 80; WEINBERGER 1967, pp. 263-264; MYSSOK 1999, pp. 281-284, 358-359; O'GRODY 1999, pp. 262-266 n. 8; O'GRODY in *I bozzetti* 2000, pp. 48-53, n. 5.

7-a. Tommaso Arrighetti, *Nudo di donna (la Terra?)* / *Female Nude (Earth?)*. Firenze, Galleria degli Uffizi, Gabinetto Disegni e Stampe, Inv. 4533F.

Cat. 8 (Tav. VII/1)

attr. a MICHELANGELO BUONARROTI
(Caprese 1475-Roma 1564)

*Figura femminile stante
(Venere?)*

1527 (?) ca.
Matita rossa, matita nera, penna e inchiostro
mm 273 x 133
Firenze, Galleria degli Uffizi,
Gabinetto Disegni e Stampe, Inv. 251F

Tradizionalmente attribuito a Michelangelo Buonarroti, questo foglio subì nel corso del XX secolo un forte riduzione della sua importanza e fu accettato come del maestro dal solo Maurice Delacre.

Tale oblio è singolare poiché, anche se fosse interamente della sua bottega, la sua ovvia connessione con una quantità di altri fogli lo rende di enorme interesse storico. Ma il foglio, sebbene sia purtroppo danneggiato, si rivela chiaramente, per la tecnica e lo stile del *recto* e per l'eccezionale bellezza dell'anatomia tanto nella forma quanto nella delicatezza con cui è modellata, come opera di Michelangelo.

La maniera con cui è trattato il torso di Venere, per esempio, è estremamente simile, nella delicata vibrante omogeneità della stesura del tratto a matita, a quella del *Cristo bambino* nel cartone di Michelangelo della *Madonna* di Casa Buonarroti (Inv. 71F).

Lo schema del *verso* è altrettanto caratteristico e la testa della figura femminile alata – che si ritrova, come ha notato il Barocchi, su un foglio all'Ashmolean Museum di Oxford (PARKER 1956, n. 317v) – e il profilo di donna, che ricorda da vicino un foglio agli Uffizi (Inv. 599E), sono certamente autografi.

Alcuni degli altri schizzi sul *verso* sono dell'aiutante di Michelangelo, Antonio Mini, ma la loro superiorità rispetto ai suoi primi disegni, fatti alle dipendenze di Michelangelo, suggerisce una datazione del foglio intorno alla metà o alla fine della seconda decade del Cinquecento. Ecco che il *recto* diventa allora di primaria importanza: la tipologia del volto è caratteristica di Michelangelo e inscindibile da quella degli angeli nel suo (?) *Vergine e Bambino con angeli* custodito alla Galleria dell'Accademia di Venezia (Inv. 199) e nel suo *Sosta durante la fuga in Egitto*, ora al J. Paul Getty Museum di Los Angeles (Inv. 93.GB.51).

La combinazione di matita rossa e nera è piuttosto frequente tra i seguaci di Andrea del Sarto, ma è relativamente insolita nei disegni di Michelangelo. La si trova comunque nel foglio al Getty Museum dove, come qui, è aggiunto inchiostro e, in maniera ancor più rilevante, nello studio preparatorio del Musée Bonnet di Bayonne (Inv. 650v) eseguito per il famoso *Baccanale dei fanciulli* della Collezione Reale al Castello di Windsor. In tutti e tre i disegni l'impiego dei due mezzi è più per fornire alternative di codice-

colore che per un effetto pittorico. Come quello di Bayonne, anche il disegno in esame fu senza dubbio eseguito come preparazione di un disegno omaggio, *Venere e Cupido* – ora perduto – copiato da Francesco Salviati (Cat. 9). Anche il presente disegno ebbe comunque una certa circolazione: fu copiato in un foglio pontormesco nel Gabinetto Disegni e Stampe di Roma (Inv. 124259).

Questa figura femminile è caratterizzata da forme allungate e sinuose. Tale morfologia femminile era già stata sperimentata da Michelangelo circa vent'anni prima nel disegno a penna, ora custodito a Chantilly, in cui egli trasse la forma femminile da quella maschile di un antico e frammentario Satiro.

Ma oltre al cambio di genere, Michelangelo si spinse a modificare l'antica fonte per conformarsi a un canone di proporzioni femminee appreso dal Botticelli. A partire dal 1520 fu questo lo stile combinatorio cui egli dette impulso. Questo per sondare una fonte fondamentale delle figure femminili del Primaticcio, in primo luogo di quelle negli stucchi a Fontainebleau.

Il soggetto è chiaramente *Venere e Cupido*, anche se Cupido è a oggi perduto. Inizialmente, Venere sorreggeva l'arco di Cupido nella mano destra, mentre lo sguardo era diretto in basso a sinistra in direzione di suo figlio, che sta senza dubbio implorandola di restituirgli l'arco. In questa versione Venere ha una certa somiglianza con la *Vergine che cammina con il Cristo bambino e il Battista fanciullo (o Carità?)*, un altro progetto di Michelangelo noto per un disegno frammentario custodito a Parigi, al Louvre (Inv. 710*v*), e uno schizzo appena accennato che si trova all'Ashmolean Museum di Oxford (LLOYD 1977, A.66c).

In una seconda versione, Venere si sta studiando in uno specchio che tiene nella mano destra: qui la vanità ha vinto la prudenza. Quest'idea ebbe ulteriore sviluppo nel disegno copiato dal Salviati, in cui Cupido è lasciato ai suoi propri strumenti.

Come nella *Venere e Cupido* per Bartolomeo Bettini, Michelangelo partì da un'azione elementare, che gli era familiare, cioè dalla pittura – prima di tutti – di Lucas Cranach, e poi mescolò due idee in una singola immagine, per creare una struttura ironica tipica del suo stile poetico, nonché della sua mentalità.

attr. to MICHELANGELO BUONARROTI
(Caprese 1475-Roma 1564)

*Standing female nude
(Venus?)*

c. 1527?
Red chalk, black chalk, pen and ink
279 x 133 mm
Firenze, Galleria degli Uffizi,
Gabinetto Disegni e Stampe, Inv. 251F.

Traditionally attributed to Michelangelo, this sheet dropped out of consideration in the twentieth century, accepted as his only by Maurice Delacre. Such neglect is strange since, even were it entirely assistant work, its self-evident connection with a number of other sheets would make it of great historical interest. But, although sadly damaged, the technique and handling of the *recto*, and the exceptional beauty of the body both in its form and the subtlety with which it is modelled, show it clearly to be by Michelangelo. The treatment of Venus' torso, for example, is very like that of the *Christ Child* in Michelangelo's *Madonna* cartoon in Casa Buonarroti (Inv. 71F) in its subtly varied continuity of chalk application. The layout of the verso is also characteristic and the winged female head – found again, as Barocchi noted, on a sheet in the Ashmolean Museum, Oxford (PARKER 1956, II, no. 317*v*) – and the female profile, which closely resembles one on Uffizi (Inv. 599E), are certainly autograph. Some of the other verso sketches are by Michelangelo's assistant Antonio Mini, but their superiority to his earliest drawings made in Michelangelo's employ suggests a date for the sheet of the mid-to late-1520s. Here it is the *recto* that is of primary concern. The facial formula is characteristic of Michelangelo and inseparable from those of the angels in his (?) *Virgin and Child with Angels* in the Galleria dell'Accademia, Venice (Inv. 199), and his *Rest on the Flight into Egypt* in the J. Paul Getty Museum, Los Angeles (Inv. 93.GB.51). The combination of red and black chalk occurs frequently among the followers of Andrea del Sarto, but is relatively uncommon in Michelangelo's drawings. However, it is found on the Getty Museum sheet where, as here, ink is added, and, still more relevantly, in the preparatory study in the Musée Bonnat, Ba-

yonne (Inv. 650*v*) for the famous *Bacchanal of Infants* in the Royal Collection at Windsor Castle. In all three drawings, the employment of two media is less for pictorial effect than to colour-code alternatives. Like that in Bayonne, the present drawing too was no doubt made in preparation for a presentation drawing, the lost *Venus and Cupid* copied by Francesco Salviati (Cat. 9). However, the present drawing too had some circulation: it was copied on a Pontormesque sheet in Rome, Gabinetto Disegni e Stampe (Inv. 124259). The forms of this female figure are characterized by elongation and sinuousness. This female type had been tried by Michelangelo at least twenty years earlier, in the pen drawing now in Chantilly (Inv. 29*r*), in which he generated his female form from a fragmentary antique male *Satyr*. But as well as changing its gender, Michelangelo further modified the antique source to conform to a canon of female proportion learned from Alessandro Botticelli. In the 1520s it was this combinatory style that he revived. It was to prove a fundamental source for the female types of Primaticcio, most obviously his stuccos at Fontainebleau. The subject is clearly Venus and Cupid, even though Cupid has now been lost. Initially, Venus held Cupid's bow in her right hand, while looking down to her left at her son, who was no doubt pleading with her to return it. In this version she bears a certain resemblance to Michelangelo's designs of a *Virgin walking with the Christ Child and the Infant Baptist* (or a *Charity*?) known in a fragmentary drawing in the Louvre (Inv. 710*v*), and a lightly-sketched panel in the Ashmolean Museum, Oxford (LLOYD 1977, A.66c). In the revised version, Venus studies herself in a mirror held in her right hand, vanity having overcome caution. This idea was developed further in the drawing copied by Salviati, in which Cupid is left to his own devices. As with the *Venus and Cupid* for Bettini, Michelangelo started with a simple action, familiar from paintings by, above all, Lucas Cranach, and then fused two ideas into a single image to create an ironic structure typical of his poetical style – and his mentality.

Paul Joannides

BIBLIOGRAFIA / BIBLIOGRAPHY
DELACRE 1938, p. 522; BAROCCHI 1962, n. 243; JOANNIDES 1981, p. 683.

Cat. 9 (Tav. VII/2)

FRANCESCO SALVIATI
(Firenze 1510-Roma 1563)
da MICHELANGELO

Venere e Cupido

1539 (?)
Matita rossa
mm 355 x 243
Firenze, Galleria degli Uffizi,
Gabinetto Disegni e Stampe, Inv. 14673F

Il presente disegno fu attribuito al Rosso da Berenson – che vi vide un'allegoria di ispirazione michelangiolesca – nel 1903 e in successive occasioni. Nel 1963 Michael Hirst ne trasferì la paternità al Salviati, un'attribuzione accettata da tutti gli studiosi che vennero dopo tranne che da Mortari (1992). Nel 1981 chi scrive suggerì che esso replichi un perduto disegno omaggio di Michelangelo, preparato dal Maestro in 251F *recto* (Cat. 8). Hirst (1963) definì il disegno – senza alcuna spiegazione – un'*Allegoria della Prudenza*. La sua interpretazione può essere stata suggerita da un elaborato disegno di Michelangelo eseguito intorno al 1520, andato perduto, ma noto attraverso copie di numerosi artisti, tra cui Raffaello da Montelupo (British Museum, WILDE 1953, n. 89 *recto*), Battista Franco (Uffizi, Inv. 614E) e lo stesso Salviati (Köln, Wallraf-Richartz Museum, Inv. 21999; MONBEIG-GOGUEL in *Francesco Salviati* 1998, p. 31, fig. 9-b), spesso ritenuto una rappresentazione della *Prudenza*. Questa composizione mostra una donna vestita in maniera elaborata che si studia allo specchio mentre dei bambini giocano davanti e dietro di lei e uno di essi minaccia un altro con una grande maschera tenu-

ta al contrario. Il senso dell'allegoria non è comunque chiaro e non è stato ancora citato alcun testo in grado di fornire lumi. La donna appare di fatto così preoccupata di se stessa che sembra trascurare il nutrimento della prole o i suoi doveri. Ma quale che sia il significato – e Paul Barolsky (in PAOLETTI 1992, p. 434, n. 23) fece l'interessante ipotesi che tale figura rappresenti in realtà la *Vanità* – il suo unico concreto collegamento con il presente disegno è che la figura protagonista sorregge uno specchio. In alternativa, l'opinione di Hirst potrebbe essere stata ispirata dall'apparente volto di Giano del presente disegno, che sembra echeggiare quello della *Prudenza* di Raffaello nella Stanza della Segnatura. Ma un attento esame rivela che questo secondo volto è semplicemente una maschera sollevata sul vero viso della donna, come un cappuccio, nella definizione di Berenson, e un'altra maschera abbandonata è collocata a sinistra. La donna è indubbiamente Venere e l'arciere fanciullo accanto a lei è chiaramente Cupido: Michelangelo lo ritrasse nuovamente in forme simili nel suo *modello* del 1537 per una saliera destinata al duca di Urbino, oggi al British Museum di Londra (WILDE 1953, n. 66). Per Michelangelo gli specchi erano veicoli semantici multipli. Se l'individuazione dell'argomento del disegno perduto copiato da Raffaello da Montelupo e gli altri è corretta, uno specchio potrebbe allora indicare la *Prudenza*. Segnala anche la conoscenza di sé: Michelangelo stesso è mostrato con uno specchio in mano nel rilievo perduto dello zoccolo della Cappella Orsini a Trinità dei Monti (JAFFÉ 1991). E infine, potrebbe significare vanità, come nel presente *Venere e Cupido* e in un perduto *Vanità e Morte* disegnato da Michelangelo intorno allo stesso periodo nello stile di Baldung, conosciuto oggi solo tramite un'incisione ("The illustrated Bartsch", 31, 439 n. 1, 541; v. fig. 9-a). Senza dubbio Michelangelo eseguì gli originali di entrambe le composizioni per farne dono a degli amici: potevano addirittura essere stati intesi come una coppia indivisibile. Qui Venere è talmente infatuata della propria bellezza che Cupido le lasciato libero di compiere liberamente le sue marachelle. Hirst datò questa composizione intorno al 1550, ma il Salviati conservò uno scarso interesse per figure snelle come questa dopo avere visto il *Giudizio Universale* e la data più probabile è il 1539, durante un suo breve ritorno a Firenze. Egli sicuramente vide a quel tempo l'originale di Michelangelo nella collezione del suo proprietario. Mentre tre dei destinatari dei doni sono noti, Gherardo Perini, Tommaso Cavalieri e Andrea Quaratesi, molti disegni omaggio i cui proprietari non sono annotati sopravvivono per testimoniare che anche altri beneficiarono della generosità di Michelangelo. Egli eseguì sicuramente molti più disegni di questo tipo di quanti non si tenda a presumere. Il presente disegno e l'incisione della *Vanità* veicolano, in modo arguto e non privo di uno spunto di erotismo, delle serie lezioni morali circa i pericoli dell'innamoramento di sé, tanto importante per i moderni storici dell'arte quanto per i giovani contemporanei di Michelangelo.

9-a. Ignoto incisore da Michelangelo / Unidentified engraver after Michelangelo, *La Vanità e la Morte / Vanity and Death*, London, British Museum, Department of Prints and Drawings.

FRANCESCO SALVIATI
(Firenze 1510-Roma 1563)
after MICHELANGELO

Venus and Cupid

1539?
Red chalk
355 x 243 mm
Firenze, Galleria degli Uffizi,
Gabinetto Disegni e Stampe, Inv. 14673F

The present drawing was given to Rosso in 1903 and subsequently by Berenson, who called an allegory of Michelangelesque inspiration. In 1963, Michael Hirst transferred it to Salviati, an attribution, accepted by all later scholars save Mortari (1992). In 1981 the present writer suggested that it replicates a lost presentation drawing by Michelangelo, prepared by the master in 251F *recto* (Cat. 8), Hirst (1963) called the drawing – without explanation – an *Allegory of Prudence*. His interpretation may have been suggested by an elaborate drawing by Michelangelo of c. 1520, lost, but known in copies by several artists - including Raffaello da Montelupo (British Museum; WILDE, no. 89 *recto*), Battista Franco (Uffizi, Inv. 614E), and Salviati himself (Köln, Wallraf-Richartz Museum, Inv. 21999; MONBEIG-GOGUEL in *Francesco Salviati* 1998, p. 31; see fig. 9-b) – often thought to represent *Prudence*. This composition shows an elaborately dressed woman studying herself in a mir-

ror, whilst children play before and behind her, one of them menacing another with a large inverted mask. This allegory is opaque, however, and no text has yet been adduced to elucidate it: indeed, the woman is so self-preoccupied that she seems to neglect the nurture of her offspring or charges. But whatever its meaning – and Paul Barolsky (in PAOLETTI 1992, p. 434, n. 23) made the compelling suggestion that this figure in fact represents *Vanity* – its only substantive link with the present drawing is that the protagonist holds a mirror. Alternatively, Hirst's opinion may have been prompted by the apparent Janus-face of the present drawing which might seem to echo that of Raphael's *Prudence* in the Stanza della Segnatura. But close examination reveals that this second visage is simply a mask pulled back from her true face, "like a cap," as Berenson said, and another doffed mask is placed to the left. The woman is undoubtedly Venus and the infant archer beside her is clearly Cupid: Michelangelo portrayed him again in similar form in his *modello* of 1537 for a salt cellar for the Duke of Urbino, in the British Museum, London (WILDE 1953, no. 66).

For Michelangelo mirrors were multiple signifiers. If the subject identification of the lost drawing copied by Raffaello da Montelupo and others is correct, then a mirror could indicate *Prudence*. It also signalled self-knowledge: Michelangelo himself was shown holding a mirror in Daniele da Volterra's lost relief in the dado of the Orsini chapel in Trinita al Monte (JAFFÉ 1991). Finally, it could signify vanity, as in the present *Venus and Cupid*, and in a lost Baldungesque *Vanity and Death*, drawn by Michelangelo at about the same time, now known only from an engraving ('The Illustrated Bartsch', 31, 439, no. 1, 541; see fig. 9-a).

No doubt Michelangelo made the originals of both compositions as gifts for friends: they may even have been intended as pendants. Here Venus is so enamoured of her own beauty that

Cupid is left free to wreak mischief. Hirst placed this copy c. 1550, but Salviati retained little interest in such slender types after his experience of the *Last Judgement*, and the most likely date for it is 1539, during his brief return to Florence. He no doubt saw then Michelangelo's original in the collection of its owner.

While three of the recipients of Michelangelo's gifts are known, Gherardo Perini, Tommaso Cavalieri and Andrea Quaratesi, several presentation drawings whose original owners are not recorded survive to testify that others also benefited from Michelangelo's generosity. He surely made many more drawings of this type than

we now tend to assume. The present design and the engraved *Vanity* convey, wittily and not without an erotic edge, serious moral lessons on the perils of self-love – as relevant to modern art-historians as to Michelangelo's young contemporaries.

Paul Joannides

BIBLIOGRAFIA / BIBLIOGRAPHY
BERENSON 1903 (and subsequent editions), n. 2433; BAROCCHI 1950, p. 222; HIRST 1963, p. 164; JOANNIDES 1981, p. 683; MORTARI 1992, no. 131.

9-b. Battista Franco da Michelangelo, *Allegoria della Prudenza (?)* / *Allegory of Prudence (?)*. Firenze, Galleria degli Uffizi, Gabinetto Disegni e Stampe, Inv. 614E.

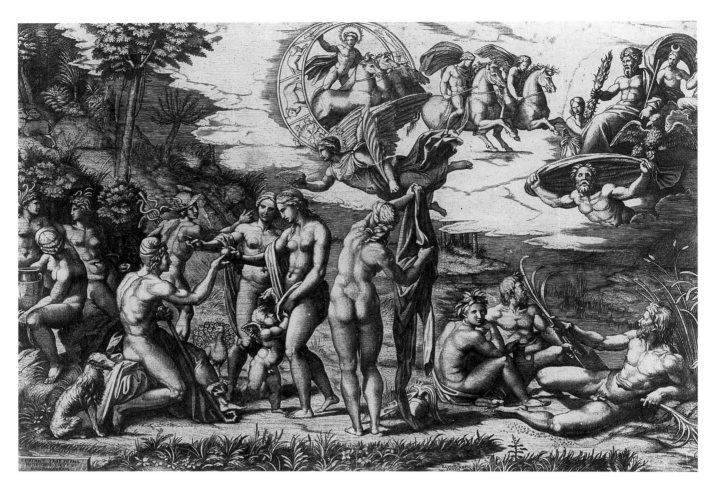

Cat. 10

MARCANTONIO RAIMONDI
(Argini 1475/1480-Bologna 1527/1534)
da RAFFAELLO

Il giudizio di Paride
1517-1520
Incisione
mm 296 x 444
Firenze, Galleria degli Uffizi,
Gabinetto Disegni e Stampe, Inv. St. Sc. 346
Iscrizioni:
(a sinistra in basso)
SORDENT PRAE FORMA / INGENIVM • VIRTVS • / REGNA • AVRVM
(al centro in basso)
RAPH • URBI / INVEN / MAF

Tre aspetti di questa famosa incisione si legano alla nostra mostra: la rappresentazione della bellezza femminile, la posa del dio fluviale e il contributo di due artisti alla stessa opera. La nostra maggior fonte di informazione sulla storia di quest'opera è rappresentata dalla citazione del Vasari nella *Vita* di Marcantonio. L'artista aveva realizzato un'incisione tratta dal disegno della Lucrezia di Raffaello «con tanta diligenza e bella maniera che [...] egli [Raffaello] si dispose a met-

tere fuori in istampa [...] un disegno che già avea fatto, del giudizio di Paris, nel quale Raffaello per capriccio aveva disegnato il carro del sole, le Ninfe de' boschi, quelle delle fonti e quelle de' fiumi [...] E così risoluto furono di maniera intagliate da Marcantonio, che ne stupì tutta Roma" (VASARI 1568/1966-1997, V, p. 9).
Giove, seduto in alto a destra, con uno scettro in mano e un'aquila al suo fianco, guarda in basso a sinistra verso Paride, che ne riflette la postura. Il regale pastore siede con il cane ai suoi piedi e regge il bastone con una mano e con l'altra il pomo d'oro. Mercurio, in piedi lì vicino, ha reso nota la volontà di Giove che Paride decida chi tra Venere, Minerva e Giunone sia la più bella. Il pastore audacemente chiede alle dee di svestirsi, e noi vediamo il momento in cui conferisce il pomo d'oro a Venere, riconoscibile per la posa "pudica" e per la presenza del Cupido alato. Dietro di lei Giunone, con il pavone ai suoi piedi, irritata punta il dito verso il giudice. Al centro, Minerva si affretta a rivestirsi, avendo ancora scudo ed elmo appoggiati a terra, e pudicamente volta le spalle allo spettatore. L'iscrizione nell'angolo in basso a sinistra si riferisce alla preferenza di Paride per il dono promesso da Venere – una bella ragazza – rispetto a quelli offerti dalle altre dee. Pertanto, il significato dell'allegoria è che intelligenza, virtù,

potere e ricchezze sembrano insignificanti in confronto alla bellezza.
Questa storia diede a Raffaello l'opportunità di raffigurare tipi diversi di bellezza, dato che le tre dee rappresentano chiaramente differenti qualità. Nonostante ciò, in questa come in tutte le altre rappresentazioni del mito, tutte le figure femminili mostrano lo stesso ideale di bellezza. Nell'*Aretino* (1557, p. 174), Lodovico Dolce lodava Raffaello poiché, a differenza di Michelangelo, «le sue figure variando, ha fatto nudi ricercati secondo il bisogno». Ma mentre Michelangelo ha creato tipi di nudo femminile diversi per la *Leda* e la *Venere*, e poi per la *Notte* e per l'*Aurora*, Raffaello non variò la sua rappresentazione della bellezza per Venere, Minerva o Giunone. Ma c'è di più. Ognuna di queste figure, dal seno piccolo e corpo eccezionalmente sodo, possiede una muscolatura molto più sviluppata di quanto non si ritrovi in natura o nell'arte antica, una caratteristica generalmente associata solo con Michelangelo. Per molte delle figure in questa scena, e per la composizione generale, Raffaello trovò ispirazione in un sarcofago ora a Villa Medici. Il rilievo comprendeva anche il dio fluviale che Raffaello dipinse all'estrema destra. Questo tipo di figura ci è noto attraverso molti esempi antichi, tra cui l'*Arno*, oggi in Vaticano,

restaurato nel Rinascimento, e forse dallo stesso Michelangelo (COLLARETA 1985). Questo tipo di dio fluviale ha fornito il prototipo per l'impostazione generale e per la posizione del braccio della Venere nel cartone di Michelangelo.

Come nella *Venere e Cupido* per Bettini, due artisti hanno contribuito alla creazione di questo *Giudizio di Paride*: uno ha fornito il disegno e l'altro ha realizzato l'opera finale. Damisch (1992, p. 72) ha osservato come, nel caso delle incisioni, il processo che conduce dai disegni preparatori al prodotto finito deve essere considerato unitario, in quanto anche le idee iniziali nascevano e si sviluppavano nella prospettiva della loro riproduzione finale o "traduzione". Analogamente, quando ci troviamo di fronte alle difficoltà di attribuire a Michelangelo o a Pontormo certe fattezze o qualità della *Venere e Cupido*, dobbiamo tenere presente che il cartone era stato creato proprio con l'intento specifico di essere "tradotto" in pittura.

MARCANTONIO RAIMONDI
(Argini 1475/1480-Bologna 1527/1534)
after RAPHAEL

The Judgment of Paris
1517-1520
Engraving
296 x 444 mm
Firenze, Galleria degli Uffizi,
Gabinetto Disegni e Stampe, Inv. St. Sc. 346
Inscriptions: (lower left)
SORDENT PRAE FORMA / INGENIVM • VIRTVS • / REGNA • AVRVM
(lower center)
RAPH • URBI / INVEN / MAF

Three aspects of this famous engraving relate to themes in this exhibition: the representation of female beauty, the pose of the river god, and the contribution of two artists to a single work. Our main source of information about its history is the account in Vasari's *Life* of Marcantonio.

He had engraved Raphael's drawing of Lucrezia in "so accurate and beautiful of manner that... [Raphael] determined to publish in the form of engraving [...] a drawing he had previously made of the Judgment of Paris, in which, by caprice, he had represented the chariot of the sun, the nymphs of the woods, those of springs, and those of rivers [...] And they were engraved in such a decisive way by Marcantonio that all Rome was astonished". (VASARI 1568/1966-1997, V, p. 9).

Zeus, seated in the upper right, with scepter in his hand and eagle at his side, looks down to the lower left at Paris, who echoes his pose. The royal shepherd sits with his dog at his feet and holds his staff in one hand, the golden apple in the other. Mercury, standing nearby, had conveyed Zeus' request that Paris decide whether Venus, Minerva, or Juno were the most beautiful. The shepherd boldly asked the goddesses to disrobe, and we see the moment when he gives the golden apple to Venus, identifiable by her 'Pudica' pose and the winged Cupid. Behind her Juno, peacock at her feet, angrily points her finger toward the judge. In the center, Minerva hurries to dress, her shield and helmet still on the ground, and modestly turns her back to the viewer. The inscription in the lower left corner refers to Paris' preference for the gift promised by Venus – a beautiful girl – over those offered by the other goddesses. The allegory thus signifies: wisdom, virtue,

kingdoms, and gold seem insignificant in comparison with beauty. This story gave Raphael the opportunity to depict different types of beauty, given that the three goddesses clearly represent different qualities. Nevertheless, in this and all other Renaissance representations of the myth, all the female figures show the same ideal of beauty. In the *Aretino* (1557, p. 174), Lodovico Dolce praised Raphael, in contrast to Michelangelo, because "in diversifying his figures, he produced elaborate nudes as the need arose". But whereas Michelangelo created different types of female nudes for the *Leda* and *Venus*, or the *Night* and *Dawn*, Raphael did not vary his representation of beauty for Venus, Minerva, or Juno. Moreover, each of these small-breasted and unusually firm figures have a musculature more developed than one usually finds in nature or ancient art, a quality usually associated only with Michelangelo.

For many figures in this scene, and for the general composition, Raphael found inspiration in a sarcophagus now in the Villa Medici. The relief also included the reclining river god that Raphael depicted on the far right. This type of figure is known from many ancient examples including the *Arno* in the Vatican, which may have been restored by Michelangelo himself (COLLARETA 1985). These ancient river gods provided the prototype for the overall pose and arm positions of the *Venus* in Michelangelo's cartoon.

As in the Bettini *Venus and Cupid*, two artists contributed to the creation of this *Judgment of Paris*: one provided the drawing, and the other realized the final work. Damisch (1992, p. 72) observed that with engravings, it is often difficult to establish the precise moment of invention within the process leading from preparatory drawings to the finished product; this process must be considered, from the start, in relation to its final reproduction or "translation". Similarly, when confronted with difficulties in attributing to Michelangelo or Pontormo certain features or qualities in the *Venus and Cupid*, we must remember that the cartoon was created for a specific function: to be "translated" into painting.

Jonathan Katz Nelson

BIBLIOGRAFIA/BIBLIOGRAPHY
VASARI 1568/1966-1997, V, p. 9; DAMISCH 1992; PETERMANN in *Venus Bilder* 2001, p. 260 n. G3.

Cat. 11 (Tav. XVI/1)

ANDREA DEL BRESCIANINO
(documentato a Siena dal 1506 al 1524,
a Firenze nel 1525)

Venere, Cupido e un putto
1525-1527 ca.
Olio su tavola
cm 68 x 149
London, Collezione privata

L'attribuzione di questo quadro ad Andrea del
Brescianino, dovuta a Bernard Berenson, è indi-
scutibile. Il dipinto è inseparabile da un'altra *Ve-
nere, Amore e putto* (Roma, Galleria Borghese,
Inv. 334; fig. 11-a) e da una *Famiglia di Adamo* di
Collezione privata (MACCHERINI in *Domenico Bec-
cafumi* 1990, p. 295, fig. 7), realizzati dallo stes-
so artista alla fine della sua carriera, dopo che
ebbe aperto una bottega a Firenze nel 1525.
L'influenza della cultura fiorentina su questi dipinti
è evidente soprattutto nel modo di trattare il pae-
saggio, ma anche nella ripresa di certi motivi. Per
esempio, i due putti della prima opera citata, la
Venere Borghese, derivano dalla *Madonna delle
arpie* di Andrea del Sarto (Firenze, Galleria degli
Uffizi), il fanciullo seduto nella *Famiglia di Adamo* è
la copia conforme del Bambino Gesù della
Madonna del baldacchino (Firenze, Galleria
Palatina) e il putto in piedi visibile a destra nel qua-
dro londinese riprende il Bambino Gesù della
Madonna del cardellino (Firenze, Galleria degli
Uffizi), entrambe opere fiorentine di Raffaello.
Nondimeno il motivo della donna nuda allungata si
ritrova spesso nella pittura senese dell'inizio del XVI
secolo, come attestano la *Venere, Cupido e putti*
di Girolamo del Pacchia (Collezione privata; cfr.
BARTALINI 1990, p. 133 e p. 35, fig. 16), la *Venere
e due putti* attribuita a Giovanni di Lorenzo (Siena,

Collezione Chigi Saracini; cfr. DE MARCHI in *Da
Sodoma* 1991, pp. 53-54 e v. Cat. 22) e la *Venere
e putto* di Beccafumi (Birmingham, Barber Institute
of Fine Arts). Il quadro di Beccafumi, dipinto verso
il 1519 per la "camera" di Francesco Petrucci (cfr.
BARTALINI in *Domenico Beccafumi* 1990, p. 133),
servì probabilmente da modello ad Andrea del Bre-
scianino. L'influenza di Michelangelo, sensibile nel-
la posa della *Venere* di Beccafumi, ispirata a quel-
la di Adamo nella *Creazione di Eva* della volta della
Sistina, si ritrova uguale nel quadro di Brescianino,
che si situa così tra la tradizione fiorentina e quel-
la senese.
L'iconografia di Amore allungato su Venere adottata
da Andrea del Brescianino sembra fare del quadro
londinese un precedente per l'opera di Miche-
langelo, ma potrebbe anche darsi che fosse il rifles-
so di un'idea del Buonarroti. In effetti, Brescianino
dovette frequentare a Firenze la bottega di
Michelangelo e avere accesso diretto ai suoi dise-
gni come dimostra la posa della *Venere Borghese*
derivata dai fogli degli Uffizi (cfr. Cat. nn. 8 e 9).
La tavola di Londra, dipinta prima del 1527 (data
della morte di Andrea del Brescianino al momen-
to della peste), ha più di un riferimento miche-
langiolesco; fra questi la posa del corpo femmi-
nile, la cui origine si trova nel già ricordato inte-
resse che gli artisti senesi avevano per le crea-
zioni romane di Michelangelo, specialmente per
la volta della Sistina che utilizzavano come reper-
torio di forme e di figure. Più che un vero e pro-
prio precedente, questa *Venere e Cupido* sem-
brerebbe una prefigurazione della ben più ele-
gante opera di Michelangelo/Pontormo.
Per quanto riguarda l'iconografia, Brescianino
seguì la tradizione senese della rappresentazio-
ne di Venere con putti.
Nelle sue raffigurazioni di Venere, l'artista rap-
presenta il piccolo amore che porta lo stesso
oggetto ornato di campanelle, un giocattolo o
un sonaglio da bambino.

Giocattoli simili compaiono nelle tavole di Giro-
lamo del Pacchia e di Beccafumi (un ombrellino
nel dipinto di Girolamo del Pacchia e una giran-
dola in quello di Beccafumi), che in questo mo-
do sottolineano l'aspetto terrestre e ludico del-
l'amore. Non si ritiene invece più valida l'inter-
pretazione data nel catalogo redatto al momen-
to della vendita del quadro, secondo cui il dipin-
to era interpretato come una rappresentazione
dell'Amore sacro e dell'Amore profano in ragio-
ne della funzione processionale attribuita a que-
sto oggetto.

ANDREA DEL BRESCIANINO
(documented in Siena from 1506 to 1524,
in Firenze in 1525)

Venus, Cupid and a putto
c. 1525-1527
Oil on wood
68 x 149 cm
London, Private collection

Bernard Berenson's attribution of this painting to
Andrea del Brescianino is indisputable. The painting
must be considered together with another *Venus,
Cupid and Amoretto* (Roma, Galleria Borghese,
Inv. 334, fig. 11-a) and the *Family of Adam* now in
a Private collection (cf. MACCHERINI in *Domenico
Beccafumi* 1990, p. 295, fig. 7), created by the
same artist towards the end of his career, after he
had opened a workshop in Florence in 1525.
The influence of Florentine culture on these paintings
is most evident in the manner of treating the landscape
but also in the reutilization of certain motifs. For exam-
ple, the two Amoretti in the first work mentioned, the
Borghese *Venus*, derive from the *Madonna of the
Harpies* by Andrea Del Sarto (Firenze, Galleria degli

Uffizi); the young boy seated in the *Family of Adam* is the exact copy of the Christ Child in the *Madonna of the Baldachin* (Florence, Galleria Palatina) while the putto seen standing on the right in the London painting is modeled on the Christ Child in the *Madonna of the Bullfinch* (Firenze, Galleria degli Uffizi), both Florentine works by Raphael.

Concurrently, the motif of the elongated nude woman was frequent in Sienese painting of the early Cinquecento, as the *Venus, Cupid and putti* by Girolamo del Pacchia (Private collection, cf. BARTALINI in *Domenico Beccafumi* 1990, p. 133 and p. 35, fig. 16), the *Venus with Two putti* attributed to Giovanni di Lorenzo (Siena, Chigi Saracini Collection; cf. DE MARCHI in *Da Sodoma* 1991, pp. 53-54; v. Cat. 22) and the *Venus and putto* by Beccafumi (Birmingham, Barber Institute of Fine Arts) demonstrate. The painting by Beccafumi, completed around 1519 for the chamber of Francesco Petrucci (cf. BARTALINI in *Domenico Beccafumi* 1990, p. 133), was probably Andrea del Brescianino's model. The influence of Michelangelo, evident in the pose of Beccafumi's *Venus* inspired by that of Adam in the *Creation of Eve* in the vault of the Sistine Chapel, is identical to the one found in the painting by Brescianino who thus draws on the traditions of both Florence and Siena.

The iconography adopted by Brescianino of Cupid lying along the figure of Venus could possibly point to the London painting as a precedent for Michelangelo's creation; but, there is also the possibility that it reflects an idea of Buonarroti. Indeed, Brescianino not only must have frequented the workshop of Michelangelo in Florence but also have had direct access to his drawings as the pose of the Borghese *Venus*, derived from the Uffizi drawings (cf. Cats. 8 and 9), demonstrates.

The London panel, painted before 1527 (the date of Andrea del Brescianino's death at the time of the plague), has more than one Michelangelesque reference: one being the pose of the female body the origin of which goes back to the previously mentioned interest of Sienese artists for the Roman works of Michelangelo, especially the Sistine Chapel vault that was used as a repertoire of forms and figures. More than a true precedent, the *Venus with Cupid* appears to be a prefiguration of the much more elegant creation by Michelangelo/Pontormo.

Regarding iconography, Brescianino followed Sienese tradition in the representation of Venus with Amoretti. In his other representations of Venus as well, the little cupid is depicted holding the same belled-object, a child's toy or rattle.

Similar toys appear in the paintings by Girolamo del Pacchia and Beccafumi (a small umbrella in the painting by Girolamo del Pacchia and a small gyrating fan in the work by Beccafumi) as a way of underlining the earthly and playful nature of love. The interpretation given in the catalog compiled for the sale of the painting, in which the object served a processional function and the painting represented Sacred and Profane Love, can no longer be considered valid.

Philippe Costamagna

BIBLIOGRAFIA / BIBLIOGRAPHY
BERENSON 1968, I, p. 66; MACCHERINI in *Da Sodoma* 1988, p. 72; MACCHERINI in **Domenico Beccafumi** 1990, p. 293; *Catalogo Asta Christie's*, London 13 dicembre 2000, p. 198, n. 78.

11-a. Andrea del Brescianino, *Venere, Amore e putto / Venus, Cupid and a putto*. Roma, Galleria Borghese.

Cat. 12 (Tav. IX/1)

MICHELE TOSINI,
detto MICHELE DI RIDOLFO DEL GHIRLANDAIO
(Firenze 1503-1577)
da MICHELANGELO

Testa ideale (Zenobia?)
ca. 1540 (?)
Olio su tavola
cm 76 x 56
Firenze, Galleria dell'Accademia, Inv. 1890/6072

Questo dipinto deriva da un famoso e molto copiato disegno a matita nera di Michelangelo, uno dei tre donati al suo giovane amico Gherardo Perini intorno al 1524 e ora agli Uffizi (Inv. 598E; Tav. IX/1; fig. 12a).
Il soggetto è tradizionalmente noto come *Zenobia* e, anche se non è chiaro come sia nato questo appellativo, esso potrebbe essere esatto. Zenobia era nel III secolo la regina di Palmira, un'indomita guerriera che fu alla fine sconfitta dall'imperatore Aureliano, che le permise di trascorrere la sua vita in esilio a Roma. Era originaria della Siria, e i tratti della donna michelangiolesca potrebbero ben corrispondere a un origine orientale.
Celebrata nel *De claris muliebris*, Zenobia non era un soggetto comune nell'arte rinascimentale, ma Boccaccio la descrive in termini che potrebbero ben avere attratto Michelangelo: fisicamente potente, di energia mascolina, casta e aliena da ogni rapporto con il marito tranne che a fini procreativi.
La castità coniugale, come suggeriva il compianto Sir Ernst Gombrich (1986), sembra essere quello che Michelangelo sottintendeva nel suo cartone per l'*Epifania* del British Museum (WILDE 1953, n. 75), e potrebbe anche essere il tema di questo progetto. Sarebbe del tutto in

linea con la visione di Michelangelo della temperanza sessuale, come riporta in termini generali il Vasari, e in modo più specifico il suo allievo Tiberio Calcagni (v. ELAM 1998, pp. XLIV-XLV). Se ciò è corretto, Zenobia si allontanerebbe dal marito per dare nutrimento al proprio bambino. Almeno un altro dei disegni di teste femminili di cui Michelangelo fece dono è identificabile: la *Cleopatra*, fatta per Tommaso de' Cavalieri, oggi alla Casa Buonarroti (Inv. 2F), e potrebbe anche essere che, come suggeriva Mendelsohn, anche altri rappresentassero figure storiche.
Altre identificazioni proposte per il soggetto sono *Venere, Cupido e Vulcano* o un *Combattimento tra Marte e Venere*. Il primo non è probabile, poiché l'elmo che l'uomo indossa non è appropriato per Vulcano, mentre il bambino non reca nessuno degli attributi di Cupido. Che Michelangelo abbia disegnato un *Combattimento tra Marte e Venere* è invece plausibile, poiché un tal soggetto riferito a lui e copiato da Giulio Clovio, è riportato nell'inventario di Clovio.
Tuttavia, anche se la presente composizione potrebbe suggerire avversione e disprezzo, è arduo vederci propriamente un combattimento. Tale descrizione meglio si adatta a un curioso disegno a più figure di Clovio conservato nel Département des Arts Graphiques nel Museo del Louvre (Inv. 2767), dove il confronto è tra due gruppi di dèi, ma essi sono divisi secondo ragione e passione, con Marte e Venere che combattono a fianco. Potrebbe essere questo il disegno menzionato nell'inventario di Clovio – che non è completamente degno di fede – ma che esso sia una copia da Michelangelo è cosa opinabile, dato che le invenzioni figurative non richiamano le sue.
Qualunque sia l'identità dei protagonisti del presente dramma, il tema sembra essere desiderio e ripulsa. Una scena paragonabile è rappresentata in un altro disegno destinato a un dono (Uffizi, Inv. 603E; fig. 12-b), probabilmente di poco precedente. Sebbene sovente non considerato, esso è, nell'opinione del professor Hirst (vergato in annotazione sulla montatura del disegno) e quella di chi scrive, di sicuro autografo dell'artista. Anche qui la disposizione sottintende un intento narrativo piuttosto che allegorico, e l'atmosfera è parimenti di tensione.
Nel 1524 la composizione di Michelangelo era insolita nel contesto fiorentino e suggerisce una sua precoce coscienza nella narrativa episodica di cui erano pionieri i pittori veneziani, in particolar modo Tiziano e Giorgione. Il fatto che questa tendenza veneziana fosse a sua volta ispirata a lavori sperimentali di Leonardo e Mantegna faceva sì che fosse prontamente assimilabile da Michelangelo.
Il presente modo di affrontare il soggetto di Michele di Ridolfo, che produsse numerose versioni da boudoir di composizioni michelangiolesche (Cat. 13 dalla *Notte* di Michelangelo ne è un ulteriore esempio), cassa le due teste accessorie e rimpiazza la seriosità morale di Michelangelo con un certo fascino lezioso.

MICHELE TOSINI
called MICHELE DI RIDOLFO DEL GHIRLANDAIO
(Firenze 1503-1577)
after MICHELANGELO

Ideal Head (Zenobia?)
c. 1540 (?)
Oil on wood
76 x 56 cm
Firenze, Galleria dell'Accademia, Inv. 1890/6072

This painting is based on a famous, much replicated, black chalk drawing by Michelangelo, one of three sheets given to his young friend Gherardo Perini c. 1524, and now in the Uffizi (Inv. 598E; Pl. IX/1; fig. 12-a). The subject is traditionally known as *Zenobia*, but while it is unclear how and when this identification originated, it may well be correct. Zenobia was a third-century queen of Palmyra, a fearless warrior who, finally defeated by the Emperor Aurelian, was allowed to live out her life in exile in Rome. She was Syrian, and the features of Michelangelo's woman could well suggest an Eastern origin. Celebrated in *De Claris Muliebris*, Zenobia was not commonly represented in Renaissance art but Boccaccio describes her in terms that would have appealed to Michelangelo: physically powerful, of masculine energy, chaste and refusing intercourse with her husband except for procreation. Conjugal chastity seems, as the late Sir Ernst Gombrich (1986) suggested, to have

12-a. Michelangelo, *Testa ideale (Zenobia?)* / *Ideal Head (Zenobia?)*. Firenze, Galleria degli Uffizi, Gabinetto Disegni e Stampe, Inv. 598E.

been implied by Michelangelo in his *Epifania* cartoon in the British Museum, (WILDE 1953, no. 75) and it may also be the theme of this design. It would fit Michelangelo's views of sexual restraint as recorded in general terms by Vasari and specifically by his pupil Tiberio Calcagni (see ELAM 1998, pp. XLIV-XLV). If this is correct Zenobia would be turning away from her husband to nurture her child. At least one of Michelangelo's other presentation drawings of female heads is identifiable, the *Cleopatra* made for Tommaso de' Cavalieri now in Casa Buonarroti (Inv. 2F), and it may be, as Mendelsohn has suggested, that others also represent specific historical figures. Other proposed identifications of the subject are *Venus, Cupid and Vulcan* or a *Combat of Mars and Venus*. The former is improbable, since the helmet worn by the man is inappropriate for Vulcan and the child bears none of the attributes of Cupid. That Michelangelo designed a *Combat of Mars and Venus* is likely, since a treatment of the subject ascribed to him, copied by Giulio Clovio, was recorded in Clovio's inventory. However, while the present composition might suggest aversion and disdain it is hard to see it as a combat. Such a description better fits a puzzling multi-figured drawing by Clovio in the Département des Arts Graphiques, Musée du Louvre (Inv. 2767) between two groups of gods, but they are divided according to reason and passion, with Mars and Venus fighting on the same side. This might be the drawing mentioned in Clovio's inventory – which is not fully trustworthy – but whether it copies a composi-

tion by Michelangelo is questionable, since the figural inventions are unlike his. Whatever the identity of the actors in the present drama, the theme seems to be of desire and rejection. A comparable scene is represented in another presentation drawing (Uffizi, Inv. 603E; fig. 12-b), which is probably a little earlier in date. Although often dismissed it is, in the opinion of Professor Hirst (expressed in annotation on the drawing's mount) and that of the present writer, certainly autograph. Here too the arrangement implies a narrative rather than an allegory and the mood is similarly tense. In 1524 Michelangelo's composition was unusual in a Florentine context and suggests his early awareness of the half-length narratives pioneered by Venetian painters, most notably Titian and Giorgione. Since this Venetian mode was in turn inspired by experiments by Leonardo and Mantegna, it would have been readily acceptable by Michelangelo. The present treatment by Michele di Ridolfo, who produced numerous "boudoir" versions of Michelangelo's compositions (Cat. 13 after Michelangelo's *Night*, is a further example), excises the two subsidiary heads and replaces Michelangelo's moral seriousness with a certain coy charm.

Paul Joannides

BIBLIOGRAFIA / BIBLIOGRAPHY
MENDELSOHN 1988; JOANNIDES in *Michelangelo* 1996, p. 44; FERINO-PAGDEN in *Vittoria Colonna* 1998, p. 323.

12-b. Michelangelo, *Due teste / Two Heads*. Firenze, Galleria degli Uffizi, Gabinetto Disegni e Stampe, Inv. 603E.

Cat. 13 (Tav. XI/2)

Michele Tosini,
detto Michele di Ridolfo del Ghirlandaio
(Firenze 1503-1577)

La Notte

1565 ca.
Olio su tavola
cm 135 x 196
Roma, Galleria Colonna

Il dipinto della *Notte* di Michele di Ridolfo, oggi liberato dalle vesti del primo Ottocento e da uno spesso strato di vernice ingiallita (fig. 34e), offre un esempio importante di come i contemporanei di Michelangelo copiassero e trasformassero le sue rappresentazioni di nudi femminili distesi. Molti committenti del Cinquecento possedevano repliche di quattro prototipi elaborati circa tra il 1525 e il 1533: la *Leda*, l'*Aurora*, la *Notte* e la *Venere* (cfr. saggio Nelson).

Sebbene queste opere fossero state realizzate per tre ambientazioni completamente diverse, e avessero i significati iconografici più disparati, acquisirono un senso nuovo come «nudi femminili di Michelangelo». Copie e varianti di questi capolavori moderni erano riuniti insieme in molti ensemble di cui si ha notizia.

Vasari dipinse almeno due "paia" di *Leda* e di *Venere*, l'allievo di Michele, Brina, ne trasse una serie completa di piccoli dipinti attualmente nella Casa Buonarroti, a Firenze (*Appendice II*, 5), e lo stesso Michele diede il proprio contributo al gruppo più importante con la *Notte*, l'*Aurora* e la

Venere, ora a Palazzo Colonna (per la provenienza, si veda Cat. 34 e Costamagna 2000). Queste opere dalle identiche dimensioni, un tempo adornavano il palazzo fiorentino di Jacopo di Alamanno Salviati (1537-1586). L'inventario del 1583 elenca: «tre [quadri] simili [con adornamenti] tocchi d'oro dentrovi la Notte [...] e l'Aurora di mano del Bronzino Vecchio». Nello stesso inventario due voci sotto troveremo la *Venere* del Bronzino: «un quadro grande simile a tre sopradetti...». Gli studiosi concordano sul fatto che il Bronzino dipinse quest'ultima negli anni 1553-1554, ma la maggior parte correttamente attribuisce gli altri tre dipinti a Michele Tosini, allievo di Ridolfo del Ghirlandaio, e collaboratore del Vasari a Palazzo Vecchio tra il 1557 e il 1565. Su basi stilistiche, i dipinti Colonna sono databili alla metà degli anni Sessanta del Cinquecento. Comprendendo una seconda rappresentazione della *Venere* (e non della *Leda*), questo insieme di quattro dipinti va a costituire un incantevole contributo alla colta e spesso arida disquisizione su riproduzione di copie e creatività nel Rinascimento fiorentino. Il committente di Bronzino, identificato dal Vasari con Alamanno Salviati (1510-1571), capì che questa sofisticata variazione dalla *Venere e Cupido* di Michelangelo-Pontormo avrebbe solo guadagnato in un confronto con il prototipo, e così ordinò una replica di questa famosa opera, allora nella collezione di suo nipote, il duca Cosimo. A questa intelligente combinazione di copia e variante, egli aggiunse due "trasposizioni" in pittura dalla scultura: la *Notte* e l'*Aurora* di Michele. Il numero di dipinti era stato probabilmente obbligato dalla forma della stanza originale; sebbene questa non sia stata in-

dividuata, un inventario del 1704 elenca le quattro opere come "sopraporta". Inoltre le figure appaiono più riuscite se viste collocate più in alto, come vediamo la *Notte* nella Sagrestia Nuova. Della statua di Michelangelo, lodata da Bocchi come una delle sole quattro opere d'arte perfette a Firenze (1571, in Fragenberg 1998, p. 194), Michele copiò fedelmente la posa e completò anche la mano sinistra non finita, l'unico passaggio maldestro di questo quadro. Come molti artisti, egli trasformò la figura estremamente muscolosa in un esemplare più prossimo ai canoni tradizionali di bellezza femminile e, dopo il recente restauro, l'incarnato appare anche più delicato di prima. Sorprendentemente Michele riprodusse accuratamente la strana forma del seno sinistro. Anche se il pittore non riconobbe i tre segni caratteristici del cancro – l'areola rigonfia, le profonde rientranze e la protuberanza – egli evidentemente capì che Michelangelo aveva intenzionalmente scolpito queste deformazioni, e soltanto per il seno sinistro (Nelson-Stark 2000).

Gli altri attributi del marmo riappaiono nel dipinto: il copricapo con la stella e la luna crescente, la maschera, il gufo (il cui piumaggio era stato allargato nel primo Ottocento per coprire la coscia della *Notte*), le piante oggi smaglianti di mele e rose. Sulla sinistra Michele aggiunse due maschere, tratte dalla *Venere e Cupido*, un vaso dorato, simile a quello nell'*Aurora*, una clessidra e una lanterna. Quest'ultimo dettaglio potrebbe rispecchiare la perduta variante della *Notte* del Bugiardini (Vasari 1568/1966-1997, V, pp. 283). Per accentuare il senso di profondità, Michele dipinse un putto che accende la torcia, illuminando il cielo notturno.

I colori brillanti e le espressioni spiritose di alcuni dei visi conferiscono a quest'opera un carattere piacevole e faceto, lontano dal senso di magistrale mistero riscontrabile nella austera scultura funebre di Michelangelo.

Questo marcato aumento dell'accessibilità, rintracciabile anche nella replica in terracotta (Cat. 15), caratterizza tre dipinti della *Notte*, della Cerchia di Michele: una piccola tavola alla Casa Buonarroti, già menzionata, che faceva parte di un insieme di nudi femminili michelangioleschi; una versione inferiore e molto semplificata (Brescia, mercato antiquario, 57 x 77), e un dipinto più grande e più complesso (*Antologia*, 1992, n. 11, 64 x 100, fig. 13-a). Quest'ultima opera enfatizza l'aspetto comico ed erotico: un putto guarda la figura nuda dormiente attraverso una maschera capovolta, un motivo adattato da un disegno di Michelangelo (Dempsey 2001; fig. 9-b), e un'altra maschera barbuta sembra sbirciare licenziosamente tra le gambe della figura femminile, un dettaglio che richiama le composizioni della *Venere* sia di Michelangelo che del Bronzino.

MICHELE TOSINI,
called MICHELE DI RIDOLFO DEL GHIRLANDAIO
(Firenze 1503-1577)

Night

c. 1565
Oil on panel
135 x 196 cm
Roma, Galleria Colonna

Michele di Ridolfo's painting of the *Night*, now liberated from its nineteenth-century clothing and a thick layer of yellowed varnish, (fig. 34e) offers an impressive example of how Michelangelo's contemporaries copied and transformed his representations of reclining female nudes. Many patrons in the Cinquecento owned replicas of four prototypes created between about 1525 and 1533: the *Leda*, *Dawn*, *Night*, and *Venus* (see Nelson's essay). Though these works were made for three completely different settings, and had disparate iconographic meanings, they took on new life as "Michelangelo's female nudes". Copies and variations of these modern masterpieces were united in many documented ensembles. Vasari painted at least two 'pairs' of the *Leda* and *Venus*, Michele's student Brina carried out a complete set of small paintings now in the Casa Buonarroti, Florence (*Appendice II*, 5), and Michele himself contributed the *Night*, *Dawn*, and *Venus*, to the most important group, now in the Palazzo Colonna (for the provenance, see Cat. 34 and COSTAMAGNA 2000). These works, with identical dimensions, once adorned the Florentine palazzo of Jacopo di Alamanno Salviati (1537-1586). The 1583 inventory lists: "three similar [paintings with] gilded [frames] in which are the Night... and the Dawn by the hand of Bronzino the Elder". Two entries down we find Bronzino's *Venus*: "a large panel similar to the three mentioned above..." Scholars agree that Bronzino painted the latter in 1553-1554, but most rightly give the other three paintings to Michele Tosini, Ridolfo del Ghirlandaio's student, and, between 1557 and 1565, Vasari's collaborator in the Palazzo Vecchio. On stylistic grounds, the Colonna paintings date from the mid 1560s. By including a second depiction of *Venus* (and not the *Leda*), this medley of four paintings constitutes a delightful contribution to the learned but often arid discussions in Renaissance Florence about reproduction and creativity. Bronzino's patron, identified by Vasari as Alamanno Salviati (1510-1571), understood that this sophisticated variation on the Michelangelo-Pontormo *Venus and Cupid* would only by enhanced from comparison with the prototype, and thus he ordered

a replica of the famous work, then in the collection of his nephew, Duke Cosimo. To this intelligent combination of copy and variation, Alamanno added two "transpositions" from sculpture to painting: Michele's *Night* and *Dawn*. The number of paintings was probably determined by shape of the original room; though this has not been identified, a 1704 inventory lists the four works as "overdoors". Moreover, the figures look best when viewed from below, just as we see the *Night* in the New Sacristy. From Michelangelo's statue, praised by Bocchi as one of only four perfect works of art in Florence (1571, in FRAGENBERG 1998, p. 194), Michele carefully copied the pose and even completed the unfinished left hand, the only awkward passage in this painting. Like many artists, he transformed the highly muscular figure into one closer to traditional canons of female beauty, and after the restoration, her flesh appears even softer than before. Surprisingly, Michele accurately reproduced the odd shape of the left breast. Even if the painter did not recognize the three signs of cancer, the swollen areola, deep indentations, and lump, he evidently understood that Michelangelo had intentionally depicted these imperfections, and only in the left breast. (NELSON-STARK 2000).

The other attributes in the marble reappear in the painting: the star and crescent-moon headpiece, mask, owl (whose wing was extended in the 19th century to cover the *Night*'s left haunch), and plants, now rich with apples and roses. On the left side, Michele added two masks, borrowed from the *Venus and Cupid*, a golden vessel, similar to one in his *Dawn*, an hourglass, and a lantern. This last detail may reflect Bugiardini's lost variation on the *Night* (Vasari 1568 /1966-1997, V, p. 283). To augment the sense of depth, Michele depicted a putto who lights his torch and illuminates the night sky. The bright colors and humorous expression on some of the faces give this work a pleasing and amusing character, far from sense of magisterial mystery found in Michelangelo's austere funerary sculpture. This marked increase in accessibility, also found in the terracotta replica (Cat. 15), distinguishes three related paintings of the night from Michele's circle: the small panel in the Casa Buonarroti, mentioned above, which formed part of a set of michelangelesque female nudes; a highly simplified and inferior version (Brescia, art market, 57 x 77), and larger, more complex painting (*Antologia* 1992, n. 11, 64 x 100, fig. 13-a). The latter work emphasizes the comic and erotic: a putto looks at the sleeping nude though an inverted mask, a motif adapted from a drawing by Michelangelo (DEMPSEY 2001; fig. 9-b), and another bearded mask seems to gaze lecherously between the legs of the female figure, a detail which recalls the *Venus* compositions by both Michelangelo and Bronzino.

Jonathan Katz Nelson

BIBLIOGRAFIA / BIBLIOGRAPHY
SAFARIK 1981, p. 88 n. 116; HORNIK 1990, p. 253, n. 29; NEGRO 2001, pp. 21, 23.

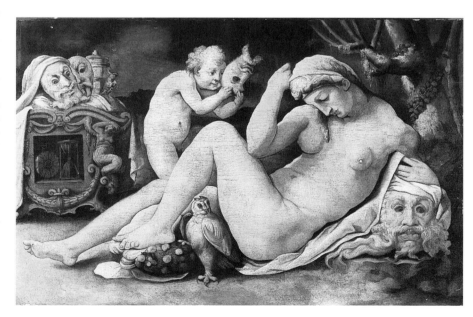

13-a. Cerchia di Michele Tosini, *La Notte / The Night*.
Già Brescia, mercato antiquario / *Formerly Brescia, art market.*

Cat. 14 (Tav. VII/3)

Niccolò Pericoli detto il Tribolo
(Firenze 1497-1550)
da Michelangelo

Aurora
1534-1537
Terracotta
cm 55 x 53 x 27
Firenze, Museo Nazionale del Bargello, Inv. 313S

Le due coppie di figure, personificazioni delle "parti del giorno" e allegorie dell'incessante fluire del tempo, che Michelangelo eseguì per ornare i sarcofagi delle tombe medicee di Lorenzo duca di Urbino e Giuliano duca di Nemours, nella Sagrestia Nuova di San Lorenzo, erano ultimate tra giugno e agosto del 1531 (lettera di G. B. Mini a Baccio Valori, 29 settembre 1531, in Buonarroti 1965-1983, III, pp. 329-333). Da quel momento l'entusiasmo e l'ammirazione che le statue suscitarono furono enormi e straordinaria l'influenza da esse esercitata sugli scultori e i pittori manieristi (Cat. 13), grazie anche alla diffusione delle idee creative di Michelangelo da parte dell'Accademia del Disegno, che dal 1563 al 1567 ebbe sede proprio nella cappella medicea e favorì la produzione e la vendita di copie ridotte ad artisti e collezionisti (Berti in *Adolescente* 2000, pp. 46-47).
Tra le numerose copie che ne furono fatte, per lo più di formato ridotto e in terracotta, stucco o bronzo, di cui alcune ancora conservate in colle-

zioni pubbliche e private, quelle eseguite dal Tribolo, identificabili con le terrecotte raffiguranti l'*Aurora*, il *Crepuscolo*, il *Giorno*, oggi al Museo del Bargello (Rossi 1932, p. 21), trovano precisa testimonianza nella biografia vasariana dello scultore (Vasari 1568/1966-1997).
La serie rimase priva fin dall'inizio della figura della *Notte*, di cui, secondo il racconto vasariano, il Tribolo fece dono al priore di San Lorenzo, Giovanni Battista Figiovanni, in segno di riconoscenza per avergli consentito di frequentare la cappella durante l'esecuzione delle copie. Della scultura, donata poi al duca Alessandro de' Medici, che a sua volta la donò al Vasari, non è oggi nota la sorte, essendo fondata su un equivoco: una vec-

chia ipotesi (Rossi 1893) – non corretta poi da Tolnay (1948) – che la identificava con una terracotta del Victoria and Albert Museum, raffigurante invece l'*Aurora* (Pope-Hennessy 1964, cat. 446).
Negli anni che precedettero la realizzazione di queste copie, Niccolò Tribolo aveva lavorato a due statue che avrebbero dovuto raffigurare la Terra e il Cielo e che facevano parte del precedente programma decorativo dei sepolcri medicei (Cat. 7). In quel periodo, come riporta Vasari, il Tribolo fu afflitto da gravi problemi di salute e la successiva interruzione dei lavori della Sagrestia Nuova, a causa della morte di Clemente VII e della partenza di Michelangelo per Roma nel 1534, cambiò il corso delle cose, facendo così sfumare le prospettive di collaborazione del Tribolo e di altri giovani artisti fiorentini alle opere del Buonarroti.
L'esecuzione delle copie da parte del Tribolo si colloca in un momento di scarsa attività dell'artista seguito a tali eventi, negli anni a cavallo tra il 1534 e il 1537, anno dell'uccisione del duca Alessandro de' Medici.
Al pari delle figure virili, allegorie del *Giorno* e del *Crepuscolo*, l'*Aurora* è modellata in argilla, completamente rifinita anche nella parte posteriore, con la superficie solcata da sottili linee incise parallele che sottolineano graficamente l'andamento dei volumi. In origine la figura poggiava su quattro pilastrini in terracotta, che formavano un tutt'uno con la parte superiore. La perdita di tali elementi ha successivamente motivato la costruzione delle attuali basi in legno che alludono alla forma del sepolcro mediceo.
La terracotta, svuotata nella parte inferiore fino all'interno della figura, mostra quella sapienza acquisita nel "fare di terra" per cui il Tribolo veniva tenuto in gran considerazione e incaricato di fare da arbitro nelle controversie relative alla valutazione di lavori del genere (Baldini in *Adolescente* 2000, p. 23).
Nonostante i danni, dovuti anche all'alluvione del 1966, e le patinature con cere che la terracotta ha ricevuto, in parte finalizzate ad attenuare fratture e ricostruzioni, è abbastanza conservata sulla superficie la finitura chiara che in origine

14-a. Michelangelo,
Aurora / Dawn,
Firenze, San Lorenzo,
Sagrestia Nuova.

era stata applicata sul tono ocra aranciato del-l'argilla cotta, probabilmente per alludere al colo-re del marmo dell'originale michelangiolesco.

Dal confronto con l'*Aurora* di Michelangelo, nella terracotta la posizione della figura risulta accu-ratamente rispettata, come lo sono, a un grado molto elevato, le proporzioni e la resa dell'anato-mia. Non con la stessa puntualità sono rese le forme della statua marmorea in altre copie ridotte, di dimensioni inferiori a questa di circa un terzo, quali per esempio l'*Aurora* del Victoria & Albert (POPE HENNESSY 1964, cat. 446), e quella della Col-lezione Chigi Saracini (GENTILINI-SISI in *Scrittura* 1989, cat. 35a-b), dove la figura è adagiata su una base rettilinea e il corpo si distende perdendo la decisa angolazione del busto (quasi 45°) che è propria dell'originale michelangiolesco.

L'unica parte del corpo in cui si notano diffe-renze tra la terracotta del Tribolo e il suo mo-dello è il volto, che nella riduzione si connota per un fluire più morbido e continuo delle linee e delle forme, e l'espressione intensa, quasi ve-nata di angoscia, dell'*Aurora* del maestro viene meno nella copia, dove l'ovale si fa più pieno, si distende la ruga tra gli occhi, che diventano più grandi e meno profondi, le labbra, carnose, perdono quell'accento vagamente amaro per arricchirsi di una nota sensuale.

L'artista ha poi modellato con qualche libertà il panneggio su cui la figura è distesa, accurata-mente definito nelle pieghe e nella minuta fran-gia che rifinisce i bordi, mentre un trattamento più sommario è riservato alla massa di argilla che sostiene la schiena come pure alla doppia voluta che funge da supporto, richiamando la forma del sarcofago mediceo.

Rispetto all'originale marmoreo, la terracotta sembra assumere una qualità più terrena, pal-pabile quasi nella sua evidenza fisica, e nel complesso, pur nell'àmbito di una sostanziale fedeltà, la forza del modellato michelangiole-sco si stempera nella copia in un'eleganza raf-finata dove l'armonia delle forme ha il soprav-vento sul significato simbolico dell'opera.

Il pezzo è stato restaurato per la presente mostra.

NICCOLÒ PERICOLI called IL TRIBOLO
(Firenze 1497-1550)
after MICHELANGELO

Dawn

1534-1537
Terracotta
55 x 53 x 27 cm
Firenze, Museo Nazionale del Bargello, Inv. 313S

The two couples of figures, representing person-ifications of the "times of day" and allegories of the incessant flux of time were created by Michelangelo as embellishments for the sarco-phagi of the tombs of Lorenzo de' Medici, Duke of Urbino and Giuliano de' Medici, Duke of Ne-mours, in the New Sacristy of San Lorenzo; they were completed between June and August of 1531 (G. B. Mini's letter to Baccio Valori, Sep-tember 29, 1531 in BUONARROTI 1965-1983, III, pp. 329-333). From that moment on, the statues stirred enormous enthusiasm and admiration, exercising an extraordinary influence on man-nerist sculptors and painters (Cat. 13). This was also due to the diffusion of the creative ideas of Michelangelo promoted by the Academy of Design, which from 1563 to 1567 convened in the Medici Chapel itself thus favoring the produc-tion and sale of smaller copies to artists and col-lectors (BERTI in *Adolescente* 2000, pp. 46-47). Among the many copies produced – the majori-ty reduced in size and made out of terracotta, stucco or bronze – some can still be found in public and private collections. The terracotta sculptures representing *Dawn*, *Dusk* and *Day* now in the Museo del Bargello have been recog-nized as those executed by Tribolo (ROSSI 1932, p. 210) mentioned by Vasari in his biography of the artist (VASARI 1568/1966-1997).

According to Vasari, the series was missing the figure of *Night* from its origin because Tribolo had given it to the prior of San Lorenzo, Giovanni Battista Figiovanni, in thanks for the canon's per-mission to visit the chapel during the execution of the copies. The whereabouts of the sculpture, subsequently donated to Duke Alessandro de' Medici who later gave it to Vasari, is presently unknown. A former hypothesis (ROSSI 1893), never corrected by Tolnay (1948), based on an error in identification, mistook the *Night* for a terracotta figure now in the Victoria and Albert Museum representing *Dawn* instead (POPE-HENNESSY 1964, cat. 446).

In the years preceding the creation of these co-pies, Niccolò Tribolo had worked on the com-pletion of two statues representing the *Earth* and the *Heaven* that were part of an earlier dec-orative scheme for the Medici tombs (Cat. 7). At that time, as Vasari recounts, Tribolo was afflict-ed with serious health problems. The subse-quent interruption of the work in the Sacristy due to the death of Clement VII and the depar-ture of Michelangelo for Rome in 1534 changed the course of events, dissipating any hopes of the collaboration of Tribolo and other young Flo-rentine artists on the works of Buonarroti.

In the wake of these events, the execution of the copies by Tribolo coincide chronologically with a the period in the artist's career – between 1534 and 1537, the year of the assassination of Duke Alessandro de' Medici – characterized by low productivity and psychological stress. Like the male allegories of *Day* and *Dusk* in the Bargello series, the *Dawn* is sculpted in clay and completely finished on its backside with surface marks made by thin incised parallel lines that accentuate graphically the morphology of the volumes. Originally, the figure rested on four small pilasters in terracotta that joined as a whole with the upper zone. The loss of these elements subsequently necessitated the con-struction of the present wooden bases that allude to the form of the Medici tomb. The ter-racotta, hollowed out in its lower portion up to the interior of the figure, demonstrates effec-tively the expertise in clay sculpting for which Tribolo was famed and frequently consulted as arbiter in controversies regarding works of that type (BALDINI 2000, p. 23).

Despite the damages from the flood of 1966 and the wax patina applied to the terracotta, aimed in part at attenuating the fractures and recon-structions, the clear finish that was originally applied to the orange ochre tone of the fired clay is fairly well preserved. It was probably intended to allude to the color of the marble in the Michelangelesque original.

The position of the terracotta figure reproduces accurately that of the *Dawn* of Michelangelo and, on a very high level, its proportions and anatom-ical description. This punctual replication of the forms of the marble statue is not found in other undersized copies, smaller than this one by a third, such as the *Dawn* in the Victoria and Albert (POPE HENNESSY 1964, cat. 446), as well as the exemplar in the Chigi Saracini Collection (GEN-TILINI-SISI in *Scultura* 1989, cat. 35a-b) where the figure rests on a rectilinear base and the body lies in a pose lacking the decided angulations of the bust (almost 45 degrees) evident in the Miche-langelesque original.

The only part of the body in which differences between Tribolo's terracotta and its model are notable is in the face, that in the smaller copy is distinguished by a softer and continuous flow of the lines and forms. The intense expression, almost stirred by anguish in the *Dawn* of the master is lacking in the copy, where the oval is fuller and the wrinkle between the bigger and shallower eyes smoothed; the fleshy lips also lose that vaguely bitter accent to curl up in a sensual note. Additionally, the artist modeled the drapery on which the figure is resting with a certain freedom, accurately defining its pleats and the minute fringe on its borders. Concur-rently, a more summary treatment has been re-served for the clay mass that supports the back and also for the double volute that functions as a support, recalling the form of the Medici sar-cophagus. With respect to the marble original, the terracotta sculpture appears to assume a more earthy quality, almost palpable in its phys-ical prominence; overall, within a context of substantial fidelity, the force of Michelangelo's modeling is tempered in the copy by a refined elegance in which the harmony of form sur-passes the symbolic meaning of the work. The piece has been restored for the exhibit.

Maria Grazia Vaccari

BIBLIOGRAFIA / BIBLIOGRAPHY
VASARI 1568/1966-1997, V, p. 204-205; ROSSI 1893, p. 13; ROSSI 1932; TOLNAY 1948, III, p. 155.

Cat. 15

IGNOTO SCULTORE DEL CINQUECENTO
da MICHELANGELO

La Notte

Seconda metà XVI secolo
Terracotta
cm 29 x 31 x 11
Roma, Museo Nazionale di Palazzo Venezia, Inv. 13441

La piccola terracotta riproduce una delle quattro figure allegoriche che Michelangelo scolpì per le tombe medicee nella Sagrestia Nuova di San Lorenzo. Testimonianza della straordinaria fortuna che le statue ebbero presso gli artisti contemporanei e che non conobbe interruzioni nei due secoli successivi, l'opera proviene dalla cospicua collezione dello scultore e restauratore romano Bartolomeo Cavaceppi, appassionato collezionista e figura di spicco nel commercio antiquario della capitale nell'ultimo quarto del Settecento.

Il Cavaceppi aveva disposto che dopo la sua morte, avvenuta nel 1799, l'Accademia di San Luca accogliesse la sua collezione che comprendeva, oltre a marmi e disegni, una vasta raccolta di modelli e bozzetti, ma la volontà dell'artista non riuscì a trovare realizzazione e attraverso varie vicende che sono state ricostruite (BARBERINI GASPARRI 1994), la *Notte* è arrivata infine a Palazzo Venezia nel 1948 dalla collezione del cantante greco Evan Gorga (*Catalogo* 1948, p. 9, Inv. 130), insieme con il nucleo più consistente dei modelli e bozzetti posseduti dal Cavaceppi. Da quel momento l'attribuzione a Michelangelo che aveva accompagnato la terracotta fin dalla nota scritta dello scultore-restauratore romano del 1770, è stata sostituita da una più generica indicazione di copia da Michelangelo, fino alla recente attribuzione al Tribolo (BARBERINI 1996).

Dal confronto con l'originale marmoreo, il busto della *Notte* presenta una torsione meno evidente, come pure risulta leggermente variata l'inclinazione decisa della testa sul petto, evocativa dell'abbandono che segue il sonno; inoltre viene a indebolirsi nella riduzione il forte effetto di "contrapposto" voluto da Michelangelo e da lui accentuato portando la gamba sinistra più in alto, in modo da conferire alla figura una forma chiusa. Mancano poi del tutto la civetta, la maschera, gli emblemi del sonno, come pure la treccia sul lato destro, mentre i capelli sono raccolti da un velo che ricade sulla schiena. Il panneggio sotto la figura non è neppure accennato e una massa di argilla sommariamente abbozzata funge da appoggio. Tali differenze rispetto all'originale, più accentuate che nelle altre copie conosciute, e la mancanza dei simboli, hanno indotto a supporre di recente (DELLA CHIESA D'ISASCA 2001-2002, p. 15) un rapporto tra la *Notte* di Palazzo Venezia e un bozzetto, identificato con la terracotta della Collezione Pietri di Caracas, precedente al modello a grandezza naturale. A

parte la difficoltà della critica più recente (CECCHI in *Adolescente* 2000, p. 192) nel riconoscere a Michelangelo l'*Aurora* e la *Notte* della collezione argentina, considerate semmai copie di modelli dell'artista, l'ipotesi prima riferita, sebbene non del tutto priva di suggestioni, resta opinabile in mancanza di ulteriori elementi che conducano nella stessa direzione.

Andata dispersa la *Notte* della serie del Bargello, risulta oggi impossibile un confronto tra le due copie, che sarebbe stato illuminante per la discussione sull'ipotesi di attribuzione allo stesso scultore della *Notte* qui presentata.

Per avere comunque qualche elemento di valutazione potrà forse essere di aiuto un'analisi comparata con l'*Aurora* del Tribolo, presente pure in mostra (Cat. 14). Sarà intanto da osservare che la *Notte*, più piccola di circa un terzo rispetto all'*Aurora* del Bargello, mostra una superficie molto levigata, non c'è alcuna traccia di patinature, né di quelle sottili linee incise in fase di modellazione e di rifinitura che sottolineano graficamente i volumi della terracotta del Tribolo. Al di sotto della base è stata praticata una parziale svuotatura della massa per favorire la cottura. Ma, nonostante l'indubbia qualità del pezzo, non pare di poter ravvisare elementi, né tecnici né stilistici, chiaramente riconducibili a un particolare scultore, né risulta avvertibile alcuna consonanza con l'interpretazione che, pur nella sostanziale fedeltà della copia, il Tribolo fornisce della statua di Michelangelo accentuando, rispetto alla potente rappresentazione allegorica della statua distesa sul sepolcro di Lorenzo de' Medici, l'eleganza fluida delle forme allungate e la morbida sensualità del corpo femminile. Di conseguenza sembrerebbe troppo precoce e priva di argomenti una datazione intorno al 1534.

La terracotta romana mostra ampi rifacimenti nel braccio destro, nel collo, nel velo, riferibili a epoca moderna, dal momento che è stato usato un impasto di colore diverso per differenziare volutamente l'integrazione. Mancano invece totalmente il piede destro, le dita del sinistro ed è danneggiato il naso.

ANONYMOUS SCULPTOR OF THE CINQUECENTO
after MICHELANGELO

Night

Second half of XVI century
Terracotta
29 x 31 x 11 cm
Roma, Museo Nazionale di Palazzo Venezia, Inv. 13441

The small figure in terracotta reproduces one of the four allegorical figures that Michelangelo sculpted for the Medici Tombs in the New Sacristy of San Lorenzo, proof of the extraordinary regard the statue enjoyed among contemporary artists and that continued without interruption for two

centuries to come. The work comes from the extensive collection of the Roman sculptor and restorer Bartolomeo Cavaceppi, a passionate collector and prime figure on the Roman art market during the last quarter of the Settecento.

Upon his death in 1799, Cavaceppi willed his collection to the Academy of St. Luke. It included a vast collection of models and preparatory studies as well as marbles and drawings.

His wishes however were never carried out and through a series of circumstances that have been retraced by Barberini Gasparri (1994), the *Night* came to Palazzo Venezia in 1948 from the collection of the Greek singer Evan Gorga (*Catalog* 1948, p. 9, Inv. 130), together with the most substantial nucleus of models and preparatory studies from the Cavaceppi collection. At that time, the attribution to Michelangelo, assigned to the terracotta since the note written by the Roman sculptor-restorer in 1770, was classified more generally as a copy after Michelangelo, until the recent attribution to Tribolo (BARBERINI 1996).

As compared to the marble original, the torsion of bust of Night is less evident and the inclination of the head towards the chest, evoking the abandonment of sleep, is slightly varied; additionally, weaker in the smaller version is the effect of "contrapposto" created by Michelangelo and accentuated by higher positioning of the left leg that gives the figure a closed form. Completely absent are the owl, the mask, the emblems of sleep as well as the braid on the right side; the hair instead is gathered in a veil that falls down the back of the figure. The drapery under the figure is totally absent and a mass of roughly formed clay functions as a base. These differences with respect to the original, more accentuated than in the other known copies, as well as the lack of symbols, has induced the recent supposition (DELLA CHIESA D'ISASCA 2001-2002, p. 15) that relations exist between the *Night* of Palazzo Venezia and a preliminary study, identified with the terracotta in the Pietri collection in Caracas, thought to be earlier than the life size original. Regardless of the reticence of recent critics

(CECCHI in *Adolescente* 2000, p. 192) to recognize the hand of Michelangelo in the *Dawn* and *Night* in the Argentine collection that are considered at most to be copies of models by the artist, the aforementioned hypothesis, though fascinating, remains doubtful also for lack of further indications that point to the same conclusion.

Due to the loss of the *Night* once part of Tribolo's Bargello series, the two copies cannot be compared – an assessment that certainly would have proved useful in evaluating the hypothetical attribution to the same sculptor of the statue under exam. To find an evaluative element perhaps the *Dawn* by Tribolo, on exhibit here (Cat. 14), is the best aid in a comparative analysis. The first thing to notice is that the *Night*, smaller by a third than the *Dawn* in the Bargello, has a very smooth surface and no trace of patina nor those subtle incised lines made in the modeling and refinishing process that graphically underline the volumes in Tribolo's terracotta figure. The mass of the figure has been partially emptied from under the base in order to facilitate the firing process. But despite the statuette's undoubted quality, there seems to be neither technical nor stylistic elements that can

clearly be referred to a single sculptor. Nor is there any apparent relation with the interpretation that Tribolo, despite the substantial fidelity to the original, furnishes of statue by Michelangelo in which, as compared to the powerful allegorical representation of the figure resting on the tomb of Lorenzo de' Medici, the accent falls on the fluid elegance of the elongated forms and the softened sensuality of the female body. Therefore, a date for this piece of around 1534 would seem too early.

The Roman terracotta presents consistent restoration on the right arm, the neck, and the veil. These are certainly modern interventions given that there is a deliberate change in the color of the clay permitting the identification of the original with respect to the modern restorations. The right foot, the toes of the left are totally missing and the nose has been damaged.

Maria Grazia Vaccari

BIBLIOGRAFIA/BIBLIOGRAPHY
BARBERINI-GASPARRI 1994; BARBERINI in *Masterpieces* 1996, cat. 5, p. 48; DELLA CHIESA D'ISASCA 2001-2202.

15-a. Michelangelo, *Notte / Night*, Firenze, San Lorenzo, Sagrestia Nuova.

ma quella dell'uovo con l'ombra portata sul terreno così come è rappresentato nelle tre incisioni sopra citate. Si tratta solo di una ipotesi, che sembra però incoraggiata anche dallo stile della versione veneziana, elegante, sensuale, di una fattura morbida e tenera, di un colorismo lucente e intenso, caratteri che rimandano alla mano di un artista italiano prossimo alla cultura artistica sofisticata della corte di Fontainebleau. Il problema dell'attribuzione dell'opera del Correr rimane comunque una questione aperta, nonostante le svariate ipotesi che in passato sono state formulate senza però alcun riscontro attendibile. Il dipinto è stato infatti attribuito a Bettino del Bene, a un seguace del Correggio, a Daniele da Volterra, al Pontormo, a un pittore veneto del XVI secolo (MARIACHER 1957, con bibliografia); rimane comunque un'indicazione verosimile quella del Tolnay che riferisce l'opera del museo veneziano a un pittore cinquecentesco del nord Italia (TOLNAY 1948).

NORTHERN ITALIAN (?) MASTER
after MICHELANGELO

Leda
Fourth-fifth decade of the XVI century
Oil on wood
114.5 x 115.5 cm
Venezia, Museo Correr, Inv. 1295

The work is a copy of the *Leda* painted by Michelangelo in tempera on wood between 1529 and 1530 for Alfonso I d'Este, destroyed in the XVII century. As is known, the patron never received the painting or the relative cartoon and the artist gave it to his collaborator Antonio Mini with instructions to sell the panel to Francis I. Janet Cox-Rearick has traced the complex and controversial tale of the two Michelangelesque creations, brought the following year to Paris by Mini, in this volume (Cat. 17).
Early sources attest to the existence of numerous copies of the Michelangelesque original, proof of the interest his invention stimulated. Once in France, Mini himself together with Benedetto del Bene were among the first to replicate the famous composition that could have been studied directly from either the cartoon that had returned to Florence in 1540 or the painting itself, initially found in the house of Giuliano Buonaccorsi, treasurer of the King of France, and later possibly transferred to the royal residence at Fontainebleau.
The three engravings by Étienne Delaune, Cornelis de Bos and Nicola Béatrizet (Cat. 18), apparently are modeled after the painting with a few variations. They all include the egg from which the twin Dioscurus had been born, fruit of the union of the two lovers – a detail included in Condivi's description of the painting by Buonarroti (CONDIVI 1553/1746, pp. 36-37; RAGIONIERI in

Cat. 16 (Tav. VIII/2)

ARTISTA DEL NORD ITALIA (?)
da MICHELANGELO

Leda
Quarto-quinto decennio del XVI secolo
Olio su tavola
cm 114,5 x 115,5
Venezia, Museo Correr, Inv. 1295

L'opera presenta una copia dalla *Leda* dipinta da Michelangelo a tempera su tavola fra il 1529 e il 1530 per Alfonso I d'Este, andata distrutta nel XVII secolo. Come è noto, il dipinto e il relativo cartone non pervennero mai nelle mani del loro committente ma furono dati dall'artista al suo collaboratore Antonio Mini, che ebbe l'incarico di vendere la tavola a Francesco I. La complessa e controversa storia delle due opere michelangiolesche, portate l'anno seguente a Parigi dal Mini è ripercorsa in questa sede da Janet Cox-Rearick (Cat. 17).
Già le fonti ricordano varie copie dell'opera del Buonarroti, che testimoniavano l'interesse suscitato dalla sua invenzione. Una volta in Francia, lo stesso Mini insieme a Benedetto del Bene furono fra i primi artisti che replicarono la celebre composizione michelangiolesca. Quest'ultima poteva essere desunta da due fonti dirette: il cartone tornato a Firenze nel 1540 e il dipinto entrato prima in casa di Giuliano Buonaccorsi, tesoriere del re di Francia, e poi forse trasferito nella residenza reale di Fontainebleau.
Al dipinto sembrano far riferimento le tre incisioni di Étienne Delaune, Cornelis de Bos e Nicola Béatrizet (Cat. 18), le quali con poche varianti

includono l'uovo appena partorito e i due Dioscuri fanciulli nati dal congiungimento dei due amanti, particolari inclusi dal Condivi nella descrizione del quadro del Buonarroti (1553/ 1746, pp. 36-37; RAGIONIERI in *Vita* 2001, pp. 79-80, n. 50). Rispetto a queste incisioni, nella copia dipinta del Museo Correr, come nelle altre a noi pervenute, non sono rappresentati il parto di Leda né i fanciulli; inoltre al posto della veste con l'ampia manica pendente alle spalle della donna si trova un semplice drappo, mentre il cigno appoggia il collo sull'amata senza affondare nelle pieghe del suo ventre (per le copie dalla *Leda* di Michelangelo: ROY 1923, pp. 65-82; TOLNAY 1948, pp. 192-193; BAROCCHI 1962, pp. 101-126; FALCIANI e SCHMIDT in *Leonardo* 2001, pp. 164-167, nn. IV.5 e IV.6). È stato quindi ipotizzato che tali opere non derivino dalla tavola dipinta ma dal cartone che, tornato a Firenze nel 1540, probabilmente comprendeva solo le figure dei due amanti in una versione non del tutto definitiva (CARROLL 1987-1988, n. 102, seguita da COX-REARICK 1995, pp. 237-241, 275-277). Di diverso parere è invece Carlo Falciani – insieme a parte della critica precedente – secondo il quale il dipinto di Michelangelo non giunse mai a Fontainebleau dove si trovava in sua vece una copia parziale, unico punto di riferimento per le altre (FALCIANI in *Leonardo* 2001, pp. 164-165, n. IV. 5).
A nostro parere, bisogna comunque tenere presente il fatto che il dipinto di Michelangelo risulta presto in condizioni assai precarie (Cox-Rearick in Cat. 17) e probabilmente di difficile lettura tanto da dare adito a fraintendimenti. Frutto di questi fraintendimenti potrebbe essere nell'opera del Museo Correr quella sorta di manica su un drappo rosso in primo piano a sinistra, la cui forma richia-

Vita 2001, pp. 79-80, n. 50). As compared to the engravings, the painted copy in the Correr Museum as well as other surviving replicas, do not include the representation of either Leda's birth giving or the children; additionally, the garment with the full sleeve hanging from the shoulder of the woman is replaced by a simple drapery and the neck of the swan, instead of sinking into the folds of her abdomen, merely rests on her lightly (for the copies of *Leda* by Michelangelo: ROY 1923, pp. 65-82; TOLNAY 1948, pp. 192-193; BAROCCHI 1962, pp. 101-126; FALCIANI-SCHMIDT in *Leonardo* 2001, pp. 164-167, nos. IV.5 and IV.6). These omissions have led to the hypothesis that these works do not depend on the painting but rather on the cartoon that was in Florence after 1540 and probably included only the figures of the two lovers in a somewhat unfinished state (CARROLL 1987-1988, no. 102, followed by COX-REARICK 1995, pp. 237-241, 275-277). However,

Falciani – with some earlier scholars – conversely maintains that the painting by Michelangelo never reached Fontainebleau where, in its stead, only a partial copy existed as a reference point for the other copies (FALCIANI 2001, pp. 164-165, no. IV.5).

It should be remembered, however, that early in the history of the work by Michelangelo, its relatively precarious conditions and problematic legibility (Cox-Rearick in Cat. 17) gave rise to misinterpretations. In the Correr painting, the sleeve shown against the red drapery could possibly be fruit of a similar misreading, its form and shadow on the ground recalling that of the egg as it is seen in the three engravings cited above. This mere hypothesis finds support however in the elegant, sensual Venetian style of the painting characterized by soft and tender handling and an intense and lucent use of color that points to the hand of an Italian artist close to the sophisticated

artistic milieu of the court of Fontainebleau. Nonetheless, the attribution of the Correr painting remains an open debate despite the varied hypotheses formulated in the past, none however with a solid basis. The painting has in fact been assigned to Bettino del Bene, to a follower of Correggio, to Daniele da Volterra, to Pontormo, to a XVI century Venetian master (MARIACHER 1957, with bibliography), the most accurate indication remaining the one advanced by Tolnay who assigned the painting now in the Venetian museum to a Northern Italian master of the sixteenth-century (TOLNAY 1948).

Elena Capretti

BIBLIOGRAFIA / BIBLIOGRAPHY
TOLNAY 1948, p. 193, fig. 283; BAROCCHI 1950, pp. 79-80; MARIACHER 1957, pp. 188-189.

Cat. 17 (Tav. IX/3)

**attr. a GIOVANNI BATTISTA DI JACOPO
detto IL ROSSO FIORENTINO**
(Firenze 1494-Paris 1540)
da MICHELANGELO

Leda

1533-1538 ca.
Matita nera
cm 170 x 248
London, Royal Academy of Arts, Inv. 156

Oltre alle allegorie dei momenti del Giorno – l'*Aurora* e la *Notte* (Catt.14, 15) – eseguite da Michelangelo per la Sacrestia Nuova di San Lorenzo, il più importante precedente del monumentale nudo femminile disteso della sua *Venere e Cupido* (Cat. 23) fu la *Leda* del 1529-1530. Dato che il dipinto andò distrutto in Francia alla fine del XVII secolo, qui viene esposto un disegno attribuito a Rosso Fiorentino copiato in Francia alla metà degli anni Trenta del Cinquecento da un cartone per il dipinto.
Gli eventi che ruotarono intorno alla commissione e all'esecuzione della *Leda* sono collegati dai biografi di Michelangelo al contesto della vita dell'artista nel 1529-1530. Il Vasari (1550/1966 - 1997, VI, p. 62) narra che Michelangelo «diede fine a una Leda in tavola lavorata a tempera, che era divina, la quale mandò poi in Francia per Anton Mini suo creato». Il Condivi (1553/1746, pp. 36-37) parla della commessa dell'opera a Michelangelo, che nel 1529 era in missione politica a Ferrara, da parte del duca Alfonso d'Este, e continua: «E tornato a Firenze, tuttavia principiò un quadrone di sala, rappresentando il concubito del

Cigno con Leda: ed appresso, il parto dell'uova, di che nacquero Castore e Polluce [la "prolessi"], secondoché nelle favole degli antichi scritto si legge». Michelangelo potrebbe avere scelto quel soggetto per incontrare il gusto del committente di uno studiolo decorato con scene di baccanale da Giovanni Bellini e Tiziano, il cui *Baccanale degli Andriani* mostra un sensuale nudo femminile disteso, con la cui bellezza Michelangelo potrebbe bene aver desiderato che la sua *Leda* competesse (WALLACE 2001, pp. 480-485). Michelangelo terminò la *Leda* nell'ottobre del 1530, ma non la consegnò mai al suo committente, il duca (ROSENBERG 2000, pp. 89-100).
Alla genesi della *Leda* è collegato un gruppo di disegni di Michelangelo su un modello maschile (WILDE 1957, pp. 270-280): un torso di figura distesa (Firenze, Archivio Buonarroti, codex XIII, c. 151 *verso*); un torso e una coscia sinistra di figura distesa (che richiama anche uno per la *Notte* nella Sacrestia Nuova; London, British Museum, Inv. 1859-6-25-569); un nudo disteso (Firenze, Galleria degli Uffizi, Gabinetto Disegni e Stampe, Inv. 611F *verso*); un braccio destro disteso (Firenze, Casa Buonarroti, Inv. 60F); e una testa (Firenze, Casa Buonarroti, Inv. 7F).
La storia della *Leda* di Michelangelo in Francia dal 1531 al 1536 è estremamente complessa (COX-REARICK 1995, pp. 237-240 e bibliografia). I resoconti dei biografi di Michelangelo, lettere del 1530-1536, e un ricordo del 1540 rivelano che nel 1531 Michelangelo consegnò l'opera (e il cartone) al suo garzone Antonio Mini, che la trasportò a Lione. Lì si fece fare tre copie e la portò a Parigi con l'intenzione di venderla al re Francesco I. Sappiamo da una lettera di Mini del 1532 (o 1533) che la *Leda*, il suo cartone e una copia eseguita da Benedetto del Bene furono

tutti consegnati al tesoriere del re, Giuliano Buonaccorsi, a Luigi Alamanni e al Rosso, che fece una grande e pesante cornice per la tavola di Michelangelo. Nel valutare questa importante prova documentaria è importante tenere in mente che l'originale era un grande pannello dipinto a tempera. Se il disegno della Royal Academy, fatto sul cartone per l'opera, che misura cm 170 x 248, riflette la misura dell'originale, questo era davvero un *quadrone*, come lo chiama il Condivi. Alla morte di Mini, avvenuta nel 1533, fu intentata una causa, di esito sfavorevole, affinché la *Leda* di Michelangelo fosse riconsegnata agli eredi di Mini, ma a partire da questo punto non vi è più alcun resoconto di prima mano circa il dipinto (COX-REARICK 1995, pp. 240-241 e bibliografia). L'evidenza suggerisce comunque in termini stringenti che il dipinto entrò a fare parte della collezione di Francesco I direttamente dal Buonaccorsi, dato che il Rosso ebbe pagata la sua parte nel 1536 per il trasferimento dalla casa del Buonaccorsi al castello reale di Fontainebleau di un dipinto di Leda di proprietà del re.
In Italia nel tardo XVI secolo era opinione comune che la *Leda* di Michelangelo fosse effettivamente nella Collezione reale. Scrive Condivi: «fu mandata in Francia, e dal Re Francesco comperato, dove ancora è». VASARI (1568/1966-1997, VI, p. 64), seguito da successivi autori italiani e francesi, specifica che fu venduta al re e rimase al castello, mentre il cartone relativo, insieme agli altri cartoni e ai disegni di Michelangelo che Mini aveva con sé, furono rimandati a Firenze.
A dispetto della ripetuta testimonianza che il dipinto di Michelangelo si trovasse a Fontainebleau, i successivi "avvistamenti" della *Leda* in quel luogo sono problematici, data specialmente una documentata esistenza di tre copie fatte dal cartone. Un dipinto di Michelangelo lì fu visto nel 1630, ma non ne è citato il titolo fino al 1642, quando il Père Dan, curatore della collezione d'arte di Fontainebleau, descrisse una *Leda* di Michelangelo (1642, p. 134). Si trattava probabilmente dell'originale: è il primissimo dipinto nel capitolo sul *Cabinet des Peintures*, incluso, come disse, per il prestigio del suo autore, malgrado le condizioni di degrado dell'opera. Tali condizioni potevano benissimo essere dovute al fatto di essere stato dipinto a tempera e, forse, non essere mai stato terminato (COX-REARICK 1995, p. 241).
La storia seguente della *Leda* di Michelangelo è fatta di leggende, dicerie e confusione tra varie versioni dell'opera (COX-REARICK 1995, p. 241 e bibliografia). Non vi è nessuna *Leda* di Michelangelo tra i dipinti inventariati a Fontainebleau nel 1683 o nel 1692; una nota del 1691 a una voce d'inventario relativa al disegno ora alla Royal Academy fornisce tuttavia un'informazione di fondamentale importanza circa la sorte del dipinto di Michelangelo (*Inventaire* 1899, p. 623): «La Regina Madre ha bruciato la tavola».
La distruzione della *Leda* di Michelangelo da parte della bigotta Anna d'Austria a causa del suo soggetto lascivo, menzionata più volte da

fonti del tardo XVII secolo e del XVIII, è sintomatica di un profondo cambiamento nel gusto francese circa l'arte di Michelangelo. Sembra così verosimile che la storia del rogo sia vera, sebbene sia oggi impossibile essere in assoluto certi se a subire tale destino sia stato l'originale di Michelangelo o una copia ritenuta l'originale.

La composizione della perduta *Leda* michelangiolesca è documentata da incisioni cinquecentesche di Nicolas Béatrizet (Cat. 18), Étienne Delaune e Cornelius Bos (a rovescio), così come in numerose copie dipinte o disegnate nello stesso verso dell'originale. Poiché queste non mostrano la prolessi o il vestito di Leda, che compaiono invece nelle incisioni tratte dall'originale di Michelangelo, devono essere state tratte dal cartone (CARROLL in ROSSO 1987). Tre di esse sono qui in mostra: il grande disegno attribuito al Rosso, che è l'argomento di questa scheda; un dipinto di artista dell'Italia Settentrionale (?) (Cat. 16) e un disegno a matita rossa che sembra essere stato eseguito dal Correggio, nel Nord d'Italia, prima che Mini portasse il dipinto e i cartoni in Francia nel 1532 (Cat. 19).

La più importante di queste copie è il disegno attribuito al Rosso, che eseguì tale opera a Fontainebleau. Stando al Vasari (1568/1966-1997, IV, p. 489), dopo la morte del Rosso «si trovarono anco fra le sue cose, due bellissimi cartoni: in uno de' quali è una Leda che è cosa singolare». Sarebbe estremamente strano che il Rosso non avesse fatto questo disegno basandosi sul cartone di Michelangelo che Mini aveva portato a Parigi insieme al dipinto di *Leda* nella primavera del 1532. Come accennato sopra, un aspetto che condivide con la supposta composizione del cartone è l'illustrare *Leda*, il cigno e la disposizione dei drappeggi, ma non la prolessi e l'abito di Leda, che compaiono nell'incisione basata sul dipinto (Cat. 18).

L'associazione del disegno di Londra con il cartone di cui riferisce il Vasari dipende dall'accettazione della sua attribuzione al Rosso, che fu stabilita da Béguin e Carroll e che è stata generalmente accettata (COX-REARICK 1995, SCAILLIÉREZ 1992). Bisogna tuttavia ammettere che, per essere una copia di opera di altro artista, il disegno non mostra nessuno dei manierismi grafici del Rosso. È per questa ragione che Franklin (1988), seguito da Falciani (2001), mette in dubbio l'attribuzione al Rosso, oltre che per la poca logica ravvisabile nel fatto che il Rosso avesse eseguito una tale copia elaborata di un'opera che il suo protettore, il re, già possedeva.

Carroll paragona il disegno del Rosso all'incisione di Bos, segnalando il cambio di enfasi in Rosso, dalla potenza fisica dell'immagine michelangiolesca a una figura più elegante e allungata, mantenendo la sua estetica di sudente grazia, e fa analogie con le opere eseguite da Rosso intorno al 1536-1538. Carroll sposta così la datazione della *Leda* del Rosso al 1538 o a un momento successivo, segnalando inoltre che l'essere stata ritrovata nello studio del pittore dopo la sua morte, nel 1540, potrebbe indicare che fu eseguita in preparazione di un dipinto, l'esecuzione del quale fu impedita dalla morte.

Lo stabilire che il disegno di Londra provenga dalla collezione reale francese è anche in qualche modo problematico, poiché la sua moderna storia inglese inizia solo dal momento della sua comparsa nel 1771 nella collezione di William Lock il Vecchio, dove era erroneamente ritenuto il cartone per la *Leda* dello stesso Michelangelo. Malgrado l'incompletezza della sua storia, tuttavia, si può dimostrare la tesi che Francesco I lo abbia acquistato alla morte del Rosso e che il disegno sia rimasto nella collezione reale fino al momento in cui vi fu inventariato per l'ultima volta nel 1691. Un disegno di *Leda* è tra i cinque lavori di Rosso elencati da Cassiano dal Pozzo nel 1625 (MÜNTZ 1885): «una Leda col Cigno, fatta dal disegno di quella di Michel Agnolo». Un disegno di *Leda*, che deve essere lo stesso, è incluso nell'inventario di Le Brun del 1683 (BREJON DE LAVERGNÉE 1987) e in uno del 18 giugno 1691 (*Inventaire* 1899). Come sopra menzionato, c'è a questa voce d'inventario una nota in cui si dichiara che il dipinto di Michelangelo era stato bruciato. La nota conclude, riferendosi al disegno, «da bruciare». La comparsa del lavoro del Rosso nel 1771 in Inghilterra sembrerebbe suggerire che esso si sottrasse al destino del dipinto di Michelangelo, forse per essere alienato mediante vendita in una data tra il 1691 e il 1709, data dell'Inventario Bailly della Collezione reale, in cui esso non compare.

attr. to GIOVANNI BATTISTA DI JACOPO
called IL ROSSO FIORENTINO
(Firenze, 1494-Paris 1540)
after MICHELANGELO

Leda

c. 1533-1538
black chalk
170 x 248 cm
London, Royal Academy of Arts, Inv. 156

Besides Michelangelo's allegories of the Times of Day – the *Dawn* and the *Night* (Cats. 14, 15) – in the New Sacristy of San Lorenzo, the major precedent for the monumental female reclining nude in Michelangelo's *Venus and Cupid* (Cat. 23) was his *Leda* of 1529-1530. Since the painting was destroyed in France in the late seventeenth century, a drawing attributed to Rosso Fiorentino, which was copied in France in the mid-1530s after the cartoon for the painting, is exhibited here.

The events surrounding the commission and execution of the *Leda* are related by Michelangelo's biographers in the context of the artist's life in 1529-1530. Vasari (1550/1966-1997, VI, p. 62) relates that "Michelangelo completed a Leda in tempera on panel, which was divine and which he then sent to France with his pupil Antonio Mini".

Condivi (1553/1746, pp. 36-37) tells about Duke Alfonso d'Este's commission of the work from Michelangelo, who was on a diplomatic and military mission to Ferrara in 1529, continuing: "When he returned to Florence, [...] he began a large easel painting representing the union of Leda and the swan, and nearby, the hatching of the egg from which Castor and Pollux [the prolepsis] were born, as we read in the ancient myths".

Michelangelo may have chosen the subject to appeal to the taste of the patron of a 'studiolo' decorated with bacchanals by Giovanni Bellini and Titian, whose *Bacchanal of the Andrians* features a sensous reclining female nude with whose beauty Michelangelo might well have wanted his *Leda* to compete (WALLACE 2001, pp. 480-485). Michelangelo finished the *Leda* in October 1530, but never delivered it to its ducal patron (ROSENBERG 2000, pp. 89-100).

A group of Michelangelo drawings after a male model are related to the genesis of the *Leda* (WILDE 1957, pp. 270-280): a torso of a reclining figure (Firenze, Archivio Buonarroti, codex XIII, c. 151 *verso*); a torso and left thigh of a reclining figure (also similar to one for the *Night* in the New Sacristy; London, British Museum 1859-6-25-569); a reclining nude (Firenze, Galleria degli Uffizi, Gabinetto Disegni e Stampe, Inv. 611F *verso*); an extended right arm (Firenze, Casa Buonarroti, Inv. 60F); and a head (Firenze, Casa Buonarroti, Inv. 7F).

The history of Michelangelo's *Leda* in France from 1531 to 1536 is extremely convoluted (COX-REARICK 1995, pp. 237-240, with bibliography). The accounts of Michelangelo's biographers, letters of 1530-1536, and a *ricordo* of 1540 reveal that in 1531 Michelangelo gave the work (and its cartoon) to his pupil Antonio Mini, who transported it to Lyon. There he had three copies made and then took it to Paris with the intention of selling it to King Francis I.

We learn from a letter from Mini of 1532 (or 1533) that the *Leda*, its cartoon, and a copy by Benedetto del Bene were all consigned to Giuliano Buonaccorsi (the king's treasurer), Luigi Alamanni, and Rosso, who made a large and heavy frame for Michelangelo's panel. In assessing this documentary evidence, it is helpful to bear in mind that the original was a large panel painted in tempera; if the Royal Academy drawing after the cartoon for it, which measures 1.70 x 2.49 m, reflects its size, it was truly a "quadrone", as Condivi termed it.

On Mini's death in 1533, there was an unsuccessful lawsuit for the return of Michelangelo's *Leda* to Mini's heirs, but thereafter this point there is no first-hand account of the painting (COX-REARICK 1995, pp. 240-241 with bibliography). The evidence, however, strongly suggests that the painting did enter the collection of Francis I directly from Buonaccorsi, for Rosso was paid in 1536 for his part in the transfer from Buonaccorsi's house to the royal château at Fontainebleau of a Leda painting belonging to the king.

In Italy in the later sixteenth century it was generally held that Michelangelo's *Leda* was indeed in the Royal Collection. Condivi writes: "It was sent to France, bought by King Francis, and it is still there" (VASARI 1568/1966-1997, VI, p. 64), followed by later Italian and French writers, specifies that it was sold to the king and remained at the château, while its cartoon and the other cartoons and drawings by Michelangelo that Mini had with him were returned to Florence.

In spite of the repeated testimony that Michelangelo's painting was at Fontainebleau, later "sightings" there of the *Leda* are problematic, especially given the documented existence of three copies made from the cartoon. A painting by Michelangelo was seen there in 1630, but it is not mentioned by name until 1642 when Père Dan, curator of the art collection at Fontainebleau, described a *Leda* by Michelangelo (1642, p. 134). This was probably the original: it is the very first painting in Dan's chapter on the *Cabinet des Peintures* – included, he says, because of its prestigious authorship and in spite of its poor condition. The ruined state of the painting may well have been due to its having been painted in tempera and, possibly, never having been finished (COX-REARICK 1995, p. 241).

The subsequent history of Michelangelo's *Leda* consists of legend, hearsay, and confusion among various versions of the work (COX-REARICK 1995, p. 241 with bibliography). There is no *Leda* by Michelangelo among the paintings inventoried at Fontainebleau in 1683 or 1692; however, a note to an inventory entry of 1691 of the drawing now in the Royal Academy provides crucial information about the fate of Michelangelo's painting (*Inventaire* 1899, p. 623): "The Queen Mother burned the painting". The destruction of Michelangelo's *Leda* by the prudish Anne of Austria because of its lascivious subject, mentioned repeatedly in the late seventeenth- and eighteenth-century sources, was a symptom of a major shift in French taste regarding Michelangelo's art. It thus seems likely that the story of the burning is true, although it is impossible now to be absolutely certain whether it was Michelangelo's original or a copy thought to be the original that suffered this fate.

The composition of Michelangelo's lost *Leda* is recorded in the sixteenth-century engravings by Nicolas Béatrizet (Cat. 18), Étienne Delaune, and Cornelius Bos (in reverse), as well as in numerous painted and drawn copies in the same direction as the original. Since these do not show the prolepsis or Leda's dress, which appear in the engravings after Michelangelo's painting, they must have been made from the cartoon (CARROLL in Rosso 1987). Three of them are exhibited here: the large drawing attributed to Rosso, which is the subject of this entry; a painting by a North Italian (?) artist (Cat. 16); and a red chalk drawing with variations in Leda's pose, which appears to have been executed by Correggio in Northern Italy before Mini took the painting and its cartoon to France in 1532 (Cat. 19).

The most important of these copies is the drawing attributed to Rosso, who executed such a drawing at Fontainebleau. According to Vasari (1568/1966-1997, IV, p. 489), after Rosso's death "two very beautiful cartoons were also found among his possessions: in one of these is a Leda of singular beauty". It would be most surprising if Rosso had not made this drawing after Michelangelo's cartoon, which Mini had brought to Paris, together with the *Leda* painting, in the spring of 1532. As noted above, a feature it shares with the presumed composition of the cartoon is its depiction of *Leda*, the swan, and the drapery setting, but not the prolepsis and Leda's dress, which appear in the engravings after the painting (Cat. 18).

The association of the London drawing with the cartoon mentioned by Vasari depends on the acceptance of its attribution to Rosso, which Béguin and Carroll established and which has been generally accepted (COX-REARICK 1995, SCAILLIÉREZ 1992). It must be admitted however, that as a copy of another artist's work, the drawing does not display Rosso's graphic mannerisms. Because of this, Franklin (1998) followed by Falciani (2001), questions the attribution to Rosso, as well as the logic of Rosso's making such an elaborate copy of a work that his patron, the king, already owned.

Carroll compares Rosso's drawing to the Bos engraving, noting Rosso's shift of emphasis from Michelangelo's powerfully physical image to a more elegant and elongated figure in keeping with his aesthetic of "ingratiating loveliness", and making analogies with Rosso's works of c. 1536-1538. Carroll thus dates Rosso's *Leda* to 1538 or later, further noting that its having been found in the painter's studio after he died in 1540 may indicate that it was made in preparation for a painting, the execution of which was precluded by his death.

The establishment of a provenance from the French royal collection for the London drawing is somewhat problematic because its modern history in England dates only from its appearance in 1771 in the collection of William Lock the Elder, where it was erroneously thought to be Michelangelo's own *Leda* cartoon. In spite of its incomplete history, however, a case may be made for its having been acquired by Francis I upon Rosso's death and remaining in the royal collection until it was last recorded there in 1691. A *Leda* drawing is among the five works by Rosso listed by Cassiano dal Pozzo in 1625 (MÜNTZ 1885): "a Leda with the Swan, taken from the drawing of her by Michelangelo". A *Leda* drawing that must be the same one is recorded in Le Brun's inventory of 1683 (BREJON DE LAVERGNÉE 1987) and in an inventory of 18 June 1691 (*Inventaire* 1899).

As mentioned above, there is a marginal note to this entry which declares that Michelangelo's painting had been burned. The note concludes, in reference to the drawing: "To be burned". The appearance of Rosso's work in 1771 in England would suggest that it escaped the fate of Michelangelo's painting, perhaps having been disposed of by sale at some date between 1691 and 1709 (Bailly's inventory of the royal collection, in which it does not appear).

Janet Cox-Rearick

BIBLIOGRAFIA / BIBLIOGRAPHY
VASARI 1550/1966-1997, IV, p. 489; MÜNTZ 1885, p. 269; *Inventaire* 1899, p. 623; BÉGUIN in *École* 1972, n. 205; BREJON DE LAVERGNÉE 1987, n. 369; CARROLL in ROSSO 1987, n. 102; FRANKLIN 1988, p. 325; SCAILLIÉREZ 1992, p. 19; COX-REARICK 1995, pp. 227, 237-241, 277; FALCIANI in *Leonardo* 2001, pp. 164-165.

Cat. 18

NICOLAS BÉATRIZET
(Lunéville 1515-? post 1565)
da MICHELANGELO

Leda

1545-1550 ca.
Incisione
mm 272 x 400
Iscrizione: «MICHEL ANGELUS INV»
Napoli, Museo Nazionale di Capodimonte,
Gabinetto Disegni e Stampe, Inv. 87688

L'incisione di Nicolas Béatrizet (attivo tra il 1532
e il 1562), tratta dalla *Leda* di Michelangelo, è

una delle tre incisioni della metà del Cinquecento
eseguita da artisti nordeuropei dal dipinto perdu-
to. Le altre sono di Étienne Delaune e Cornelius
Bos (in immagine speculare e recante l'iscrizione
«MICHAEL / ANGELUS / INVENTOR / CB»). Tutte rappre-
sentano l'attributo di Leda della prolessi – l'uovo
e i due Dioscuri – e gli elaborati drappeggi che
caratterizzano l'ambientazione e l'abito di Leda
che erano nel dipinto originale di Michelangelo.
Sebbene Béatrizet identifichi la fonte della com-
posizione in Michelangelo nell'iscrizione posta
accanto al piede destro di Leda, al contrario di
quanto si riscontra nelle altre incisioni che fece
da Michelangelo negli anni Quaranta e nei primi
anni Cinquanta del Cinquecento, questa non è fir-
mata. L'attribuzione dell'incisione fu fatta sulla
base della sua tecnica.

NICOLAS BÉATRIZET
(Lunéville 1515-? post 1565)
after MICHELANGELO

Leda

c. 1545-1550
Engraving
271 x 401 mm
Inscribed: "MICHAEL ANGELUS INV"
Napoli, Museo Nazionale di Capodimonte,
Gabinetto Disegni e Stampe, Inv. 87688

The engraving by Nicolas Béatrizet (active
1532-1562) after Michelangelo's *Leda* is one of
three mid sixteenth-century engravings by North
European artists after the lost painting; others
are by Étienne Delaune and Cornelius Bos (in
mirror image and inscribed "MICHAEL / ANGELUS /
INVENTOR / CB"). All depict Leda's attribute of the
prolepsis (the egg and the two Dioscuri) and
the elaborate drapery setting including Leda's
dress that was in Michelangelo's original paint-
ing. Although Béatrizet identifies the source of
the composition as Michelangelo in the inscrip-
tion next to Leda's right foot, in contrast to other
engravings he made after Michelangelo in the
1540s and early 1550s, it is not signed. The
attribution of the engraving to him was made on
the basis of its technique.

Janet Cox-Rearick

BIBLIOGRAFIA / BIBLIOGRAPHY
ROTILLI in *Fortuna* 1964, n. 33 (con bibliografia); CECCHI
in *Genius* 1992, n. 100; RAGIONIERI in *Vita* 2001, p. 80.

Cat. 19

attr. ad ANTONIO ALLEGRI
detto IL CORREGGIO
(Correggio 1489-1534)

Leda

1530 ca.
Matita rossa, tocchi di gessetto bianco
mm 91 x 120
Paris, Musée du Louvre,
Département des Arts Graphiques, Inv. 775

Questo disegno, chiaramente derivato dall'invenzione della *Leda* di Michelangelo, girata nello stesso senso, è stato collegato al suo nome già dalla fine dell'Ottocento. Popham fu il primo ad attribuirlo a Correggio nel 1957, basandosi senza dubbio sull'aspetto generale del disegno e l'eccellenza del tratto a matita rossa.

Si nota subito la forza dell'immagine, di misure paradossalmente ridotte in confronto ai tanti altri disegni tratti dalla stessa fonte e generalmente a matita nera, tecnica usuale per i cartoni finiti. Il famoso gruppo della donna col cigno, presto conosciuto nel Cinquecento nella sua forma antica, non è semplicemente copiato, ma intelligentemente interpretato sia nella forma che nella posa. Le caratteristiche dell'ideale di bellezza potente michelangiolesca sono addolcite e i volumi, ammorbiditi dall'uso della matita rossa, corrispondono a quelli di un corpo femminile più giovane, che si definirebbe spontaneamente come più "grazioso".

Nel disegno ci sono da notare alcuni cambiamenti rispetto al prototipo. Il braccio, invece di essere rappresentato orizzontalmente all'altezza

della spalla, o anzi, leggermente alzato, è visto qui abbassato in diagonale. La mano sinistra, invece di pendere in segno di abbandono, come nell'immagine michelangiolesca, appare appoggiata sul piano, come se portasse il peso del corpo.

Questi particolari si ritrovano nell'incisione di un'altra *Leda e il Cigno* di Marcantonio Raimondi, probabilmente tratto da un disegno di Giulio Romano (Bartsch XIV/26, n. 232), sembra possibile quindi che il Correggio abbia fatto riferimento a uno di questi due precedenti o magari a un prototipo comune. La forma compatta potrebbe inserirsi benissimo nella curva di una lunetta, anche se bisogna tener conto del fatto che il foglio è stato ritagliato nella parte sinistra, ciò che accentua otticamente l'effetto semicircolare. Non si vedono i dettagli delle due uova di Castore e Polluce e dei due gemelli, ma questo non basta per concludere che possa essere una copia dal cartone qui esposto (Cat. 17) o del quadro corrispondente della National Gallery, privi di questi elementi. C'è nell'interpretazione in misure ridotte della figura michelangiolesca una qualità spaziale, un equilibrio, una freschezza di visione, una capacità di sintesi che è il segno di un ottimo disegnatore, un'opinione tra l'altro condivisa da Béguin (comunicazione orale).

L'attribuzione piuttosto convincente di Popham è stata respinta da Di Giampaolo che non parla del disegno nella sua monografia sui disegni di Correggio (1988), anche se questo autore (comunicazione orale) volle soprattutto respingere l'ipotesi di una attribuzione all'allievo di Correggio, Giorgio Gandini, più vicino al Gatti, suggerita dalla De Grazia (1984). Per chi scrive, ci sono buone ragioni per tornare al nome di

Correggio, che del nudo sdraiato e della sensualità femminile ha dato una bellissima espressione grafica nello studio, anch'essa a matita rossa, per la *Venere dormiente* (Windsor Castle, Royal Library, 0594; cfr. DI GIAMPAOLO 1988, n. 91, ripr. colore) del quadro del Louvre, *Venere, Cupido e Satiro*. C'è nel nudo di Windsor, memore di quella «morbidezza delle carni» notata da Vasari (1568/1966-1997, IV, p. 112), un'eco della *Tentazione di Adamo e Eva* di Michelangelo nel soffitto della Sistina come aveva sottolineato Wilde (in POPHAM-WILDE 1949, p. 213, n. 246).

Il problema del viaggio di Correggio a Roma e dei contatti diretti che avrebbe potuto avere con le opere del Vaticano negli anni 1518/1519 rimane aperto, come lo è il possibile passaggio verso il 1520 a Firenze quando era abate della Badia Fiorentina Girolamo da Monferrato, che conosceva bene il pittore parmense, affiliato alla congregazione benedettina cassinense (si veda MUZZI in DI GIAMPAOLO-MUZZI 1993, p. 7).

Il collegamento tra l'episodio dell'assedio di Firenze del 1530 e la creazione della *Leda* di Michelangelo esclude che Correggio abbia potuto vederla in occasione di questo viaggio.

Rimane per adesso aperta la questione di sapere quale è stato il punto di partenza del disegno del Louvre. Che sia di Correggio o di un artista emiliano vicino a lui, la data può esserne fissata, per ragioni stilistiche, verso il anni Trenta. Un'ipotesi potrebbe essere che il disegnatore ebbe la possibilità di vedere il prezioso materiale artistico che Antonio Mini trasportava con sé nel mese di dicembre 1531, andando verso Lione, e fermandosi sicuramente in Emilia, a Bologna (il 1° dicembre) e a Piacenza qualche giorno dopo, come attestato dalle sue lettere (TOLNAY 1948/1970, p. 190).

Nel quadro oggi conservato a Berlino (Staatliche Museen), databile insieme con gli altri quadri della serie degli *Amori di Giove*, eseguiti per essere donati a Carlo Quinto, verso il 1531/1532, Correggio dipinse «una Leda ignuda» (VASARI 1568/1966-1997, IV, p. 115), completamente estranea, nella sua delicatezza neo-raffaellesca, alla fortissima *Leda*, quasi contemporanea, del maestro fiorentino.

Interessante confrontare il foglio che potrebbe essere uno studio per una figura più dinamica, nuovamente pensata, con un altro disegno della *Leda*, a matita nera, che è una vera e propria copia, anche quella nella stesso senso della composizione originale, di bella qualità (Paris, Musée du Louvre, RF 586r [fig. 19-a]; si veda JOANNIDES, in corso di stampa, n. 81, come Scuola francese del XVI secolo).

Il luminismo delicato, che risulta da una particolare sensibilità al chiaroscuro e da una capacità tecnica nell'uso dello sfumato, farebbe quasi pensare a una interpretazione neo-leonardesca, forse milanese e ancora anteriore alla metà del secolo del motivo michelangiolesco, deviato dal suo significato estetico originale di una forma perfettamente delineata.

attr. to ANTONIO ALLEGRI
called IL CORREGGIO
(Correggio 1489-1534)

Leda

c. 1530
Red chalk, touches of white chalk; 91 x120 mm
Paris, Musée du Louvre,
Département des Arts Graphiques, Inv. 775

This drawing – clearly dependent on the invention of the *Leda* by Michelangelo in the similar turn of the figure – had been associated with the master's name since the end of the nineteenth century. Popham was the first to attribute it to Correggio in 1957, basing his assertion on the general aspect of the drawing and on the excellence of the draftsmanship in red chalk. The force of the image is immediately perceptible although paradoxically reduced in size as compared to the many other drawings taken from the same source that are generally made in black chalk, the most common technique in finished cartoons. The famous group of the woman with the swan has not been simply copied but intelligently interpreted in both form and pose. The characteristics of Michelangelo's powerful ideal of beauty are sweetened and the volumes, softened through the use of the red chalk, correspond to those of a younger female body that could be defined spontaneously as more 'graceful'. In the drawing, evident changes have been made with respect to the prototype. The arm, instead of being represented horizontally at the height of the shoulder – or better – slightly higher, is lowered in diagonal. The left hand, instead of hanging in sign of abandonment, as in the Michelangelesque image, appears to be resting on the ground as though to hold up the weight of the body. These same details appear in the engraving of another *Leda* by Marcantonio Raimondi, probably taken from a drawing by Giulio Romano (Bartsch XIV/26, n. 232). Possibly, therefore Correggio was making reference to one of these precedents or even a common prototype. The compact form would fit perfectly into the curve of a lunette, although the fact that the semicircular effect has been accentuated by the curtailment on the left of the sheet must be considered. The detail of the two eggs of Castor and Pollux and the two twins are not visible, but this does not suffice to conclude that the drawing is a copy of either the cartoon on exhibit (Cat. 17) or the corresponding painting in the National Gallery, also without those elements. The interpretation in reduced size of the Michelangelesque figure possesses a spatial quality, an equilibrium, a freshness in vision, a capacity of synthesis that is the sign of an excellent draftsman – an opinion shared moreover by Béguin (oral communication). Popham's more than convincing attribution has been rejected by Di Giampaolo who does not mention the drawing in his monographic study on the drawings of Correggio (1988), although that same author (oral communication) above all excludes the hypothesis of the attribution to the pupil of Correggio, Giorgio Gandini, closer to Gatti, suggested by De Grazia (1984). In my opinion, there are good reasons to return to the name of Correggio who furnished an extraordinary example of the reclining nude and open feminine sensuality in a study once again in red chalk for the figure of *Sleeping Venus* (Windsor Castle, Royal Library, 0594; cf. DI GIAMPAOLO 1988, no. 91, color reproduction) in the painting now in the Louvre of *Venus, Cupid and a Satyr*. In the Windsor nude, reminiscent of that "softness of the flesh" noted by Vasari (1568/1966-1997, IV, p. 112), an echo of the *Temptation of Adam and Eve* that Michelangelo painted on the ceiling of the Sistine Chapel as Wilde already noted (in POPHAM-WILDE 1949, p. 213, n. 246). The problem of Correggio's trip to Rome and the direct contacts that he might have had with the works in the Vatican in the years between 1518-1519 remains an open question, as does his possible passage through Florence around 1520 when a well-known acquaintance of the painter, Girolamo da Monferrato, affiliated with the congregation of the Monte Cassino Benedictines, was abbot of the Badia Fiorentina (see MUZZI in DI GIAMPAOLO-MUZZI 1993, p. 7). The link between the episode of the siege of Florence in 1530 and the creation of the *Leda* by Michelangelo excludes the possibility that Correggio saw the work during that sojourn. The point of departure for the Louvre drawing thus remains an open issue. Whether it is by Correggio or an Emilian artist close to him, the date can be established, for stylistic reasons, around the 1530s. Another hypothesis might be that the artist had the possibility to see the invaluable artistic material that Antonio Mini was carrying with him during the month of December 1531, on his way to Lyon. He certainly stopped in Emilia at Bologna (December 1st) and Piacenza a few days later, as his letters prove (TOLNAY 1948/ 1970, p. 190). In the painting today in Berlin (Staatliche Museen), datable together with the other paintings from the series the *Loves of Jove*, executed as a gift for Charles V towards 1531/ 1532, Correggio painted "a nude Leda" (VASARI 1568/1966-1997, IV, p. 115), completely estranged in its neo-Raphaelesque delicacy from the powerful *Leda*, almost its contemporary, by the Florentine master. An interesting comparison with the sheet that could be a study for a more dynamic reinvented figure, can be found in another drawing of fine quality of the *Leda*, in black chalk that is a true and proper copy, in which the figure also rotates in the same direction as the original composition (Paris, Musée du Louvre, RF 586; see JOANNIDES, forthcoming, no. 81, as French School, XVI century). The delicate luminosity that derives from a particular sensitivity to chiaroscuro and a technical capacity to use "sfumato" brings to mind an almost neo-Leonardesque interpretation, perhaps Milanese, of the Michelangelesque motif dating before the mid-century, deviated from its original æsthetic meaning of a perfectly delineated form.

Catherine Monbeig Goguel

BIBLIOGRAFIA/BIBLIOGRAPHY
POPHAM 1957 n. 84; TOLNAY 1948/1970, p. 192; GOULD 1976, p. 134-135; DE GRAZIA in *Correggio* 1984, p. 186; LABBÉ E BICART-SÉE 1987, II, p. 43; JOANNIDES, in corso di stampa, n. 80.

19-a. da Michelangelo, *Leda*. Paris, Musée du Louvre, Département des Arts Graphiques, Inv. RF586r.

una notevole fortuna, un gran numero di testimonianze figurative nelle epoche successive sicuramente fino alla fine del V secolo d. C. (*LIMC* 1992, *s. v. Leda* pp. 233, 243 nn. 25, 122-125). Molte le classi di materiali che adottano questo motivo figurativo: sarcofagi, rilievi, affreschi, mosaici, lucerne (*LIMC* 1992, pp. 242-244 n. F), ma soprattutto le gemme, come quella di Napoli, diventano uno dei materiali preferiti dagli incisori antichi per riprodurre questo momento della storia di Leda.

Leda
III century A. D.
Onyx
26.6 x 15 cm
Napoli, Museo Archeologico Nazionale,
Inv. 25967/134

Cat. 20

Leda
III secolo d. C.
Onice
cm 26,6 x 15
Napoli, Museo Archeologico Nazionale, Inv. 25967/134

Questo cammeo, con la figura di Leda distesa, faceva parte della collezione di Lorenzo il Magnifico e doveva quindi essere ben noto a Michelangelo quando creò il cartone per la sua *Leda*, per quanto non costituì certo, né per lui né per gli altri artisti del Rinascimento, l'unica fonte di provenienza classica, essendo il tema in questione assai frequentemente raffigurato in antico (MONACO, in *Leonardo* 2001, pp. 72-79).
Appartenuto già nel 1457 alla dattilioteca del veneziano cardinale Pietro Barbo (dal 1464, papa Paolo II), il cammeo passò con tutta la collezione al suo successore Sisto IV, per essere poi donata da quest'ultimo, come atto di amicizia verso i Medici, nel 1471, al giovane Lorenzo de' Medici. Nel 1537 Margherita d'Austria, vedova di Alessandro dei Medici, andata sposa in seconde nozze a Ottavio Farnese, trasferisce con sé la collezione e la gemma (per la sua storia successiva, vedi PANNUTI 1994).
Personaggio estremamente sfaccettato e controverso all'interno di una mitografia che la vede ora strumento divino ora oggetto erotico, Leda è figlia dell'etolico Thestios e sposa del re di Sparta Tyndareos. Molti i figli che gli vengono attribuiti, ma i più noti sono Castore e Polluce (Dioscuri) ed Elena, causa della rovina di Troia. Secondo le fonti letterarie già nei canti Ciprii, Nemesi, in forma di oca dopo l'incontro con Zeus sotto le spoglie di un cigno, partorirà l'uovo che Leda troverà o, secondo altri autori antichi, le verrà affidato da Hermes, per volere di Zeus; protetto sotto le calde ceneri di un sacrificio, si schiuderà facendo nascere Elena, e per altri, anche i Dioscuri
La fortuna di questo tema – una sorta di propaganda ideologico-politica a seguito della pace di Nicia, che metteva fine, temporaneamente, alla

guerra tra Atene e Sparta – è comunque testimoniata anche dalla coeva produzione ceramografica attica a figure rosse e da quella più tarda dell'Italia meridionale, dove l'episodio della nascita di Elena con la presenza di Leda ricorre anche sotto forma di parodia. Solo più tardi e sicuramente con Euripide (*Elena*, vv. 16-22 ed *Ephigenia in Aulide* vv. 794-800) – anche grazie alla teatralità che il personaggio e la sua storia potevano esprimere – Leda riacquista il ruolo di protagonista assoluta dell'avventura con Zeus, che trasformatosi in cigno, la possiede sulle rive dell'Eurota in Laconia, dopo che lei lo salva dall'inseguimento di un'aquila; e dall'uovo da lei concepito nascerà Elena e, secondo altri, anche i Dioscuri (EITREM, in PAULY WISSOWA 1924, XII, coll. 1116-1125 *s. v. Leda*).
E proprio questa nuova versione del mito sarà quella che raccoglierà il più ampio consenso nell'iconografia greco-romana. Le immagini trasmesseci dall'antichità sono fissate nell'atto dell'amplesso tra il dio e la regina di Sparta, con capolavori assoluti quali la *Leda e il cigno* di Timótheos della metà del IV secolo a.C., elaborato per il tempio di Asclepio a Epidauro, di cui possediamo un numero cospicuo di copie di età romana, tra le quali quella conservata ai Musei Capitolini di Roma costituisce la più felice replica (cfr. MATTEI in *Leonardo* 2001, p. 90), che meglio di ogni altra esemplifica il tipo iconografico originale.
Abbandonato il piano religioso delle più antiche raffigurazioni, con la tarda età ellenistica acquista sempre più forte l'interesse per l'aspetto erotico-sensuale della storia: Leda non protegge più con l'ampio mantello Zeus-cigno dall'assalto dell'aquila, ma partecipa a pieno al *symplegma* amoroso con il dio ed è proprio questo momento che viene fissato in numerose sculture, pitture parietali, sarcofagi, rilievi, mosaici, oltre che su lucerne, specchi, piatti, vasi e gemme. Anche il cammeo napoletano s'inserisce in questo filone, anche se l'iconografia cambia: Leda, non si presenta stante, ma è sdraiata e assume una posa ancora più erotica nell'amplesso.
Questo schema è attestato già alla fine del IV secolo a.C. in un castone d'oro conservato in una collezione privata britannica e troverà, con

This cameo representing the reclining figure of Leda was once part of the collection of Lorenzo il Magnifico and therefore must have been well known to Michelangelo when he created the cartoon for his own *Leda*. However, it certainly was not the only classical reference of the theme frequently portrayed in antiquity for Michelangelo and other Renaissance masters, (MONACO in *Leonardo* 2001, pp. 72-79). In 1457 the cameo belonged of the collection of gems of cardinal Pietro Barbo (from 1464, Pope Paul II) passing with the entire collection into the hands of his successor, Sistus IV who subsequently gave it to the young Lorenzo il Magnifico de' Medici in 1471 as a gesture of friendship towards his family. In 1537, Margherita of Austria, the widow of Alexander de' Medici married for a second time Ottavio Farnese. In her transfer, she took the collection and the gem with her (for the subsequent history, see PANNUTI 1994).
Leda, the daughter of the Aetolian Thestius and wife of the King of Sparta Tyndareus, is an extremely complex and controversial personage within mythological accounts. Described both as a divine instrument and an erotic object, she is said to be the mother of many children, the most famous being Castor and Polux (the Dioscuri) and Helen, the cause of the ruin of Troy. According to literary sources already present in the Cyprian chants, Nemesis, in the form of a goose after an encounter with Zeus disguised as a swan, laid the egg that Leda found. Some ancient authors affirm that the egg was given into her custody, as Zeus wished, by Hermes; protected under the hot cinders of a sacrificial fire, the egg then hatched giving birth to Helen and, according to some sources, also to the Dioscuri.
The popularity of the theme – a type of ideological-political propaganda following the peace of Nicia, which put an end, temporarity, to the war between Athens and Sparta – can be encountered in the coeval production of Attic red-figure ware

and by the later southern Italian production where the episode of the birth of Helen with the presence of Leda reoccurs under the form of a parody. Only later and certainly with Euripides (*Helen*, vv. 16-22 and *Iphigenia in Aulis*, vv. 794-800) – also thanks to the theatrical sense that the personage and the story embodied – Leda reacquires the role of absolute protagonist of the adventure: Zeus in the form of a swan is saved by Leda from a preying eagle; he possesses her on the banks of the Eurota in Laconia and from the egg that she conceives Helen is born and, according to some sources, also the Dioscuri (EITREM, in PAULY WISSOWA, 1924, XII, coll. 1116-1125 ff., *s.v.* Leda).

It is precisely this version of the myth that will enjoy the largest consensus in Greek-Roman iconography. The images passed down to us from antiquity focus on the act of love-making between the god and the queen of Sparta, expressed in great masterpieces such as Timotheus' *Leda and the Swan* dating to the mid-fourth century B.C., created for the temple of Asclepius at Epidaurus of which we have a number of Roman copies, one of the most notable being the exemplar housed in the Capitoline Museums in Rome (cf. MATTEI, in *Leonardo* 2001, p. 90), that better than any other exemplifies the original iconographical type. Abandoning the religious connotations of the more ancient representations, an ever stronger interest for the erotic-sensual aspect of the story comes with the late Hellenistic age: Leda no longer protects Zeus the swan from the attack of the eagle with her wide mantle, but participates fully in the amorous *symplegma* with the god and precisely that moment is the one portrayed in numerous sculptures, wall paintings, sarcophagi, reliefs, mosaics as well as oil burning lamps, mirrors, plates, vases and gems. The Neapolitan cameo is part of this trend, although the iconography changes: Leda is not seen standing but lying down in an even more erotic love making pose.

This solution had already been seen at the end of IV century B. C. in a gold cabochon now found in a private collection in Britain and finds notable diffusion in a grand number of figurative testimonies of subsequent ages lasting surely to the end of the V century A. D. (*LIMC* 1992, pp. 233, 243 no. 25, 122-125). Many classes of materials use this figurative motif: sarcophagi, reliefs, frescoes, mosaics, oil lamps (*LIMC* 1992, pp. 242-244 n. F), but above all gems, like the one in Naples, become the preferred materials of the ancient carvers in producing this moment of the story of Leda.

Mario Cygielman

BIBLIOGRAFIA/BIBLIOGRAPHY
PANNUTI in *Museo Archeologico... di Napoli*, II, 1994, pp. 104-105 n. 74, fig. 74 con bibliografia; MONACO in *Leonardo* 2001, p. 156 con bibliografia.

Cat. 21

MICHELANGELO BUONARROTI
(Caprese 1475-Roma 1564)

Studio di gambe
1524 (?)
Penna e inchiostro
mm 145 x 193
Firenze, Casa Buonarroti, Inv. 44F

Sebbene questo studio sia stato a volte messo in relazione con la *Leda*, con cui condivide alcune caratteristiche della posa – la gamba destra ritratta sotto il corpo e la sinistra di profilo – non c'è tra le due opere alcun collegamento diretto. Il piede sinistro è chiaramente appoggiato su una superficie, e la porzione inferiore della gamba destra è piegata all'indietro con un'angolazione talmente sotto tensione per sostenere la natica destra da essere non solo in una posa di straordinaria difficoltà, ma da suggerire dolore piuttosto che piacere. La gamba sinistra della *Leda*, gettata sull'ala destra del cigno, pende libera, con le dita del piede che si muovono per il piacere, mentre la gamba destra, sebbene piegata all'indietro, giace con un angolo molto più rilassato. Michelangelo compì appositi studi sulle pose mostrate nel presente disegno in un altro foglio – Casa Buonarroti, Inv. 48F (fig. 21-a) –, in cui la muscolatura della coscia sinistra è indicata nei contorni e quella della destra, qui nascosta, è accennata con pochi tratti multidirezionali. Sebbene il presente foglio non sia così ovviamente un frammento come quello di Casa Buonarroti, Inv. 48F, i cui bordi sono abbondantemente irregolari, è anch'esso senza dubbio un

frammento di un foglio più grande, probabilmente lo stesso a cui apparteneva in origine anche Inv. 48F.
Questi studi appartengono a un gruppo di disegni a penna che include quelli di Casa Buonarroti Inv. 10 e Inv. 11F – di straordinaria potenza e vigore –, probabilmente eseguiti, come indicato da Wilde (1953) nel 1524-1526. In essi vengono studiate sia la figura reclinata che quella seduta, e sebbene nessuno mostri una posa identica ad alcuna figura tanto scolpita che progettata per le tombe della Sacrestia Nuova, sono stati per certo tracciati avendo quelle in mente. In questi disegni Michelangelo impiegò un'ampia varietà di tratti a penna per creare forme nelle quali il gioco dei muscoli e dei tendini assume un'intensa forza espressiva, una maniera che deriva dai *Prigioni*, ora all'Accademia, e che anticipa quella del *Giudizio Universale*. Dato che nel gruppo tombale progettato per la Sacrestia Nuova l'elemento collettivo, scenografico e pittorico predomina necessariamente su quello localmente plastico, l'energia delle figure in effetti scolpite da Michelangelo era ridotta al paragone di quella che si può osservare nei disegni. È significativo comunque che le forme progettate per la cappella, le quattro divinità fluviali, più plasticamente potenti, sarebbero poi state quelle la cui superficie e muscolatura ricordano più da vicino il presente disegno e quelli associati. Wilde notò la somiglianza tra lo stile di questo disegno e la superficie del modello del *Dio fluviale* donato all'Accademia da Bartolomeo Ammannati e ora nella Casa Buonarroti, unico sopravvissuto dei quattro progettati da Michelangelo (vedi saggio Nelson, fig. 12).
In seguito a questi disegni a penna, Michelangelo eseguì studi in matita nera nei quali elaborò le forme più sviluppate delle figure. Ne soprav-

vivono numerosi destinati alle figure distese delle *Allegorie*, in cui viene raggiunto un compromesso tra la continuità della superficie e il palpito dei muscoli.
La *Leda* e la *Notte* derivano ovviamente da una medesima antica fonte. Un rilievo di *Leda* ebbe uno sviluppo nella scultura potentemente tridimensionale della *Notte*, che fornì l'ispirazione per una *Leda* dipinta molto più complessa dell'antico prototipo. La stessa *Leda* dipinta fu a sua volta trasformata in una statua in marmo, ora al Bargello, generalmente attribuita a Bartolomeo Ammannati. Non c'è tuttavia nessuno scontato collegamento con le opere di Ammannati di attribuzione certa, e vale la pena di considerare la possibilità che la statua sia opera di Daniele da Volterra, l'amico di Michelangelo che il Vasari cita per avere fatto una *Leda* per Michael Fugger.
Dei disegni preparatori per il dipinto di *Leda* sopravvissuti, tutti meno uno sono in matita rossa. Fa eccezione un piccolo e gravemente danneggiato studio a penna per il braccio destro di *Leda* ora alla Casa Buonarroti (Inv. 60F): esso fu in un primo momento messo in relazione con il dipinto da Wilde, che lo riconobbe anche come facente un tempo parte di un foglio che contiene un *ricordo* datato 6 gennaio 1530. Il fatto che questo studio estremamente sommario sia a penna può non essere del tutto occasionale: Michelangelo probabilmente vi ricorse per dargli un'accentuazione, per ricordare a se stesso che la piega dell'avambraccio e l'angolo del polso e della mano occupavano un posto particolare nell'economia espressiva del dipinto.

MICHELANGELO BUONARROTI
(Caprese 1475-Roma 1564)

Study of Legs
1524 (?)
Pen and ink
145 x 193 mm
Firenze, Casa Buonarroti, Inv. 44F

Although this study has sometimes been connected with the *Leda*, with which it shares certain characteristics of pose – the right leg drawn under the body and the left leg in profile – the two are not directly linked. The left foot is clearly resting upon a surface, and the right lower leg is bent back at so tense an angle to support the right buttock that it is not merely a pose of extraordinary difficulty but suggests pain rather than pleasure. Leda's left leg, slung over the swan's right wing, hangs free, with the toes curled in delight, and the right leg, although folded back, lies at a much more relaxed angle. The pose shown in the present drawing was studied from directly above by Michelangelo on another sheet in Casa Buonarroti, Inv. 48F (fig. 21-a), in which the musculature of the left thigh is indicat-

ed in outline, and that of the right thigh, hidden in the present drawing, is laid in in short multidirectional strokes. Although the present sheet is not so obviously fragmentary as Casa Buonarroti Inv. 48F, whose edges are notably irregular, it too is no doubt a fragment of a larger sheet, probably that on which Inv. 48F was also to be found. The place of these studies is with a group of pen-drawings – which includes Casa Buonarroti Inv. 10F and Inv. 11F – of extraordinary power and vigour, probably made, as Wilde (1953) indicated, 1524-1526. They study either reclining or seated figures and although none of them is identical in pose with any of the figures either as sculpted or as planned for the tombs in the New Sacristy, they were certainly drawn with those in mind. In these drawings, Michelangelo employed a wide variety of pen strokes to create forms in which the play of muscles and sinews assumes an intense expressive force, a manner which derives from the *Prigioni* now in the Accademia and which anticipates that of the *Last Judgement*. Given that in the tomb-ensembles planned for the New Sacristy the collective, scenic, pictorial element necessarily predominated over the locally plastic, the energy of the figures that Michelangelo actually carved was reduced in comparison with that seen in the drawings. However, it is significant that the most powerfully plastic forms planned for the chapel, the four river gods, would have been those whose surfaces and musculature resembled most closely the present drawing and its companion. Wilde noted the similarity between this drawing style and the surface of the *River God* model given to the Accademia by Bartolomeo Ammanati and now in Casa Buonarroti, the single survivor of the complement of four that Michelangelo planned (see Nelson's essay, fig. 12).

Subsequent to these pen drawings, Michelangelo made studies in black chalk in which he worked out the more developed forms of the figures. Several survive for the reclining *Allegories* and in those that compromise is achieved between surface continuity and palpitating musculature. The *Leda* and the *Notte*, of course, are derivations from the same antique source. A relief of *Leda* was developed into the powerfully three dimensional sculpture of *Night* which, in turn, became the inspiration for a painted *Leda* much more complicated than the antique prototype. In turn, the painted *Leda* was itself transformed into a small marble sculpture now in the Bargello, generally attributed to Bartolomeo Ammanati. However, it has no very obvious links with Ammanati's certain work and it is worth considering the possibility that it is by Michelangelo's friend Daniele da Volterra, recorded by Vasari as having made a *Leda* for Michael Fugger.
All save one of the surviving drawings made in preparation for the painting of *Leda* are in red chalk. The exception is a small and badly damaged pen study for Leda's right arm in Casa Buonarroti (Inv. 60F); it was first connected with the painting by Wilde who recognised also that it had once formed part of a sheet bearing a *ricordo* dated 6 Janaury 1530. The fact that this very summary study is in pen may not be entirely adventitious: Michelangelo probably adopted it for accentuation, to remind himself that the bend of the forearm and the angle of the wrist and hand occupied a particular place in the painting's expressive economy.

Paul Joannides

21-a. Michelangelo, *Studio di gambe / Study of Legs*. Firenze, Casa Buonarroti, Inv. 48F.

BIBLIOGRAFIA / BIBLIOGRAPHY
BAROCCHI 1962, n. 74; TOLNAY 1975-1980, n. 299.

Cat. 22 (Tav. II/1)

**attr. a
AGNOLO TORI detto IL BRONZINO**
(Firenze 1503-1572)

Ritratto di Dante
1532-1533
Olio su tela
cm 130 x 136
Firenze, Collezione privata

Vasari ricorda che il Bronzino, al suo ritorno da Pesaro, fece «a Bartolomeo Bettini, per empiere alcune lunette d'una sua camera, il ritratto di Dante, Petrarca e Boccaccio, figure dal mezzo in su, bellissime» (*Appendice I*). Nella vita di Pontormo aveva precisato che la *Venere e Amore* dipinta dal Pontormo su cartone di Michelangelo doveva raggiungere una stanza della casa di Bartolomeo Bettini «nelle lunette della quale aveva cominciato a fare dipingere dal Bronzino, Dante, Petrarca e Boccaccio, con animo di farvi gli altri poeti che hanno con versi e prose toscane cantato d'Amore» (*Appendice I*). Sembra evidente che il Bronzino doveva dipingere nelle lunette di una stanza della casa fiorentina di Bartolomeo Bettini le effigi dei principali poeti che avevano celebrato l'amore in lingua toscana, ma solamente i ritratti di Dante, Petrarca e Boccaccio erano completati

quando il ricco mercante lasciò Firenze per Roma entro il 1536. Dei ritratti di Petrarca e di Boccaccio non ci sono pervente tracce, mentre il ritratto di Dante era conosciuto attraverso un disegno preparatorio conservato a Monaco (Cat. 25), una replica di bottega (Washington, National Gallery of Art, Tav. IV/2) diverse copie grafiche (Cat. 26) e una xilografia del busto del poeta, pubblicata nel frontespizio della *Commedia* curata da Francesco Sansovino (Giovanbattista Marchiò Sessa e fratelli, Venezia, 1564).

La riscoperta in collezione privata fiorentina di un *Ritratto di Dante*, dipinto su tela centinata, permette di riprendere in considerazione il fatto. La tela è pressappoco identica alla versione americana, già riferita alla bottega di Vasari e resa al Bronzino da Berti (1964, p. 102; cfr. anche CECCHI 1996, p. 20, fig. 20 riprodotto a colori). Cecchi (1991, p. 18), sostenendo che la calligrafia dei versi della *Commedia* nella tavola della collezione americana corrispondeva a quella del codice manoscritto autografo del Bronzino nel Fondo Magliabechiano della Biblioteca Nazionale Centrale di Firenze (Cat. 35), proponeva che si trattasse di una replica autografa. Potrebbe darsi quindi che il quadro della collezione privata fiorentina sia l'originale fino ad ora considerato come disperso. L'opera, dipinta fin dall'origine su tela, non è di facile lettura. Rimossa dalla sua collocazione originale in un epoca imprecisata, comunque non recente, ha subito le

aggressioni del tempo ed è rimasta a lungo arrotolata, di modo che si sono verificate importanti perdite di colore soprattutto nel fondo, in una parte del libro nel Monte del Purgatorio e nel brano di paesaggio sotto la mano destra del poeta, oggi interamente ridipinta. Ciò nondimeno, la figura centrale, cioè Dante, si presenta leggibile malgrado l'usura generale. Il tipo di incarnato del viso e delle mani corrisponde a quello che si ritrova in opere contemporanee, in particolare il *Ritratto del suonatore di Liuto* degli Uffizi (dipinto verso il 1534) e la coperta del ritratto di Francesco Guardi, il *Pigmalione e Galatea*, anch'esso agli Uffizi, ancora marcato dallo stile del Pontormo. L'influenza pontormesca è particolarmente evidente nel modo di trattare i tessuti che ricordano il tessuto blu che si ritrova nella *Venere e Cupido*, ma anche i drappeggi del *Noli me tangere* (Busto Arsizio, Collezione privata; Tav. VIII/1), che il Bronzino replicò al suo ritorno da Pesaro, alla fine del 1532 (Firenze, Casa Buonarroti, Saggio Aste fig. 8). Il Dante della lunetta si distingue anche per la straordinaria attenzione con cui è trattato il grande mantello rosso, il cui panneggio appare nettamente più morbido e meno meccanico che nella versione americana, peraltro restaurata radicalmente. Come avevano già suggerito Nelson (1992, pp. 64, 67-68) e Plazzotta (1998, p. 257) e come conferma il paragone con la lunetta qui esposta, la versione su tavola deve essere considerata una replica uscita dalla bottega del Bronzino, realizzata probabilmente dopo il 1541 per uno dei suoi amici dell'Accademia Fiorentina, a cui l'artista fu ammesso fino al 1547 (data della riforma dell'istituzione). In effetti, oltre al drappeggio rosso, la lunetta presenta una calligrafia più sicura, un modo più solido di trattare il paesaggio, oltre a una grande sensibilità nel modellato del volto del poeta. L'autore della replica non ha nemmeno saputo trasporre la sottigliezza del digradare del colore dal giallo al blu, prodotto dall'alone luminoso emanante dal Paradiso e non ha colto la raffinatezza del Bronzino nella scelta dei due rossi ben distinti, per il copricapo e per il mantello. Il pannello della National Gallery of Art di Washington permette comunque di ricostruire la parte più danneggiata della lunetta, il Monte del Purgatorio che emerge dal mare, dove non è più possibile distinguere i dettagli, in particolare i piccoli personaggi che camminano sui cerchi.

Queste considerazioni permettono di suggerire che la lunetta, presentata al pubblico per la prima volta in questa occasione, sia effettivamente l'originale dipinto dal Bronzino per Bartolomeo Bettini. Nulla permette, nel testo di Vasari, di affermare che le lunette del Bronzino fossero originariamente dipinte a fresco e, nonostante il supporto di tela fosse raramente utilizzato in Toscana nel Cinquecento, conviene perfettamente al luogo a cui era destinato.

La scoperta della tela permette di immaginare l'architettura generale della stanza, coperta probabilmente da una volta che potremmo definire "a ombrello", poggiante su una successione di

piccole lunette. La centinatura della tela indica inoltre che la volta era ribassata, struttura tipica dell'architettura rinascimentale. Il bordo superiore nero, potrebbe corrispondere al prolungamento in trompe-l'œil degli elementi architettonici. La simmetria dello sguincio, che sottintende un punto di vista centrale, ci autorizza a ipotizzare che la figura di Dante fosse collocata al centro della parete. Tra le differenti copie, il disegno attribuito a Carlo Dolci conservato al Fitzwilliam Museum di Cambridge (Inv. 1176; cfr. SCRASE 1996, pp. 205-206), è il solo che comprende il bordo nero, ma adattato dal copista alla luce dell'alone. All'epoca della decorazione della stanza di Bettini, il Bronzino si trovò nuovamente in contatto con l'arte di Michelangelo e in particolare con le sculture della cappella medicea che l'artista stava completando su domanda di Clemente VII. Per la posa del poeta, il Bronzino adattò la figura serpentinata che Michelangelo aveva ideato a San Lorenzo. La similitudine tra la figura di Dante e la scultura tradizionalmente identificata con Giuliano de' Medici è impressionante ed è anche probabile che lo scultore abbia suggerito direttamente al Bronzino la posa da adottare. Anche se Bettini ottenne il cartone di Venere e Amore subito dopo l'esecuzione delle tre lunette, come sostiene Vasari, è comunque possibile che la decorazione completa fosse diretta da Michelangelo stesso sin dall'inizio, visti i legami che univano il mercante e lo scultore. L'impronta della scultura michelangiolesca si ritrova nei ritratti realizzati dal Bronzino subito dopo le lunette dei poeti, in particolare nel Ritratto del suonatore di Liuto (Firenze, Galleria degli Uffizi) e nel Ritratto di Ugolino Martelli (Berlin, Gemäldegalerie), ma anche nei ritratti dipinti a Roma alla stessa epoca da Sebastiano del Piombo, dimostrando che Michelangelo esercitò la sua influenza anche in un campo che gli era apparentemente estraneo, come quello del ritratto.

Nel contesto delle repressioni orchestrate dal nuovo duca Alessandro de' Medici, la scelta del XXV Canto del Paradiso, dove Dante esprime il suo desiderio di rientrare dall'esilio (cfr. NELSON 1992, p.70), non poteva essere fortuita e riguardava tanto Bartolomeo Bettini che Michelangelo. Entrambi erano impegnati nella difesa della Repubblica e, come Michelangelo (cfr. CONDIVI 1998, pp. 42, 44), Bettini doveva temere l'attitudine tirannica del duca. Il Canto illustrava anche la situazione dei parenti di Bartolomeo e di uno in particolare, tale Girolamo di Francesco Bettini, la cui condanna all'esilio, il 29 novembre 1530, fu confermata il 17 novembre 1533 (cfr. RASTRELLI 1781, I, p. 225; II, p. 41). Il programma della decorazione è inscindibile dal clima letterario nel quale vivevano i vari protagonisti, a cui si aggiunse Benedetto Varchi, rientrato a Firenze nel 1531. La difesa del volgare toscano, esposta chiaramente nella decorazione della stanza, corrispondeva alle scelte letterarie di Pietro Bembo (amico tanto di Varchi che di Bettini), che possedeva ugualmente dei ritratti di Dante, Petrarca e Boccaccio, dipinti da Giovanni Bellini. Il Bronzino, influenzato

da Michelangelo, cercò di dare la massima plasticità ai suoi poeti toscani, come vediamo non solo nel Ritratto di Dante, l'unico pervenuto fino a noi, ma anche nella ripresa proposta da Vasari nei Sei poeti toscani di Minneapolis (Cat. 24, Tav. IV/1), probabile sintesi delle lunette del Bronzino. Di questo quadro dipinto per Luca Martini, Vasari fece fare una replica destinata al Museo degli Uomini Illustri di Paolo Giovio. Per l'illustrazione di Dante negli Elogia (Giovio 1577, p. 10), la xilografia di Tobias Stimmer non si riferisce tuttavia al quadro vasariano, ma ad un'altra raffigurazione di Dante custodita nella collezione di Paolo Giovio, probabilmente derivata dal quadro in possesso di Pietro Bembo. Nella seconda metà degli anni Cinquanta, quando il Bronzino fece, forse per Benedetto Varchi, il ritratto della poetessa Laura Battiferra (Firenze, Palazzo Vecchio), riprendeva la posizione che aveva adotato per il Ritratto di Dante, allora conosciuto da tutti, mettendo così la poetessa al livello del massimo scrittore toscano (cf. PLAZZOTTA 1998; KIRKHAM 1998).

attr. to AGNOLO TORI called BRONZINO
(Firenze 1503-1572)

Portrait of Dante

1532-1533
Oil on canvas
130 x 136 cm
Firenze, Private collection

Vasari records that, upon his return from Pesaro, Bronzino made "the portraits of Dante, Petrarca and Boccaccio for Bartolomeo Bettini, very beautiful half-length figures to fill some lunettes in one of his chambers" (*Appendix I*). In the life of Pontormo, he states precisely that the *Venus and Cupid* painted by Pontormo on Michelangelo's cartoon was to be placed in the room in the house of Bartolomeo Bettini "in the lunette in which Bronzino had begun to paint Dante, Petrarca and Boccaccio, intending to paint other poets who had sung the praises of Love with verses and prose in the Tuscan tongue" (*Appendix I*).

Evidently, Bronzino was charged with depicting the effigies of the principal poets who had celebrated love in the Tuscan language in the lunettes of the room in the Florentine home of Bartolomeo Bettini but only the portraits of Dante, Petrarca and Boccaccio were complete when the rich merchant left Florence for Rome by 1536. No traces of the portraits of Petrarca and Boccaccio have survived and the portrait of Dante was known to us only through the preparatory drawings now in Munich (Cat. 25), a workshop replica (Washington, National Gallery of Art, Pl. IV/2) various drawn copies (Cat. 26), and a woodcut of the bust of the poet,

published as the frontispiece of the *Divine Comedy* edited by Francesco Sansovino (Giovanbattista Marchiò Sessa e Fratelli, Venezia, 1564).

The discovery of a *Portrait of Dante* painted on an arched canvas in a private Florentine collection permits a reconsideration of the question. The canvas is almost identical to the version in America that had previously been assigned to the workshop of Vasari and attributed to Bronzino by Berti (1964, p. 102; cf. also CECCHI 1996, p. 20, fig. 20 color reproduction). Cecchi (1991, p. 18) noting that the calligraphy of the verses of the *Comedy* on the panel in the American collection corresponds to that found in the autograph manuscript codex by Bronzino in the Magliabechi section of the Biblioteca Nazionale Centrale in Florence (Cat. 35), suggested it was an original replica. Therefore, there is the possibility that the original painting is the one now in the private collection in Florence, thought until now to have been lost. The painting, which has always been on canvas, is not easy to "read". Removed from its original placement at some undetermined moment in the not too recent past, it has suffered from the aggression of time and significant losses in color – principally in the background, in a portion of the book in the Mount of Purgatory and in the area of the landscape under the right hand of the poet, today entirely repainted – as a result of the painting being rolled up for a long period. Nonetheless, despite the general wear, the central figure of Dante is still legible. The type of coloring in the face and the hands corresponds to that found in contemporary works by Bronzino, in particular the *Portrait of the Lute Player* in the Uffizi (painted around 1534) and the cover for the portrait of Francesco Guardi, the *Pygmalion and Galatea*, also in the Uffizi, in which the stylistic influence of Pontormo is still evident. The modes of Pontormo are particularly evident in the treatment of the cloth, recalling the blue fabric found in the *Venus and Cupid*, but also the drapery of the *Noli me tangere* (Busto Arsizio, Private collection; Pl. VIII/1) that Bronzino replicated upon his return from Pesaro at the end of 1532 (Firenze, Casa Buonarroti, Aste's essay, fig. 8).

The Dante of our lunette is striking also for the extraordinary attention afforded to the large red cape, the folds of which appear clearly softer and less mechanical than those in the American version that moreover has undergone radical restoration. As Nelson (1992, pp. 64, 67-68) and Plazzotta (1998, p. 257) have already suggested and as the comparison with the lunette under examination confirms, the version on panel must be a replica made in the workshop of Bronzino probably after 1541 for one of his friends in the Florentine Academy to which the artist was admitted in 1547 (date of the reform of the institution). Besides the red drapery, the lunette shows a surer hand, a

more solid treatment of the landscape as well as an acute sensitivity in the modeling of the poet's countenance.

The author of the replica, incapable of transferring the subtlety of the gradation in color from yellow to blue produced by the luminous aura emanating from Paradise, was also unable to capture the Bronzino's refined choice of color in the two distinctly different reds used for the head covering and the mantle. However, the panel in the National Gallery of Art in Washington allows us to reconstruct the most damaged parts of the lunette such as the Mount of Purgatory emerging from the sea where the details, especially the small figures circulating on the ledges, are no longer distinguishable.

These considerations justify the assumption that the lunette, exhibited to the public for the first time on this occasion, is effectively the original painting Bronzino created for Bartolomeo Bettini. Nothing in Vasari's description indicates that Bronzino's lunette was originally in fresco and despite the fact that canvas painting was rare in Tuscany in the sixteenth-century, it fits perfectly into the setting for which it was designed.

The discovery of the canvas permits us to imagine the general aspect of the room, probably covered by a vault of the so-called "umbrella-form" type, resting on a series of small lunettes. The upper curvature of the canvas indicates that the vault was elliptical, a typical structure in renaissance architecture while the upper black border may correspond to the *trompe-l'œil* elongation of the architectural elements. The symmetry of the curvature, inferring a central viewpoint, authorizes the hypothesis that the figure of Dante was at the center of the room. Among the various copies, the drawing attributed to Carlo Dolci in the Fitzwilliam Museum of Cambridge (Inv. 1176; cf. SCRASE 1996, pp. 205-206) is the only one that includes the black border that, however, the copyist adapted to the light of the aura.

At the time of the decoration of Bettini's chamber, Bronzino came once again into contact with the art of Michelangelo and in particular with the sculptures of the Medici chapel that the artist was completing at the request of Clement VII. For the pose of the poet, Bronzino adapted the serpentine figure that Michelangelo had devised for San Lorenzo. The similarity between the figure of Dante and the sculpture traditionally identified as Giuliano de' Medici is striking and probably the pose adopted was suggested to Bronzino directly from the sculptor himself. Even if Bettini received the cartoon of *Venus and Cupid* immediately after the execution of the three lunettes, as Vasari claims, it is nonetheless possible that from the beginning Michelangelo himself was in charge of the entire decorative scheme, given the friendship that united the merchant and the sculptor.

The influence of the Michelangelesque sculpture is likewise evident in the portraits Bronzino created immediately following the creation of the lunettes with the poet series, in particular in his *Portrait of the Lute Player* (Firenze, Galleria degli Uffizi) and that of *Ugolino Martelli* (Berlin, Gemäldegalerie). The Michelangelesque imprint is equally evident in the portraits painted in Rome at this same time by Sebastiano del Piombo, demonstrating how Michelangelo's influence effected a field, like that of portraiture, apparently outside his own range of activity.

In the context of the repressions organized by the new duke Alessandro de' Medici, the choice of the XXV Canto of Paradise, in which Dante expresses his desire to return from exile (cf. NELSON 1992, p. 90), could not have been a casual one and regarded both Bartolomeo Bettini and Michelangelo. Both were engaged in the defense of the Republic and like Michelangelo (cf. CONDIVI 1998, pp. 42, 44), Bettini must have feared the tyrannical behavior of the duke. The Canto additionally reflects on the circumstances relating to Bettini's relatives and one in particular, a certain Girolamo Francesco

Bettini, whose sentence of exile on November 29 1530 was confirmed on November 17 1533 (cf. RASTRELLI, 1781, I, p. 225; II, p. 41).

The decorative program is inseparable from the literary climate in which the various protagonists were living and to which Benedetto Varchi, who reentered Florence in 1531, belonged. The defense of the Tuscan vernacular, expressed clearly in the decoration of the room, corresponded to the literary choices of Pietro Bembo (a friend of both Varchi and Bettini) who also owned portraits of Dante, Petrarca and Boccaccio painted by Giovanni Bellini. Bronzino, under the influence of Michelangelo, tried to imbue his Tuscan poets with the maximum plasticity as we can see not only from the *Portrait of Dante*, the only surviving element, but also in the replication of the same theme proposed by Vasari in his *Six Tuscan Poets* created for Luca Martini now in Minneapolis (Cat. 24, Pl. IV/1), a probable compendium of the lunette by Bronzino. Vasari had a replica of the painting made for Paolo Giovio's Museum of Illustrious Men, but the woodcut by Tobias Stimmer used for the illustration of Dante in the *Elogia* (GIOVIO 1577, p. 10) does not refer to the Vasarian image, but to another representation of Dante that Paolo Giovio had in his collection, a probable derivation of the painting owned by Pietro Bembo.

During the second half of the 1550s, when Bronzino painted the portrait of the poetess Laura Battiferra (Firenze, Palazzo Vecchio) – possibly for Benedetto Varchi – he replicated the pose adopted in the *Portrait of Dante*, then known to all, thus placing the poetess on the same level with the greatest of Tuscan writers (see PLAZZOTTA 1998; KIRKHAM 1998).

Philippe Costamagna

BIBLIOGRAFIA/ BIBLIOGRAPHY
COSTAMAGNA 2002, p. 211.

Cat. 23 (Tav. II/2 e Tav. III/1-3)

JACOPO CARUCCI, detto IL PONTORMO (?)
(Pontorme 1494-Firenze 1557)
su cartone di MICHELANGELO BUONARROTI
(Caprese 1475-Roma 1564)

Venere e Cupido

1533 ca. (dipinto); 1532-1533 (cartone)
Olio su tavola
cm 128,5 x 193
Firenze, Galleria dell'Accademia, Inv. 1890/1570

[NOTA: Questa scheda è incentrata su come colui che dipinse la *Venere e Cupido* dell'Accademia, interpretò il cartone di Michelangelo, e sullo stile e sull'attribuzione di questa versione recentemente restaurata: per una analisi sulla complessa iconografia, sulla composizione e sui tipi delle corporature nel cartone di Michelangelo, si rimanda al saggio di Nelson; per la questione della commissione, del mecenate e della collocazione del quadro, si rimanda al saggio di Aste; per la relazione sul restauro cfr. *Appendice V*, per le indagini scientifico-tecniche cfr. saggio Bellucci-Frosinini e *Appendice IV*; per le sedici copie della *Venere e Cupido*, si veda in *Appendice II* e Catt. 28, 31].

La storia della *Venere e Cupido*, elogiata da molti scrittori del tempo (*Appendice I*; Cat. 30), è riferita da Vasari nelle sue *Vite* di Michelangelo, Bronzino e specialmente Pontormo. Bartolomeo Bettini, mercante e banchiere fiorentino, fece fare a Michelangelo un disegno a grandezza naturale (cartone) di «una Venere ignuda con un Cupido che la bacia, per farla fare di pittura al Pontormo e metterla in mezzo a una sua camera, nelle lunette della quale aveva cominciato a fare dipingere dal Bronzino Dante, Petrarca e Boccaccio». Il dipinto della *Venere e Cupido* fu sequestrato al Pontormo dagli emissari del duca Alessandro de' Medici (1511-1537), «per far male a Bettino», che otten-

ne il cartone, ora perduto. Il Duca pagò a Pontormo 50 scudi, che egli utilizzò per costruire una casa, ultimata nel 1534.

La storia e lo stile della *Venere e Cupido* indicano che il Pontormo dipinse questa tavola intorno al 1533. Vasari affermava che Bronzino aveva appena iniziato i ritratti dei poeti, un presupposto che stabilisce una data compatibile con lo stile del suo disegno preparatorio per il *Dante* (Cat. 25) e con il dipinto stesso (Cat. 22). Il racconto del Vasari suggerisce che Michelangelo debba aver eseguito il cartone nel 1532-1533, data che coincide con lo stile di uno schizzo autografo della composizione (Cat. 29). Wilde (1953, p. 93) propose verosimilmente che anche il disegno che Michelangelo fece di una mano sinistra (Casa Buonarroti, n. 37A *verso*; TOLNAY 1975-1980, n. 226; fig. 23-b) fosse per la *Venere*.

Il dipinto acquisito dal Duca Alessandro compare nell'inventario della collezione dei Medici del 1553, nella *guardaroba* di Palazzo Vecchio, che costituì la base della collezione della moderna Galleria degli Uffizi. La presente opera fu scoperta nel deposito del museo nel 1850 (MILANESI 1881), sebbene fosse stata già menzionata nell'edizione delle *Vite* del Vasari del 1832-1838 (p. 831, n. 49), quando la Venere era coperta da estesi drappeggi che andavano da metà coscia fin sopra il seno. Prima che la *Venere e Cupido* venisse esposta al pubblico, nel 1861 (MANTZ 1876), queste vesti furono rimosse da Ulisse Forni, che orgogliosamente descrisse il procedimento nel suo influente manuale per restauratori (1866; *Appendice V*). I metodi da lui usati hanno provocato un grave danneggiamento dell'intera superficie dipinta, in special modo il corpo della Venere. Egli aggiunse anche un piccolo lembo di tessuto in corrispondenza del pube e stese una vernice pigmentata su tutto il dipinto. Tutto ciò è stato rimosso dall'attuale restauro.

Grazie a questo intervento, assottigliata la patina e la vernice che avevano appiattito l'opera, la *Venere* ha acquistato un senso scultoreo anche più grandioso, specialmente nelle parti che hanno subito minor danno, come l'avambraccio destro della Venere, il ginocchio e una vicina area della coscia della gamba destra, e l'intera figura di Cupido. I corpi appaiono più muscolosi e monumentali, le linee di contorno più precise e le pose più scattanti. Tale effetto aumenta se il quadro viene osservato da qualche metro di distanza e dal basso – sicuramente il punto di vista designato, data la posa della figura e la collocazione della maggior parte dei dipinti, in alto, sulle pareti delle camere del Rinascimento. Le figure, e in particolare la Venere, si staccano dalla scena, come sculture davanti a un fondale, sospinte verso il piano della rappresentazione.

La potente immagine di questa nuova *Venere* deve molto del suo effetto al disegno ma, data la scomparsa del cartone originale di Michelangelo, possiamo solo congetturare quali elementi questo contenesse. Gli studiosi hanno formulato l'ipotesi fondata che Michelangelo, mai particolarmente interessato ai paesaggi, avrebbe dato poca o addirittura nessuna indicazione per lo sfondo. Nella versione dell'Accademia, il primo piano è dominato dalla terra marrone, con solo una traccia di prato verde nell'angolo in basso a destra, e la collina sullo sfondo ha ricevuto solo una caratterizzazione sommaria. Al contrario, molte delle copie (per es. Catt. 28, 31) presentano colline dettagliate con molta più vegetazione. Una simile divergenza appare nei dipinti basati sul cartone di Michelangelo per il *Noli me tangere* (si veda in saggio Aste, figg. 3, 8), realizzato subito prima della *Venere e Cupido*. Per entrambe le opere, stando al Vasari, Michelangelo volle che il Pontormo eseguisse il dipinto, e la versione di Busto Arsizio (Varese) del *Noli me tangere* di Pontormo (Tav. VIII/1) presenta, alle spalle, uno sfondo semplificato, distante dalla massiccia rappresentazione del Cristo e della Maria Maddalena. Come ha osservato Wallace (1988), le versioni del dipinto alla Casa Buonarroti mostrano una maggiore integrazione delle figure all'interno del paesaggio, e il dipinto di Battista Franco, in particolare, contiene un panorama più dettagliato.

Varie differenze, visibili a occhio nudo, distinguono la tavola dell'Accademia dalle altre versioni esposte in mostra. In questa tavola lo spazio tra il primo e il secondo dito del piede della Venere appare curiosamente largo. Nel disegno sottostante, rivelato dalla riflettografia, tutti i dipinti mostrano un piede dalle identiche fattezze, ma nelle altre tre versioni un'ombra tra le dita svolge la funzione di ridurre la misura apparente dell'apertura. Inoltre la *Venere* dell'Accademia ha una marcata rientranza tra le falangi dell'alluce e ciò conferisce alla linea di contorno superiore, in quest'opera piuttosto che nelle altre versioni, un aspetto nodoso. Fra i dettagli importanti per l'iconografia dell'opera (vedi saggio Nelson) e in questo caso anche per l'interazione psicologica tra le figure, è, invece, la rappresentazione dell'occhio di Cupido. Soltanto

nel dipinto dell'Accademia esso guarda indietro, in direzione delle frecce, invece che verso le labbra di sua madre. Questo particolare accentua il senso dell'inganno nel rapporto di Cupido con Venere. Lo stesso sguardo e l'antiestetica divaricazione tra le dita del piede di Venere, sono presenti anche in alcune copie della *Venere e Cupido*, per esempio, quella a Londra (Tav. V/1). Comunque, solo la tavola dell'Accademia contiene un piccolo ma significativo dettaglio, nella rappresentazione delle frecce che scivolano verso la gamba di Venere. Qui le punte metalliche di *tutte* le frecce sono visibili, indicandone chiaramente l'orientamento verso il basso; in tutte le altre copie note, della freccia centrale è stata rappresentata soltanto l'asta. Altri tre aspetti in cui la versione dell'Accademia si differenzia – la statuetta che giace sul fondo del contenitore, la maschera di satiro e la composizione generale delle figure – offrono parallelismi rilevanti con dipinti indiscutibilmente del Pontormo o comunque con il suo stile. Il restauro ha rivelato che il corpo della statuetta ha un colorito grigio-bluastro, come la stessa scatola di pietra serena, ma il viso è dipinto intensamente e con mano sciolta, con colori simili a quelli di un essere vivente. Questo oscillare disorientante tra figura umana e artificiale è caratteristico del Pontormo. In *Giuseppe in Egitto* (1518-1519) – cfr. saggio Aste, fig. 16 – la statua "danzante" in cima alla colonna sul carro processionale, nell'angolo in basso a destra, sembra più animata di tutte le altre. Questo stato di ambiguità – si tratta di una rappresentazione di artificio o natura? – riappare più chiaramente che mai nella tavola dell'Accademia, oggi restaurata. Nelle altre versioni di questo dipinto, l'intero corpo della statuetta sembra di pietra, con il viso colpito dalla luce. Analogamente, il volto carnoso, le labbra piene e l'espressività della maschera del satiro, distinguono questo viso vivido dalle maschere che appaiono più artificiali, in tutte le altre copie della *Venere e Cupido*.

Anche la composizione del quadro dell'Accademia, dove molti elementi o figure risultano tagliati, è elemento tipico di molti dipinti del Pontormo: il risultato è una forte compressione delle forme, che ne aumenta la monumentalità. Sebbene la tavola non sia stata tagliata, il ginocchio sinistro di Venere quasi tocca il bordo inferiore del quadro, mentre vaso e arco sono tagliati dal bordo sinistro. Le altre versioni della Venere qui esposte hanno in comune un maggiore spazio su tutti i lati della composizione e di conseguenza un più ampio e calmo respiro, un effetto di più distesa "normalità". Inoltre, il dipinto dell'Accademia appare scuro in tutti e quattro gli angoli. Questa gamma di colori – sicuramente scelta dal pittore – serve così a bordare le figure che occupano quasi tutto il piano della rappresentazione. La trama coloristica, lo sfondo scuro e tetro, e il trattamento dei capelli di Cupido, richiamano anche due dipinti eseguiti in questo periodo, il *Noli me tangere* e il *Martirio dei diecimila* (Firenze, Galleria Palatina). Quest'ultima opera, disegnata da Pontormo ma che molto deve a Michelangelo, mostra anche notevoli somiglian-

ze con la *Venere*, nella definizione della muscolatura, specialmente per la figura centrale seduta. Significativamente, date le differenze nelle rappresentazioni dei paesaggi nelle varie copie della *Venere e Cupido*, non ci sono differenze sostanziali nel disegno sottostante, come appare nella riflettografia a raggi infrarossi eseguita sulle quattro versioni dipinte della *Venere e Cupido*: le tre qui esposte in mostra, e il dipinto di Michele Tosini a Roma. Queste riflettografie, precise fino a un quarto di millimetro, rivelano anche che tutti e quattro i disegni sottostanti di fatto hanno le stesse misure, a partire dalle figure nel loro complesso fino alla forma e dimensione dei più piccoli dettagli. Le variazioni sono così poco significative che, sovrapponendo le riflettografie, esse appaiono come

23-a. Alessandro Allori, *Venere e Cupido/ Venus and Cupid*. Paris, Musée du Louvre, Département des Arts Graphiques, Inv. 1029.

un'unica immagine. Questa riproduzione quasi maniacale, nelle diverse opere di differenti artisti, deve rispecchiare lo straordinario rispetto che essi avevano per il disegno di Michelangelo. Evidentemente il cartone originale di Michelangelo (o forse il dipinto del Pontormo) è servito da base per la creazione di uno o più cartoni esecutivi estremamente precisi, impiegati poi da altri artisti. Uno di questi cartoni probabilmente è stato usato come modello per il disegno a grandezza reale, conservato a Napoli (Cat. 27). Lo stile meccanico e la

notevole somiglianza tra i disegni sottostanti, evidenziati nelle riflettografie, indicano che non fu tracciato a mano libera. Tuttavia le quattro riflettografie evidenziano alcune differenze importanti. Solo il disegno per il dipinto dell'Accademia presenta linee sicure e decise. Questo si differenzia dal più esitante e incerto disegno sottostante visibile nelle riflettografie delle altre tre versioni della *Venere e Cupido*.

La riflettografia fornisce anche un'informazione utile al dibattito sull'ideazione della scatola presente sul lato sinistro, contenente vari simboli che alludono al tema dell'amore. Tolnay (1975-1980) suggeriva che fosse stato Pontormo ad aggiungere questo elemento; Costamagna (1994) propose che il pittore avesse seguito i suggerimenti di Michelangelo, il quale avrebbe eseguito dei disegni preparatori per le maschere. Il disegno sottostante mostra invece che il pittore cui si deve la tavola dell'Accademia si attenne a un cartone, per disegnare contenitore e contenuto. Il tipo di tratto è diverso da quello con cui sono tracciate le figure principali, un dato che suggerisce che l'artista possa aver usato due cartoni separati; il fatto non sorprende, considerate le dimensioni di questo grande dipinto. Questa misteriosa scatola, a cui sembra indicare Venere, forse più visibile in una copia disegnata (fig. 23-a; v. *Appendice II*. 36), deve essere stata pensata da Michelangelo, data l'importanza che riveste per l'iconografia e l'equilibrio visivo dell'opera. Questa struttura compare in quasi tutte le versioni della *Venere e Cupido* anche in quelle in cui gli artisti si sono presi delle libertà per il paesaggio. Inoltre, una scatola rettangolare con delle maschere appare anche in posizione preminente nel disegno di Michelangelo per *Il Sogno* (si veda Catt. 41, 42), realizzato proprio in questo periodo (MARONGIU 2001, p. 84 n. 53).

Questi caratteri stilistici, e le differenze tra il quadro dell'Accademia e le altre versioni della *Venere e Cupido* contribuiscono a supportare la sua identificazione con l'opera della collezione medicea lodata da Vasari. Molti studiosi l'hanno attribuita a Pontormo senza dubbi (WILDE 1953; BERENSON 1963; FORSTER 1966; BERTI 1973; HIBBARD 1975; SHEARMAN 1983; COSTAMAGNA 1994; FORLANI-TEMPESTI-GIOVANNETTI 1994; CONTI 1995), o con riserve (CLAPP 1916; GAMBA 1921; TOLNAY 1975-1980; BERTI 1993; FRANKLIN 2001). Altri hanno raccolto l'attribuzione senza ulteriori commenti, lasciando forse a intendere una scarsa convinzione (BECHERUCCI 1944; COX-REARICK 1964; LEVEY 1967; KEACH 1978; NATALE 1979) e un certo numero di autorevoli autori ha sconfessato decisamente l'opera o espresso forti dubbi (POPP 1922; STEINMAN 1925; TOLNAY 1948; BAROCCHI 1962; MAURER 1967; SANMINATELLI 1956; FREEDBERG 1983).

Senza dubbio lo stile del dipinto dell'Accademia si distacca sensibilmente da quello delle opere più famose del Pontormo, come quelle nella Cappella Capponi a Santa Felicita, apprezzate per le qualità manieristiche. Lo stesso Vasari suggeriva una ragione possibile. Dopo avere fatto menzione dei cartoni per la *Venere e Cupido* e per il *Noli*

me tangere, osservava che i "disegni di Michelangelo furono cagione che considerando il Puntormo la maniera di quello artefice nobilissimo, se gli destasse l'animo e si risolvesse per ogni modo a volere secondo il suo sapere imitarla e seguitarla» (1568/1966-1997, V, p. 326). Già agli occhi del Vasari, lo stile della Venere e Cupido e del Noli me tangere appariva atipico per il Pontormo. Non solo si stava cimentando a dipingere in uno stile michelangiolesco, ma il Pontormo doveva anche seguire fedelmente un cartone, invece di comporre alla sua maniera. La tipologia delle figure e la procedura di lavorazione che il pittore usava abitualmente, erano completamente diverse. Naturalmente i dipinti che ne risultarono costituiscono un insieme a parte rispetto agli altri, nell'opera del Pontormo. Sebbene lo stato di conservazione del dipinto dell'Accademia dia ampiamente motivo di cautela, lo stile del dipinto come lo si può giudicare dalle parti in migliore stato di conservazione, unito alla particolare forza di impatto dell'immagine, al carattere del disegno sottostante, alla provenienza e alla sua qualità indiscutibilmente più raffinata rispetto a tutte le copie note, tutto contribuisce a sostenere un'attribuzione a Pontormo.

Jacopo Carucci, called il Pontormo (?)
(Pontorme 1494-Firenze 1557)
following cartoon
by Michelangelo Buonarroti
(Caprese 1475-Roma 1564)

Venus and Cupid

c. 1533 (painting); 1532-1533 (cartoon)
Oil on panel
128.5 x 193 cm
Firenze, Galleria dell'Accademia, Inv. 1890/1570

[Note: This entry focuses on how the painter of the Accademia Venus and Cupid interpreted Michelangelo's cartoon, and on the style and attribution of this recently restored version. For a discussion of the complex iconography, composition, and body types in Michelangelo's design, see Nelson's essay; for the commission, patron, and physical setting, see Aste's essay; for the restoration report see Appendix IV; for technical examinations, see essay by Bellucci and Frosinini and Appendix V; for sixteen painted copies of the Venus and Cupid, see Appendix II and Cats. 28, 31.]

The history of the Venus and Cupid, celebrated by many writers of the period (Appendix I; Cat. 30), is recounted by Vasari in his Lives of Michelangelo, Bronzino, and especially Pontormo. Bartolomeo Bettini, a Florentine merchant-banker, had Michelangelo make a full-size drawing or cartoon of "a nude Venus with a Cupid who kisses her, in order to have Pontormo paint it, and to put it in the middle of his chamber, in the lunettes of which Bronzino had begun to paint Dante, Petrarch, and Boccaccio". The Venus

and Cupid painting was confiscated from Pontormo by the agents of Duke Alessandro de' Medici (1511-1537) "in order to do an injury to Bettini", who received the cartoon, now lost. The ruler paid Pontormo 50 scudi which he used to build a house, completed in 1534.
The history and style of the Venus and Cupid indicate that Pontormo painted this panel in about 1533. Vasari stated that Bronzino had already begun the poet portraits, which establishes a date consistent with the style of his preparatory drawing of Dante (Cat. 25) and of the painting itself (Cat. 22). Vasari's account suggests that Michelangelo executed the cartoon in 1532-1533, a date which corresponds to an autograph composition sketch (Cat. 29). Wilde (1953, p. 93) plausibly proposed that Michelangelo's drawing of a left hand (Casa Buonarroti, n. 37A verso; Tolnay 1975-1980, 226; fig. 23-b) was also made for Venus.
The painting, acquired by Duke Alessandro, appears in the 1553 inventory of the Medici Collections, in the Palazzo Vecchio guardaroba, which constituted the basis of the collection of the modern Galleria degli Uffizi. The present work was discovered in the museum storage in 1850 (Milanesi 1881), though it had already been mentioned in the 1832-1838 edition of Vasari's Lives (p. 831 n. 49), with extensive draperies extending from mid-thigh to above the breasts. Before the Venus and Cupid was put on public view in 1861 (Mantz 1876), this clothing was removed by Ulisse Forni, who proudly described the process in his influential manual for restorers (1866; see Appendix V). The methods he used severely damaged the entire paint surface, especially the body of Venus. He also added a small piece of drapery over her groin and a colored varnish over the entire painting. These were removed in the present restoration.
Without the grime and varnish that had flattened the work, the Venus has acquired an even greater sculptural sense, especially in the isolated areas that suffered less damage, such as Venus' right forearm, the knee and part of the thigh of her right leg, and the entire figure of Cupid. The bodies are more muscular and monumental, the outlines more precise, and the poses more tense. This effect is augmented if one views the painting from a few feet away and from below – surely the intended point of view, given the pose of the figure and the placement of most paintings high on the walls in Renaissance chambers. Nevertheless, the main figure and the two masks have lost much of the shadow and modeling that originally created these forms. As a result, the figures, especially Venus, seem like sculptures detached from their setting, like sculptures before a background, pushed up against the picture plane.
The powerful image of this new Venus derives much of her impact from the design, but given the loss of Michelangelo's original cartoon, we can only surmise what elements it contained. Scholars have made the reasonable assumption that Michelangelo, never particularly interested in landscapes, gave little or no indication of the

setting. In the Accademia version, the foreground is dominated by the brownish earth, with only a hint of green grass in the lower right corner; the background hill received only summary treatment. In contrast, many of the copies (e.g., Cats. 28, 31) show lush, detailed hills and much greenery. A comparable divergence appears in the paintings based on Michelangelo's cartoon of the Noli me tangere (see Aste's essay, figs. 3, 8), made immediately prior to the Venus and Cupid. For both works, according to Vasari, Michelangelo wanted Pontormo to carry out the painting, and Pontormo's version of Noli me tangere (Pl. VIII/1) shows a simplified setting behind and detached from the massive representations of Christ and Mary Magdalene. As Wallace has observed (1988), the versions of the painting in the Casa Buonarroti show a greater integration of the figures into the landscape, and Battista Franco's painting in particular includes a more detailed landscape.
Several differences visible to the naked eye distinguish the Accademia panel from the other versions here exhibited: two paintings and a full-scale drawing. In this panel the space between Venus' first and second toe appears unusually wide. In the underdrawing revealed by the infrared reflectographs, all the paintings show identical feet, but in the other three versions a shadow between the toes serves to reduce the apparent size of the opening. The Accademia Venus has a sharp indentation between the phalanges of her large toe, giving the upper outline of her foot a uniquely gnarled appearance. More importantly for the iconography of the work (see Nelson essay) and for the psychological interaction of the figures, the Cupid in the Accademia painting looks back at

23-b. Michelangelo, Studio di mano sinistra / Study of left hand. Firenze, Casa Buonarroti, Inv. 37A v.

the arrows, instead of toward his mother's lips. This detail adds to the sense of deception in Cupid's relationship with Venus. The same gaze, and the disturbingly wide space between Venus' toes, also appears in some copies of the *Venus and Cupid*, for example the one in London (Pl. V/1). Only the Accademia panel, however, includes a small, telling detail in the depiction of the arrows falling toward Venus's leg. Here, the metal points of *all* the arrows are visible, indicating that they all point down; in all the other known copies, only the shaft of the central arrow is represented. Three other aspects in which the Accademia version distinguishes itself from the other versions – the statuette lying on the bottom of the container, the satyr mask, and the overall placement of the figures, have striking parallels in paintings unquestionably by Pontormo or with his style. The restoration revealed that the body of the statuette is bluish-gray, like the *pietra serena* box itself, but the face is vividly and loosely painted with colors like those of a living person. This disconcerting slippage between artifact and human figure also appears in the statue atop the column on the processional float in the lower right corner of Pontormo's *Joseph in Egypt* (1518-1519) – see essay Aste, fig. 16 –: the dancing figure seems more animated than anyone else in the painting. This ambiguous status – is it a representation of art or nature? – reappears more clearly than ever in the restored Accademia panel. In the other versions of this painting, the entire statuette appears to be stone, with light hitting the face. Analogously, the fleshy surface, full lips, and expressiveness of the satyr mask distinguish this life-like face from the more artificial masks in all other copies of the *Venus and Cupid*.

Those paintings also include more space on all sides of the composition. In contrast, the Accademia painting appears highly compressed, adding to the sense of monumentality of the main figure. Though the panel has not been cut down, Venus' left knee nearly reaches the lower edge of the panel, and the vase and bow are cut off by the left edge. This placement of the figures within the composition, typical of many Pontormo paintings, does not appear in the other versions of the *Venus* here exhibited. Moreover, only the Accademia *Venus* is dark in all four corners. This color scheme – surely selected by the painter – thus serves to frame the figures that take up nearly the entire picture plane. The colors, the dark, somber setting, and the treatment of Cupid's hair also recall two paintings executed at this time, the *Noli me tangere* and the *Martyrdom of the Ten Thousand* (Florence, Galleria Palatina).

The latter work, designed by Pontormo but heavily indebted to Michelangelo, also shows strong similarities with the *Venus* in the depiction of musculature, especially in the central seated figure.

Significantly, given the differences in the landscape found in the copies of the *Venus and Cupid*, there are no substantial differences in the underdrawings, as revealed by the infrared reflectographs (IRR) of the three painted versions of the *Venus and Cupid* on view in this exhibition, and of Michele Tosini's painting in Rome. These IRR, accurate to within a quarter of a millimeter, also reveal that all four underdrawings are virtually identical in size, from the overall figures to the shape and length of the smallest details. Variations are so insignificant that when the IRR are superimposed, they appear as one unique image. This almost maniacal reproduction in different works by different artists must reflect the extraordinary respect they had for Michelangelo's design.

Evidently, Michelangelo's original cartoon (or perhaps Pontormo's painting) served as the basis for the creation of one or more extremely accurate cartoons used by other artists. One of these working cartoons probably served as the model for the full-scale drawing, now in Naples (cat. 27). The mechanical style and remarkable similarity of the underdrawings in the IRR indicate that they were not made free hand. Nevertheless, the four IRR do show some differences. Only the one for the Accademia painting has firm, decisive lines. This differs from the more hesitant and tentative underdrawings in IRR of the three other versions of the *Venus and Cupid*.

The reflectographs also provide useful information for the debate over the invention of the container at the left side with various symbols alluding to love. Tolnay suggested that Pontormo added this feature; Costamagna (1994) proposed that the painter followed the suggestions of Michelangelo, who probably made preliminary drawings for the masks. The underdrawing, however, clearly shows that the painter who executed the Accademia panel followed a cartoon for the container and its contents. The type of line differs from that used for the main figures, which suggests that the artist used two different cartoons; this would hardly be surprising, given the size of the large painting. The mysterious box, to which Venus seems to point, perhaps more visible in a drawn copy (fig.23-a; see *Appendix II*. 36) must have been planned by Michelangelo, considering its importance to the iconography and the visual balance of the work. The structure appears in virtually all identified versions of the *Venus and Cupid*; artists took liberties with the background, but not with this. In addition, a rectangular box and masks also appear prominently in Michelangelo's drawing of *The Dream* (see Cat. 41 and Cat. 42), made during this very period (MARONGIU 2001, p. 84 n. 53). These stylistic qualities, and the differences between the Accademia Venus and the other versions, all strongly support its identification as the very work by Pontormo praised by Vasari. Many scholars have attributed it to Pontormo with-

out question (WILDE 1953; BERENSON, 1963; FORSTER 1966; BERTI 1973; HIBBARD 1975; SHEARMAN 1983; COSTAMAGNA 1994; FORLANI-TEMPESTI-GIOVANNETTI 1994; CONTI 1995), or with reservations (CLAPP 1916; GAMBA 1921; TOLNAY 1975-1980; BERTI 1993; FRANKLIN 2001). Others have recorded the attribution without comment, perhaps implying a lack of conviction (BECHERUCCI 1944; COX-REARICK 1964; LEVEY 1967; KEACH 1978; NATALE 1979), and a number of respected authors have rejected the work outright or expressed grave doubts (POPP 1922; STEINMAN 1925; TOLNAY 1948; SANMINIATELLI 1956; BAROCCHI 1962; MAURER 1967; FREEDBERG 1983).

Undoubtedly, the style of the Accademia painting differs sensibly from that in Pontormo's most famous works, such as those in Santa Felicita, celebrated for their mannerist qualities. Vasari himself provided one possible reason. After mentioning the cartoons for the *Venus and Cupid* and *Noli me tangere*, he observed that "these drawings by Michelangelo were the reason that Pontormo, considering the style of that most noble artist, gave over his soul to Michelangelo and resolved to imitate his style insofar as he was able". (VASARI 1568/1966-1997, V, p. 326). For Vasari, the style of the *Venus and Cupid* and *Noli me tangere* appeared atypical for Pontormo. Not only was he attempting to paint in a Michelangelesque style, but Pontormo also had to closely follow a cartoon, instead of building up elements in his own manner. The figures types and the working procedure were extremely different from those usually used by the painter. Naturally, the resulting paintings stand apart from all others in Pontormo's *œuvre*.

Though the state of conservation of the Accademia painting gives ample reason for caution, the history, underdrawing, overall appearance, and better preserved areas of the painting all support an attribution to Pontormo.

Jonathan Katz Nelson

BIBLIOGRAFIA / BIBLIOGRAPHY
VASARI 1832-1838, p. 831 n. 49; FORNI 1866, p. 136; MANTZ 1876, p. 159; MILANESI 1881; CLAPP 1916, pp. 63, 142-145; GAMBA 1921, p. 13; POPP 1922, pp. 147-148; STEINMAN 1925, pp. 8-9; BECHERUCCI 1944, p. 20; TOLNAY 1948, pp. 108-109, 194-196; SANMINIATELLI 1956, p. 243; BAROCCHI 1962, p. 1940; COX-REARICK 1964, p. 294 n. 14; LEVEY 1967, p. 32; TOLNAY 1975-1980 n. 302; II, p. 87; WILDE 1953, p. 93; BERENSON 1963, I, p. 180; FORSTER 1966, p. 145 n. 41; MAURER 1967, p. 145; BERTI 1973, p. 105 n. 116; HIBBARD 1975, p. 226; KEACH 1978, p. 327; NATALE 1979, p. 92; SHEARMAN 1983, p. 227; FREEDBERG 1983, p. 178; BERTI 1993, p. 260; COSTAMAGNA 1994; FORLANI-TEMPESTI e GIOVANNETTI 1994, pp. 15, 136-137; CONTI 1995, p. 51; FRANKLIN 2001, p. 75.

Martini sopravvive in molteplici copie. Lo stesso Martini deve avere suggerito uno schema iconografico senza precedenti per il dipinto, che sembra ricreare gli accesi dibattiti all'interno dell'Accademia Fiorentina. Il committente, Bettini, Bronzino e Michelangelo erano tutti membri di questa istituzione culturale, in cui letterati e dilettanti prendevano parte a vivaci disquisizioni e lezioni sulla lingua toscana. (Martini e Bettini compaiono anche come personaggi in un inedito dialogo del XVI secolo. Cfr. saggio Leporatti). Molti accademici presentavano Petrarca come il miglior poeta italiano, ma il dipinto del Vasari attribuisce a Dante una posizione d'onore, essendo la figura centrale e l'unica raffigurata seduta. Questo schema riflette gli interessi del committente, che aveva portato avanti importanti studi filologici sulla *Commedia* e aveva commissionato il rilievo della *Morte del conte Ugolino della Gherardesca* a Pierino da Vinci. Il committente, come molti studiosi nel Rinascimento, aveva anche analizzato la topografia dell'*Inferno* e del *Purgatorio* e sicuramente avrà apprezzato l'importanza data dal Vasari al compasso, al quadrante e ai globi dei cieli e della terra.

Per il gruppo centrale di persone sedute e in piedi intorno a un tavolo, Vasari rielaborò la composizione di Raffaello per il *Ritratto di papa Leone X con due cardinali* (Firenze, Galleria degli Uffizi). I quattro poeti coronati appaiono disposti su due file parallele, con Dante e il tavolo sulla sinistra dello spettatore. Poco più a sinistra, e dietro al gruppo principale, si vedono Landino e Ficino in piedi. Così Vasari intendeva incorniciare i grandi poeti del Trecento tra due gruppi di studiosi di letteratura: gli umanisti del Quattrocento, Ficino e Landino e, di fronte al quadro, Martini e i suoi eruditi amici. La complessa struttura, e gli attributi di Dante, indicano uno slittamento dell'enfasi rispetto al ciclo del Bronzino per Bettini. Piuttosto che dipingere ritratti isolati di poeti d'amore, Vasari mise in scena i vivaci dibattiti tra e a proposito dei grandi e colti autori toscani.

Cat. 24 (Tav. IV/1)

GIORGIO VASARI
(Arezzo 1511-Firenze 1574)

Sei Poeti Toscani

1544
Olio su tavola
cm 130 x 130
Minneapolis, Institute of Arts, Inv. 71.24

In un ricordo del 15 settembre 1544, Vasari annotò di avere consegnato a Luca Martini un grande dipinto con sei figure – Dante, Petrarca, Boccaccio, Cavalcanti, Cino da Pistoia e Guittone d'Arezzo – e che Bronzino ne aveva concordato il prezzo. Per questo ritratto di gruppo molto animato, menzionato anche nella *Vita* di Vasari stesso e in una lettera a lui indirizzata da Paolo Giovio nel 1546, l'artista attinse dal ciclo dei ritratti di poeti dipinto dal Bronzino, nel 1532 circa, per Bartolomeo Bettini (Cat. 23). Per la figura centrale Vasari adottò il caratteristico profilo di Dante adattandone l'orientamento della testa; la posizione inusuale del braccio probabilmente è tratta dalla posa di Cupido nella *Venere e Cupido*, anche questa realizzata per Bettini (Cat. 232). Vasari raffigura il poeta rivolto verso Cavalcanti, mentre tiene in mano un libro aperto su cui appare l'iscrizione «VIRGILIUS»,

un'allusione all'*Inferno* (X. 61-63), in cui Dante scriveva come il suo amico disdegnasse l'antico poeta. La loro conversazione appare interrotta da Petrarca, proteso in avanti in atto di gesticolare con una mano; l'altra mano è poggiata sul suo libro di versi dedicati a Laura, il cui volto di profilo adorna il volume. Il viso pingue di Boccaccio appare alle spalle di Dante e Petrarca, una posizione che dimostra la sua condizione di terzo per importanza tra i poeti coronati. È piuttosto probabile che questi ritratti di Boccaccio, Petrarca – e forse lo stesso Cavalcanti – fossero ispirati da dipinti andati perduti e disegni preparatori del Bronzino. Le due figure sull'estrema sinistra, invece, derivano dai ritratti di Marsilio Ficino e Cristoforo Landino in un affresco di Domenico Ghirlandaio in Santa Maria Novella (BOWRON 1971-1973). Unici due personaggi ad indossare copricapi del XV secolo al posto di corone d'alloro, questi umanisti neoplatonici rappresentano la tradizione di interpretare Dante a Firenze. L'identità delle due figure fu evidentemente confusa nel resoconto del dipinto fatto dallo stesso Vasari, che spesso faceva degli errori nel descrivere le proprie opere. Secondo un ricordo del 1548, i sei poeti che Vasari aveva indicato come presenti nella tavola di Martini apparivano in un dipinto su tela che egli stesso aveva realizzato per Giovio, e l'artista probabilmente confuse le due opere (KLIEMAN 1981). Nonostante il dipinto di Giovio non si sia conservato, la versione per

GIORGIO VASARI
(Arezzo 1511-Firenze 1574)

Six Tuscan Poets

1544
Oil on panel
130 x 130 cm
Minneapolis, Institute of Arts, Inv. 71.24

In a 'ricordo' of 15 September 1544, Vasari noted that he had delivered a large painting to Luca Martini with six figures – Dante, Petrarch, Boccaccio, Cavalcanti, Cino da Pistoia and Guittone d'Arezzo – and that Bronzino had approved the price. For this animated group portrait, also mentioned in *Vita* of Vasari, and in a 1546 letter to him from Paolo Giovio, the artist bor-

rowed from the cycle of poet portraits painted by Bronzino in ca. 1532 for Bartolomeo Bettini (Cat. 22). For the central figure Vasari appropriated Dante's distinctive profile and adapted the turn of his head; the unusual position of his arm probably reflects Cupid's pose in the *Venus and Cupid*, also made for Bettini (Cat. 23). Vasari has the poet address Cavalcanti while holding an open book inscribed "VIRGILIUS", an allusion to *Inferno* (X. 61-63) where Dante wrote that his friend had disdain for the ancient poet. Their conversation seems to be interrupted by Petrarch, who leans forward and gestures with one hand; the other one rests on his book of verses for Laura, whose profile adorns the volume. The fleshy face of Boccaccio appears behind Dante and Petrarch, a position that evinces his status as the third of the crown poets. Quite possibly these portraits of Boccaccio, Petrarch – and conceivably, even Cavalcanti – were inspired from lost paintings and preparatory drawings by Bronzino.

The two figures on the far left, however, derive from the portraits of Marsilio Ficino and Cristoforo Landino in a fresco by Domenico Ghirlandaio in Santa Maria Novella (BOWRON 1971-1973). The only ones wearing fifteenth-century caps instead of laurel wreath, these Neo-Platonic humanists represent the Florentine tradition of interpreting Dante. The two figures were evidently misidentified in the account of the paint-

ing given by Vasari, who often made errors when describing his own works. According to a 'ricordo' of 1548, the six poets Vasari had mentioned as in the Martini panel also appeared in a canvas painting he made for Giovio, and the artist probably confused the two works (KLIEMANN 1981). Though Giovio's painting does not survive, the version for Martini exists in several copies.

Martini himself must have suggested the unprecedented iconography for his painting, which seems to recreate the heated debates within the Accademia Fiorentina (NELSON 1992). The patron, Bettini, Bronzino, and Michelangelo were all members of this cultural institution, where writers and dilettantes joined in spirited discussions and lectures on the Tuscan language (PARKER 1998). Martini and Bettini also participate in an unpublished sixteenth-century dialogue about Ariosto (see Leporatti's essay, in this volume).

Many Academicians presented Petrarch as the finest Italian writer, but Vasari's painting gives the position of honor to Dante, the central and only seated figure. This reflects the interests of the patron, who carried out important philological studies of the *Commedia*, and commissioned Pierino da Vinci's relief of the *Death of Count Ugolino della Gherardesca*.

The patron, like many Renaissance scholars, also analyzed the topography of the *Inferno*

and *Purgatorio*, and surely appreciated the prominence Vasari gave to the compass, quadrant, and the globes of the Heavens and Earth. For the central group of seated and standing figures behind a table, Vasari elaborated on the composition in Raphael's *Portrait of Pope Leo X with Two Cardinals* in the Uffizi (NELSON 1995). The four crowned poets appear in two parallel lines, with Dante and his table to the left of the viewer. Even further to the left, and behind the main group, stand Landino and Ficino. Vasari thus framed the great poets from the Trecento between two groups of literary scholars: within the painting, the humanists from the Quattrocento, Ficino and Landino, and in front of the work, the patron Luca Martini and his erudite friends.

This complex structure, and Dante's attributes, indicates a shift in emphasis from Bronzino's cycle for Bettini. Rather than depicting isolated portraits of love poets, Vasari showed the lively debates between and about the great and learned Tuscan authors.

Jonathan Katz Nelson

BIBLIOGRAFIA/ BIBLIOGRAPHY
BOWRON 1971-1973, pp. 43-53; KLIEMANN in *Giorgio Vasari* 1981, p. 123; NELSON 1992; NELSON 1995, pp. 284-285; PARKER 1998.

Cat. 25

AGNOLO TORI detto IL BRONZINO
(Firenze 1503-1572)

Studio per una testa di Dante

1532-1533 ca.
Matita nera su carta bianca
mm 292 x 215
München, Staatliche Graphische Sammlung, Inv. 2147

Questo disegno, incontestabilmente di mano del Bronzino, è servito di riferimento alla critica per illustrare la lunetta di Dante dipinta dall'artista per Bartolomeo Bettini, finora ritenuta dispersa. Si tratta di uno studio soltanto per il volto del poeta che, rispetto alla versione finale, mostra alcune notevoli differenze. Dante è qui rappresentato di profilo, mentre nell'opera finita l'artista scelse un profilo perduto, spostando leggermente la testa verso sinistra, e in funzione della collocazione della lunetta lo rappresentò di sotto in su. D'altronde, nel disegno il copricapo di Dante è più accuratamente studiato e presenta nella sua parte superiore uno sbuffo di tessuto, assente nella versione definitiva, ma che doveva trovarsi nel modello utilizzato dal Bronzino, verosimilmente prossimo alla miniatura in cui è rappre-

sentato il poeta conservata a Firenze alla Biblioteca Riccardiana (cfr. NELSON 1992, fig. 6).
Il foglio di Monaco sembra di fatto essere, più che il disegno preparatorio alla figura della lunetta, la copia del modello che doveva servire di riferimento all'autore. Certamente era stato deciso, all'inizio, che i poeti toscani sarebbero stati rappresentati di profilo, come la sottostante *Venere e Cupido*.
A eccezione dell'affresco di Domenico di Michelino del Duomo, dove Dante è dipinto di tre quarti (vedi saggio Leporatti, fig. 8), il maggior numero di opere pittoriche che lo raffigurano a Firenze lo presentano di profilo, ciò che rende difficile sapere esattamente quale fu il modello utilizzato da Bronzino (sulle diverse raffigurazioni di Dante, cfr. CAPRETTI in FORLANI-TEMPESTI e CAPRETTI 1996, pp. 103-104). Per padroneggiare bene i lineamenti danteschi, Bronzino si applicò con cura alla resa del modello del volto, lasciando il resto quasi allo stato di abbozzo.
Stilisticamente il disegno di Monaco è avvicinabile allo studio di Chatsworth, preparatorio per il *Ritratto di suonatore di liuto* degli Uffizi, databile verso il 1532-1534, il che permette di suggerire che l'artista sin dal suo ritorno da Pesaro, alla fine del 1532, si dedicò alla decorazione della "camera" di Bettini.
La tecnica di tratteggio per piccoli tratti paralleli e l'utilizzazione dello spessore della matita nera ricordano il disegno di Michelangelo che il Bronzino studiò sicuramente di nuovo in questa occasione.

AGNOLO TORI called BRONZINO
(Firenze 1503-1572)

Study for the head of Dante

c. 1532-1533
Black chalk on white paper
292 x 215 mm
München, Staatliche Graphische Sammlung,
Inv. 2147

This drawing, universally accepted as an original by Bronzino, has served scholars in discussions regarding the lunette representing Dante painted by the artist for Bartolomeo Bettini — up to now thought to have been lost.

The drawing regards only the head of the poet and presents notable differences with respect to the final version. Here Dante is represented in profile, while in the finished work the artist opted for a lost profile, shifting the head slightly towards the left and calculating the viewpoint from below in consideration of the higher location of the lunette.
Hence Dante's head covering is more detailed in the drawing and includes a tuft of cloth at the top that is absent in the final version. The detail was probably present, however, in the model used by Bronzino that, in all likelihood, resembled the miniature portraying the poet now in the Biblioteca Riccardiana, Firenze (cf. NELSON 1992, fig. 6).
The sheet from München, more than a preparatory drawing for the figure in the lunette, appears to be a copy of the model that must have served as a point of reference for the author. It is certain that initially it was decided that the Tuscan poets were to have been portrayed in profile, like the *Venus and Cupid* below.
With the exception of the fresco by Domenico di Michelino in the Cathedral (see Leporatti's essay, fig. 18) in which Dante is portrayed in a three-quarter turn, the majority of paintings representing the poet in Florence portray him in profile, making the identification of Bronzino's exact model problematic (on the various representations of Dante cf. CAPRETTI 1996, pp. 103-104). In mastering Dante's likeness, Bronzino paid special attention to the facial traits, leaving all else almost in the state of a draft. Stylistically the Münich drawing is close to the study in Chatsworth, a preparatory drawing for the *Portrait of the Lute Player* in the Uffizi, dating about 1532-1534. This suggests that just after his return from Pesaro at the end of 1532, the artist dedicated himself to the decoration of the Bettini chamber. The drawing technique characterized by small parallel lines and the use of the thickness of the black chalk are reminiscent of the drawings of Michelangelo that Bronzino surely studied anew for this occasion.

Philippe Costamagna

BIBLIOGRAFIA / BIBLIOGRAPHY
HARPRATH in *Zeichnungen* 1983, p. 23, n. 9 (con bibliografia); NELSON 1992, pp. 65, 75, n. 44; COSTAMAGNA 1994, p. 221; SMITH 1996, p. 32; PLAZZOTA 1998, p. 256.

Cat. 26

ANONIMO FIORENTINO DEL SETTECENTO
da FEDERICO ZUCCARI

Ritratto di Dante

Databile tra il 1738 e il 1753
Matita nera su carta bianca
mm 260 x 205
Firenze, Galleria degli Uffizi,
Gabinetto Disegni e Stampe, Inv. 14287F

Questo foglio, che ripete la composizione della lunetta del Bronzino per la "camera" di Bartolomeo Bettini, faceva parte del volume della *Divina Commedia* (Firenze, Galleria degli Uffizi, Inv. 3474-3560F) illustrata da Federico Zuccari durante il suo soggiorno all'Escoriale verso il 1587-1588, date risultanti dall'iscrizione sul *verso* dei fogli Inv. 3547F e 3550F.

Il presente disegno, di mano di un anonimo artista fiorentino, andò a rimpiazzare l'originale a matita rossa e matita nera che era stato sciolto e incorniciato, come risulta dall'inventario della Galleria, redatto dal Pelli nel 1784 (BRUNNER 1993) e fu eseguito tra il 1738 (data dell'entrata in Galleria del volume) e il 1753 (data della prima menzione, in un inventario, del disegno di Federico staccato dal volume).

Le dimensioni risultano identiche a quelle dell'originale (mm 260 x 205), il che non lascia dubbi sul fatto che si tratti di una copia. Nel 1865 fu anch'esso tolto dal volume per essere restaurato e quindi raggiungere il cassetto degli anonimi italiani del Settecento.

Il foglio di Federico Zuccari, perduto all'inizio dell'Ottocento, è stato ipoteticamente ravvicinato, da Michel Brunner e Cristina Acidini Luchinat, al disegno eseguito a sanguigna e matita nera del Fitzwilliam Museum di Cambridge (Inv. 1176; acquisito nel 1926). Oltre alle dimensioni che sono diverse (mm 232 x 201), la qua-

lità della sanguigna, più rossa di quella utilizzata da Federico per le illustrazioni della *Divina Commedia*, rende poco credibile questa ipotesi e infatti, come ha dimostrato David Scrase (1996, pp. 205-206), il disegno di Cambridge presenta le caratteristiche della scuola fiorentina del Seicento e potrebbe essere di mano di Carlo Dolci, realizzato direttamente dalla lunetta. Come indica il presente disegno degli Uffizi, inoltre, l'originale di Federico non teneva conto della forma arrotondata della lunetta.

Non deve sorprendere che Federico Zuccari scegliesse, per il primo foglio del suo volume, un *Ritratto di Dante* del Bronzino, visto che nel frontespizio del libro che aveva utilizzato come modello, *La Commedia* curata da Francesco Sansovino nel 1564 per i tipi dei veneziani Giovanbattista Marchiò Sessa e Fratelli (BRUNNER 1993, p. 71), si trovava un busto del poeta inciso dalla lunetta del Bronzino, inserito in una cornice manierista (ZAPPELLA 1988, tav. 27).

Ciononondimeno, diverse incertezze persistono sul modello utilizzato da Federico Zuccari.

Effettivamente l'artista risiedette a Firenze dal 1575 al 1579, dieci anni prima della realizzazione dell'illustrazione della *Divina Commedia* e vi ritornò solo per brevi soggiorni tra il 1590 e il 1594, quindi quando realizzò il suo volume o si valse di vecchi disegni in suo possesso o fece ricorso a un altro modello, a sua volta copiato dal prototipo del Bronzino. L'interesse di Agnolo per Dante non deve comunque suscitare meraviglia in quanto l'artista assimilava segretamente le vicende della sua carriera all'ingiusta persecuzione che Dante dovette subire (ACIDINI LUCHINAT 1999, II, p. 112).

ANONYMOUS FLORENTINE
OF THE EIGHTEENTH-CENTURY
after FEDERICO ZUCCARI

Portrait of Dante

Dating between 1738 and 1753
Black chalk on white paper
260 x 205 mm
Firenze, Galleria degli Uffizi,
Gabinetto Disegni e Stampe, Inv. 14287F.

This sheet, that replicates the composition of the lunette by Bronzino for the chamber of Bartolomeo Bettini, was once part of the volume of the *Divine Comedy* (Firenze, Galleria degli Uffizi, Inv. 3474-3560F) illustrated by Federico Zuccari during his sojourn at the Escorial at a date around 1587-1588 as the inscription on the verso of the sheets inv. 3547 F and 3550F indicates.

The drawing under examination, attributed to an anonymous Florentine master, replaced the original by Zuccari in red and black chalk that had been detached from the volume and

framed, as the inventory of the Galleria compiled by Pelli in 1784 mentions (BRUNNER 1993). It was executed between 1738 (the year the volume entered the Gallery) and 1753 (the date of the first inventory recording the drawing by Federico detached from the volume). The dimensions are identical to those of the original (260 x 205 mm), proving beyond doubt that the sheet was indeed a copy of Zuccari's *Dante*. In 1865, the eighteenth century version was also removed from the volume for restoration and subsequently stored in the drawer of anonymous Italian masters of the eighteenth-century.

Michel Brunner and Cristina Acidini Luchinat have hypothetically associated the sheet by Zuccari, lost at the beginning of the nineteenth-century, with the drawing in sanguigna and black chalk in the Fitzwilliam Museum of Cambridge (Inv. 1176; purchased in 1926), an unconvincing hypothesis given the diverse dimensions (232 x 201 mm) and the quality of the sanguigna, redder than the one used by Federico for the illustrations of the *Divine Comedy*. As David Scrase has demonstrated (1996, pp. 205-206), the Cambridge drawing is characteristic of the Florentine school of the Seicento and possibly is a work by Carlo Dolci, a direct copy from the lunette. Moreover, the original drawing by Federico disregarded the rounded form of the lunette, as the Uffizi drawing proves.

Federico Zuccari's choice of the *Portrait of Dante* by Bronzino for the first sheet of his volume becomes less surprising when we consider that the book that he used as his model, the *Commedia* designed by Francesco Sansovino in 1564 for the Venetian press of Giovanbattista Marchiò Sessa e Fratelli (BRUNNER 1993, p. 71), had an engraving of the bust of the poet modeled after the lunette by Bronzino, inserted in a mannerist frame (ZAPPELLA 1988, Pl. 27) as its frontispiece.

Various doubts persist, nonetheless, in regards to the model used by Federico Zuccari. In actuality, the artist lived in Florence from 1575 to 1579, ten years before the creation of the illustrations of the *Divine Comedy* and he returned there only for brief periods between 1590 and 1594.

Therefore, when he executed his volume, he either was using old drawings in his possession or he resorted to another model, in turn copied from the prototype of Bronzino. Agno-lo's interest in Dante should also be of no surprise given that the artist secretly paralleled the vicissitudes of his career to the unjust persecution of the poet (ACIDINI LUCHINAT 1999, II, p. 112).

Philippe Costamagna

BIBLIOGRAFIA/BIBLIOGRAPHY
BRUNNER 1993, pp. 72-73 (con bibliografia); ACIDINI LUCHINAT 1999, II, p. 168.

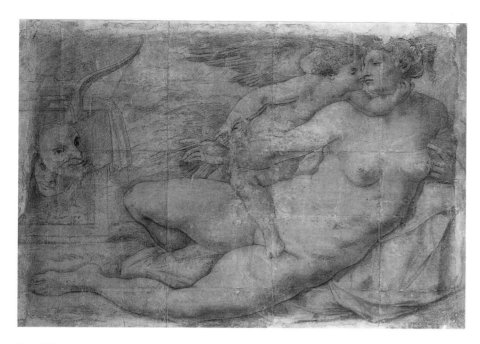

Cat. 27

ARTISTA IGNOTO DEL XVI SECOLO
da MICHELANGELO

Venere e Cupido
1540 ca.
Carboncino
cm 127,7 x 183,3
Napoli, Museo Nazionale di Capodimonte, Inv. 86654

Le recenti indagini e l'intervento conservativo sul cartone di Capodimonte e la dotta e attenta analisi che ne ha fatto Rossana Muzii (1993), sono stati di grande aiuto per la risoluzione di un annoso problema: la discrepanza tra l'illustre provenienza del cartone e la sua qualità, non certo all'altezza.

La provenienza non potrebbe essere più elevata e importante: non c'è bisogno di ripetere qui che Bartolomeo Bettini, che non ricevette mai il dipinto del Pontormo, sembra abbia avuto, a parziale risarcimento, il permesso di tenere il cartone, che in via di principio avrebbe dovuto dopo l'uso essere restituito a Michelangelo (il cartone del *Noli me tangere*, fatto anch'esso da Michelangelo perché Pontormo ne traesse un dipinto, una volta che il Pontormo ebbe finito fu restituito ad Antonio Mini). Bettini si trasferì definitivamente a Roma nei tardi anni Trenta del Cinquecento, senza dubbio portando con sé il cartone, e si può ragionevolmente supporre che in seguito questo sia passato nella collezione romana di Paolo Orsini, il fedele servitore dei Farnese. Un inventario del 1600 lo annota per la prima volta come proprietà dell'Orsini, che lo lasciò in eredità ai suoi protettori, grandi collezionisti di disegni michelangioleschi, che lo inclusero nella propria collezione, passata poi ai loro eredi. Tale

provenienza incoraggiò perfino un grande studioso di Michelangelo come Johannes Wilde (1953) ad ammettere la possibilità che il cartone di Napoli potesse essere l'originale dell'artista. Ulteriori esami della carta su cui è tracciato hanno rivelato una filigrana molto simile – anche se non identica – a quella, Roberts Crossbow D, trovata sulla carta impiegata da Michelangelo all'incirca tra il 1530 e il 1560.

Ma a contrastare tanto la carta che la provenienza c'è la mano con cui è eseguito il lavoro, che non può avere nessuno stretto rapporto con qualunque altra opera michelangiolesca giunta fino a noi. La tecnica, per esempio, è del tutto differente da quella della *Madonna* di Casa Buonarroti (Inv. 71F), e ciò ha reso restii anche gli studiosi di più ampie vedute sui disegni di Michelangelo ad accettare il disegno come un lavoro di suo pugno. È probabilmente vero che il disegno, ora molto più leggibile che in passato, non è accettato come autografo da nessuno degli odierni studiosi. Ma respingere l'attribuzione implica ammettere che già nel 1600, e senza dubbio anche prima, uno dei più importanti collezionisti, possessore di numerosi disegni autentici di Michelangelo, e che viveva nel palazzo degli ultimi e più grandi mecenati dell'artista, si sbagliò nel giudicare la paternità del cartone. Quando si mette direttamente a paragone il cartone per *Venere e Cupido* con il frammento di quello per la *Crocifissione di san Pietro* – sempre di proprietà Orsini – i dettagli del quale sono assai accurati, sembra inevitabile notare che la messa a fuoco è meno precisa, le figure modellate con minor forza, e i contorni meno incisivi. Come si può allora spiegare questa situazione? Si potrebbe dedurre che Michelangelo non eseguì il cartone per Bettini di proprio pugno, ma lo affidò a un assistente. Ma non sembra verosimile, tanto Michelangelo era onesto e coscienzioso. Pontormo potrebbe aver restituito a Bettini

una copia del cartone, piuttosto che l'originale, ma se avesse tentato di imbrogliare Michelangelo si sarebbe dimostrato uno sciocco, oltre che un disonesto, cose che Pontormo non era. E se il cartone di Napoli fosse stato disegnato da Pontormo, la cosa risulterebbe evidente: dopo tutto Pontormo aveva un suo stile nel disegnare, potente e caratteristico. Dato che entro il 1544 il Vasari aveva dipinto almeno tre accurate copie del quadro del Pontormo, a quanto pare a Roma e Venezia, è evidente che egli debba aver posseduto un cartone di esso. Sarebbe quindi un ovvio candidato per la paternità del cartone di Napoli. Ma anche in questo ci vuole un po' di prudenza: lo stile del disegno non richiama immediatamente quello del Vasari, e le ali di Cupido sono nel disegno più aperte e appiattite alla sommità della composizione sia rispetto alla tavola del Pontormo che alle copie dipinte dal Vasari e altri. Ciò potrebbe ben essere una caratteristica di chi ha eseguito il disegno, piuttosto che del modello copiato.

Allo stato presente delle conoscenze, si può provvisoriamente concludere che il cartone è di mano ignota; che non fu probabilmente eseguito direttamente né dal quadro del Pontormo, né dal cartone di pugno di Michelangelo – presumibilmente perduto – e che Paolo Orsini fu vittima o di un astuto venditore oppure del proprio ottimismo. Nondimeno, essendo un cartone a piena grandezza, su carta grosso modo coeva di quella su cui dev'essere stato fatto l'originale, questo lavoro riveste ovviamente un'eccezionale importanza storica. È un esempio estremamente raro che è sopravvissuto, una replica di un'opera di uno dei più grandi maestri, ma probabilmente un lavoro non fatto nella sua bottega o sotto la sua supervisione, destinato a facilitare l'iterazione di un'immagine famosa e molto ricercata.

UNIDENTIFIED ARTIST OF SIXTEENTH CENTURY
after MICHELANGELO

Venus and Cupid
c. 1540 (?)
Charcoal
127.7 x 183.3 cm
Napoli, Museo Nazionale di Capodimonte, Inv. 86654

The recent examination and conservation of the Capodimonte cartoon, and Rosanna Muzii's informed and closely-reasoned analysis of it (1993), have helped resolve a long-standing problem: the discrepancy between the cartoon's illustrious provenance, and its less than masterly visual quality.
The provenance could hardly be more elevated. It needs no repetition here that Bartolomeo Bettini, who never received Pontormo's painting, seems to have been allowed as part compensation, to keep the cartoon, which would in

principle have been returned to Michelangelo after use (the cartoon of the *Noli me tangere*, also made by Michelangelo for Pontormo to execute as a painting, was returned to Antonio Mini once Pontormo had finished with it). Bettini moved permanently to Rome in the later 1530s, no doubt taking the cartoon with him and it would be reasonable to suppose that it later passed into the Roman collection of Paolo Orsini, the loyal servant of the Farnese. First recorded in Orsini's possession in an inventory of 1600, he bequeathed it to his patrons, great collectors of Michelangelo's drawings, in whose collection and that of their heirs it remained. This provenance encouraged even so great a scholar of Michelangelo as Johannes Wilde (1953) to allow the possibility that the Naples cartoon might be Michelangelo's original. Furthermore, examination of the sheets of paper on which it is drawn has revealed that they bear a watermark very similar to – though not identical with – a watermark, Roberts Crossbow D, found on paper employed by Michelangelo between c.1530 and 1560.

But countering both paper and pedigree is the handling of the work, which cannot be compared closely with any surviving work by Michelangelo – its technique, for example, is radically different from that of the Casa Buonarroti *Madonna* (Inv. 71F) – and which has discouraged its acceptance even by scholars with an expansive attitude to Michelangelo's drawings. Now much more legible than before, it is probably true to say that no present-day scholar accepts it as an autograph work. But to reject it entails admitting that as early as 1600, and no doubt earlier, a major collector, who possessed several authentic drawings by Michelangelo and who lived in the palace of Michelangelo's greatest later patrons, was misled in his estimation of the cartoon's authorship.

It seems inescapable, when the *Venus and Cupid* cartoon is compared directly with the cartoon fragment of the *Crucifixion of Saint Peter* – also owned by Orsini – whose detail is unerring, that its focus is less precise, its modelling less forceful, and its contours less incisive. How therefore, is this situation to be explained? It might be argued that Michelangelo did not himself make the cartoon for Bettini but assigned it to an assistant.

But this seems unlikely: Michelangelo was both honest and conscientious. Pontormo might have returned to Bettini a copy of the cartoon rather than the original, but it would have been a very foolish – as well as dishonest – man, neither of which Pontormo was, to try to swindle Michelangelo. And had Pontormo drawn the Naples cartoon, it would surely have been obvious: Pontormo, after all, was a powerful and very distinctive draughtsman.

Given that by 1544 Vasari had painted at least three accurate copies of Pontormo's painting, in, it seems, both Rome and Venice, it is evident that he must have possessed a cartoon of it. He would therefore be an obvious candidate for the authorship of the Naples cartoon. But a note of caution is called for.

The drawing style does not immediately recall Vasari's and the wings of Cupid in the cartoon are stretched further and more flatly across the top of the composition than in either Pontormo's panel or in the painted copies by Vasari and others. This may well be a characteristic of the draughtsman rather than the form that he copied.

In the present state of knowledge it may be concluded provisionally, that the cartoon is by an unidentified hand; that it was probably not made directly either from Pontormo's painting, or Michelangelo's own cartoon – which must be presumed lost – and that Paolo Orsini was the victim either of a wily vendor or of his own optimism. Nevertheless, as a full size cartoon, on paper roughly contemporary with that on which the original must have been made, this work is obviously of exceptional historical importance. It is an example of a very rare survival, a replica after a work by a major master, but probably not made in his shop or under his supervision, intended to facilitate repetition of a famous and desirable image.

Paul Joannides

BIBLIOGRAFIA / BIBLIOGRAPHY
WILDE 1953, p. 93; TOLNAY 1975-1980, pp. 108-109; MUZII 1993, *passim*.

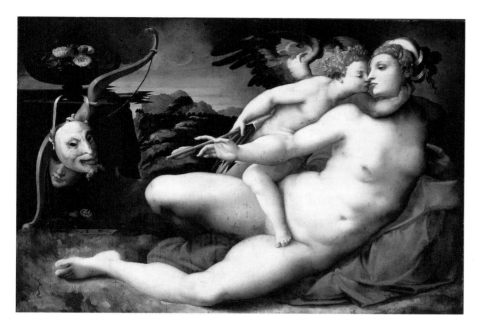

Cat. 28

CERCHIA DEL VASARI (HENDRIK VAN DEN BROEK)
su un cartone di MICHELANGELO

Venere e Cupido
Seconda metà del XVI secolo
Olio su tavola
cm 135,9 x 192,7
Napoli, Museo Nazionale di Capodimonte, Inv. 84068

Della *Venere e Cupido* di Michelangelo-Pontormo, «uno dei dipinti più copiati del Cinquecento toscano» (CONTI 1995, p. 51) possono essere riconosciute con certezza non meno di diciassette versioni. Inoltre, sedici copie – alcune delle quali presumibilmente corrispondono a opere note – sono menzionate in documenti rinascimentali o in inventari più recenti (*Appendice II*). Le cifre da sole testimoniano della straordinaria fama della composizione, e diverse variazioni, finora mai messe in evidenza, indicano come fosse reinterpretata nel Cinquecento. Questi particolari ci consentono di raggruppare le copie in tre filoni: il primo, denominato "Londra", in onore del dipinto di Kensington Palace (Tav. V/1), è il più fedele alla tavola dell'Accademia (Cat. 23); il secondo, detto "Napoli" dalla tavola di cui tratta questa scheda, presenta diversi piccoli cambiamenti; il terzo, in generale "Varianti", è costituito da opere che presentano modifiche sostanziali. In aggiunta alle caratteristiche che unicamente afferiscono alla versione della *Venere e Cupido* dell'Accademia, di cui si è trattato in Cat. 23, il gruppo di "Napoli" presenta una dozzina di particolari che lo differenziano dal tipo di "Londra": Cupido guarda in basso, verso le labbra della madre e lei ha uno sguardo perso nel vuoto; la faretra e il nastro tra i capelli di Venere sono di un rosso brillante; e il paesaggio dietro ai personaggi è molto

più verde, rigoglioso e dettagliato. Nella parte bassa del dipinto, un'ombra sembra ridurre la larga fessura tra le dita del piede di Venere; il ginocchio di lei non appare troppo vicino al bordo inferiore della tavola; l'angolo in basso a destra è più luminoso; e alcune rocce e/o piante riempiono lo spazio in basso a sinistra. Al di sopra di questa zona, il bordo del quadro non taglia il vaso di rose e l'arco; la lenta e spessa corda usata per portare l'arco non è legata all'estremità inferiore; la maschera da satiro, abbastanza inespressiva, ha sopracciglia sottili; la statuetta è fatta completamente di pietra e si distingue per la forma ovale del viso. Il dipinto di Napoli appare più descrittivo e decorativo della tavola dell'Accademia, essendo assente tutta la solennità e la tesa interazione psicologica che traspaiono in quest'ultima.

Tutte le caratteristiche di cui sopra compaiono nei tre dipinti di *Venere e Cupido* che hanno quasi le stesse dimensioni – ovvero circa sette centimetri maggiori in altezza rispetto al prototipo – conservati a Dublino (*Appendice II*. 3), Roma (fig. 28-a) e Firenze (in deposito a Pisa, Cat. 31), e in tre dipinti più piccoli (ciascuno di ca. 50 x 65,5 cm) a Burghley House, Firenze (Casa Buonarroti) e Ginevra. Sul piano stilistico, le grandi tavole di Dublino e Roma sono state convincentemente attribuite a Michele Tosini, datate intorno alla metà degli anni Sessanta del Cinquecento, subito dopo la collaborazione dell'artista con il Vasari, in Palazzo Vecchio. Le opere più piccole devono essere di un artista vicino alla sua cerchia, forse identificabile con Francesco Brina.

A eccezione di Hornik (1990), tutti gli autori concordano che Tosini non abbia eseguito la tavola di Napoli, ma l'attribuzione rimane incerta. La superficie nitida e compatta dei colori, le tonalità fredde, l'esecuzione strettamente aderente, i boccoli fortemente arricciati, quasi metallici della capigliatura di Cupido, i tratti somatici della Venere, estrema-

mente rifiniti, e la raffinatezza generale del dipinto, rimandano alle opere di Vasari. È stato attribuito al maestro stesso (COSTAMAGNA 1994) e, più verosimilmente, al suo collaboratore fiammingo, Hendrik Van den Broek, come suggerito da Longhi (1953, p. 15). Gli autori moderni hanno con ragione respinto l'attribuzione ad Allori (CLAPP 1916). Nella sua *Vita*, Vasari citava tre copie della *Venere* che egli realizzò dal cartone di Michelangelo: una tavola, 2,5 x 3,5 braccia [ca. 146 x 204 cm], commissionata a Firenze da Ottaviano de' Medici, nel 1541; una tavola che nel 1542 Vasari stesso portò a Venezia e vendette a Don Diego Hurtado de Mendoza; una terza realizzata nel 1544 per Bindo Altoviti, a Roma. Nelle sue lettere e nei *ricordi*, Vasari faceva anche menzione di una *Venere* inviata a Venezia nel 1542 a Francesco Leoni, della misura di 2,5 x 3,5 braccia, che potrebbe essere identificabile con una delle versioni citate nella *Vita*, e/o con una *Venere* del Vasari, presente a Venezia e lodata in una lettera di Aretino, nel 1542. Ognuno di questi dipinti della *Venere* si disse che fosse basato su un cartone di Michelangelo e, a eccezione di quello di Altoviti, tutti avevano un *pendant* con una *Leda*, creando in tal modo un insieme di nudi femminili michelangioleschi. Nel 1544, Vasari si dispose a inviare a Leoni anche un'altra *Venere* nuda, seguendo presumibilmente lo stesso disegno (si veda *Appendice I, II*). Oltre all'attribuzione, è necessario considerare tre fattori, nel valutare una possibile associazione dei dipinti ricordati dal Vasari con la tavola di Napoli. In primo luogo le misure di questo: ca. 2,3 x 3,3 braccia; vicine ma non identiche alle dimensioni di una (o due) copie documentate. In secondo luogo, Shearman (1983, pp. 277-278 n. 302) ha persuasivamente attribuito a Vasari la *Venere e Cupido* di Londra, che per dimensioni e dettagli si avvicina più alla tavola dell'Accademia che al dipinto di Napoli. Se Vasari avesse dipinto entrambe le copie, avrebbe dato vita a due tipologie di dipinti di Venere, con due formati diversi, con due stili diversi e anche, presumibilmente, eseguiti in momenti diversi. In terzo luogo, le riflettografie a raggi infrarossi (IRR) delle tavole di Roma e Napoli corrispondono non solo nelle misure, come ci si aspettava, ma anche nei dettagli grafici più minuti (si veda la trattazione in Cat. 23, e nel saggio di Bellucci-Frosinini). Per esempio, una serie di piccole righe sul palmo della mano destra di Venere e sulla maschera da satiro compare esattamente in queste due versioni allo stesso modo, ma non nella tavola dell'Accademia o in quella in deposito a Pisa.

Questa corrispondenza delle riflettografie e della carpenteria delle due tavole suggerisce fortemente che la stessa bottega, e probabilmente lo stesso artista, abbia realizzato il disegno sottostante delle tavole di Roma e Napoli.

Da un punto di vista stilistico, comunque, la pittura vera e propria deve essere stata eseguita da due artisti diversi. Il confronto, in questa mostra, tra la neo-restaurata *Venere* di Napoli e le opere di Allori, Bronzino, Tosini e Vasari, dovrebbe aiutare a chiarire il dibattito sull'attribuzione, che circonda quest'opera.

CIRCLE OF VASARI (HENDRIK VAN DEN BROEK)
following cartoon by MICHELANGELO

Venus and Cupid

Second half of the XVI century
Oil on panel; 135.9 x 192.7 cm
Napoli, Museo Nazionale di Capodimonte, Inv. 84068

Of the Michelangelo-Pontormo *Venus and Cupid*, "one of the most copied Tuscan paintings of the sixteenth century" (CONTI 1995, p. 51), no less than seventeen versions can be firmly identified. Moreover, sixteen copies – some of which presumably correspond with known works – are mentioned in Renaissance documents or more recent inventories (*Appendix II*). The numbers alone attest to the extraordinary fame of the composition, and several hitherto unnoticed variations indicate how it was reinterpreted in the Cinquecento. These details allow us to divide the copies into three groups: the first, called 'London' in honor of the painting in Kensington Palace (Pl. V/1), is most faithful to the Accademia panel (Cat. 23); the second, called 'Naples' after the panel discussed in this entry, exhibits several small changes; and the third, 'Variations' consists of works with prominent alterations. In addition to the features unique to the Accademia version of the *Venus and Cupid*, discussed in Cat. 23, the 'Naples' type has a dozen characteristics that distinguish it from the 'London' type: Cupid looks down toward the lips of his mother, who has an unfocused gaze; his quiver and the ribbon in Venus's hair are bright red; and the landscape behind them is much greener, richer, and more detailed. In the lower part of the painting, a shadow seems to reduce the large space between Venus' toes; her knee does not reach the lower edge of the panel; the lower right corner is lighter; and some rocks and/or plants fill in the space in the lower left. Above this area, the edge of the panel does not cut off the vase of roses or the bow; the loose, thick cord used to carry the bow is not attached at the lower end; the relatively inexpensive satyr mask has thin eyebrows; the statuette is entirely made of stone and has a distinctive, oval face. The Naples painting seems more descriptive and decorative than the Accademia panel, with none of the solemnity and tense psychological interplay of the latter.

All of these characteristics appear in three *Venus and Cupid* paintings with virtually the same dimensions – thus c. 7 cm higher than the prototype – in Dublin (*Appendix II*. 3); Rome (fig. 28-a), and Florence (on deposit in Pisa, Cat. 31), and in three smaller paintings (each c. 50 x 65.5 cm) in Burghley House; Firenze (Casa Buonarroti) and Geneva. On the basis of style, the large panels in Dublin and Rome have been convincingly attributed to Michele Tosini, in the mid 1560s, soon after his collaboration with Vasari in the Palazzo Vecchio, Florence. The smaller works must be by an artist in his immediate circle, perhaps Francesco Brina. With the exception of Hornik (1990), all authors agree that Tosini did not execute the Naples panel, but the attribution remains uncertain. The cool tonalities, smooth and compact rendering of the colors, closely coiled and almost metallic curls of Cupid's hair, highly refined facial features of Venus, and overall preciousness of the painting recall the works of Vasari. It has been attributed to the master himself (COSTAMAGNA 1994), and, more plausibly, to his Flemish collaborator, Hendrik Van den Broek, tentatively suggested by Longhi (1953, p. 15). Recent authors have rightly rejected the attribution to Allori (CLAPP 1916). In his *Life*, Vasari mentioned three copies he had made of the *Venus*: a panel, 2.5 x 3.5 *braccia* [ca. 146 x 204 cm], commissioned by Ottaviano de' Medici in Florence in 1541; a panel which Vasari brought to Venice in 1542, and sold to Don Diego Hurtado de Mendoza; and third made for Bindo Altoviti in Rome in 1544. In his letters and *ricordi*, Vasari also mentioned a *Venus* sent to Fran-cesco Leoni in Venice in 1542, 2.5 x 3.5 *braccia*, which may be identifiable with one of the versions mentioned in the *Life*, and/or with a *Venus* by Vasari, in Venice, and praised in a 1542 letter by Aretino. Each of these *Venus* paintings was said to be based on Michelangelo's cartoon and, with the exception of *Leda*, thus creating a matched set of michelangelesque female nudes. In 1544, Vasari prepared to send Leoni yet another nude *Venus*, presumably following the same design (for references, see *Appendix I, II*).

We should consider three factors, in addition to the attribution, when considering the possible association between Vasari's recorded paintings and the Naples panel. First, this measures about 2.3 x 3.3 *braccia*; close, but not identical to the size of one (or two) of the documented copies. Second, Shearman (1983, pp. 277-278 n. 302) convincingly attributed to Vasari the London *Venus and Cupid*, which in size and details corresponds much more closely to the Accademia panel than the Naples painting. If Vasari painted both of these copies, he would have made two types of Venus paintings, in two different sizes, and in two different styles, and thus presumably at different times. Third, the infrared reflectograms (IRR) of the Naples and Rome panels correspond not only in size, as expected, but also in the minutest graphic details (see Cat. 23, and essay of Bellucci-Frosinini) For example, a series of small lines on Venus' right palm and on the satyr mask appear exactly alike in these two versions, but not in the panels in the Accademia or on deposit in Pisa. This correspondence in the IRR, and in the carpentry of the two panels, strongly suggests that the same workshop, and probably the same artist, made the underdrawings of the Naples and Rome panels. On stylistic grounds, the paintings themselves must be by different artists. The comparison in this exhibition between the newly restored Naples *Venus* and works by Allori, Bronzino, Tosini, and Vasari should help clarify the attributional debate surrounding this work.

Jonathan Katz Nelson

BIBLIOGRAFIA / BIBLIOGRAPHY
CLAPP 1916, pp. 144, 219-220; LONGHI 1953, p.15; HORNIK 1990, p. 258; COSTAMAGNA 1994, p. 220 n. 70.9; MUZII in *Museo* 1995, pp. 104-105.

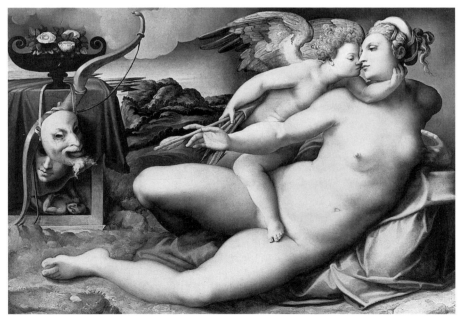

28-a. Michele Tosini, *Venere e Cupido / Venus and Cupid*, Roma, Galleria Colonna (*Appendice II*. 14).

Cat. 29

MICHELANGELO BUONARROTI
(Caprese 1475-Roma 1564)

Venere e Cupido
1532
Penna e inchiostro
mm 85 x 121
London, British Museum, Inv. 1859-6-25-553

Pierre-Jean Mariette, che scrisse a metà del Settecento, riteneva che la *Leda* di Michelangelo riflettesse la sua conoscenza dell'arte veneziana fatta nel 1529 (1851-1862) nel corso del suo soggiorno in quella città. Mariette conosceva probabilmente una replica del dipinto michelangiolesco, piuttosto che l'originale, forse una copia eseguita nella stessa Venezia dal Vasari. Nondimeno, sia o no vero che il colore e lo stile della *Leda* documentano una risposta di Michelangelo al *colorito* veneziano, è verosimile che il soggetto di un nudo femminile sdraiato esplicitamente erotico fosse influenzata da quanto vide a Venezia e Ferrara, quest'ultima prevista destinazione finale della *Leda*.

Il cartone che Michelangelo fece, appena dopo, per un dipinto di *Venere e Cupido*, che il Pontormo doveva eseguire per il suo amico Bartolomeo Bettini, è ancora più rivelatore della sua esperienza veneziana. Di ispirazione veneziana sono tanto il soggetto che il modo di trattare la forma. La disposizione del presente disegno – il solo studio compositivo conosciuto eseguito da Michelangelo per questo dipinto e forse il suo più tardo *concetto* a penna sopravvissuto – mostra Venere in una posa vicina a quella del disegno finale, mentre Cupido ne ha una molto differente. Egli rimane sulla sinistra, senza toccare Venere, con il braccio sinistro allungato in avanti e il destro tirato indietro. Wilde interpretò la sua posa come colta nell'atto di

tendere l'arco, nel qual caso egli starebbe per scagliare una freccia a distanza ravvicinata contro sua madre. Ma è arduo credere che Michelangelo abbia avuto in mente un'azione così aggressiva e grossolana, oltre che poco filiale. Un'interpretazione alternativa tanto della disposizione delle braccia di Cupido che della sua posa instabile è che stia tentando di togliere a sua madre con entrambe le mani qualcosa che lei sta sorreggendo con la sinistra. Anche se l'oggetto della disputa non è visibile, deve essere o un arco o una freccia. Quest'ultima è di gran lunga l'oggetto più probabile. Il disegno è, nell'azione e nella relazione tra Venere e Cupido, molto vicino alla *Venere che disarma Cupido* di Palma il Vecchio custodito al Fitzwilliam Museum (fig. 29-a). Nel dipinto di Palma, Venere sdraiata afferra la freccia per la punta togliendola a Cupido, che appare costretto a scegliere tra perdere il suo dardo o l'equilibrio. La sua espressione è quella di un bambino contrariato, mentre quella di lei è ammonitrice. Sebbene Palma mostri poco di tutto ciò, la sensazione che se ne trae è che Cupido abbia alla fine lasciato andare la freccia e che l'improvvisa perdita del contrappeso stia per provocare un rapido scatto in avanti della freccia medesima, che andrà a pungere il seno di Venere. D'altronde, la mediocre capacità di Palma nel tradurre in disegno il linguaggio mimico ha come conseguenza una mancanza di chiarezza immediata nel suo dipinto, che difatti è stato raramente interpretato in maniera corretta. Ignoriamo dove si trovasse nel 1529 il dipinto di Palma, o se Michelangelo abbia potuto avere l'opportunità di vederlo, ma il presente disegno sfrutta la medesima idea in maniera molto più ricca e con molta maggiore attenzione alla tensione fisica e a quella psicologica. Il disegno finale di Michelangelo coglie la tensione drammatica della scena ancor più in profondità. Cupido e Venere rimangono, evidentemente, entrambi disarmati: l'arco giace contro il contenitore aperto entro cui sono le maschere che lei si è tolta. Cupido, infante, si ar-

rampica liberamente sul corpo di sua madre per darle un bacio, senza accorgersi che Venere gli dà quella libertà per distrarlo e avere l'agio di togliergli di mano una freccia da cui potrebbe essere punta. Ma mentre sta per prendergliela dalle dita e lui tenta di resistere, il suo contorcersi rovescia la faretra e, senza che nessuno dei due se ne accorga, le altre frecce in essa contenute– con la punta in su, contrariamente a ogni buona pratica di arciere – cadono e pungono Venere sulla coscia. Michelangelo costruisce così un poema sintetico e complesso sugli inganni multipli e reciproci e l'impossibilità di evitare le ferite d'amore.

Nel produrre il suo progetto finale Michelangelo fece riferimento a una soluzione che aveva impiegato appena poco tempo prima nel suo disegno *Dalila che trionfa su Sansone*, ora allo Ashmolean Museum di Oxford (PARKER 1956, II, n. 319; fig. 29-b). In quel periodo egli era molto interessato alle varie forme del *trionfo* e la sua natura talvolta ambigua. Quando circa vent'anni più tardi ritornò su questo tema con una serie di schizzi su *Davide e Golia*, ora divisi tra la Morgan Library di New York e lo Ashmolean Museum, il suo approccio fu molto meno ambiguo. Le forme della Venere supina di Michelangelo sono massicce, in contrasto con le sue sinuose Veneri in piedi della seconda decade del Cinquecento e questo potrebbe essere un riflesso dello studio delle grandi figure che si vedono al Fondaco dei Tedeschi. Tiziano, che per certo conosceva i disegni di Michelangelo, restituì l'omaggio in una serie di nudi sdraiati iniziati alla metà del XVI secolo in cui egli infuse nella delicatezza della sua prima maniera qualcosa dell'energia michelangiolesca. Rubens, naturalmente, fu il loro comune erede.

MICHELANGELO BUONARROTI
(Caprese 1475-Roma 1564)

Venus and Cupid
1532
Pen and ink
85 x 121 mm
London, British Museum, Inv. 1859-6-25-553

Pierre-Jean Mariette writing in the mid-eighteenth century thought that Michelangelo's *Leda* reflected his experience of Venetian art during his sojourn in the city in 1529 (1851-1862). Mariette probably knew a version of Michelangelo's painting rather than the original, perhaps a copy produced in Venice itself by Vasari. Nevertheless, whether or not the *Leda*'s colour and hand-ling registered a response by Michelangelo to Venetian *colorito*, it is likely that the subject of a directly erotic recumbent female nude was affected by what he saw in Venice and in Ferrara, the *Leda*'s planned destination. Michelangelo's slightly later *Venus and Cupid*, a cartoon for a painting to be executed by Pontor-

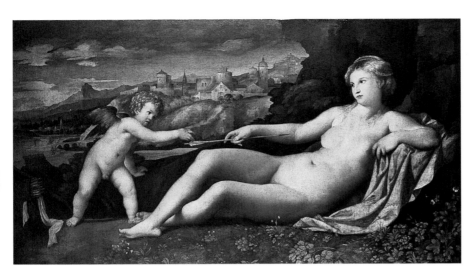

29-a. Jacopo Palma detto Palma il Vecchio, *Venere che disarma Cupido / Venus Disarming Cupid.*
 Cambridge, Fitzwilliam Museum.

mo for Michelangelo's friend Bartolomeo Bettini, is still more revealing of his experience of Venice. Venice inspired both the subject and the treatment of form. The arrangement of the present drawing – Michelangelo's only known compositional study for the painting and perhaps the latest pen *concetto* by him to survive – shows Venus in a pose close to that in the final design, but Cupid in a very different one. He stands to the left, not touching Venus, with his left arm outstretched and his right drawn back. Wilde interpreted his action as that of drawing a bow, in which case he would be launching an arrow at point-blank range at his mother. But it is difficult to believe that Michelangelo would have planned an action so aggressive and unsubtle, not to mention unfilial. An alternative interpretation both for the arrangement of Cupid's arms and for his unstable pose is that he is attempting to pull away from his mother with both hands something that she is extending with her right. While the object of dispute is not indicated, it must be either a bow or an arrow. The latter is much the more probable. In action, and the relation of Venus and Cupid, the design is closely similar to Palma Vecchio's *Venus Disarming Cupid* in the Fitz-william Museum (fig. 29-a). In Palma's painting, reclining Venus seizes the arrow by the tip, drawing it away from Cupid, who is faced with the choice of losing either his missile or his equilibrium. His expression is of a thwarted child; hers is admonitory. Although Palma makes little of it, the residual implication is that as Cupid has finally released his arrow, the sudden loss of counter-force will cause it to jerk forward and prick Venus's own breast. However, Palma's moderate capacities as a designer of body language mean that the content of his painting is not immediately clear and, indeed, it has rarely been interpreted correctly. We do not know where Palma's painting was to be found in 1529 or whether Michelangelo could have seen it, but the present drawing exploits the same idea much more richly and with a much greater alertness to physical and psychological tension.

Michelangelo's final design further enmeshes the drama. Cupid and Venus have both, seemingly, disarmed: his bow rests against the open cupboard which contains her doffed masks. The infant clambers freely over his mother to kiss her, unaware that Venus allows him this distracting freedom in order to ease from his grasp an arrow by which she might be wounded. But, as she twists it from his fingers and he tries to retain it, his wriggling tips his quiver and, unnoticed by either, the other arrows stored within it – head-upwards in contravention of good toxophilic practice – fall forward to puncture Venus's thigh. Michelangelo thus constructs a compressed and complex poem about multiple and reciprocal deceptions and the impossibility of avoiding love's wounds.

In producing his final design Michelangelo referred to an arrangement he had employed shortly before in his drawing of *Delilah triumphant over Samson* in the Ashmolean Museum, Oxford (PARKER 1956, II, no. 319; fig. 29-b). In this period he was much occupied by permutations of triumph and its sometimes equivocal nature. When he returned to this formulation some twenty years later in a series of sketches of *David and Goliath*, divided between the Morgan Library in New York and the Ashmolean Museum, his treatment was much less ambiguous.

The forms of Michelangelo's reclining Venus are massive, unlike his sinuous standing Venuses of the 1520s, and this may reflect his experience of the ample figures displayed upon the Fondaco de' Tedeschi. Titian, who certainly knew Michelangelo's design, returned the compliment in his series of recumbent nudes begun in the 1550s, in which he infused the softness of his early manner with something of Michelangelo's energy. Rubens, of course, was their joint heir.

Paul Joannides

BIBLIOGRAFIA / BIBLIOGRAPHY
WILDE 1953, n. 56; TOLNAY 1975-1980, n. 302; KEACH 1978.

29-b. Michelangelo, *Dalila trionfa su Sansone / Delilah triumphant over Samson.*
 Oxford, Ashmolean Museum, Inv. Parker II, 319.

Cat. 30

ANONIMO FIORENTINO (?) DEL CINQUECENTO

Sonetto sopra la Venere e Cupido
di Michelangelo e Pontormo
1540-1550 ca.
Inchiostro su carta
mm 297 x 241
Firenze, Casa Buonarroti,
Archivio Buonarroti, XVII, c. 14r

Trascrizione del testo:
Sopra la miracolosa Pittura de la Venere
Da Michelagnolo disegnata et da il Pontormo
Colorita: Sonetto

Deh, perché 'l bello, et il buon, com'io vorrei
non posso a pien di te spiegare in carte?
Ché la natura esser' vinta da l'Arte
a chi mai non ti vidde, mosterrei.
Se così bella in ciel Venere sei,
come si vede qui parte per parte,
ben puossi, et con ragion, felice Marte,
anzi beato dir, fra gli altri idei.
Non han le rose, le viole, et i gigli
sì puro, acceso, vivo, almo colore,
né l'oro, né i rubin, sì dolce ardore.
Cosa mortal non è che ti simigli:
et che sia 'l ver, di te piagato il core,
si sforza, quant'ei può, baciarti Amore.

Il sonetto è scritto su un foglio staccato, raccolto nel Codice XVII, insieme ad altre «Composizioni sopra Michelagnolo Buonarroti trovate in casa», come si legge a c. 1 per mano di Filippo Buonarroti, cioè una serie di omaggi poetici di amici e corrispondenti dell'artista, pubblicati dal Frey (*Buonarroti* 1897, nn. CLXVII-CXCIII). Prima che fossero riordinate nel 1882, queste carte erano comprese nel Codice XVI, insieme a quelle che compongono l'attuale Codice XIII; il numero in alto a destra del foglio (26, poi corretto in 25), da attribuire a Filippo Buonarroti, rinvia all'antico ordinamento, a cui ancora si riferisce il Guasti (1863, pp. LII-LIV). La scritta in basso a destra, «era in casa di Bart[olome]o Bettini», attribuita dal Frey a Filippo Buonarroti, è ripetuta sul verso del foglio in alto. Sempre sul verso, ma scritto in verticale, in modo da rimanere visibile quando il foglio era piegato, si legge: «Sopra la venere»; ciò fa pensare che anche il presente componimento sia stato inviato a Michelangelo, come altri del codice, alcuni dei quali recano sul verso l'intestazione. Le numerazioni a lapis in basso sono moderne.

Il principale interesse del sonetto, come già aveva visto il Levey (1967, p. 32), seguito da Keach (1978, p. 328), sta nel fatto che offre la testimonianza contemporanea di un'interpretazione della Venere in termini neoplatonici, come bellezza ideale e quindi simbolo di amore spirituale (precisata fin dall'inizio col binomio *bello-buono*), anche se non possiamo sapere se l'autore avesse presente il quadro di Pontormo, come vorrebbe la didascalia, oppure il cartone o una delle molte copie.

Del tutto originale è invece, col paradosso finale, l'interpretazione di Amore, di solito abituato a colpire senza risparmiare neppure gli dei, che resta lui per primo vittima della bellezza della madre («di te piagato il core»), al punto che non può fare a meno di baciarla. Lo sforzo descritto nel verso finale allude all'avvitamento della figura del fanciullo che si protende per il bacio e al suo insinuante abbraccio da dietro.

Una certa convenzionalità traspare nelle strofe centrali del sonetto, dove, nonostante la dichiarazione di insufficienza al verso 2, l'autore, nel tentativo di restituire a parole la bellezza della Venere, non trova di meglio che richiamare l'invidiabile condizione di Marte che può godere della dea e ricorre, nella prima terzina, al trito espediente dell'enumerazione delle cose più belle, come fiori e pietre preziose: proprio quelle formule stigmatizzate dal Berni (*Poeti* 2001, pp. 799-803) nel suo capitolo in lode della poesia di Michelangelo: «Tacete *unquanco, pallide viole* E *liquidi cristalli* e *fere snelle*: Ei dice cose, e voi dite parole» (vedi saggio Leporatti).

L'autore del sonetto è anonimo, ma probabilmente fiorentino: vedi forme come v. 4 *vidde* e soprattutto *mosterrei*, e, volendo, v. 12 *simigli* (al v. 8 *gli altri idei* andrà considerato un fatto grafico per *i[d]dei*). Una vicinanza agli ambienti fiorentini legati a Michelangelo è deducibile anche dalla cultura che traspare dal testo. Per lodare l'artista, l'autore non si rivolge direttamente a lui, come di solito in questi omaggi poetici, bensì al soggetto di una sua opera, come fa il Bronzino nel suo sonetto per il *Perseo* del Cellini (post 1553). L'espediente può essere interpretato come una discreta allusione alla straordinaria pla-

sticità delle creazioni michelangiolesche, quasi esseri viventi, ma forse anche al potere di questa "miracolosa" Venere di far innamorare la gente, come già quella di Prassitele, secondo quanto scrive il Varchi nelle *Due Lezzioni* (vedi saggio Nelson), dove parla con ammirazione dell'opera «che disegnò Michelangelo a M. Bartolomeo Bettini, colorita di mano di M. Iacopo Pontormo». Si noti la precisazione delle responsabilità negli stessi termini della didascalia del sonetto; mentre è interessante che anche il Vasari nella seconda edizione delle *Vite* scriva che la Venere del Bettini «riuscì cosa miracolosa» (VASARI 1568 /1966-1997, V, p. 327).

Il sonetto è un omaggio agli artisti che hanno eseguito l'opera, ma anche più sottilmente a Michelangelo poeta, che l'autore dimostra di conoscere bene. Il concetto espresso al verso 3 – «Ché la natura esser' vinta da l'Arte... mosterrei» –, che riformula il motivo tradizionale dell'arte che imita la natura, e che dilagherà, proprio in relazione a Michelangelo, soprattutto a partire dalle celebrazioni per le sue esequie (*Divine* 1964, p. 29), si richiama a versi dell'artista, che fu forse il primo a enunciarlo in modo così perentorio: vedi per esempio il Sonetto 239 a Vittoria Colonna (composto prima del 1546) dove Michelangelo scrive che «dall'arte è vinta la natura». Anche il verso 12 «Cosa mortal non è che ti simigli», che compendia in sé il concetto di trasfigurazione ideale, e anzi religiosa, della bellezza fisica maturato con la tradizione poetica stilnovistica e neoplatonica, si richiama al Sonetto 105 scritto per Tommaso Cavalieri, ossia quello stesso testo che il Varchi propone, nella sua prima lezione sulla poesia di Michelangelo, come il più rappresentativo fra «tutti i componimenti di lui pieni d'amore Socratico e di concetti Platonici» (cfr. saggio Leporatti).

Viste le numerose coincidenze con la lezione del Varchi, è probabile che il sonetto sia stato composto sull'onda del successo di quella. Certo, più in generale, va messo in relazione a questi primi riconoscimenti pubblici della Venere e della poesia di Michelangelo e alla moda delle copie, avviata dal Vasari agli inizi degli anni Quaranta. Una datazione tra gli anni 1540 e 1550 del secolo è compatibile anche con la grafia.

ANONYMOUS FLORENTINE (?) OF THE CINQUECENTO

Sonnet on the Venus and Cupid
by Michelangelo and Pontormo
c. 1540-1550
Ink on paper
297 x 241 mm
Firenze, Casa Buonarroti,
Archivio Buonarroti, XVII, c. 14 *recto*

On the miraculous painting of Venus designed by Michelangelo and colored by Pontormo:

Sonnet

Pray, why cannot I fully describe in words
 Your beauty and good as I would like?
 Indeed, how Art has vanquished nature
I would show those who never looked upon you.
Venus, if you are as beautiful in heaven
 As you appear here in every detail
 Certainly and with reason may Mars be called
 [the happy one
 Or better blessed among the other gods.
Not roses, violets or lilies possess
 Such pure, brilliant, lively, lofty color
 Not gold or rubies such sweet ardor.
No mortal being possesses your likeness:
 And if the truth be said, with a heart wounded
 [by you,
 Cupid tries, as hard as he can, to kiss you.

The sonnet is written on a loose sheet, included in Codex XVII, together with other "Compositions on Michelangelo Buonarroti found in the house", as the inscription in the hand of Filippo Buonarroti on c. 1 reads. It contains in effect a series of poems by friends and correspondents paying homage to the artist, published by Frey (*Buonarroti* 1897, no. CLXVII-CXCIII). Before being reordered in 1882, the sheets were found in Codex XVI, together with those that are presently in Codex XIII; the number on the upper right of the sheet (26, later corrected to 25), attributable to Filippo Buonarroti, applies to an earlier arrangement to which Guasti refers (1863, pp. LII-LIV). The phrase on the lower right "it was in the house of Bart[olome]o Bettini', attributed by Frey to Filippo Buonarroti, is repeated at the top of the verso of the sheet. Written on that same side, but vertically so as to be legible when the sheet is folded is: "On the Venus"; this suggests that the poem under examination was sent to Michelangelo, like others in the codex, some of which preserve the heading on the verso side. The numeration in pencil at the bottom is modern.

The main interest of this sonnet, already noted by Levey (1967, p. 32) and confirmed by Keach (1978, p. 328), rests on the fact that it is a contemporary interpretation in neo-platonic terms of the Venus as ideal beauty and thus a symbol of spiritual love (explicit from the sonnet's begin-

ning with the binomial *beauty-good*). This holds true even though we cannot be sure the author was definitely referring to the painting by Pontormo as the heading declares or rather to a cartoon or one of the many copies. Original instead is the final paradoxical interpretation of Cupid – commonly portrayed as the one who strikes with his arrow and no regard even for the gods – as a victim of the beauty of his mother (his heart wounded by you), to the point that he cannot resist kissing her. The effort described in the final line alludes to the twisting figure of the youth as he stretches to kiss his mother and his insinuating embrace from behind.

A certain conventionality transpires in the central verses of the sonnet, where, despite the declaration of insufficiency in line 2, the author can find nothing better, in an attempt to describe in words the beauty of Venus, than to recall the enviable condition of Mars who takes pleasure with the goddess. In the first triplet, the author resorts to the trite expedient of listing very beautiful things like flowers and precious stones: exactly the formula stigmatized by Berni (*Poeti* 2001, pp. 799-803) in his chapter in praise of the poetry of Michelangelo: "Be silent, once and for all, *pallid violets* and *liquid crystals* and *lithe beasts*: he says things and you say words".

The author of the sonnet is unknown but probably Florentine: see forms such as in v. 4 *vidde* and above all *mosterrei*, and even, v. 12 twelve *simigli* (line 8 *gli altri idei* should be considered a calligraphic variation of *i[d]dei*). Ties to Florentine circles close to Michelangelo can also be deduced from the culture that transpires in the text. To praise the artist, the author does not address him directly as is common in a poetic homage, but rather the subject of his work, as does Bronzino in his sonnet on *Perseus* by Cellini (post 1553). The expedient may be interpreted as a discrete allusion to the extraordinary plasticity in the creations of Michelangelo, almost living beings, but perhaps also to the power that this 'miraculous' Venus possesses. Her ability to make others fall in love with her, like the Venus of Praxiteles, accords with Varchi's comments in his *Due Lezzioni* (see Nelson's essay), when he speaks with admiration of the work "that Mi-

chelangelo designed for Messer Bartolomeo Bettini, colored by the hand of Messer Jacopo Pontormo". Note the use of the same terms in the heading of the sonnet; it is also interesting that Vasari in the second edition of his *Lives* also states in his comment on the Venus for Bettini that it "was a miraculous thing" (VASARI 1568/1966-1997, V, p. 327).

The sonnet is not only a homage to the artists as executors of the painting, but also an artful tribute to Michelangelo as a poet, a facet of his activity with which the author is apparently well acquainted.

The concept expressed in line 3, "...how Art has vanquished nature I would show...", reformulates the traditional prescription of art that imitates nature, an idea that spreads in strict relation to Michelangelo, especially after the celebrations of his funeral (*Divine* 1964, p. 29); it recalls the poetic verses of the artist himself. Michelangelo was the first to enounce it in such an explicit manner, for example, in Sonnet 239 to Vittoria Colonna (composed before 1546) where he writes "by art nature is won". Line 12 also "No mortal being possesses your likeness" includes in itself the concept of an ideal, or better, religious transfiguration of physical beauty matured in the poetic tradition of Stilnovism and Neo-Platonism. This harkens back to sonnet 105 written for Tommaso Cavalieri that is the same text that Varchi cites in his first lesson on the poetry of Michelangelo, as the most representative of "all of his compositions full of Socratic love and Platonic concepts" [see Leporatti's essay]. Given the numerous coincidences with Varchi's lesson, it is probable that the sonnet was composed on the wave of its success. Certainly and more generally, it relates to these first public recognitions of the *Venus* and the poetry of Michelangelo and to the vogue of the copies, started by Vasari at the beginning of the 1540s. A date between 1540 and 1550 is also compatible with the calligraphy.

Roberto Leporatti

BIBLIOGRAFIA / BIBLIOGRAPHY
LEVEY 1967, pp. 30-33; KEACH 1978, pp. 327-331.

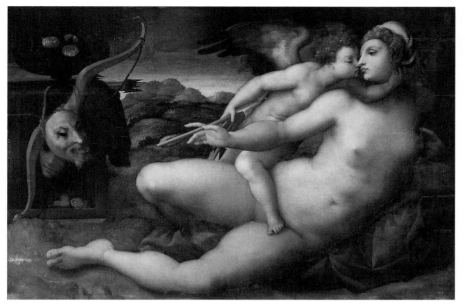

Cat. 31

CERCHIA DI GIORGIO VASARI (?)
su un cartone di MICHELANGELO

Venere e Cupido
Seconda metà del XVI secolo
Olio su tavola
cm 134 x 194,2
Firenze, Gallerie Fiorentine, Inv. 1890/5658
(in deposito a Pisa, Scuola Normale Superiore)

Questa tavola, qui illustrata per la prima volta,
fu citata brevemente da Milanesi (1881) e Co-
stamagna (1994), tra le copie della *Venere e
Cupido* dell'Accademia (Cat. 23).
Per le sue varianti da questo prototipo (com-
preso il formato), la presente tavola ha corri-
spondenze con la *Venere e Cupido* di Napoli
(Cat. 28).
Il restauro recente ha tolto i vestiti ridipinti e lo
strato estremamente spesso di sporcizia e di
vernice ingiallita (figg. 31 a-c). Questo ha rive-
lato un dettaglio che non ha corrispondenze
nelle altre copie della *Venere:* un accennato to-
no di rosso dietro alle distanti colline, che sem-
bra suggerire un'alba o forse un tramonto.
Questo dipinto, data la somiglianze con la ta-
vola di Napoli, fu probabilmente eseguito da un
artista della Cerchia di Vasari.

CIRCLE OF GIORGIO VASARI (?)
following cartoon by MICHELANGELO

Venus and Cupid
Second half of the XV century
Oil on panel
134 x 194.2 cm
Firenze, Gallerie Fiorentine, Inv. 1890/5658
(on deposit in Pisa, Scuola Normale Superiore)

This panel, here illustrated for the first time, was
briefly listed by Milanesi (1881) and Costamagna
1994), among the copies of the Accademia
Venus and Cupid (Cat. 23). The present paint-
ing, in its variations from the prototype, corre-
sponds to the *Venus and Cupid* in Naples, see
discussion in Cat. 28. The recent restoration has
removed the repainted clothes on the Venus and
an extremely thick layer of dirt and yellowed var-
nish (figs. 31 a-c). This has revealed one detail
not found in other *Venus* copies: a hint of red
behind the distant hills, suggesting dawn or per-
haps sunset. This painting, given its similarities
with the Naples panel, was probably executed by
an artist in the Circle of Vasari.

Jonathan Katz Nelson

BIBLIOGRAFIA / BIBLIOGRAPHY
MILANESI 1881, p. 295; COSTAMAGNA 1994, p. 220, n. 70.12.

31-a, b, c. Particolari della *Venere e Cupido*
durante il restauro. / Details of the *Venus
and Cupid* during restoration.

Cat. 32 (Tav. XVI/2)

**attr. a Francesco Morandini,
detto il Poppi**
(Poppi 1544 ca.-Firenze 1597)

Danae

1570 ca.
Olio su tavola
cm 29,5 x 44x 29 (misure massime del cofanetto)
cm 44 x 29 (superficie dipinta)
Firenze, Collezione privata

Il dipinto, finora inedito, si trova all'interno del coperchio di un cofanetto ligneo le cui modanature rivelano uno stile tardo cinquecentesco di matrice fiorentina. Tale datazione trova conferma nello stile pittorico dell'ornato e della composizione.
Entro una cornice a girali floreali, quattro eleganti figure monocrome di giovanetti dal corpo allungato che si avvitano su se stessi sostengono la scena narrativa centrale.
In questo dipinto, la figura di Danae – identificata anche da una scritta sulla destra – si presenta semidistesa di fianco in una posa che richiama studi michelangioleschi intorno al tema dell'*Aurora* e della *Venere e Cupido* (Cat. 23). Soprattutto si ispira alle invenzioni del Buonarroti, l'idea dell'addome girato su un fianco con le gambe semidivaricate, una distesa a terra e l'altra piegata all'indietro.
Per motivi stilistici l'opera può essere attribuita al Poppi, il cui interesse per le figure femminili presentate da opere michelangiolesche è testimoniato da vari disegni dell'artista, come la copia dall'*Aurora* riferita al Morandini dalla Giovannetti (Chatsworth, Devonshire Collection; Giovannetti 1995, pp. 215-216 n. D17, fig. 136).
Una posa analoga a questa Danae, sia pure inquadrata da un altro punto di vista, assume il personaggio femminile nella famiglia in primo

piano nell'*Età dell'oro* di Jacopo Zucchi, databile nell'ottavo decennio e riferibile al medesimo ambito culturale del cofanetto in oggetto (Firenze, Uffizi; cfr. Giovannetti in *Magnificenza* 1997, pp. 197-198 n. 153). Il soggetto è accennato nelle *Metamorfosi* di Ovidio (IV. 611; VI. 113) e nelle *Odi* di Orazio (III. 16), mentre è narrato più diffusamente da Luciano nei *Dialoghi degli dei marini* (12): Danae, figlia di Acrisio re di Argo, chiusa dal padre in una torre di bronzo, venne amata da Zeus che si unì a lei trasformandosi in pioggia d'oro; da tale unione nacque Perseo, l'eroe che avrebbe ucciso Medusa e liberato Andromeda.
Il tema di Danae e della pioggia d'oro è evidentemente legato all'oggetto, un cofanetto destinato a custodire gioielli, monete e preziosità.
La composizione pittorica rappresenta la fanciulla in un luogo appartato ma aperto sul paesaggio che si distende verso l'orizzonte sulla destra dove fra le nubi Zeus col suo scettro manda una pioggia di monete d'oro. Non è raffigurata la nutrice, rappresentata nei celebri precedenti di Primaticcio a Fontainebleau e di Tiziano ora a Capodimonte, ma assente invece nella narrazione delle fonti antiche e in altri antefatti figurativi quali l'illustrazione dell'*Hypnerotomachia Poliphili* di Francesco Colonna pubblicata nel 1499 e la *Danae* di Correggio del 1531 circa (Roma, Galleria Borghese).
Il dipinto del cofanetto rimanda alla cultura degli artisti dello Studiolo di Francesco I de' Medici in Palazzo Vecchio, realizzato nei primi anni Settanta. In particolare, l'atmosfera fiabesca e incantata, le figure allungate, di eleganza raffinata e persino languida, il paesaggio alla nordica, il pittoricismo intenso dai toni vivaci e sfumati, la linea sicura minuta e nervosa che definisce le forme, rimandano a nostro parere alla maniera iniziale del Poppi. Il confronto infatti regge soprattutto con opere giovanili quali l'*Età dell'oro* della National Gallery of Scotland a Edimburgo oppure la *Casa del Sole* del Museo di casa Vasari ad Arezzo (Giovannetti in *Magnificenza* 1997, p. 203 n.

157, p. 204 n. 158, con bibliografia), dipinti databili in prossimità con l'attività del Morandini per lo Studiolo. Inoltre si possono notare le affinità stilistiche e tipologiche del profilo della fanciulla rappresentata all'interno del cofanetto con quello di Campaspe dipinto dal Morandini nell'ovale dello Studiolo (1571) o con quello dei visi di alcuni fogli degli Uffizi (Firenze, Gabinetto Disegni e Stampe, Inv. 4257F e Inv. 4258F; Giovannetti 1991, n. 23, figg. 23 e 86).
Sull'esterno del coperchio del cofanetto è tratteggiata in chiaroscuro un'altra figura femminile semidistesa, che ha in mano una verga e nell'altra una cartella con la scritta LIBERA. Purtroppo gli scarsi attributi e la lacunosità dell'altra scritta nascosta dalla modanatura della cornice ostacolano l'identificazione del personaggio. Ma può essere interessante notare che la tipologia del cofanetto recante un'immagine allegorica al di sopra del coperchio rimanda agli studi per cofanetti di Francesco Salviati, come quello con la *Prudentia* alla Pierpont Morgan Library di New York, nonostante il loro stile decisamente più ricco e sontuoso.

**attr. to Francesco Morandini,
called il Poppi**
(Poppi c. 1544-Firenze 1597)

Danae

c. 1570
Oil on wood
29.5 x 44 x 29 cm
(maximum dimensions of the coffer)
44 x 29 cm (painted surface)
Firenze, Private collection

The painting, published here for the first time, is found on inner side of the cover of a small wooden coffer carved in the style prevalent in Florence in the late sixteenth century.
This date is confirmed also by the pictorial style of the ornament and composition. Within a frame of floral traceries, four elegant grisaille figures of youthful elongated serpentine bodies support the central narrative scene.
In this painting the figure of Danae – identified also by an inscription on the right – is shown half-reclining on her side in a pose that recalls Michelangelesque studies of the theme of *Dawn* and the *Venus and Cupid* (Cat. 23). Primarily inspired by the inventions of Buonarroti is the idea of the abdomen twisting to the side with the legs slightly spread, one straight on the ground and the other bent back.
For stylistic reasons the work can be attributed to il Poppi, whose interest in the female figures found in the works of Michelangelo is attested to by various drawings by the artist, like the copy of *Dawn* referred to Morandini by Giovannetti (Chatsworth, Devonshire Collection; Giovannetti in *Magnificenza* 1995, pp. 215-216 no. D17, fig. 136).

32-a. e 32-b Cofanetto ligneo (sull'interno del coperchio la *Danae* del Poppi, sull'esterno una figura femminile semidistesa) / Wooden coffer (on the inside of the cover, il Poppi's *Danae*, on the outside, a reclining female figure). Firenze, Collezione privata.

The pictorial composition represents the young woman in a secluded setting but open to a landscape that stretches to the horizon on the left where among the clouds Zeus with his scepter in hand sends a rainfall of golden coins.

The nurse, included in the famous precedents by Primaticcio at Fontainebleau and Titian now in the Capodimonte Museum, is absent here as she is in the narrative as told by the ancient sources and in other figurative precedents such as the illustration of the *Hypnerotomachia Poliphili* of Francesco Colonna published in 1499 and the *Danae* by Correggio painted in approximately 1531 (Roma, Galleria Borghese).

The painting on the coffer can be related to the culture of the artists of the Studiolo of Francesco I de' Medici in the Palazzo Vecchio, completed in the early 1570s. In particular, the fable-like enchanted atmosphere, the elongated figures, the refined almost languid elegance, the northern landscape, the intense painterly modes characterized by vivacious tones and "sfumato" handling, the sure, minute and nervous draftsmanship that defines the forms, all point, in my opinion, to the early style of Poppi.

The comparison can be made with the early works such as the *Golden Age* in the National Gallery of Scotland in Edinburgh or the *House of the Sun* in the Museum of Casa Vasari in Arezzo (GIOVANNETTI in *Magnificenza* 1997, p. 203 no. 157, p. 204 no. 158, with bibliography), paintings that coincide chronologically with Poppi's work in the Studiolo.

Moreover, stylistic and typological affinities can be found in the profile of the young girl in our coffer painting and that of the figure of Campaspe painted by Morandini in the oval of the Studiolo (1571) or with one representing study of heads in a few drawings in the Uffizi (Firenze, Gabinetto Disegni e Stampe, Inv. 4257F and 4258F; GIOVANNETTI 1991, no. 23, figs. 23 and 86).

On the outside of the lid of the coffer, another half-reclining female figure is traced in *chiaroscuro*; she has a stick in one hand and in the other a card with the inscription LIBERA on it.

Unfortunately the scarcity of her attributes and the illegibility of the other inscription hidden by the moldings of the frame obscure the identification of the personage.

But it is interesting to note that the typology of the coffer with an allegorical image on the cover goes back to the preparatory studies for coffers by Francesco Salviati, like the one depicting *Prudence* in the Pierpoint Morgan Library in New York, although the latter are decidedly richer and more sumptuous in style.

Elena Capretti

An analogous pose to this one, seen however from a different point of view, can be found in the female figure in the family in the foreground of Jacopo Zucchi's *Golden Age*, dating to the eighth decade of the century and a product of the same cultural milieu as the coffer under discussion (Firenze, Galleria degli Uffizi; cf. GIOVANNETTI in *Magnificenza* 1997, pp. 197-198 no. 153).

The subject is mentioned in Ovid's *Metamorphoses* (IV. 611; VI. 113) and in Horace's *Odes* (III. 16) but more extensively treated in Lucian's *Dialogues of the Sea Gods* (12): Danae, daughter of King Acrisius of Argos, shut by her father in a bronze tower, was visited by Zeus in the form of a shower of gold and from that union gave birth to Perseus, the hero that would kill the Medusa and free Andromeda.

The theme of Danae and the shower of gold were evidently chosen in association with this object, a coffer used to keep jewels, coins and precious things.

Cat. 33

TIZIANO VECELLIO E BOTTEGA
(Pieve di Cadore 1488 ca.-Venezia 1576)

Venere e Cupido
1550 ca.
Olio su tela
cm 139,2 x 195,5
Firenze, Galleria degli Uffizi,
Depositi, Inv. 1890/1431

L'opera è entrata nelle collezioni medicee nel
secondo decennio del Seicento, donata da Pao-
lo Giordano Orsini a Cosimo II de' Medici. Fin dal
suo ingresso nelle raccolte granducali il dipinto
è stato riferito a Tiziano, anche se la critica più
recente vi ha visto l'intervento della bottega ri-
tenendolo eseguito intorno al 1550 (per la sto-
ria del quadro e la sua fortuna critica cfr. SQUEL-
LATI 1978).
La composizione rappresenta Venere, nuda, se-
midistesa su un fianco voltata verso l'osservato-
re, ma con il volto vicino a Cupido che l'abbrac-
cia e l'accarezza stando alle sue spalle. Come è
già stato più volte notato tale formula potrebbe
ispirarsi al cartone con *Venere e Amore* esegui-

to da Michelangelo nel 1532-1533, che Tiziano
potrebbe avere visto in occasione del suo viag-
gio a Roma nel 1545, oppure potrebbe avere
conosciuto indirettamente attraverso le copie
fatte da Vasari nei primi anni Quaranta per com-
mittenti veneziani. Del resto si tenga presente
che, per parte sua, Michelangelo, realizzando
l'opera per Bartolomeo Bettini, poteva essersi
richiamato a opere venete osservate durante il
suo breve soggiorno nella città lagunare nel
1529. Infatti, in ambito veneziano, importante
precedente per il motivo della figura femminile
nuda semidistesa in un paesaggio era stata la
Venere dormiente ora a Dresda (Gemäldegalerie)
eseguita da Giorgione con la collaborazione del-
lo stesso Tiziano, che vi aggiunse ai piedi della
dea l'immagine di Cupido andata poi perduta.
Questa formula – che tanta fortuna ebbe nell'ar-
te veneta, ma anche in quella d'oltralpe – era di
lontana ascendenza classica, essendo pertinen-
te al repertorio iconografico offerto dai temi del
thiasos marino con tritoni e naiadi e del consesso
so bacchico con ninfe satiri e menadi, ma anche
da temi singolari quali quello dell'Ermafrodita
con Cupido (BROWN 1999, p. 430; cfr. anche DAL-
LI REGOLI in *Leonardo* 2001, p. 158).
Spinto dunque da suggestioni di matrice giorgio-
nesca, Tiziano ha trasposto l'invenzione di Miche-
langelo in una chiave di lettura inconfondibilmente

veneta, adottando però un linguaggio tutto perso-
nale che ben si conciliava con il piglio energico e
plastico del Buonarroti. Nella composizione degli
Uffizi, la dea è ornata da preziosi gioielli, fra cui le
perle, prerogativa delle donne dell'aristocrazia,
maritate. Il personaggio si trova su un candido
letto, adagiato su un manto di un rosso lucente.
Ha vicino a sé un tavolino con una gamba scolpi-
ta a forma di leone e sopra un vaso di vetro con
rose, quelle stesse che tiene nella mano sinistra e
che per il loro profumo sono un attributo della
dea. Ai piedi della figura femminile si trovano il tur-
casso e le frecce di Cupido abbandonati e un ca-
ne pezzato che abbaia alla pernice appollaiata sul
davanzale in secondo piano: se il cane è ritenuto
solitamente simbolo di fedeltà, la pernice potreb-
be alludere sia alla lussuria che alla fecondità. Al
di là di un tendaggio si distende un ampio paesag-
gio montuoso che si perde all'orizzonte in toni
sempre più caldi.
Non è questa la sede per addentrarsi nella que-
stione dei significati simbolici celati nei vari ele-
menti della composizione (si veda, fra gli altri:
GOFFEN 1997, pp. 157-159), intendendo piuttosto
presentare l'interpretazione del nudo femminile
proposta da Tiziano attraverso la figura di Ve-
nere. La scena del dipinto degli Uffizi è caratte-
rizzata da un erotismo dolce e sensuale: a tale
intonazione concorrono la figura femminile nuda

riportata in una dimensione coeva da monili e arredi, le tenere carezze di Cupido sul seno, gli sguardi languidi dei due personaggi, il contatto delicato della mano della stessa Venere sulla propria gamba, l'epidermide del suo corpo pieno di cui con lo sguardo si possono percepire la tenerezza e la morbidezza propri del tatto. E tale sensualità così sottaciuta sembra riecheggiata nel paesaggio avvolto nella struggente luce serotina del tramonto.

La composizione fa parte di una fortunata serie di opere che l'artista veneto dedicò al tema di Venere distesa: dalla *Venere di Urbino* del 1538 (Firenze, Galleria degli Uffizi), ai tre dipinti con *Venere e l'organista* (due al Prado e uno allo Staatliche Museen, Berlin) prossimi per datazione all'opera qui presentata, fino al gruppo più tardo di opere con *Venere e l'organista* (Cambridge, Fitzwilliam Museum; New York, Metropolitan Museum of Art); fra gli altri, cfr. GOFFEN 1997.

TITIAN VECELLIO AND WORKSHOP
(Pieve di Cadore c. 1488-Venezia 1576)

Venus and Cupid

c. 1550
Oil on canvas
139.2 x 195.5 cm
Firenze, Galleria degli Uffizi,
Depositi, Inv. 1890/1431

The work entered the Medici collection in the second decade of the seventeenth century, a gift from Paolo Giordano Orsini to Cosimo II de' Medici. It has been assigned to Titian since its entrance into the Granducal collections, although in more recent scholarship it is considered a product of workshop collaboration executed around 1550 (for the history of the painting and its analysis cf. SQUELLATI 1978).

The composition represents a nude Venus half-reclining on her side turned towards the observer, but twisting her head towards Cupid who embraces her and caresses her from behind. As has often been noted, this formula could be inspired by the cartoon with *Venus and Cupid* executed by Michelangelo in 1532-1533, that Titian possibly saw on his way to Rome in 1545 or may have known indirectly through the copies Vasari made of it for Venetian patrons in the early 1540s. On the part of Michelangelo, instead it should be remembered that in creating the work for Bartolomeo Bettini he possibly made reference to Venetian works seen during his brief sojourn in the lagoon in 1529. In fact, the important precedent in Venetian circles for the motif of the semi-reclining female nude in a landscape was the *Sleeping Venus* now in Dresden (Gemäldegalerie), a work painted by Giorgione with the collaboration of Titian himself who added the image of Cupid at the foot of the goddess, subsequently lost. This formula — that encountered great fortune in Venetian art, but also beyond the Alps — was of distant classical derivation, being related to the iconographic repertoire offered by themes of marine *thiasos* with tritons and naiads and of bacchanalian rites with nymphs, satyrs and maenads, but also those more singular such as that of Hermaphrodite with Cupid (BROWN 1999, p. 430; see also DALLI REGOLI in *Leonardo* 2001, p. 158).

Stimulated therefore by suggestions stemming from Giorgione, Titian transformed the invention of Michelangelo into an interpretation unmistakably Venetian in nature, adopting nonetheless, a very personal language that fit in well with the energetic and plastic modes of Buonarroti.

In the Uffizi composition, the goddess is adorned with precious jewels, including pearls, a prerogative of aristocratic married women. The figure lies on a candid bed that rests in turn on a bright red covering. Nearby, a small table with lion-shaped legs bears a glass vase filled with roses, the same roses the goddess holds in her left hand and that for their odor are her attribute. The abandoned arrows and quiver of Cupid lie at the foot of the female figure while a spotted dog barks at the partridge perching on the window sill in the background: as the dog is usually held to be a symbol of fidelity, so the partridge may allude to both lasciviousness and fertility. Beyond the curtain, a vast and mountainous landscape stretches to the horizon, described in gradations of ever-warmer tonalities.

The discussion regarding the symbolic meanings hidden behind the various elements of the composition would take us far from our purpose here (see, among others: GOFFEN 1997, pp. 157-159), which is the presentation of Titian's interpretation of the female nude as seen in the figure of Venus. The scene in the painting in the Uffizi is characterized by a sweet and sensual eroticism: contributing to this tone are the transposition of the female nude as seen in coins and furnishings into a contemporary setting, the tender caress of Cupid on her breast, the languid gazes of the two personages, the delicate contact of Venus' own hand on her leg, the flesh of her full body that, at a glance, betrays tenderness and softness to the touch, a softened and subtle sensuality reflected in the landscape engrossed by the tender light of late summer sunset.

The composition belongs to a fortunate series of works the Venetian artist dedicated to the theme of the reclining Venus: from the *Venus of Urbino* dating 1538 (Firenze, Galleria degli Uffizi), to the three paintings with *Venus and the Organist* (two in the Prado and one in Berlin, Staatliche Museen) near in time to the work presented here and the later group of works depicting *Venus and the Organist* (Cambridge, Fitzwilliam Museum; New York, Metropolitan Museum of Art); among others, cf. GOFFEN 1997.

Elena Capretti

BIBLIOGRAFIA/BIBLIOGRAPHY
SQUELLATI in *Tiziano* 1978, pp. 60-65 n. 9, con bibliografia; MEIJER in *Rinascimento* 1999, pp. 528-529 n. 154, con bibliografia; SCHOEER-TRAMBOWSKY in *Kaiser* 2000, pp. 318-319 n. 352; NATALI in *I mai visti* 2001, pp. 82-83.

Cat. 34 (Tav. XI/1)

AGNOLO TORI detto IL BRONZINO
(Firenze 1503-1572)

Venere, Cupido e un Satiro
1553-1554 ca.
Olio su tavola
cm 135 x 231
Firmato nell'angolo inferiore sinistro: «A. BRONZ. FIOR. F.»
Roma, Galleria Colonna, Inv. 32

Al quadro di Bronzino *Venere, Cupido e un Satiro* fa riferimento il Vasari (1568) a proposito dell'attività dell'artista degli inizi degli anni Cinquanta, dopo la *Resurrezione* del 1552 (Firenze, SS. Annunziata) e prima della sua partenza per Pisa, avvenuta nel 1554. Egli lo descrive come dipinto per Alamanno Salviati (1510-1571): «Fece poi Bronzino al Signor Alamanno Salviati una Venere con un satiro appresso, tanto bella, che par Venere veramente Dea della bellezza». Raffaello Borghini (1584) lo vide in seguito nella casa del figlio di Alamanno, Jacopo: «In casa di Jacopo Salviati è un quadro fatto da lui [Bronzino] Venere con un satiro pittura bellissima».
Intorno alla stessa epoca (1583), il quadro fu inventariato nella casa di Jacopo come: «Un quadro grande simile a tre sopra detti con adornamento tocco d'oro, dentrovi una Venere di mano del detto» (FAZZINI 1993). Gli altri tre, erroneamente anch'essi attribuiti a Bronzino, erano di Michele di Ridolfo del Ghirlandaio: una *Venere e Cupido* (Tav. X/1) era derivata dal dipinto di Michelangelo-Pontormo, mentre l'*Aurora* (Tav. X/2) e la *Notte* (Cat. 13; Tav. XI/2) erano tratti dalle sculture michelangiolesche per la Sagrestia Nuova.
Il dipinto del Bronzino è di provenienza complessa (COSTAMAGNA 2000, p. 219): inviate nel 1699 a Roma, le quattro opere furono inventariate nel 1704, alla morte del duca Anton Maria Salviati (Biblioteca Apostolica Vaticana, Fondo Salviati 26, nn. 55-58: «quattro sopraporte del Bronzino

rappresentanti quattro Veneri ignudi [sic]». Passarono poi, come parte della dote di Caterina Zeffirina Salviati, che nel 1718 andò sposa a Fabrizio Colonna, nella Collezione Colonna. Considerata una tale documentazione, la firma, la paternità e la data della *Venere, Cupido e un Satiro* del Bronzino non sono mai state messe in discussione nella moderna letteratura sull'artista (SAFARIK 1981).
Oltre al quadro Colonna, Bronzino riprese il tema di Venere e Cupido altre due volte: nella famosa *Allegoria di Venere* (London, National Gallery, 1544-1545 ca.; Tav. XII/1; BACCHESCHI 1973, n. 50), e nella *Venere, Cupido e Gelosia* (o *Invidia*; Tav. XII/2; fig. 34-c) che è firmato, ma forse dipinto con la collaborazione della bottega, ed è una versione meno erotica e più classicheggiante del soggetto (Budapest, Szépmüvészeti Múzeum, 1550 ca.; BACCHESCHI 1973, n. 93). Egli eseguì anche un sonetto intitolato *Sopra una pittura di una Venere* (Cat. 30): «Poi, ch'in terra odio, e 'in Cielo Invidia, e Ira». Mentre è chiaro che tale poesia non si riferisce al quadro Colonna, la sua interpretazione è di componimento in lode della *Venere e Cupido* di Michelangelo-Pontormo (PARKER 2000, pp. 47, 153); l'armoniosa alleanza tra Venere e Cupido che vi è narrata e la menzione dell'Invidia sono state anche lette come un'allusione al dipinto del Bronzino di Budapest (SMITH 1981, pp. 251, 257; GASTON 1991, p. 267). Per un'altra lettura, si veda la convincente associazione di Leporatti di questo sonetto con la *Primavera*, arazzo del Bronzino che egli ribattezza *Primavera-Venere* (Cat. 36, Tav. XIII).
Bronzino prese come punto di partenza per la commessa del Salviati la *Venere e Cupido* di Michelangelo-Pontormo (Cat. 23, Tav. II/2 e Tav. III/1-3), anche se bisogna sottolineare che nessuno degli arti di questa Venere reclinata ripete quelli della figura di Michelangelo. Suo modello sembrano piuttosto essere state le divinità distese dipinte nel 1537-1543 dal Pontormo nella loggia della villa di Castello (perdute) per il duca Cosimo de' Medici (si veda: Firenze, Galleria degli Uffizi,

Gabinetto Disegni e Stampe, Inv. 17405F e Inv. 6683F [fig. 34-d]; COX-REARICK 1981, nn. 324, 344).
Bronzino reinterpretò il tema e la composizione del dipinto di Michelangelo-Pontormo per tramite di un proprio dipinto precedente, l'*Allegoria di Venere* (Londra), riadoperando il motivo di quell'opera, Venere che alza le braccia tenendo una delle frecce di Cupido. La riflettografia a raggi infrarossi del dipinto di Roma, eseguita durante i restauri dell'opera nel 1994, rivela in quest'area dei pentimenti (PASTORELLO 1995). Le immagini pubblicate mostrano sotto lo strato di colore tracce del disegno; esse indicano che, durante l'esecuzione della Venere, Bronzino spostò il braccio più in alto e girò leggermente il volto sulla destra.
In entrambe le *Allegorie di Venere*, Bronzino rese più esplicita l'interazione sessuale tra la dea e il figlio, mutando il più infantile *Cupido* di Michelangelo in un adolescente atteggiato in un esagerato contrapposto che mette in risalto le sue natiche. Nel quadro per il Salviati, Bronzino dà ulteriore enfasi al tema erotico introducendo un Satiro dallo sguardo lubrico, figura che può essere uno sviluppo della maschera satiresca del dipinto di Michelangelo-Pontormo. Il Satiro-*voyeur* del Bronzino mostra una viva propensione a entrare nella scena dirigendo il suo sguardo al giovane Cupido, riflettendo così la posizione voyeuristica dello stesso osservatore, *vis-à-vis* con la Venere nuda.
Questa figura di ragazzo entrò a fare parte del repertorio del Bronzino, comparendo più volte nei suoi dipinti dell'anno 1565 ca. sotto forma di angelo (*Allegoria della felicità*, Firenze, Galleria degli Uffizi; *Martirio di san Lorenzo*, Firenze, San Lorenzo; e *Due angeli con calice*, dipinto dall'Allori nella Cappella di Eleonora del Bronzino, Firenze, Palazzo Vecchio).
Anche Allori usò motivi presi dalla *Venere, Cupido e un Satiro* del suo maestro nei propri dipinti. Circa nello stesso periodo delle opere sopra menzionate, Allori riprese il *Cupido* del Bronzino in forma di angelo nella sua *Cacciata* (Firenze, SS. Annunziata, Cappella Montauto; 1560-1564 ca.) mentre la sua *Venere e Cupido*, eseguita intorno al 1570 (Cat. 43), è una variazione sull'omonimo dipinto di Michelangelo-Pontormo con aggiunti elementi tratti dal dipinto del Bronzino. Le figure sono disposte nella direzione che hanno nell'opera michelangiolesca, ma Cupido ha la stessa tipologia di adolescente di quello del Bronzino. La testa di Venere è di tre-quarti come in Bronzino, piuttosto che di profilo come nel quadro di Michelangelo-Pontormo e (a eccezione delle braccia) la figura reclinata ha la posa della *Venere* del Bronzino, non di quella di Michelangelo. Anche la *Venere* di Allori è completamente nuda e rispecchia le condizioni originali della *Venere* del Bronzino prima della ridipintura, ora ripristinate.
Le quattro figure femminili delle sopraporte del Salviati erano tutte descritte come nude fino al 1704, poi, nel XIX secolo, furono avvolte in voluminosi drappeggi che ne coprivano il corpo dai seni alle cosce (SAFARIK 1999). Quando nel 1994 l'opera fu restaurata, fu rimosso uno spesso stra-

to di vernice ingiallita, ma furono lasciati i drap-
peggi che coprivano Venere. Dettaglio interes-
sante: nel 1860 fu aggiunta alla *Venere* di Londra
una piccola porzione di drappeggio a coprire il
pube, poi rimossa nel 1958 (COX-REARICK 1995, p.
234). Nella serie del Salviati, i drappeggi sono
stati recentemente eliminati dalla *Venere e
Cupido* del Tosini (Michele di Ridolfo del Ghirlan-
daio; fig. 34-f), dalla *Notte* (Cat. 13, Tav. XI/2; fig.
34-e), e poi dalla *Venere, Cupido e Satiro*. Questo
intervento di restauro, discusso più avanti (fig. 34
a-b), rende più chiaro il carattere originario di
un'opera che mescola un perverso erotismo con
ciò che Federico Zeri (1966) chiamò «l'effetto
superbamente freddo e marmoreo».

34-b. Bronzino, *Venere, Cupido e un Satiro / Venus, Cupid and a Satyr*,
prima del restauro / *before restoration*.

AGNOLO TORI called IL BRONZINO
(Firenze 1503-1572)

Venus, Cupid and a Satyr

c. 1553-1554
Oil on panel
135 x 231 cm.
Signed in the lower left corner: "A. BRONZ. FIOR. F."
Roma, Galleria Colonna, Inv. 32

Bronzino's *Venus, Cupid and a Satyr* is men-
tioned by Vasari (1568) in the context of the
artist's work of the early 1550s, after the
Resurrection of 1552 (Firenze, SS. Annunziata)
and before his departure for Pisa in 1554. He

34-a. Bronzino, *Venere, Cupido e un Satiro*
Venus, Cupid and a Satyr, durante il restauro
/ *during restoration*.

describes it as painted for Alamanno Salviati
(1510-1571): "Bronzino then painted for Signor
Alamanno Salviati a Venus with a satyr beside her,
the Venus being so beautiful that she is indeed the
goddess of Beauty". Raffaello Borghini (1584)
later saw it in the house of Alamanno's son Jacopo:
"In Jacopo Salviati's house is a beautiful painting
by Bronzino of Venus with a satyr". At about the
same time (1583) the painting was inventoried in
Jacopo's house as "a large painting similar to the
three mentioned above, with gilded frame, in
which is a Venus by the same hand" (FAZZINI
1993); the other three, erroneously also given to
Bronzino, were by Michele di Ridolfo del Ghirlan-
daio: a *Venus and Cupid* (Pl. X/1) was derived
from the Michelangelo-Pontormo painting, while
the *Dawn* (Pl. X/2) and the *Night* (Cat. 13; Pl.
XI/2) were after Michelangelo's sculptures in the
New Sacristy.
The provenance of Bronzino's painting is complex
(COSTAMAGNA 2000, p. 219). Sent to Rome in 1699,
the four pictures were inventoried on the death of
Duke Anton Maria Salviati in 1704 (Biblioteca
Apostolica Vaticana, Fondo Salviati 26, no. 55-58:
"four overdoor paintings by Bronzino represent-
ing four nude Venuses [*sic*]". They passed to the
Colonna collection as part of the dowry of
Caterina Zeffirina Salviati, who married Fabrizio
Colonna in 1718. Given this documentation and
the signature, the authorship and date of
Bronzino's *Venus, Cupid and a Satyr* have never
been questioned in the modern literature on the
artist (SAFARIK 1981).
Besides the Colonna picture, Bronzino painted
the theme of Venus and Cupid twice: in the fa-
mous *Allegory of Venus* (London, National
Gallery, c. 1544-1545 [Pl. XII/1]; BACCHESCHI
1973, no. 50), and in the *Venus, Cupid, and
Jealousy* (or *Envy* [Pl. XII/2; fig. 34-c]), which is
signed, but perhaps painted with workshop par-
ticipation, and is a less erotic, more classicizing

version of the subject (Budapest, Szépmüvészeti
Múzeum, c. 1550; BACCHESCHI 1973, no. 93). He
was also the author of a sonnet entitled *Sopra
una pittura d'una Venere* (Cat. 30: "Poi, ch'in
terra odio, e 'n Cielo Invidia, e Ira"). While this
poem clearly does not refer to the Colonna paint-
ing, it has been interpreted as praising the Miche-
langelo-Pontormo *Venus and Cupid* (PARKER
2000, pp. 47, 153); its harmonious alliance be-
tween Venus and Cupid and mention of Invidia
have also been seen to allude to Bronzino's Bu-
dapest painting (SMITH 1981, pp. 251, 257; and
GASTON 1991, p. 267). For another reading, see
Leporatti's convincing association of this sonnet
with Bronzino's *Primavera* tapestry, which he re-
names *Primavera-Venus* (Cat. 36, Pl. XIII).
Bronzino took the Michelangelo-Pontormo *Ve-
nus and Cupid* (Cat. 23, Pl. II/2 and Pl. III-1-3)
as a starting point for the Salviati commission, al-
though it should be noted that none of the limbs
of his reclining Venus repeat those of Michelan-
gelo's figure; rather, his model seems to have
been the reclining deities painted by Pontormo in
the loggia of Villa Medici at Castello (lost) for Du-
ke Cosimo de' Medici in 1537-1543 (see Firen-
ze, Galleria degli Uffizi, Gabinetto Disegni e Stam-
pe, Inv. 17405F and Inv. 6683F [fig. 34-d]; COX-
REARICK 1981, no. 342, 344). Bronzino reinter-
preted the theme and composition of the Miche-
langelo-Pontormo painting by way of his own ear-
lier *Allegory of Venus* (London), reusing that
picture's motif of Venus' raised arm holding one
of Cupid's arrows. Infra-red reflectographs of
the Rome painting, carried out when the work
was restored in 1994, reveal pentimenti in this
area (PASTORELLO 1995). The published images
show traces of what is described as the prepara-
tory drawing under the paint layer. These indi-
cate that when painting the Venus, Bronzino mo-
ved her forearm higher, and shifted slightly her
face to the right.

34-c. Bronzino, *Venere, Cupido e Gelosia*
Venus, Cupid and Jealousy.
Budapest, Szépmüvészeti Múzeum.

34-d. Pontormo, *Studio per la decorazione della loggia nella villa medicea di Castello*
Study for decoration of the loggia in the Medici Villa at Castello,
Firenze, Galleria degli Uffizi, Gabinetto Disegni e Stampe, Inv. 6683F.

34-e. Michele di Ridolfo del Ghirlandaio,
La Notte / The Night
(Cat. 13; Tav. XI/2),
prima del restauro / *before restoration.*

34-f. Michele di Ridolfo del Ghirlandaio,
Venere e Cupido / Venus and Cupid
(Tav. X/1), prima del restauro
before restoration.

In both of his Venus allegories Bronzino made more explicit the sexual interaction between the goddess and her son, turning Michelangelo's more youthful Cupid into an adolescent posed in an exaggerated contrapposto which emphasizes his buttocks. In his painting for Salviati, Bronzino further enhanced the erotic theme by introducing a leering satyr who may have been developed from the satyrlike mask in the Michelangelo-Pontormo painting. Bronzino's satyr-*voyeur* leans eagerly into the scene, directing his gaze at the young Cupid, thus reflecting the observer's own voyeuristic position vis-à-vis the nude Venus. This boy becomes a stock figure in Bronzino's paintings of about 1565, appearing several times as an angel (*Allegory of Happiness*, Firenze, Galleria degli Uffizi; the *Martyrdom of St. Lawrence*, Firenze, San Lorenzo; and *Two Angels with a Chalice*, painted by Allori in Bronzino's Cappella di Eleonora (Firenze, Palazzo Vecchio). Allori also used motifs from his master's *Venus, Cupid and a Satyr* in his own works. About the same time as the paintings mentioned above, he reprised Bronzino's Cupid as the angel in the *Expulsion* (Firenze, SS. Annunziata, Cappella Montauto; c. 1560-1564), and his *Venus and Cupid* of c. 1570 (Cat. 43), is a variation on the Michelangelo-Pontormo *Venus and Cupid* overlaid with borrowings from Bronzino's painting. The figures are in the same direction as Michelangelo's, but the Cupid is of the same adolescent type of Bronzino's. Venus's head is in three-quarter view as in Bronzino's rather than profile as in the Michelangelo-Pontormo painting, and (with the exception of her arms) the reclining figure is posed like Bronzino's, not Michelangelo's *Venus*. Allori's *Venus* is also completely nude, reflecting the original condition of Bronzino's *Venus* before its overpainting, now removed.

All four of the women in the Salviati *sopraporte* (overdoors), described as nudes as late as 1704, were "dressed" in voluminous draperies covering their bodies from breasts to thighs, in the XIX century (SAFARIK 1999). When the Bronzino was restored in 1994, a thick layer of yellowed varnish was removed, but the draperies were left to cover Venus. Interesting, a bit of drapery was added in 1860 to cover Venus's pubis in the London *Venus*, and removed in 1958 (COX-REARICK 1995, p. 234) In the Salviati series, the draperies were recently removed from Tosini *Venus and Cupid* (fig. 34-f) and the *Night* (Cat. 13, Pl. XI/2; fig. 34-e), and now from the *Venus, Cupid and a Satyr*. This restoration (figs. 34a-b), makes clearer the original character of a work that combines a perverse eroticism with what Federico Zeri (1966) termed a "superbly cold and marmoreal effect".

Janet Cox-Rearick

BIBLIOGRAFIA / BIBLIOGRAPHY

VASARI 1568/1966-1997, VI, p. 235; BORGHINI 1584/1967, II, p. 537; EMILIANI 1960, pl. 85; ZERI 1966, p. 42; BACCHESCHI 1973, n. 94; SAFARIK 1981, n. 32; FAZZINI 1993, p. 204; COSTAMAGNA 1994, p. 220; PASTORELLO 1995; NEGRO 1994; SAFARIK-PUJIA 1996, pp. 610, n. 66; SAFARIK 1999, p. 196; COSTAMAGNA 2000, pp. 180, 191, 219 n. 157.

Cat. 35

AGNOLO TORI detto IL BRONZINO
(Firenze, 1503-1572)

Sopra una Pittura d'una Venere
1540-1550 (copia 1565-1566)
Inchiostro su carta
mm 227 x 158 x 40
Firenze, Biblioteca Nazionale, Cod. II IX 10,
«Prima parte delle rime del Bronzino», c. 69 *recto*

SOPRA UNA PITTURA D'UNA VENERE

Poi, ch'in terra Odio, e 'n Cielo Invidia, e Ira
 Scorse Venere bella, al santo Figlio
 Rivolto il vago, e luminoso ciglio
 Disse qual Donna, che d'amor sospira:
«Ergiti al Cielo omai, ch'odioso gira
 Senza il tuo Foco, e 'l livido, e 'l vermiglio
 Lume asserena; io della terra piglio
 Cura, che senza noi piange, e s'adira».
Obedì il Nato, alla pietosa, e saggia
 Onde il Ciel tosto d'amorosa face
 S'accese, che sentì gl'orati strali.
D'Amor la Terra, et di tranquilla pace
 S'empiè, fugato il reo di tutti i mali,
 Scoprendo Rose, e Fior per ogni Piaggia.

Il codice, trascritto da un calligrafo ma con molte correzioni d'autore, contiene il canzoniere del Bronzino con 265 poesie, discusso di recente da Parker (2000), che bilancia la sua più nota produzione burlesca (cfr. BRONZINO 1988). L'alta qualità della raccolta giustifica le lodi che gli furono decretate dai contemporanei anche in veste di poeta, a cominciare dal Varchi: «Voi sol, sol voi, che già gran tempo avete La dotta mano a pen-
nel dotto pari, Farne doppia potete eterna storia» (MORENI 1823, p. 2). La continua dialettica di questo doppio esercizio nel Bronzino, come nelle frequenti allusioni letterarie della sua pittura, trova riscontro nel canzoniere in molti componimenti dedicati ad artisti e a riflessioni sull'arte, alcuni anche a opere precise: per lo più i suoi celebrati ritratti, ma anche il *Perseo* del Cellini, e questa pittura di una Venere.

La dea descritta nel sonetto non è la giovinetta sensuale e compiacente delle famose allegorie, ma una lucreziana Venere *genitrix* che vince il male e, spargendo ovunque fiori, restituisce alla terra pace e fecondità. Allo stesso modo Cupido non è il dio bellicoso invocato in altre rime perché affini le sue armi contro la resistenza dell'amata, ma l'Amore celeste complice della madre benevola, fregiato addirittura del titolo di "santo Figlio" di solito attribuito a Cristo, come l'Anteros o *Amor virtutis*, privo di arco e frecce che intreccia ghirlande di fiori, in un epigramma dell'Antologia Palatina riproposto anche dall'Alciati (cfr. saggio Mendelsohn).

L'opera a cui il sonetto si riferisce non è identificata, o è perduta, magari anche perché effimera, come le tante realizzate dal Bronzino per feste e apparati celebrativi (per esempio, per l'ingresso di Giovanna d'Austria nel 1566; VASARI 1878-1885, VIII, pp. 530-535).

Il sonetto è stato avvicinato alla *Venere e Cupido* di Michelangelo e Pontormo (PARKER 2000, pp. 88 e 185; Cat. 23), e anche, in modo più persuasivo, alla tavola con *Venere, Cupido e l'Invidia* di Budapest (Tav. XII/2; SMITH 1981, pp. 251-257; GASTON 1991, p. 267). Qui si propone il suo accostamento all'arazzo della cosiddetta *Primavera* e al suo *pendant* con la *Giustizia che vendica l'Innocenza*, eseguiti su disegno del Bronzino,
per le ragioni che saranno esposte nella scheda seguente (Cat. 36).

Il rapporto fra arte e poesia, che trova nella penna e nel pennello del Bronzino un così mirabile compendio, si realizza a detta del Varchi nella distinzione e complementarità delle competenze: alla prima spetta il *di fuori*, la rappresentazione esteriore, alla seconda il *di dentro*, l'espressione dell'interiorità del soggetto.

La possibilità di riassumere a pari livello tutte e due le discipline in una stessa mano realizza quindi a pieno l'ideale michelangiolesco e rinascimentale dell'artista, ed è auspicabile che si traduca in una contiguità almeno ideale, meglio ancora se fisica, tra parola e immagine. Il sonetto, oltre a descrivere delle azioni e un paesaggio, dà voce a Venere consentendole di esprimere le sue preoccupazioni e intenzioni, e così completa la «poesia mutola» della pittura a cui si riferisce. Trattandosi però in questo caso di una "pittura di storia", e non di un ritratto, il rapporto tra parola e immagine si realizza in modo più complesso. Alla staticità dell'immagine il testo può opporre una durata, un racconto, che illustra anche premesse e sviluppi, ciò che avrebbe bisogno di almeno due quadri per essere restituito visivamente: un "prima", con la raccomandazione di Venere al figlio e l'intervento con la vittoria sul male; un "dopo", che ne rappresenta i benefici effetti. La coppia di arazzi in un certo senso ripropone questi due tempi.

La rappresentazione di una rinata età dell'oro è probabile che abbia un valore anche celebrativo, in riferimento alla stabilità finalmente riconquistata dal regime mediceo con la sua promessa di pace e prosperità (Cat. 38 e Cat. 36), anche se nel sonetto mancano espliciti riferimenti dinastici. L'idea di Cosimo I che rinnova l'età felice del "Magnifico Lorenzo Vecchio" si porta dietro il richiamo alle Veneri e Primavere botticelliane con il loro "doppio" poetico, le *Stanze* del Poliziano: si rammentino le ottave con gli amorini che spargono rose (I. 123) e con l'*alma Venus* che, «Ovunque vola, veste la campagna Di rose, gigli, violette e fiori» (I. 77).

Ma i colori a tinte forti usati nella seconda quartina a rappresentare il tempo della discordia scoprono risonanze che ci portano oltre la storia medicea della città, per risalire alle origini più alte della sua mitologia: *livido* (un aggettivo di forte suggestione dantesca: «la livida palude», *Inferno*, III. 98, ecc.), descrive i colori freddi dell'inverno vinti dalla temperata luce primaverile, ma evoca anche un pallore di morte; *vermiglio*, di solito il colore dei fiori e comunque sempre in poesia con un valore positivo, ha qui al contrario una connotazione sinistra: richiama l'arsura dell'estate, ma anche immagini di fuoco e forse di sangue. Allora, se è vero come diceva il Varchi che Bronzino teneva «tutto Dante... nella memoria», il sonetto vagheggia anche il recupero della Firenze di Cacciaguida (*Paradiso*, XV, 97-99 e XVI, 148-154), quando la città «si stava in pace, sobria e pudica», e, non ancora dilaniata dall'odio e dalle lotte intestine, il suo gonfalone, "il giglio", non era ancora mai stato "per division fatto vermiglio".

AGNOLO TORI called IL BRONZINO
(Firenze 1503-1572)

On a painting of a Venus

1540s (copied in 1565-1566)
Ink on paper
227 x 158 x 40 mm
Firenze, Biblioteca Nazionale, cod. II IX 10,
"Prima parte delle rime del Bronzino", c. 69 *recto*

On a painting of a Venus

Since, Beautiful Venus perceived Hate on Earth
 Envy and Wrath in Heaven, to her holy Son
 She turned her fair and luminous gaze
 And said as a woman whose every breath is love:
"Rise to heaven at last, as wickedly it turns
 Without your Fire, and temper the livid and
 Vermilion light; the Earth that weeps and rages
 Without us, will be my care".
He born to her obeyed the merciful and wise one
 Thus, struck by the golden arrows,
 Heaven soon glowed with the loving flame.
Banished the root of all evils, Earth filled with
 Love and tranquil peace, sprouting
 Roses and Flowers in every field.

The codex, transcribed by a calligrapher but with many corrections by the author, contains the rhymes of Bronzino consisting of 265 poems, discussed recently by Parker (2000), that counterbalance his better-known burlesque production (cf. BRONZINO 1988). The high quality of the collection justifies the praise given him as a poet by his contemporaries, beginning with Varchi: "You alone, only you, have at length possessed a learned hand equal to the learned paintbrush, with them you can double eternal history" (MORENI 1823, p. 2).
The continuous dialectics of this twofold activity in Bronzino finds, as a counterpart to the frequent literary allusions in his paintings, the many poetical compositions dedicated to artists and reflections on art, some regarding precise works: largely his famous portraits but also Cellini's *Perseus* and this "painting of a Venus". The goddess described in the sonnet is not the sensual and compliant young woman of Bronzino's famous allegories, but the Venus *genitrix* of Lucretius who triumphs over evil, and

spreading flowers everywhere, restores peace and fertility to the earth. In the same way, Cupid is not the troublesome god invoked in other rhymes intent on sharpening his weapons to overcome the resistance of a lover, but Celestial Love, the collaborator of his benevolent mother, adorned with the title of "holy Son" commonly attributed to Christ alone; he is similar to the Anteros or *Amor Virtutis* who, without bow and arrows, braids garlands of flowers in an epigram of *The Greek Anthology* reproposed by Alciati (cf. see Mendelsohn's essay).
The work to which the sonnet refers has not been identified or may be lost, given that many works created by Bronzino for festivals and celebrative occasions (for example, the entrance of Giovanna d'Austria in 1565; VASARI 1878-1885, VIII, pp. 530-535) were ephemeral in nature. The sonnet has been related to the *Venus and Cupid* by Michelangelo and Pontormo (PARKER 2000, pp. 88 and 185; Cat. 23), and, more persuasively, to the panel with *Venus, Cupid and Envy* in Budapest (Pl. XII/2; SMITH 1981, pp. 251-257; GASTON 1991, p. 267). Here proposed is the comparison with the tapestry of the so-called *Primavera* and its pendant representing *Justice Vindicating Innocence*, designed by Bronzino, for reasons explained in the entry below (Cat. 36).
The relationship between art and poetry, that finds in the pen and paintbrush of Bronzino such admirable union, proceeds according to Varchi from the distinction and complementary nature of the two activities: the former deals with the *outside*, the exterior image; the latter with the *inside*, the expression of the inner workings of the subject. Thus, when one hand commands both disciplines at equal level, the Michelangelesque and Renaissance ideal of the artist is attained and thus translates promisingly at the least into an ideal or better yet authentic contiguity between work and image.
The sonnet, beyond the description of actions and a natural setting, gives Venus a voice and allows her to express her preoccupations and intentions thus completing the "mute poetry" of the painting to which it refers. However, because in this case we are dealing with a 'history painting' and not a portrait, the rapport between word and image becomes more complex. Beyond the static nature of the image, the text

offers a duration, a story that includes a premise and development which, in a visual restitution, calls for at least two paintings: the 'first' depicting the recommendation of Venus to her son and the intervention of the triumph over evil, the 'aftermath' representing the beneficent effects. The pair of tapestries in a certain sense represents these two moments. The representation of a rebirth of the golden age probably also has a celebrative significance, in reference to the stability finally reacquired by the Medici regime with its promise of peace and prosperity (Cat. 38 and Cat. 36), even though the sonnet contains no explicit dynastical references. The idea of Cosimo I renewing the age of the 'Magnificent Lorenzo the Elder' brings with it the recollections of Botticellian *Venus* paintings and the *Primavera* with their poetic 'double', the *Stanze* by Politian: we recall the octaves with the little cupids scattering roses (I. 23) and with Lofty Venus who "Wherever she flies, dons the countryside with roses, lilies, violets and flowers" (I. 77).
However, the strong tinted colors used in the second quatrain to represent the time of discord rouse memories that take us from the Medicean history of the city to the loftiest origins of its mythology: *livid* (an adjective strongly suggestive of Dante: 'the livid marsh', *Inferno* III. 98, etc.), describes the cold colors of winter won over by the temperate light of the Spring, but also evokes the pallor of death; *Vermilion*, usually the color of flowers and in any case always used in poetry with a positive value, finds here instead a sinister meaning: it recalls the heat of the summer, but also images of fire and perhaps blood.
If the truth lies in Varchi's affirmation that Bronzino kept "all of Dante... in his memory", then the sonnet harkens back to the Florence of Cacciaguida (*Par.* XV. 97-99 and XVI. 148-154), when the city "abode in peace, sober and modest" and not yet torn by hatred and visceral controversies, its standard, "the lily", never yet "made vermilion by division".

Roberto Leporatti

BIBLIOGRAFIA:/BIBLIOGRAPHY
SMITH 1981, pp. 251-257; GASTON 1991, p. 267; PARKER 2000, pp. 88, 185.

Cat. 36 (Tav. XIII)

AGNOLO TORI detto IL BRONZINO
(1503-1572)
Tessitore JAN ROST (notizie dal 1535 al 1564)

Primavera-Venere
1545-1546
Arazzo
(trama: lana, seta, oro e argento;
ordito: lana, 7-9 fili per cm)
cm 235 x 168
Firenze, Palazzo Pitti, Deposito Arazzi, Inv. 541

Questa portiera, tra i primi arazzi eseguiti nell'a-razzeria fiorentina voluta da Cosimo I, risulta già consegnata nel 1546, ed è menzionata nel primo elenco (1549) come «la prima vera», insieme con il suo *pendant*, «l'Innocenza del Bronzino», cioè *La Giustizia che vendica l'Innocenza* (fig.36-a; v. MEONI 1998, p. 166).
Panofsky (1939/1975) identificò il nostro araz-zo, fino ad allora considerato una *Flora*, come *Primavera*, insieme ai suoi simboli astrologici, Gemelli, Toro e Ariete, e osservò che, per la fi-gura femminile «che si libra, più che cavalcarlo, su un ariete» (p. 120), il Bronzino potrebbe es-sersi ispirato al modello classico della Venere su un capro. Benché lui ritenesse che questo dove-va essere il primo di una serie dedicata alle quattro stagioni, e l'*Innocenza* parte di un pro-gettato dittico in contrapposizione alla Lussuria (p. 128), gli studiosi che successivamente se ne sono occupati (COX-REARICK 1982 e 1984, BOSCH 1983, ADELSON 1990) hanno rivendicato una concezione unitaria e compiuta ai due pezzi,

ricordandone le dimensioni quasi identiche e le stesse bordure con le armi dei Medici-Toledo. Questi studi hanno individuato il principale lega-me tra le due opere nel contesto delle celebra-zioni medicee, ben evidente nella *Primavera* con la figura femminile sopra un ariete, il segno zo-diacale caro a Cosimo a partire dalla nascita del suo primogenito Francesco, il 25 marzo 1541, il primo giorno di primavera e dell'anno secon-do il calendario fiorentino (COX-REARICK 1982 e 1984), che si richiama allo stesso soggetto di un'antica gemma già nelle collezioni di Lorenzo il Magnifico (Cat. 37), a cui si era ispirato il Pon-tormo nel suo disegno di Venere e Cupido (Cat. 38). Ciò non significa, comunque, che gli arazzi debbano essere letti come due pagine di uno stesso libro; come portiere infatti, non erano neppure destinate a essere viste sincronicamen-te l'una di fianco all'altra (ADELSON 1990, p. 115). Con il nostro arazzo, come per alcuni suoi ritratti, il Bronzino sembra avere raccolto l'invito dell'ami-co Varchi a trattare un soggetto con tutte e due gli "stili" a sua disposizione: «Anzi scrivete e dipin-gete insieme» (MORENI 1823, p. 49). Infatti, la figu-ra femminile ha forti analogie con il sonetto dedi-cato a Venere (Cat. 35): come la dea nei versi, sparge ghirlande di fiori tra cui si distinguono le rose dei Medici e i gigli di Firenze (COX-REARICK 1984), e rivolge il suo sguardo e sembra come discendere verso il basso, prendendosi cura della terra (vv. 6-7), rappresentata con un paesaggio

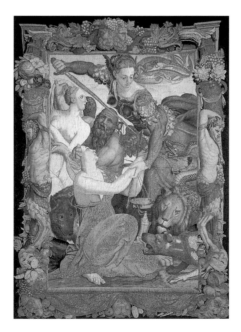

36-a. Agnolo Bronzino-Jan Rost, *La Giustizia che vendica l'Innocenza /Justice vindicating Innocence.*
Firenze, Palazzo Pitti, Deposito Arazzi.

naturale florido e verdeggiante, mentre gli Amori le volano intorno affaccendati a diffondere i suoi salutari effetti in tutte le direzioni. Uno di loro, il più in evidenza in alto a destra, e quasi con un ruolo di co-protagonista come nel sonetto, sembra ese-guire l'ordine, che nei versi gli è impartito dalla madre, di salire verso il cielo («Ergiti al Cielo omai»), da cui si diffonde una luce calda e rosata, come di una nuova alba, che avvolge e rasserena tutta la scena.
Nonostante i documenti si riferiscano sempre al-l'arazzo come a una *Primavera*, queste affinità con il sonetto, così come la casta nudità della fi-gura femminile, il fatto di essere accompagnata dal suo tradizionale corteggio di amorini, nonché il parallelo con la gemma antica e il disegno del Pontormo, fanno propendere per una sua identifi-cazione con la stessa Venere genitrice, che torna a restituire la pace e la prosperità, senza ormai più ostacoli, dopo il tempo terribile della giustizia. Va detto comunque che non c'è reale conflitto fra l'identificazione della figura come Venere, Prima-vera o Flora, essendo in sostanza la stessa mani-festazione di un triplice simbolo.
Nell'*Innocenza*, anche la raffigurazione dei quat-tro animali – un serpente, un leone, un cane e un lupo – sembra avere un significato politico, e una, più esile, connessione con il sonetto del Bronzino. Per Panofsky (1939/1975) sono la rappresentazione delle potenze del male scon-fitte dalla Giustizia: Invidia, Avarizia, Furia, Perfi-dia; per Bosch alludono al simbolo della divinità egizia Serapide, con un serpente circolare che ha al centro una figura tricipite con un leone, un lupo e un cane, che rappresenta il Tempo (la pro-posta è raccolta da COX-REARICK 1984 e ADELSON 1990, che tuttavia ritiene che non escluda quel-la tradizionale di PANOFSKY 1939/1975).
Non è stato osservato, comunque, che il lupo, isolato rispetto agli altri animali e quasi nascosto dietro l'Innocenza, ha un aspetto mansueto, e anzi persino timoroso, soprattutto nei confronti del cane che al contrario è rappresentato fero-ce, e ricorda molto la lupa dantesca, con le "bra-mose" cagne che dilaniano gli scialacquatori in *Inferno*, XIII. Ma tutte e tre le fiere minacciose, raccolte sul lato destro dell'arazzo, con la lonza sostituita dal serpente, richiamano alla memoria quelle incontrate da Dante all'inizio del suo cam-mino, anche da un punto di vista iconografico, con la stessa disposizione verticale che si ritro-va in tante illustrazioni del canto iniziale della *Commedia*, e per il loro significato non dovremmo essere lontani dai vizi elencati nel primo verso del sonetto del Bronzino: Odio, Invidia e Ira. Una lettura che rinvenga in questi simboli riferimenti ai mali che hanno colpito Firenze negli anni precedenti, finalmente fugati dall'instaura-zione del governo illuminato di Cosimo, rimane la più probabile.

AGNOLO TORI called IL BRONZINO
(1503-1572)
weaver JAN ROST
(documented from 1535-1564)

Primavera-Venus

1545-1546
Tapestry
(woof: wool, silk, gold and silver;
warp: wool, 7-9 threads per cm)
235 x 168 cm
Firenze, Palazzo Pitti, Deposito Arazzi, Inv. 541

This door covering, among the first taspetries executed in the Florentine tapestry manufactury promoted by Cosimo I, was already completed in 1546, and was mentioned in the first listing (1549) as "la prima vera [the Spring]", together with its *pendant*, the "Innocence of Bronzino", that is *Justice vindicating Innocence* (fig. 36-a; MEONI 1998, p. 166). Panofsky (1939/ 1975) identified the tapestry, previously considered a representation of *Flora*, as the figure of *Primavera* shown with her astrological symbols, Gemini, Taurus and Aries, observing that Bronzino might have been inspired by the classical model of Venus on Goat for his female figure, "hovering over, rather than riding on, a ram" (p. 120).
Although Panofsky held this work to be the first in a series dedicated to the four seasons and the *Innocence* tapestry as one side of a diptych with *Lasciviousness* as its counterpart (p. 128), subsequent scholars who have studied these works (COX-REARICK 1982 and 1984, BOSCH 1983, ADELSON 1990) have noted the almost identical dimensions and the same border with the Medici-Toledo coats of arms on the *Primavera* and the *Innocence*. As a result, they have proposed that the tapestries constitute a complete and unified set, a unitary and exclusive origin for the two pieces has been proposed, identifying the main link between the two works within the context of the Medici celebrations. In the *Primavera*, this is especially evident in the image of the female figure riding the ram, the sign of the

zodiac dear to Cosimo from the time of the birth of his first born son, Francesco, on 25 March 1541, the first day of Spring and of the year according to the Florentine calendar (COX-REARICK 1982 and 1984). The invention can be traced to an identical image found on an ancient gem once in the collection of Lorenzo il Magnifico (Cat. 37), that also inspired Pontormo in his design for *Venus and Cupid* (Cat. 38). This does not signify however that the tapestries were intended to be read like two pages of the same book; in effect, as door coverings they were never meant to be seen synchronically, one next to the other (ADELSON 1990, p. 115).
As in some of his portraits, for our tapestry Bronzino seems to have heeded the words of his friend Varchi to treat the subject in both "styles" at his command: "Indeed write and paint together" (MORENI 1823, p. 49). In effect, the female figure presents strong analogies with the sonnet dedicated to Venus (Cat. 35): like the goddess in the poem, she scatters garlands of flowers, recognizably the roses of the Medici and the lilies of Florence (COX-REARICK 1984); she orients her gaze and her a moviment down ward, her attention drawn to the earth depicted as a natural landscape, flourishing and green. In the meanwhile, the *Putti* fly around her, busy diffusing their healthy effects in all directions. As in the sonnet, one of them on the upper right stands out most prominently, taking on the role of a quasi-protagonist. He seems to be following the order given in the verses by his mother ("Rise to the heavens at last"), as a warm and rosy light spreads like the light of a new dawn enveloping in tranquility the surroundings. Despite the fact that the documents refer constantly to the tapestry as a *Primavera*, the affinities with the sonnet, her chaste nudity, the accompaniment of her traditional court of *Putti* as well as the parallel with the antique gem and the drawing of Pontormo all suggest that she be equated with Venus *genetrix*, who returns to restore peace and prosperity free from the obstacles that marked the terrible time of justice. One must remember, however, that no real conflict exists in identifying the figure with

Venus, Primavera or Flora, each being, in substance one facet of a triple symbol.
In the *Innocenza*, the representation of the four animals – a serpent, a lion, a dog and a wolf – also seems to have a political meaning and, less evidently, a connection to the sonnet by Bronzino. For Panofsky (1939/1975) they represent the power of evil defeated by Justice: Envy, Avarice, Anger, Perfidy; for Bosch, they allude to the symbol of the Egyptian deity Serapis, with the circular serpent with at its center the tricuspid figure of the lion, the wolf and the dog that represent time (the proposal is accepted by COX REARICK 1984 and ADELSON 1990 who however contends that this does not exclude Panofsky's traditional interpretation). What has not been noted, however, is that the wolf, isolated with respect to the other animals and almost hidden behind *Innocence*, has a tame demeanor, even frightened if you will, above all in regards to the dog that instead appears ferocious, very much recalling the she-wolf in Dante or the "ravenous" bitches tearing the spendthrifts piecemeal in *Inf.* XIII. But all three of the menacing beasts gathered on the right of the tapestry, with the serpent in place of the she-leopard, recall to mind the beasts encountered by Dante at the beginning of his pilgrimage even from an iconographic point of view for their significance, they are not distant from the vices listed in the first lines of the sonnet by Bronzino, Hate, Envy and Wrath and for the vertical arrangement is similar to that found in many illustrations of the *Commedia*. A reading that detects in these symbols a reference to the evil that had afflicted Florence in the years predating the foundation of Cosimo's enlightened rule remains the most convincing.

Roberto Leporatti

BIBLIOGRAFIA / BIBLIOGRAPHY
PANOFSKY 1939 [trad. ital. 1975], pp. 114-124; COX-REARICK 1982 pp. 184-185; BOSCH 1983, pp. 75-76, 78-79; COX-REARICK 1984, pp. 285-286; ADELSON 1990, pp. 113-119; MEONI 1998, pp. 162-166, con bibliografia.

Cat. 37

Afrodite su capro
Età tardo-ellenistica
Cammeo in agata-onice
mm 25 x 20,8
Napoli, Museo Archeologico Nazionale, Inv. 25845

Al centro del cammeo è raffigurata, di prospetto, una figura femminile seduta in groppa a un capro che corre verso destra, solcando i flutti del mare. La donna è avvolta dai fianchi alle caviglie in un ampio mantello, le cui estremità si increspano in pieghe sinuose tutt'intorno alle gambe, mentre un lembo, gonfiato dal vento e trattenuto con la mano destra, si solleva dietro le spalle a mo' di nimbo, il cui profilo segue il margine superiore del cammeo. La mano sinistra impugna un attributo identificabile forse con uno scettro. Attaccato alla coda dell'animale e con le gambe immerse nelle onde è un piccolo Erote.

L'iconografia della figura femminile in groppa ad un capro è attestata con una certa frequenza nel repertorio figurativo greco-romano di età ellenistica (FLEISCHER in DELIVORRIAS 1984, pp. 98-100), in terrecotte, bronzi, monete, cammei e incisioni, che raffigurano probabilmente Afrodite Epitraghìa (su un capro): si tratterebbe nella maggior parte dei casi, e questo vale anche per il nostro cammeo (PESCE 1935; PANNUTI 1994), di tarde rielaborazioni del gruppo bronzeo di Afrodite Pandemos, opera di Skopas, ricordata da Pausania (VI. 25. 1) nel *temenos* della dea a Elis, in cui la dea era appunto raffigurata in groppa a un capro. La semi-nudità della dea nel nostro cammeo sarebbe invece un'invenzione ellenistica, come sembrano dimostrare alcune monete di Elis riproducenti il gruppo di Skopas, in cui la dea appare interamente coperta da chitone e *himation* (FLEISCHER in DELIVORRIAS 1984, p. 100, n. 976).

Si è da tempo ipotizzata una valenza astrale della Pandemos, soprattutto in connessione con il culto di Afrodite Urania, venerato nello stesso santuario di Elis e che sicuramente aveva specifiche connotazioni celesti (SETTIS 1966). Già Furtwängler (1900), che nell'attributo in mano all'Afrodite del nostro cammeo riconosceva

una fiaccola, non mancò di sottolineare la valenza di divinità connessa con la luce, propria dell'Afrodite sul capro.

L'iscrizione LAU. R. MED., un tempo visibile nella parte superiore destra ora perduta, ma riprodotta in un calco della raccolta Cades (III, B, 11; LIPPOLD 1922), ci documenta l'appartenenza del cammeo alla collezione glittica di Lorenzo il Magnifico, ed è probabile la sua identificazione con un pezzo citato nell'inventario di Lorenzo del 1492, descritto come «chammeo legato in oro, chon una aquila [ma SPALLANZANI-GAETA BERTELÀ 1992, leggono, in modo più pertinente con la scena raffigurata, "aqua"] drentovj uno bucho suvj una femina gnuda chon uno panno a vela, uno bambino apichato alla coda el detto animale, champo nero...» (DACOS-GIULIANO-PANNUTI 1973).

La presenza del cammeo nelle collezioni medicee fiorentine dovette probabilmente favorire le interpretazioni in chiave allegorica della scena raffigurata, in cui presto si tenderanno a riconoscere i simboli cari all'ideologia politica della famiglia. In particolare, la facile trasposizione del capro nel simbolo zodiacale dell'ariete, sotto il cui segno era nato nel 1541 l'erede di Cosimo I, Francesco, e la conseguente interpretazione della figura femminile come allegoria della Primavera, una delle immagini chiave della propaganda medicea elaborata all'indomani del ritorno dall'esilio, sembrano trovare una precisa eco in un disegno di Pontormo (Cat. 38) e in un arazzo eseguito su disegno di Bronzino (Cat. 36, Tav. XIII), due opere realizzate intorno al 1545 su committenza del duca Cosimo.

Aphrodite riding a Goat
Late Hellenistic age
Cameo in agate-onyx
25 x 20.8 mm
Napoli, Museo Archeologico Nazionale, Inv. 25845

The center of the cameo represents, from a side-view, a female figure seated on the back of a goat as it moves to the right riding the waves of the sea. The woman is wrapped from her ankles to her hips in a large mantle, the borders of which curl in sinuous folds around her legs while a piece of cloth billowing in the wind that she holds with her right hand rises above her shoulders like a nimbus, its profile following the upper margin of the cameo. In her left hand, she holds something that may be a scepter while a *putto* hangs on the tail of the animal, his legs immersed in the waves.

The iconography of a female figure on the back of a goat is a fairly frequent image in the Greek-Roman figurative repertoire (FLEISCHER in DELIVORRIAS 1984, pp. 98-100) seen on terracottas bronzes, coins, cameos and carvings. It probably represents Aphrodite Epitraghia (on

a goat): in the majority of cases and this holds true for our cameo (PESCE 1935; PANNUTI 1994) a late re-elaboration of the bronze group of Aphrodite Pandemos, a work by Skopas in which the goddess was, in effect, represented riding on a goat, recorded by Pausanias (VI. 25. 1) in the *temenos* of the deity at Elis. The semi-nudity of the goddess in this cameo would appear to originate instead in Hellenistic times, inasmuch as the images of the group by Skopas found on a few coins from Elis show the goddess entirely covered by a chiton and a *himation* (FLEISCHER in DELIVORRIAS 1984, p. 100, n. 976).

For some time, an astrological significance has been associated with the Pandemos, principally in connection with the cult of Aphrodite Urania, venerated in that same sanctuary of Elis and who certainly possessed specific celestial connotations (SETTIS 1966). Furtwängler (1900), who recognized the attribute in the hand of Aphrodite on our cameo as a torch, already underscored the affiliation of Aphrodite on a Goat with a divinity connected to light.

The inscription LAU. R. MED. once visible on the upper right of the cameo, although lost, was reproduced in the casting in the Cades collection (III. B. 11: cf. LIPPOLD 1922), thus, attesting to the cameo's inclusions in the glyptic collection of Lorenzo il Magnifico.

It can probably be identified with the piece cited in the inventory of Lorenzo in 1492 as a "cameo mounted in gold with an eagle (*aquila*) [but SPALLANZANI-GAETA BERTELÀ 1992, p. 38 read water (*aqua*), more pertinent to the scene represented] with inside a buck on which rests a female nude with a sail-like cloth, a child stuck to the tail of said animal, black background..." (DACOS-GIULIANO-PANNUTI 1973).

The presence of the cameo in the Medici collection in Florence must have favored allegorical interpretations of the figurative image, in which symbols dear to the political ideology of the family soon were recognized. In particular, the simple transformation of the goat into the zodiacal symbol of the ram under whose sign the heir of Cosimo I, Francesco, was born in 1541 and the consequent interpretation of the female figure as an allegory of the Primavera, one of the key images in Medicean propaganda after their return from exile, seem to find a precise echo in the drawing by Pontormo (Cat. 38) and in the tapestry designed by Bronzino (Cat. 36, Pl. XIII), both works commissioned by Duke Cosimo and completed about 1545.

Anna Maria Riccomini

Bibliografia / BIBLIOGRAPHY
FURTWÄNGLER 1900, II, p. 262; LIPPOLD 1922, tav. XXIV, 5; PESCE 1935, p. 61, n. 7; FLEISCHER in DELIVORRIAS 1984, p.100, n. 971; DACOS-GIULIANO-PANNUTI in *Tesoro* 1973, p. 50, n. 16; SPALLANZANI-GAETA BERTELÀ in *Libro* 1992, p. 38, c. 19v; PANNUTI 1994, p. 142, n. 109, con bibliografia.

stretto collegamento stilistico e tematico con la *Primavera*, che ritrae una divinità aerea simile a Venere con segni zodiacali, uno dei quali, l'Ariete, significava la nascita di Francesco. La stagione primaverile era un antico *topos* dei Medici, per indicare il loro ritorno al potere dopo l'esilio, e la *Primavera*, indicata dai segni zodiacali dell'Ariete (in basso a destra come nel disegno del Pontormo), Toro e Gemelli, è un'allegoria della rinascita dei Medici. In maniera simile, la *Venere e Cupido con i segni zodiacali di Capricorno e Ariete* del Pontormo allude al potere mediceo, e in maniera specifica alla sua ri-nascita sotto il duca Cosimo e alla sua continuazione con Francesco.

Prototipi tematici e stilistici di questa avvincente immagine si trovano nelle divinità planetarie Saturno, Marte e Mercurio intrecciate con segni zodiacali a rappresentare la posizione dei pianeti nell'oroscopo del duca nel giorno della sua elevazione alla carica nel 1537 dipinte da Pontormo in una loggia alla Villa di Castello tra il 1537 e il 1543 (perduto; COX-REARICK 1981, pp. 302-308, nn. 336, 340-344; EADEM 1984, pp. 258-266; fig. 38-a). Pontormo potrebbe aver avuto anche dimestichezza con un antico cammeo raffigurante *Venere che cavalca un capro*, che faceva parte della collezione di Lorenzo de' Medici, il Magnifico (Cat. 37).

JACOPO CARUCCI, called IL PONTORMO
(Pontorme 1494-Firenze 1557)

Venus and Cupid with the Zodiac Signs of Capricorn and Aries

c. 1545
black chalk squared in black chalk
175 x 176 mm
Paris, Musée du Louvre,
Département des Arts Graphiques, Inv. 10396

Cat. 38

JACOPO CARUCCI detto IL PONTORMO
(Pontorme 1494-Firenze 1557)

Venere e Cupido con i segni zodiacali del Capricorno e dell'Ariete

1545 ca.
Matita nera riquadrata in matita nera
mm 175 x 176
Paris, Musée du Louvre,
Département des Arts Graphiques, Inv. 10396

Questo disegno fu senza dubbio eseguito per un progetto commissionato dal più importante tra i mecenati del Pontormo, il duca Cosimo de' Medici. Cosimo adottò il segno del Capricorno come una delle sue personali "imprese", o emblemi, a causa della sua credenza nel fatto che tale segno, in posizione chiave nel proprio oroscopo come ascendente, avrebbe avuto un'influenza favorevole sul suo destino. Esso compare di frequente in medaglie, arazzi, affreschi e altre opere commissionate da lui a partire dal 1537, anno in cui egli ascese alla carica ducale (COX-REARICK 1984, pp. 258-282). Alcuni degli arazzi ritraggono il Capricorno del duca appaiato con il segno dell'Ariete (COX-REARICK 1984, pp. 285-286; COSTAMAGNA 1994, p. 241). Questo segno

ha posizione preminente nell'oroscopo dell'erede di Cosimo, Francesco – nato il 25 marzo 1541, primo giorno dell'Ariete (e anche Festa dell'Annunciazione e, nel Rinascimento, il Capodanno fiorentino) – ed era ritenuto doppiamente di buon auspicio, essendo anche il suo ascendente nel segno dell'Ariete.

Nella prima pubblicazione del disegno del Louvre Cox-Rearick (1970) seguì il suggerimento di Shearman che si trattasse di uno studio preparatorio per l'*apparato* scenico per le nozze tra il duca e Eleonora di Toledo, avvenute nel 1539. In effetti, mentre il Capricorno ducale appare molte volte in quelle decorazioni (ora perdute), il soggetto di Venere con i segni del Capricorno e dell'Ariete non vi è menzionato. Né si fa in alcun luogo parola che Pontormo abbia preso parte a quei lavori, probabilmente poiché nel 1539 egli era occupato alla decorazione della villa medicea di Castello.

Il disegno del Louvre, che è riquadrato per essere ingrandito, è più verosimilmente un lavoro preparatorio per un arazzo a *portiera*, simile agli arazzi per porta come la *Primavera,* interpretato convincentemente come *Primavera/Venere* (Cat. 36, Tav. XIII), commissionata dal duca al Bronzino nel 1545. (Questi erano rettangolari, e il disegno del Pontormo deve essere stato tagliato nel suo presente formato rotondo in una data successiva). A quanto pare, dal progetto del Pontormo non fu eseguito nessun arazzo, ma esso presenta uno

This drawing was unquestionably made for a project commissioned by Pontormo's chief patron, Duke Cosimo de' Medici. Cosimo adopted the sign of Capricorn (the goat) as one of his personal *imprese* (devices) because of his belief that its key position as the Ascendant sign of his horoscope would favorably influence his destiny. It appears frequently in medals, tapestries, frescoes, and other works commissioned by him beginning in 1537, the year that he ascended to the dukedom (COX-REARICK 1984, pp. 258-282). Some of these tapestries feature the duke's Capricorn paired with the sign of Aries – the ram (COX-REARICK 1984, pp. 285-286; COSTAMAGNA 1994, p. 241). This sign is prominent in the horoscope of Cosimo's heir, Francesco, whose birth on 25 March 1541, the first day of Aries (also the Feast of the Annunciation and, in the Renaissance, the Florentine New Year) was doubly auspicious because the sign of Aries was also the Ascendant in his horoscope.

38-a. Pontormo, *Studio per la decorazione della loggia nella villa medicea di Castello; particolare con Saturno col segno del Capricorno* / Study for decoration of the loggia of the Medici Villa at Castello; detail *Saturn with the Sign of Capricorn*, Firenze, Galleria degli Uffizi, Gabinetto Disegni e Stampe, Inv. 6510F.

In the first publication of the Louvre drawing, Cox-Rearick (1970) followed Shearman's suggestion that it was preparatory to the wedding apparato of the duke and Eleonora di Toledo in 1539. While the ducal Capricorn did appear several times in these lost decorations, the subject of Venus with the signs of Capricorn and Aries is not recorded there. Moreover, Pontormo is not mentioned as having participated in the enterprise, probably because he was occupied in 1539 on the decoration of the Medici Villa Castello. The Louvre drawing, which is squared for enlargement, is more likely to have been preparatory to a tapestry *portiera*, similar to door hangings such as *La Primavera*, interpreted convincingly as *Primavera /Venus* (Cat. 36, Pl. XIII), which Duke Cosimo commissioned from Bronzino in 1545. (These were rectangular, and

Pontormo's drawing must have been cut to its present roundel format at a later date).

Apparently no tapestry was made from Pontormo's design, but it is very closely related stylistically and thematically to the *Primavera*, which depicts an airborne Venus-like deity with zodiac signs, one of them Aries, signifying the birth of Francesco.

Spring was an ancient Medici topos for their return to rule after exile, and the *Primavera* is an allegory of Medici renewal, indicated by the spring zodiac signs of Aries (to the lower right as in Pontormo's drawing), Taurus, and Gemini. Likewise, Pontormo's *Venus and Cupid with the Zodiac Signs of Capricorn and Aries* alludes to Medici rule – specifically to its renewal under Duke Cosimo and its continuation under Francesco.

Thematic and stylistic prototypes for this engaging image are found in the planetary deities Saturn, Mars, and Mercury intertwined with zodiac signs representing planetary positions in the duke's horoscope on the day of his elevation to the dukedom in 1537, painted by Pontormo in a loggia at Villa Castello in 1537-1543 (lost; COX-REARICK 1981, pp. 302-308, nos. 336, 340-344; EADEM 1984, pp. 258-266; fig. 38-a). Pontormo may also have been familiar with an ancient cameo showing *Venus riding on a goat*, which had been in the collection of Lorenzo de' Medici, il Magnifico (Cat. 37).

Janet Cox-Rearick

BIBLIOGRAFIA / BIBLIOGRAPHY
COX-REARICK 1970, pp. 371-372, cat. 344a (ristampa in COX-REARICK 1981); COX-REARICK 1984 pp. 285-286; COSTAMAGNA 1994 p. 241.

Cat. 39

JACOPO CARUCCI detto IL PONTORMO
(Pontorme 1494-Firenze 1557)

Madonna che allatta il Bambino
1535-1545 ca.
Matita nera
mm 280 x 405
Firenze, Galleria degli Uffizi,
Gabinetto Disegni e Stampe, Inv. 6534F *recto*

Questo grande foglio è noto da molto tempo agli studiosi del Pontormo (Clapp, Berenson), che ne hanno collocato la datazione nei primi anni della quarta decade del Cinquecento e lo hanno giudicato una derivazione della *Venere e Cupido* di Michelangelo-Pontormo (Cat. 23). Qui Pontormo trasforma il suo modello in una *Madonna che allatta il Bambino*. Ha rovesciato la figura di Venere, ma ha mantenuto immutata la posizione aperta delle gambe, usata da Michelangelo anche in un disegno coevo della *Venere e Cupido*, il *Tito* del 1532 (Castello di Windsor, Collezione Reale, Inv. 12771). Anche Pontormo impiegò questa posizione in due disegni di nudi del 1532-1534, che sono di diverso soggetto, ma hanno una qualità immediatamente dipendente dalla *Venere e Cupido*: uno studio per un giocatore del calcio fiorentino destinato a un affresco per la villa medicea di Poggio a Caiano (Firenze, Galleria degli Uffizi, Gabinetto Disegni e Stampe, Inv. 6505F; COX-REARICK 1981, n. 308) e uno studio completo di una *Venere nuda*, probabilmente per la *Venere e Adone*, che Pontormo era stato incaricato di dipingere a Poggio a Caiano, ma che non eseguì mai (Firenze, Galleria degli Uffizi, Gabinetto Disegni e Stampe, Inv. 6586F; COX-REARICK 1981, n. 329). Pontormo mutò la posizione

del braccio destro di Venere in modo da farle reggere un libro, e abbassò il Cupido – ora trasformato nel Cristo Bambino – collocandolo in una posizione tra le gambe della madre in modo tale da poter succhiare il seno sinistro mentre lei lo osserva.
Il nuovo motivo del bambino viene sperimentato attraverso numerosi pentimenti. Questo spostamento di soggetto colloca il disegno nell'ambito di un famoso dipinto del Pontormo databile tra il 1535 e il 1545, noto come *Madonna del Libro*, che si trovava nella collezione di Ottaviano de' Medici (perduto e noto solo attraverso le molte copie; COX-REARICK e FREEDBERG 1983, pp. 521-527; COSTAMAGNA 1994, n. 73). Esso è anche prossimo come stile a un altro disegno di *Madonna con Bambino*, collegato a quel dipinto (Hamburg, Kunsthalle, Inv. 21173 *verso* [fig. 39-a]; COX-REARICK 1981, n. 333).

JACOPO CARUCCI, called IL PONTORMO
(Pontorme 1494-Firenze 1557)

Madonna and Nursing Child

c. 1535-1545
Black chalk
280 x 405 mm
Firenze, Galleria degli Uffizi,
Gabinetto Disegni e Stampe, Inv. 6534F *recto*

This large sheet has long been known in the Pontormo literature (Clapp, Berenson), where it was dated to the early 1530s as derived from the Michelangelo-Pontormo *Venus and Cupid* (Cat. 23). Here Pontormo transformed his model into a Madonna and nursing Child. He reversed the

direction of the Venus but maintained her open leg position, which Michelangelo had also used in a drawing contemporaneous with the *Venus and Cupid*, the *Tityus* of 1532 (Windsor Castle, The Royal Collection, Inv. 12771). Pontormo also used this pose in two drawings of nudes of 1532-1534, which are of diverse subjects but have a quality of immediate dependence on the *Venus and Cupid*: a study for a fallen soccer player for a fresco at the Medici Villa Poggio a Caiano (Firenze, Galleria degli Uffizi, Gabinetto Disegni e Stampe, Inv. 6505F; COX-REARICK 1981, no. 308), and a finished study of a nude Venus, probably for the *Venus and Adonis* that Pontormo was commissioned to paint, but never executed, at Poggio a Caiano (Firenze, Galleria degli Uffizi, Gabinetto Disegni e Stampe, Inv. 6586F; COX-REARICK 1981, no. 329).
Pontormo changed the position of Venus' right arm so that she holds a book and lowered the Cupid – now transformed into the Christ Child – to a position between his mothers's legs so that he could nurse at her left breast as she observes him. The new motif of the child is investigated through numerous *pentimenti*. This shift of subject places the drawing in the orbit of a famous Pontormo painting datable to 1535-1545 known as the *Madonna del Libro*, which was in the collection of Ottaviano de' Medici (lost and known only through many copies; COX-REARICK and FREEDBERG 1983, pp. 521-527; COSTAMAGNA 1994, no. 73). It is also close in style to another *Madonna and Child* drawing which is related to that painting (Hamburg, Kunsthalle, Inv. 21173 *verso* [fig. 39-a]; COX-REARICK 1981, no. 333).

Janet Cox-Rearick

BIBLIOGRAFIA / BIBLIOGRAPHY
CLAPP 1914, pp. 136-137; BERENSON 1938, I, p. 319; II, n. 2037; COX-REARICK 1981, n. 325; COSTAMAGNA 1994, pp. 218, 225, 226; FALCIANI in *Pontormo* 1996, n. V.10.

39-a. Pontormo, *Madonna con Bambino / Madonna and Child*,
Hamburg, Kunsthalle, Inv. 21173v.

Cat. 40

JACOPO CARUCCI detto IL PONTORMO
(Pontorme 1494-Firenze 1557)

Venere e Cupido

1540-1545 ca.
Matita rossa su debole matita nera,
su carta chiazzata di tannino
mm 130 x 206
Firenze, Galleria degli Uffizi,
Gabinetto Disegni e Stampe, Inv. 15644F *recto*

Tra gli artisti della prima generazione di manieristi fiorentini, nessuno mantenne un dialogo così profondo con l'arte di Michelangelo come Pontormo, molti disegni e dipinti del quale, eseguiti dopo il 1530 circa, rivelano il suo interesse nei confronti dell'opera del maestro. Come narra il VASARI 1568/1966-1997, V, p. 326), fu a quel tempo che il Pontormo eseguì due dipinti su cartoni di Michelangelo: «I quali disegni di Michelangelo furono cagione che considerando il Puntormo la maniera di quello artefice nobilissimo, se gli destasse l'animo e si risolvesse per ogni modo a volere secondo il suo sapere imitarla e seguitarla».

Uno di questi, il cartone per la *Venere e Cupido*, che Michelangelo dette al suo amico Pontormo intorno al 1532-1533 perché ne traesse un dipinto (Cat. 23), fu per Pontormo il punto di partenza per una quantità di disegni. Queste varianti di ricerca testimoniano la continuità del fascino che su di lui esercitavano le *invenzioni* di Michelangelo (che mai copiò direttamente), come l'adozione da parte sua, nella quarta decade del Cinquecento, della tecnica di disegno a matita nera del maestro. Due disegni, quello qui esposto in mostra e quello di Firenze Galleria degli Uffizi, Gabinetto Disegni e Stampe, Inv. 6754F *verso* (matita nera, mm 266 x 402; fig. 40-a; si veda COX-REARICK 1981, n. 383; COSTAMAGNA 1994, p. 218), ritraggono *Venere e*

Cupido, ma si distaccano in maniera significativa dal tema e dalla composizione di Michelangelo. In un terzo disegno, Pontormo trasforma la coppia incestuosa in una *Madonna che allatta il Bambino* (Cat. 39). A quanto si conosce, Pontormo non fece mai un dipinto basato su alcuno di questi disegni, e toccò al Bronzino realizzare il tema in pittura, con il dipinto *Venere, Cupido e un Satiro*, del 1553-1554. (Cat. 34, Tav. XI/1).

In questi disegni di *Venere e Cupido*, Pontormo abbandonò il tema michelangiolesco dei pericoli di Amore (l'aggressione di Cupido a Venere, il tentativo di lei di sottrargli la freccia, e il gesto che fa verso il cuore a significare le ferite d'Amore) e mostrò Venere in un atteggiamento più materno, mentre abbraccia teneramente il suo bambino gettandogli le braccia attorno alle spalle e alle natiche. Egli evitò inoltre la posa delle gambe, così fortemente teatrale, della Venere di Michelangelo, dipingendo invece una Venere dall'atteggiamento più contenuto, a gambe unite, quella di dietro incrociata su quella davanti.

Per questa posa Pontormo attinse a una sua propria opera dello stesso periodo, le figure distese delle *Allegorie* della loggia della Villa di Castello del 1537-1543 (perdute), che avevano una posa simile (Firenze, Galleria degli Uffizi, Gabinetto Disegni e Stampe, Inv. 17405F e Inv. 6683F, fig. 34-d; COX-REARICK 1981, cat. 342, 344).

Il disegno qui esposto mostra Venere reclinata sulla sinistra, in posizione rovesciata rispetto alla Venere del dipinto di Michelangelo-Pontormo. Essa si distende all'indietro sul gomito, con Cupido che, a cavalcioni della coscia e con il braccio intorno al collo, la bacia. Le gambe, piegate, sono disegnate in numerose posizioni diverse, con molti pentimenti, verosimilmente nella ricerca di una differente posa delle gambe rispetto alla Venere dipinta. In Uffizi (Inv. 6754F *verso*; fig. 40-a) Pontormo ritrasse Venere distesa sulla destra, nello stessa *verso* della Venere del dipinto; comunque, come nel disegno in mostra, inclinata all'indietro sul gomito con

Cupido a cavalcioni della coscia, che la bacia. Qui tuttavia Pontormo porta a compimento la posizione chiusa delle gambe che stava sviluppando nel nostro disegno degli Uffizi.

Il motivo michelangiolesco di Cupido che bacia Venere, che Pontormo riprende con delle variazioni in questi disegni, compare di nuovo in un altro disegno a matita nera che mostra solo la testa e le spalle delle figure (Köln, Wallraf-Richartz Museum Inv. 5583, fig. 40b; mm 120 x 141; BREJON DE LAVERGNÉE in *Raffael* 1990, n. 45; GOGUEL 1994, p. 6; COSTAMAGNA 1994, pp. 218, 229). Brejon de Lavergnée e Goguel associano il disegno di Colonia con quello degli Uffizi, Inv. 6354F *recto* (Cat. 39), che ritrae tuttavia una Madonna che allatta, non che bacia, il proprio bambino. Più probabilmente il disegno di Colonia è un frammento che deve essere stato tagliato da un più compiuto disegno compositivo per una *Venere e Cupido* successivo a questo degli Uffizi. In contrasto con quel disegno, l'abbraccio è più erotico e reciproco, dato che Cupido ha entrambe le braccia attorno al collo di Venere e lei, rispetto alla posizione più reticente e inclinata di questa degli Uffizi (Inv. 15644F) solleva la testa per restituire il bacio. L'altro disegno di *Venere e Cupido* (Galleria degli Uffizi, Inv. 6754F *verso*, fig. 40-a) può essere datato 1545-1550, leggermente posteriore a questo in mostra. È collegato stilisticamente agli studi del Pontormo per il suo ultimo lavoro, gli affreschi del coro della chiesa medicea di San Lorenzo (perduti). In effetti, questo è il *verso* di uno studio per il *Diluvio* o la *Resurrezione dei morti*, affreschi che furono dipinti in seguito nello stesso ciclo (COX-REARICK 1981, n. 375; FALCIANI in *Pontormo* 1996, n. IX.16). Una quantità di disegni per questi affreschi ritrae figure distese molto simili a questa: in uno a Firenze (Galleria degli Uffizi, Inv. 6560F) la Venere è trasformata in un nudo maschile con le braccia sopra la testa (COX-REARICK 1981, n. 381) e copie di questi affreschi rivelano che vi erano altre figure simili (COX-REARICK 1981, nn. A216, A237-238). Ciò suggerisce che, anche nei suoi ultimissimi anni, il Pontormo era ancora ossessionato dal dipinto di *Venere e Cupido* di vent'anni prima, nel quale aveva effettivamente collaborato con Michelangelo.

JACOPO CARUCCI, called IL PONTORMO
(Pontorme 1494-Firenze 1557)

Venus and Cupid

c. 1540-1545
Red chalk over faint black chalk on tan flecked paper
130 x 206 mm
Firenze, Galleria degli Uffizi,
Gabinetto Disegni e Stampe, Inv. 15644F *recto*

Among the members of the first generation of Florentine Mannerist painters, none maintained as profound a dialogue with the art of Michelangelo as Pontormo, many of whose draw-

ings and paintings after about 1530 reveal his preoccupation with the master's work. As Vasari (1568/1966-1997, V, p. 326) relates, it was at this time that Pontormo made paintings from two of Michelangelo's cartoons. "These drawings by Michelangelo were the reason that Pontormo, considering the style of that most noble artist, gave over his soul to Michelangelo and resolved to imitate his style insofar as he was able".

One of these, the *Venus and Cupid* cartoon which Michelangelo gave his friend Pontormo to paint about 1532-1533 (Cat. 23) was a point of departure for a number of drawings by Pontormo. These exploratory variations testify to his continuing fascination with Michelangelo's *invenzione* (which he never copied directly), as well as his adoption in the early 1530s of the master's black chalk drawing technique.

Two drawings, the study exhibited here and Firenze, Galleria degli Uffizi, Gabinetto Disegni e Stampe, Inv. 6754F *verso* black chalk, 266 x 402 mm, fig. 40-a (see Cox-Rearick 1981, no. 383; Costamagna 1994, pp. 218), depict *Venus and Cupid* but depart significantly from Michelangelo's theme and composition. In a third drawing Pontormo transformed the incestuous pair into a *Virgin and Nursing Child* (Cat. 39). As far as is known, Pontormo never did a painting based on any of these drawings, and it was left to Bronzino to realize the theme in paint in his *Venus, Cupid, and a Satyr* (1553-1554; Cat. 34, Tav. XI/1).

In these drawings of *Venus and Cupid*, Pontormo abandoned Michelangelo's theme of the dangers of Love (Cupid's assault on Venus, her attempt to steal his arrows, and her gesture towards her heart to signify Love's wounds)

and showed Venus in a more maternal mode, tenderly embracing her son and placing her arm around his shoulders or buttocks. Moreover, he avoided the strikingly dramatic open leg pose of Michelangelo's Venus, depicting instead a more modestly posed Venus with closed legs, the back crossed over the front. For this pose Pontormo drew on a contemporaneous work of his own, the reclining Allegories of the Villa Castello loggia of 1537-1543 (lost), which were similarly posed (Firenze, Galleria degli Uffizi, Gabinetto Disegni e Stampe, Inv. 17405F and Inv. 6683F [fig. 34-d]; see Cox-Rearick 1981, cat. 342, 344).

The exhibited drawing shows Venus reclining to the left in reverse of the Venus in the Michelangelo-Pontormo painting. She leans back on her elbow with Cupid astride her hip, his arms around her neck as he kisses her. Her bent legs are drawn in several different positions with many *pentimenti*, seemingly a search for a different leg position from that of the painted Venus. In Uffizi 6754F *verso* (fig. 40-a) Pontormo depicted Venus reclining to the right in the same direction as the Venus of the painting; however, as in the exhibited drawing, she leans back on her elbow with Cupid astride her hip, kissing her. Here Pontormo finalized the closed position of the legs, which he was developing in Uffizi 15644F.

The Michelangelo motif of Cupid kissing Venus that Pontormo reprises with variations in these drawings appears again in another black chalk drawing showing only the head and shoulders of the figures (120x141 mm; Köln, Wallraf-Richartz Museum, Inv. 5583), (fig. 40-b), (see Breon de Lavergnée in *Raffael* 1990, no. 45; Goguel 1994, p. 6; Costamagna 1994, pp. 218,

40-b. Pontormo, *Venere e Cupido / Venus and Cupid*, Köln, Wallraf-Richartz Museum, Inv. 5583.

229). Brejon de Lavergnée and Goguel associate the Cologne drawing with Uffizi 6534F *recto* (Cat. 39), which, however, depicts a Madonna who is nursing, not kissing, her child. Rather, the Cologne drawing is a fragment which must have been cut from a more finished compositional drawing for a Venus and Cupid subsequent to Uffizi 15644F. In contrast to that drawing, the embrace is more erotic and mutual, for Cupid has both arms around Venus' neck and she raises her head from the more reticent inclined position in Uffizi Inv. 15644F to return his kiss.

The other Venus and Cupid drawing, Uffizi 6754F *verso* (fig. 40-a), may be dated 1545-1550 – somewhat later than Uffizi 15644F. It is related in style to Pontormo's studies for his last work, the frescoes in the choir of the Medici church of San Lorenzo (lost). Indeed, it is the verso of a study for the *Deluge* or the *Resurrection of the Dead*, frescoes that were painted late in that cycle (Cox-Rearick 1981, no. 375; Falciani in *Pontormo* 1996, no. IX.16).

A number of drawings for these frescoes depict reclining figures very similar to this one: Firenze, Galleria degli Uffizi, Gabinetto Disegni e Stampe, Inv. 6560F transforms the Venus into a male nude with arms above his head (Cox-Rearick 1981, cat. 381), and copies after the frescoes reveal that there were other such figures (Cox-Rearick 1981, no. A216, A237-238). These suggest that even in his very last years Pontormo was haunted by the Venus and Cupid painting of two decades earlier, in which he had actually collaborated with Michelangelo.

Janet Cox-Rearick

Bibliografia/Bibliography

Cox-Rearick 1981, n. 383a; Costamagna 1994, pp. 218, 229.

40-a. Pontormo, *Venere e Cupido / Venus and Cupid*, Firenze, Galleria degli Uffizi, Gabinetto Disegni e Stampe, Inv. 6754F *verso*.

Cat. 41 (Tav. XV/1)

ALESSANDRO ALLORI
(Firenze 1535-1607)

Il Sogno
(verso)

Ritratto di Bianca Cappello
(recto; fig. 41-a)

Inizio ottavo decennio del XVI secolo
Olio su rame; cm 37 x 27
Firenze, Galleria degli Uffizi, Inv. 1890/1514.

Questo dipinto allegorico si basa su un disegno deteriorato di Michelangelo (London, Courtauld

Institute Galleries), più leggibile in due incisioni del XVI secolo: una già attribuita a Béatrizet (fig. 41-b; MARONGIU 2001, p. 100) e un'altra, a opera del Lafréri, denominata *Il Sogno* da Vasari nel 1568, e *Il sogno della vita umana* nell'elenco delle sue incisioni, pubblicato nel 1573 ca. (MORGANTI 1997, p. 5 n. 5). Tolnay (1975-1980, II, n. 333, pp. 102-103) datava il disegno originale al 1535-1536, e certamente prima del 1537, quando Battista Franco riprese l'angelo per il suo dipinto della *Battaglia di Montemurlo*. Insieme al cartone di Michelangelo per la *Venere e Cupido*, il *Sogno* fa parte di una serie di disegni complessi sotto il profilo iconografico e visivo, realizzati negli anni Trenta del Cinquecento, che trattano il tema dell'amore e della bellezza.

Entrambe le opere, inoltre, comprendono due enigmatici dettagli, un contenitore rettangolare e delle maschere.

Al centro un bel giovane nudo si adagia su un contenitore rettangolare e una sfera e si volge a guardare verso l'alto. Sembra essersi destato da un sonno e ora scruta attentamente l'angelo alato che scende soffiando in un lungo corno, posto vicino alla testa del giovane. Tutt'intorno al giovane, le personificazioni dei *peccati mortali* appaiono in una densa nebbia. In senso antiorario, dalla sinistra in basso, queste rappresentano: *gola* (delle figure in atto di cucinare e bere), *lussuria* (un amplesso tra un uomo itifallico e una donna riluttante; nudi di due figure maschili; il bacio di una coppia vestita; una mano che regge un fallo), *avarizia* (delle mani con un sacchetto di denari), *invidia* (un uomo intento a mordersi la mano), *ira* (delle persone che lottano) e *accidia* (delle figure sonnolente). La sfera su cui il giovane appoggia le braccia, caratterizzata nel dipinto come un globo terrestre con l'Europa al centro, può indicare il settimo peccato, la *superbia*, o più genericamente la natura terrena di tutti i vizi. Nel contenitore sottostante, i vari tipi di maschera alludono ai sogni voluttuosi (DEMPSEY 2001, p. 266 nota 49), o forse alla teoria di San Girolamo secondo cui i peccati rappresentano le maschere che nascondono la vera essenza di ognuno di noi (WINNER 1992, p. 233).

Una poesia del 1523 di Giovanni Francesco Pico della Mirandola fornisce il contesto per l'immaginario di Michelangelo e potrebbe esserne stata la fonte (GOMBRICH 2000, pp. 130-132). Intitolata *Esortazione a risorgere dal sonno miserabile della vita mortale verso una perpetua veglia della vita felice* (A misero moribundae vitae somno ad perpetuam foelicis vitae vigiliam excitati), i versi di apertura esortano il lettore a respingere i desideri sensuali, ad aprire gli occhi addormentati e rivolgerli verso il Cielo, ora che la nebbia è stata dissolta. Il giovane di Michelangelo rappresenta la condizione umana sulla terra, e non solo «la Mente umana richiamata alla Virtù dai Vizi», come proposto nel 1642 da Hyeronimus Tetius, poi seguito da Panofsky (1939/1972, p. 224) e dalla maggior parte degli studiosi moderni. Una iscrizione datata 1545, sul verso di un piatto di maiolica a Detroit che rappresenta questa composizione, descrive il soggetto, erroneamente, come il sogno di Daniele (LEE 1946).

Ma chi è a svegliare il giovane? Winner (1992) respinge giustamente l'identificazione, avanzata da Panofsky, della figura alata con la fama, ma sostiene con argomentazioni poco persuasive, che l'angelo infonda l'anima in un corpo senza vita. La figura celestiale rappresenta probabilmente la Bellezza che, come spiegava Benedetto Varchi, risveglia l'anima verso l'oggetto proprio dell'amore (SUMMERS 1981, p. 215).

Nella sua lezione su un sonetto di Michelangelo (BUONARROTI 1960, n. 151) pronunciata presso l'Accademia Fiorentina nel 1546, Varchi spiegò che nella maggior parte delle persone, il più nobile sentimento d'amore «giace quasi sepolto in un sonno

41-a. Alessandro Allori, *Ritratto di Bianca Cappello,*
recto de *Il Sogno / Portrait of Bianca Cappello,*
recto of *The Dream.* Firenze, Galleria degli Uffizi.

profondissimo» e in molti, questo amore «si sve-
glia qualche volta nel vedere alcuna bellezza parti-
colare e corporea». Costoro «si possono chiama-
re veri e perfetti artefici del vero e perfetto
amore», e qui è racchiuso il messaggio del «dotto
e maraviglioso sonetto» (VARCHI 1549/ 1858-
1859, p. 626). Michelangelo, che lodò il commen-
to del Varchi in una lettera del 1549 a Luca Martini,
scriveva in una poesia, coeva del *Sogno*, che con-
templando il bel viso del suo signore (Cavalieri), la
sua anima era ascesa alla contemplazione del Di-
vino (BUONARROTI 1960, n. 83). Cavalieri, a cui
Michelangelo aveva dato molti dei suoi disegni e
poesie d'amore degli anni Trenta, potrebbe essere
stato sia l'ispiratore che il destinatario del *Sogno*.
Questa famosa composizione fu ripresa in molti
dipinti e disegni, la maggior parte dei quali mu-
tilò la rappresentazione esplicita della lussuria.
Le modifiche più drastiche compaiono in tre di-
pinti attribuiti a un allievo del Bronzino, Alessan-
dro Allori. Al posto dei due "amanti" un fanciullo
bacia e tocca il seno di una donna distesa che
si copre la nudità, un gruppo che ricorda la *Ve-
nere e Cupido* di Michelangelo-Pontormo (RUVOLDT
1999, p. 189).
Questo prototipo fu fedelmente copiato in un di-
segno al Louvre, probabilmente ascrivibile alla
bottega di Allori (*Appendice II. 36*). Per il *Sogno*,
tuttavia, Allori riprese il tipo di corporatura e il ge-
sto del Cupido che si vede in un disegno degli Uf-
fizi (Inv. 6655F; fig. 41-c), pubblicato da Cox-Rea-
rick (1981, n. A120) come probabile copia di una
versione più rifinita di Pontormo sul *verso* del
disegno Uffizi 6754F. Allori esplorò ulteriormente

la composizione della *Venere e Cupido* in altre
due opere qui in mostra (Catt. 43, 44).
Nel *Sogno* esplicitamente presentò il fanciullo (e
anche la più pudica figura femminile?) in atteg-
giamenti lussuriosi. Accanto, dietro all'uomo vi-
sto di schiena, stanno le due figure intente a ba-
ciarsi. Nel disegno di Michelangelo il genere del-
la figura più in basso risulta ambiguo. Quando
traspose questa immagine in pittura, Allori con-
ferì alla figura un tono della pelle più scuro e di
conseguenza, tra i due, l'uomo si viene a trova-
re più in basso rispetto alla donna lussuriosa.
In questa interpretazione del *Sogno* di Michelan-
gelo, Allori trasformò anche la figura del goloso
seduto a tavola in una donna possente, attribuen-
dole anche un tovagliolo, una bottiglia e un pane.
Dietro alla rappresentazione della lussuria, Allori
aggiunse un paesaggio con una città murata,
presso un fiume, e un tempio rotondo coperto a
cupola con delle michelangiolesche finestre "ingi-
nocchiate".
Sul *recto* di questo piccolo dipinto su rame, Allori
dipinse un ritratto di Bianca Cappello, che sposò
Francesco I de' Medici nel 1579 dopo esserne
stata l'amante per quindici anni. Secondo Marabot-
tini (1956), seguito da Lecchini Giovannoni (1991;
di nuovo 1998) il *Sogno* fa riferimento a questa
relazione e celebra la forza purificatrice dell'amo-
re, ma più verosimilmente si tratta di una generica
allegoria della potenza della bellezza. Lecchini Gio-
vannoni, con argomentazioni convincenti, datava il
dipinto all'inizio degli anni Settanta del Cinquecento
sulla base dello stile pittorico, dell'aspetto fisico di
Bianca e degli abiti che indossa; significativamen-
te una Venere ne adorna la capigliatura.

ALESSANDRO ALLORI
(Firenze 1535-1607)

The Dream
(*verso*)

Portrait of Bianca Cappello
(*recto*; fig. 41-a)

Early 1570s
Oil on copper
37 x 27 cm
Firenze, Galleria degli Uffizi, Inv. 1890/1514

This allegorical painting is based on a damaged
drawing by Michelangelo (London, Courtauld
Institute Galleries), and most legible in two six-
teenth-century engravings: one formerly attrib-
uted to Béatrizet (fig. 41-b; MARONGIU 2001, p.
100); and another by Lafréri, identified as *The
Dream* by Vasari in 1568, and as *The Dream of
Human Life* in a list of the engraver's works
published in c. 1573 (MORGANTI 1997, p. 5 n. 5).
Tolnay (1975-1980, II, n. 333, pp. 102-103)
dated the original drawing to 1535-1536, and
certainly before 1537, when Battista Franco re-
used the angel in his painting of the *Battle of

Montemurlo. Together with Michelangelo's car-
toon for the *Venus and Cupid*, the *Dream* forms
part of a series of iconographically and visually
complex drawings from the 1530s that address
the themes of love and beauty. Both works,
moreover, include two puzzling details, a rectan-
gular container and masks.
In the center a handsome naked male youth re-
clines on a rectangular box and sphere and
turns to look upward. He seems to have been
sleeping, and now gazes intently at the descen-
ding winged angel who blows into a long horn,
placed near his forehead. All around the youth,
personifications of the Deadly Sins appear in a
thick mist. Moving counterclockwise from the
lower left, these represent *gluttony* (figures
cooking and drinking), *lust* (an aroused man
embraces a reluctant woman; two nude male
figures; a clothed couple kissing; a hand hold-
ing a phallus), *greed* (hands holding a bag of
money), *envy* (man biting his own hand), *anger*
(fighters), and *sloth* (sleepers). The sphere on
which the youth rests his arms, depicted in the
painting as a terrestrial globe with Europe in the
center, may indicates the seventh sin, *pride*, or
more generally the earthly nature of all vices. In
the box below, the various types of masks allude
to sensual nightmares (DEMPSEY 2001, p. 266
note 49), or perhaps to St. Jerome's view that
sins are the masks which hide ones' true self
(WINNER 1992, p. 233).
A poem of 1523 by Giovanni Francesco Pico
della Mirandola provides a context for Miche-
langelo's imagery and may have been his sour-
ce (GOMBRICH 2000, pp. 130-132). Entitled *A
call to rise up from the wretched sloth of
mortal life to the perpetual vigil of the happy
life (A misero moribundae vitae somno ad
perpetuam foelicis vitae vigiliam excitatio)*,
the opening lines exhort the reader to reject
sensual desires, open his sleepy eyes, and turn
them toward heaven, now that the mist has
been driven back. Michelangelo's youth repre-
sents the human condition on earth, and not
only "the human Mind called back to Virtue
from the Vices", as proposed in 1642 by Hyero-
nimus Tetius, and followed by Panofsky (1939/
1972, p. 224) and most modern scholars. An
inscription, dated 1545, on the back of a majo-
lica plate in Detroit which reproduces this com-
position, incorrectly described the subject as
the dream of Daniel (LEE 1946).
But who wakes up the youth? Winner (1992)
rightly rejected Panofsky's identification of the
winged figure as fame, but argued unconvinc-
ingly that he infuses a soul into the lifeless body.
The celestial figure probably represents Beauty
which, as Benedetto Varchi explained, awakens
the soul to the proper object of love (SUMMERS
1981, p. 215). In his lecture on a sonnet by
Michelangelo (BUONARROTI 1960, n. 151), deliv-
ered to the Accademia Fiorentina in 1546, Var-
chi explained that in most people, the noblest
type of love "lies almost buried in a very deep
sleep", and in many, this love "wakes up at

41-b. da Michelangelo, *Il Sogno / The Dream*, incisione / engraving. Firenze, Galleria degli Uffizi, Gabinetto Disegni e Stampe, Inv. St. Sc. 967.

41-c. (*in alto*) da Pontormo, *Venere e Cupido / Venus and Cupid*, particolare / detail. Firenze, Galleria degli Uffizi, Gabinetto Disegni e Stampe, Inv. 1890/6655F.

times, by seeing some special and corporeal beauty". But only a few, "having seen some earthly beauty, rise from one thought to another to that divine beauty".

These "can be called the true and perfect artists of true and perfect love", and herein lies the message of "this learned and marvelous sonnet" (VARCHI 1549/ 1858-1859, p. 626) Michelangelo, who praised Varchi's commentary in a letter of 1549 to Luca Martini, wrote in a poem contemporary with the *Dream* that by gazing at the beautiful face of his lord (Cavalieri), his own soul has risen up to contemplate the Divine (BUONARROTI 1960, n. 83).

Cavalieri, to whom Michelangelo gave many of his love poems and drawings in the 1530s, may have been both the inspiration for and recipient of the *Dream*.

This famous composition was copied in many paintings and drawings, most of which emasculate the explicit representation of lust. The most dramatic changes appear in three paintings attributed to Bronzino's student Alessandro Allori. In place of the "lovers", a young child

kisses and touches the breast of a reclining woman who covers her nudity, a group which recalls the Michelangelo-Pontormo *Venus and Cupid* (RUVOLDT 1999, p. 189). This prototype was carefully copied in a Louvre drawing, probably by Allori's workshop (*Appendix II.* 36). For the *Sogno*, however, Allori used the body type and gesture of Cupid found in an Uffizi drawing (Inv. 6655F; fig.41-c) published by Cox-Rearick (1981, n. A120), as probably a copy after a more finished version of Pontormo's Uffizi, Inv. 6754F verso. Allori further explored the *Venus and Cupid* composition in two other works here on view (Cats. 43, 44).

In the *Dream* Allori evidently presented the boy (and also the more modest woman?) as lustful. Nearby, beyond the nude man seen from behind, are the kissing figures. In Michelangelo's drawing the gender of the woman's companion is ambiguous. When he translated this image into paint, Allori gave the figure darker skin tones, thus the man is lower than the lustful woman. In this interpretation of Michelangelo's *Dream*, Allori transformed the gluttonous figure seated at the table

into a powerful woman, and gave her a napkin, bottle, and bread. Beyond the representations of lust, Allori added a landscape with a walled city next to a river, and a round, domed temple with Michelangelesque "kneeling" windows. On the *recto* of this small copper painting, Allori depicted Bianca Cappello, who married Francesco I de' Medici in 1579 after being his lover for fifteen years. For Marabottini (1956), followed by Lecchini Giovannoni (1991; and 1998) the *Sogno* refers to this relationship and celebrates the purifying force of love, but more likely it is a general allegory about the power of beauty. Lecchini Giovannoni convincingly dated the painting to the early 1570s on the basis of the painting style, Bianca's physical appearance, and her clothes; significantly, a Venus adorns her hairpiece.

Jonathan Katz Nelson

BIBLIOGRAFIA / BIBLIOGRAPHY
MARABOTTINI 1956; LECCHINI GIOVANNONI 1991, n. 191; LECCHINI GIOVANNONI in *Magnificenza*, 1998, p. 208 n. 162.

Cat. 42 (Tav. XIV/19)

ALESSANDRO ALLORI (?)
(Firenze 1535-1607)

Il Sogno
Inizio ottavo decennio del XVI secolo
Olio su tavola ovale
cm 73 x 33
New York, Collezione privata

Questo dipinto pressoché inedito del *Sogno* corrisponde fedelmente alla composizione e allo stile della versione di Firenze di Allori (Cat. 41).

Pur con le riserve dovute al fatto di avere preso conoscenza dell'opera solo tramite immagini fotografiche, la sua alta qualità e l'accurata esecuzione sembrano validamente motivare un'attribuzione allo stesso Allori, nei primi anni Settanta del Cinquecento, come suggerito da Simon (2000), oppure alla sua bottega. La differenza più evidente rispetto al dipinto degli Uffizi, a parte le maggiori dimensioni, il tipo di supporto e la forma ovale, è l'inserimento del motivo dell'acqua in primo piano. Forse ispirato all'incisione del Lafréri, quest'elemento serve a riempire la zona inferiore dell'ovale. Sul piano iconografico l'acqua, insieme al cielo aperto e al paesaggio – si noti, vicino al tempio rotondo, la statua che raf-

figura un uomo in piedi con un bastone in mano – riflette il messaggio universale dell'allegoria.
Questo dipinto comprende una nuova figura tra le rappresentazioni della pigrizia, non rintracciabile nel disegno originale di Michelangelo o nelle incisioni a esso collegate: una figura barbuta alla estrema destra, di profilo, con larghe maniche, compare anche nel dipinto degli Uffizi, ma in questa versione più piccola la figura è tagliata fuori dal confine del dipinto. Troncate risultano anche: dalla stessa parte, il vecchio con il turbante, subito al di sopra della figura "nuova"; dalla parte opposta, l'angolo del tavolo; nella zona inferiore le dita del piede del giovane al centro. Si può presumere che tutte queste figure fossero complete nella composizione del *Sogno* originale di Allori, come del resto appaiono in altre due versioni del dipinto, una grande tavola rettangolare in una collezione privata a Roma (MARABOTTINI 1956), e una copia di qualità inferiore nella Casa Buonarroti (LECCHINI GIOVANNONI, 1991, p. 306).
Dato che il quadro degli Uffizi possiede ancora le dimensioni originali, si potrebbe affermare che si basi su una versione o cartone più grande che include tutti i dettagli visibili nella presente tavola.
La forma ovale ricorda i dipinti realizzati nei primi anni Settanta del Cinquecento per lo Studiolo di Francesco I a Palazzo Vecchio. A questo progetto Allori contribuì con la sua opera più famosa, i *Pescatori di Perle*. Qui il pescatore al centro e la vicina figura femminile di profilo mostrano straordinarie somiglianze con due delle figure del *Sogno*, nella rappresentazione della lussuria: il nudo maschile e la donna distesa. Questi parallelismi, insieme con il formato ovale, rafforzano la probabilità che il *Sogno* di Allori sia databile all'inizio degli anni Settanta del Cinquecento. In quel periodo, se non precedentemente, Allori eseguì anche una copia inedita di una composizione di Michelangelo. Un piccolo dipinto su rame del *Noli me tangere* (New York, Collezione privata; fig. 42-a) riproduce fedelmente le figure del cartone che Michelangelo aveva eseguito per Pontormo all'inizio degli anni Trenta. Il dipinto, di mano di quest'ultimo (Busto Arsizio, Collezione privata; Tav. VIII/1), è servito come base di riferimento per la copia dell'allievo di Pontormo, Bronzino (Firenze, Casa Buonarroti, vedi saggio Aste, fig. 8), e per quella dell'allievo di Bronzino, Allori, appunto.
Secondo Simon (2000), la presente versione del *Sogno* proviene dalla collezione del cardinale Aldobrandini, a Firenze; nel corso del XIX secolo, è stata venduta tre volte nelle aste di Christie's, a London: il 18 maggio 1804, lotto 80 (come opera di Venusti, proveniente dalla Collezione di Robert Udny); il 9 marzo 1811, lotto 40 (come Michelangelo, dalla Collezione di Richard Troward, London); e il 30 aprile 1825, lotto 92 (dalla Collezione di Francis Du Roveray, London).

ALESSANDRO ALLORI (?)
(Firenze 1535-1607)

The Dream

Early 1570s
Oil on oval panel
73 x 33 cm
New York, Private collection

This virtually unknown painting of the *Dream* corresponds closely to the composition and style of Allori's version in Florence (Cat. 41). To judge from photographs, the high quality and careful execution of this work support an attribution to Allori himself, in the early 1570s, as suggested by Simon (2000), or to his workshop.

The most obvious difference from the Uffizi painting, apart from the larger size, support, and oval shape, is the inclusion of water in the foreground. Perhaps inspired by the Lafréri engraving, this serves to fill in the lower part of the oval. Iconographically the water, together with the open sky and the landscape – note the statue, near the round temple, of a standing man with a staff – indicate the universal message of the allegory.

The present painting includes a new figure among the representations of sloth, not found in Michelangelo's original drawing or the related engravings: a bearded figure on far right, in profile, with large sleeves. He also appears in the Uffizi painting, but in this smaller version the figures is cut off by the edge of the painting. Also cropped are, on the same side, the old man with a turban directly above the "new" figure; on the opposite side, the corner of the table; and on the lower side, the toes of the central youth. Presumably, all of these figures were complete in Allori's original composition of the *Dream*; they appear in two other versions of the painting, a large rectangular panel in a private collection in Roma (MARABOTTINI 1956), and an inferior copy in the Casa Buonarroti (LECCHINI GIOVANNONI 1991, p. 306). Given that the Uffizi painting has its original dimensions, it is probably based on a larger cartoon or prototype which included all the details found in the present panel.

The oval shape recalls the paintings made in the early 1570s for the Studiolo di Francesco I in Palazzo Vecchio. To this ensemble Allori contributed his most famous work, the *Pearl Fishers*. Here the central fisherman and the nearby woman in profile show striking similarities to two figures amidst the representation of lust in the *Dream*: the male nude and the reclining woman. These parallels, and the oval format, reinforce the probable dating of Allori's *Dream* to the early 1570s.

42-a. attr. ad Alessandro Allori, *Noli me tangere*.
New York, Collezione privata.

From that time, if not earlier, Allori also executed a previously unknown copy of a Michelangelo composition. A small copper painting of the *Noli me tangere* (New York, Private collection; fig. 42-a) carefully reproduces the figures in the cartoon which Michelangelo made for Pontormo in the early 1530s.

Pontormo's painting (Busto Arsizio, Private collection; Pl. VIII/1) served as the basis for a copy by Pontormo's student, Bronzino (Firenze, Casa Buonarroti; see Aste's essay, fig. 8), and Bronzino's student, Allori. According to Simon (2000), the present version of the *Dream* comes from the collection of Cardinal Aldobrandini, Florence and was sold in three nineteenth-century auctions at Christie's in London: on 18 May 1804, lot 80 (as Venusti, from the Collection of Robert Udny, London); 9 March 1811, lot 41 (as Michelangelo, from the Collection of Richard Troward, London); and 30 April 1825, lot 92 (Collection of Francis Du Roveray, London).

Jonathan Katz Nelson

BIBLIOGRAFIA / BIBLIOGRAPHY
Catalogue 1802, no. 152; SIMON 2000, p. 58.

Cat. 43 (Tav. XV/2)

ALESSANDRO ALLORI
(Firenze, 1535-1607)

Venere e Cupido
1570 ca.
Olio su tavola
cm 29 x 38, 5
Firenze, Galleria degli Uffizi, Inv. 1890/1512

Se questa piccola tavola di *Venere e Cupido* fu effettivamente commissionata da Francesco de' Medici per celebrare il suo amore per Bianca Cappello, la sua esecuzione è databile ai primi anni Settanta, come sembrerebbe confermare l'analisi stilistica (cfr. LECCHINI GIOVANNONI 1991). All'epoca l'artista lavorava per Alamanno Salviati, nella cui collezione ebbe modo di studiare di nuovo le copie da Michelangelo di Michele di Ridolfo (Cat. 13; Tavv. X/1, X/2, XI/2) e il quadro del Bronzino che rappresenta *Venere, Cupido e un satiro* (Cat. 34, Tav. XI/1).
Dal suo maestro l'Allori riprese, invertendola, la figura di Venere che adattò al motivo usato da Michelangelo. Come molti suoi contemporanei Allori studiò sicuramente il quadro di Michelangelo-Pontormo (la copia di Napoli [Cat. 28] gli fu persino attribuita) e incitò i suoi allievi a fare altrettanto: è nella sua bottega che fu disegnata la copia conservata al Louvre (Inv. 24, fig. 43-a). Alessandro Allori realizzò, nel caso della tavoletta degli Uffizi, un'opera molto raffinata, privilegiando l'estetica a scapito della poesia. Sostituì all'altare dell'amore una coppia di colombe, attingendo alla tradizione iconografica quattrocentesca. La composizione di Allori ebbe grande successo come indicano le quattro versioni autografe realizzate in grandi dimensioni (cm 140 x

220 ca.) che sono arrivate fino a noi (Montpellier, Musée Fabre; Los Angeles, County Museum of Art; Hampton Court, Collezioni Reali inglesi; Auxerre, Musée des Beaux-Arts; cfr. LECCHINI GIOVANNONI 1991, pp. 243-244, nn. 60-63). Raffaello Borghini (1584, p. 625) menzionava ugualmente una *Venere e Amore* di Allori (forse la versione che oggi si trova a Montpellier, proveniente dalla collezioni dei principi di Condé e dei duchi d'Orléans), il cui cartone preparatorio si trovava a Firenze nella collezione di Baccio Valori (1535-1606).
Il quadro citato dal Borghini formava un insieme con *Venere e Marte* e *Narciso alla fonte* esposti nella residenza parigina del fiorentino Lodovico da Diacceto. Comunque la presenza del cartone in casa di Baccio Valori, membro dell'Accademia Fiorentina, è un'ulteriore dimostrazione di quanto il tema di Venere e Cupido fosse apprezzato nell'ambiente letterario fiorentino, soprattutto dopo la tavola di Michelangelo-Pontormo.

ALESSANDRO ALLORI
(Firenze 1535-1607)

Venus and Cupid
c. 1570
Oil on wood
29 x 38.5 cm
Firenze, Galleria degli Uffizi, Inv. 1890/1512

If this little panel representing *Venus and Cupid* was truly commissioned by Francesco de' Medici as a celebration of his love for Bianca Cappello, its execution can be dated to the early 1570s, as stylistic analysis confirms (cf.

LECCHINI GIOVANNONI 1991). At the time, the artist was working for Alamanno Salviati, in whose collection he was able to study anew the copies of Michelangelo made by Michele di Ridolfo (Cat. 13; Pls. X/1, X/2, XI/2) and the painting of *Venus Cupid and a Satyr* by Bronzino (Cat. 34; Tav. XI/1).
From his master Allori took the figure of Venus, reversing and adapting it to the motif used by Michelangelo. Like many of his contemporaries, Allori surely studied the painting by Michelangelo-Pontormo (the copy in Naples; Cat. 28) has even been attributed to him) inciting his pupils to do likewise: the copy now in the Louvre was in fact designed in his workshop (Inv. 24; fig. 43-a). In the small Uffizi panel, Alessandro Allori created a work of great refinement favoring aesthetics over poetry. He substituted the altar of love with a pair of doves, drawing on an iconographic tradition of the fifteenth century.
Allori's composition was much admired as the four autograph versions of large size (c. 140 x 220 cm) still surviving would seem to indicate (Montpellier, Musée Fabre; Los Angeles, County Museum of Art; Hampton Court, English Royal Collections; Auxerre, Musée des Beaux-Arts, cf. LECCHINI GIOVANNONI 1991, pp. 243-244, no. 60-63). Raffaello Borghini (1584, p. 625) mentioned likewise a *Venus and Cupid* by Allori (perhaps the version today in Montpellier, coming form the collections of the prince of Condé and the dukes of Orléans), the preparatory cartoon of which was in Florence in the Collection of Baccio Valori (1535-1606).
The painting cited by Borghini was part of an ensemble including *Venus and Mars* and *Narcissus at the Font* that hung in the Parisian residence of the Florentine Lodovico da Diacceto. Nonetheless, the presence of the preparatory drawing in the house of Baccio Valori, a member of the Florentine Academy, shows once again how popular the theme of Venus and Cupid was in Florentine literary circles, especially after the realization of the panel by Michelangelo-Pontormo.

Philippe Costamagna

BIBLIOGRAFIA/BIBLIOGRAPHY
LECCHINI GIOVANNONI 1991, pp. 225-226, n. 24 (con bibliografia); COSTAMAGNA 1994, p. 220.

Cat. 44

ALESSANDRO ALLORI
(Firenze 1535-1607)

Studio per una Venere e Cupido
1570 ca.
Matita nera su carta bianca
mm 255 x 206
Firenze, Galleria degli Uffizi,
Gabinetto Disegni e Stampe, Inv. 1432S

Il tema di Venere e Amore è stato trattato diverse volte da Alessandro Allori a partire dai primi anni Settanta, epoca a cui si può datare, su basi stilistiche, questo schizzo degli Uffizi. Qui l'arti-sta ha scelto di rappresentare Venere, le braccia aperte e la testa girata per baciare Amore, riprendendo un'idea già sviluppata dal Pontormo nello studio del Louvre (Cat. 38), probabilmente preparatorio a un cartone di arazzo che rappresenta *Venere e Cupido tra i segni zodiacali dell'ariete e del capricorno*. Da un punto di vista formale, nel disegno degli Uffizi Allori ha associato ai modelli del Bronzino – si veda per esempio l'*Allegoria della Felicità* (Firenze, Galleria degli Uffizi) – la sua conoscenza dei disegni di Michelangelo, come dimostrano le due donne e il viso individuabili in secondo piano. Di fatto, l'atmosfera del disegno coincide con quella che ritroviamo nel disegno del *Sogno* di Michelangelo (London, Courtauld Institute Galleries), ripreso da Allori nel verso del *Ritratto di Bianca Cappello* degli Uffizi (Cfr. Cat. 41). Il disegno e il ritratto sono opere contemporanee, datando anche quest'ultimo ai primi anni Settanta (LECCHINI GIOVANNONI 1991, p. 306 e ID. in *Magnificenza* 1997, p. 208 n. 162). Benché manchino elementi probanti, si potrebbe ritenere il disegno come una prima idea per il verso del *Ritratto di Bianca Cappello*, abbandonato poi in favore di una allegoria di ispirazione neoplatonica, il *Sogno*. Al posto della coppia di amanti, raffigurata nel disegno di Michelangelo, Allori sostituisce il motivo della donna che gira la testa per baciare un putto. Il tema di Venere e Cupido conveniva perfettamente al ritratto di un'amante e Allori lo utilizzò per la figura centrale rappresentata nel gioiello che orna la capigliatura di Bianca Cappello. Il disegno è in ogni caso inseparabile dal contesto delle opere di piccolo formato dipinte da Allori per il principe reggente Francesco de' Medici, quali il michelangiolesco *Ercole incoronato dalla Muse* (Firenze, Galleria degli Uffizi) e *Venere e Cupido* (Cat. 43), dove l'artista riprende il motivo di Venere che trattiene il braccio di Amore, già schizzato nel disegno.

ALESSANDRO ALLORI
(Firenze 1535-1607)

Study for a Venus and Cupid
c. 1570
Black chalk on white paper
255 x 206 mm
Firenze, Galleria degli Uffizi,
Gabinetto Disegni e Stampe, Inv. 1432S

Alessandro Allori chose to represent the theme of Venus and Cupid several times beginning in the early 1570s, the period to which this drawing can be assigned for stylistic reasons. Here, the artist chose to represent Venus with her arms open and her head turned to kiss Cupid, reworking an idea already developed by Pontormo in the study in the Louvre (Cat. 38) that was probably a preparatory drawing for a tapestry cartoon representing *Venus and Cupid amidst the zodiacal signs of Aries and Capricorn*. In the Uffizi drawing, from a formal point of view, Allori combined models by Bronzino, such as the *Allegory of Happiness* (Firenze, Galleria degli Uffizi), with his knowledge of the drawings of Michelangelo, as the two women and the face visible in the background demonstrate. In effect, the atmosphere of the drawing resembles that found in Michelangelo's drawing of the *Dream* (London, Courtauld Institute Galleries), that Allori took up again on the *verso* of his *Portrait of Bianca Cappello* in the Uffizi (cfr. Cat. 41). The drawing and the painting are coeval works, the latter also dating to the early 1570s (LECCHINI GIOVANNONI 1991, p. 306 e ID. in *Magnificenza* 1997, p. 208 n. 162). Despite the lack of conclusive evidence, the Uffizi drawing could very well be a first idea for the *verso* of the *Portrait of Bianca Cappello*, subsequently abandoned in favor of an allusion, of neoplatonic inspiration. On the back of the portrait, in place of the pair of lovers represented on the right of Michelangelo's drawing, Allori substituted the motif of the woman turning her head to kiss a putto. The theme of Venus and Cupid was perfectly suited to the portrait of a lover and Allori used it for the central figure represented in the jewel that adorns the coiffeur of Bianca Cappello.

The drawing, in any case, should be considered within the context of the works of small format painted by Allori for the reigning prince Francesco de' Medici, such as the Michelangelesque *Hercules crowned by the Muses* (Florence, Galleria degli Uffizi) and *Venus and Cupid* (Cat. 43) in which the artist once again presents the motif of Venus with Cupid in her arms, already sketched in the drawing.

Philippe Costamagna

43-a. Bottega di Alessandro Allori, *Venere e Amore / Venus and Cupid*.
Paris, Louvre, Département des Arts Graphiques, Inv. 24.

BIBLIOGRAFIA/BIBLIOGRAPHY
LECCHINI GIOVANNONI 1991, p. 226 n. 25 (con bibliografia).

APPARATI
APPENDICES

Appendice I / **Appendix I**

Jonathan Katz Nelson

RIFERIMENTI NEL CINQUECENTO AI DIPINTI DI "VENERE E CUPIDO" DI MICHELANGELO-PONTORMO E DEL VASARI

SIXTEENTH-CENTURY REFERENCES TO THE 'VENUS AND CUPID' PAINTINGS BY MICHELANGELO-PONTORMO AND BY VASARI

1541, 11 luglio
Ricordo di Vasari (1923-1940, II, p. 838 n. 111).
Ricordo, come a dì undici di luglio 1541 messer Ottaviano de Medici mi fecie fare un ritratto di una Venere igniuda con uno Cupido, che la bascia et abraccia; quale fu il cartone dipinto di mano di Michelagniolo Buonarroti, et il dipinto di Iacopo da Puntormo; per prezzo di scudi cinquanta. La quale era il quadro grande, braccia tre e mezzo larga, et braccia due e mezo alta, laquale si lavorò a olio con diligentia grande; et si confumò oncie una d'oltramarino di scudo 10 l'oncia.

1541, 20 luglio
Lettera di Vasari da Firenze a Francesco Leoni in Venezia (1923-1940, I, p. 109).
Intanto la Signoria vostra pensi, che i quadri s'incasseranno di quest'altra settimana per mandarveli; dico della Leda e Venere, già profetavi.

1541, 10 ottobre
Ricordo di Vasari (1923-1940, II, p. 838 n. 116).
Ricordo, come a dì 10 d Ottobre 1541 io mandai a Venetia a Francesco Lioni Fiorentino duo quadri grandi, di braccia 3 e mezzo lunghi et braccia 2 e mezzo larghi l'uno. Drentovi in uno la Venere, ritratta da Michelagniolo Buonarroti, et nell'altro la Leda pur di detto; coloriti a olio con gran diligentia. E quali si mandorono per il vechio vetturale fino a Bologna per ordine di Batista di Berto.

1542, dopo il 16 aprile
Lettera dell'Aretino da Venezia
"al Duca d'Urbino" Guidobaldo della Rovere
(1916, II, pp. 264-265; vedi saggio Nelson).
...Dirò bene che non mi è suto men piacere l'esservi piaciuto di acettare i quadri, dei quali messer Giorgio [Vasari] vi fece un presente, che la merce predetta. Certo che il vostro imbasciador si stupì nel vedergli, imperoché, oltra la sufficienza del giovane che gli ha dipinti, i cartoni di cotali figure son di mano del grande, del mirabile e del singulare Michelagnolo. L'una de le due imagini è Leda, ma in modo morbida di carne, vaga di membra e svelta di persona, e talmente dolce, piana e soave d'attitudine, e con tanta grazia ignuda da tutte le parti de lo ignudo, che non si può mirar senza invidiare il cigno, che ne gode con affetto tanto simile al vero, che pare, mentre stende il collo per basciarla, che le voglia essalare in bocca lo spirito de la sua divinità. L'altra mò è Venere, contornata con maravigliosa rotondità di linee. E, perché tal dea diffonde le proprietà sue nel desiderio dei due sessi, il prudente uomo le ha fatto nel corpo di femina i muscoli di maschio, talché ella è mossa da sentimenti virili e donneschi, con elegante vivacità d'artifizi. Benché la degnità vostra è per dare tutta quella perfezione, de la quale pur mancasse.

1543, 12 novembre
Ricordo di Vasari (1923-1940, II, p. 861 n. 136).
Ricordo, come a dì 12 di Novembre 1543 messer Bindo Altoviti ricevé da me un quadro di una Venere igniuda con un Cupido, che la abbraccia et bascia, ritratto da Michelagniolo Buonarroti, di grandezza di braccia 3 et alta due e 1/3 colorita a olio con diligentia; della quale promesse farmi buoni scudi cinquanta doro...

1544, 21 luglio
Lettera di Vasari da Lucca a Francesco Leoni in Venezia (1923-1940, I, p. 132; v. saggio Nelson).

La nuda Venere o per me o prima forse sarà portata; che ha avuto tante fortune, che l'esercito di Dario non l'ebbe tante. L'è viva et è ancor vergine, con tutto che per esser buona roba, ci sia stato voluto far il bordello; tamen la madre l'ha avuta in custodia di sorte, che è libera dal puttanesimo per mia mani. Quando sarà con voi, bisognerà, ci haviate cura, che per essere di morbida maniera, non vi fussi levata su.

1545 ca.
Anonimo Magliabechiano
(FREY 1982, p. 290, sotto MICHELANGELO).

Fece il disegno della Venere, colorita poi per Iacopo da Pontormo...

1550
Varchi, *Due Lezzioni*
lezione fatta nel 1547 (1998, p. 45).

Non dice egli che gli uomini medesimi si sono innamorati delle statue di marmo, come avvene alla Venere di Prassitele? Benché questo stesso avviene ancora oggi tutto il giorno nella Venere che disegnò Michelangelo a M. Bartolommeo Bettini, colorita di mano di M. Iacopo Pontormo...

1540-1550 ca.
Anonimo fiorentino (?), *Sopra la miracolosa Pittura de la Venere Da Michelagnolo disegnata et da il Pontormo Colorita: Sonetto*
(si veda Cat. 30).

1550
Vasari, *Vita di Michelangelo* (1966-1999, VI, p. 113).
Vegghinsi i suoi cartoni, i quali non hano avuto pari: come... quello d'una Venere, che donò a Bartolomeo Bettini.

1553, 27 ottobre
Inventario mediceo
(Firenze, Archivio di Stato, Guardaroba Medicea 28, c.13v).

Un quadro di pittura dentrovi una venere con Cupido, et fornimento di noce intagliato, et Cortina di taffettà verde di mano di Iacopo da Pontormo...

1555
Inventario mediceo
(Firenze, Archivio di Stato, Guardaroba Medicea 31, c. 39r).

Un quadro di pittura entrovi una Venere con Cupido et fornimento di noce intagliato, et cortina di taffettà verde di mano di Iacopo da Pontormo...

1568
Vasari, *Vita di Michelangelo* (1966-1999, VI, p. 113).
A Bartolomeo Bettini fece e donò un cartone d'una Venere con Cupido che la bacia, che è cosa divina; oggi appresso agli eredi in Fiorenza...

1568
Vasari, *Vita del Pontormo* (1966-1999, V, pp. 326 e 327).
Veggendosi adunque quanta stima facesse Michelangelo del Puntormo, e con quanta diligenza esso Puntormo conducesse a perfezzione e ponesse ottimamente in pittura i disegni e ' cartoni di Michelangelo, fece tanto Bartolomeo Bettini, che il Buonarruoti suo amicissimo gli fece un cartone d'una Venere ignuda con un Cupido che la bacia, per farla fare di pittura al Pontormo e metterla in mezzo a una sua camera, nelle lunette della quale aveva cominciato a fare dipignere dal Bronzino Dante, Petrarca e Boccaccio, con animo di farvi gl'altri poeti che hanno con versi e prose toscane cantato d'amore.

Avendo intanto finito Iacopo di dipingere la Venere dal cartone del Bettino, la quale riuscì cosa miracolosa, ella non fu data a esso Bettino per quel pregio che Iacopo gliele avea promessa, ma da certi furagrazie, per far male al Bettino, levata di mano a Iacopo quasi per forza e data al duca Alessandro, rendendo il suo cartone al Bettino...

1568
Vasari, *Vita di Michelangelo* (1966-1999, VI, p. 381, 382, 383-389).
Nel medesimo tempo ch'io feci questa tavola [l'Allegoria della Concezione, cioè nel 1540/1541]... feci a messer Ottaviano de' Medici una Venere et una Leda con i cartoni di Michelagnolo...

Finalmente giunsi in Vinezia con due quadri dipinti di mia mano con i cartoni di Michelagnolo, gli donai a don Diego di Mendozza, che mi mandò duecento scudi d'oro.

Di nuovo tornato a Roma l'anno 1544, oltre a molti quadri che feci a diversi amici, de' quali non accade far memoria, feci un quadro d'una Venere col disegno di Michelagnolo a messer Bindo Altoviti, che mi tornavo seco in casa...

1584
Raffaello Borghini, *Il Riposo*
(1967 p. 484, sotto PONTORMO).

Havendo Michelagnolo Buonarruoti fatto il famoso cartone della Venere ignuda che bacia Cupido, il Puntormo da quel cartone ritraendola ne dipinse una che per lo disegno di Michelagnolo, e per lo colorito di Iacopo riuscì cosa rarissima, e l'hebbe e tenne molto caro il Duca Alessandro...

Appendice II / **Appendix II**

Jonathan Katz Nelson

COPIE E REPLICHE
DELLA "VENERE E CUPIDO"
DI MICHELANGELO-PONTORMO

COPIES AND REPLICAS
OF THE MICHELANGELO-PONTORMO
'VENUS AND CUPID'

nn. 1-16: dipinti visti in riproduzione o di persona
nn. 17-32: dipinti non identificabili elencati in documenti o
 vecchi inventari
nn. 33-36: disegni

NB: In confronto con il prototipo, il dipinto di Firenze, Galleria dell'Accademia (cm 128,5 x 193; Cat. 23), queste opere presentano diversi piccoli cambiamenti che ci consentono di raggrupparle in tre filoni. Nel primo, il più fedele, Cupido guarda le frecce e il paesaggio rimane molto semplice. L'esempio principale è il quadro di Vasari a Londra, Kensington Palace (n. 10); questo gruppo include opere di artisti diversi (nn. 1, 4, 12, 15, 16, 35, 36). Il secondo filone è discusso in Cat. 28, nella scheda dell'esemplare di Napoli, Museo Nazionale di Capodimonte (n. 11) e comprende opere della Cerchia di Vasari e Michele Tosini (nn.2, 3, 5, 6, 7, 8, 14, 33, 34). I quadri nel terzo filone hanno varianti nel paesaggio, oppure mancano gli oggetti simbolici a sinistra (nn. 9, 13, 17 e forse 19).

1. Bucarest, Muzeul National de Arta al României, Inv.7998/32
 Tavola, cm 55 x 83, Cerchia del Bronzino/Allori (?)
 Bibl.: COSTAMAGNA 1994, n. 70.2; *Da Antonello da Messina a Rembrandt* 1996, pp. 36-37, tav. col. 7.

2. Burghley House, Marquess of Exeter
 Tavola, cm 50,8 x 71, Cerchia di Michele Tosini (Brina?)
 Un drappo pende dietro alle figure; a sinistra si vede un vaso, per terra, e sospese a un albero le due maschere e la faretra.
 Bibl.: NATALE 1979, p. 92; COSTAMAGNA 1994, n. 70.3
 Foto: London, Courtauld Institue of Art, n. B57/1487, copia presso Firenze, Villa I Tatti, Fototeca Berenson.

3.

Dublin, National Gallery of Ireland, Inv. 77
Tavola, cm 135 x 193, Michele Tosini
Estremamente simile all'esemplare di Roma (n. 14).
Bibl.: NATALE 1979, p. 92; *National Gallery of Ireland* 1981, p. 165; HORNIK 1990, p. 257 n. 32 (come Tosini); COSTAMAGNA 1994, n. 70.4; NEGRO 2001, p. 18 (tav. col.).

4. Già Dublin, Hugh Lane Municipal Gallery of Modern Art (?)
 Tavola, cm 26 x 54, Vasari (?)
 Frammento, con le parte superiore delle due figure, estremamente simile a London (n. 10).
 Foto: Firenze, Villa I Tatti, Fototeca Berenson (come nel Municipal Gallery of Modern Art, Dublin).

5. Firenze, Gallerie Fiorentine, Inv. 1890/5409
 in deposito a Firenze, Casa Buonarroti
 (vedi saggio Nelson, fig. 23).

Tavola, cm 50 x 66, Cerchia di Michele Tosini (Brina?)
Simile all'esemplare di Roma (n. 14)
Bibl.: MILANESI 1881, p. 295; PROCACCI 1965, p. 201 (ill.); COSTAMAGNA 1994, p. 220; MARONGIU in *Vita* 2001, p. 84.

6. Firenze, Gallerie Fiorentine
 in deposito a Pisa, Scuola Normale Superiore (Cat. 31)
 Tavola, cm 134 x 194.2, Cerchia del Vasari.

7. Già Firenze, Collezione Cattaneo Fungoli-Baroni
 cm 123 x 174
 Cupido guarda Venere, che è totalmente nuda
 Foto: Firenze, Kunsthistorisches Institut, 120928.

8.

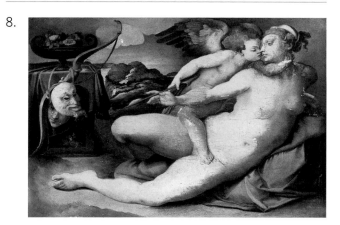

Genève, Musée d'Art et d'Histoire, Inv. CR 354
Tavola, cm 48 x 66, Cerchia di Michele Tosini (Brina?)
Molto simile all'esemplare di Roma (n. 14).
Bibl.: CLAPP 1916, p. 145; NATALE 1979, pp. 91-92 (ill.); HORNIK 1990, p. 259 n. 34; COSTAMAGNA 1994, n. 70.6.

9. Già Hildesheim, Städtisches Museum (esposto nel 1884)
 Tela, cm 123 x 160
 Precedentemente a Berlin, Kaiser-Friedrich Museum, Inv. 233, comperato nel 1881. Variante con solo figure; forse identificabile con il n. 19.
 Bibl.: MILANESI 1881, VI, p. 294; THODE 1908, II, p. 328; CLAPP 1916, p. 144; TOLNAY 1948, p. 195; NATALE 1979, p. 92; COSTAMAGNA 1994, n. 70.1.
 Foto: Köln, Foto Bildarchiv (83526); copia presso Firenze, Kunsthistorisches Institut (122739, 177047).

10.

London, Kensington Palace, Royal Collection (Tav. V/1)
Tavola, cm 129 x 193, Vasari
Probabilmente identificabile con n. 20, 25, 29, 30 o 31;
già a Hampton Court.
Bibl.: Milanesi 1881, p. 294; Thode 1908, II, p. 328; Clapp
1916, p. 144; Tolnay 1948, p. 195; Natale 1979, p. 92;
Shearman 1983, p. 277; Costamagna 1994, n. 70.7.

11. Napoli, Museo Naz. di Capodimonte, Inv. 84068 (Cat. 28).
Tavola, cm 135.9 x 192.7, Cerchia del Vasari (Hendrik
Van den Broek?).

12.

New York, Sotheby's, 25 maggio 2000 (Asta NY 7481,
lotto 11).
Tavola, cm 99 x 144
Precedentemente a Lucerne, Kunsthandel A. G., vendita
23-35 agosto 1928 (lotto 387) e a München, Julius
Böhler, nel 1926.
Bibl.: Natale 1979, p. 92; Costamagna 1994, n. 70.8.

13. Già Paris, Collezione d'Atri
Tavola, cm 96 x 177
Variante, forse da Maarten van Heemskerck
(vedi saggio Nelson, fig. 29).
Bibl.: Costamagna 1994, n. 70.11.
Foto: Firenze, Kunsthistorisches Institut (212405).

14.

Roma, Galleria Colonna, Inv. 117 (Tav. X/1, dopo il restauro)
Tavola, cm 134.5 x 193, Michele Tosini
Foto prima del restauro
Originariamente Firenze, Collezione Salviati (v. Cat. 13).
Bibl.: Thode 1908, II, p. 329; Clapp 1916, p. 145; Tolnay
1948, p. 195; Natale 1979, p. 92; Hornik 1990, p. 255
n. 31; Costamagna 1994, n. 70.13; Negro 2001.

15.

Venezia, Collezione privata
Tavola, cm 56 x 78 (tavola); ca. 52 x 76 (dipinto)
Già Paris, Vivier Stephens; molto restaurato, estrema-
mente simile a Bucarest (n. 1).
Bibl.: Costamagna 1994, nn. 70.10 (Paris), 70.14 (Venezia).

16.

Collocazione ignota
cm 132 x 195
Simile a Bucarest (n. 1).
Foto: Firenze, Villa I Tatti, Fototeca Berenson (con le misure); Firenze, Kunsthistorisches Institut (212171, qui riprodotta).

17. Erfurt, Städlisches Museum, n. 32.
Bibl.: *Katalog* 1909, p. 8; CLAPP 1916, pp. 144, 199 (come una variante); COSTAMAGNA 1994, n. 70.5.

18. Già Firenze, eredi di Luigi Riccieri
Bibl.: MILANESI 1881, p. 295 (come Fiorentino, seconda metà del Cinquecento, un terzo più piccolo degli altri, quindi circa cm 85 x 130); CLAPP 1916, p. 144.

19. Già Firenze prima del 1880 ca.
(forse identificabile con il n. 9)
Bibl.: MILANESI 1881, p. 295 (come una tavola, più piccola delle altre; la Venere è descritta totalmente nuda, senza gli oggetti simbolici); CLAPP 1916, p. 144.

20. Già Firenze, Collezione Ottaviano de' Medici
In un ricordo del 11.VII.1541, Vasari annota una commissione da Ottaviano de' Medici per una copia della *Venere e Cupido* di Michelangelo-Pontormo, 2.5 braccia x 3.5 braccia (cm 146 x 204 ca.); nella sua *Vita* del 1568, conferma che ha fatto una *Venere* e una *Leda* per Ottaviano nel 1540-1541 (vedi *Appendice I*).
Con l'eccezione di BRACCIANTE 1984, gli studiosi presumono che questi quadri siano identificabili con quelli spediti a Venezia nel 1541. L'associazione non è certa e non

spiegherebbe perché Vasari, nel 1568, specifica che i quadri furono fatti per Ottaviano.
Bibl.: CLAPP 1916, p. 145; TOLNAY 1948, p. 196; SHEARMAN 1983, p. 277; BRACCIANTE 1984, p. 89.

21. Già Genova, Palazzo di Pietro Gentile
Bibl.: RATTI 1780/1976, I, p. 120; TOLNAY 1948, p. 196; MUZII 1993, p. 27.

22. Già Heidelberg, Scholss
Bibl.: THODE 1908, II, p. 326 (elencato nell'inventario del 1685 come «Venus et Cupido, durch Angeli Bonarota»); CLAPP 1916, p. 144.

23. Già Milano, Collezione Pompeo Leoni
Bibl.: MEZZATESTA 1980 (nell'inventario del 1615 come «La Venere del S.r Michel Angel scudi 100»); HELMSTUTLER DI DIO, in corso di stampa (nell'inventario del 1609 come «Una Venere che è sopra uno letto che viene da Leonardo con la cornice scudi quindeci»).

24. Già Paris, Collection Edmond Blanc
Bibl.: THODE 1908, II, p. 326; CLAPP 1916, p. 144; COSTAMAGNA 1994, p. 220 (venduta a Paris, Hôtel Drouot, 3 maggio 1876, pp. 3-4 n. 1).

25. Già Roma, Collezione Bindo Altoviti
In un ricordo del 12.XI.1543, Vasari annota che Bindo Altoviti ha ricevuto la sua *Venere e Cupido*, «ritratto da Michelagniolo», 2 1/3 x 3 1/2 braccia (cm 136 x 204 ca.), e nella sua *Vita* del 1568 la data al 1544 (v. *Appendice I*). Per Altoviti Vasari fece anche un affresco di una Venere (seduta) con cupido, ora perduto, ma conosciuto attraverso un'incisione (DAVIS 1979, pp. 197-224); le braccia ricordano la composizione di Michelangelo
Bibl.: CLAPP 1916, p. 145; TOLNAY 1948, p. 196; SHEARMAN 1983, p. 277.

26. Già Roma, Galleria Giustiniani
Bibl.: THODE 1908, II, p. 326; CLAPP 1916, p. 144.

27. Già Roma, Palazzo Barberini
Bibl.: TITI 1763/1978, p. 333 (come affresco); THODE 1908, II, p. 326; CLAPP 1916, p. 144; TOLNAY 1948, p. 196.

28. Già Torino, Palazzo Reale
 Bibl.: THODE 1908, II, p. 326 (nell'inventario del 1635; bruciato su ordine di Carlo Emanuele di Savoia); CLAPP 1916, p. 144; TOLNAY 1948, p. 196.

29. Già Venezia
 In una lettera del 20.VII.1541, Vasari fa riferimento a due quadri, una *Venere* e una *Leda*, che manderà prossimamente a Leoni e in un ricordo del 10.X.1541 annota che ha spedito le tavole, sia l'una che l'altra di 2.5 x 3.5 braccia e «ritratta da Michelagniolo» (v. n. 20 e *Appendice I*).
 Bibl.: CLAPP 1916, p. 145; TOLNAY 1948, p. 196; SHEARMAN 1983, p. 277.

30. Già Venezia
 In una lettera del 21.VII.1544 Vasari spiega che presto porterà o manderà un dipinto di una Venere, presumibilmente da Michelangelo e diverso dal n. 29 (v. *Appendice I*). Forse identificabile con la tela che Vasari aveva promesso di mandare a Leoni in una lettera del 9.VIII.1544 (VASARI 1923-1940, I, p. 133).
 Bibl.: CLAPP 1916, p. 145; TOLNAY 1948, p. 196; SHEARMAN 1983, p. 277.

31. Già Venezia, Don Diego Hurtado de Mendoza
 Nella sua *Vita* del 1568 Vasari racconta che nel 1542 fu chiamato a Venezia da Pietro Aretino e arrivato lì «con due quadri dipinti di mia mano con i cartoni di Michelagnolo, gli donai a don Diego di Mendozza».
 Probabilmente gli stessi dipinti erano stati offerti prima a Guidobaldo della Rovere, secondo una lettera scritta dall'Aretino dopo il 16.IV.1542 (vedi n. 20 e *Appendice I*).
 Bibl.: CLAPP 1916, p. 145; TOLNAY 1948, p. 196; SHEARMAN 1983, p. 277.

32. Vienna, vendita Sanct Lucas, 3-4 marzo 1921, n. 11
 cm 46 x 64
 Bibl.: NATALE 1979, p. 92; COSTAMAGNA 1994, n. 70.15.

33. London, British Museum, Inv. 1946-7-13-371
 Carta, mm 248 x 198
 Bibl.: WILDE 1953 n. 99; PAOLETTI 1992, pp. 439-440 (fig. 18); COSTAMAGNA 1994, p. 221.

34. Napoli, Museo Nazionale di Capodimonte, Inv. 86654 (Cat. 27)
 Carta, cm 127,7 x 182,4. Cerchia del Vasari

35.

Paris, Musée du Louvre, Département des Arts Graphiques, Inv. 24 (vedi Catalogo, 43-a)
Carta, mm 301 x 421. Alessandro Allori o bottega
Bibl. *Raffaello* 1993, p. 28; COSTAMAGNA 1994, pp. 220-221.

36.

Paris, Musée du Louvre, Département des Arts Graphiques, Inv. 1029
Carta, mm 282 x 421, bottega di Alessandro Allori (?).
Bibl.: *Raffaello* 1993, p. 28; COSTAMAGNA 1994, pp. 220-221.

Appendice III / **Appendix III**
Roberto Leporatti

TESTI LETTERARI

LITERARY TEXTS

Le versioni di Girolamo Benivieni dall'*Amor fugitivo* di Mosco (A) e da Properzio, *Elegiae*, II XII (B) si trovano in GIROLAMO BENIVIENI, *Opere* (Giunti, Firenze 1519, pp. 121*r*-122*v*).

I testi di Benedetto Varchi sono tratti dal cod. II VIII 146 della Biblioteca Nazionale di Firenze, scritto da un copista ma con correzioni d'autore, intitolato *[...] et varie traduzzioni et componimenti, parte colle rime et parte e senza, di M. Benedetto Varchi*; la versione dell'*Amor fugitivo* (C) di Varchi è alle cc. 18*r*-19*r* e fu pubblicata in VARCHI 1810 pp. I-III, VARCHI 1841, II, pp. 36-38; VARCHI 1858-1859, p. 496 (per le varianti autografe v. saggio LEPORATTI).

Le ottave di *Cupido* (D) sono alle cc. 83*r*-85*r* e sono inedite.

A
Amore fugitivo di Mosco poeta græco
tradocto in lingua latina per M. Agnolo Politiano et di latina in toscana per Hyeronimo Benivieni.

Venere intenta el suo figlo chiamando:
 «Se forse in terra alcun veduto Amore
 Havessi ir vago e fugitivo errando,
Mio figlio è – dicea –. Quel ch'il suo errore
 Ne monstra un bacio harà; se per ventura 5
 Me 'l prendi, Amico, el premio fia maggiore.
Giovane è anchor, fanciul, ma di figura
 Notabil; veston le sue membra nude
 Quasi un vivo color di fiamma pura.
Ardon le luce sue vehemente et crude, 10
 La mente iniqua, placide e suave
 Parole ha in bocca, e 'l cor cuopre altro et chiude.
Dolce è qual mel sua voce, ma se grave
 Ira l'infiamma, l'effrenata mente
 Ben si può alhor veder tal quale el have: 15
Falsa, iniqua, mendace; e crudelmente
 Scherza el crudel fanciul. Sopra a la fronte
 Crespa ha la chioma, e l'impia faccia ardente
Proterva è el volto; et benché picciol', prompte
 Le mani, in modo che lontan saecta, 20
 Saecta insin nel regno di Acheronte;
Nude le membra son, velata e strecta
 La mente, e come uccel movendo l'ale
 Hor questo afflige, hor quella parvoletta.
Picciolo è l'arco suo: sopr'epso un strale 25
 Breve certo è, ma qualhor l'arco tende
 Insino al ciel dal nervo scosso sale.
A tergo pien d'aspre saecte pende
 Picciol turcasso, et contro a me talhora,
 Madre, el protervo arcier suoi stral' intende. 30
Crudele è in tutto, e più crudele anchora
 Se stesso afflige. Breve è la sua face,
 Ma epso Hyperïon vincendo accora.
Se questo prendi, el miserel fallace
 Batti senza pietà; et se quel piange, 35
 Non ti fidar del pianto suo mendace;
Se lieto arride e 'l flebil pianto cange,
 Tanto più el tira; e se baciar ti vuole,
 Ogni sua speme alhor, fuggendo, frange.
Nelle infecte sue labra asconder suole 40
 Letal veneno, onde e suoi baci infecti
 Son tutti; e se con sue dolce parole
Ti priega e vuol che le sue armi accepti,
 E dica: 'Amico, io te le cedo et dono',
 Fa' che sopra a suo don' le man' non metti: 45
Fallaci questi, e quelle ardente sono».

B
Descriptione del medesimo "amore"
da una *Elegia* di Propertio

Non furo al tuo parer maravigliose
 Le man di quel, che in giovenil figura,
 Qualunque e fussi, Amor pingendo pose?
Questo de' ciechi amanti la natura
 Conobbe, e come fuor d'ogni ragione 5
 Perdon lor primi ben' per leggier cura.
 Né l'ale agl'homer' suoi senza cagione
 Ponendo, el fé con human cor volare,
 Perché quelle alme, in cui suo nido pone,
Mentre per questo tempestoso mare 10
 Corron da l'onde alterne rebuttate,
 Son così che già mai si pòn fermare.
L'arco suo incurvo e le saecte hamate,
 Che dagl'homeri suoi sospese pendono
 Ond'egli ha sempre le sue mani armate, 15
Certo nulla altro a' nostri occhi pretendono,
 Se non che pria che alcun di lor si accorga,
 Dal nervo scosse in mezo al cor suo scendono.
O felice colui, se è alcun che scorga
 L'insidie e ' lacci pria che 'l cieco seno 20
 Agli amorosi stral' denudi et porga!
Perché quel miser cor che un tal veneno,
 Una tal peste incautamente accogle,
 Da questo impio infelice e cieco freno
Raro, e talhor mai si snoda e sciogle. 25

C
Benedetto Varchi dal Greco di Mosco:
L'Amor fugitivo

Mentre la bella Dea, che Cipri honora,
* Smarrito havendo il suo figluolo Amore,*
* Ad alta voce il già chiamando ogn'hora:*
«Alcuno è – dicea – qui Ninfa o Pastore,
* Che veduto habbia il caro nato mio* 5
* Girsen vagando d'uno in altro errore?*
Niun fia senza pro cortese e pio,
* che chi 'l mi mostrarrà, per sua mercede*
* un bacio havrà di quei che so dar' io.*
E chi pregione il menarà, per fede 10
* Tenga, ch'havrà non pure un bacio solo,*
* Ma quel che 'l bacio dopo se richiede.*
Agevol è conoscer mio figliuolo,
* Ma chi nol conoscesse, ascolti un poco:*
* Segni darò ch'a lui convengon solo.* 15
Questo reo garzoncel molto né poco
* Bianco non è, ma qual fiamma vermiglio;*
* Gl'occhii sfavillan come ardente foco.*
Dolci parole ha 'l mio vezzoso figlio,
* Ma la mente è fallace, onde fuggire* 20
* Le sue false lusinghe è san consiglio.*
E s'avvien che già mai sdegni o s'adire,
* Con assai men fatica un cerro antico*
* Si svelle ch'ei gli sdegni ponga e l'ire.*
Solo è d'inganni, e di menzogne amico; 25
* Se ride, ò scherza, allor cerca d'aprirti*
* Il petto, e trarti il cor, sì t'è nemico.*
I crini ha in capo inanellati et hirti,
* Ma nel volto non ha vergogna alcuna;*
* Misero è ben chi rompe in cotai sirti.* 30
Picciole man', ma sì gran forza aduna,
* Quando le fiere sue saette avventa,*
* Che 'l ciel perquote e l'infima lacuna.*
* Nude ha le membra, ché solo argomenta*
* Coprir la mente, e quasi augel coll'ale* 35
* Hor a Ninfa, hor ad huom ratto s'avventa.*
Sopra la corda tien sempre lo strale,
* E sempre al lato manco indrizza l'arco,*
* Che quanto par minor tanto più vale.*
Un turcasso di ferro e d'oro carco 40
* Porta a sinistra, il qual contra me, lasso,*
* Che pur sua madre son, ben spesso ha scarco.*
Che dir più debb'io? Anzi quai cose passo?
* A questi solo ancidere huomin' piace;*
* Solo è d'ogni pietate ignudo e casso.* 45

Ei solo il Sol con sì picciola face
> *Accende in ciel, tanto è possente e forte,*
> *Solo il mondo mantien, solo il disface.*
Costui, se 'l prendi mai per senno o sorte,
> *Menalmi preso, e se pietà n'havrai,* 50
> *In guiderdon n'aspetta acerba morte.*
E se piangere il vedi, allor dirai:
> *'Questi ingannar mi vuol'; s'ei ride, allora*
> *Più stretto il lega, e men pietoso il trai.*
E se dar baci ti volesse ancora, 55
> *Oimè fuggi, che ne' labbri suoi*
> *Peste solo e venen sempre dimora.*
S'ogni sua arma ti largisce poi,
> *No lle tocchar, ché son fallaci, e tinte*
> *In fuoco, onde lento arda o tosto muoi,* 60
Veri pianti faccendo, e risa finte.

D
Mascherata. *Cupido favella*

1 Dalla terza del ciel più vaga spera,
 Dove la madre mia Venere regna,
 Tra voi bella, cortese, honesta schiera,
 Che portate di me nel viso insegna,
 Anzi pur dalla dolce vostra altera
 Luce, ch'amare e riverire insegna,
 Son qui disceso a mostrarvi l'errore
 Del vulgo cieco, che tien cieco Amore,

2 E dir che folle è ben chïunche folli
 Crede i miei servi a voi, donne, soggetti;
 A voi, ne' cui begli occhii e dentro i molli
 Né casti men che delicati petti,
 Le faci, l'arco, e le saette volli
 Tutte ripor con tutti i miei diletti,
 Non perché feste i cor co' chiari raggi
 Di saggi stolti, ma di stolti saggi.

3 Chi è sì fero, Donne, e sì selvaggio,
 Qual core è tanto basso e così vile,
 Che solo all'apparir d'un vostro raggio
 Mansueto non venga, alto e gentile?
 Chi così folle, cui non faccia saggio,
 Chi tanto altero, cui non renda humile
 Un muover d'occhio, una parola, un cenno
 Vostro, ch'assai più val ch'ogn'altrui senno?

4 E questi sei via più saggi e migliori
 Di quanti fusser mai dentro il mio regno,
 Per dar trastullo al volgo, che 'l di fuori
 Rimira sempre e mai non tocca il segno,
 Si travestir da matti, e i loro amori
 Con habito velar d'essi non degno,
 Per discovrir sotto contrarii manti
 Quai sono et esser denno i saggi amanti.

5 Non sia dunque di voi, Donne, ch'inganni
 Il vestir finto e le mentite larve;
 Sol quel di dentro, e l'opre, non i panni
 Puon l'altrui fede e 'l gran valor mostrarve;
 E sovvengavi ancor, che 'n non molti anni
 Molta bellezza molte volte sparve.
 Io, ch'Amor son, per voi con lor tutto ardo,
 Né chieggio altro però ch'un solo sguardo.

6 *Ben puote un guardo sol degl'occhii vostri,*
 Non pur chi v'ama far lieto e contento,
 Ma dovunche pietoso unqua si mostri,
 Tornare in vita un huom di lume spento.
 Voi pur sapete che le nevi e gl'ostri
 De' più bei volti passan come vento,
 E nulla puonno, ove prima han virtute
 Dare a sé fama eterna, altrui salute.

7 *Perché voi dunque, hor ch'è fiorito e verde*
 Il prato, ch'ogn'hor più par che si secchi,
 non v'accorgete che, chi il tempo perde,
 Altro non truova poi che spine e stecchi?
 Che la sfiorita età mai non rinverde?
 Dimandatene pure i vostri specchi,
 E quei quattro Amador fidi e prudenti
 Lo vi diran cantando in dolci accenti.

Madrigale cantato dopo le stanze precedenti da 4 musici

Donne, la beltà vostra
Altro non è ch'à mezzo Aprile un fiore,
Che piace e giova sì, ma tosto muore:
Vaga, fresca, odorata, amena rosa,
Chi non coglie alla brina,
Secca, la trova poi la sera, spina:
E chi tien bella e ricca gioia ascosa,
Non pure indegno, oimè, di lei si rende,
Ma 'l Mondo tutto, e più se stesso offende.

Appendice IV / **Appendix IV**

INOA Firenze, Gruppo Beni Culturali
(Istituto Nazionale di Ottica Applicata)
Marzia Materazzi, Luca Pezzati, Pasquale Poggi

LA RIFLETTOGRAFIA INFRAROSSA

INFRARED REFLECTOGRAPHY

La riflettografia infrarossa è una tecnica ottica da decenni largamente impiegata da restauratori e storici dell'arte nella diagnostica dei dipinti. Questo metodo di indagine, che può essere applicato a dipinti, su tavola o su tela, e a pitture murali, permette in maniera assolutamente non distruttiva, la visualizzazione di particolari nascosti dallo strato pittorico superficiale grazie alla parziale trasparenza alla radiazione infrarossa dei materiali che lo compongono. La radiazione nella regione spettrale del vicino infrarosso (0.8-2.0 μm) riesce infatti ad attraversare i materiali che costituiscono il film pittorico e viene riflessa e diffusa dagli strati ad esso sottostanti. Dall'acquisizione della radiazione riflessa si può ricostruire la cosiddetta immagine riflettografica (o *riflettogramma*) del dipinto.

Tra le applicazioni più eclatanti della riflettografia si trova certamente la visualizzazione del disegno preparatorio, eseguito dall'artista in certi casi come linea guida alla realizzazione del dipinto, in molti altri come parte integrante della resa pittorica finale. La visibilità di quest'ultimo dipende da vari fattori quali lo spessore e la natura dei colori dello strato pittorico, il contrasto fra la radiazione riflessa dalla preparazione e quella assorbita dal disegno, nonché dalla tecnica e dal materiale utilizzato per tracciarlo: è infatti generalmente migliore se esso è stato eseguito con materiali che assorbono l'infrarosso (per esempio carboncino o grafite). La riflettografia è inoltre in grado di svelare l'esistenza di stesure pittoriche, nascoste da altre stesure, sovrapposte per volontà dell'artista (*pentimenti*) o dovute a ritocchi successivi per mano di altri. Questi e molti altri particolari nascosti alla visione diretta, contribuiscono tutti insieme alla conoscenza delle tecniche di realizzazione dell'opera d'arte e del suo stato di conservazione, come pure al suo inquadramento storico.

La riflettografia ad alta risoluzione nasce all'Istituto Nazionale di Ottica Applicata intorno al 1990 con la realizzazione di un dispositivo a scansione innovativo per la ripresa

Infrared reflectography is an optical technique that for decades has been widely used in painting diagnostics by conservators and curators alike. This non-destructive investigative method can be applied to paintings on canvas or wood panel as well as to wall paintings. A completely non-destructive analytical technique, infrared reflectography allows for the visualization of details hidden under the layers of paint, due to the fact that the materials making up the paint layers are partially transparent to infrared radiation. Radiation in the near-infrared spectrum (0.8-2.0 μm) can pass through the materials contained the paint layer. The radiation then is diffused and reflected by the layers underlying the paint. From the acquisition of the reflected radiation the so-called reflectographic image (or reflectogram) of the painting can be constructed.

Certainly one of the most remarkable applications for reflectography is the visualization of the preparatory underdrawing. In some cases, underdrawings are executed by the artist as guidelines for the laying on of the paint, and in many other cases, the underdrawing makes up an integral part of the final pictorial rendering. The ability to see the underdrawing is dependent on various factors: the thickness and types of colors used in the paint layers, the contrast between the radiation reflected by the underlying ground preparation and the radiation which is absorbed by the underdrawing, as well as the types of materials and techniques used to make the drawing. In fact, it is usually better if the underdrawing was made using materials that absorb the infrared radiation (for example, charcoal or graphite). In addition, reflectography can reveal the existence of paint and paint layers that are hidden by subsequently painted layers. These initial paint layers may have been woked over by the artist himself (*pentimenti*) or they may be as a result of subsequent retouching by someone else. These and many other details hidden from normal vision all contribute to the knowledge of the techniques used in making the art work, its conservation condition and its historical setting.

di immagini nell'infrarosso. Lo scanner IR consente di acquisire il riflettogramma di un dipinto con caratteristiche di risoluzione spaziale e di dinamica tonale che non si ottengono con alcuna delle tecniche tradizionalmente adottate per la riflettografia infrarossa (telecamere Vidicon o CCD).

Una recente ricerca, condotta all'Istituto Nazionale di Ottica Applicata in collaborazione con l'Opificio delle Pietre Dure, ha poi condotto alla realizzazione del prototipo di un'unità optoelettronica di concezione innovativa, capace di acquisire simultaneamente, ad alta risoluzione spaziale e perfettamente sovrapponibili, il riflettogramma e l'immagine a colori di un dipinto. Il dispositivo, denominato *testa colore*, è stato concepito per essere integrato allo scanner IR e aggiunge un significativo contributo all'evoluzione della tecnica dal punto di vista interpretativo.

Lo scanner per riflettografia infrarossa a colori

Due slitte motorizzate scandiscono una superficie di 1 m² con una risoluzione spaziale di 4 x 4 punti/mm². La testa ottica, formata dal sistema di illuminazione e da quello di rivelazione, si muove solidamente con la traslazione verticale alla velocità di 150 mm/s (fig. 1). La distanza di sicurezza della testa ottica dal dipinto è stata fissata a 150 mm.

Due lampade alogene, alimentate a bassa tensione, sono fissate ai lati del rivelatore, formando un angolo di 45° con la normale alla superficie del dipinto e illuminando una piccola area di circa 10 cm² (fig. 2a). Poiché il sistema di illuminazione si muove solidamente con il sistema di rivelazione, il riscaldamento della superficie è minimizzato e l'illuminazione uniforme è assicurata sia durante la scansione che nelle misure successive; la stabilità nel tempo è ottenuta alimentando le lampade con un generatore stabilizzato in corrente.

Un doppietto acromatico standard, di focale 75.0 mm, raccoglie la radiazione riflessa dal punto scandito sul dipinto, e la focalizza nelle terminazioni di quattro fibre ottiche, ciascuna accoppiata con un rivelatore. Le terminazioni delle fibre sono montate in un supporto appositamente costruito che mantiene una distanza *core-core* uguale al passo di campionamento (250 µm). Ogni terminazione è inoltre fissata a una distanza dal doppietto leggermente differente, a seconda della distanza focale effettiva associata alla lunghezza d'onda trasportata dalla fibra.

Il sistema di rivelazione è basato su tre fotomoltiplicatori miniaturizzati appositamente filtrati per le bande rossa (R), verde (V) e blu (B), e da un fotodiodo InGaS con risposta spettrale nell'intervallo 0.9-1.7 µm (vicino infrarosso). L'uso di singoli elementi sensibili invece che di sensori spazialmente estesi, come le matrici o gli *array*, rimuove sia il problema dell'illuminazione non uniforme sia quello del trovare ottiche prive di aberrazione per la regione spettrale del vicino IR. Il segnale dei quattro fotorivelatori è digitalizzato da un convertitore A/D a 12 bit, cui cor-

High-resolution reflectography was developed by the Istituto Nazionale di Ottica Applicata (National Institute of Applied Optics, in Florence) in about 1990. At that time, an innovative infrared scanning device was developed for imagining in infrared spectral band. It is possible to acquire the refectogram of a painting using the IR scanner with spatial resolution and tonal dynamics that are unobtainable by any of the techniques traditionally used for infrared reflectography [Vidico (video camera) or CCD (charge-coupled device camera)]. In recent collaboration between the Istituto Nazionale di Ottica Applicata and the Opificio delle Pietre Dure, the prototype for an innovative optoelectronic device has been developed. This device is capable of simultaneously acquiring the reflectogram and the color image of a painting, both with high spatial resolution and which can be perfectly superimposed one on the other. The device called *testa colore* ('color head') was conceived to be integrated with the IR scanner thereby adding, in terms of image interpretation, a significant contribution to the scanner's technical evolution.

THE SCANNER FOR COLOR INFRARED REFLECTOGRAPHY

Two motorized sliding tracks with a spatial resolution of 4 x 4 points/mm² scan over a 1 square meter surface. The optical head consists of the illumination system and the detector system. Both move jointly on the vertical translation at the rate of 150 mm/s (fig. 1). The safety distance of the optical head from the painting is fixed at 150 mm.

Two low-voltage halogen lamps are fixed at either side of the detector, forming a 45° angle with the normal to the painting surface, and they illuminate a small area of approximatly 10 cm² (fig. 2a). The illumination system moves jointly with the detector system thereby minimizing heat on the painting surface. This system also assures a uniform illumination, during both the scanning as well as the taking of subsequent measurements; illumination stability in time is obtained by powering the lights through current stabilized generator.

Figura/ *Figure* 1.

risponde una dinamica tonale di oltre 4000 livelli di grigio. L'immagine a colori e il riflettogramma sono ricostruiti in un formato immagine standard tramite un software appositamente sviluppato. Grazie alla configurazione del sistema ottico, le quattro immagini digitalizzate sono perfettamente sovrapponibili con una semplice traslazione di 250 μm.

Figure / *Figure* 2a, 2b.

STIMA DELL'ERRORE METRICO NELLE MISURE RIFLETTOGRAFICHE

Per ciascuna direzione di scansione, lo scanner acquisisce un punto ogni 0.25 mm. Ai punti acquisiti viene poi associata, a livello software, una metrica, ovvero nella ricostruzione dell'immagine si impone che la distanza tra due punti successivi sia pari a 0.25 mm. Questo procedimento non introdurrebbe nessun errore se il piano del dipinto fosse esattamente parallelo al piano scandito dalla testa ottica. Oltre a un attento allineamento, preliminare alla misura, e alla precisione della scansione meccanica (su cui torneremo dopo), un elemento di controllo di questo parallelismo è la messa a fuoco del sistema di rivelazione.

La testa ottica mantiene a fuoco la superficie scandita entro una distanza di 5 mm lungo l'asse ottico (che idealmente unisce il punto sul dipinto al sistema di rivelazione). Da questa tolleranza nella messa a fuoco deriva un errore metrico nell'attribuzione della distanza tra due punti nei casi in cui il dipinto non stia esattamente in un piano parallelo a quello scandito dalla testa ottica.

In questo caso infatti non viene scandita la superficie del dipinto ma la sua proiezione sul piano di scansione della testa ottica. Questo avviene, per esempio, nei casi in cui il dipinto sia imbarcato o semplicemente disposto trasversalmente (fig. 2b).

La situazione per cui viene calcolato l'errore è quella in cui, entro il tratto scandito **L'**, che si suppone retto, la distanza del dipinto dalla testa ottica lungo l'asse ottico vari esattamente di 5 mm (fig. 2b). Questo caso riveste un carattere di generalità in quanto, anche nel caso di dipinti imbarcati, si può sempre pensare di suddividere il tratto curvo da scandire in tratti sufficientemente piccoli da poterli approssimare come segmenti di retta.

A standard achromatic duplet lens system, with focal length of 75.0 mm, gathers the reflected radiation from the scanned point on the painting and focuses it on the terminations of four optic fibers, each coupled to a detector. The terminations of the fibers are mounted into a support specifically constructed for them that maintains a core-core distance equal to the pace of the sampling (250μm). In addition, each individual termination is fixed at a slightly different distance from the duplet, according to the effective focal distance associated with the wavelength transported by the individual fiber.

The detector system is based upon three miniaturized photomultipliers filtered specifically for red (R) green (G) and blue (B) spectral bands, and by an InGaAs (indium gallium arsenide) photodiode with a spectral response in the 0.9-1.7 μm region (near infrared). The use of single sensitive elements rather than spatially extensive, such as matrixes or arrays, removes both the problem of non-uniform illumination as well as that of finding optics without aberrations for the near-IR spectral region. The signal from the four photodetectors is digitalized by an A/D-converter (analogue/digital converter) at 12 bits, corresponding to a tonal dynamic of over 4000 grey levels. The color image and the reflectogram are reconstructed in a standard image format using specifically developed software.

Due to the configuration of the optics system, the four digitalized images are perfectly overlapping with a simple translation of 250μm.

ESTIMATE OF THE METRIC ERROR
IN THE REFLECTOGRAPHIC MEASUREMENTS

For each scanning direction, the scanner acquires one point every 0.25 mm. By means of the software, a metric is then assigned to he acquired points. That is, during the reconstruction of the image the distance between two subsequent points is assigned as being equal to 0.25 mm. This procedure would not introduce any errors if the plane of the painting were exactly parallel to the plane scanned by the optical head. In addition to a careful alignment prior to measurement, and to the precision of the mechanical scanning itself (discussed further on), a necessary control aspect of this parallelism is the detector system's focusing capacity.

The optical head keeps the scanned surface in focus within a distance of 5mm along the optical axis (which ideally unites the point on the painting to the detector system). Due to this tolerance in the focusing capability, a metric error is derived in the attribution of the distance between two points in those cases where the painting is not exactly on a parallel plane to that scanned by the optical head. In fact, in this case the actual surface of the painting is not scanned, but instead its projection on the scanning plane of the optical head. This happens for example, in those cases where the painting is curved or distorted or if it is simply aligned at an angle (Fig. 2b).

Indichiamo con **L** la reale distanza tra due punti nel dipinto e con $\Delta L = L\text{-}L'$ la differenza tra le due distanze, che corrisponde anche all'errore metrico assoluto su **L**. Indichiamo inoltre con α l'angolo tra il piano del dipinto e quello scandito dalla testa. Con semplici considerazioni trigonometriche è possibile ricavare che:

$$\text{tg}\alpha = 5 \text{ mm}/ \, L'(\text{mm}) \tag{1}$$
$$L' = L \cdot \cos\alpha \tag{2}$$
$$\Delta L = L\text{-}L' = L \cdot (1-\cos\alpha) = L' \cdot (1-\cos\alpha)/\cos\alpha \tag{3}$$

In *Tabella 1* sono riportati i valori di ΔL calcolati per una serie di valori di **L'**. La ragione del segno positivo di ΔL è che in ogni caso **L'** è una sottostima del valore vero **L**.

L'(mm)	Δ**L**(mm)
800.0	+0.015
400.0	+0.03
200.0	+0.06
100.0	+0.12
10.0	+1.2

Tabella / Table 1.

Si noti che, stabilito l'angolo α per il tratto **L'**, la (3) vale per tutti i tratti intermedi **l**, purché si sostituisca **l** ad **L'**.

Dai valori riportati in tabella risulta che, per le distanze che secondo la nostra esperienza sono di interesse in situazioni di misura reali, l'errore metrico ΔL è direttamente proporzionale a **L'** e non è mai superiore al decimo di millimetro.

I valori calcolati devono essere confrontati con gli errori legati alle caratteristiche costruttive delle due traslazioni motorizzate (errore metrico intrinseco). Un contributo all'errore metrico intrinseco è legato alla deviazione massima dalla linea retta che può avere un oggetto posto sul carrello in corsa. Il costruttore dichiara che tale deviazione ha un andamento lineare con la corsa e varia secondo la legge:

$$D = 0.0042 + 4 \cdot 10^{-5} \, L' \tag{4}$$

Dove **D** è la deviazione dalla linea retta (in mm) e **L'** è lo stadio della corsa a cui si vuole conoscere la deviazione. Con considerazioni trigonometriche analoghe a quelle fatte per ottenere ΔL, si può ricavare che l'errore metrico legato a questo fattore, ΔL_p, vale:

$$\Delta L_p = L\text{-}L' = L' \cdot (\cos\beta - 1) \tag{5}$$
$$\text{sen}\beta = D/L' \tag{6}$$

The situation for which the error is calculated is that in where, within the scanned distance **L'** assumed to be straight, the distance of the painting from the optical head along the optical axis varies exactly 5 mm (Fig. 2b). This can be characterized as a generality because, even when the painting's surface is not perfectly plane, the curved distance to be scanned can always be subdivided into sufficiently small distances as to be able to be treated as segments of a line.

We can use **L** to indicate the real distance between two points on the painting and we can use $\Delta L = L\text{-}L'$ to indicate the difference between the two distances, which also corresponds to the absolute metric error of **L**. We use to indicate the angle between the plane of the painting and that scanned by the optical head.

With some simple trigonometric considerations, it is possible to obtain:

$$\text{tg}\alpha = 5 \text{ mm}/ \, L'(\text{mm}) \tag{1}$$
$$L' = L \cdot \cos\alpha \tag{2}$$
$$\Delta L = L\text{-}L' = L \cdot (1-\cos\alpha) = L' \cdot (1-\cos\alpha)/\cos\alpha \tag{3}$$

The values for ΔL calculated for a series of values **L'** are given in *Table 1*. The positive sign for ΔL is due to the fact that in every case **L'** is an underestimate of the true value **L**.

It can be seen that once the angle α is established for the distance **L'**, equation (3) is true for all the intermediate distances **l** as long as **l** substitutes **L'**.

From the values given in *Table 1* it can be seen that, according to our experience for the distances of interest in real measurements, the metric error ΔL is directly proportional to **L'** and is never greater than one-tenth of a millimeter.

The calculated values must be compared against the errors associated with the construction characteristics of the two motorized translations (intrinsic metric error).

A contribution to the intrinsic metric error is tied to the maximum deviation from the straight line that an object can have while it is in motion of the carriage. The device constructor states that this type of deviation has a linear trend with the run and varies according to the law:

$$D = 0.0042 + 4.10^{-5} \cdot L' \tag{4}$$

Where **D** is the deviation from the straight line (in mm) and **L'** is the point in the run at which one wants to know the deviation. With analogous trigonometric considerations as made for obtaining ΔL, it can be derived that the metric error tied to this factor ΔL_p, has the value:

$$\Delta L_p = L\text{-}L' = L' \cdot (\cos\beta - 1) \tag{5}$$
$$\sin\beta = D/L' \tag{6}$$

Where β is the angle formed between the scanned plane and that of the painting.

Table 2 gives the values calculated for ΔL_p and **D** for several

Dove β è l'angolo tra il piano scandito e quello del dipinto. In Tabella 2 sono riportati i valori calcolati di ΔL_D e **D** per valori diversi di **L'**. La ragione del segno negativo di ΔL_D è che in ogni caso **L'** è una sovrastima del valore vero **L**.

Dai risultati riportati in *Tabella 2* risulta evidente come que-

values **L'**. The negative sign for ΔL_D is due to the fact that in every case, **L'** is an overestimate of the true value **L**.

Based on the results given in *Table* 2 it is evident that this error source is certainly negligible with respect to the ΔL metric error discussed in first part of this section.

L' (mm)	**D** (mm)	ΔL_D (mm)
800.0	0.035	$-7.4 \cdot 10^{-7}$
400.0	0.020	$-4.7 \cdot 10^{-7}$
200.0	0.012	$-3.5 \cdot 10^{-7}$
100.0	0.0080	$-3.2 \cdot 10^{-7}$

Tabella / *Table 2*

sta fonte di errore sia senz'altro trascurabile rispetto all'errore metrico ΔL discusso nella prima parte di questa sezione.

Più ancora, in base alle accuratezze dichiarate dal costruttore, è possibile concludere che, per ciascuna traslazione, l'errore metrico dovuto alle caratteristiche strutturali della slitta motorizzata sia legato all'accuratezza nel posizionamento la quale è pari a +/-0.03 mm su 300mm di corsa. Per corse comprese tra i 100 mm e gli 800 mm è ragionevole ritenere che non ci si discosti molto da questo numero e comunque mai si scenda al di sotto degli 0.01 mm dichiarati per la risoluzione. Infine ricordiamo che le due slitte motorizzate vengono utilizzate con modalità di funzionamento diverse: quella orizzontale avanza di 0.25 mm ogni volta che la traslazione verticale ha compiuto una corsa, la cui lunghezza è di volta in volta stabilita in base alle caratteristiche geometriche del dipinto. In ragione di questa diversità, per quanto riguarda la traslazione verticale si deve tenere conto di un ulteriore contributo, legato alla accuratezza nella ripetibilità, compreso tra +/-0.01 e +/-0.015 a seconda della corsa.

In conclusione, nelle misure riflettografiche compiute con lo scanner, quando la superficie dipinta è sufficientemente piana ed estesa da permettere scansioni medio-lunghe, all'errore metrico totale, contribuiranno, per ciascuna direzione di scansione, sia ΔL sia l'errore legato alle caratteristiche costruttive della slitta, in quanto i due contributi sono confrontabili (nel caso di tratti intermedi **l** molto piccoli, ΔL può risultare persino trascurabile). Nel caso invece che le dimensioni del dipinto o un suo forte imbarcamento costringano a scansioni molto brevi, l'errore metrico, per ciascuna direzione di scansione, è dominato dal contributo ΔL. In ogni caso è da tenere presente che ΔL introduce comunque una sottostima del valore vero **L**.

In addition, based upon the accuracy testified to by the device constructor, it is possible to conclude that for each translation, the metric error due to the structural characteristics of the motorized sliding track is equal to ± 0.03 mm every 300 mm run and is related to the device position accuracy. For runs between 100 mm and 800 mm it can be reasonably maintained that we are not very far off this number, and in any case, it never goes below the 0.01 mm stated for the resolution.

Finally, we should remember that the two motorized sliding tracks have different working modes: the horizontal tracks advances 0.25 mm every time the vertical translation has finished a run, which length is established for each painting based on the geometrical characteristics of the work to be scanned. Due to this difference, for the vertical translation stage there is a further contribution, tied to the repetition accuracy, varying between ± 0.01 mm and ± 0.015 mm, according to the run.

In conclusion, with regard to the reflectographic measurements made with the scanner, when the painting surface is sufficiently large and flat to permit a medium-long scanning, – for both scanning directions – both ΔL and the error relating to the construction characteristics of the sliding track contribute to the total metric error because the two contributions are comparable (in the case of very small intermediate distances **l**, ΔL can result even negligible). Instead, in the case where the dimensions of the painting are such that very short scannings must be made (as in the case where the surface is very warped or curved) the metric error for both scanning directions is dominated by the ΔL contribution. In any case, it should be kept in mind that ΔL nevertheless introduces an underestimate of the true value **L**.

Appendice V / **Appendix V**
Rossella Lari

LA "VENERE E CUPIDO"
DI MICHELANGELO-PONTORMO:
RELAZIONE DI RESTAURO

THE "VENUS AND CUPID" BY MICHELANGELO-PONTORMO: RESTORATION REPORT

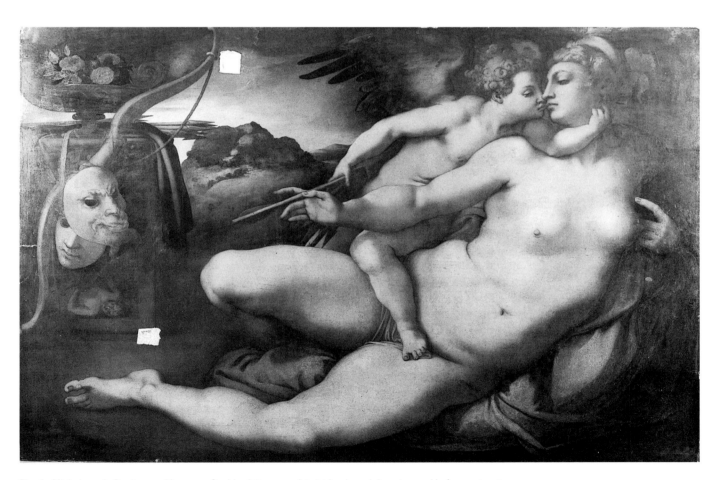

Fig. 1. Michelangelo-Pontormo, *Venere e Cupido / Venus and Cupid*, prima del restauro / before restoration.
Firenze, Galleria dell'Accademia

Restauratrice: Rossella Lari
Direzione dei lavori: Franca Falletti
Finanziamento: Fondazione non profit "Friends of Florence"

Restorer: Rosella Lari
Director of Restoration: Franca Falletti
Sponsor: "Friends of Florence" Non-profit Foundation

In occasione della mostra *Vita di Michelangelo*, organizzata a Casa Buonarroti nel luglio 2001, il dipinto (fig. 1) fu sottoposto a una manutenzione necessaria per il suo spostamento nella sede espositiva e per una migliore lettura dell'opera. Furono così fermate piccole creste e sollevamenti di colore presenti lungo la connessione delle assi centrali a sinistra e stuccati i fori di sfarfallamento di insetti xilofagi, che si notavano in particolar modo, poiché molto chiari, su uno sfondo di colore scuro. I restauri pittorici alterati che emergevano dalla policromia del dipinto furono velati, per armonizzare il più possibile l'insieme da un punto di vista cromatico. La cornice intagliata e dorata fu pulita ed eseguite le necessarie fermature; le parti mancanti furono ricostruite, stuccate e dorate a guazzo su bolo. Inoltre il legno fu trattato con antitarlo, verniciandolo per proteggerlo.

Tuttavia la visione dell'opera era fortemente ostacolata dalle patine che ne appiattivano le forme. Così, terminata la mostra a Casa Buonarroti nel gennaio 2002, il dipinto fu sottoposto a una serie di indagini preliminari per poter affrontare un restauro più approfondito.

La policromia era falsata da uno spesso strato di vernice giallastra, annerita da restauri pittorici e da svelature che neppure la pesante patina riusciva a nascondere. Facilmente intuibile, come hanno poi confermato le indagini, che il panno grigio che cingeva il fianco di Venere e ne nascondeva il pube, fosse in realtà un rifacimento pittorico. Per l'esistenza di un più ampio drappo che copriva la nudità della dea, di cui la riflettografia ci ha mostrato l'esatta forma, e per la sua remozione da parte di Ulisse Forni, restauratore delle Regie Gallerie, dopo il 1850, si veda la scheda di Cat. 23.

Operazione analoga era stata compiuta anche sulla replica della *Venere e Cupido* di Michelangelo-Pontormo delle Gallerie Fiorentine, in deposito presso la Scuola Normale Superiore di Pisa (Cat. 31) la cui ridipintura è stata tolta solo in un recentissimo restauro (2002) e pertanto da essa possiamo immaginare come, grossomodo, potesse mostrarsi la nostra prima dell'intervento del Forni (fig. 2).

Il Forni parla del dipinto di Michelangelo-Pontormo nel suo celebre *Manuale del pittore restauratore* (1866), prendendolo a esempio proprio per spiegare come sia necessaria l'azione di soda e potassa per ammorbidire ed eliminare con "raschiatoi" le ridipinture a olio. Il Forni dice anche di come le parti trattate in questa maniera finiscano per apparire inevitabilmente più chiare delle altre, e che, di conseguenza si debbano armonizzare con velature a tempera per adeguarle a quelle non toccate dall'intervento: «per ottenere ciò patina più fortemente l'incarnato di Venere che la rimanente superficie». Il passo è di grande importanza per la storia del restauro, perché ci fa capire come il Forni avesse già presente, almeno a livello teorico, il concetto di pulitura equilibrata e di rispetto delle antiche patine, laddove possibile.

La rimozione della patina nell'attuale restauro ha in effetti confermato quanto contenuto nel testo ottocentesco; va

The painting (fig. 1) underwent a conservatory cleaning both to improve its readability and in preparation for its transfer from the Galleria to Casa Buonarroti for the exhibition entitled *Vita di Michelangelo* in July 2001. At the time, small cracks and pigment detachments running along the connecting fissures of the central left panels were consolidated and the woodworm bores, whose light color was very noticeable against the darker background, were stuccoed. The pictorial restorations visible on the paint surface were veiled in order to enhance as much as possible a chromatic harmony of the entire work. The carved and gilt frame was cleaned and the necessary consolidations executed; the missing parts were reconstructed, stuccoed, prepared with bol priming and gilded. The wood was treated for termites and given a protective coating.

Nonetheless, the visual appreciation of the work was highly compromised by the patinas that flattened the forms. Thus, after the closing of the exhibition in Casa Buonarroti in January 2002, the painting underwent a series of preliminary investigations in preparation for a more in depth restoration.

A thick layer of yellowish varnish, blackened by pictorial restoration and peelings that not even the heavy patina was able to hide, falsified the colors. As suspected and confirmed by tests, the gray cloth round the hips of Venus that hides her pubic region proved to be a pictorial addition. For the existence of a larger drapery that covered the nudity of the goddess, the exact form of which has been determined by reflectography and for its removal by Ulisse Forni, restorer of the Regie Gallerie after 1850, see also Cat. 23.

An analogous operation had also been done on the replica from the Florentine Galleries of the *Venus and Cupid* by Michelangelo-Pontormo now in deposit at the Scuola Normale Superiore di Pisa (Cat. 31). The repainting on the replica, removed in a very recent restoration (2002), therefore, provides us with an idea of what, more or less, the original must have looked like before Forni's intervention (fig. 2).

Forni mentions the painting by Pontormo in his famous *Manuale del pittore restauratore* (1866), using it as an example in his explanation of how the use of soda and potassium is necessary in the softening and elimination with 'scrapers' of repainting in oil. Forni also states that the portions restored in this manner result inevitably lighter than the other zones and consequently must be treated with veils in tempera to harmonize them with those that have been left untouched by the intervention: to obtain these results, he covered the flesh of Venus with a heavier patina than on the rest of the painting. The passage – very important in the history of restoration – helps us understand how Forni was already aware, at least on a theoretic level, of the concept of balanced cleaning and respectful conservation, where possible, of early patinas.

The removal of the patina during the course of the present restoration in effect confirms the teachings of the famous restorer. The action of the 'scraper' had removed the majority of color, smoothing it and creating a strong contrast in materials with the

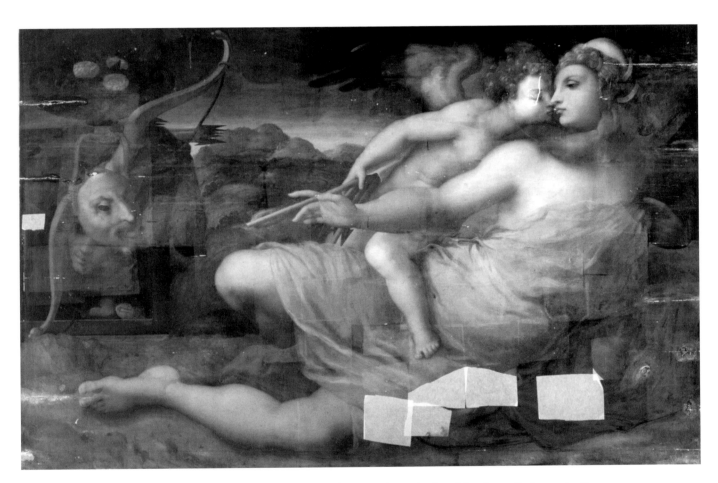

Fig. 2. da Michelangelo, Cerchia di Giorgio Vasari, *Venere e Cupido / Venus and Cupid*, prima del restauro / before restoration. Firenze, Gallerie Fiorentine (in deposito a Pisa, Scuola Normale Superiore).

comunque precisato che già la stesura originale presentava delle differenze, nel senso che il Pontormo aveva usato per gli incarnati una pennellata molto più corposa che non nelle altre parti, anche in relazione alla diversità del tipo di pigmento. Sulla gamba piegata di Venere era assai evidente la linea dove terminava il vecchio panneggio, mentre la gamba stesa, così come la spalla in luce, mostravano tracce di una pulitura particolarmente pesante, tanto che in alcuni punti affiorava la preparazione a gesso e colla.

La testa di Venere risultava come se fosse stata in ombra, rispetto al corpo, perché era più integra, almeno nei chiari.

Tolta la vernice pigmentata sono apparse più evidenti le gocciolature e la fitta rete nera della crettatura, là dove, sul corpo della dea, la sporcizia era penetrata, per effetto della soda, nella preparazione sottostante (fig. 3). La consunzione aveva inoltre evidenziato la venatura del legno, per cui si veniva a creare un ulteriore disegno geometrico orizzontale, secondo la disposizione delle fibre. Maggiormente leggibile era anche il disegno sottostante, ben documentato dalla riflettografia, assai largo ed eseguito a pennello per i corpi, più incisivo, eseguito a ricalco, per il resto del dipinto.

Rimuovendo il panno sul pube è apparso chiaro che questo doveva essere stato posto dallo stesso Forni, dopo che l'intera superficie era stata liberata dalla ridipintura precedente, perché presentava la stessa identica condizione conservativa del resto

areas that instead underwent a lighter intervention: irregularities in the original painterly surface were however already existent inasmuch as Pontormo had adopted a much more rotund brushstroke for the flesh tones than for the other parts of the painting, also related to the differences in pigment type. The line where the old drapery ended was fairly evident on the bent leg of Venus, while the straight leg and the highlighted shoulder showed traces of a particularly heavy cleaning that had left visible in some parts the gesso and sizing preparation.

The head of Venus appeared to be in the shade with respect to the rest of the body because it was more intact, at least with regard to the lighter tonalities.

Following the removal of the pigmented varnish, the drippings and the thick network of craquelure appeared more evident in those areas of the body of the goddess in which the dirt had penetrated into the underlying preparatory stratum as a result of the action of the soda (fig. 3). Wear had additionally uncovered the veins of the wood creating an ulterior horizontal geometric pattern following the disposition of the slabs of the painting. The underdrawings were also more legible, well documented in the reflectographic investigations, wide brushwork for the bodies, more incisive and executed by tracing for the rest of the painting. The removal of the cloth covering the pubes made clear that Forni himself was responsible for its placement there after the entire surface had been freed from the preceding repainting; the

Fig. 3. Michelangelo-Pontormo, *Venere e Cupido / Venus and Cupid*, particolare durante il restauro / detail during restoration. Firenze, Galleria dell'Accademia.

Figg. 4-5. Michelangelo-Pontormo, *Venere e Cupido / Venus and Cupid*, particolari durante il restauro / details during restoration. Firenze, Galleria dell'Accademia.

del corpo. Il Cupido invece aveva avuto una pulitura più rispettosa e il grigio perlato tipico delle sostanze proteiche era rotto solo sulle creste del colore (fig. 4). Era invece ridipinta completamente la coscia in secondo piano, con un colore assai più uniforme e piatto di quello originale e nascondeva parte di una delle frecce.

Una vasta ridipintura era estesa anche sulla struttura sulla quale poggia l'arco, ma non ne cambiava la forma. Abbastanza singolare nell'angolo sinistro in alto, la differenza di colore nel cielo delimitato dall'arco, nettamente più scuro, ma originale (fig. 5). Piccole mancanze erano localizzate lungo i bordi del dipinto, mentre quelle causate dagli spinotti delle ranghette erano state stuccate nel restauro precedente. In alto, fra l'apice dell'arco e quello dell'ala, alcune difformità insite nel legno creano dei rilievi ineliminabili nella pittura.

La pulitura eseguita nel presente restauro ha cercato di rispettare al massimo gli equilibri cromatici già creati dalla sensibilità del Forni, perfezionandoli e integrandoli dove possibile. Il restauro pittorico eseguito ha poi mirato al riordino generale della pittura, attenuando i contrasti troppo forti, velando le crettature nere e ammorbidendo lo sgradevole effetto delle consunzioni più evidenti, in particolare relativamente all'effetto di griglia geometrica generatosi a seguito della precedente pulitura.

Indagini preliminari eseguite: Radiografia (Opificio delle Pietre Dure), Riflettografia (Opificio delle Pietre Dure e Istituto Nazionale di Ottica Applicata), foto all'ultravioletto (Rossella Lari).

Materiali usati: Crilat, Permetar, Paraloid, essenza di trementina, alcool puro, ammoniaca, cera sbiancata, acetone, gesso, colla di guanto, acquerelli, colori a vernice, resina mastice.

area was in fact uniform in its conservation with the rest of the body. The Cupid instead had undergone a more respectful cleaning and the pearl gray typical of proteinic substances was broken only on the crest of the color (fig. 4). The thigh in the second plane, had instead been entirely repainted with a color significantly more uniform and flattened than the original covering part of one of the arrows. A vast area of repainting also extended over the structure on which the bow rests, but without changing its form. Singularly in the upper left corner, the difference in the color of the sky around the bow is considerably darker but original (fig. 5). Small losses are found along the borders of the painting while those caused by the pins had been stuccoed during the preceding restoration. At the top between the apex of the bow and that of the wing, a few deformations in the wood cause an inevitable raising of the painterly surface.

The cleaning executed during this restoration aimed at maintaining where possible the chromatic balance already created by the sensitivity of Forni, perfecting it and integrating it wherever possible. The pictorial restoration undertaken aimed towards a general reordering of the painting, mitigating contrasts that were too strong, covering the black cracks and softening the unpleasing effect of the more evident abrasions, in particular those resulting from the appearance of a geometric network resulting from the recent cleaning.

Preliminary testing: X-rays (Opificio delle Pietre Dure), Reflectography (Opificio delle Pietre Dure and Istituto Nationale di Ottica Applicata), Ultra-violet photography (Rossella Lari).

Materials used: Crilat, Permatar, Paraloid, turpentine, pure alcohol, ammonia, bleached wax, acetone, gypsum, sizing, watercolors, color varnishes, mastic resin.

Capitolo LXI

COME SI CANCELLANO I PEZZI RIDIPINTI
O RITOCCATI CON TINTE A OLIO

L'alcool che a poco per volta rinviene e cancella i restauri fatti con olii o vernici resinose, come si disse rispetto alle pitture a tempera, or qui usandolo potrebbe nuocere alle tinte originali sottostanti, le quali spesso sono di perfetta conservazione.

La potassa e la soda sono gli opportuni dissolventi per levare un vecchio restauro fatto a olio. Si prepara una lissiva satura dell'uno o dell'altro sale, e con essa, a pennello, si bagna un poco alla volta il pezzo ridipinto, o ritoccato, per cancellarlo. La tinta umettata s'intenerisce subito, per cui è necessario pulirla sollecitamente con uno stoppaccio di cotone bagnato nell'acqua di ragia, onde l'azione alcalina non rimuova il restauro che superficialmente ed a riprese. Con quest'ordine si ripuliscono le parti offese o alterate nell'opera; e quando esse saranno ridotte allo stato di una pellicola sottile, come una velatura, allora umettandole con essenza di spigo o di rosmarino, si cancellano compiutamente per mezzo degli opportuni raschiatoi. Operando con cautela e diligenza, si giunge a fare sparire quegl'imbratti, senza la minima offesa del sottostante dipinto originale, come avvenne appunto della Venere baciata da Cupido, che il Pontormo colorì per Bartolommeo Bettini sul cartone del Buonarroti.

Tornata l'opera nel primitivo suo stato, le parti scoperte dal pulimento compariscono assai più chiare di quelle non alterate dai restauri. Non pertanto si dovranno quest' ultime accordare colle prime, non ripulendole troppo: conviene invece armonizzare le recuperate col totale per mezzo di locali velature a tempera. In tal modo la pittura originale non mostrerà di aver subito verun cambiamento.

La vernice finale ed i piccoli ritocchi occorrenti formeranno il complemento del nuovo restauro.

Ulisse Forni, *Manuale del pittore restauratore*, Le Monnier, Firenze 1866, pp. 135-136

BIBLIOGRAFIA GENERALE

GENERAL BIBLIOGRAPHY

ACIDINI LUCHINAT, CRISTINA, *La fucina artistica di Castello*, in *Le ville e i giardini di Castello e Petraia a Firenze*, a cura di Cristina Acidini Luchinat - Giorgio Galletti, Pacini, Pisa 1992, pp. 13-134.

ACIDINI LUCHINAT, CRISTINA, *Taddeo e Federico Zuccari, fratelli pittori del Cinquecento*, 2 voll., Jandi Sapi, Milano-Roma 1998-1999.

ACKERMAN, GERALD MARTIN, *The Structure of Lomazzo's Treatise on Painting*, tesi di Ph.D., Princeton University, 1964.

ACOCCELLA, MARIANTONIETTA, *L'Asino d'oro nel Rinascimento: dai volgarizzamenti alle raffigurazioni pittoriche*, Longo, Ravenna 2001.

ADELSON, CANDACE J., *The Tapestry Patronage of Cosimo I de' Medici: 1545-1553*, tesi di Ph.D., New York University, 1990.

L'Adolescente dell'Hermitage e la Sagrestia Nuova di Michelangelo, catalogo della mostra (Firenze-Leningrad), a cura di Sergej Androsov - Umberto Baldini, Maschietto & Musolino, Firenze 2000.

AGNELLI, GIOVANNI, *Topo-cronografia del viaggio dantesco*, Hoepli, Milano 1891.

ALAMANNI, LUIGI, *Versi e prose*, a cura di Pietro Raffaelli, 2 voll., Le Monnier, Firenze 1859.

ALBERTI, LEON BATTISTA, *Della Architettura*, trad. di Cosimo Bartoli, a cura di Stefano Ticozzi, a spese degli editori, Milano 1833.

ALBERTI, LEON BATTISTA, *I primi tre libri della famiglia*, Sansoni, Firenze 1946.

ALBERTI, LEON BATTISTA, *Della pittura*, a cura di Luigi Malle, Sansoni, Firenze 1950.

ALBERTI, LEON BATTISTA, *On Painting*, a cura di John R. Spencer, Yale University Press, New Haven-London 1966.

ALBERTI, LEON BATTISTA, *On the Art of Building in Ten Books*, trad. di Joseph Rykwert - Neil Leach - Robert Tavernor, MIT Press, Cambridge (Mass)-London 1988.

ALDROVANDI, ULISSE, *Delle Statue Antiche, che per tutta Roma, in diversi luoghi, et case si veggono*, in LUCIO MAURO, *Le Antichità della Città di Roma* (1556), Ziletti, Venezia 1558, pp. 115-316.

ALIGHIERI, DANTE, *Commedia*, Giunti, Firenze 1506.

ALIGHIERI, DANTE, *Dante col sito, et forma dell'Inferno tratta dalla istessa descrittione del poeta*, Venezia 1515.

AMES-LEWIS, FRANCIS - ROGERS, MARY (a cura di), *Concepts of Beauty in Renaissance Art*, Ashgate, Aldershot 1998.

ANDERSON, JAYNIE, *Giorgione, Titian and the 'Sleeping Venus'*, in *Tiziano e Venezia*, atti del convegno (Venezia 1976), a cura di Neri Pozza - Massimo Gemin - Giannantonio Paladini, Neri Pozza, Vicenza 1980, pp. 337-342.

ANDERSON, JAYNIE, *Giorgione. The Painter of 'poetic brevity'*, Flammarion, Paris-New York 1997.

Andreae Alciati Emblematum fontes quatuor, rist. anast. di Augsburg 1531-Paris 1534-Venezia 1546, a cura di Henry Green, Brothers, Manchester 1870.

Andreas Alciatus, The Latin Emblems, Indexes and lists, a cura di Peter M. Daly - Virginia W. Callahan - Simon Cuttler, 2 voll., University of Toronto Press, Toronto-Buffalo-London 1985.

Antologia di Maestri Antichi, Gallerie d'Arte Armondi, Brescia 1992.

APULEIO, *Le metamorfosi o l'asino d'oro*, trad. di Claudio Annaratone, testo latino a fronte, Rizzoli, Milano 1994.

APULEIO, *Metamorphoses*, trad. di J. Arthur Hanson, Loeb Classical Library, Cambridge (Mass)-London 1996.

ARETINO, Pietro, *Lettere*, a cura di Fausto Nicolini, 2 voll., Laterza, Bari 1916.

ARETINO, PIETRO, *Lettere sull'Arte*, ed. commentata da Fidenzio Pertile e riveduta da Carlo Cordié, a cura di Ettore Camesasca, 3 voll., Ed. del Milione, Milano 1957-1960.

ARETINO, PIETRO, *Sei giornate*, a cura di Giovanni Aquilecchia, Laterza, Bari 1969.

ARMENINI, GIOVANNI BATTISTA, *De' veri precetti della pittura* (1586), a cura di Marina Gorreri, Einaudi, Torino 1988.

ASHOFF WIEBKE, *Studien zu Niccolò Tribolo*, Inaugural Dissertation, J. W. Goethe Universität, Frankfurt am Main-Berlin 1967.

BACCHESCHI, EDI, *L'opera completa del Bronzino*, Rizzoli, Milano 1973.

BAMBACH, CARMEN C., *Drawing and Painting in the Italian Renaissance workshop: Theory and Practise,1300-1600*, Cambridge University Press, Cambridge-New York 1999.

BALAS, EDITH, *Michelangelo's Medici Chapel: a New Interpretation*, American Philosophical Society, Philadelphia 1995.

BALDINI, NICOLETTA, *Nuovi documenti e alcune ipotesi su Niccolò di Raffaello di Niccolò detto il Tribolo*, in *Niccolò detto il Tribolo tra arte, architettura e paesaggio*, atti del convegno (Poggio a Caiano 2000), a cura di Elisabetta Pieri - Luigi Zangheri, Tipografia Nova, Signa 2001, pp. 19-28.

BAREGGI, CLAUDIA DI FILIPPO, *In nota alla politica culturale di Cosimo I: L'Accademia Fiorentina*, "Quaderni storici", VII, 1973, pp. 527-574.

BARKAN, LEONARD, *The Beholder's Tale: Ancient Sculpture, Renaissance Narratives*, "Representations", XLIV, 1993, pp. 133–166.

BARKAN, LEONARD, *Unearthing the Past: Archeology and Aesthetics in the Making of Renaissance Culture*, Yale University Press, New Haven-London 1999.

BARNES, BERNADINE, *Michelangelo's Last Judgment. The Renaissance Response*, University of California Press, Berkeley-Los Angeles-London 1998.

BAROCCHI, PAOLA, *Il Rosso Fiorentino*, Gismondi, Roma 1950.

BAROCCHI PAOLA, a cura di, *Trattati d'arte del Cinquecento, fra Manierismo e Controriforma*, 3 voll., Laterza, Bari 1960-1962.

BAROCCHI, PAOLA, *Michelangelo e la sua scuola. I disegni di Casa Buonarroti e degli Uffizi*, Olschki, Firenze 1962.

BAROCCHI, PAOLA, *Michelangelo e la sua scuola. I disegni dell'Archivio Buonarroti*, Olschki, Firenze 1964.

BAROCCHI PAOLA, a cura di, *Scritti d'arte del Cinquecento*, 3 voll., Einaudi, Torino 1977-1979.

BAROLSKY, PAUL, *The faun in the garden. Michelangelo and the poetic origins of Italian Renaissance art*, Pennsylvania State University Press, University Park (Penn) 1994.

Bartolomeo Cavaceppi scultore romano (1717-1799), catalogo della mostra (Roma), a cura di Maria Giulia Barberini - Carlo Gasparri, Palombi, Roma 1994.

BARZMAN, KAREN-EDIS, *The Florentine Academy and the Early Modern State. The Discipline of Disegno*, Cambridge University Press, Cambridge-New York 2000.

BASKINS, CRISTELLE L., *Cassone Painting, Humanism, and Gender in Early Modern Italy*, Cambridge University Press, Cambridge-New York 1998.

BECHERUCCI, LUISA, *Manieristi toscani*, Istituto italiano d'arti grafiche, Bergamo 1944.

BÉGUIN, SYLVIE, *Lotto et Venise*, in *Le Siècle de Titien. L'âge d'or de la peinture à Venise*, a cura di Michel Laclotte - Giovanna Nepi Scirè, Éditions de la Réunion des Musées Nationaux, Paris 1993, pp. 539-550.

BEMBO, PIETRO, *Prose e rime*, a cura di Carlo Dionisotti, Utet, Torino 1960.

BENIVIENI, GIROLAMO, *Opere di Hieronymo Benivieni*, Giunti, Firenze 1519.

BENIVIENI, GIROLAMO, *Commento di Hieronymo Benivieni sopra a più sue*

canzone e sonetti dello Amore e della Bellezza divina, Tubini, Firenze 1500.

BENSON, PAMELA JOSEPH, The Invention of the Renaissance Woman. The Challenge of Female Independence in the Literature and Thought of Italy and England, Pennsylvania State University Press, University Park (Penn) 1992.

BERENSON, BERNARD, The Drawings of the Florentine Painters: classified, criticised and studied as documents in the history and appreciation of Tuscan art ; with a copious catalogue raisonné, 2 voll., Murray, London 1903.

BERENSON, BERNARD, The Drawings of the Florentine Painters. Amplified edition, 3 voll., University of Chicago Press, Chicago 1938 [trad. Electa, Milano 1961].

BERENSON, BERNARD, Italian Pictures of the Renaissance. A List of the Principal Artists and their Works with an Index of Places. Florentine School, 2 voll., Phaidon, London 1963.

BERENSON, BERNARD, Italian Pictures of the Renaissance. A List of the Principal Artists and their Works with an Index of their Works. Central Italian and North Italian Schools, 3 voll., Phaidon, London 1968.

BERNI, FRANCESCO, I capitoli del Berni in terza rima, nuovamente con somma diligentia stampate, Navo, Venezia 1538.

BERNOULLI, JOHAN JACOB, Aphrodite, ein Baustein zu griechischen Kunstmitologie, Engelmann, Leipzig 1873.

BERTI, LUCIANO, Pontormo, Il Fiorino, Firenze 1964.

BERTI, LUCIANO, L'opera completa del Pontormo, Rizzoli, Milano 1973.

BERTI, LUCIANO, I Disegni, in Michelangelo 1965, pp. 389-506.

BERTI, LUCIANO, Pontormo e il suo tempo, Le Lettere, Firenze 1993.

BOBER, PHYLLIS PRAY - RUBINSTEIN, RUTH, Renaissance Artists and Antique Sculpture. A handbook of sources, Oxford University Press, London-Oxford 1986.

BOCCHI, FRANCESCO, Le bellezze della città di Fiorenza dove à pieno di pittura, di scultura, di sacri tempij, di palazzi i più notabili artifizi & più preziosi si contengono, Bartolomeo Sermartelli, Firenze 1591.

BOCCHI, FRANCESCO, Le bellezze della città di Fiorenza , rist. anast.di Firenze 1591, Gregg, Farnborough 1971.

BOLZONI, LINA, La stanza della Memoria, Einaudi, Torino 1995 [trad. di Jeremy Parzen, University of Toronto Press, Toronto 2002].

BORGHINI, RAFFAELLO, Il riposo, 3 voll., dalla Società Tipografica de' Classici Italiani, Milano 1807.

BORGHINI, RAFFAELLO, Il riposo (1584), a cura di Mario Rosci, 2 voll., Edizioni Labor, Milano 1967.

BOSCH, LYNETTE M. F., Time, Truth & Destiny: Some Iconographical Themes in Bronzino's 'Primavera' and 'Giustizia', "Mitteilungen des Kunsthistorisches Institutes in Florenz", XXVII, 1983, pp. 75-82.

BOWRON, EDGAR PETERS, Giorgio Vasari's 'Portrait of Six Tuscan Poets', "Bulletin of the Minneapolis Institute of Arts", LX, 1971-73, pp. 43-53.

I bozzetti michelangioleschi della Casa Buonarroti, a cura di Pina Ragionieri, Mandragora, Firenze 2000.

BRACCIANTE, ANNA MARIA, Ottaviano de' Medici e gli artisti, SPES, Firenze 1984.

BREJON DE LAVERGNÉE, ARNAULD, L'inventaire Le Brun de 1683: la collection des tableaux de Louis XIV, Editions de la Réunion des Musées Nationaux, Paris 1987.

Bronzetti e anticaglie della Guardaroba di Cosimo I, catalogo della mostra (Firenze), a cura di Anna Maria Massinelli, SPES, Firenze 1991.

BRONZINO, AGNOLO ALLORI (DETTO IL), Sonetti di Angiolo Allori detto il Bronzino ed altre rime inedite di più insigni poeti, a cura di Domenico Moreni, Magheri, Firenze 1823.

BRONZINO, AGNOLO ALLORI (DETTO IL), Rime in burla, a cura di Franca Petrucci Nardelli, Istituto della Enciclopedia Italiana, Roma 1988.

BROWN, BEVERLY LOUISE, Dall'inferno al paradiso: paesaggio e figure a Venezia agli inizi del XVI secolo, in Il Rinascimento a Venezia e la pittura del Nord ai tempi di Bellini, Dürer, Tiziano, catalogo della mostra (Venezia), a cura di Bernard Aikema - Beverly Louise Brown, Bompiani, Milano 1999, pp. 424-431.

BRUNNER, MICHAEL, Storia del «Dante historiato da Federico Zuccaro», in Federico Zuccari e Dante, catalogo della mostra (Torre de' Passeri), a cura di Corrado Gizzi, Electa, Milano 1993, pp. 71-74.

BULLARD, MELISSA M., 'Mercatores Florentini Romanam Curiam Sequentes' in the early sixteenth century, "Journal of Medieval and Renaissance Studies", VI, 1976, pp. 51-71.

BUONARROTI, MICHELANGELO, Rime di Michelangelo Buonarroti. Raccolte da Michelagnolo suo Nipote, Giunti, Firenze 1623.

BUONARROTI, MICHELANGELO, Le Rime di Michelangelo Buonarroti pittore scultore e architetto cavate dagli autografi e pubblicate da Cesare Guasti accademico della Crusca, Le Monnier, Firenze 1863.

BUONARROTI, MICHELANGELO, Die Dichtungen des Michelangelo Buonarroti, a cura di Carl Frey, Grote, Berlin 1897.

BUONARROTI, MICHELANGELO, Rime, a cura di Enzo Noè Girardi, Laterza, Bari 1960 [II ed. 1967].

BUONARROTI, MICHELANGELO, The Letters of Michelangelo, 2 voll., trad. di E. H. Ramsden, Stanford University Press, Stanford 1963.

BUONARROTI, MICHELANGELO, Il carteggio di Michelangelo, 5 voll., edizione postuma di Giovanni Poggi, a cura di Paola Barocchi - Renzo Ristori, Sansoni, Firenze 1965-1983.

BUONARROTI, MICHELANGELO, Complete Poems and Selected Letters, trad. di Creighton Gilbert, II ed., Princeton University Press, Princeton 1980.

BUSINI, GIOVAMBATTISTA, Lettere di Giovambattista Busini a Benedetto Varchi sopra l'Assedio di Firenze, a cura di Gaetano Milanesi, Le Monnier, Firenze 1860.

BUTI, GIOVANNI - BERTAGNI, RENZO, Commento astronomico della Divina Commedia, Sandron, Firenze 1966.

CADDEN, JOAN, Meanings of Sex Difference in the Middle Ages: Medicine, science and culture, Cambridge University Press, Cambridge-New York 1993.

CARO, ANNIBALE, Lettere familiari, a cura di Aulo Greco, 3 voll., Le Monnier, Firenze 1957-1961.

CARTARI, VINCENZO, Imagini dei Dei degli Antichi, Marcolini, Venezia 1556.

CARTARI, VINCENZO, Imagini degli Dei degli Antichi (1647), rist. anast. a cura di Marco Bussagli - Mario Bussagli, Nuova Stile Regina Editrice, Genova 1987.

CARTARI, VINCENZO, Le immagini degli Dèi, a cura di Caterina Volpi, De Luca, Roma 1996.

Catalogo della Collezione Gorga, Raccolte archeologiche e artistiche, Istituto Poligrafico dello Stato, Roma 1948.

Catalogue of the Entire Collection of Pictures Belonging to Robert Udny, Esq., Deceased, London 1802.

CAVALCANTI, GUIDO, Rime, con le rime di Iacopo Cavalcanti, a cura di Domenico De Robertis, Einaudi, Torino 1986.

CECCHI, ALESSANDRO, "Famose Frondi de cui santi honori…" un sonetto del Varchi e il ritratto di Lorenzo Lenzi dipinto dal Bronzino, "Artista. Critica d'arte in Toscana", II, 1990, pp. 8-19.

CECCHI, ALESSANDRO, Il Bronzino, Benedetto Varchi e l'Accademia Fiorentina: ritratti di poeti, letterati e personaggi illustri della corte medicea, "Antichità viva", XXX, 1-2, 1991, pp. 17-28.

CECCHI, ALESSANDRO, Bronzino, Scala, Antella 1996.

CELLINI, BENVENUTO, The Autobiography of Benvenuto Cellini, trad. di John Addington Symonds, a cura di Charles Hope - Alessandro Nova, Phaidon, London 1983.

CELLINI, BENVENUTO, La vita, a cura di Carlo Cordié, Ricciardi, Milano-Napoli 1996.

CENNINI, CENNINI, Il libro dell'arte, a cura di Franco Brunello, Pozza, Vicenza 1971.

CHASTEL, ANDRÉ, Art et humanisme à Florence au temps de Laurent le Magnifique, Presses universitaires de France, Paris 1961.

CHENEY, IRIS, Francesco Salviati (1510-1563), tesi di Ph.D., New York University, 1963.

CHIAVACCI LEONARDI, ANNA MARIA, Il libro di Dante dalle prime copie manoscritte all'edizione della Crusca, in Pagine di Dante. Le edizioni della Divina Commedia dal torchio al computer, Electa/Editori Umbri Associati, Perugia 1989, pp. 51-64.

CHRISTIANSEN, KEITH, Lorenzo Lotto and the Tradition of Ephithalamic Paintings, "Apollo", CXXIV, 1986, pp. 166-173.

Christie's Important Old Master Pictures, Christie's, London 13 dicembre 2000.

CLAPP, FREDERICK MORTIMER, Les Dessins de Pontormo. Catalogue raisonné, Champion, Paris 1914.

CLAPP, FREDERICK MORTIMER, Jacopo Carucci da Pontormo. His Life & Work, Oxford University Press, London 1916.

CLARK, KENNETH, The Nude. A Study in Ideal Form, A.W. Mellon Lectures in the Fine Arts, Pantheon Books, New York 1956.

COCHRANE, ERIC, Florence in the Forgotten Centuries, 1527-1800. A History of Florence and the Florentines in the Age of the Grand Dukes, University of Chicago Press, Chicago-London 1973.

Il Codice Magliabechiano, cl. XVII.17 contenente notizie sopra l'arte degli antichi e quella dei Fiorentini da Cimabue a Michelangelo Buonarroti scritte da Anonimo Fiorentino, a cura di Carl Frey, Grote, Berlin 1892.

COHN, SAMUEL, The Laboring Classes in Renaissance Florence, Academic Press, New York 1980.

COLLARETA, MARCO, Michelangelo e le statue antiche: un probabile intervento di restauro, "Prospettiva", XLIII, 1985, pp. 51-55.

COLLI CALMETA, VINCENZO, Della

ostentazione, in *Prose e lettere edite e inedite*, a cura di Cecil Grayson, Commissione per i testi di lingua, Bologna 1959.

CONDIVI, ASCANIO, *Vita di Michelangelo Buonarroti, pittore, scultore, architetto e gentiluomo fiorentino* (1553), II ed., note di Anton Francesco Gori - Pierre Jean Mariette - Filippo Buonarroti, Albizzini, Firenze 1746.

CONDIVI, ASCANIO, *Vita di Michelangelo Buonarroti* (1553), a cura di Giovanni Nencioni, SPES, Firenze 1998.

CONTI, ALESSANDRO, *Pontormo*, Jaca Book, Milano 1995.

CORDIÉ, CARLO, *L'umanista Antonio Pelotti traduttore dell'Amor fuggitivo di Mosco*, "Rendiconti dell'Istituto lombardo di scienze e lettere", LXXXIII, 1950, pp. 425-438.

Correggio and His Legacy. Sixteenth-Century Emilian Drawings, catalogo della mostra (Washington), a cura di Diane De Grazia, National Gallery of Art, Washington 1984.

CORTI, GINO, *Two Early Seventeenth-Century Inventories Involving Giambologna*, "The Burlington Magazine", CXVIII, 1976, pp. 629-633.

CORTI, LAURA, *Vasari. Catalogo completo*, Cantini, Firenze 1989.

COSTAMAGNA, PHILIPPE, *Pontormo. Catalogue raisonné de l'œuvre peint*, ed. francese e italiana, Gallimard-Electa, Paris-Milano 1994.

COSTAMAGNA, PHILIPPE, *La collection de peintures d'une famille florentine établie à Rome: L'inventaire après décès du duc Anton Maria Salviati dressé en 1704*, "Nuovi studi. Rivista di arte antica e moderna", VIII, 2000, pp. 177-233.

COSTAMAGNA, PHILIPPE, *De l'idéal de beauté aux problèmes d'attribution. Vingt ans de recherche sur le portrait florentin au XVI^e siècle*, "Studiolo. Revue d'histoire de l'art de l'Académie de France à Rome", I, 2002, pp. 193-220.

COVI, DARIO A., *Four new documents concerning Andrea del Verrocchio*, "Art Bullettin", XLVIII, 1966, pp. 97-103.

COX-REARICK, JANET, *The Drawings of Pontormo*, Harvard University Press, Cambridge (Mass) 1964.

COX-REARICK, JANET, *The Drawings of Pontormo: Addenda*, "Master Drawings", VIII, 1970, pp. 363-378.

COX-REARICK, JANET, *The Drawings of Pontormo. A Catalogue Raisonné with Notes on the Paintings*, ed. anast., con prefazione, addenda e corrigenda, 2 voll., Hacker Art Books, New York 1981.

COX REARICK, JANET, *Themes of Time and Rule at Poggio a Caiano: the Portico Frieze of Lorenzo il Magnifi-*

co, "Mitteilungen des Kunsthistorisches Institutes in Florenz", XXVI, 1982, pp. 167-210.

COX-REARICK, JANET, *Dynasty and Destiny in Medici Art: Pontormo, Leo X and the Two Cosimos*, Princeton University Press, Princeton 1984.

COX-REARICK, JANET, *The Collection of Francis I. Royal Treasures*, ed. inglese e francese, Abrams - Fonds Mercator Paribas, New York-Antwerp 1995.

COX-REARICK, JANET - FREEDBERG, SYDNEY J., *A Pontormo (partly) recovered*, "The Burlington Magazine", CXXV, 1983, pp. 521-527.

CROPPER, ELIZABETH, *Pontormo. Portrait of a Halberdier*, Getty Museum Studies on Art, Los Angeles 1997.

Da Antonello da Messina a Rembrandt: Capolavori d'arte europea dal Museo Nazionale d'Arte di Romania, Bucarest e dal Museo Nazionale Brukenthal, Sibiu, catalogo della mostra (Milano), a cura di Grigore Arbore Popescu, Electa, Milano 1996.

DALEY DAVIS, MARGARET, *Zum Codex Coburgensis: Frühe Archäologie und Humanismus im Kreis des Marcello Cervini*, in *Antikenzeichnung und Antikenstudium in Renaissance und Frübarock*, atti del convegno (Coburg 1986), a cura di Richard Harprath - Henning Wrede, Philip von Zabern, Mainz am Rhein 1989, pp. 184-199.

DALLI REGOLI, GIGETTA, *Precisazioni sul Credi*, "Critica d'Arte", XVIII, 1971, pp. 67-80.

DAMISCH, HUBERT, *Le Judgement de Paris: Iconologie analytique 1*, Flammarion, Paris 1992.

DAN, PÈRE, *Le trésor des merveilles de la maison royale de Fontainebleau*, Sebastien Cramoisy, Paris 1642.

Da Sodoma a Marco Pino. Pittori a Siena nella prima metà del Cinquecento, catalogo della mostra (Siena), a cura di Fiorella Sricchia Santoro, SPES, Firenze 1988.

Da Sodoma a Marco Pino. Addenda, a cura di Fiorella Sricchia Santoro, SPES, Firenze 1991.

DAVIS, CHARLES, *Per la attività romana del Vasari nel 1553: incisioni degli affreschi di Villa Altoviti e la Fontanalia di Villa Giulia*, "Mitteilungen des Kunsthistorischen Institutes in Florenz", XXIII, 1979, pp. 197-224.

DE GAETANO, ARMAND L., *Giambatista Gelli and the Florentine Academy. The Rebellion Against Latin*, Olschki, Firenze 1976.

DELACRE, MAURICE, *Le Dessin de Michel-Ange*, Académie Royale de Belgique, Bruxelles 1938.

DELIVORRIAS, ANGELOS - BERGER-DOER,

GRATIA - FLEISCHER, ROBERTO - KOSSATZ-DEISSMANN, ANNELISE, *Aphrodite* (ad vocem), in *Lexicon Iconographicum*, II, 1984, pp. 2-151.

DELUMEAU, JEAN, *Vie économique et sociale de Rome dans la seconde moitié du XVI^e siècle*, 2 voll., E. de Boccard, Paris 1957.

DELLA CHIESA D'ISASCA, ELEONORA, *Un bozzetto in terracotta raffigurante "La Notte" della tomba medicea di Michelangelo attribuito a Niccolò Tribolo*, tesi della Scuola di specializzazione in tutela e valorizzazione dei beni storico-artistici, Università della Tuscia, Viterbo, a. a. 2001-2002.

DEMPSEY, CHARLES, *Inventing the Renaissance Putto*, University of North Carolina Press, Chapel Hill-London 2001.

DENTI, MARIO, *Afrodite Pudica semipanneggiata*, *Archeologia Classica*, XXXVII, 1985, pp. 138-153.

DE RIDDER, ANDRÉ, *Colletion de Clercq*, III, *Les bronzes*, Ernest Leroux, Paris 1905.

Descrizione del convito e delle feste fatte in Pesaro per le nozze di Costanzo Sforza et di Cammilla d'Aragona nel maggio del 1475, a cura di Marco Tabarrini, Babèra, Firenze 1870.

DI GIAMPAOLO, MARIO, *Parmigianino, catalogo completo*, Cantini, Firenze 1991.

DI GIAMPAOLO, MARIO - MUZZI, ANDREA, *Correggio. I disegni*, Allemandi, Torino 1988.

DI GIAMPAOLO, MARIO - MUZZI, ANDREA, *Correggio. Catalogo completo dei dipinti*, Cantini, Firenze 1993.

Il disegno fiorentino del tempo di Lorenzo il Magnifico, catalogo della mostra (Firenze), a cura di Annamaria Petrioli Tofani, Silvana, Cinisello Balsamo 1992.

The divine Michelangelo: the Florentine Academy's homage on his death in 1564, introduzione, traduzione e note di Rudolf e Margot Wittkower, Phaidon, London 1964.

Dizionario biografico degli italiani, Istituto della Enciclopedia Italiana, Roma, 1960-

DOLCE, LUDOVICO, *Dialogo della pittura di m. Lodovico Dolce, intitolato L'Aretino*, Giolito, Venezia 1557.

Domenico Beccafumi e il suo tempo, catalogo della mostra (Siena), a cura di Fiorella Sricchia Santoro, Electa, Milano 1990.

DUSSLER, LUITPOLD, *Die Zeichnungen des Michelangelo, kritischer Katalog*, Mann, Berlin 1959.

L'Ecole de Fontainebleau, catalogo della mostra (Paris), a cura di Sylvie Béguin, Editions de la Réunion des

Musées Nationaux, Paris 1972.

EISENBICHLER, KONRAD, *The Boys of the Archangel Raphael, A Youth Confraternity in Florence, 1411-1785*, University of Toronto Press, Toronto-Buffalo-London 1998.

ELAM, CAROLINE, *"Che ultima mano". Tiberio Calcagni's postille to Condivi's Life of Michelangelo*, in Condivi 1998, pp. XXIII-XLVI.

EMILIANI, ANDREA, *Il Bronzino*, con un'antologia poetica, scelta e presentata da Giorgio Cerboni Baiardi, Bramante Editrice, Busto Arsizio 1960.

EQUICOLA, MARIO, *Libro di natura d'amore*, Lorio, Venezia 1525.

Eros Grec: Amour des Dieux et des Hommes, catalogo della mostra (Athènes-Paris), Ministère de la Culture de Grèce-Réunion des Musées Nationaux, Athènes-Paris 1989.

EVEN, YAEL, *The Heroine as Hero in Michelangelo's Art*, "Woman's Art Journal", XI, 1990, pp. 29-33.

FAZZINI, ANTONIO, *Collezionismo privato nella Firenze del Cinquecento. L'appartamento nuovo di Jacopo di Alamanno Salviati*, "Annali della Scuola Normale Superiore di Pisa. Classe di lettere e filosofia", 3-XXIII, 1993, pp. 191-224.

FENZI, ENRICO, *La canzone d'amore di Guido Cavalcanti e i suoi antichi commenti*, Il melangolo, Genova 1999.

FERMOR, SHARON, *Movement and Gender in Sixteenth-Century Italian Painting*, in *The Body Imaged. The Human Form and Visual Culture since the Italian Renaissance*, a cura di Kathleen Adler - Marcia Pointon, Cambridge University Press, Cambridge-New York 1993, pp. 129-146.

FERMOR, SHARON, *Poetry in motion: beauty in movement and the Renaissance concept of leggiadrìa*, in Ames-Lewis - Rogers 1998, pp. 124-133.

FICINO, MARSILIO, *De Amore*, a cura di Neri Dortelata (pseud. di Cosimo Bartoli, Pierfrancesco Giambullari), Torrentino, Firenze 1544.

FICINO, MARSILIO, *Commentaire sur le Banquet de Platon*, a cura di Raymond Marcel, Les Belles Lettres, Paris 1956.

FICINO, MARSILIO, *El libro dell'Amore*, a cura di Sandra Niccoli, Olschki, Firenze 1987.

FILIERI, ELIANA, *Disegni di "metalli" antichi del Fondo Corsini*, "Xenia", XXII, 1991, pp. 49-121.

FIRENZUOLA, AGNOLO, *Rime di M. Agnolo Firenzuola Fiorentino*, Giunti, Firenze 1549.

FIRENZUOLA, AGNOLO, *Apulejo, dell'Asino d'Oro, tradotto per M. Agnolo Fi-*

renzuola Fiorentino, Giolito, Venezia 1550.

FIRENZUOLA, AGNOLO, *Opere*, a cura di Adriano Seroni, Sansoni, Firenze 1958.

FIRENZUOLA, AGNOLO, *On the beauty of women*, trad. e a cura di Konrad Eisenbichler - Jacqueline Murray, University of Pennsylvania Press, Philadelphia 1992.

FIRPO, MASSIMO, *Gli affreschi di Pontormo a San Lorenzo: eresia, politica e cultura nella Firenze di Cosimo I*, Einaudi, Torino 1997.

FOLENA, GIANFRANCO, *La tradizione delle opere di Dante Alighieri*, in *Atti del congresso internazionale di studi danteschi*, 2 voll., Sansoni, Firenze 1965, I, pp. 49-51.

FORLANI TEMPESTI, ANNA - CAPRETTI, ELENA, *Piero di Cosimo. Catalogo completo*, Cantini, Firenze 1996.

FORLANI TEMPESTI, ANNA - GIOVANNETTI, ALESSANDRA, *Pontormo*, Cantini, Firenze 1994.

FORNI, ULISSE, *Manuale del pittore restauratore*, Le Monnier, Firenze 1866.

FORSTER, KURT W., *Pontormo. Monographie mit kritischem Katalog*, Bruckmann, München 1966.

FORTINI BROWN, PATRICIA, *Venice and Antiquity, The Venetian Sense of the Past*, Yale University Press, New Haven-London 1996.

Fortuna di Michelangelo nell'incisione, catalogo della mostra (Benevento), a cura di Mario Rotilli, con la collaborazione di Maria Catelli Isola, Abete, Benevento 1964.

Francesco Morandini detto il Poppi. I disegni. I dipinti di Poppi a Castiglion Fiorentino, catalogo della mostra (Poppi), a cura di Alessandra Giovannetti, Ed. della Biblioteca Comunale Rilliana, Firenze 1991.

Francesco Salviati (1510-1563) o la Bella Maniera, catalogo della mostra (Roma-Paris), a cura di Catherine Monbeig Goguel, Electa-Editions de la Réunion des Musées Nationaux, Milano-Paris 1998.

FRANGENBERG, THOMAS, *The notion of beauty in Francesco Bocchi's "Bellezze della città di Fiorenza"*, I, in Ames-Lewis - Rogers 1998, pp. 191-198.

FRANKLIN, DAVID, recensione di *Rosso* 1987, "The Burlington Magazine", CXXX, 1988, pp. 323- 326.

FRANKLIN, DAVID, *Painting in Renaissance Florence, 1500-1550*, Yale University Press, New Haven-London 2001.

FRATI, LODOVICO, *Giuochi ed amori alla corte d'Isabella d'Este*, "Archivio Storico Lombardo", IX, 1898, pp. 350-365.

FREEDBERG, DAVID, *The Power of Images. Studies in the History and Theory of Response*, University of Chicago Press, Chicago-London 1989 [trad it. Einaudi, Torino 1993].

FREEDBERG, SYDNEY J., *Parmigianino, His Works in Painting*, Harvard University Press, Cambridge (Mass) 1950.

FREEDBERG, SYDNEY J., *Painting in Italy 1500-1600*, II ed., Penguin, London 1983.

The French Renaissance in Prints from the Bibliothèque Nationale de France, catalogo della mostra (Los Angeles), Gardner Lithograph, Buena Park California 1994.

FURTWÄNGLER, ADOLF, *Die antiken Gemmen. Geschichte der Steinschneidekunst im klassischen Altertum*, 3 voll., Giesecke & Devrient, Leipzig-Berlin 1900.

GAMBA, CARLO, *Il Pontormo*, Fratelli Alinari, Firenze 1921.

GAMURRINI, EUGENIO, *Istoria genealogica delle famiglie nobili Toscane, & Umbre* (1679), 5 voll., Forni, Bologna 1972.

GANDOLFO, FRANCESCO, *Il "dolce tempo": mistica, ermetismo e sogno nel Cinquecento*, Bulzoni, Roma 1978.

GASTON, ROBERT W., *Love's Sweet Poison: New Reading of Bronzino's London Allegory*, "I Tatti Studies: Essays in the Renaissance", IV, 1991, pp. 249-288.

GASTON, ROBERT W., *Sacred Erotica: The Classical figura in Religious Painting of the Early Cinquecento*, "International Journal of the Classical Tradition", II, 1995, pp. 238-264.

The Genius of the Sculptor in Michelangelo's Work, catalogo della mostra (Montreal), a cura di Pietro C. Marani, Montreal Museum of Fine Arts, Montreal 1992.

GIANNOTTI, DONATO, *Dialogi de' giorni che Dante consumò nel cercare l'Inferno e 'l Purgatorio*, a cura di Deoclecio Redig De Campos, Sansoni, Firenze 1939.

GILBERT, CREIGHTON, *The Proportion of Women*, in *Michelangelo on and off the Sistine Ceiling. Selected Essays*, Braziller, New York 1994, pp. 59-114.

GINZBURG, CARLO, *Tiziano, Ovidio e i codici della figurazione erotica del Cinquecento*, "Paragone", XXIX, 339, 1978, pp. 3-24.

GIORGI, ROBERTA, *Tiziano. Venere, Amore e il Musicista in cinque dipinti*, Gangemi, Roma 1990.

Giorgio Vasari. Principi letterati e artisti nelle carte di Giorgio Vasari. La pittura vasariana dal 1532 al 1554, catalogo della mostra (Arez-

zo), Edam, Firenze 1981.

GIOVANNETTI, ALESSANDRA, *Francesco Morandini detto il Poppi*, Edifir, Firenze 1995.

Giovinezza di Michelangelo, catalogo della mostra (Firenze), a cura di Kathleen Weil-Garris Brandt - Cristina Acidini Luchinat - James David Draper - Nicholas Penny, Artificio-Skira, Firenze-Milano 1999.

GIOVIO, PAOLO, *Elogia Virorum literis illustrium quotquot vel nostra vel avorum memoria vixere*, Perna, Basel 1577.

GOFFEN, RONA, *Titian's Women*, Yale University Press, New Haven-London 1997.

GOFFEN, RONA, *Mary's Motherhood according to Leonardo and Michelangelo*, "Artibus et historiae. An art anthology", XL, 1999, pp. 35-69.

GOGUEL, CATHERINE MOMBEIG, *La madre-amante di Pontormo*, "Giornale dell'arte", giugno 1994, p. 62.

GOLDSCHEIDER, LUDWIG, *A Survey of Michelangelo's Models in Wax and Clay*, Phaidon, London 1962.

GOLDTHWAITE, RICHARD A., *Local Banking in Renaissance Florence*, "Journal of European Economic History", XIV, 1985, pp. 5-55.

GOLDTHWAITE, RICHARD A., *The Empire of Things: Consumer Demand in Renaissance Italy*, in *Patronage, Art, and Society in Renaissance Italy*, a cura di F. W. Kent - Patricia Simons, Clarendon, Oxford 1987, pp. 153-175.

GOLDTHWAITE, RICHARD A., *Wealth and the Demand for Art in Italy 1300-1600*, The John Hopkins University Press, Baltimore-London 1993.

GOMBRICH, ERNST H., *Michelangelo's Cartoon in the British Musem*, in Gombrich, Ernst H., *New Light on Old Masters*, Phaidon, London 1986, pp. 171-178.

GOMBRICH, ERNST H., *Sleeper awake!: a literary parallel to Michelangelo's drawing of 'The Dream of Human Life'*, in *Festschrift für Konrad Oberhuber*, a cura di Achim Gnann - Heinz Widauer, Electa, Milano 2000, pp. 130-132.

GORNI, GUGLIELMO, *Il nodo della lingua e il verbo d'Amore: studi su Dante e altri duecentisti* [recensione di Sonetti 1977], Olschki, Firenze 1981.

GORI, ANTONIO FRANCESCO, *Museum Etruscum exibens insigna veterum etruscorum monumenta, nunc primum edita et illustrata observationibus Antonii Francisci Gorii publici historiarum professoris volumen primum [-tertium]*, Gaetano Albizzini, Firenze 1737-1743.

GOULD, CECIL, *The Paintings of Cor-*

reggio, Faber & Faber, London 1976.

The Greek Anthology, 5 voll., trad. di William Roger Paton, Heinemann, London 1956-1960.

The Greek Bucolic Poets, trad. di John Maxwell Edmonds, Heinemann, London 1912.

GUERRAZZI, FRANCESCO DOMENICO, *L'assedio di Firenze*, 2 voll., Le Monnier, Firenze 1859.

HAAS, LOUIS, *'Il mio buono compare': Choosing Godparents and the Uses of Baptismal Kinship in Renaissance Florence*, "Journal of Social History", XXIX, 1995, pp. 341- 356.

HARRISON, JEFFERSON CABEL JR., *The paintings of Maerten van Heemskerck: a catalogue raisonné*, 2 voll., tesi di Ph.D., University of Virginia, 1987.

HELMSTUTLER DI DIO, KELLEY, *Leone Leoni's Art Collection in the Casa degli Omenoni in Milan: The 1609 Inventory*, "The Burlington Magazine", in corso di stampa.

HERSEY, GEORGE L., *The Evolution of Allure: Sexual Selection from the Medici Venus to the Incredible Hulk*, MIT Press, Cambridge (Mass) 1996.

HIBBARD, HOWARD, *Michelangelo*, II ed., Penguin, London-New York 1985.

HIRST, MICHAEL, *Michelangelo Drawings in Florence*, "The Burlington Magazine", CV, 1963, pp. 166-171.

HIRST, MICHAEL, *Michelangelo and his Drawings*, Yale University Press, New Haven-London 1988.

HORNIK, HEIDI JOSEPHA, *Michele di Ridolfo del Ghirlandaio (1503-1577) and the reception of mannerism in Florence*, tesi di Ph.D., Pennsylvania State University, 1990.

HUGHES, ANTHONY, *A Lost Poem by Michelangelo?*, "Journal of the Warburg and Courtauld Institutes", XLIV, 1981, pp. 202-206.

HUTTON, JAMES, *The Greek Anthology in Italy to the Year 1800*, Cornell University Press, Ithaca 1935.

Inventaire des tableaux du Roy rédigé en 1709 et 1710 par Nicolas Bailly, a cura di Fernand Engerand, Leroux, Paris 1899.

JACOBS, FEDERIKA H., *Aretino and Michelangelo, Dolce and Titian: Femmina, Masculo, Grazia*, "Art Bulletin", LXXXII, 2000, pp. 51-67.

JAFFÉ, DAVID, *Daniele da Volterra's Satirical Defense of his Art*, "Journal of the Warburg and Courtauld Institutes", LIV, 1991, pp. 247-252.

JOANNIDES, PAUL, recensione di *Tolnay 1975-1980*, "Art Bulletin", LXIII, 1981, pp. 679-687.

JOANNIDES, PAUL, *A Newly Unveiled Drawing by Michelangelo and the Early Iconography of the Magnifici Tomb*, "Master Drawings", XXIX, 1991, pp. 255-262.

JOANNIDES, PAUL, *Salviati e Michelangelo*, in *Francesco Salviati* 1998, pp. 53-55.

JOANNIDES, PAUL, *Inventaire général des dessins italiens*, VI, *Michel-Ange, élèves et copistes*, Editions de la Réunion des Musées Nationaux, Paris, in corso di stampa.

KAHIL, LILLY - ICARD-GIANOLIO, NOLLE - LINANT DE BELLEFONDS, PASCALE, *Leda* (ad vocem), in *Lexicon Iconographicum*, VI, 1992, pp. 231-246.

Kaiser Karl V (1500-1558). Macht und Ohnmacht Europas, catalogo della mostra (Bonn-Wien), Kunst - und Ausstellungshalle der Bundesrepublik Deutschland GmbH, Bonn 2000.

Katalog der Gemälde des städtischen Museums, Erfurt, 1909.

KEACH, WILLIAM, *Cupid Disarmed or Venus Wounded. An Ovidian source for Michelangelo and Bronzino*, "Journal of the Warburg and Courtauld Institutes", XLI, 1978, pp. 327-331.

KENT, F. W., *Ties of Neighborhood and Patronage in Quattrocento Florence*, in *Patronage, Art, and Society in Renaissance Italy*, a cura di F. W. Kent - Patricia Simons, Clarendon, Oxford 1987, pp. 75-98.

KIRKHAM, VICTORIA, *Dante's Phantom, Petrarch's Specter: Bronzino's Portrait of the Poet Laura Battiferra*, "Lectura Dantis. A forum for Dante research and interpretation", XXII-XXIII, 1998 [*Visibile Parlare. Dante and the Art of the Italian Renaissance*], pp. 63-139.

KLIEMANN, JULIAN, *Kunst als Bogenschießen. Domenichinos "Jagd der Diana" in der Galleria Borghese*, "Römisches Jahrbuch der Bibliotheca Hertziana", XXXI, 1996, pp. 273-312.

KOLSKY, STEPHEN, *Mario Equicola: the real courtier*, Droz, Genève 1991.

LABBÉ, JACQUELINE - BICART-SÉE, LISE - ARQUIÉ-BRULEY, FRANÇOISE, *La collection Saint-Morys au Cabinet des Dessins du Musée du Louvre*, notes et documents des musées de France, 2 voll., Editions de la Réunion des Musées Nationaux, Paris 1987.

LANDINO, CRISTOFORO, *Comedia del divino poeta Dante Alighieri, con la dotta e leggiadra spositione di Christophoro Landino*, Nicholo di Lorenzo della Magna, Firenze 1481.

LANDINO, CRISTOFORO, *Scritti critici e teorici*, a cura di Roberto Cardini, 2 voll., Bulzoni, Roma 1974.

LANDINO, CRISTOFORO, *Comento sopra la Comedia*, a cura di Paolo Procaccioli, Salerno, Roma 2001.

LAQUEUR, THOMAS, *Making Sex: Body and Gender from the Greeks to Freud*, Harvard University Press, Cambridge (Mass) 1990.

LAURENS, PIERRE - VUILLEMIER, FLORENCE, *De l'archéologie à l'emblème: la genèse du Liber Alciat*, "Revue de l'art", CI, 1993, pp. 86 -95.

LECCHINI GIOVANNONI, SIMONA, *Alessandro Allori*, Allemandi, Torino 1991.

LEE, SHERMAN E., *Daniel's Dream - A Significant Misnomer*, "Art Quarterly", IX, 1946, pp. 257-260.

Leonardo e il mito di Leda. Modelli, memorie e metamorfosi di un'invenzione, catalogo della mostra (Vinci), a cura di Gigetta Dalli Regoli - Romano Nanni - Antonio Natali, Silvana, Cinisello Balsamo 2001.

Lettioni d'Accademici Fiorentini sopra Dante, Doni, Firenze 1547.

LEUSCHNER, ECKHARD, *Personae, Larva, Maske, iconologische Studien aus zum 16 bis frehen 18 Jahrhundert*, Lang, Frankfurt am Main-New York 1997.

LEVEY, MICHAEL, *Sacred and Profane Significance in Two Paintings by Bronzino*, in *Studies in Renaissance and Baroque Art Presented to Anthony Blunt on his 60th birthday*, Phaidon, London 1967.

LEVI, ALDA, *Le terrecotte figurate del Museo Nazionale di Napoli*, Vallecchi, Firenze 1926.

Lexicon Iconographicum Mythologiae Classicae, direzione di Hans Christoph Ackermann - Jean-Robert Gisler, Artemis Verlag, München-Zürich 1981-1999.

LEWIS, DOUGLAS, *Rehabilitating a Fallen Athlete: Evidence for a date of 1453/1454 in the Veneto for the Bust of a Platonic Youth by Donatello*, in *Small Bronzes in the Renaissance*, a cura di Debra Pincus, Yale University Press, New Haven-London 2001, pp. 33-53.

Libro d'inventario dei beni di Lorenzo il Magnifico, a cura di Marco Spallanzani - Giovanna Gaeta Bertelà, SPES, Firenze 1922.

LIEBERT, ROBERT S., *Michelangelo: A Psychoanalytic Study of His Life and Images*, Yale University Press, New Haven-London 1983.

LIGHTBOWN, RONALD, *Sandro Botticelli*, 2 voll., University of California Press, Berkeley-Oxford 1978.

LIPPOLD, GEORG, *Gemmen und Kameen des Altertums und der Neuzeit*, Hoffmann, Stuttgart 1922.

Lisippo: l'Arte e La Fortuna, catalogo della mostra (Roma), a cura di Paolo Moreno, Fabbri Editore, Milano 1995.

LLOYD, CHRISTOPHER, *A Catalogue of the Earlier Italian Paintings in the Ashmolean Museum*, Clarendon, Oxford 1977.

LONGHI, ROBERTO, *Comprimari spagnoli della Maniera italiana*, "Paragone", IV, 43, 1953, pp. 3-15.

LUCCO, MAURO, *L'opera completa di Sebastiano del Piombo*, Rizzoli, Milano 1980.

LYDECKER, JOHN KENT, *Il patriziato fiorentino e la committenza artistica per la casa*, in *I ceti dirigenti nella Toscana del Quattrocento*, a cura di Francesco Papafava, Francesco Papafava editore, Firenze 1987a, pp. 209-221.

LYDECKER, JOHN KENT, *The Domestic Setting of the Arts in Renaissance Florence*, tesi di Ph.D., Johns Hopkins University, 1987b.

Magnificenza alla corte dei Medici. Arte a Firenze alle fine del Cinquecento, catalogo della mostra (Firenze), a cura di Mina Gregori - Detlef Heikamp, Electa, Milano 1997.

I mai visti. Capolavori dei depositi degli Uffizi, catalogo della mostra (Firenze), a cura di Annamaria Petrioli Tofani, Giunti, Firenze 2001.

MAÏER, IDA, *Ange Politien. La formation d'un poète humaniste (1469-1480)*, Droz, Genève 1966.

MANTZ, PAUL, *Michel-Ange, Peintre*, "Gazette des Beaux-Arts", 2-XIII, 1876, pp. 114-186.

MARABOTTINI, ALESSANDRO, *Il "Sogno" di Michelangelo in una copia sconosciuta*, in *Scritti di storia dell'arte in onore di Lionello Venturi*, 2 voll., De Luca, Roma 1956, I, pp. 349-358.

MARIACHER, GIOVANNI, *Il Museo Correr di Venezia dal XIV al XVI secolo*, Neri Pozza, Venezia 1957.

MARIETTE, PIERRE-JEAN, *Abecedario de P. J. Mariette et autres notes inédites de cet amateur sur les arts et les artistes*, a cura di Philippe de Chennevières - Anatole de Montaiglon, 6 voll., Jean-Baptiste Dumoulin, Paris 1851-1862.

Marsilio Ficino e il ritorno di Platone: mostra di manoscritti stampe e documenti, catalogo della mostra (Firenze), a cura di Sebastiano Gentile - Sandra Niccoli - Paolo Viti, premessa di Eugenio Garin, Le Lettere, Firenze 1984.

MARTELLI, NICCOLÒ, *Il primo libro delle lettere di Nicolo Martelli*, Doni, Firenze 1546.

MARTELLI, NICCOLÒ, *Dal primo e dal secondo libro delle lettere*, a cura di Cartesio Marconcini, Carabba, Lanciano 1916.

Masterpieces of Renaissance and Baroque Sculpture from the Palazzo Venezia, Rome, catalogo della mo-

stra (Athens, Ga), a cura di Shelley E. Zuraw - Maria Giulia Barberini, Athens (Ga) 1996.

MAURER, EMIL, *Pontormo und Michelangelo in Stil und Überlieferung in der Kunst des Abendlandes*, atti del convegno (Bonn 1964), 3 voll., Mann, Berlin 1967, II, pp. 141-149.

MCCOMB, ARTHUR, *Agnolo Bronzino. His Life and Works*, Harvard University Press, Cambridge (Mass) 1928.

MCCORQUODALE, CHARLES, *Bronzino*, Jupiter Books, London 1981.

MCCORQUODALE, CHARLES, *History of the Interior*, Vendome Press, New York-Paris 1983.

MEDICI, LORENZO DE', *Comento de' miei sonetti*, a cura di Tiziano Zanato, Olschki, Firenze 1991.

MELLER, PETER, *Un gruppo di bronzetti di Pierino da Vinci del 1547*, "Mitteilungen des Kunsthistorischen Institutes in Florenz", XVIII, 1974, pp. 251-272.

MENDEL, GUSTAVE, *Musées Impériax Ottomans. Catalogue des Sculptures Grecques, Romaines et Byzantines*, Musée Imperiale, Constantinople 1914.

MENDELSOHN, LEATRICE, *Paragone. Benedetto Vachi's Due Lezzioni and Cinquecento Art Theory*, UMI Research Press, Ann Arbor 1982.

MENDELSOHN, LEATRICE, *Boccaccio, Betussi e Michelangelo: Ritratti delle donne illustri come Vite Parallele*, in *Letteratura Italiana e Arti Figurative*, atti del convegno (Toronto-Hamilton-Montreal 1985), a cura di Antonio Franceschetti, Olschki, Firenze 1988, pp. 323-334.

MENDELSOHN, LEATRICE, *L'Allegoria di Londra del Bronzino e la retorica del carnevale*, in *Kunst des Cinquecento in der Toskana*, Italienische Forschungen, Herausgegeben des Kunsthistorishes Institut in Florenz, vol. XVII, a cura di Monika Cämmerer, Bruckmann, München 1992, pp. 152-167.

MENDELSOHN, LEATRICE, *Der Florentine Kreis: Michelangelos Sonett an Vittoria Colonna, Varchis Lezzioni und Bilder der Reformation*, in *Vittoria Colonna* 1994, pp. 265-273.

MENZEL, HEINZ, *Die römischen Bronzen aus Deutschland. II, Trier*, Philip von Zabern, Mainz am Rhein 1966.

MEONI, LUCIA, *Gli arazzi nei musei fiorentini. La collezione medicea; catalogo completo. I. La manifattura da Cosimo I a Cosimo II (1545-1621)*, Sillabe, Livorno 1998.

MEZZATESTA, MICHAEL PHILIP, *Imperial themes in the sculpture of Leone Leoni*, tesi di Ph.D., New York Uni-

versity, 1980.

Michelangelo, Artista Pensatore Scrittore, premessa di Mario Salmi, 2 voll., De Agostini, Novara 1965.

Michelangelo Draftsman, catalogo della mostra (Washington), a cura di Michael Hirst, National Gallery of Art, Washington 1988.

Michelangelo and His Influence; Drawings from Windsor Castle, catalogo della mostra (Washington-Fort Worth-Chicago-Cambridge-London), a cura di Paul Joannides, Lund Humphries, London 1996.

MILANESI, GAETANO, *Della Venere baciata da Cupido, dipinta dal Pontormo sul cartone di Michelangiolo Buonarroti*, in Vasari 1878-1885, VI, 1881, pp. 291-295.

MOLAJOLI, BRUNO, *Notizie su Capodimonte: catalogo delle gallerie e del museo*, V ed., L'arte Tipografica, Napoli 1964.

MORGANTI, CAROL, *Il "Sogno" di Michelangelo: una ricognizione iconografica*, "Grafica d'arte: rivista di storia dell'incisione antica e moderna e storia del disegno", VIII, 31, 1997, pp. 2-6.

MORTARI, LUISA, *Francesco Salviati*, De Luca, Roma 1992.

MÜNTZ, EUGÈNE, *Le Château de Fontainebleau en 1625, d'après le diarium du Commandeur Cassiano del Pozzo*, "Mémoires de la Société de l'Histoire de Paris et de l'Ile de France", XII, 1885, pp. 253-278.

MURPHY, PETER, *Lorenzo Lotto*, Yale University Press, New Haven-London 1997.

Museo Nazionale di Capodimonte. La Collezione Farnese. II: I dipinti lombardi, liguri, veneti, tosani, umbri, romani, fiamminghi. Altre scuole. Fasti Farnesiani, a cura di Nicola Spinosa, Electa Napoli, Napoli 1995.

MUZII, ROSSANA, *I disegni*, in *I Farnese: arte e collezionismo*, catalogo della mostra (Parma-Napoli-München), a cura di Lucia Fornari Schianchi - Nicola Spinosa, Electa, Milano 1995, pp. 107-112.

MYSSOK, JOHANNES, *Bildhauerische Konzeption un plastisches Modell in der Renaissance*, Rhema, Münster 1999.

NATALE, MAURO, *Catalogue raisonné des peintures. Peintures italiennes du XIVᵉ au XVIIIᵉ siècle*, Musée d'Art et d'Histoire, Genève 1979.

National Gallery of Ireland: Illustrated Summary Catalogue of Paintings, Gill and Macmillian, Dublin 1981.

NEGRO, ANGELA, *Venere e Amore di Michele di Ridolfo del Ghirlandaio. Il mito di una Venere di Michelangelo fra copie, repliche e pudiche vestizioni*, Campisano, Roma 2001.

NELSON, JONATHAN, *Dante Portraits in Sixteenth Century Florence*, "Gazette des Beaux-Arts", 6-CXX, 3, 1992, pp. 59-77.

NELSON, JONATHAN, *Creative Patronage: Luca Martini and the Renaissance Portrait*, "Mitteilungen des Kunsthistorischen Institutes in Florenz", XXIX, 1995, pp. 282-305.

NELSON, JONATHAN, *Luca Martini "dantista", and Pierino da Vinci's relief of the 'Death of Ugolino della Gherardesca and his Sons*, in *Pierino da Vinci*, atti del convegno (Vinci 1990), a cura di Marco Cianchi, Becocci, Firenze 1995, pp. 39-46.

NELSON, JONATHAN - STARK, JAMES, *The Breasts of Night: Michelangelo as Oncologist?*, letter to the editor, "New England Journal of Medicine", CCCXLIII, 21, 23 novembre 2000, pp. 1577-1578.

NICOLL, ALLARDYCE, *Masks, Mimes and Miracles*, Cooper Square, New York 1963.

O'GRODY, JEANNINE ALEXANDRIA, *Un Semplice Modello: Michelangelo and His Three-Dimensional Preparatory Works*, tesi di Ph.D., Case Western Reserve University, 1999.

O'GRODY, JEANNINE ALEXANDRIA, *Michelangelo: the Master Modeler*, in *Earth and Fire: Italian Terracotta Sculpture from Donatello to Canova*, a cura di Bruce Boucher, Yale University Press, New Haven-London 2002, pp. 35 -38.

OVIDIO, *Metamorfosi*, trad. di Piero Bernardini Marzolla, Einaudi, Torino 1979.

PANNUTI, ULRICO, *Museo Archeologico Nazionale di Napoli. La collezione glittica*, II, Istituto Poligrafico e Zecca dello Stato, Roma 1994.

PANOFSKY, ERWIN, *Studies in Iconology. Humanist Themes in the Art of the Renaissance* (1939), Icon Editions, Boulder-Oxford 1972, [trad. Einaudi, Torino 1975].

PANOSKY-SOERGEL, GERDA, *Postscriptum to Tommaso Cavalieri*, in *Scritti di storia dell'arte in onore di Roberto Salvini*, Sansoni, Firenze 1984, pp. 399-406.

PAOLETTI, JOHN T., *Michelangelo's Masks*, "Art Bulletin", LXXIV, 1992, pp. 423-440.

PARDO, MARY, *Artifice as Seduction in Titian*, in Turner 1993, pp. 55-89.

PARK KATHARINE - NYE, ROBERT A., *Destiny in Anatomy* (recensione di Laqueur 1990], "The New Republic", 18 Febbraio 1991, pp. 53-57.

PARKER, DEBORAH, *Vasari's Portrait of Six Tuscan Poets: A visibile literary History*, "Lectura Dantis. A forum for Dante research and interpretation", XXII-XXIII, 1998 [*Visibile Parlare. Dante and the Art of the Italian Renaissance*], pp. 45-62.

PARKER, DEBORAH, *Bronzino: Renaissance Painter as Poet*, Cambridge University Press, Cambridge-New York 2000.

PARKER, KARL THÉODORE, *Catalogue of the Collection of Drawings in the Ashmolean Museum*, II, *The Italian School*, Clarendon, Oxford 1956.

PARKER, PATRICIA, *Gender Ideology, Gender Change: The Case of Marie Germain*, "Critical Inquiry", 1993, pp. 337-64.

PARRONCHI, ALESSANDRO, *Opere giovanili di Michelangelo*, 5 voll., Olschki, Firenze, 1968-1996, III, *Miscellanea michelangiolesca*, 1981.

PASTORELLO, PAOLO, *Schede tecniche di restauro* in *Un restauro per dieci opere in Galleria Colonna*, Editore Colombo, Roma 1995, pp. 63-103.

PEROSA, ALESSANDRO, *Studi sulla tradizione delle poesie latine del Poliziano*, in *Studi in Onore di Ugo Enrico Paoli*, Le Monnier, Firenze 1954, pp. 539-562.

PERRY, MARILYN, *The Statuario Publico of the Venetian Republic*, "Saggi e memorie di storia dell' Arte", VIII, 1972, pp. 75-150.

PESCE, GENNARO, *Gemme medicee del Museo Nazionale di Napoli*, "Rivista dell'Istituto di Archeologia e Storia dell'Arte", V, 1935, pp. 50-97.

PICO DELLA MIRANDOLA, GIOVANNI, *Commentary on a canzone of Benivieni*, trad. di Sears Jayne, Lang, New York 1984.

PICO DELLA MIRANDOLA, *De hominis dignitate... e vari scritti*, a cura di Eugenio Garin, Vallecchi, Firenze 1942.

PICO DELLA MIRANDOLA, GIOVANNI, *Sonetti*, a cura di Giorgio Dilemmi, Einaudi, Torino 1994.

PILLIOD, ELIZABETH, *Pontormo Bronzino Allori. A Genealogy of Florentine Art*, Yale University Press, New Haven-London 2001.

PIROTTI, UMBERTO, *Benedetto Varchi e la cultura del suo tempo*, Olschki, Firenze 1971.

PLAISANCE, MICHEL, *Une première affirmation de la politique culturelle de Côme Iᵉʳ: la transformation de l'Académie des «Humidi» en Académie Florentine (1540-42)*, in *Les écrivains et le pouvoir en Italie à l'époque de la Renaissance*, a cura di André Rochon, Université de la Sorbonne nouvelle, Paris 1973, pp. 361-433.

PLAISANCE, MICHEL, *Culture et politique à Florence de 1542 à 1551: Lasca et les Humidi aux prises avec l'Académie Florentine*, in *Les écrivains et le pouvoir en Italie à l'époque de la Renaissance*, a cura di André Rochon, Université de la Sorbonne nouvelle, Paris 1974, pp. 149-242.

PLAZZOTTA, CAROL, *Bronzino's Laura*, "The Burlington Magazine", CXXXII, 1998, pp. 251-263.

Poeti del Cinquecento. I: Poeti lirici, burleschi e didascalici, a cura di Guglielmo Gorni - Massimo Danzi - Silvia Longhi, Ricciardi, Milano-Napoli 2001.

POLIZIANO, ANGELO, *Poesie volgari inedite e poesie latine e greche edite e inedite di Angelo Ambrogini Poliziano*, a cura di Isidoro Del Lungo, Barbera, Firenze 1867.

POLIZIANO, ANGELO, *Omnia opera Angeli Politiani*, Manuzio, Venezia 1498.

POLIZIANO, ANGELO, *Silvae*, a cura di Francesco Bausi, Olschki, Firenze 1996.

POLIZZOTTO, LORENZO, *The Elect Nation. The Savonarola Movement in Florence 1494-1545*, Clarendon, Oxford 1994.

POLVERINI FOSI, IRENE, *Il consolato fiorentino a Roma e il progetto per la chiesa nazionale*, "Studi romani", XXXVII, 1989, pp. 50-70.

Pontormo. Disegni degli Uffizi, catalogo della mostra (Firenze), a cura di Carlo Falciani, Olschki, Firenze 1996.

POPE-HENNESSY, JOHN, *Catalogue of Italian Sculpture in the Victoria & Albert Museum*, 2 voll., Her Majesty's Stationary Office, London 1964.

POPE-HENNESSY, JOHN, *Cellini*, Abbeville Press, New York 1985.

POPE-HENNESSY, JOHN - KEITH, CHRISTIANSEN, *Secular Painting in 15ᵗʰ-Century Tuscany*, "Metropolitan Museum of Art Bulletin", XXXVIII, 1980, pp. 4-55.

POPHAM, ARTHUR EWART - WILDE, JOHANNES, *The Italian Drawings of the XV and XVI Centuries in the Collection of His Majesty the King at Windsor Castle*, Phaidon, London 1949.

POPHAM, ARTHUR EWART, *Correggio's Drawings*, Oxford University Press, London 1957.

POPP, ANNY E., *Die Medici-Kapelle Michelangelos*, Recht, München 1922.

PREYER, BRENDA, *The "casa overo palagio" of Alberto di Zanobi: A Florentine Palace of About 1400 and Its Later Remodeling*, "Art Bulletin", LXV, 1983, pp. 387-401.

PREYER, BRENDA, *Florentine Palaces and Memories of the Past*, in *Art, Memory and Family in Early Renaissance Florence*, a cura di Giovanni Ciappelli - Patricia Rubin, Cambridge University Press, Cambridge-New York 2000, pp. 176-180.

Primo volume della scelta di stanze raccolte da M. Agostino Ferentilli, Giunti, Venezia 1584.

PROCACCI, UGO, *La Casa Buonarroti a Firenze*, Electa, Milano 1965.

QUIVIGER, FRANÇOIS, *Benedetto Varchi and the Visual Arts*, "Journal of the Warburg and Courtauld Institutes", L, 1987, pp. 219-224.

Raffael und die Zeichenkunst der italienischen Renaissance. Meisterzeichnungen aus dem Musée des Beaux-Arts in Lille und aus eigenem Bestand, catalogo della mostra (Köln), a cura di Uwe Westfehling, Wallraf-Richartz-Museum, Köln 1990.

Raffaello, Michelangelo e Bottega. I cartoni farnesiani restaurati, catalogo della mostra (Napoli), a cura di Rossana Muzii, Electa, Napoli 1993.

RASTRELLI, MODESTO, *Storia d'Alessandro de' Medici primo duca di Firenze, scritta e corredata di inediti documenti*, 2 voll., Antonio Benucci - Luigi Carlieri, Firenze 1781.

RATTI, CARLO GIUSEPPE, *Istruzione di quanto può vedersi di più bello in Genova in pittura, sculptura ed architettura* (1780), rist. anast., 2 voll., Forni, Bologna 1976.

RE, CATERINA, *Girolamo Benivieni fiorentino. Cenni sulla vita e sulle opere*, Lapi, Città di Castello 1906.

RIEBESELL, CHRISTINA, *Die Sammlung des Kardinal Alessandro Farnese: ein "studio" für Künstler und Gelehrte*, VCH, Acta Humaniora, Weinheim 1989.

Rime diverse di molti eccelletiss. Auttori nuovamente raccolte. Libro primo con nuove additione ristampato, a cura di Lodovico Domenichi, Giolito, Venezia 1546.

Il Rinascimento a Venezia e la pittura del Nord ai tempi di Bellini, Dürer, Tiziano, catalogo della mostra (Venezia), a cura di Bernard Aikema - Beverly Louise Brown, Bompiani, Milano 1999.

ROCKE, MICHAEL, *Forbidden Friendships, Homosexuality and Male Culture in Renaissance Florence*, Oxford University Press, New York-Oxford 1996

ROSAND, DAVID, *So-and-so Reclining on her Couch*, in *Titian's "Venus of Urbino"*, a cura di Rona Goffen, Cambridge University Press, Cambridge-New York 1997, pp. 37-62.

ROSENBERG, CHARLES M., *Alfonso I d'Este, Michelangelo and the man who bought pigs*, in *Revaluing Renaissance Art*, a cura di Gabriele Neher - Rupert Shepherd, Ashgate, Aldershot 2000, pp. 89-100.

ROSKILL, MARK W., *Dolce's Aretino and Venetian art theory of the Cinquecento*, New York University Press, New York 1968.

ROSSI, FILIPPO, *Il Museo del Bargello a Firenze*, Treves-Treccani-Tumminelli, Milano 1932.

ROSSI UMBERTO, *Il Museo Nazionale di Firenze nel triennio 1889-1891*, "Archivio Storico dell'Arte", VI, 1893, pp. 1-24.

Rosso Fiorentino: Drawings, Prints, and Decorative Arts, catalogo della mostra (Washington), a cura di Eugene A. Carroll, National Gallery of Art, Washington 1987.

ROTH, CECIL, *The Last Florentine Republic*, Methuen, London 1925.

RÖTTGEN, HERWARTH, *Caravaggio der Irdische Amor oder Der Sieg der Fleischlichen Liebe*, Fischer, Frankfurt am Main 1992.

ROY, MAURICE, *La Léda de Michel-Ange et celle de Rosso*, "Gazette des Beaux-Arts", 5-VII, 1923, pp. 65-82.

RUSSELL, DANIEL, *Emblematic Structures in Renaissance French Culture*, University of Toronto Press, Toronto-Buffalo-London 1995.

RUVOLDT, MARIA CATHERINE, *The Sleep of Reason: Inspiration and Creativity in Renaissance Imagery*, tesi di Ph.D., Columbia University, 1996.

RYLANDS, PHILIP, *Palma il Vecchio. L'opera completa*, Mondadori, Milano 1988.

SABBADINI, REMIGIO, *Le scoperte dei codici latini e greci ne' secoli XIV & XV*, a cura di Eugenio Garin, 2 voll., Sansoni, Firenze 1967.

SAFARIK, EDUARD A., *Catalogo Sommario della Galleria Colonna in Roma. Dipinti*, Bramante, Roma 1981.

SAFARIK, EDUARD A., *Palazzo Colonna. The Gallery*, De Luca, Roma 1999.

SAFARIK, EDUARD A. - PUJIA, CINZIA, *Inventarii italiani 2. Collezione dei dipinti Colonna. Inventari 1611-1795*, K. G. Saur, München 1996.

SANMINIATELLI, DONATO, *The Pontormo Exhibition in Florence*, "The Burlington Magazine", XCVIII, 1956, pp. 241-243.

SANNAZARO, IACOPO, *Farsa di Venere*, a cura di Giosuè Carducci, in *Scritti di letteratura e d'istruzione*. Strenna del giornale "La Gioventù", Firenze 1863.

SANNAZARO, IACOPO, *Opere volgari*, a cura di Alfredo Mauro, Laterza, Bari 1961.

SASLOW, JAMES M., *Ganymede in the Renaissance, Homosexuality in Art and Society*, Yale University Press, New Haven-London 1986.

SASLOW, JAMES M., *Michelangelo: Sculpture, Sex, and Gender*, in *Looking at Italian Renaissance Sculpture*, a cura di Sarah Blake McHam, Cambridge University Press, Cambridge-New York 1998, pp. 223-245.

SCAILLIÉREZ, CÉCILE, *Francois Ier et ses artistes dans les collections du Louvre*, Éditions de la Réunion des Musées Nationaux, Paris 1992.

SCALIGERO, GIULIO CESARE, *Poetices liber septem*, J. Crispin, Genova 1561.

SCHMITT, ANNEGRIT, *Antiken kopien und künstlerische Selbstverwirklichung in der Frürenaissance: Jacopo Bellini auf den Spuren römischer Epitaphien*, in *Antikenzeichnung und Antikenstudium in Renaissance und Frübarock*, atti del convegno (Coburg 1986), a cura di Richard Harprath - Henning Wrede, Philip von Zabern, Mainz am Rhein 1989, pp. 1-20.

SCHUBRING, PAUL, *Cassoni. Truhen und Truhenbilder der italienischen Frührenaissance*, K.W. Hiersemann, Leipzig 1923.

SCHWARZ, THEODOR, *Augst*, "Jahrbuch der schweizerischen Gesellschaft für Urgeschichte", LIX, 1963, p. 74.

SCRASE, DAVID, *A Drawing of Dante after Bronzino by Carlo Dolci in the Fitzwilliam Museum, Cambridge*, in *Hommage au dessin. Mélanges offerts à Roseline Bacou*, a cura di Maria Teresa Caracciolo, Galleria Editrice, Rimini 1996, pp. 204-209.

La scultura, bozzetti in terracotta, piccoli marmi e altre sculture dal XIV al XX secolo, catalogo della mostra (Siena), a cura di Giancarlo Gentilini - Carlo Sisi, 2 voll., SPES, Firenze 1989.

SEGNI, BERNARDO, *Storie fiorentine di Messer Bernardo Segni, gentiluomo fiorentino, dall'anno MDXXVII. al MDLV*, 3 voll., Società tipografica de' Classici italiani, Milano 1805.

SETTIS, SALVATORE, *Chelone. Saggio sull'Afrodite Urania*, Nistri-Lischi, Pisa 1966.

SEZNEC, JEAN, *The Survival of the Pagan Gods*, trad. di Barbara Sessions, Harper & Row, New York 1961.

SHEARMAN, JOHN, *A Note on the Early History of Cartoons*, "Master Drawings", XXX, 1992, pp. 5-8.

SHEARMAN, JOHN, *The early Italian pictures in the collection of Her Majesty the Queen*, Cambridge University Press, Cambridge-New York 1983.

SHEMEK, DEANNA, *Ladies Errant. Wayward Women and Social Order in Early Modern Italy*, Duke University Press, Durham-London 1998.

SHEMEK, DEANNA, *Of Women, Knights, Arms, and Love: the Orlando Furioso and Ariosto's Querelle des Femmes*, "Modern Language Notes", CIV, 1989, pp. 68-97.

SHUMATE, NANCY, *Crisis and Conversion in Apuleius' Metamorphoses*, University of Michigan Press, Ann Arbor 1996.

SMYTH, CRAIG HUGH, *Bronzino Studies*, (tesi di Ph.D., Princeton University, 1955), UMI Press, Ann Arbor 1956.

SMYTH, CRAIG HUGH, *Bronzino as Draughtsman. An Introduction*, J.J. Augustin, Locust Valley, NY 1971.

SMITH, GRAHAM, *Jealousy, Pleasure and Pain in the Allegory of Venus and Cupid*, "Pantheon", XXXIX, 1981, pp. 250-258.

SMITH, GRAHAM, *Bronzino's 'Portrait of Laura Battiferri'*, "Source", XV, 1996, pp. 30-38.

SOHM, PHILIP, *Gendered Style in Italian Art Criticism from Michelangelo to Malvasia*, "Renaissance Quarterly", XLVIII, 1995, pp. 759-808.

Sonetti e canzoni di diversi antichi autori toscani (1527), rist. anast., introduzione e indici a cura di Domenico De Robertis, 2 voll., Le Lettere, Firenze 1977.

SPINI, GIORGIO, *Politicità di Michelangelo*, "Rivista storica italiana", LXXVI, 1964, pp. 557- 600.

STEINMANN, ERNST, *Cartoni di Michelangelo*, "Bollettino d'Arte", 2-V, 1, 1925, pp. 3-16.

STEINMANN, ERNST, *Kompositionen in selten Stichen*, in *Festschrift zum 60 Geburtstage für Paul Clemen*, Cohen, Bonn 1926, pp. 420-428.

STEINMANN, ERNST, *Michelangelo e Luigi del Riccio*, Vallecchi, Firenze 1932.

Studi sulla "Divina Commedia" di Galileo Galilei, Vincenzio Borghini e altri, a cura di Ottavio Gigli, Le Monnier, Firenze 1855.

SUMMERS, DAVID, *Michelangelo and the Language of Art*, Princeton University Press, Princeton 1981.

TALVACCHIA, BETTE, *Taking Positions. On the Erotic in Renaissance Culture*, Princeton University Press, Princeton 1999.

TANTURLI, GIULIANO, *La Firenze laurenziana davanti alla propria storia letteraria*, in *Lorenzo il Magnifico e il suo tempo*, a cura di Gian Carlo Garfagnini, Olschki, Firenze 1992, pp. 1-38.

TASSO, TORQUATO, *Aminta*, Baldini, Ferrara 1581.

TASSO, TORQUATO, *Aminta*, edizione critica a cura di Bartolo Tommaso Sozzi, Liviana, Padova 1957.

TERPENING, RONNIE H., *Lodovico Dolce, Renaissance Man of Letters*, University of Toronto Press, Toronto-Buffalo-London 1997.

TERPSTRA, NICHOLAS, *The Politics of Ritual Kinship: Confraternities and Social Order in Early Modern Italy*, Cambridge University Press, Cambridge-New York 1999.

Il tesoro di Lorenzo il Magnifico. Le gemme, catalogo della mostra (Firenze), a cura di Nicole Dacos - Antonio Giuliano - Ulrico Pannuti, Sansoni, Firenze 1973.

THODE, HENRY, *Michelangelo; kritische Untersuchungen über seine Werke*,

3 voll., Grote, Berlin 1908-1913.

THORNTON, PETER, *The Italian Renaissance Interior, 1400-1600*, Weidenfield & Nicolson, London 1991.

TITI, FILIPPO, *Descrizione delle pitture, sculture e architetture esposte al pubblico in Roma* (1763), Multigrafica, Roma 1978.

Tiziano nelle Gallerie fiorentine, catalogo della mostra (Firenze), a cura di Mina Gregori, Centro Di, Firenze 1978.

TOLNAY, CHARLES DE, *Michelangelo*, 5 voll., Princeton University Press, Princeton 1943- 1960, III, *The Medici Chapel*, 1948 [rist. Princeton 1970].

TOLNAY, CHARLES DE, *The Art and Thought of Michelangelo*, Pantheon Books, New York 1964.

TOLNAY, CHARLES DE, *Sur des Vénus dessinées par Michel-Ange; à propos d'un dessin oublié du Musée du Louvre*, "Gazette des Beaux-Arts", 6-LXIX, 1967, pp. 193-200.

TOLNAY, CHARLES DE, *Corpus dei disegni di Michelangelo*, 4 voll., De Agostini, Novara 1975-1980.

TOSCAN, JEAN, *Le Carnavale du Language*, 4 voll., Université de Lille, Lille 1981.

TRENTO, DARIO, *Pontormo e la corte di Cosimo I*, in *Kunst des Cinquecento in der Toskana*, Italienische Forschungen, Herausgegeben des Kunsthistorishes Institut in Florenz, vol. XVII, a cura di Monika Cämmerer, Bruckmann, München 1992, pp. 139-144.

TROVATO, PAOLO, *Per una nuova edizione dell'"Aminta"*, in *Torquato Tasso e la cultura estense*, 3 voll., a cura di Gianni Venturi, Olschki, Firenze 1999, III, pp. 1003-1027.

TURNER, JAMES GRANTHAM, a cura di, *Sexuality and Gender in Early Modern Europe. Institutions, texts, images*, Cambridge University Press, Cambridge-New York 1993.

VANDELLI, GIUSEPPE, *Il più antico testo della Divina Commedia*, "Studi Danteschi", V, 1922, pp. 41-98.

VANDELLI, GIUSEPPE, *Per il testo della "Divina Commedia"*, a cura di Rudy Abardo, con un saggio introduttivo di Francesco Mazzoni, Le Lettere, Firenze 1989.

VARCHI, BENEDETTO, *Due Lezzioni nella prima delle quali si dichiara un sonetto di M. Michelagnolo Buonarroti, nella seconda si disputa quale sia piu nobile arte la scultura, o la pittura, con vna lettera d'esso Michelagnolo & piu altri eccellentiss. pittori, et scultori, sopra la quistione sopradetta*, Torrentino, Firenze 1549/1550.

VARCHI, BENEDETTO, *La seconda parte delle lezzioni di M. Benedetto Varchi, Giunti, Firenze 1561.

VARCHI, BENEDETTO, *Storia Fiorentina di Messer Benedetto Varchi*, 5 voll., Società tipografica de' Classici Italiani, Milano 1803-1804.

VARCHI, BENEDETTO, *Delle trasformazioni di Publio Ovidio Nasone libro XIII tradotto da lingua latina in volgare fiorentino in versi sciolti*, in *Opuscoli inediti di celebri autori toscani, l'opere dei quali sono citate dal vocabolario della Crusca*, 2 voll., Stamperia di Borgo Ognissanti, Firenze 1809, II, pp. 167-189.

VARCHI, BENEDETTO, *Amore fuggitivo, idillio di Mosco tradotto da Benedetto Varchi*, Antonio Curti, Venezia 1810.

VARCHI, BENEDETTO, *Questione sull'alchimia*, Magheri, Firenze 1827.

VARCHI, BENEDETTO, *Saggio di rime inedite estratte dai manoscritti originali della Biblioteca Rinucciniana*, a cura di Giuseppe Aiazzi, Piatti, Firenze 1837.

VARCHI, BENEDETTO, *Lezione sopra quei versi del Trionfo d'Amore del Petrarca, "Quattro destrier via piu che neve bianchi..."*, in *Lezioni sul Dante e prose varie di Benedetto Varchi la maggior parte inedite*, 2 voll., Società Editrice delle storie del Nardi e del Varchi, Firenze 1841, II, pp. 17-38.

VARCHI, BENEDETTO, *Opere*, a cura di Antonio Racheli, 2 voll., Lloyd austriaco, Trieste 1858-1859.

VARCHI, BENEDETTO, *Liber Carminum Benedicti Varchii*, a cura di Aulo Greco, Abete, Roma 1969.

VARCHI BENEDETTO - BORGHINI, VINCENZIO, *Pittura e scultura nel Cinquecento*, a cura di Paola Barocchi, Sillabe, Livorno 1998.

VASARI, GIORGIO, *La vita di Michelangelo nelle redazioni del 1550 e del 1568*, 5 voll., a cura di Paola Barocchi, Ricciardi, Milano-Napoli 1962.

VASARI, GIORGIO, *Le opere di Giorgio Vasari pittore e architetto aretino*, Passigli, Firenze 1832-1838.

VASARI, GIORGIO, *Le vite dei più eccellenti pittori, scultori ed architettori scritte da M. Giorgio Vasari*, Giunti, Firenze 1568, con nuove annotazioni e commenti di Gaetano Milanesi, 9 voll., Sansoni, Firenze 1878-1885.

VASARI, GIORGIO, *Le vite de' piu eccellenti pittori scultori ed architettori nelle redazioni del 1550 e 1568*, a cura di Rosanna Bettarini - Paola Barocchi, 11 voll., Sansoni, Firenze 1966-1997.

VASARI, GIORGIO, *Lives of the Most Eminent Painters, Sculptors, and Architects*, trad. di Gaston C. Du Vere, (1912-1915),10 voll., [rist. AMS Press, New York 1976].

VASARI, GIORGIO, *Il libro delle ricordanze di Giorgio Vasari*, a cura di Alessandro del Vita, Casa del Vasari, Arezzo 1929.

VASARI, GIORGIO, *Der Literarische Nachlass*, a cura di Carl Frey, 3 voll., Georg Müller, München 1923-1940.

VASOLI, CESARE, *Benivieni Girolamo* (ad vocem), in *Dizionario biografico*, VIII, 1966, pp. 550-555.

VENTURINI, LISA, *Modelli fortunati e produzione di serie* in *Maestri e botteghe: pittura a Firenze alla fine del Quattrocento*, catalogo della mostra (Firenze), a cura di Mina Gregori, Antonio Paolucci, Cristina Acidini Luchinat, Silvana, Cinisello Balsamo 1992.

Venus. Bilder einer Göttin, catalogo della mostra (München), a cura di Claudia Denk - Evelina Paul - Konrad Renger, Bayerischen Staatsgemäldesammlungen, München 2001.

Venus, Vergeten Mythe. Voorstellingen van een godin van Cranach tot Cézanne, catalogo della mostra (Köln-München-Antwerp), a cura di Ekkehard Mai, Koninklijk Museum voor Schone Kunsten, Antwerp 2001.

VERMIGLIOLI, GIOVANNI BATTISTA, *Memorie per servire alla vita di Francesco Maturanzio, oratore e poeta perugino*, C. Baduel, Perugia 1807.

VERTOVA, LUISA, *Cupid and Psyche in Renaissance Painting before Raphael*, "Journal of the Warburg and Courtauld Institutes", XLII, 1979, pp. 104-121.

VERTOVA, LUISA, *Maestri toscani del Quattro e primo Cinquecento*, Istituto Alinari, Firenze 1981.

Visions and Vistas; Old Master Paintings and Drawings, catalogo della mostra, a cura di Robert B. Simon, Berry-Hill Gallery, New York 2000.

Vita di Michelangelo, catalogo della mostra (Firenze), a cura di Lucilla Bardeschi Ciulich - Pina Ragionieri, Mandragora, Firenze 2001.

Vittoria Colonna. Dichterin und Muse Michelangelos, catalogo della mostra (Wien), a cura di Sylvia Ferino Pagden - Agostino Attanasio, Skira, Milano 1997.

WALDMAN, LOUIS A., *'Miracol' novo et raro': Two Unpublished Contemporary Satires on Bandinelli's Hercules and Cacus*, "Mitteilungen des Kunsthistorischen Institutes in Florenz", XXXVIII, 1994, pp. 419-27.

WALLACE, WILLIAM E., *Studies in Michelangelo's Finished Drawings, 1520-34*, tesi di Ph.D., Columbia University, 1983.

WALLACE, WILLIAM E., *Il 'Noli Me Tangere' di Michelangelo tra sacro e profano*, "Arte cristiana", LXXVI,

1988, pp. 443-450.

WALLACE, WILLIAM E., *Michelangelo's Leda: the diplomatic context*, "Renaissance Studies", XV, 2001, pp. 473-499.

WEINBERG, MARTIN, *Michelangelo the Sculptor*, 2 voll., Columbia University Press, New York 1967.

WEISSMAN, RONALD F.E., *Ritual Brotherhood in Renaissance Florence*, Academic Press, New York 1981.

WEISSMAN, RONALD F.E., *The Importance of Being Ambiguous: Social Relations, Individualism, and Identity in Renaissance Florence*, in *Urban Life in the Renaissance*, a cura di Susan Zimmerman - Ronald F. E. Weissman, Associated University Presses, London-Cranbury (NJ) 1989, pp. 269-280.

WHEELER, ARTHUR LESLIE, *Tradition in the Epithalamium*, "American Journal of Philology", LI, 1930, pp. 205-223.

WILDE, JOHANNES, *Italian Drawings in the Department of Prints and Drawings in the British Museum. Michelangelo and his Studio*, 2 voll., Trustees of British Museum, London 1953.

WILDE, JOHANNES, *Notes on the genesis of Michelangelo's Leda*, in *Fritz Saxl 1890-1948. A volume of memorial essays from his friends in England*, a cura di Donald J. Gordon, Thomas Nelson, London 1957, pp. 270-280.

WILLIAMS, ROBERT, *The notion of beauty in Francesco Bocchi's "Bellezze della città di Fiorenza"*, I, in Ames-Lewis - Rogers 1998, pp. 199-205.

WINNER, MATTHIAS, *Michelangelo's Il Sogno as an Example of an Artist's Visual Reflection in His Drawings*, "Studies in the History of Art", XXXIII, 1992 [Michelangelo Drawings, a cura di Craig Hugh Smyth - Ann Gilkerson], pp. 227-244.

WOLFTHAL, DIANE, *Images of Rape. The "Heroic" Tradition and its Alternative*, Cambridge University Press, Cambridge-New York 1999.

YALOM, MARILYN, *A History of the Breast*, Ballantine Books, New York 1997.

YAVNEH, NAOMI, *The Ambiguity of Beauty in Tasso and Petrarch*, in Turner 1993, pp. 133-157.

ZAPPELLA, GIUSEPPINA, *Il ritratto nel libro italiano del Cinquecento*, 2 voll., Editrice bibliografica, Milano 1988.

Zeichnungen aus der Sammlung des Kurfürsten Carl Theodor, catalogo della mostra (München), a cura di Richard Harprath, Staatliche Graphische Sammlung, München 1983.

ZERI, FEDERICO, *La Galleria Colonna a Roma*, in *Tesori d'arte delle grandi famiglie*, a cura di Douglas Cooper, Mondadori, Milano 1966, pp. 21-46.

INDICE DELLE OPERE IN MOSTRA

LIST OF EXHIBITED WORKS

Venere / *Venus*, da un originale di età ellenistica, metà del II sec. a. C. / after an original from the Hellenistic age mid II century B. C. **(Cat. 1)** — 148

MICHELANGELO BUONARROTI, *Quattro studi di antica statua frammentaria di Venere / Four Studies of a Fragmentary Antique Statue of Venus* **(Cat. 2, 3, 4, 5)** — 150

attr. a MICHELANGELO BUONARROTI, *Figura femminile in piedi / Standing Female Figure* **(Cat. 6)** — 152

MICHELANGELO BUONARROTI, *Nudo femminile (La Terra?) / Female Nude (Earth?)* **(Cat. 7)** — 154

attr. a MICHELANGELO BUONARROTI, *Figura femminile stante (Venere?) / Standing female nude (Venus?)* **(Cat. 8; Tav. VII/1)** — 156

FRANCESCO SALVIATI da MICHELANGELO, *Venere e Cupido / Venus and Cupid* **(Cat. 9; Tav. VII/2)** — 158

MARCANTONIO RAIMONDI da RAFFAELLO, *Il giudizio di Paride / The Judgment of Paris* **(Cat. 10)** — 160

ANDREA DEL BRESCIANINO, *Venere, Cupido e un putto / Venus, Cupid and a putto* **(Cat. 11; Tav. XVI/1)** — 162

MICHELE TOSINI, detto MICHELE DI RIDOLFO DEL GHIRLANDAIO da MICHELANGELO, *Testa ideale (Zenobia?) / Ideal Head (Zenobia?)* **(Cat. 12; Tav. IX/1)** — 164

MICHELE TOSINI, detto MICHELE DI RIDOLFO DEL GHIRLANDAIO, *La Notte / Night* **(Cat. 13; Tav. XI/2)** — 166

NICCOLÒ PERICOLI detto IL TRIBOLO da MICHELANGELO, *Aurora / Dawn* **(Cat. 14; Tav. VII/3)** — 168

IGNOTO SCULTORE DEL CINQUECENTO da MICHELANGELO, *La Notte / Night* **(Cat. 15)** — 170

ARTISTA DEL NORD ITALIA (?) da MICHELANGELO, *Leda / Leda* **(Cat. 16; Tav. VIII/2)** — 172

attr. a GIOVANNI BATTISTA DI JACOPO detto IL ROSSO FIORENTINO da MICHELANGELO, *Leda / Leda* **(Cat. 17; Tav. IX/3)** — 174

NICOLAS BÉATRIZET da MICHELANGELO, *Leda / Leda* **(Cat. 18)** — 177

attr. ad ANTONIO ALLEGRI detto IL CORREGGIO *Leda / Leda*, **(Cat. 19)** — 178

Leda / Leda, III secolo d. C. / *III Century A. D.* **(Cat. 20)** — 180

MICHELANGELO BUONARROTI, *Studio di gambe / Study of Legs* **(Cat. 21)** — 182

attr. a AGNOLO TORI detto IL BRONZINO, *Ritratto di Dante / Portrait of Dante* **(Cat. 22; Tav. II/1)** — 184

MICHELANGELO-PONTORMO (?), *Venere e Cupido / Venus and Cupid* **(Cat. 23; Tav. II/2 e Tav. III/1-3)** — 187

GIORGIO VASARI, *Sei Poeti Toscani / Six Tuscan Poets* **(Cat. 24; Tav. IV/1)** — 191

attr. a AGNOLO TORI detto IL BRONZINO, *Studio per una testa di Dante / Study for the head of Dante* **(Cat. 25)** — 193

ANONIMO FIORENTINO DEL SETTECENTO da FEDERICO ZUCCARI, *Ritratto di Dante / Portrait of Dante* **(Cat. 26)** — 194

ARTISTA IGNOTO DEL XVI SECOLO da MICHELANGELO, *Venere e Cupido / Venus and Cupid* **(Cat. 27)** — 195

CERCHIA DEL VASARI (HENDRIK VAN DEN BROECK?) su un cartone di MICHELANGELO, *Venere e Cupido / Venus and Cupid* **(Cat. 28)** — 197

MICHELANGELO BUONARROTI, *Venere e Cupido / Venus and Cupid* **(Cat. 29)** — 199

ANONIMO FIORENTINO (?) DEL CINQUECENTO, *Sonetto sopra la Venere e Cupido di Michelangelo e Pontormo / Sonnet on the Venus and Cupid by Michelangelo and Pontormo* **(Cat. 30)** — 201

CERCHIA DI GIORGIO VASARI (?) su un cartone di MICHELANGELO, *Venere e Cupido / Venus and Cupid* **(Cat. 31)** — 197

attr. a FRANCESCO MORANDINI, detto IL POPPI, *Danae / Danae* **(Cat. 32; Tav. XVI/2)** — 204

TIZIANO VECELLIO E BOTTEGA, *Venere e Cupido / Venus and Cupid* **(Cat. 33)** — 206

AGNOLO TORI detto IL BRONZINO, *Venere, Cupido e un Satiro / Venus, Cupid and a Satyr* **(Cat. 34; Tav. XI/1)** — 208

AGNOLO TORI detto IL BRONZINO, *Sopra una Pittura d'una Venere / On a painting of a Venus* **(Cat. 35)** — 211

AGNOLO TORI detto IL BRONZINO - JAN ROST, *Primavera-Venere / Primavera-Venus* **(Cat. 36; Tav. XIII)** — 213

Afrodite su capro / Aphrodite riding a Goat, Età tardo-ellenistica / *Late Hellenistic Age* **(Cat. 37)** — 215

JACOPO CARUCCI detto IL PONTORMO, *Venere e Cupido con i segni zodiacali del Capricorno e dell'Ariete / Venus and Cupid with the Zodiac Signs of Capricorn and Aries* **(Cat. 38)** — 216

JACOPO CARUCCI detto IL PONTORMO, *Madonna che allatta il Bambino / Madonna and Nursing Child* **(Cat. 39)** — 218

JACOPO CARUCCI detto IL PONTORMO, *Venere e Cupido / Venus and Cupid* **(Cat. 40)** — 219

ALESSANDRO ALLORI, *Il Sogno (verso); Ritratto di Bianca Cappello (recto) / The Dream (verso); Portrait of Bianca Cappello (recto)* **(Cat. 41; Tav. XV/1)** — 221

ALESSANDRO ALLORI (?), *Il Sogno / The Dream* **(Cat. 42; Tav. XIV/19)** — 224

ALESSANDRO ALLORI (?), *Venere e Cupido / Venus and Cupid* **(Cat. 43; Tav. XV/2)** — 226

ALESSANDRO ALLORI, *Studio per una Venere e Cupido / Study for a Venus and Cupid* **(Cat. 44)** — 227

INDICE DEI NOMI

INDEX OF NAMES

I numeri in corsivo si riferiscono alle immagini, quelli in neretto alle schede di catalogo intestate al nome relativo. L'indice è riferito al testo italiano dei saggi e delle schede; i riferimenti a "Michelangelo Buonarroti" sono limitati alle schede e alle immagini di opere a lui attribuite.

Numbers in italics refer to images; those in bold refer to catalogue entries attributed to the relative name. The index is limited to the Italian text of the essays and entries; references to "Buonarroti, Michelangelo" are limited to the entries and illustrations of works attributed to him.

Acuto, Giovanni (John Hawkwood) 112
Adimari, famiglia, *15*
Alamanni, Luigi, 79, 87n, 88n, 89n, 174
Alano da Lilla, 107n
Alberti, Leon Battista, 12, 15, 16, 38, 43, 44
Albizzi, famiglia, 10
Alciati, Andrea, 91-93, 97, 102, 106n
Aldobrandini, Ippolito, 224
Alighieri, Dante, *9*, 13-15, 29, 41, 42, *42*, 43, 56, *64*, 65, *66*, 70, 71, *71*, 72, 73, 82, 83n-85n, 88n, *132*, *134*, 184, *184*, 185, 187, 191, *191*, 193, *193*, *194*, 213
Allori, Alessandro, *49*, 53, *53*, 60n, 62, 82, *146-147*, *188*, 197, 208, **221**, 222, *222*, **224**, *225*, **226**, **227**, *227*
Altoviti, Bindo, 197
Ammannati, Bartolomeo, 182
Andrea da Barberino, 86n
Andrea del Sarto (Andrea d'Agnolo *detto*), 156, 162
Anna d'Austria, 174
Antinori, Amerigo, 6, *8*, 65
Apuleio, 80, 103
Aretino, Pietro, 29, 30, 35, 38-40, 48-50, 52, 55, 56, 57n, 59n, 60n, 62, 63, 96, 100, 197
Ariosto, Ludovico, 44, 65, 84n
Aristotele, 73
Armenini, Giovanni Battista, 112
Arrighetti, Tommaso, 154, *155*
Asclepio (Esculapio), 180
Aureliano, Lucio Domizio, 164
Avicenna, 37
Baglioni, Malatesta, 3, 4
Baldini, Vittorio, 87n
Bandinelli, Baccio, 58n
Barbo, Pietro, *vedi* Paolo II
Barnes, Barnabe, 87n
Battiferra, Laura, 185
Béatrizet, Nicola, 172, 175, **177**, 221
Beccafumi, Domenico, 162
Bellini, Giovanni, 174, 185
Bellini, Jacopo, 105n
Bembo, Pietro, 67, 70, 72, 73, 84n, 85n, 88n, 185

Bencivenni, Giuseppe, 154
Benintendi, Giovanni, 6, 9, 19
Benivieni, Antonio, 85n
Benivieni, Girolamo, 48, 62, 69, *69*, 70, 72, 76-78, 80, 85n-87n
Berni, Francesco, 72
Bettini, famiglia, 10-12, *10*, *11*, 23n
Bettini, Bartolomeo (Baccio), 3-19, 21n, 23n, 24n, 28, 29, 40-42, 44, 45, 47, 50, 56, 58n, 60n, 65, 66, 70, 72, 73, 75, 84n, 115, 117, 119, 157, 161, 184, 185, 187, 191, 193-195, 201, 206
Bettini, Domenico, 22n
Bettini, Giovanni Maria, 22n
Bettini, Girolamo, 185
Bettini, Jacopo, 11, 23n
Bettini, Lionardo di Zanobi, 11, 23n
Bettini, Luca, 23n
Bianchi, Giuseppe, 154
Boccaccio, Giovanni, 13-15, 41, 44, *64*, 66-68, *66*, 70, 73, 82, 83n, 98, 164, 184, 185, 187, 191, *191*
Bocchi, Francesco, 38, 40, 48, 166
Boiardo, Matteo Maria, 107n
Boni, Bono, 23n
Borgherini, Pierfrancesco, 6, 9, 19
Borghini, Raffaello, 70, 84n, 208, 226
Boschetti, Isabella, 107n
Botticelli, Sandro (Alessandro Filipepi *detto*), *16*, 18, *133*, 157
Brescianino, Andrea del (Andrea Piccinelli, *detto*), 30, 63, *148*, 152, **162**, *163*
Brina, Francesco, 50, *51*, 166, 197
Broek, Hendrik Van den, *vedi* Van den Broek, Johannes Hendrik
Bronzino, Agnolo (Agnolo di Cosimo Tori *detto* il), 3, 5-9, *8-10*, 11, 13, 14, 19, 23n, 29, 42, *42*, 53, *54*, 65, 70, *71*, 80-82, *80*, *81*, 84n, 85n, 98, *98*, 99, 102-104, *134*, *143-145*, 148, *149*, 150, 166, 182, **184**, 185, 187, 191, **193**, 194, 197, 201, **208**, *210*, **211**, *213*, 215, 216, 219, 222, 224, 226, 227
Bugiardini, Giuliano, 166
Buonaccorsi, Giuliano, 174

Buonarroti, Filippo, 201
Buonarroti, Lionardo, 12
Buonarroti, Michelangelo, *vedi* Michelangelo Buonarroti
Busini, Giovambattista, 13, 60n
Calcagni, Tiberio, 164
Calmeta, Vincenzo, 37
Cambini, famiglia, 5
Cappello, Bianca, 222, *222*, 226, 227
Capponi, Niccolò, 3
Caravaggio (Michelangelo Merisi *detto* il), 91, *92*
Carlo V, 3, 18, 100, 178
Carlo VIII, *11*
Caro, Annibal, 21n, 29, 57n, 60n
Carucci, Jacopo, *vedi* Pontormo
Cartari, Vincenzo, 39, 40, 60n, 87n
Castellani, Tommaso, 88n, 89n
Castiglione, Baldassarre (Baldesar), 7, 37
Cavaceppi, Bartolomeo, 170
Cavalcanti, Guido, 62, *64*, 66, *66*, 67, 69, 75, 83n, 84n, *134*, 191, *191*
Cavalcanti e Giraldi, società, 12
Cavalieri, Tommaso de', 34, 48, 60, 74, 79, 158, 164, 201, 222
Cellini, Benvenuto, 5, 42, 96, 211
Cennini, Cennino, 60n, 109, 110, 115, 121n
Cicerone, Marco Tullio, 48, 73
Cinelli, Giovanni, 154
Cino da Pistoia, 67, 83n, 84n, 191
Clemente VII (Giulio de' Medici), 4-6, 12, 18, 72, 168, 185
Clovio, Giulio, 164
Colonna, Fabrizio, 208
Colonna, Francesco, 204
Colonna, Stefano, 3
Colonna, Vittoria, 201
Correggio (Antonio Allegri *detto* il), 95, *98*, 100, 172, 175, 178, 204
Cranach, Lucas, il Vecchio, 157
Crashaw, Richard, 87n
Daniele da Volterra (Daniele Ricciarelli *detto*), 172, 182
d'Avalos, Alfonso, 5, 21n, 28
Davanzati, Alessandro, 13, 41, 65
de Bos, Cornelius, 172, 175, 177
de Greyss, Benedetto, 154

del Bene, Benedetto (Bettino), 172, 174
del Pozzo, Cassiano, 175
del Riccio, Luigi, 74
Delacre, Maurice, 156
Delaune, Étienne, 172, 175, 177
della Casa, Giovanni, 73
della Rovere, famiglia, 6, 7
della Rovere, Guidobaldo II, 7, *8*, 55
Delli, Dello, 15
Demostene, 73
Giovanni Battista di Jacopo, *vedi* Rosso Fiorentino
Dino del Garbo, 68
Dolce, Ludovico, 33, 34, 37, 59n, 60n, 160
Dolci, Carlo, 185, 194
Domenico di Michelino, 70, *71*, 193
Donatello (Donato de' Bardi di Niccolò *detto*), 96
Doni, Anton Francesco, 38, 59n
Dürer, Albrecht, 106n
Equicola, Mario, 34
Erasmo da Rotterdam, 107n
Este, Alfonso I d', 51, 172, 174
Este, Ercole II d', 107n
Este, Isabella d', 15
Euripide, 180
Farnese, famiglia, 56, 195
Farnese, Alessandro, *vedi* Paolo III
Farnese, Orazio, 58n
Farnese, Ottaviano, 55, 180
Ficino, Marsilio, 48, 49, 62, *64*, 66, 67, *67*, 68, 69, 75, 76, 78, *134*, 191, *191*
Figiovanni, Giovanni Battista, 168
Filipepi, Alessandro, *vedi* Botticelli, Sandro
Firenzuola, Agnolo, 31-33, 38, 48, 58n, 79, 87n, 107n
Florio, John, 53
Forni, Ulisse, 187
Francesco I di Francia, 100, 172, 174, 175
Franco, Battista, 158, *159*, 187, 221
Fugger, Michael, 182
Galilei, Galileo, 70, 84n
Gandini, Giorgio, 178
Gatti, Bernardino, 178
Gelli, Giambattista, 83n

Ghirlandaio, Domenico (Domenico Bigordi *detto* il), 191
Ghirlandaio, Michele di Ridolfo (Michele di Ridolfo Bigordi *detto* del), 69, *141-143*, 166
Giambullari, Bernardo, 70, 75
Giannotti, Donato, 70, 74, 84n
Giorgione (Giorgio Zorzi *detto*), 18, 164, 206
Giottino (Giotto di maestro Stefano *detto*), 110
Giovanna d'Austria, 82, 211
Giovanni da Milano, 110
Giovanni di Lorenzo, 162
Giovanni di Ser Giovanni, *vedi* Scheggia
Giovio, Paolo, 66, 67, 83n, 185, 191
Girolamo del Pacchia, 162
Girolamo da Monferrato, 178
Giulio Romano (Giulio Pippi *detto*), 33, 95, *95*, 96, 100, 104, 178
Gondi, Benedetto, 61
Gonzaga, Federigo, 100, 107n
Gorga, Evan, 170
Granacci, Francesco, *11*
Grazzini, Anton Francesco, *vedi* Lasca
Grimani, famiglia, 94
Guardi, Francesco, 6
Guicciardini, famiglia, 12
Guidotti, famiglia, 5
Guinizzelli, Guido, 88n
Guittone d'Arezzo, 66, 67, 83n, 84n, 191
Hurtado de Mendoza, Diego, 197
Jacopo del Caraglio, 106n
Jonson, Ben, 87n
Lafréri, Antonio, 221, 224
Landino, Cristoforo, 66, 69, 70, 78, 83n, *134*, 191
Lanzi, Luigi, 148
Lasca (Anton Francesco Grazzini *detto* il), 60n, 83n
Leonardo da Vinci, 58n, 112, 164
Leone X (Giovanni de' Medici), 9, 12
Leoni, Francesco, 52, 53, 197
Leonicino, Niccolò, 107n
Ligorio, Pirro, 33, 37
Lisippo, *90*, 94, *94*, 95
Lock, William, the Elder, 175
Lodovico il Moro (Ludovico Sforza *detto*), 87n
Lomazzo, Gian Paolo, 37, 43
Lorenzo di Credi, 86n
Lotto, Lorenzo, 18, *19*
Luciano di Samosata, 204
Luigini, Federico, 32
Machiavelli, Niccolò, 83n
Malvezzi, Matteo, 22n
Manetti, Antonio, 70
Mantegna, Andrea, 164
Margherita d'Austria, 4, 180
Mariette, Pierre Jean, 199
Marot, Clement, 87n
Martelli, Niccolò, 36, 41, 60n
Martini, Luca, 13, 24n, 29, 41-43, 60, 65-67, 70, 72, 73, 83n, 84n, 88n, 185, 191, 222

Masaccio (Tommaso di Ser Giovanni Cassai *detto*), 49
Maturanzio, Francesco, 87n
Medici, famiglia de', 3-6, 9, 10, 13, 14, 18, 60n, 78, 180, 213
Medici, Alessandro de', 3, 4, *4*, 5, 6, 21, 22n, 42, 50, 57n, 168, 180, 185, 187
Medici, Cosimo I de', 13, 78, 80, 81, 85n, 96, 148, 208, 211, 213, 215, 216
Medici, Cosimo II de', 206
Medici, Eleonora de', 85n
Medici, Francesco I de', 82, 204, 213, 215, 216, 222, 224, 226, 227
Medici, Giovanni de', *vedi* Leone X
Medici, Giuliano de', duca di Nemours, 37, 39, 59n, *74*, 78, 152, 154, 168, 185
Medici, Giulio de', *vedi* Clemente VII
Medici, Leopoldo de', 148
Medici, Lorenzino de', 4
Medici, Lorenzo de', il Magnifico, 4, 5, *49*, 66, 67, 68, *68*, 78, 180, 211, 213, 215, 216
Medici, Lorenzo II de', duca di Urbino, *37*, 75, 152, 168, 170
Medici, Ottaviano de', 51-53, 197, 218
Mendoza, Diego, *vedi* Hurtado de Mendoza, Diego
Merisi, Michelangelo, *vedi* Caravaggio
Michelangelo Buonarroti, 7, *26*, 30-37, *39-41*, 43-45, 47, 49, 74-76, 79, *134-135*, *136-142*, 146, **150**, **152**, **154**, **156**, *158*, *159*, *164*, *165*, *168*, **170**, *171*, **172**, **174**, **177**, *179*, **182**, *183*, **187**, *189*, **195**, **197**, **199**, *200*, **203**, *223*
Michele di Ridolfo del Ghirlandaio (Michele Tosini *detto*), 44, 50, 57n, **164**, **166**, *167*, 188, 197, *198*, 208, *210*, 226
Milan, Pierre, *100*
Mini, Antonio, 152, *152*, *156*, 172, 174, 175, 178, 195
Morandini, Francesco, *vedi* Poppi
Mosco, 42, 46, 47, 50, 75-79, 80, 82, 86n-89n, 97-99, 102, 106n, 107n
Neroni, Carlo, 6
Nifo, Agostino, 57n
Omero, 61, 73
Orazio, 204
Orsini, Paolo Giordano, 56, 195, 206
Ovidio Nasone, Publio, 18, 45, 46, 53, 75, 80, 88n, 102-104, 204
Palma il Vecchio (Jacopo Negretti *detto*), 18, *18*, 199, *200*
Paolo II (Pietro Barbo), 180
Paolo III (Alessandro Farnese), 4, 12
Paolo Uccello (Paolo di Dono *detto*), 112
Parmigianino (Francesco Mazzola *detto* il), 94, *94*, 100
Pausania, 94, 95
Pazzi, famiglia, 10
Pelotti, Antonio, 87n

Pericoli, Niccolò, *vedi* Tribolo
Perin del Vaga (Pietro Bonaccorsi *detto*), 106n
Perini, Gherardo, 158, 164
Pesellino (Francesco di Stefano *detto*), 97, *97*
Petrarca, Francesco, 13-15, 41, *64*, 66, *66*, 67, 68, 70, 72, 73, 80, 82, 83n, 84n, 97, 98, 102, 106n, 107n, *134*, 184, 185, 187, *191*
Petrucci, Francesco, 162
Pico della Mirandola, 48, 62, 69, 72, 78, 79, 87n
Pico della Mirandola, Giovanni Francesco, 221
Pierino da Vinci (Pier Francesco di Bartolomeo *detto*), 13, 152
Piero di Cosimo (Piero di Lorenzo *detto*), *17*, 18, *133*
Platone, 67, 72, 75, 93
Plinio, Secondo Gaio, *detto* Plinio il Vecchio, 44, 45
Plotino, 93
Poliziano, Angelo (Agnolo Ambrogini, *detto* il, 66, 68, 76-78, 86n, 87n
Pontormo (Jacopo Carucci *detto* il), 3, 5-9, *6-8*, 11, 14, 19, *20*, 21n-23n, *26*, 27-30, 42, 44-46, 49, *49*, 50, 55, 57n, 66, 72, 73, 75, *76*, 79-81, 79, 91, 96, 98, 100-104, 108n, 115, 119, *134-135*, *140*, 161, 166, 172, 184, **187**, 188, 189, 195, 197, 199, 201, 208, *210*, 211, 213, **216**, *217*, **218**, *218*, **219**, *220*, 222, *223*, 224, 226
Poppi (Francesco Morandini *detto* il), *148*, **204**
Portinari, Beatrice, 85n
Prassitele, 44, 45, 95, 96, 106n, 148, 150, 201
Primaticcio, Francesco, 157, 204
Properzio, Sesto, 78-80, 87n
Quaratesi, Andrea, 158
Quintiliano, Marco Fabio, 43
Raffaello da Montelupo (Raffaele Sinibaldi *detto*), 158
Raffaello Sanzio, 33, 35, 39, 100, 103, 112, 158, 160, 162, 191
Raimondi Marcantonio, 33, **160**, 178
Rosso Fiorentino (Giovan Battista di Jacopo *detto*, 100, *100*, 102, 106n, *140*, 158, **81**, *145*, **213**, *213*
Rost, Jan, 81, *145*, **213**, *213*
Rubens, Pieter Paul, 199
Rugasso, Domenico, 58n
Salviati, famiglia, 9
Salviati, Alamanno, 166, 208, 226
Salviati, Anton Maria, 208
Salviati, Caterina Zeffirina, 208
Salviati, Francesco, 62n, *139*, 157, **158**, 204
Salviati, Jacopo, 166, 208
Sannazzaro, Jacopo, 78, 87n-89n
Sansovino, Francesco, 184, 194
Savonarola, Girolamo, 5, 78
Scaligero, Giulio Cesare, 94

Scheggia (Giovanni di Ser Giovanni *detto* lo), *15*, 17
Sebastiano del Piombo (Sebastiano Luciani *detto*), 35, 49, 108n, 185
Segni, Bernardo, 4
Sforza, Francesco II, 89n
Sforza, Lodovico, *vedi* Lodovico il Moro
Shakespeare, William, 53, 63n
Sisto IV (Francesco della Rovere), 180
Sodoma (Giovan Antonio Bazzi *detto* il), 58n
Spenser, Edmund, 87n
Speroni, Sperone, 38
Stimmer, Tobias, 185
Strozzi, Agostino, 37, 59n
Strozzi, Carlo, 73
Suidas, 60n
Tasio, Baccio, 13, 65, 83n
Tasso, Torquato, 78, 87n, 88n
Teocrito, 87n
Terenzio Afro Publio, 52
Tetius, Hyeronimus, 221
Timoteo, 180
Tiziano Vecellio, 7, 29, 30, 33, 50, 55, *55*, 56, 164, 174, 199, 204, **206**
Tori, Agnolo, *vedi* Bronzino
Tosini, Michele, *vedi* Michele di Ridolfo del Ghirlandaio
Tribolo (Niccolò Pericoli *detto* il), 42, 80, *139*, 152, 154, **168**, 170
Ubaldini, famiglia, 22n
Uberto, Sebastiano, 21n
Valeriano, Publio Licinio, 60n
Valori, famiglia, 10
Valori, Baccio, 22n, 226
Van den Broek, Johannes Hendrik, *56*, *137*, **197**
Van der Straet, Jan (Giovanni Stradano), *2*
Van Heemskerck, Maarten, 53, *54*
Varchi, Benedetto, 4, 10, 13, 14, 21n, 24n, 28, 29, 34, 40-45, 48, 60, 65, 70, 72-75, 79, 80, 82, 84n, 85n, 88n, 89n, 96-99, 102, 107n, 185, 201, 211, 213, 221, 222
Vasari, Giorgio, *2*, 3, 4, *4*, 6, 7, 13-15, 21n, 28-30, 35, 43, 49, 51-53, *52*, 55, 56, *56*, 57n, 62, 63, *64*, 65-67, *66*, *67*, *68*, 70, 82, 83n, 84n, 100, 102, 109, 112, 115, *136*, *137*, *146*, 154, 160, 164, 166, 168, 174, 175, 178, 182, 184, 185, 188, **191**, 195, **197**, 199, **203**, **206**, **208**
Verrocchio (Andrea di Cione *detto* il), 77, *77*, 86n
Vespucci, Simonetta, 78
Virgilio (Publio Virgilio Marone), 73, 191
Vitelli, Alessandro, 8, 22n
Vitruvio Pollione, 43
Wechel, Christian, 106n
Zati, famiglia, 5
Zenoe, Antonio, 86n
Zuccari, Federico, **194**
Zucchi, Jacopo, 204
Zufolina, 57n, 60n